S0-AJB-826

Years ago, someone who was twenty-three in 1900 gave me an inkling of what Art Nouveau meant for his generation. I was speaking against it to my uncle Jean Schlumberger when he retorted: "We were suddenly discovering nature. It was spring, plants shooting everywhere . . . we felt a vitality, an enthusiasm. Ma petite, you cannot imagine what it was like!"

Dominique de Menil

Exhibition Dates

Rice Museum, Houston
March 26, 1976, to June 27, 1976

The Art Institute of Chicago
August 28, 1976, to October 31, 1976

ART NOUVEAU BELGIUM FRANCE

Catalogue of an Exhibition
Organized by the Institute for the Arts,
Rice University, and
The Art Institute of Chicago

Yvonne Brunhammer et al.

· · 3445

INSTITUTE FOR THE ARTS, RICE UNIVERSITY, 1976

Copyright © 1976 by the Institute for the Arts, Rice University,
P.O. Box 1892, Houston, Texas 77001. First paperback and
clothbound editions published in 1976.
Library of Congress Catalogue Card Number: 76-1649
ISBN: 0-914412-11-6 (pbk.)
ISBN: 0-914412-10-8 (cloth)
Printed and bound in the United States of America.

All rights reserved. No part of this publication may be reproduced or
transmitted in any form or by any means, electronic or mechanical,
including photocopy, recording, or any information storage and
retrieval system, without permission in writing from the publisher.

Photo Credits. All photographs except those listed below are
courtesy of the respective lenders. Other photographs,
identified by catalogue numbers, or by page numbers when not
in the exhibition, are credited as follows: A.C.L., Brussels,
346, 479, 487, 553, 554, 556; Archives d'Architecture
Moderne, Brussels, 520–52, 557–80, p. 323, pp. 327–28, p.
330; Bulloz, Paris, 11; Maurice Gorégues, Paris, p. 267;
Hickey and Robertson, Houston, 319, 411, 628–32, 634–91,
693–99, 706–11, 714–22, 724–29, 732–33; Laurent Sully
Jaulmes, Paris, 1, 16, 28, 30–33, 35, 44–45, 48, 68–70,
156, 198, 208, 215–16, 219, 225, 268, 287–88, 292, 303,
308, 313, 352, 355–58, 363–65, 371, 393, 409, 414, 416,
424, 439, 453, 488, 581–90, 595–609, 611–12, 615–16,
616 (color), 619, 620, 625, 633, 692, 700–705, 712–13,
723, 730–31, p. 404; Marilyn M. Jones, Houston, 5, 66, 96;
Photographie Giraudon, Paris, 30 (color); Allen Mewbourn,
Houston, 39, 175, 178–80, 181, 323, 339, 341, 419, 432,
454; Tornes Mock, Houston, 3, 12, 364; Musées Nationaux de
France, 19, 21, 99; Nathan Rabin, New York, 4, 194, 217,
229, 252, 428, 429; Secrétariat d'Etat à la Culture,
Commission Regionale d'Inventaire de Lorraine, 591–94;
Photo d'Art Speltdoorn, Brussels, 50, 77, 238, 248,
250, 297, 304, 305, 334, 388–90, 436, 462, 465,
466, 475, 476, 505, 512, 516, 517, 519; Taylor and Dull,
New York, 163, 183, 184, 186, 437, 438, 444.

Design: Arnold Skolnick
Composition: Zimmering and Zinn
Production: Catherine Crompton, Kathryn Chandler
Black-and-white Printing: The Meriden Gravure Company
Color Printing: Rapoport Printing Corporation
Binding: Tapley-Rutter Company

Contents

Acknowledgments

A comprehensive exhibition such as this, and its catalogue, require contributions both numerous and diverse in nature, and these came from many dedicated and talented people. Credit goes first to Yvonne Brunhammer, Conservateur, Musée des Arts Décoratifs, Paris, in charge of late 19th- and 20th-century collections, who brought to the project her extensive knowledge of the period and her enthusiasm. She helped shape the exhibition, directed us to the collectors and the museums, collaborated in the selection of the pieces, and made a large contribution to the catalogue. Susan Barnes, staff researcher at Rice, worked closely with her, taking major responsibility for the research and arranging the loans—she was the driving force behind the exhibition. Molly Kelly, editor at Rice, assumed the responsibility of organizing and editing the catalogue material.

The scope and quality of the exhibition are in large part due to the Musée des Arts Décoratifs, Paris, and to François Mathey, Conservateur en Chef, who lent to the exhibition with exceptional generosity. The help and cooperation of the following were invaluable: Marie-Noëlle de Gary, Conservateur; Nadine Gasc, Conservateur; Anne-Marie Cotoni, Secrétaire de la Conservation; Sonia Edard, Chargé du Service Photographique.

Most of the research was done at the Bibliothèque des Arts Décoratifs in Paris. We extend here special thanks to Geneviève Gaëtan Picon, to Geneviève Bonté, and to the staff for the exceptional services that they provided.

A great debt is owed to Francis de Lulle and Catherine de Croës of the Service de la Propagande Artistique, Ministère de la Culture Française of Belgium, who were responsible for organizing the Belgian loans, photographing the pieces, and packing them for shipment.

Special thanks are also due to Monsieur and Madame Wittamer—de Camps for their generous loans and their unfailing support, and to Claire Maurice-Denis for her kind and efficient assistance.

We would further like to acknowledge the help of the following: William Agee, Director, The Museum of Fine Arts, Houston; Emilio Ambasz, Curator of Design, The Museum of Modern Art, New York; Donald Anderle, Chief, Art and Architecture Division, The New York Public Library; Dennis R. Anderson, Curator, Chrysler Museum at Norfolk; Elizabeth Aslin, Director, Bethnal Green Museum, London; Sigrid Barten, Konservator, Museum Bellerive, Zürich; Gerhard Bott, former Direktor, Hessisches Landesmuseum, Darmstadt; Robert Brill, Director, The Corning Museum of Glass; Riva Castleman, Curator of Prints, The Museum of Modern Art, New York; Phillip Dennis Cate, Director, Rutgers University Fine Arts Collection; Ann Chevalier, Conservateur Adjoint, Musée de l'Art Wallon, Liège; Walter P. Chrysler, Jr., Director, Chrysler Museum at Norfolk; Maurice Culot, Directeur, Archives d'Architecture Moderne, Brussels; L. Daenens, Conservateur, Museum voor Sierkunst, Ghent; Maurice Daumas, Professeur, Musée des Techniques, Conservatoire National des Arts et Métiers, Paris; Mrs. Leo J. Dee, Curator of Drawings and Prints, Cooper-Hewitt Museum of Design, Smithsonian Institution, New York; R. de Roo, Conservateur en Chef, Musées Royaux d'Art et d'Histoire, Brussels; Franz-Adrian Dreier, Direktor, Kunstgewerbemuseum Staatliche Museen Preussischer Kulturbesitz, Berlin; Arthur Drexler, Director, Department of Architecture and Design, The Museum of Modern Art, New York; Cécile Dulière, Conservateur, Musée Horta, Brussels; Joy Feinberg, Curator of Collections, University Art Museum, Berkeley; Miss Y. T. Feng, Assistant Director for Research Library Services, Boston Public Library; Wen Fong, Special Consultant for Far Eastern Affairs and Far Eastern Art, The Metropolitan Museum of Art, New York; Lucien François, Bibliothécaire de l'E.N.S.A.A.V., Brussels; Anna-Christa Funk, Geschäftsführerin, Henry-van de Velde-Gesellschaft, Hagen; Herman H. Fussler, Director, The University of Chicago Library; Eleanor Garvey, Curator, Department of Printing and Graphic Arts, Houghton Library, Harvard University, Cambridge; Norah C. Gillow, Assistant-in-Charge, William Morris Gallery, London Borough of Waltham Forest; Ludwig Glaeser, Curator, The Museum of Modern Art, New York; Charles E. Greene, Keeper of the Rare Book Reading Room, Princeton University Library; Bernd Hakenjos, Konservator, Hetjens-Museum, Deutsches Keramikmuseum, Düsseldorf; Erika Gysling-Billeter, former Konservator, Museum Bellerive, Zürich; John Harris, Curator, Royal Institute of British Architects, London; Carl B. Heller, Konservator, Hessisches Landesmuseum, Darmstadt; James Henderson, Chief of Re-

search Libraries, The New York Public Library; J. Hendrick, Conservateur, Musée de l'Art Wallon, Liège; Suzanne Henrion-Giele, former Conservateur, Musée Horta, Brussels; Helmut Hentrich, Düsseldorf; Kathryn B. Hiesinger, Associate Curator, Decorative Arts after 1700, Philadelphia Museum of Art; J. G. A. Hoole, Assistant Keeper of Art, Southampton Art Gallery; Thomas Hoving, Director, The Metropolitan Museum of Art, New York; Anthony Howarth, Assistant Director of Leisure Services, City of Southampton; Pontus Hulten, Directeur des Arts Plastiques, Centre National d'Art et de Culture Georges Pompidou, Musée National d'Art Moderne, Paris; Colta Feller Ives, Associate Curator, Acting-in-Charge, Department of Prints and Photographs, The Metropolitan Museum of Art, New York; Harold Joachim, Curator, Prints and Drawings, The Art Institute of Chicago; Stewart Johnson, Curator of Decorative Arts, Cooper-Hewitt Museum of Design, Smithsonian Institution, New York; William R. Johnston, Assistant Director, The Walters Art Gallery, Baltimore; L. Lindsey Jones, Curator of Decorative Arts, Chrysler Museum at Norfolk; Albert Klein, Direktor, Hetjens-Museum, Deutsches Keramikmuseum, Düsseldorf; Brigitte Klesse, Direktor, Kunstgewerbemuseum der Stadt Köln; Dwight P. Lanmon, Curator of European Glass, The Corning Museum of Glass; René Le Bihan, Conservateur, Musée Municipal, Brest; John Palmer Leeper, Director, The Marion Koogler McNay Art Institute, San Antonio; John G. Lorenz, Acting Librarian of Congress, The Library of Congress; A. M. Mariën, Conservateur, Musées Royaux d'Art et d'Histoire, Brussels; Edward Mayo, Registrar, The Museum of Fine Arts, Houston; Marceline McKee, Assistant for Loans, The Metropolitan Museum of Art, New York; Philip J. McNiff, Director, Boston Public Library; Robert C. Moeller III, Curator, Museum of Fine Arts, Boston; Barbara Mundt, Konservator, Kunstgewerbemuseum Staatliche Museen Preussischer Kulturbesitz, Berlin; Annaliese Ohm, Direktor, Museum für Kunsthandwerk, Frankfurt; Richard E. Oldenburg, Director, The Museum of Modern Art, New York; Jean Paladilhe, Conservateur, Musée Gustave Moreau, Paris; Jacques Payen, Maître Assistant, Musée des Techniques, Conservatoire National des Arts et Métiers, Paris; Howardena Pindell, Assistant Curator, Department of Prints and Illustrated Books, The Museum of Modern Art, New York; Olga Raggio, Chairman of Western European Arts, The Metropolitan Museum of Art, New York; Richard H. Randall, Jr., Director, The Walters Art Gallery, Baltimore; Helmut Ricke, Kustoden, Kunstmuseum Düsseldorf; Robert Rosenthal, Curator, Special Collections, The University of Chicago Library; Elizabeth Roth, Keeper of Prints, The New York Public Library; Kent Sabotik, Chief Curator, The Museum of Fine Arts, Houston; Herbert J. Sanborn, Exhibits Officer, The Library of Congress; Carl-Wolfgang Schümann, Konservator, Kunstgewerbemuseum der Stadt Köln; Laurence Sickman, Director, Nelson Gallery-Atkins Museum, Kansas City; Claude Simon, Directeur, Galerie d'Art, Namur; Penelope Hunter Stiebel, Assistant Curator of Western European Arts, The Metropolitan Museum of Art, New York; Lisa Taylor, Director, Cooper-Hewitt Museum of Design, Smithsonian Institution, New York; Richard L. Tooke, Supervisor, Rights and Reproductions, The Museum of Modern Art, New York; Germain Viatte, Conservateur en Chef, Centre National d'Art et de Culture Georges Pompidou, Musée National d'Art Moderne, Paris; Jacqueline Viaux, Conservateur en Chef, Bibliothèque Forney, Paris; Mary Jane Victor, Assistant Curator, Menil Foundation Collection, Houston; Wend von Kalnein, Direktor, Kunstmuseum Düsseldorf; Axel von Saldern, Direktor, Museum für Kunst und Gewerbe, Hamburg; David B. Warren, Associate Director, The Museum of Fine Arts, Houston; James Wells, Associate Director, The Newberry Library, Chicago; Gilbert Weynans, L'Ecuyer, Brussels; Marc F. Wilson, Curator of Chinese Art, Nelson Gallery-Atkins Museum, Kansas City; Martin Wittek, Conservateur en Chef, Bibliothèque Royale Albert Ier, Brussels.

Distinguished scholars and specialists contributed essays to the catalogue, and in many cases additional material that appears in the documentation and biographical entries. Included are Victor Beyer, Conservateur en Chef, Département des Sculptures, Musée du Louvre; Alain Blondel and Yves Plantin of the Galerie du Luxembourg, Paris, who are preparing the catalogue raisonné of Guimard; Yvonne Brunhammer; Maurice Culot, Directeur of the Archives d'Architecture Moderne, Brussels; François Loyer, architectural critic and historian teaching at Rennes; Jacques-Grégoire Watelet, O.P., art historian whose particular field is Belgian Art Nouveau architecture and furniture; Alain Weill, Conservateur, Bibliothèque des Arts Décoratifs, Paris, in charge of the poster collection. Peter A. Wick, Eleanor M. Garvey, and Anne Blake Smith kindly allowed us to reprint selections from their catalogue *The Turn of a Century, 1885–1910: Art Nouveau–Jugendstil Books.*

W. G. Ryan translated all of the essays from the French; his exceptional gifts preserved the idiosyncrasies of the authors and provided easily readable texts. Cheryl Casey, staff assistant at Rice, translated from the French the great amount of information on the works and the many biog-

raphies of the artists and architects. William M. Montgomery and Gary Smith translated some important source material from the German.

We received scholarly advice and assistance from the following: Jean d'Albis, Laurens d'Albis, Chantal Bizot, Ralph Culpepper, Pie Duployé, Martin Eidelberg, Raphael Esmerian, Ralph Esmerian, Fance Franck, Jean-Claude Graissard, Laurent Jaulmes, Donald Karshan, Robert Koch, Shelby Miller, and Antonio Santos.

The preparation of biographies of the artists drew on the collective efforts of the staff at Rice, the contributors of the catalogue essays, and other scholars and researchers. The entire roster of persons involved in the compiling and writing of biographies is as follows: Susan J. Barnes, Sigrid Barten, Rachel Berry, Chantal Bizot, Yvonne Brunhammer, Cheryl W. Casey, Christine Castelnau, Maurice Culot, Sandra Curtis, Robert-L. Delevoy, Martin Eidelberg, Bernd Hakenjos, Jacques-Grégoire Watelet, and Alain Weill. Heidi Renteria, consultant to the staff at Rice, organized all information and documents, and compiled the bibliography and the index.

Harris Rosenstein, Administrator of the Institute for the Arts at Rice, was editorial and publishing executive for the catalogue. He brought to a most complex task his indefatigable energy and great professional ability. Arnold Skolnick designed the catalogue and provided important services in the production.

In the organizing phases of the exhibition, many of the same people and others participated. They include Sandra Curtis, Registrar of the Institute for the Arts at Rice; Karen Knecht, Staff Assistant of the Institute for the Arts; Cheryl Casey; and Heidi Renteria.

Paul Winkler drew the plans of the installation at the Rice Museum. Construction was carried out by Jesse Lopez, Production Manager at Rice, assisted by A. C. Conrad, Bernard Pendergraft, Gary "Bear" Parham, Hobert Wesley III, Goran Milutinovic, and Debra Watson.

Other Houston support came from Jocelyn Austin, Rachel Berry, Katherine Brown, William Camfield, Karen Coffey, Elsian Cozens, Geri Edwards, Philip Oliver-Smith, Walter Widrig, and Dadi Wirz. In New York we had help from Simone Swan and Candace Marie Albertal.

It was a great pleasure working with John Keefe, Curator of Decorative Arts of The Art Institute of Chicago. He provided invaluable encouragement by his interest in the exhibition in its formative stages. Most important too were the support and understanding of E. Lawrence Chalmers, President of The Art Institute of Chicago, and John Maxon, Vice President for Collections and Exhibitions.

Dominique de Menil, Director
Institute for the Arts, Rice University

Lenders to the Exhibition

Archives d'Architecture Moderne, Brussels
Archives Henry van de Velde, E.N.S.A.A.V., Brussels
The Art Institute of Chicago
Bibliothèque des Arts Décoratifs, Paris
Bibliothèque Forney, Paris
Bibliothèque Royale Albert Ier, Brussels
Blondel and Plantin Collection, Paris
Dr. Maxine T. Brillhart, Kansas City
Mr. and Mrs. James Caldwell
Cazalis-Sorel Collection, Paris
Centre National d'Art et de Culture Georges Pompidou, Musée National d'Art Moderne, Paris
J. P. Christophe, Paris
Chrysler Museum at Norfolk
Cooper-Hewitt Museum of Design, Smithsonian Institution, New York
The Corning Museum of Glass
J. and F. d'Albis Collection, Limoges
Jean Delhaye, Brussels
D. & J. de Menil Collection, Houston
Collection Dominique Maurice-Denis
Gertrud and Dr. Karl Funke-Kaiser Collection, Cologne
Galerie d'Art, Namur
Galerie du Luxembourg, Paris
Harvard College Library, Department of Printing and Graphic Arts, Cambridge
Henry-van de Velde-Gesellschaft, through the Karl Ernst Osthaus Museum, Hagen
Collection Hentrich, on loan to the Hetjens-Museum, Deutsches Keramikmuseum, Düsseldorf
Hessisches Landesmuseum, Darmstadt
Laurence and Barlach Heuer, Paris
Maria and Dr. Hans-Jörgen Heuser, Marxen am Berge
Edwin Janss, Jr., Thousand Oaks, California
Lenoir M. Josey, Inc., Houston
Kunstgewerbemuseum Staatliche Museen Preussischer Kulturbesitz, Berlin
Kunstmuseum Düsseldorf, Collection Hentrich
L'Ecuyer, Brussels
Gérard Lévy Collection, Paris
Sydney and Frances Lewis Collection
The Library of Congress
Collection Félix Marcilhac, Paris
McNay Art Institute, San Antonio

Menil Foundation, Houston
The Metropolitan Museum of Art, New York
Musée de l'Art Wallon, Liège
Musée des Arts Décoratifs, Paris
Musée des Beaux-Arts, Brest
Musée Gustave Moreau, Paris
Musée Horta, Commune de Saint-Gilles, Brussels
Musée Symbolistes et Nabis, Saint-Germain-en-Laye
Musée des Techniques, Conservatoire National des Arts et Métiers, Paris
Musées Royaux d'Art et d'Histoire, Brussels
Musées Royaux d'Art et d'Histoire, Bibliothèque, Brussels
Museum Bellerive, Collection of the Kunstgewerbemuseum, Zürich
The Museum of Fine Arts, Houston
Museum für Kunst und Gewerbe, Hamburg
The Museum of Modern Art, New York
Museum voor Sierkunst, Ghent
Lillian Nassau, New York
Nelson Gallery—Atkins Museum, Kansas City
The Newberry Library, Chicago
The New York Public Library, Art and Architecture Division
Collection Michel Périnet, Paris
Princeton University Library
Trustees of the Public Library of the City of Boston
Royal Institute of British Architects, London
Rutgers University Fine Arts Collection, New Brunswick, New Jersey
Mr. and Mrs. Derald H. Ruttenberg
Mr. and Mrs. Herbert D. Schimmel
Southampton Art Gallery
Collection Magda Taylor, on loan to The Corning Museum of Glass
Mr. and Mrs. Trillat-Felgères, France
University Art Museum, Berkeley
The University of Chicago Library
Mme. Robert Walker, Paris
The Walters Art Gallery, Baltimore
Dr. Siegfried Wichmann, Starnberg
William Morris Gallery, London Borough of Waltham Forest
L. Wittamer—de Camps, Brussels
Marcel Wolfers, Vieusart

Introduction

The study of Art Nouveau calls for two different approaches. One is through art history, and seeks to determine the external factors leading to the formation of the style considered as a phase of history. The other concerns what might be called its ethic and its aesthetic, and probes the psychology underlying the style.

Much has been written about Art Nouveau in recent years to account for its wide diffusion and the brevity of its life-span, and to identify its many sources. But art history, rationalistic and formalistic as it is, could not be expected to get into the realm of existential determinations. There is nothing surprising about this: the apparent contradictions of Art Nouveau can hardly be resolved by the methods of contemporary historical research. Art Nouveau became a fad, but also a style; it spread over wide areas; there was something of aesthetic affectation in it, yet it also reflected social awareness and concern; and in twenty years it disappeared. It might be objected that the situation of the art of 1400, which also swept rapidly over Europe, was not so different from that of Art Nouveau; but that art was nourished over the course of a century, and people had time to come to terms with it. The Louis XVI style was as short-lived, but it evolved within a continuity, and it was the agent of a Classical reaction. The differences with Art Nouveau are fundamental.

Scholars and critics have detected a number of influences in Art Nouveau—Flamboyant Gothic, Rococo, elements borrowed from Classical antiquity and the Moslem East, strong infiltrations of Far Eastern art, particularly Japonisme, and, more immediately, the seduction of English Pre-Raphaelitism, which was itself steeped in the Italian Renaissance. These are undeniable facts, but what concerns us is the state of mind, around 1900, which explains them. Hence these contributions will be taken up one at a time and examined briefly.

The resurgence of Gothic art in its Flamboyant aspect—the closest, in fact, to Art Nouveau—was not an innovation but rather a residue from the "troubadour" style, the Gothic revival of the 1830s. It is also significant that in England, which gave birth to the Perpendicular style with its linear dynamic, this resurgence passed readily through the drawplate of Pre-Raphaelite art. The example of the bedroom "in the English taste," designed in 1897 by an unknown artist and illustrated by Mario Amaya in *Art Nouveau,*[1] is very revealing. One of the works usually cited as an example of medieval inspiration in 1900 art is Dampt's *Chevalier et la jeune femme* in ivory and steel, but there are two distinct influences here—19th-century historicism in the helmeted, armored knight, and Art Nouveau in the elegant damsel in ivory—and the two form not a synthesis, but harmony in tension. At any rate the medieval element, while present, seldom really merges with Art Nouveau properly so called.

As for Classical antiquity, Maurice Rheims gives an excellent treatment of the subject in his book *L'Objet 1900,*[2] but here again it is clear that art around 1900 absorbed quite diverse inspirations; and these, falling as they no doubt do in the category of elective affinities, still do not necessarily make up Art Nouveau. If it is true that each period of our civilization formed its particular idea of Greece, the Art Nouveau period constructed a highly personal image. The antiquity it refers to—is it not that of Medusa and Pan? Is it not first of all Dionysian Greece as opposed to Apollonian Greece, to borrow Nietzsche's language in *The Birth of Tragedy?* And while, for instance, the Vienna Sezession and its *Ver Sacrum* refer to Athena and the classic Greek helmet, it is not so much in terms of serenity and measure in the sense of *arete* that they express themselves as in the appearance of the mask, the idol, and therefore of tragic *terribilità.* So it is antiquity with its burden of symbols that haunted Art Nouveau, even when it was intended to be noble and Classical, like the antiquity that inspired the Germanic *Reformkleid,* and, shortly after, the costumes and dance movements of Isadora Duncan.

The relations of the Louis XV style, the Rococo, to Art Nouveau are equally indisputable. Yet the analogy should not delude us. We must remember that the period of Napoleon III excelled at fabricating Louis XV art—at times a somewhat heavy pastiche, although often very well done. But Art Nouveau could not have drunk at this fountain, so singularly lacking in youthfulness. Moreover, Rococo is far removed from the Baroque impulse, which is expressed in curves and countercurves, rolled and turned borders; it generally appears as something added on, a kind of epidermal

allurement. Rococo, which is ornament, rarely has the compulsive dynamism that penetrates and determines the whole work of art, whether it be architecture, sculpture, stained glass, furniture, or, especially, jewelry. But this dynamism, this compulsiveness, is precisely what characterizes 1900 art, which aimed at meeting demands that went well beyond pleasure-giving and the graces of the drawing-room.

As for the contributions from the Orient, they were essential, and a combination of circumstances made them available to Europe in the late 19th century. Japan, under pressure behind its ancestral walls, removed the last barriers to foreigners in 1868. Some years earlier its products had been timidly displayed in Paris and in London, where an international exposition was organized in 1862. In London, too, Arthur Lasenby Liberty sold exotic articles and Whistler promulgated Japonisme. Artists in Paris and Nancy followed the lead of Bracquemond and Gallé, and with their sensibilities sharpened by the 1867 and 1878 expositions and by Bing's boutique, became infatuated with the Far East. On the other hand, European artists, among them Toorop and Emil Orlik, traveled to the antipodes, to Japan, China, and Indonesia, not neglecting the Near East.

Islam exerted its influence in two ways. It spread abroad the Ottoman iconography—romantic, billowing with fabrics and veils—and popularized its grammar of ornament, parsed with damascening and earthenware of Isnik. In addition Islam flaunted the captivating charm of its calligraphies, Kufic and others, and of its *tûgras* and sultan's seals, a play of lines fixed, even codified, by the speculative thought of the theologians.

These oriental components can be ranged in three categories: that of undulant lines and juxtaposed color fields; that of rare, shimmering materials; and that of tales and legends, of poetry and symbols. The wavy lines formed the twisting shapes of hair and plants, of clouds and waters, as well as of pure ornaments. In conjunction with the unrealistic, conventional disposition of planes and the eccentric juxtapositions out of which the Nabis created their colored beaches, they achieved a large part of their effect by repetition and undulatory movement.

Now the materials—lacquers, enamels, and slips, in colors and nuances of color. In this regard Maurice Rheims cites the boudoir of Huysmans' hero des Esseintes: "Amidst small pieces of furniture carved out of pale Japanese camphor wood, under a sort of tent made of the pink satin of India, the flesh was softly colored by light filtering through the cloth."[3] And Gabriele Sterner recalls Verlaine's *Art poétique:* "For we still want nuance, not color, nothing but nuance. Oh! The nuance and the nuance alone weds dream to dream and flute to horn."[4] It is readily seen that these aesthetic predilections lead straight to Symbolism; and poetry—the poetry of Saadi and the *Arabian Nights,* and of the Japanese tales collected by Lafcadio Hearn in particular—came to affirm, reinforce, and lend color to this Symbolism.

Gothic, Rococo, Orient, and the rest—a crowd of spirits around the cradle of Art Nouveau. This superabundance of sources makes one pause and reflect. The truth is that a deep, powerful motivation was needed to effect a choice among such a throng of possibilities and to appropriate it with such insatiable hunger. This delight in curves, spirals, meanders, these effects of trailing vines, of serpents, of coiled springs supple and tense at once—do not such pleasures signal the decline, if not in fact the end, of the civilization for which the First World War tolled the knell? This revel of serpentine forms wove, as it were, a mesh of anguish around a prey, and the prey was the amateur, the user, the person who sensed the crisis, even in the very lap of prosperity. Years ago in a study devoted to the 14th century, I expressed myself in terms that essentially characterize Art Nouveau: "Besides a calligraphic treatment which is extremely seductive but is also so facile as at times to betray nothing more than skin-deep sentiment and to sink into affectation, we observe that web of profound needs which binds the work to the play of graphics. Now, just as our modern art has fed, no doubt consciously but driven by an imperious impulse, upon the archaic arts of the world . . . so 14th-century art . . . seems drawn by affinity to rejoin those earlier arts, all of which manifest a surge of the irrational."[5]

Here the irrational makes use of the form which is pure ornament—a strange fact, since ornament proves nothing, and expresses nothing that is in nature or that knowingly opposes nature. This ornamental trend reappears in troubled periods. And do we not seem to detect something profound, magical in its essence, in this process of evocation and resurrection of gestures and signs? Consider the power of the gesture or the sign in a magical incantation: doesn't it come up from the depths of time and, at certain critical moments of our existence, bring to the surface the urges of the primitive soul? Again the 14th century provides an analogy: concerning Guillaume de Machaut's *Messe Notre-Dame* (1364), the eminent musicologist Charles van Borren writes, "A strange composition . . . based upon a hard counterpoint at times monodic, at others laced with serpentine figurations that seem to emanate from the depths of the ages."[6]

But there is more. Hans H. Hofstätter, discussing Jan Toorop in his excellent *Geschichte der europäischen Jugendstil-malerei*,[7] states that this artist carries Art Nouveau as far as it can possibly go; he makes the subject treated say more than it *can* say. Clearly this is the general tendency of the *Gesamtkunstwerk*, the total work of art, which in the final analysis depends more on idea or ideology than on form. Art Nouveau, going beyond its broadest grammar of arabesque and calligraphy, creates an object, a "thing" that looks like an insect or some sort of idol, often with erotic, uterine, or phallic overtones. The work of the Glasgow School, that of Mackintosh in particular, abounds in examples of this kind. On what does Mackintosh's door for the "Room de luxe" of the Willow Tea-Rooms in Glasgow open or close? What strange presence do certain of Kate Allen's and Philippe Wolfers' jewels embody?[8] Of course the references to the world of nature are *per se* agreeable and healthy, and the sumptuousness of birds and butterflies could delight lovers of enamels and semiprecious stones; but if the allusions to serpents and octopuses have something perverse about them, the world of insects also has a troubling effect—night butterflies with their eyes open upon mystery, creatures that have no human sensibility and sow a vague fear, scarabs weighed down with symbols since the days of ancient Egypt.

These products of Art Nouveau—"objects" bound to the *daimonia* of insects, even when meant as luxurious trifles, or else pure plastic inventions—project us into the very center of Symbolist thought. Thus materialized and crystallized in an almost incantatory form the symbol is the sign, and the domain of Art Nouveau is the gesture, the sharp contraction of the body. To a certain extent might one not take the position that Symbolism is the thought of 1900, while Art Nouveau is its gesture, its spasm? What Jean Cassou[9] (wrongly, we think) considers to be something superadded, superfluous, "something illegitimate, the phenomenon of an impurity," I prefer to recognize as "the curvilinear medal of anguish," to use the excellent formula coined by Francine-C. Legrand regarding Edvard Munch.[10]

But are we going to confuse the Symbolist artists with the champions of Art Nouveau? Not at all. The Symbolists had a care for realism, they clothed their concerns and obsessions with the raiment furnished by nature and tradition, whereas the others revealed them unwittingly, so to speak, in the spasm of form which is pleasure and suffering at once. It is of some interest to note that the socially oriented realism of George Minne, Käthe Kollwitz, Eugène Carrière, and Medardo Rosso, which too was a response to the malaise of the end of the century, is shot through with 1900-type reflexes. In a general way one might obviously think that in a Europe bursting with ideas, the various trends—the academic, Art Nouveau and all those opposing tradition (the Impressionists, Pont-Aven, and soon the Fauves)—lived side by side without touching, in the most complete isolation from each other. The fact, however, is that all of them—Toulouse-Lautrec, Bonnard (and the *Revue Blanche*), Gauguin, Van Gogh, Barlach, Munch, Segantini, even Seurat—were more or less deeply affected by the 1900 reflex.

It is not intended to reduce everything that came out of the turn of the century to Art Nouveau, but to propose that this art is a phenomenon which reveals our civilization at a critical moment in its development, in an almost clinical sense. Referring to the real borrowings from arts and styles already well defined in time and space simply pushes back the problem of 1900 art; it does not explain its validity, or its essence.

Needless to say, these few pages make no claim to furnish a rigorous analysis of the phenomenon. They are intended only to offer matter for reflection, in connection with an exhibition that links Belgium and France—a privileged relationship which allows us to perceive other relationships, determinative also, that situate the two countries in the European adventure, along with England and Germany, and with Austria, Spain, and Italy and their various "secessions." What we have attempted is to go beyond art history as it is usually understood, and to sketch a pathology of art in Europe.

Victor Beyer

1 Mario Amaya, *Art Nouveau* (London: Studio Vista, Dutton Pictureback, 1966), p. 78.

2 Rheims, *L'Objet 1900* (Paris: Arts et Métiers Graphiques, 1964), p. 17.

3 Ibid., p. 25.

4 Gabriele Sterner, *Jugendstil: Kunstformen zwischen Individualismus und Massengesellschaft* (Cologne: M. DuMont Schauberg, 1975), p. 20.

5 Victor Beyer, "Originalité du XIVème siècle," *Revue d'Alsace* 91 (1952), pp. 81–91.

6 Charles van Borren, "L'Ecole et le temps de Guillaume de Machaut et de Francesco Landini," in *La Musique des origines à nos jours*, ed. Norbert Dufourcq (Paris: Larousse, 1946), p. 116.

7 Hans H. Hofstätter, *Geschichte der europäischen Jugendstilmalerei* (Cologne: M. DuMont Schauberg, 1963), pp. 151–52.

8 Gabriel Mourey, Aymer Vallance, et al., *Art Nouveau Jewelry and Fans* (New York: Dover Books, 1973), pl. 65. See also the exhibition catalogue by H. Meurrens, *Philippe Wolfers (1858–1929), Précurseur de l'Art Nouveau statuaire* (Brussels: L'Ecuyer, 1972).

9 Jean Cassou, "Les Sources du XXe siècle," in the exhibition catalogue *Les Sources du XXe siècle* (Paris: Musée National d'Art Moderne, 1960–61), p. xx.

10 Francine-Claire Legrand, *Le Symbolisme en Belgique* (Brussels: Laconti, 1971), p. 139.

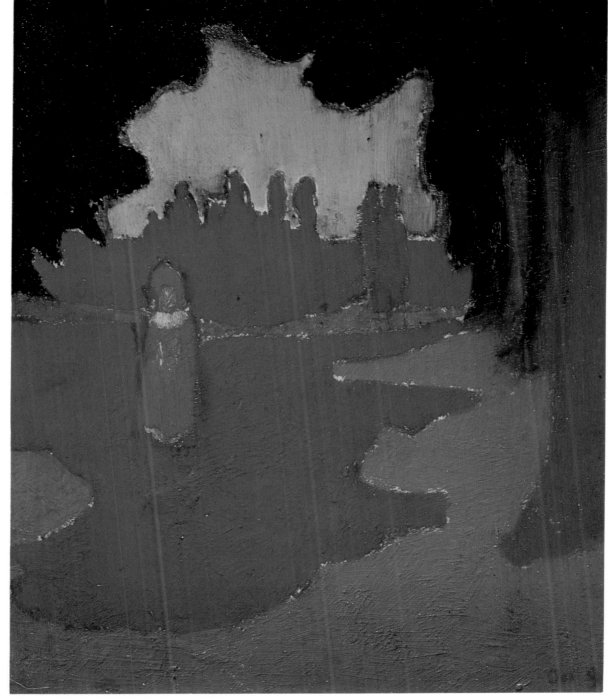

30. Denis. *Taches de Soleil sur la Terrasse.* 1890.

RR 12726 1/5/77

17

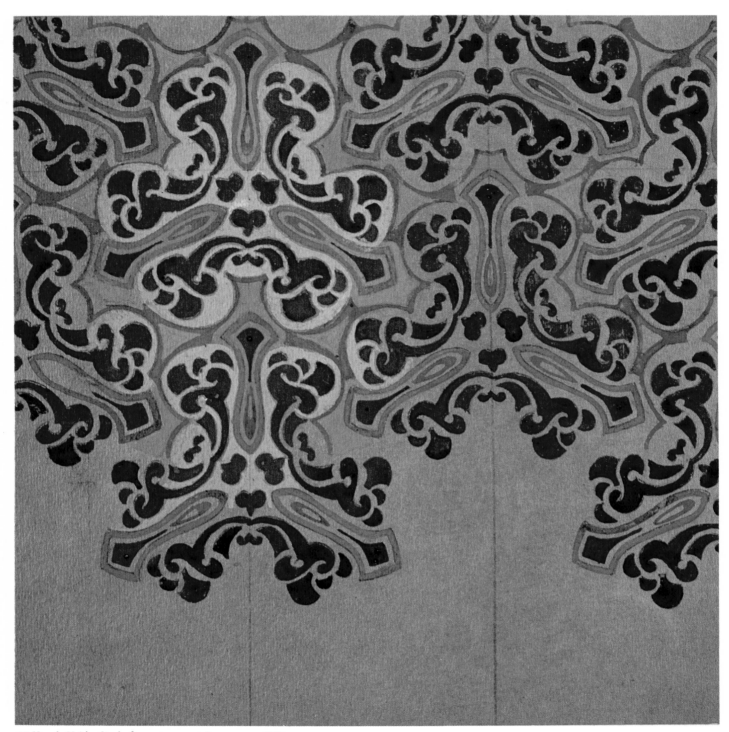

90. Van de Velde. Study for an ornamental pattern. c. 1900.

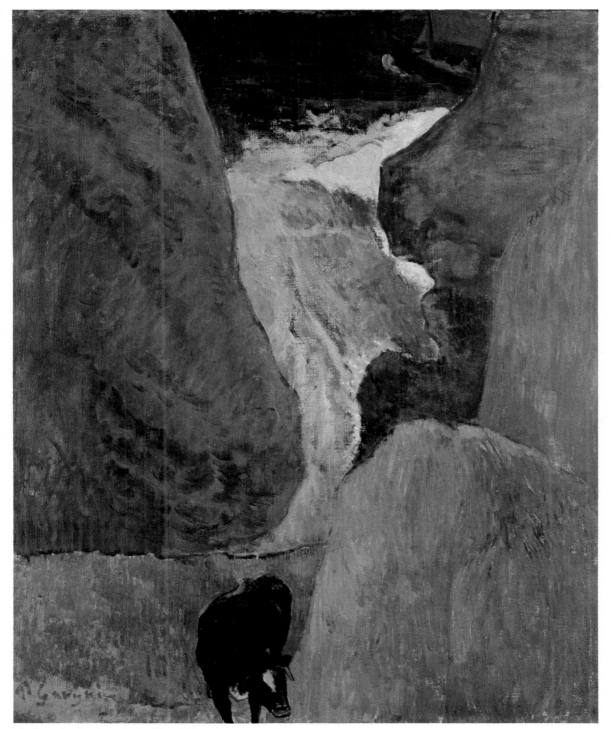

38. Gauguin. *Au-dessus du Gouffre*. 1888.

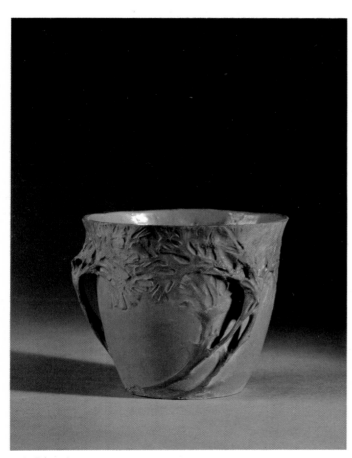

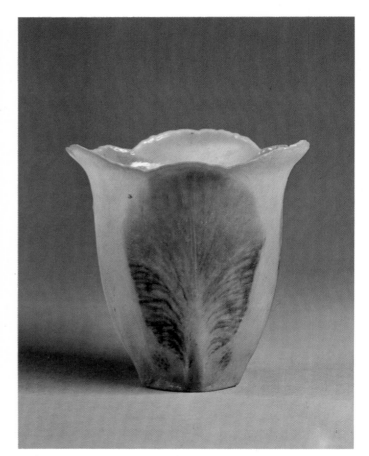

270. Décorchemont. Cup. 1906.

256. Dammouse. Cup. c. 1909.

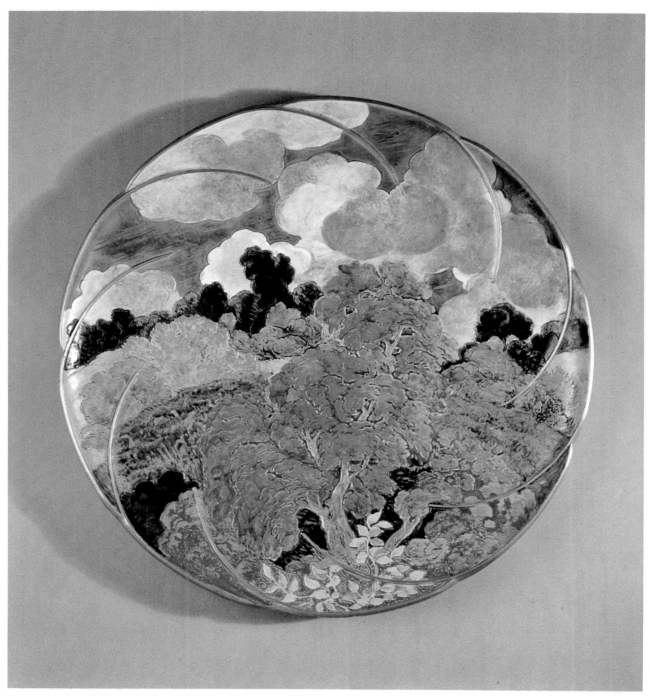

152. Bracquemond. Plate. 1874.

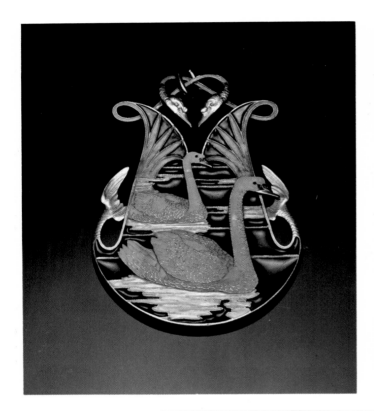

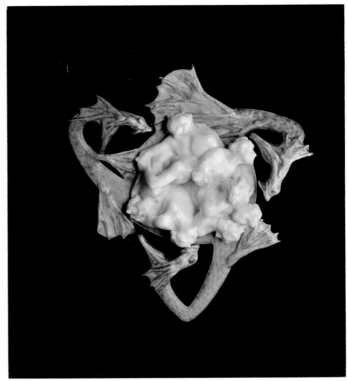

399. Lalique. Pendant.
c. 1897–98.

416. Lalique. Brooch.
c. 1903–1905.

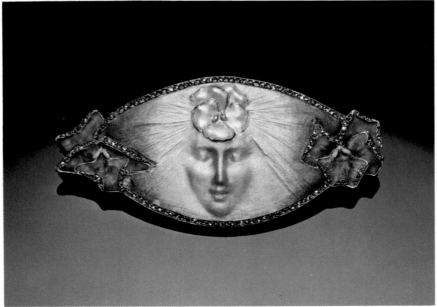

405. Lalique. *La Pensée*. Brooch. c. 1899–1901.

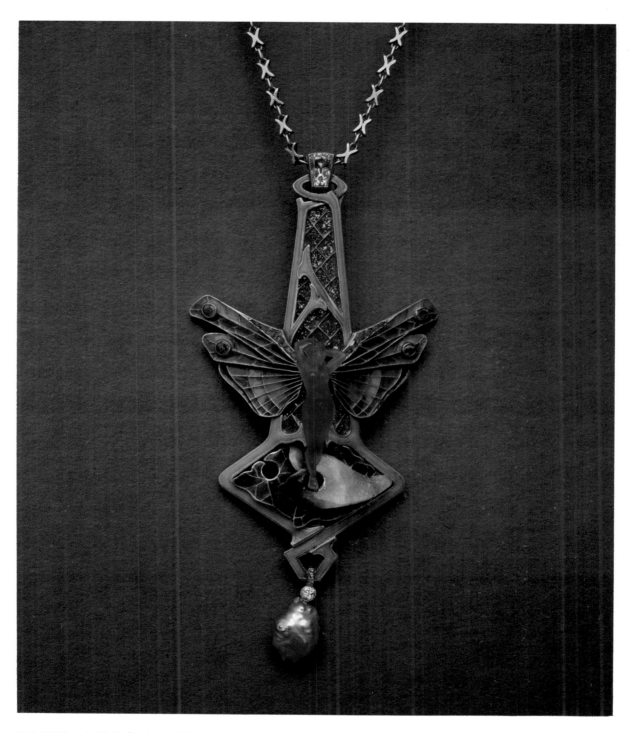

514. Wolfers. *La Nuit*. Pendant. 1899.

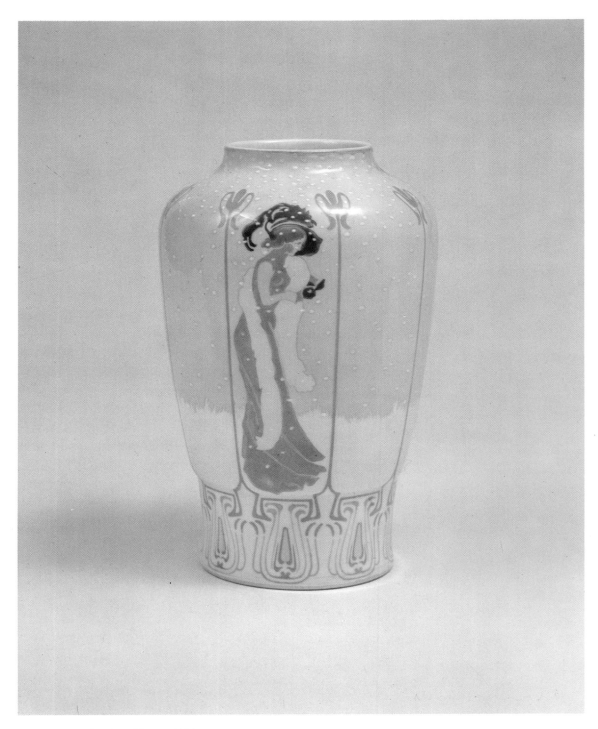

273. De Feure. *La Neige.* Vase. c. 1901.

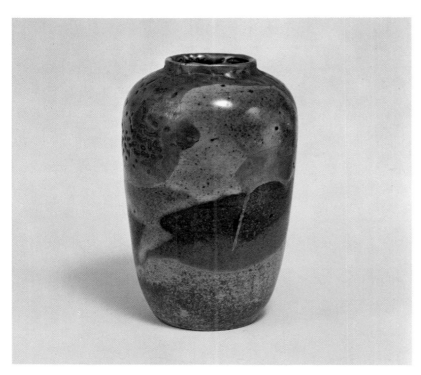

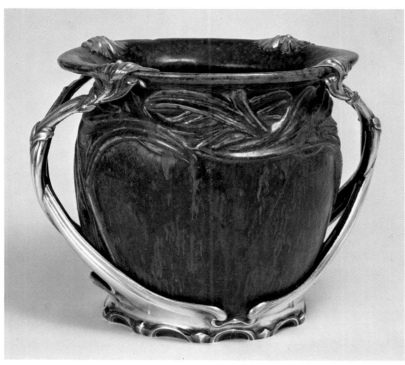

222. Carriès. Vase. c. 1890–94.

299. Dufrêne and Bonvallet. Mounted vase. c. 1899.

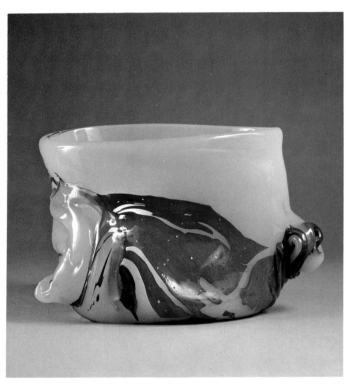

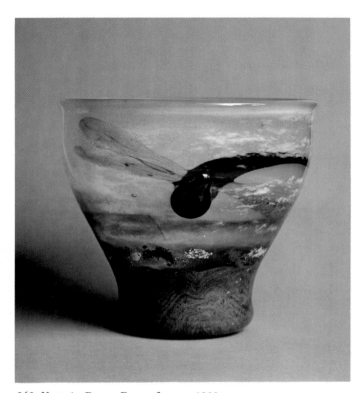

461. E. Rousseau. Jardinière. 1884.

262. Verreries Daum. Dragonfly vase. 1900.

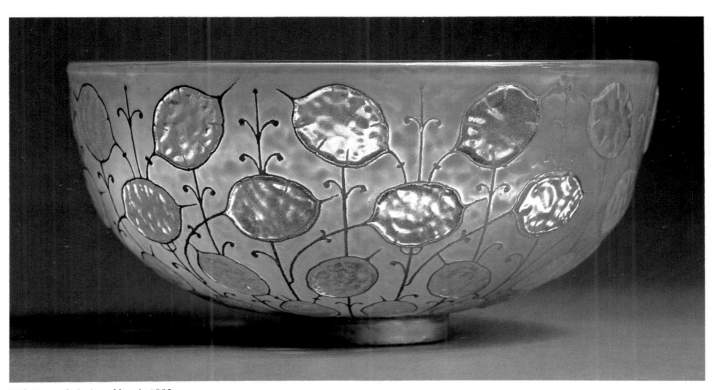

214. Brocard. Satinpod bowl. 1885.

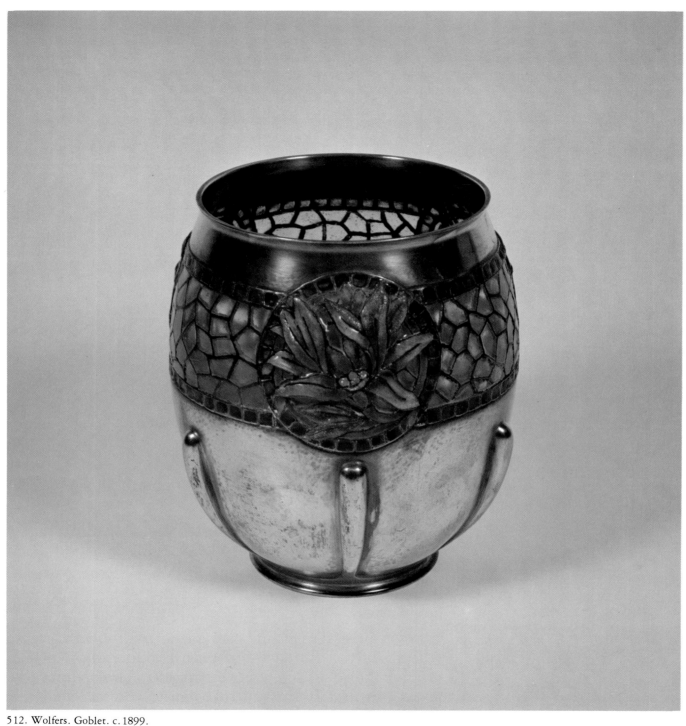

512. Wolfers. Goblet. c. 1899.

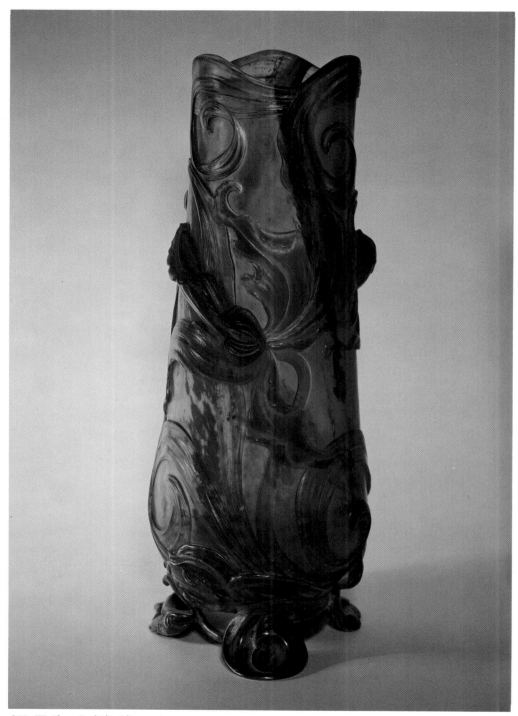

519. Wolfers. *Orchidée*. Mounted vase.

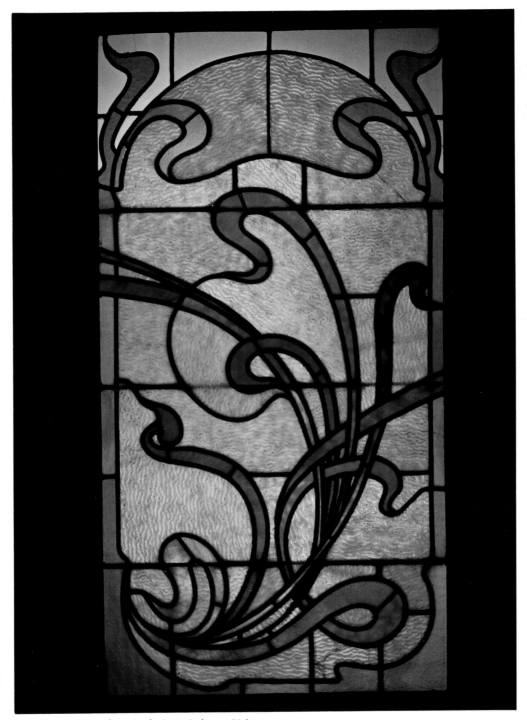

380. Horta. Panel of a stained-glass window. 1894.

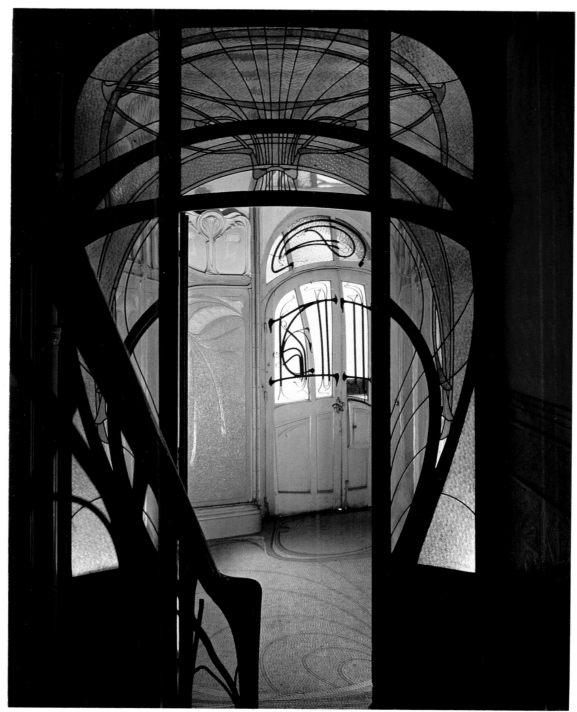

616. Guimard. Maison Coilliot, entrance hall. 1898—1900.

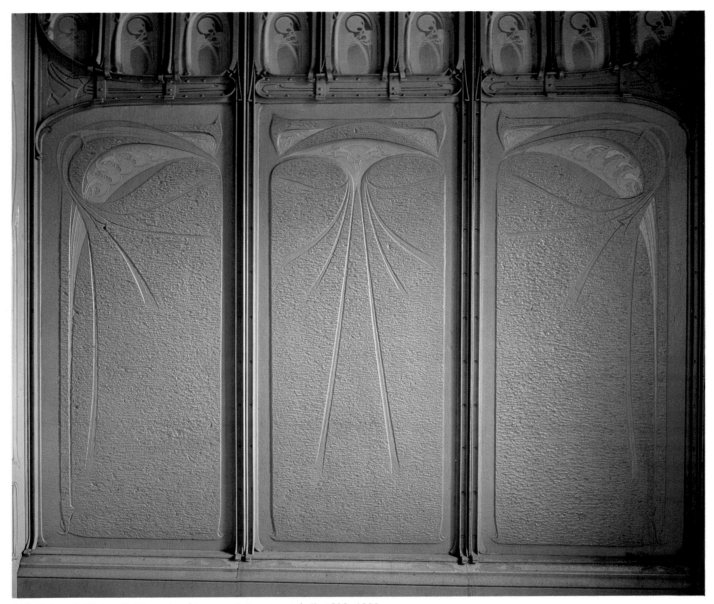

616. Guimard. Maison Coilliot, glazed lava panels in entrance hall. 1898–1900.

THE DIFFUSION OF ART NOUVEAU: EXPOSITIONS, ART REVIEWS, AND MUSEUMS
Yvonne Brunhammer

EXPOSITIONS

In the 19th and 20th centuries international expositions took over a role previously reserved to sovereigns: to give a name to the style of the time. Thus the Paris Exposition Universelle of 1900 became the symbol of the art which since the 1860s had represented the break with the Greco-Latin world. Similarly, twenty-five years later, the Exposition des Arts Décoratifs et Industriels Modernes in Paris represented the trends which from 1909 to 1930 defined the style of the period.

The exposition, whether international, national, or built around a specialized theme, was a phenomenon peculiar to the 19th century, intimately bound up with the development of industry. In a new society open to a growing number of people there was a need to inform, to arouse, and to stimulate. The first of all the expositions devoted to the "products of industry" opened on the Champ de Mars, Paris, in August 1798. It was exclusively French, and its aim was to show that independent workers could produce objects as fine as those made under the authority of the old guilds. The government proclaimed that industry was to continue in a close interdependent relationship with science and art: this was the condition *sine qua non* of progress.[1]

National expositions followed one another in Paris during the first half of the 19th century: 1801 ("Statues will stand beside plowshares, paintings will be hung side by side with textiles"),[2] 1802, 1806, 1819, 1823, 1834, 1839, 1844, 1849. But through these years there ran a constant refrain of criticism levied against "pastiche and spurious luxury," expressing the fears aroused by the lack of creativity that characterized the art industries. The rift between art and industry was becoming clearer; and France, at the same time, was stifling under protectionism.

1851–1878. An entirely different conception of the industrial world gained place in England, which resolutely opened its doors to competition in 1851, when the Society of Arts organized an exhibition in London. Prince Albert, asked whether the exhibition should be national or international, stated, "It must embrace foreign productions," and added with emphasis, "International, certainly."[3] So, for the first time in history, the products of the East and West were brought together in one place—the Orient and the Islamic countries were broadly represented, although Japan, closed to foreigners since 1640, was an exception—and their products could be compared. The stakes were high, as many contemporaries warned, but the Western world defended its own civilization: "If you want to form a quick and passably exact idea of the degree of advancement attained by the industry of a given people, don't look at their gold or silver, but at their iron."[4] As proof they pointed to Joseph Paxton's Crystal Palace, the huge greenhouselike structure of iron, wood, and glass that was raised in record time in Hyde Park, under the architect's direction, to house the Great Exhibition. Six million visitors walked its aisles and affirmed this superiority.

The London exposition gave rise to questions to which Art Nouveau brought a provisory answer. Each new exposition, whether international or national, was an additional step forward in the quest for identity that preoccupied the occidental mind and particularly the world of the arts. Industry with its prodigious possibilities, which were just beginning to be perceived, raised anew the question of Western man's self-expression and of his attitude towards his environment. For this reason the decorative arts, then described as "arts applied to industry," were of prime concern. Jean Cassou has correctly stated the new concept: "The dignity of work itself . . . especially of that particular brand of workman represented by the craftsman. . . . The opposition between the term 'fine arts' and those of minor, mechanical, manual,

menial arts tended to disappear and to be replaced in France by that of *Arts et Métiers,* in England by that of *Arts and Crafts,* while Germany evolved the concept of *Kunsthandwerk.*"[5]

In 1855 Paris in turn organized an international exposition. The two high spots were the Galerie des Machines, on the bank of the Seine between the Pont de la Concorde and the Pont de l'Alma, and the Palais de l'Industrie, which for several decades thereafter housed a number of exhibitions. The 1855 show organizers refused to exhibit Courbet's *L'Enterrement à Ornans,* but he put the painting on display in the "Pavillon du Réalisme," which he built at his own expense.

The year 1867 witnessed a great economic upswing in France. The Exposition Universelle held in Paris in that year was housed in concentric oval galleries, which were built on the Champ de Mars around a garden adorned with palm trees and sculptures. (It was Manet's turn to have his work excluded and to build his own pavilion: *L'Exécution de Maximilien* had to be withdrawn at the last minute for political reasons.) The traditional report published after the closing deplored the exhibition's "temporary character" and advanced the idea of a permanent show—in other words, the museum idea.[6] Social concerns were in the foreground of the 1867 program—an emphasis that was then new but which was returned to continually thereafter. Thus a category was set up to include all "objects specially put on view in order to improve the physical and moral condition of the people." Particular emphasis was placed on "les costumes populaires"—clothes designed for the common people—as well as on "inexpensive" housing and furniture.[7]

Japan, which had not participated in the London exposition in 1851, was represented in 1867, and for the first time the French public came into contact with the arts of that country. The effect was felt immediately—the more so since Japonisme was becoming popular among the friends of Félix Bracquemond, the engraver, who had been acquainted with Japanese prints since 1856. The workers in glass—Eugène Rousseau first, then Emile Gallé, and practically all the rest—and the furniture makers and metal craftsmen, notably Christofle, proceeded to borrow shapes and themes from Japanese art. The public came to know this art progressively, both through European products inspired by it and through objects brought from Japan. After 1867 economic exchanges with Japan increased, and the Tokyo government encouraged visits by foreign travelers. Among the visitors were Henri Cernuschi the economist and Théodore Duret the critic in 1871–72, Samuel Bing the art dealer in 1875, and, in 1876, the industrialist Emile Guimet, who was drawn to the Far East by his interest in the study of religions.[8] Shops featuring Japanese objets d'art were opened in Paris, the best known being Samuel Bing's at 19 rue Chauchat (1877). In 1869 the Union Centrale des Beaux-Arts Appliqués à l'Industrie, a private association of industrialists, set up an exhibition of oriental art which included Japanese objects.

Subsequent expositions were held outside of France, that country having suffered a bitter defeat and a revolution. The exposition of 1871 took place in London, that of 1873 in Vienna, where the fine arts played an important part. In 1876 the United States celebrated the centennial of its independence with a world's fair at Philadelphia (where for the first time the press had a pavilion).

1878–1889. In 1878 France had paid off its war debts, and, to prove that it still held a preponderant place in the modern world, put on a new industrial fair in Paris. This exposition confirmed the trends of 1867 and brought new men to the fore. The Japanese section included a significant number of ceramics, porcelains, and stoneware pieces, which completely upset the French conception of ceramic art. Potters discovered much there, like specialized craft techniques, new shapes, new ideas in decoration; but more than that, they found a respect for the object itself that was almost unknown in the Western world, where the "decorative" arts were also labeled "minor." Many a sculptor and painter, following the example of the Japanese, turned to the craft of pottery. Among them were Paul Gauguin (for a time at least), Jean Carriès, Emile Grittel, Georges Hoentschel, André Methey, and others. Samuel Bing supplemented the lessons learned from the Japanese section by exhibiting a collection of Far Eastern ceramics.

The 1878 exposition was a landmark in the development of Art Nouveau in more than one way. Tiffany and Company of New York put on a display of jewelry that was markedly free of European historicism. Emile Gallé had a section all to himself—his first important public exhibition. The range of his experiments, and a *clair de lune* glass that was widely imitated, won him much attention.[9] The French contribution to the exposition showed, on the whole, a strong influence of Japonisme, notably in the work of Eugène Rousseau, Théodore Deck, Albert Dammouse, and Christofle.

The Union Centrale, which had organized an exhibition of oriental art in 1869, thus manifesting its interest in innovations that might revitalize the applied arts, continued to set up specialized exhibitions. These, alternating with the

world's fairs, strengthened the creative thrust of the last three decades of the century, and enabled artists to make direct contact with the public. The founders of the Union Centrale, most of them industrialists, based their thinking on the decisive influence of the 1851 exhibition on the economy of Europe, particularly on industry in England. Their first principles were "patriotism and faith in society," and their goals, "to maintain in France the cultivation of the arts that pursue the realization of the beautiful in the useful, . . . to excite the emulation of artists whose works, while popularizing the sentiment of the beautiful and improving the public's taste, help our art industries to retain their well-earned but now threatened preeminence throughout the world."[10]

In 1884 the Union Centrale merged with the Société du Musée des Arts Décoratifs and became the Union Centrale des Arts Décoratifs. The expositions it organized were theme-oriented, and contemporary works were shown in the context of the history of the technique fixed upon. "Clothing" was the theme in 1874, "Tapestry" two years later. In 1880 came the first technological exposition; its subject was "Metal," and a retrospective on "Metal Arts" was included. In 1882 the theme was "The Arts of Wood, Paper, Textiles," in 1884 "Stone, Wood, Earth, and Glass," accompanied by a survey of "Arts of the Fire." For this occasion Emile Gallé wrote the famous "Notices d'Exposition" on his work in ceramics and glass, in which each technique—and they were numerous and diversified—is described in the language of a specialist and a poet.[11] In 1887 the Union presented a survey of "The Fine Arts Applied to Industry"; in 1892 it turned to an exhibition, international in scope, on the "Arts of the Woman."

1889–1900. The intervals between expositions grew shorter as the end of the century drew near. The salons usually reserved for painting and sculpture were opened, gradually and hesitantly, to the decorative arts: we may mention the salons of the Société Nationale des Beaux-Arts and the Société des Artistes Français. The Salon des Indépendants, which Seurat and his friends started in 1882, boasted of its freedom and its suppression of the "jury obstacle," but it turned down the piece of furniture that one of its founders wanted to show in 1890. So it was that Rupert Carabin, the sculptor, had to wait until the Société Nationale des Beaux-Arts admitted the applied arts in 1891 to put the famous Montandon bookcase on display.[12]

The Exposition Universelle of 1889 took place at a pivotal date: creative artists demonstrated their freedom from the restraints of Classicism. Having more and more elaborate techniques at their disposal they dared to dream the impossible, and the world's fairs allowed some dreams to come true: witness the erection of the Eiffel Tower. In preparation for the exhibition glassworkers, ceramists, and artists in metal, wood, and fabric carried their experiments further. Emile Gallé fashioned his first furniture and his loveliest things in glass; Christofle obtained new models for silversmithing from Chéret and Carrier-Belleuse; Chaplet, the ceramist, executed his finest flambé *sang-de-boeuf* pieces; Emile Müller, just before his death, perfected his stoneware plaques for exterior decoration, which revolutionized architectural ceramic work. Tiffany demonstrated that his work was no mere imitation of French Art Nouveau.

The *style moderne* began taking hold everywhere. Paris prepared for the 1900 exposition.

Meanwhile world's fairs were held in other countries, and fruitful exchanges resulted. People who went to the World's Columbian Exposition in 1893 discovered Louis Sullivan and the Chicago School. The Director of the Beaux-Arts engaged Samuel Bing, who was going to the United States in connection with the Chicago fair, to "give an account of American art and its possibilities for the future." On his return Bing published his remarkable study entitled *La Culture Artistique en Amérique,* and in 1895 he opened his shop, L'Art Nouveau, where the best European and American decorative artists were shown together.

Belgium, a rich country whose geographical location made it an excellent meeting place, played a fundamental role in the birth and growth of Art Nouveau. Cultural exchanges with France, England, and Germany went on continually. Avant-garde artistic activity was orchestrated in the 1880s by Octave Maus, a lawyer who organized the Groupe des Vingt (1883–93) and its successor, La Libre Esthétique (1894–1914). Their concerts, lectures, and annual exhibitions were a decisive factor in launching the modern arts in Europe. The Exposition Internationale of 1897, held in Brussels with a section devoted to the Congo in the suburb of Tervueren, made Belgium for a time the center of the industrial world. Although Victor Horta's project for a pavilion to house the colonial section was not accepted, still Hankar, Serrurier-Bovy, and Van de Velde had a hand in the interior arrangements. Thanks to the collaboration of such notable artists, the Brussels-Tervueren fair, more than any previous exposition, was an excellent advertisement for Art Nouveau. Also at this fair the public was introduced to the wonders of African art.

The 1889 exposition had scarcely closed its doors when plans were begun for 1900. "All branches of human activity will draw equal profit from this comprehensive exhibit, which will throw light on the material and moral conditions of contemporary life," wrote Jules Roche, Minister for Commerce and Industry, in 1892.[13] Roche envisioned a series of expositions: "Peaceful *fêtes* to which all producers and workers in the world will be invited . . . periodic celebrations of work. . . . In the field of the fine arts, for instance, it will be easy to bring out and define the principal characteristics of the artistic movement under way at the present time, and, by displaying some few basic works, to show the difference between the art of the second half of the century and Romantic as well as Classical art."[14] The Paris fair in 1900 summed up the thirty years just ending. It marked both the triumph and the decline of Art Nouveau, which there revealed its last marvels. Behind a grille made of female figures in bronze, Lalique displayed jewelry unlike anything done in previous centuries. "Thanks to him," wrote Henri Vever, "the jewel became once more an art object in which splendid workmanship brought together sumptuousness and delicate, gracious refinement."[15] Bing's Art Nouveau pavilion was dedicated to "La Femme," as was the Théâtre de la Loïe Fuller, designed by Henri Sauvage. Majorelle scored a triumph with his waterlily furniture, and Emile Gallé with his "talking glassware" *(verreries parlantes)*. A faint odor of decadence hung over this art, which with few exceptions would yield no more masterpieces. Reaction set in, making itself more and more strongly felt at the fairs held in the early years of the 20th century—Glasgow in 1901, Turin in 1902, St. Louis in 1904, Liège in 1905, Dublin in 1907, and London in 1908.

THE ART REVIEWS

Expositions and salons put people in the physical presence of works of art. Other means were used toward the end of the 19th century to give still wider publicity to the new forms, and to spread knowledge of them among an ever-increasing number of artists, manufacturers, and consumers.

Art reviews furnished the public with information of historical or critical import, and especially with illustrations. The earliest was the *Revue des Arts Décoratifs,* published by the Union Centrale. Originally devoted to articles on art history and to reports on the gradual organization of the Musée des Arts Décoratifs, in later years it broadened its field of investigation and opened its pages to the best contemporary art.

In 1893 *The Studio* began publication in London. Through this review Europe was informed about the English movement, which had so strong an influence on Art Nouveau in Belgium and France. In Brussels the avant-garde organ was *L'Art Moderne.* In Munich it was *Dekorative Kunst,* which appeared for the first time in October 1897; the French edition, called *L'Art Décoratif,* came out in October 1898. Its editors were H. Bruckmann in Munich and Julius Meier-Graefe in Paris. With antennae in both Germany and France, the journal was an important channel of communication between the two countries.

In 1897 *Art et Décoration* was introduced in Paris as "the monthly review of modern art." Its first issue contained an article entitled "Le Vitrail," followed by a study with the title "L'Art Décoratif en Belgique: Un Novateur: Victor Horta." These reviews are still the best source of information on the history of the period.

MUSEUMS OF DECORATIVE ART

Among the means which the Union Centrale des Beaux-Arts Appliqués à l'Industrie planned to use "in order to maintain in France the cultivation of the arts that pursue the realization of the beautiful in the useful," top priority was given to a contemporary as well as historical museum, to be accompanied by an exhibition program, a library, courses, and public lectures. The Museum's purpose was to put before artists and craftsmen works from the past that would illustrate the original contribution of each period—this in order to combat the tendency to copying and pastiche which was bringing discredit upon contemporary products. From its opening in 1877, therefore, the Musée des Arts Décoratifs followed a twofold policy, acquiring both past and present works. Objects were bought at world's fairs and other exhibitions. The curators kept up with what was being done in the studios, and every year bought new works from Gallé, Delaherche, Chaplet, Deck, and others. An examination of the museum's inventory lists makes it possible even today to fix the chronology of these artists' work, and to gauge public opinion of the period.

The model of a museum of this kind, and the earliest to be established, is the South Kensington Museum (today the Victoria and Albert) in London, organized following the Great Exhibition of 1851. In Vienna a museum of art and industry opened in 1864. Most German and Austrian cities

had associations for the development of the decorative arts, the Kunstgewerbevereine, which bought works, organized exhibitions, published specialized and illustrated periodicals, and set up schools. In 1868 the Deutsches Gewerbe Museum opened its first rooms in Berlin, soon to be followed by the Museum für Kunst und Gewerbe in Hamburg.

The second half of the 19th century brought diversified and mutually complementary instruments to the art and science of communication. Expositions made it possible for men the world over to exchange their ideas and the results of their research, and to share all this with the public at large; magazines used text and pictures to spread new ideas abroad and created an ongoing dialogue; museums put past and present on view, thus committing themselves to the future. Of these innovations Art Nouveau was a fortunate beneficiary.

1 "Origines de l'Exposition et Evolution de l'Art Moderne," in *Exposition Internationale des Arts Décoratifs et Industriels Modernes, Paris, 1925: Rapport Général,* vol. 1, p. 15.

2 Ibid.

3 Quoted in C.H. Gibbs-Smith, *The Great Exhibition of 1851* (London: Victoria & Albert Museum, 1964), p. 6. See also Gilbert Cordier, "A propos des Expositions Universelles, essai d'intégralisme," *Architecture, mouvement, continuité,* no. 17 (1970), p. 7.

4 Michel Chevalier, "1er Aperçu Philosophique," in *L'Exposition Universelle de Londres considérée sous les rapports Philosophique, Technique, Commercial et Administratif au point de vue français (Ouvrage dédié aux producteurs de la Richesse Universelle)* (Paris, 1851), fasc. 1, p. 12.

5 Jean Cassou, "The Climate of Thought," in *The Sources of Modern Art* (London: Thames and Hudson, 1962), p. 17.

6 *Rapport sur l'Exposition Universelle de 1867, à Paris* (Paris, 1869), vol. 2, *Appendice sur l'avenir des Expositions,* pp. 266–328.

7 *Exposition Universelle de 1867, Rapports du Jury International: Meubles, Vêtements et Aliments de toute origine distingués par les Qualités Utiles unies au Bon Marché* (Paris, 1867), pp. 775–76.

8 Martin Eidelberg and William R. Johnston, "Japonisme and French Decorative Arts," in Gabriel P. Weisberg et al., *Japonisme: Japanese Influence on French Art, 1854–1910* (Cleveland: The Cleveland Art Museum, The Rutgers University Art Gallery, and The Walters Art Gallery, 1975), p. 143.

9 See Emile Gallé, "Notices d'Exposition (1884): Notice sur la production du verre," in *Ecrits pour l'Art* (Paris: Henri Laurens, 1908), p. 303.

10 See the "Notice historique" published in the *Annuaire de l'Union Centrale des Arts Décoratifs* for 1904 and subsequent years.

11 See note 9 above.

12 See Yvonne Brunhammer, "Un Oublié de l'Art Nouveau: Rupert Carabin," in the exhibition catalogue *L'Oeuvre de Rupert Carabin, 1862–1932* (Paris: Galerie du Luxembourg, 1974), p. 5.

13 *Exposition Universelle Internationale de 1900 à Paris: Actes Organiques* (Paris, June 1896), p. 7.

14 Ibid., pp. 5–6.

15 Henri Vever, *La Bijouterie française au XIXe siècle* (Paris, 1908), vol. 3, p. 740.

PAINTING
AND
GRAPHIC ARTS

All measurements are given first in centimeters and then in inches
parenthetically, and listed in the order of height, width, and depth.

PAINTING AND GRAPHIC ARTS:

SOURCES
AND
COMPARISONS

1
Four prints.
Japanese.
Color woodcuts.
Approximately 36 x 25 each (14⅛ x 9⅞)
Saint-Germain-en-Laye,
Musée Symbolistes et Nabis.
Formerly in the collection
of Maurice Denis.

Purchased by Maurice Denis between 1890 and
1900.

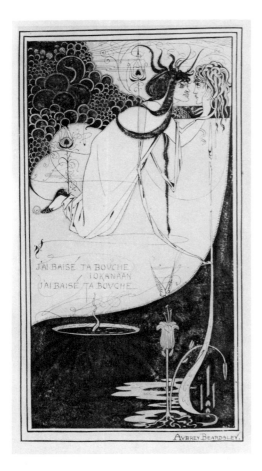

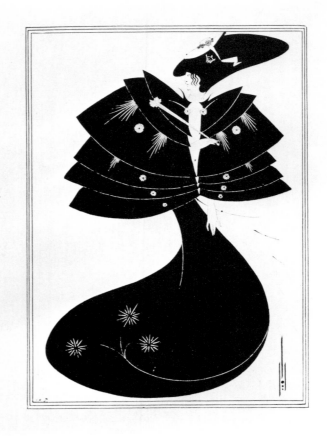

2
J'ai Baisé Ta Bouche Iokanaan.
Aubrey Beardsley. 1893.
India ink on paper; green watercolor wash
added later.
29.2 x 15.4 (11½ x 6⅛)
AUBREY BEARDSLEY, lower right.
Princeton University Library.

Inspired by a reading of the French text of
Wilde's *Salome,* this drawing was published in
1893, accompanying a laudatory article on
Beardsley written by Joseph Pennell for the
first issue of *The Studio.* Upon seeing it John
Lane commissioned Beardsley to illustrate an
English edition of the play.

Bibl: Pennell 1893, p. 19 illus.

Exh: New York 1960, no. 21; London 1966c,
no. 362.

3
Salome, a Tragedy in One Act, by Oscar Wilde.
Translated by Lord Alfred Douglas.
Binding design and illustration by Aubrey
Beardsley. London: Elkin Mathews and John
Lane; Boston: Copeland and Day, 1894.
Blue cloth binding, gilt-stamped; ten
full-page illustrations.
21.6 x 15.5 (8½ x 6⅛)
The University of Chicago Library.

"Wilde had written *Salome* in French in 1891
expressly for Sarah Bernhardt. The highly
wrought Byzantine opulence of this
prose-poem immediately attracted her. She was
to open in the title role at the Palace Theatre in
1892, but the British censor intervened.

"Beardsley's first meeting with Wilde was
in 1891, and his illustrations for this edition
were commissioned in 1893. He had
received fresh impetus from a series of visits to
the Greek vase collection in the British
Museum, and to Whistler's famous Peacock
Room in Prince's Gate. Walter Crane observed
that the one fault in the *Salome* drawings lay in
the slick texture of the pictures suggestive of
other media than pen and ink" (Garvey et al.
1970, p. 31).

All fourteen of Beardsley's illustration
designs were exhibited in 1894 at the Salon de
la Libre Esthétique, Brussels.

Bibl: Pennell 1893, p. 19 illus.; *Studio 2*
(1894), p. 185 illus.; Ross 1909, pp. 24,
45–46; Mason 1914, pp. 369–80; Reade
1967, pl. 271; Jullian 1969, p. 255; Garvey et
al. 1970, p. 31.

Exh: Chicago 1971.

4

The Yellow Book, Volume I.
Cover design by Aubrey Beardsley. London:
Elkin Mathews and John Lane, 1894.
Yellow cloth binding, printed in black.
20.7 x 17.2 (8⅛ x 6¾)
Mr. and Mrs. Herbert D. Schimmel.

"Elkin Mathews and John Lane became
partners in 1887 and opened their book shop in
Vigo Street, London, under a sign with the
head of Sir Thomas Bodley. In 1894 they
parted, after the publication of the first two
numbers of *The Yellow Book,* a venture
sponsored by Lane for which Mathews had
little sympathy. Thirteen issues, or volumes,
of the quarterly were published in the three
years between April, 1894 and April, 1897.
The American Henry Harland was the editor
and Aubrey Beardsley the art editor. He was
dismissed at the time of the Wilde trial by
Lane, bowing to unjustified pressures, since
Wilde had never contributed to *The Yellow
Book* nor been particularly close to Beardsley,
who had come to epitomize the decadent taste
of the Nineties and was thus victimized. Vol. 4
(January, 1895) is the last issue of *The Yellow
Book* in which Beardsley's name appears among
the contributors" (Garvey et al. 1970, pp.
33–34). Wilde in fact seems to have felt a
certain antipathy to *The Yellow Book* from the
outset. Of the cover design shown here he
remarked to a friend: "Oh, you can imagine
the sort of thing. A terrible naked harlot
smiling through a mask—and with ELKIN
MATHEWS written on one breast and JOHN
LANE on the other" (quoted in Reade and
Dickinson 1966, no. 396).

Bibl: Reade and Dickinson 1966, no. 396;
Garvey et al. 1970, pp. 33–34.

5

Le Japon Artistique, Numbers 1–12.
Published by S. Bing. 1888–89.
32.7 x 25.5 (12⅞ x 10)
Houston, D. & J. de Menil Collection.

Published monthly from May 1888 to April
1891, with editions in English and German as
well as French, *Le Japon Artistique* offered its
readers an impressive group of illustrations,
and texts by some of the well-known art critics
of the day. The contributors to Bing's
magazine included Edmond de Goncourt,
Théodore Duret, Ary Renan, Roger Marx, and
Louis Gonse.

Bibl: Weisberg 1969a; Ives 1974, pl. 70;
Weisberg et al. 1975, pp. 147–48.

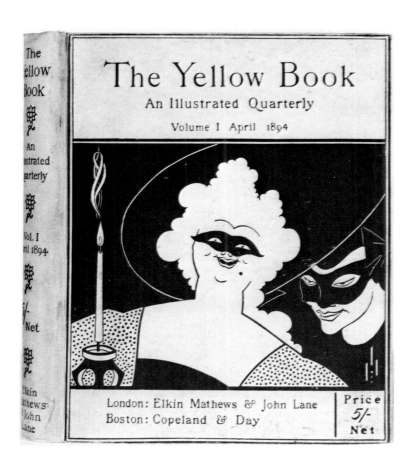

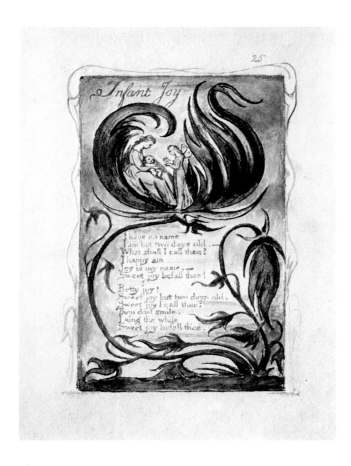

6

Infant Joy.
William Blake. c.1789.
Etching, hand-colored with watercolor and metallic paint.
21.6 x 13 (8½ x 5⅛)
New York, The Metropolitan Museum of Art, Inv. 17.10.25. Jacob S. Rogers Fund, 1917.

One of the plates from *Songs of Innocence,* Blake's first illuminated book. The plates were etched and the first copy published in 1789; however, Blake retained the copper plates for the *Songs,* as for his other works, and issued numerous versions through the years. Each plate was printed in a single color and then hand-tinted. Earlier copies generally have simpler color schemes in lighter tones, while those produced later in Blake's life are richer in color (Blunt 1959, pp. 44–46).

The *Songs of Innocence* caught the attention of Dante Gabriel Rossetti when he was only eighteen and Blake's work was generally

forgotten. Rossetti's enthusiasm for Blake, while well documented, is important enough to bear repeating, for it carried enormous weight with the Pre-Raphaelites, and later with the Century Guild. Through the works of these artists Blake's influence reached the Continent.

Bibl: Blunt 1959, pp. 44–46; Schmutzler 1964, fig. 26; Madsen 1967, p. 57 illus.

7

Flora's Feast.
Walter Crane. London: Cassell & Co., 1889.
Forty color-lithographed illustrations.
24.8 x 18.4 (9¾ x 7¼)
Courtesy of The Library of Congress.

Subtitled *A masque of flowers, penned & pictured by Walter Crane. Flora's Feast* was shown, along with a number of Crane's other picture books, at the Salon des Vingt in Brussels in 1891.

This was the breakthrough year which saw ceramics and illustrated books first exhibited in the company of paintings, drawings, and sculpture at official salons. The revolution was brewing in Paris as well, for the Société Nationale des Beaux-Arts inaugurated a section called Objets d'Art that same year. In both Brussels and Paris the applied arts entries were few at first—at Les Vingt there were only Crane's books, two ceramic panels by Finch, and a small group of wood reliefs and ceramics by Gauguin—but thereafter for many years their number would increase.

Bibl: Schmutzler 1964, pl. 3.

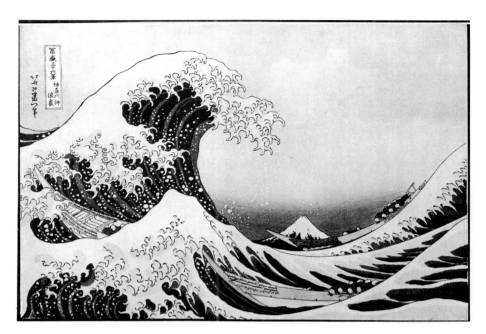

8
The Great Wave off Kanagawa.
Katsushika Hokusai. c. 1823–29.
Color woodcut.
25.7 x 38 (10⅛ x 15)
Hokusai Aratamé I-itsu fudé, upper left.
New York, The Metropolitan Museum of Art,
The H. O. Havemeyer Collection, Inv. Jap.
Pt. 1847. Bequest of Mrs. H. O. Havemeyer,
1929.

From the series *Thirty-six Views of Mount Fuji.*

Bibl: Ives 1975, frontispiece.

9
Untitled.
Katsushika Hokusai.
Color woodcut.
21.5 x 27 (8½ x 10⅝)
Houston, Menil Foundation, Inv. P74–11.

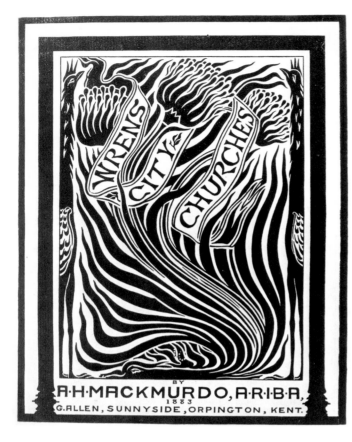

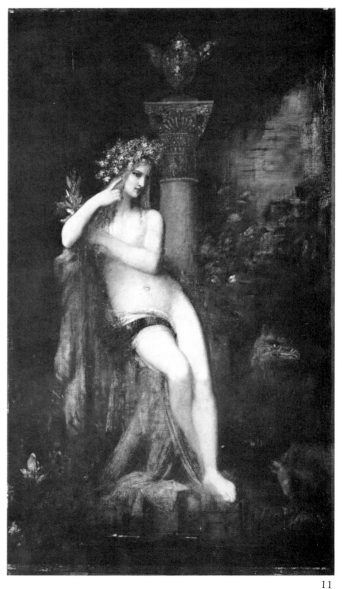

11
La Fée aux Griffons (Fairy and Griffons).
Gustave Moreau. c. 1880.
Oil on canvas.
212 x 120 (91¼ x 47¼)
Paris, Musée Gustave Moreau, Inv. 183.

10
Wren's City Churches.
Arthur Heygate Mackmurdo.
Orpington: G. Allen, 1883.
Illustrated title page.
30.5 x 24.1 (12 x 9½)
Courtesy of The Library of Congress.

This title page and the design in the back of
Mackmurdo's chair (cat. no. 168) are generally
considered to be among the first expressions of
the Art Nouveau style.

Bibl: Madsen 1956, p. 159, p. 158 illus.;
Schmutzler 1964, p. 111 illus.; Rheims 1966,
fig. 519; Madsen 1967, p. 77; Pevsner 1968,
p. 42 illus.

11

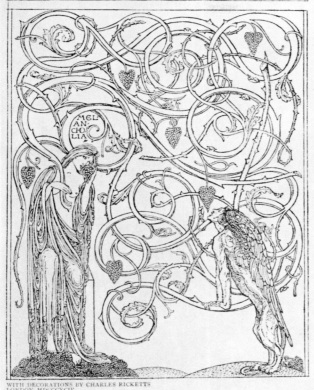

THE SPHINX BY OSCAR WILDE

WITH DECORATIONS BY CHARLES RICKETTS
LONDON MDCCCXCIV
ELKIN MATHEWS AND JOHN LANE, AT THE SIGN OF THE BODLEY HEAD.

THE SPHINX

IN A DIM CORNER OF MY ROOM FOR LONGER THAN MY FANCY THINKS
A BEAUTIFUL AND SILENT SPHINX HAS WATCHED ME THROUGH THE SHIFTING GLOOM.

INVIOLATE AND IMMOBILE SHE DOES NOT RISE SHE DOES NOT STIR
FOR SILVER MOONS ARE NAUGHT TO HER AND NAUGHT TO HER THE SUNS THAT REEL.

RED FOLLOWS GREY ACROSS THE AIR THE WAVES OF MOONLIGHT EBB AND FLOW
BUT WITH THE DAWN SHE DOES NOT GO AND IN THE NIGHT-TIME SHE IS THERE.

DAWN FOLLOWS DAWN AND NIGHTS GROW OLD AND ALL THE WHILE THIS CURIOUS CAT
LIES COUCHING ON THE CHINESE MAT WITH EYES OF SATIN RIMMED WITH GOLD.

UPON THE MAT SHE LIES AND LEERS AND ON THE TAWNY THROAT OF HER
FLUTTERS THE SOFT AND SILKY FUR OR RIPPLES TO HER POINTED EARS.

COME FORTH MY LOVELY SENESCHAL! SO SOMNOLENT, SO STATUESQUE!
COME FORTH YOU EXQUISITE GROTESQUE! HALF WOMAN AND HALF ANIMAL!

COME FORTH MY LOVELY LANGUOROUS SPHINX! AND PUT YOUR HEAD UPON MY KNEE!
AND LET ME STROKE YOUR THROAT AND SEE YOUR BODY SPOTTED LIKE THE LYNX!

AND LET ME TOUCH THOSE CURVING CLAWS OF YELLOW IVORY AND GRASP
THE TAIL THAT LIKE A MONSTROUS ASP COILS ROUND YOUR HEAVY VELVET PAWS!

12
The Sphinx, by Oscar Wilde.
Binding design, page design, and illustration by Charles Ricketts. Printed by Ballantyne Press. London: Elkin Mathews and John Lane at the Sign of the Bodley Head; Boston: Copeland and Day, 1894. Illustrated title page and nine full-page illustrations; vellum binding, gilt-stamped.
17.8 x 22.2 (7 x 8¾)
The University of Chicago Library.

Of *The Sphinx* Ricketts later remarked: "This is the first book of the modern revival printed in three colours, red, black and green: the small bulk of the text and unusual length of the lines necessitated quite a peculiar arrangement of the text; here I made an effort away from the Renaissance towards a book marked by surviving classical traits, printing it in Capitals. In the pictures I have striven to combine, consciously or unconsciously, those affinities in line work broadcast in all epochs. My attempt there as elsewhere was to evolve what one might imagine as possible in one charmed moment or place, just as some great Italian masters painted as they thought in the antique manner, studying like Piero della Francesca, for instance, to fulfill the conditions laid down by Apelles, whom he had of course never seen, but had taken on trust" (Garvey et al. 1970, p. 17).

Bibl: *The Dial* 3 (1893), p. 18 illus.; Ricketts 1899, pp. 24–26; Wilde 1906, pp. 263–64; Mason 1914. pp. 392–400 illus.; Symons 1930, p. 106 illus.; Moore 1933, pls. xxx-xxxiii; Holmes 1936; Schmutzler 1964, p. 86, p. 185 illus.; Taylor 1967, p. 83 illus. Garvey et al. 1970, p. 17.

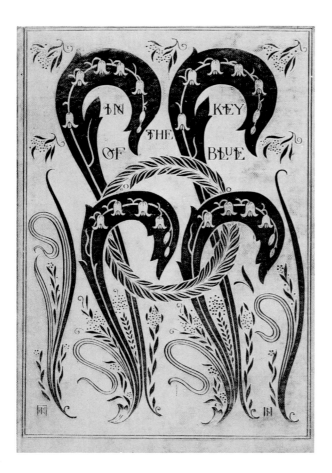

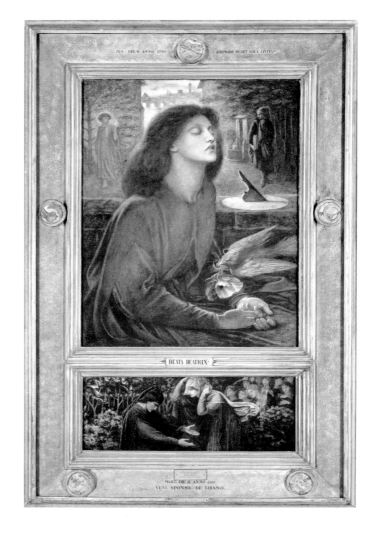

13

In the Key of Blue and Other Prose Essays, by John
Addington Symonds. Binding designed by
Charles Ricketts. Printed by Ballantyne,
Hanson and Co., London and Edinburgh, and
bound by Harry Leighton. London: Elkin
Mathews & John Lane; New York: Macmillan
& Company, 1893. White cloth binding,
gilt-stamped; front and back covers identical.
19.7 x 14 (7¾ x 5½)
Ricketts' monogram, lower left. Leighton's
monogram, lower right.
The University of Chicago Library.

"Covers were sometimes gilt-stamped on white
cloth to simulate vellum. In his early designs,
Ricketts may have been influenced by Selwyn
Image's intricate cover for *The Tragic Mary.*
The naturalistic design for this cover of *In the
Key of Blue* seems to be a transition from the
somewhat overcomplex pattern of *The House of
Pomegranates* to the greater clarity and
simplicity of his later work" (Garvey et al.
1970, p. 13).

Bibl: *Studio* 4 (1894), p. 17 illus.; Selz et al.
1959, p. 21 illus.; Garvey et al. 1970, p. 13.

Exh: Chicago 1971.

14

Beata Beatrix.
Dante Gabriel Rossetti. 1872.

Oil on canvas.
85.8 x 67.4 (33¾ x 26½)
Rossetti's monogram and *1872,* lower left.
Predella: 24.2 x 67.4 (9½ x 26½)
The Art Institute of Chicago, Inv. 25.722.
Gift of Charles L. Hutchinson.

A replica of Rossetti's 1853 painting of his
wife, Elizabeth Siddal (Tate Gallery). The
added predella shows Dante meeting Beatrice
in Paradise. Rossetti also designed the frame.

Bibl: Chicago 1961, p. 404, and bibliography.

Exh: St. Louis 1904.

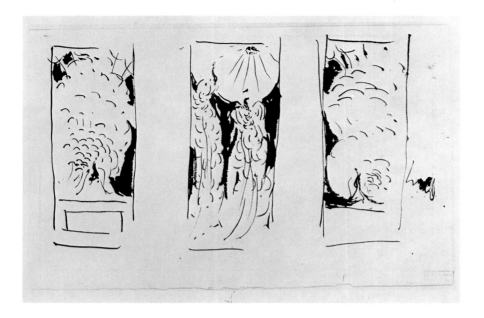

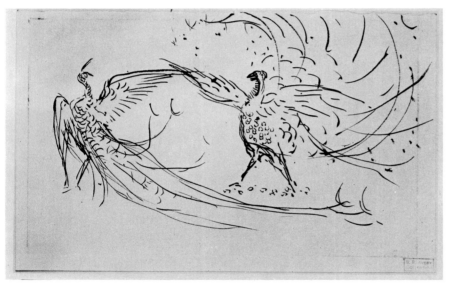

15
Two sketches of peacocks from the Peacock Room [not in exhibition].
James McNeill Whistler. c. 1876–77.
Pen and ink.
The New York Public Library, Prints Division, Astor, Lenox, and Tilden Foundations, S. P. Avery Collection.

Whistler's belief that "the painter must also make of the wall upon which his work hung, the room containing it, the whole house, a Harmony, a Symphony, an Arrangement, as perfect as the picture or print which became a part of it" (*Whistler Journal,* p. 299, quoted in Sutton 1963, p. 80) led him to devise decorative schemes for his own homes and those of his friends. The most famous of them, and the only one known to survive today, was surely the most extensive and elaborate he ever did—the Peacock Room, for the home of F. R. Leyland, now in the Freer Gallery, Washington, D. C.

Originally consulted by the Leylands in the summer of 1876 about color schemes for their house, Whistler took advantage of their absence from London, and in short order was painting over the Cordova leather which covered the walls in the dining room. The final decoration of peacocks in gold on blue was completed in February 1877, but the painter's audacity in executing it cost him the friendship and patronage of Leyland, who in 1879 would be one of the chief creditors at Whistler's bankruptcy trial.

Whistler later stated that the composition of the Peacock Room evolved as he was painting it, that he did not do preparatory studies. Because of this it is thought that the New York Public Library sketches and those in the Birnie Philip Bequest, Glasgow, were made after the decoration.

Bibl: Sutton 1963, pp. 80–85.

Exh: New York 1971, no. 25.

PAINTING AND GRAPHIC ARTS:

BELGIUM AND FRANCE

17
Confidence (The Secret).
Edmond Aman-Jean. c. 1897–98.
Oil on canvas.
197 x 104 (77½ x 41)
Aman-Jean, lower right.
Paris, Musée des Arts Décoratifs, Inv. 11942.
Gift of Jules Maciet, 1905.

One of two works (the other entitled *L'Attente*)
given by Maciet to the Musée des Arts
Décoratifs for the installation of the Salle
1900, where they still hang today.

Bibl: De Lostalot 1898, p. 303; Dalligny
1898, p. 1; Bénédite 1898a, p. 461; Hamel
1898, p. 880; Bénédite 1898b, p. 65 illus.;
Art in 1898 3, p. 8, p. 9 illus.; Coquiot 1900,
p. 334; Kahn 1900, p. 651; Beaunier 1902,
p. 139 illus.; *Art et Décoration* 27 (1910), opp.
p. 108 illus.; Segard 1914, pp. 103–106;
Guide illustré, p. 161.

Exh: Paris 1898, Salon SNBA; Paris 1900;
Paris 1970c, no. 53; Paris 1973, no. 5.

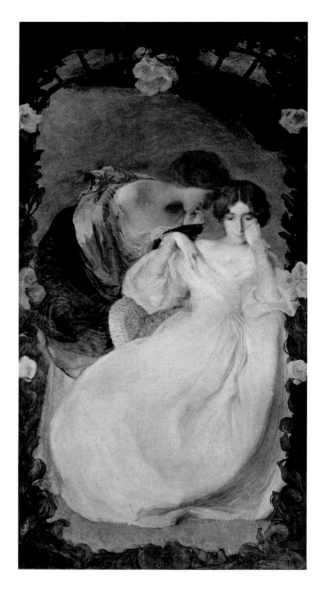

16
Invitation card for L'Art Nouveau Bing.
French. 1900.
Printed on paper.
12.2 x 18.2 (4⅞ x 7⅛)
Saint-Germain-en-Laye,
Musée Symbolistes et Nabis.
Formerly in the collection
of Maurice Denis.

Monsieur S. BING
vous prie de lui faire
l'honneur de venir visiter
le Pavillon de L'ART NOUVEAU
situé à l'Exposition Universelle sous
les quinconces des Invalides côté
de la Rue de Constantine.

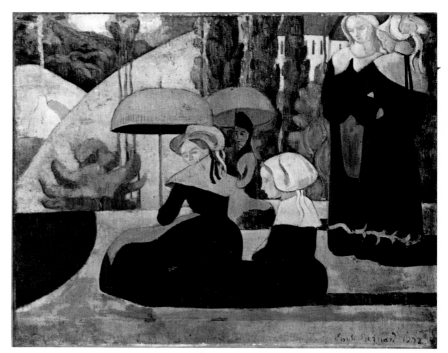

19
Bretonnes aux ombrelles (Breton Women with Parasols).
Emile Bernard. 1892.
Oil on canvas.
80.5 x 100 (31¾ x 39⅜)
Emile Bernard 1892, lower right.
Paris, Centre National d'Art et de Culture Georges Pompidou, Musée National d'Art Moderne, Inv. AM3373P.

Exh: Paris 1955, no. 49; Saint-Denis 1961; Tokyo 1961; Caen 1963; London 1966b, no. 98; Zürich 1966; Lille 1967, no. 35; Munich 1968; Cairo 1969.

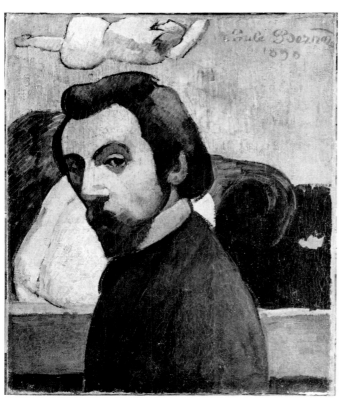

18
Portrait de l'artiste.
Emile Bernard. 1890.
Oil on canvas.
55.5 x 46 (21⅞ x 18⅛)
Emile Bernard/ 1890, upper right.
Brest, Musée des Beaux-Arts, Inv. 74.11.1.

Bibl: Chantelou 1974.

Exh: Pau 1973; Paris 1974d, no. 54.

20
Two Poodles.
Pierre Bonnard. 1891.
Oil on canvas.
36.2 x 39.4 (14¼ x 15½)
PBonnard/ 1891, upper left.
Southampton Art Gallery.

Bibl: Towndrow 1952, p. 79 illus.;
Dauberville 1965, no. 27 illus.; Barilli 1967b,
p. 103 illus.

Exh: London 1966a, no. 6; London 1970.

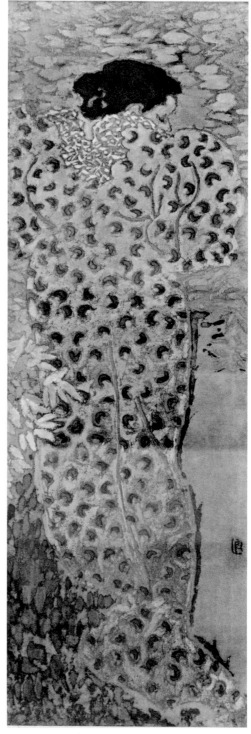

21

21
Le Peignoir.
Pierre Bonnard. c. 1890.
Oil on fabric.
148.5 x 50.5 (58½ x 19⅞)
Bonnard's monogram, lower right.
Paris, Centre National d'Art et de Culture
Georges Pompidou, Musée National d'Art
Moderne, Inv. AM2216P.

Bibl: Dauberville 1965, no. 14, bibliography
and exhibitions.

Exh: New York 1960, no. 42; Berlin 1965,
no. 44; Tokyo 1968b.

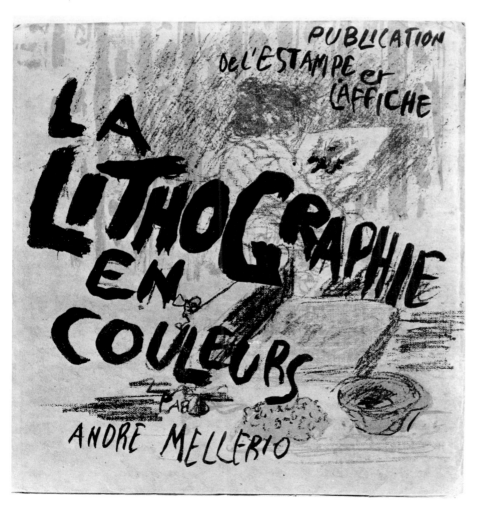

22
La Lithographie Originale en Couleurs,
by André Mellerio.
Illustrated by Pierre Bonnard. Printed by the
Société Typographique, Châteaudun. Paris:
L'Estampe et l'Affiche, 1898.
Buff wrappers, upper cover with color
lithograph; lithographed frontispiece.
20.6 x 20.3 (8⅛ x 8)
Cambridge, Harvard College Library,
Department of Printing and Graphic Arts.
Gift of Philip Hofer.

"Bonnard decorated his book covers in broad,
deceptively haphazard designs with
imbalanced brush lettering splashed across the
page. . . . Mellerio characterizes Bonnard as a
'gray painter, fond of purplish, russet, somber
tones.' He notes his 'shrewd observation, his
impish gaiety . . . a curious line in movement,
of a monkeylike suppleness'" (Garvey et al.
1970, p. 53).

Bibl: Rewald 1948, p. 30; Garvey et al.
1970, p. 53.

Exh: Cambridge 1961, no. 26; Cambridge
1970, no. 57.

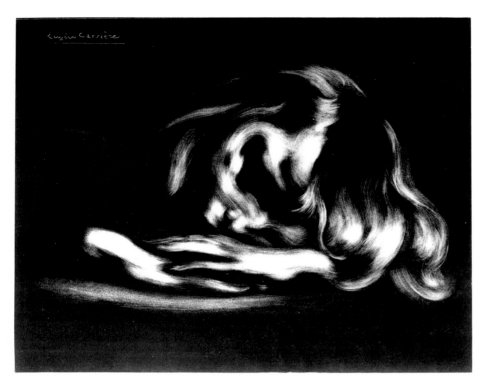

23
Sleep (Jean-René Carrière).
Eugène Carrière. 1897.
Lithograph.
33.9 x 42.7 (13¼ x 16¾)
Eugène Carrière, upper left.
New York, The Museum of Modern Art,
Inv. 610.56. Gift of Peter H. Deitsch.

This lithograph was first published in 1897 in
the *Album d'estampes originales.* Jean-René
Carrière, one of the artist's seven children, later
became a sculptor.

Bibl: *Album d'estampes originales* (1897), illus.;
Delteil 1913, no. 36 illus.

Exh: Paris 1907b, no. 282 (under the title
Enfant endormi); New York 1960, no. 56; New
York 1972.

24
Essay on Broom-Corn.
Edward Colonna. Dayton, Ohio, 1887.
Illustrated with photographs and
line drawings.
12.7 x 20.3 (5 x 8)
Trustees of the Public Library of the City
of Boston.

Colonna's picture essay, which dates from his
period of employment in the United States,
was rediscovered only recently by Martin
Eidelberg (Eidelberg 1971). Though its
designs anticipate the first expressions of
French and Belgian Art Nouveau ornament by
several years, this small volume seems to have
been unknown even in its own day. Of the
hundred or so copies printed, only three or four
were distributed.

Bibl: Eidelberg 1971.

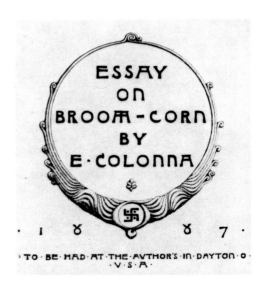

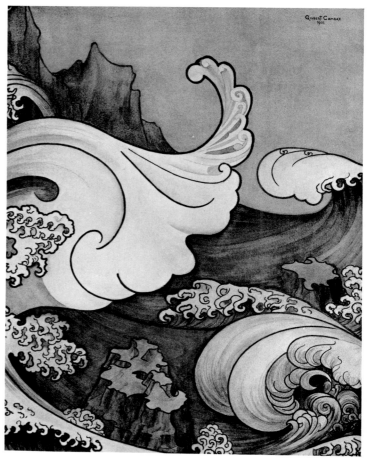

25
Menu for the First International Congress
of Lawyers.
Gisbert Combaz. 1897.
Lithographed in two colors.
23.2 x 15 (9⅛ x 5⅞)
Gisbert/ Combaz/ 1897, upper right.
Brussels, L. Wittamer—de Camps.

Besides the menu shown here, Combaz
executed a poster for the Congress of Lawyers
which he signed *Me* (maître) *Gisbert
Combaz*—alluding to the fact that he had
himself studied law and practiced it briefly
before becoming an artist. Edmond Picard, the
eminent jurist who presided over the congress,
was also one of the founders of the Maison
d'Art in Brussels (Oostens-Wittamer 1973,
no. 21).

26
La Vague (The Wave).
Gisbert Combaz. 1901.
Watercolor, pencil, india ink, and pastel
on paper.
51.7 x 40.5 (20⅜ x 15⅞)
GISBERT COMBAZ/ 1901, upper right.
Brussels, L. Wittamer—de Camps.

Acquired from Combaz's private collection.

27
La Porte des Rêves, by Marcel Schwob.
Illustrated by Georges de Feure under the
direction of Octave Uzanne.
Printed by A. Lahure. Paris: Les Bibliophiles
Indépendants, chez Henry Floury, 1899.
Etched and hand-colored frontispiece; sixteen
full-page wood engravings, and numerous
vignettes; printed floral wrappers.

26.3 x 22.2 (11⅜ x 8¾)
de Feure, lower right of title page.
Cambridge, Harvard College Library,
Department of Printing and Graphic Arts.

Bibl: Uzanne 1898; Hofstätter 1968, p. 50;
Garvey et al. 1970, pp. 59, 61.

Exh: Cambridge 1970, no. 68.

28
Untitled.
Georges de Feure. c. 1900.
Watercolor.
54 x 42 (21¼ x 16½)
de Feure, lower left.
Paris, Mme. Robert Walker.

Bibl: Vaizey 1971, p. 26 illus.

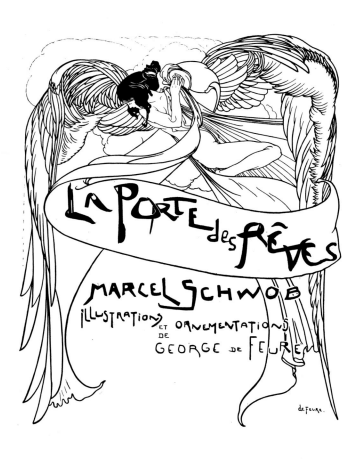

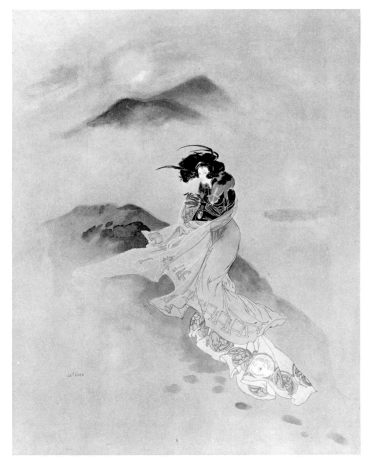

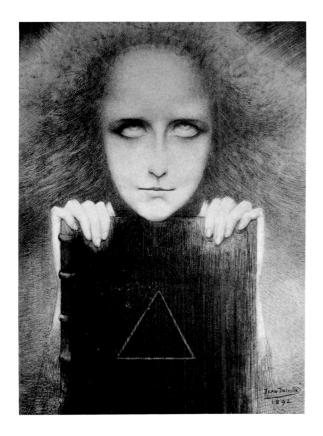

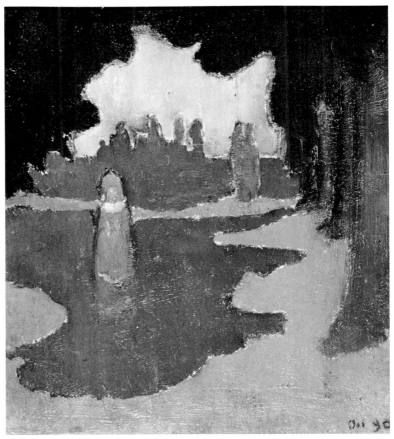

30
Taches de Soleil sur la Terrasse (Sunlight on the Terrace).
Maurice Denis. 1890.
Oil on cardboard.
24.5 x 21 (9⅝ x 8¼)
Oct. 90, lower right.
Saint-Germain-en-Laye, Musée Symbolistes et Nabis.

Exh: Paris 1970b, no. 14; Bremen 1971, no. 9; Honfleur 1975, no. 6.

Also illustrated in color.

29
Mrs. Stuart Merrill.
Jean Delville. 1892.
Colored chalk on paper.
38.1 x 27.9 (15 x 11)
Jean Delville/ 1892, lower right.
Thousand Oaks, Cal., Edwin Janss, Jr.

Bibl: Legrand 1972, pl. 40; Jullian 1971b, dust jacket and pl. 96.

Exh: Paris 1972, no. 16; New York 1974b, no. 10.

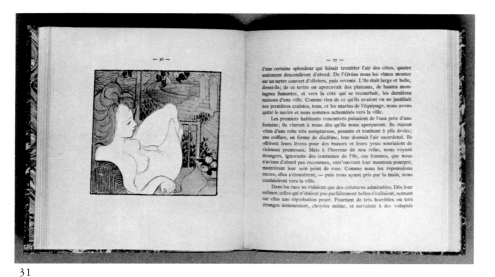

31

31
Le Voyage d'Urien, by André Gide.
Illustrated by Maurice Denis. Lithographs
printed by Edward Ancourt, text printed by
Paul Schmidt. Paris: Librairie de l'Art
Indépendant, 1893.
Thirty lithographed illustrations. Copy
number 158 in an edition of 302.
20.5 x 20 (8⅛ x 7⅞)
Collection Dominique Maurice-Denis.

The illustrations were drawn by Denis directly
on the lithographic stone.

Bibl: Garvey 1958, pp. 381–82 illus.; Madsen
1967, p. 98; Garvey et al. 1970, p. 50.

Exh: Paris 1970b, no. 275; Paris 1970d;
Bremen 1971, no. 191.

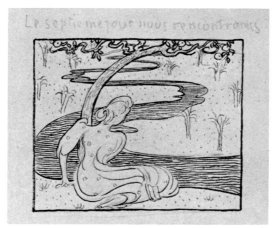

a

b

32
Ellis waits beneath an apple tree. Studies for
page 57 of *Le Voyage d'Urien.*
Maurice Denis. c. 1892–93.
a) Ink on paper.
20.5 x 19 (8 x 7½)
Le septieme jour nous remontrèmes, across top. 57,
lower right.
b) Ink on paper.
18.5 x 18.5 (7¼ x 7¼)
c) Ink on paper.
14.5 x 10 (5¾ x 4)
Le/ nous, upper right. 57, lower right.
Private collection.

33
Two women with fans.
Study for page 23 of
Le Voyage d'Urien.
Maurice Denis. c. 1892–93.
Gouache on paper.
8.2 x 14.8 (3¼ x 5⅞)
23, lower right.
Private collection.

34
Three woodcuts.
Maurice Denis. c. 1889–93.
Color woodcuts, mounted together.
27.5 x 37.7 (10⅞ x 14⅞)
New York, The Museum of Modern Art, Inv.
648.54. Gift of Abby Aldrich Rockefeller.

c

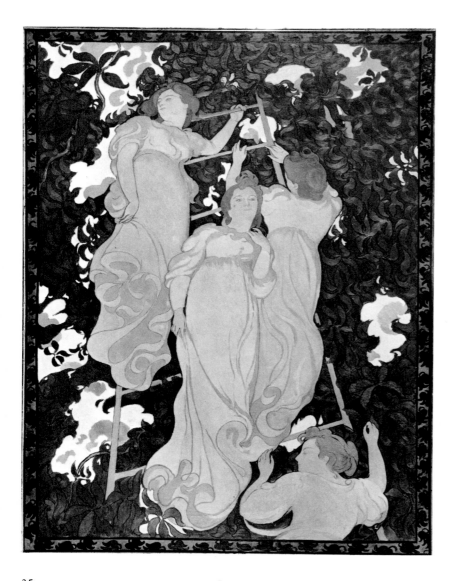

35
L'Echelle dans le Feuillage (Ladder in the Foliage).
Maurice Denis. 1892.
Oil on canvas, mounted on heavy cardboard.
235 x 172 (92⅛ x 67¾)
Denis' monogram and *92,* middle right. *M.M.* in border, lower left.
Saint-Germain-en-Laye, Musée Symbolistes et Nabis. Formerly in the collection of Maurice Denis.

Painted as a ceiling decoration for the composer and painter Henri Lerolle; the ornamental border is by Marthe Meurier, who became Denis' wife in 1893. This is an example of a device appearing frequently in Denis' work, the "multiple portrait," which shows several views of the same person. The subject here is Lerolle's daughter Yvonne, of whom Denis painted a conventional portrait in 1896 (Dayez 1970, p. 28).

Bibl: Dayez 1970, p. 28.

Exh: Saint-Germain-en-Laye 1892, no. 102; Paris 1970b, no. 37; Bremen 1971, no. 27; Honfleur 1975, no. 14.

36
Auto-da-fé.
James Ensor. 1893.
Etching.
8.6 x 12.1 (3⅜ x 4¾)
James Ensor 1893 in pencil, lower right.
New York, The Museum of Modern Art, Inv. 330.54. Gift of Samuel A. Berger.

Etched after a small painting of 1891 entitled *Philip II in Hell.* Ensor took the likeness of the King of Spain from a coin.

Bibl: Delteil 1925, no. 85 illus.; Croquez 1947, no. 87 illus.; Taevernier 1973, no. 87, p. 220 illus.

37
Le Christ aux Enfers (Christ in Hell).
James Ensor. 1895.
Etching.
8.9 x 14.3 (3½ x 5⅝)
J. Ensor, at top. *James Ensor 1895* in pencil, lower right.
New York, The Museum of Modern Art, Inv. 334.54. Gift of Samuel A. Berger.

Croquez states that Ensor considered this to be a study for a stained glass window, and that he colored several impressions with pastels.

Bibl: Delteil 1925, no. 103 illus.; Croquez 1947, no. 103 illus.; Taevernier 1973, no. 103, p. 254 illus.

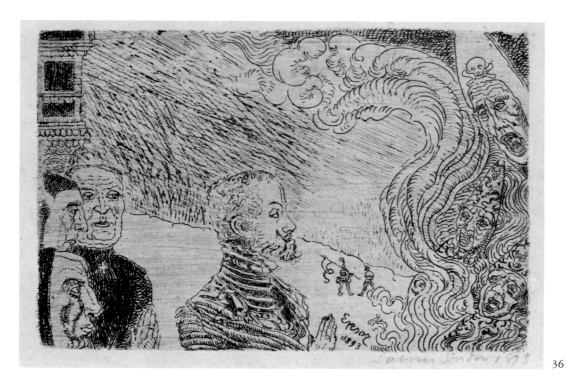

36

37

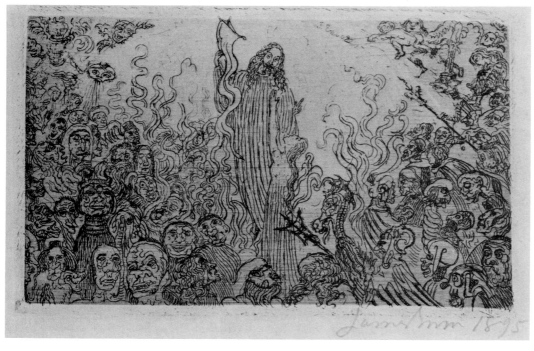

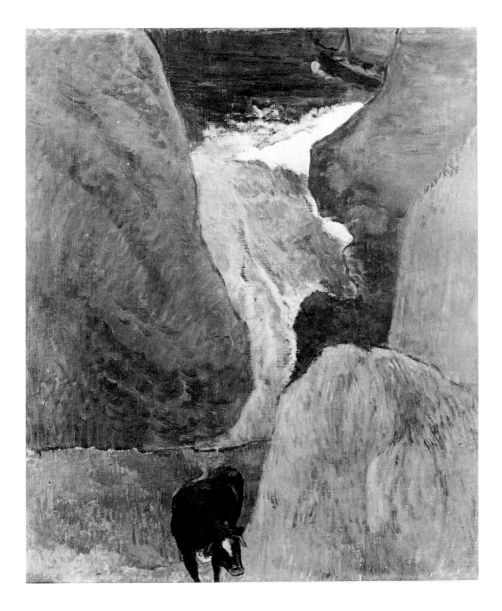

38
Au-dessus du Gouffre (Above the Abyss).
Paul Gauguin. 1888.
Oil on canvas.
73 x 60 (28¾ x 23⅝)
P. Gauguin 88, lower left.
Paris, Musée des Arts Décoratifs, Inv. 29196.
Bequest of the Vicomte du Cholet.

Bibl: Wildenstein 1964, no. 282,
bibliography and exhibitions.

Also illustrated in color.

39
Le Peintre Roy.
Paul Gauguin. 1889.
Oil on canvas.
40.5 x 32.5 (16 x 12¾)
Expo. Synthé, upper right.
Houston, Lenoir M. Josey, Inc.

The painter Roy participated in the Exposition de peintures du groupe impressioniste et synthétiste held at the Café Volpini in 1889. It is believed that this portrait was painted during this period (Wildenstein 1964, no. 317 *bis*).

Bibl: Wildenstein 1964, no. 317 *bis*.

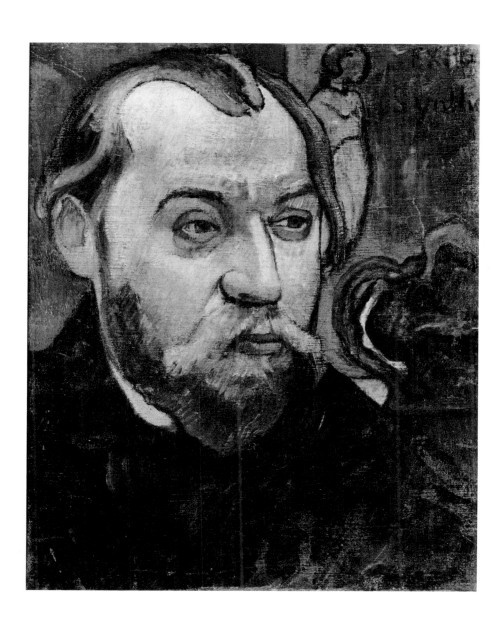

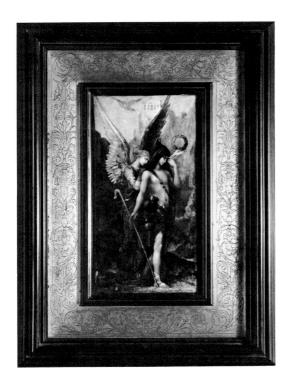

40
Les Voix (The Voices).
Paul Grandhomme and Alfred Garnier, after
the watercolor by Gustave Moreau. 1889.
Painted enamel; ebony frame with pewter inlay
and engraved decoration.
37 x 27 with frame (14⅝ x 10⅝)
PG conjoined, in gold, lower left. *LES VOIX,*
lower center. *Gustave Moreau* and *GM*
intertwined, lower right. *L. Falize Dir ˣᴵᵀ/
Grandhomme Garnier/ Emailleurs/ 1889/ PARIS,*
on back. *CADRE EN EBENE/ I. CH. SENE
EBENISTE/ PARIS 1889,* inlaid in pewter on
back of frame.
Paris, Musée des Arts Décoratifs, Inv. 4911.

Purchased in 1889 from Grandhomme, this
piece was exhibited by the Union Centrale des
Arts Décoratifs at the Paris Exposition
Universelle, 1900, and was among the works
the museum sent to the Louisiana Purchase
Exposition in St. Louis, 1904.

Bibl: *Revue des Arts Décoratifs* 20 (1900),
p. 216 illus.; *Les Arts* (1905), p. 44 illus.

Exh: Chicago 1893; Paris 1900; St. Louis
1904.

41
Les Mois, douze compositions.
Illustrated by Eugène Grasset. Engraved by
Boileau. Paris: G. de Malherbe, c. 1896.
Watercolors and wood engravings.
Watercolors: 21.3 x 16.2 (8⅜ x 6⅜)
Binding: 31.7 x 24.1 (12¼ x 9½)
Grasset's monogram on each watercolor and
each engraving.
New York, private collection.

"This series of decorative calendar pages is a
lady's book à la mode with comely maidens
dressed in 'aesthetic' free-flowing costumes
joyfully tending their well-ordered,
full-flowering gardens. Grasset shows himself
here more as an illustrator than a flamboyant
stylist or theorist. These garden settings are a
foil for his sense of formalized surface pattern,
showing the influence of Walter Crane. In his
Méthode de composition ornementale, published in
1904, Grasset wrote: 'Every curve gives the
idea of movement and life . . . the line of the
curve should be full, rounded, closed and
harmonious like a stalk of young sap'" (Garvey
et al. 1970, p. 48).

Bound in brown morocco by Marius-Michel,
this copy of *Les Mois* contains Grasset's twelve
original watercolor compositions for the
illustrations as well as two color proofs, one
printed on china paper, for each engraving.

Bibl: Hofstätter 1968, p. 44; Garvey et al.
1970, p. 48.

Exh: Cambridge 1970, no. 50.

BÚTTER-CUP BOÚTON D'OR Die GOLDBLUME

42

Histoire des Quatre Fils Aymon.
Illustrated by Eugène Grasset. Printed by
Charles Gillot. Paris: H. Launette, 1883.
Pictorial wrappers, printed in color; numerous
illustrations and vignettes.
28.6 x 24.2 (11¼ x 9½)
Trustees of the Public Library of the City
of Boston.

"The *Histoire des Quatre Fils Aymon* is one of the
seminal forerunners of Art Nouveau book
design in France, perhaps the first illustrated
book in which text and illustration were
conceived as a coordinated *mise en page,* one
complementing and integrating with the other
to the extent that Grasset's pictorial borders
not only surround the pages of type, but often
serve as a muted background over which the
type is printed. Grasset's decorations combine
pictorial images of the Middle Ages intermixed
with strong doses of Celtic and Japanese
ornament" (Garvey et al. 1970, p. 46).

Bibl: Uzanne 1894, pp. 37–42; Uzanne 1898,
p. 9 illus.; Madsen 1956, p. 181 illus., p. 219
illus.; Fern 1959, pp. 38–39 illus.; Abdy
1967, p. 115; Madsen 1967, p. 64 illus.;
Garvey et al. 1970, p. 46.

43

La Plante et ses Applications Ornementales.
Eugène Grasset. Paris: Librairie des
Beaux-Arts, E. Lévy, 1897. Two volumes.
Illustrated title page and seventy-two color
lithographs in each volume, after watercolors
by Grasset. Drawn and signed in the stone by
eleven different draftsmen.
45.7 x 33 (18 x 13)
The New York Public Library.

"Christopher Dresser's *Rudiments of Botany,*
1859, was one of the first influential books to
apply the theory of plant form to decorative
arts. In the last quarter of the nineteenth
century a whole flood of pattern books
appeared with plants as the principal motifs.
Grasset, by juxtaposing accurate illustrations
of individual plants with geometrized and
stylized adaptations for use in the applied arts,
promulgates his theory that a return to the
direct study of nature is the only true source of
comprehension of ornamental motifs. The
plates, executed by his pupils and brilliantly
printed under the supervision of Emile Lévy,
are strong in pattern and color, appropriate for
wallpaper, fabric and ceramic as well as applied
metalwork" (Garvey et al. 1970, p. 46).

Bibl: Soulier 1897, pp. 187–89; Soulier
1900b, pp. 93–96; Schmutzler 1964, p. 101;
Garvey et al. 1970, p. 46.

44
Jealousy.
Eugène Grasset. c. 1896.
Watercolor.
Diameter 66 (26)
Grasset's monogram, lower right.
Paris, Mme. Robert Walker.

This and the following watercolor are original
compositions for plates in *Estampes décoratives,* a
series of ten lithographs published in late 1896
by G. de Malherbe.

Bibl: *Art et Décoration* 6 (1899),
opp. p. 33 illus.

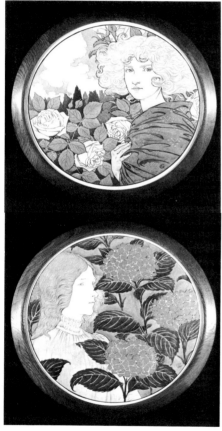

45
Untitled.
Eugène Grasset. c. 1896.
Watercolor.
Diameter 66 (26)
Grasset's monogram, lower right.
Paris, Mme. Robert Walker.

Bibl: *Art et Décoration* 1 (1897), pp. 24–25,
opp. p. 96 illus.

46
*Catalogue de la Deuxième Exposition du Salon
des Cent Réservée à un ensemble d'Oeuvres
d'Eugène Grasset.*
Vignettes by Eugène Grasset. Paris:
Typographie A. Davy, 1894.
Twenty-four pages; paper binding printed
with the design for the exhibition poster
(cat. no. 118).
22.5 x 14.2 (8⅞ x 5⅝)
Paris, Bibliothèque des Arts Décoratifs, Br.
2263.

A listing of the 366 works shown, with an
introduction, "L'Oeuvre d'Eugène Grasset,"
by Arsène Alexandre. Included in the
exhibition were several studies for stained-glass
windows for an unidentified church in
Houston.

47
La Princesse Lointaine, by Edmond Rostand.
Binding by Léon Gruel. Printed by
Imprimeries Réunies. Paris: G. Charpentier
et E. Fasquelle, 1895.
White morocco binding; gold and silver
appliqués set with pavé diamonds and garnets;
clasp set with a cabochon amethyst, garnets,
and tourmalines.
19.7 x 14 (7¾ x 5½)
SB and *Quand Même* (Bernhardt's motto), in
gold appliqué on back. *A madame Sarah
Bernhardt puis-je ne pas dédier cette pièce? E.R.,*
inscribed on flyleaf.
New York, private collection.

A presentation copy Rostand offered to Sarah
Bernhardt, who appeared as the play's heroine,
the oriental princess Mélissinde.

Bibl: Garvey et al. 1970, p. 57.

Exh: Cambridge 1970, no. 63.

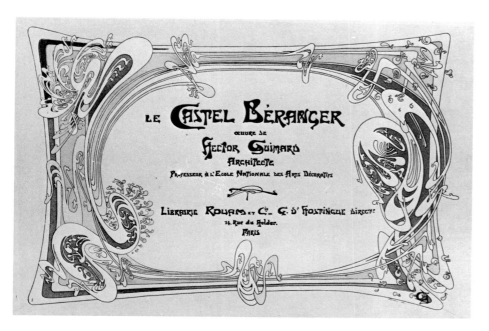

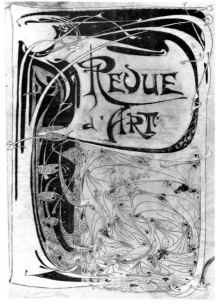

48

*Le Castel Béranger. L'Art dans l'Habitation
Moderne.* Portfolio.
Hector Guimard. Paris: Librairie Rouam
et Cie., 1898.
Fiberboard cover, lithographed title page, and
stenciled color loose-leaf plates.
33.5 x 44.5 (13¼ x 17½)
Paris, Blondel and Plantin Collection.

An album showing in great detail the
architecture and interior furnishings of the
Castel Béranger, and supplying as well the
names of the craftsmen who realized Guimard's
designs in ceramic, stained glass, wood, fabric,
and wallpaper. The plates from the album,
along with Guimard's watercolor studies and a
number of objects from the building, were
shown in the Exposition Le Castel Béranger,
which Guimard arranged to promote his newly
completed masterpiece. The exhibition was
held in the Salons du Figaro, on the rue
Rossini, from April 5 to May 5, 1899.
Guimard's publicity efforts seem to have been
successful, for soon afterwards he was
commissioned to design the Métropolitain
entrances. Not all the reaction to the
exhibition was favorable, however. The
correspondent of *The International Studio* was
provoked to remark that "If these were the
productions of some ordinary artist, some
nobody, I should have nothing to say; but they
are conceived on so large a scale, with so
much unity of purpose, as to constitute a
real danger."

Bibl: Champier 1899, p. 1 illus.; Boileau
1899, pp. 120–21; *International Studio* 8
(1899), pp. 49–50.

Exh: New York 1970, nos. 57–58;
Paris 1971b, no. 119.

49

Design for the cover of *Revue d'Art*.
Hector Guimard. 1899.
India ink, pencil, and watercolor on
tracing paper.
40 x 26.5 (15¾ x 10⅜)
Paris, Musée des Arts Décoratifs.

The *Revue d'Art* was a weekly edited by
Maurice Méry. Its first issue, November 4,
1899, contained an article by Frantz Jourdain
singing Guimard's praises. This cover appeared
on the first seven issues. The magazine ceased
publication after the appearance of No. 11, in
January 1900 (Brunhammer et al. 1971, p.
136).

Exh: New York 1970, no. 61; Paris
1971b, no. 122.

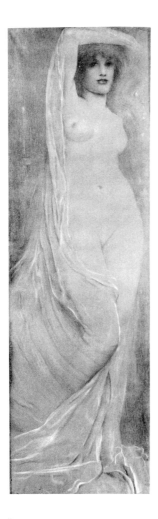

51

Falaises à Camaret (Cliffs near Camaret).
Georges Lacombe. c. 1892.
Oil on canvas.
81 x 61 (31⅞ x 24)
GL, lower left. *GL* and *Atelier Georges Lacombe,*
stamped on back at upper right.
Brest, Musée des Beaux-Arts, Inv. 69.1.1.

The suggestion of human profiles in the sharp
lines of the cliffs is characteristic of Lacombe's
landscape paintings during this period.
Gauguin's *Au-dessus du Gouffre* (cat. no. 38),
which Lacombe may have seen at the Gauguin
sale in Paris, February 23, 1891, inspired the
composition (G. Lacambre 1972, p. 61).

Bibl: Barilli 1967b, p. 98 illus.;
Barilli 1967c, p. 58 illus.; Ansieau 1968;
J. Lacambre 1972, p. 478; Jullian 1973,
no. 77 illus.

Exh: Paris 1924b, no. 24; Mannheim 1963,
no. 146; Munich 1966, no. 22; Düsseldorf
1967, no. 7; Brest 1971, no. 57; London
1972, no. 96; Madrid 1972, no. 83; Paris
1974d, no. 57.

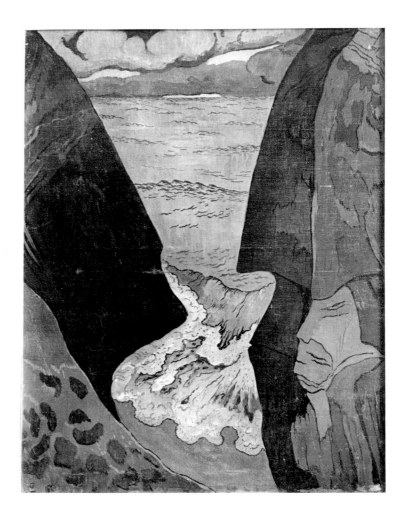

50

Study for *Acrasia.*
Fernand Khnopff. c. 1897.
Charcoal and chalk on gray paper.
150 x 44 (59 x 17⅜)
FERNAND KHNOPFF, lower left.
Brussels, L'Ecuyer.

The finished version, in oil on canvas, is now
in the collection of Anne-Marie
Gillion-Crowet, Brussels. The catalogue *L'Art
Décoratif Moderne Belge à l'Exposition de Milan,
1906* (p. 28) mentions that Khnopff exhibited
a triptych in pastel and wax whose parts were
entitled *Acrazia, L'Isolement,* and *Britomart.*

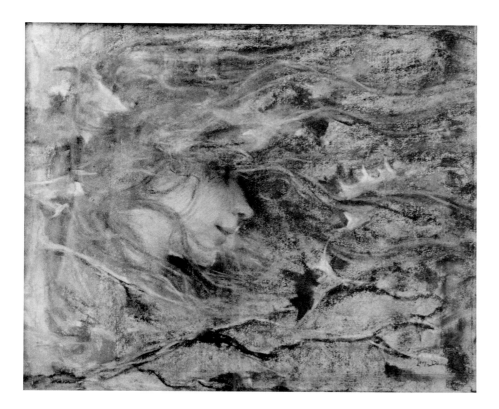

53
La Bourrasque (The Gust of Wind).
Lucien Lévy-Dhurmer. c. 1895–96.
Pastel on paper.
40 x 48 (15¾ x 18⅞)
Lévy-Dhurmer, lower right.
Paris, Gérard Lévy Collection.

One of several treatments by Lévy-Dhurmer of the same theme.

Bibl: Soulier 1898, p. 1 illus.
(another version).

Exh: Paris 1970a, no. 84; London 1972, no. 114; Madrid 1972, no. 97; Paris 1973, no. 66.

52
Loïe Fuller.
Georges Lemmen.
Conté crayon on paper.
46 x 69.5 (18⅛ x 27⅜)
Lemmen's monogram, lower right.
Brussels, L. Wittamer–de Camps.

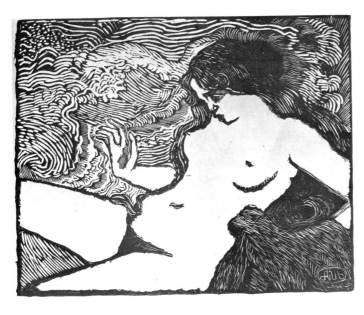

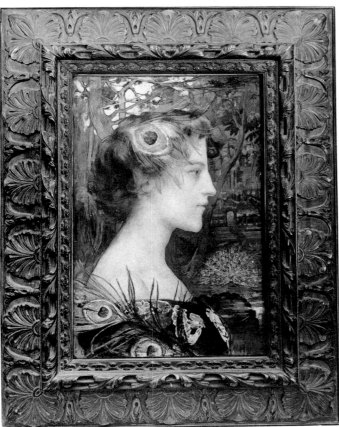

54
The Wave.
Aristide Maillol. 1898.
Wood engraving.
17.2 x 19.7 (6¾ x 7¾)
New York, The Museum of Modern Art, Inv.
610.54. Gift of Mrs. Donald B. Straus.

Exh: Cambridge 1972; New York 1975b.

55
Profil au paon (Profile with Peacock).
Edgard Maxence. Before 1896.
Pastel and gouache, touched with silver paper;
frame carved by the artist.
46 x 30 (18⅛ x 11⅞)
Edgard Maxence, lower right.
Paris, Gérard Lévy Collection.

Bibl: Schurr 1971, p. 56 illus.;
Jullian 1971b, p. 46 illus.;
Jullian 1973, p. 18 illus.

Exh: Paris 1970a, no. 99; London 1972, no.
133; Madrid 1972, no. 114.

56
L'An, poems by Thomas Braun.
Illustrated by Franz Melchers. Brussels:
E. Lyon-Claeson, 1897.
Sixteen full-page color woodblock prints;
printed cover.
30.8 x 30.8 (12⅛ x 12⅛)
Brussels, L. Wittamer—de Camps.

Bibl: Reviewed in *Art et Décoration,* January
1898, supplement, p. 4; Garvey et al.
1970, p. 76.

Exh: Paris 1899, Salon SNBA.

56

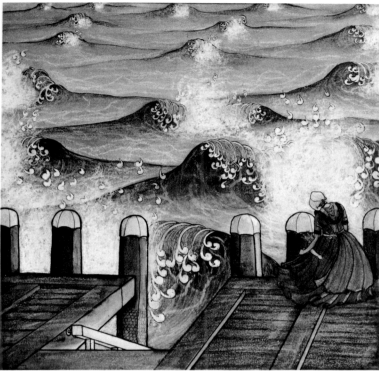

57

Les Tempêtes de Mars (March Storms).
Franz Melchers. 1896.
Pastel, gouache, and india ink on paper.
33 x 33 (13 x 13)
Melchers' monogram, lower left.
Brussels, L. Wittamer–de Camps.

The original composition for the illustration,
published in *L'An,* of Braun's poem of the
same name:
L'âpre aquilon soulève les flots gris,
Les flots jaunes, les flots verts dont l'écume
Va s'écraser contre les pilotis
De la jetée, avec un bruit d'enclume
Et, secoués par l'eau qui les parfume,
Sous le ciel bas aux nuages croulants,
Branlent les bois noircis et ruisselants
Dans la pluie et le choc des vagues glauques
Où passe le vol fou des goëlands
Epouvantant les airs de leurs cris rauques.

58

Les Sapins de Décembre (December's Firs).
Franz Melchers. 1896.
Watercolor, gouache, and india ink on paper.
35 x 33.5 (13¾ x 13¼)
Melchers' monogram, lower right.
Brussels, L. Wittamer–de Camps.

Project for an illustration of another of Braun's
poems in *L'An*:
Le froid durcit les plaines, les marais
Et les chemins où les feuilles inertes
Se tassent sous la bise des forêts.
Plus rien ne vit. Les branches sont désertes
Et les mousses à l'âpre givre offertes.
Seul, dédaigneux des pâleurs de l'hiver,
Un grand carré de sapins reste vert
Et la couleur des rigides ramures
Tranche au ciel gris, immobile et couvert
Où se sont tus les plus faibles murmures.

59

Documents Décoratifs, plates 19, 29, 30[a],
64, 68[b], 72.
Alphonse Mucha. Paris: Librairie Centrale des
Beaux-Arts, E. Lévy, 1903–1904.
Seventy-two lithographed plates.
37 x 28 each (14½ x 11)
Paris, Bibliothèque Forney.

A collection of decorative designs and studies,
published with an introduction by Gabriel
Mourey in 1902, whose origin Mucha
describes: "More and more frequently I was
asked to design all sorts of objects in every type
of material from wood, gold, ceramics to paper
and tapestry. It was impossible to meet all
these requests and I decided to publish a
special work containing decorative elements
and items where these elements could be used
so that everybody would find what he wanted
ready made. At the end there were two such
works: *Documents Décoratifs* and, five years
later, *Figures Décoratives,* and they were not my
first works of this kind either. . . . *Documents
Décoratifs* contained a number of motifs, some
of them in colour for two-dimensional and
plastic exploitation. The enterprising
publishers sold the work to schools and
libraries of nearly all the countries of Europe,
and I think it made some contribution towards
bringing aesthetic values into the arts and
crafts. Of course I imagined quite wrongly that
now I would be left in peace. Not at all. I
started getting even more requests from people
who wanted jewellery or some other things
that the others hadn't got. 'I saw in your book
Documents Décoratifs a very nice pendant,' they
wrote, 'I would like to have one like it—but a
little different. Could you please design it for
me?' Another wanted silverware—'the same,
but a little different'. Another a vase; another a
lamp. Soon I became the victim of my own
device" (quoted in Mucha 1966, pp. 230–31).

Bibl: *Art et Décoration* 14 (1903), pp.
301–304; Mucha 1966, pp. 230–31.

b

a

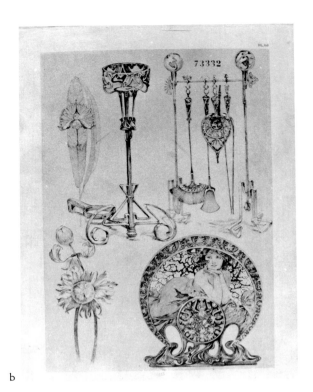

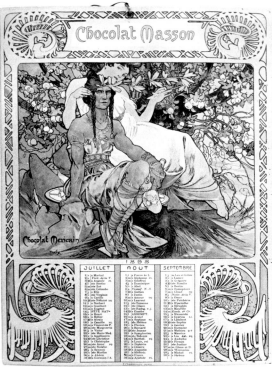

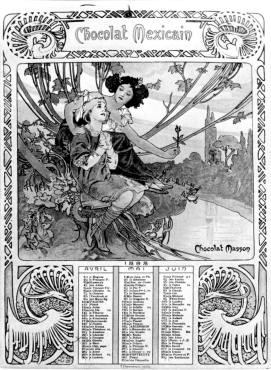

60
Chocolat Masson, Chocolat Mexicain. Calendar.
Alphonse Mucha. Paris: Imprimerie
Champenois, 1896.
Printed on cardboard in four parts.
43 x 60 each (16⅞ x 23⅝)
Paris, Bibliothèque Forney.

61

Title page for *L'Estampe Moderne.*
Alphonse Mucha. c. 1898.
41 x 31 (16⅛ x 12¼)
Mucha, lower left.
Paris, Bibliothèque Forney.

"A monthly publication containing four
original, unpublished prints, in black and
white and colors, by the principal French and
foreign artists. Published by Imprimerie
Champenois." Twenty-four issues, each
published in a deluxe edition of 150, appeared
between May 1897 and April 1899.

62

Le Mouvement Idéaliste en Peinture,
by André Mellerio.
Wrapper design and chapter headings by
Henri Nocq; frontispiece by Odilon Redon.
Paris: H. Floury, 1896.
Printed wrapper; lithographed frontispiece;
wood-engraved chapter headings.
20 x 14 (7⅞ x 5½)
HN, left center of wrapper.
Cambridge, Harvard College Library,
Department of Printing and Graphic Arts.
Gift of Peter A. Wick.

Mellerio's essay "presents the thesis that four
artists have contributed to the *mouvement
idéaliste* in painting: Puvis de Chavannes,
Gustave Moreau, Odilon Redon and Paul
Gauguin" (Garvey et al. 1970, p. 58).
The Redon frontispiece is shown in Mellerio
1968, no. 159.

Bibl: Mellerio 1968, no. 159 illus.;
Garvey et al. 1970, p. 58.

Exh: Cambridge 1970, no. 66.

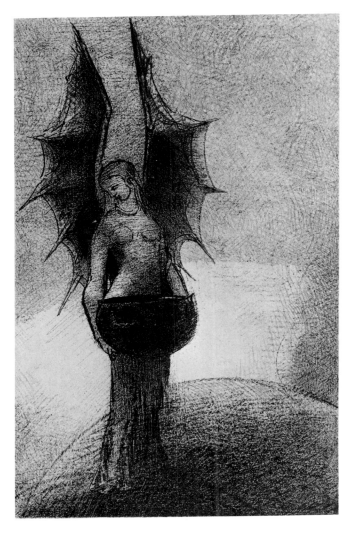

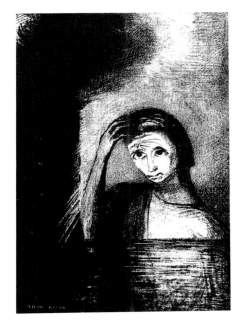

63
Ténèbres, by Iwan Gilkin.
Lithographed frontispiece by Odilon Redon.
Brussels: Edmond Deman, 1892.
Half red morocco binding.
26.6 x 19 (10½ x 7½)
Cambridge, Harvard College Library,
Department of Printing and Graphic Arts.
Gift of Mr. and Mrs. Arthur Vershbow.

"Gilkin, a Belgian poet, admired Redon, and
the artist influenced the poet's imagery.
Ténèbres was intended as a part of a trilogy,
which included *La Damnation de l'Artiste,* and a
third, *Satan,* unpublished. The winged figure
holding a cauldron, lithographed by Redon in
rich black on white, is a wonderful foil for the
exotic lapidary cover." Fernand Khnopff
designed the title page and colophon (Garvey
et al. 1970, p. 69).

Bibl: Mellerio 1968, no. 121 illus.; Garvey
et al. 1970, p. 69.

Exh: Cambridge 1961, no. 255; Cambridge
1970, no. 79.

64
Les Débâcles, by Emile Verhaeren.
Frontispiece by Odilon Redon. Ornamentation
by Théo van Rysselberghe. Brussels:
E. Deman, 1889.
14.2 x 9.7 (5⅝ x 3¾)
Odilon Redon, lower left of frontispiece.
Brussels, Bibliothèque Royale Albert Ier.

The frontispiece is present in only
fifty-two copies.

Bibl: Mellerio 1968, no. 101 illus.

Exh: Brussels 1962, no. 194.

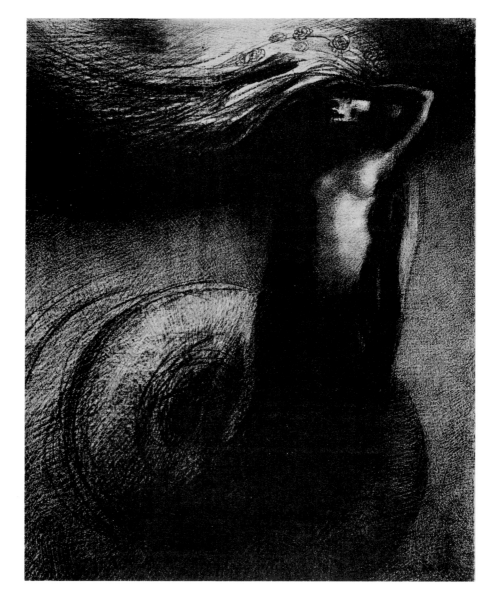

65

La Mort: Mon Ironie Dépasse toutes les Autres!
(Death: My Irony Exceeds All Others).
Odilon Redon. 1889.
Lithograph.
26.2 x 19.7 (10⅜ x 7¾)
The Art Institute of Chicago, Inv. 1920.1651.
E. H. Stickney Fund.

From Redon's second series of lithographs on
the *Tentation de Saint-Antoine,* by Gustave
Flaubert. According to John Rewald (1961, p.
36), *La Mort* so impressed Gauguin that he
gave Redon one of his ceramics in exchange for
a print of it.

Bibl: Rewald 1961, p. 36; Mellerio 1968,
no. 97 illus.

Exh: New York 1961, no. 151.

67

La Löie Fuller, by Roger Marx.
Illustrated by Pierre Roche. Type cast by G.
Peignot; text printed by Ch. Hérrissey
under the direction of Gautherin.
Illustrations executed by Presses de Maire.
Evreux: Eugène Rodrigues, 1904.
Twenty-seven unbound pages, fourteen
illustrated; illustrated paper wrapper.
26 x 20 (10¼ x 7⅞)
Chicago, Wing Foundation,
The Newberry Library.

"Gypsography" was the name Roche gave his
technique for producing these embossed color
prints. To our knowledge this is the only
book to have been illustrated with
gypsographs throughout.

66

Béatrice.
Odilon Redon. 1897.
Color lithograph, proof print on
chine appliqué.
56 x 42.5 (22⅛ x 16¾)
Redon's monogram, upper right.
Houston, Menil Foundation, Inv. P73–12.

One of the pieces published by Vollard in
Album des Peintres-Graveurs.

Bibl: Mellerio 1968, no. 168 illus.

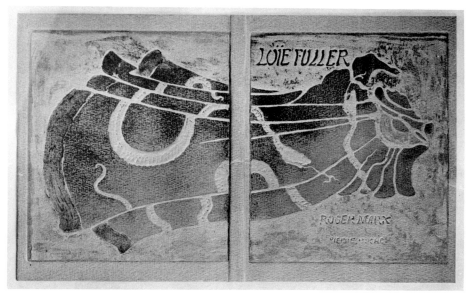

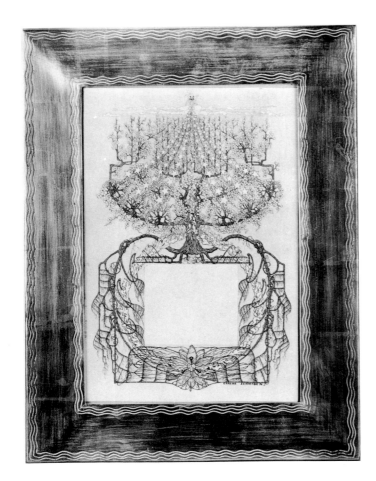 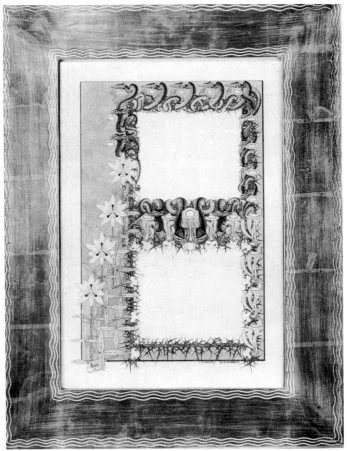

68
Design for a funeral memento.
Carlos Schwabe. 1894.
Pencil, ink, and watercolor on paper.
33 x 22 (13 x 8⅝)
CARLOZ SCHWABE 94 in ink, lower right.
Paris, Collection Félix Marcilhac.

Bibl: Soulier 1899, p. 137 illus.

69
Drawing.
Carlos Schwabe. 1894.
Pencil, ink, and watercolor on paper.
33 x 22 (13 x 8⅝)
CARLOZ SCHWABE 94, lower right.
Paris, Collection Félix Marcilhac.

Possibly a study for a book illustration.

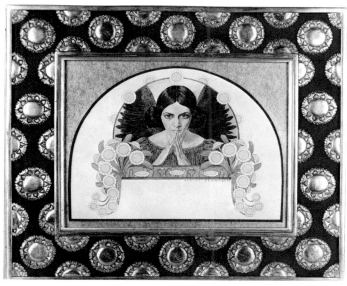

70

70
Drawing.
Carlos Schwabe. 1895.
Pencil and watercolor on paper.
19 x 24 (7½ x 9⅜)
CARLOS SCHWABE 95 in pencil,
center right.
Paris, Collection Félix Marcilhac.

71
Woman with Swans.
Jan Toorop. c. 1899.
Color lithograph.
21.9 x 33.3 (8⅝ x 13⅛)
J. Toorop in ink, lower right.
New York, The Museum of Modern Art,
Inv. 570.42. Given anonymously.

Exh: New York 1972.

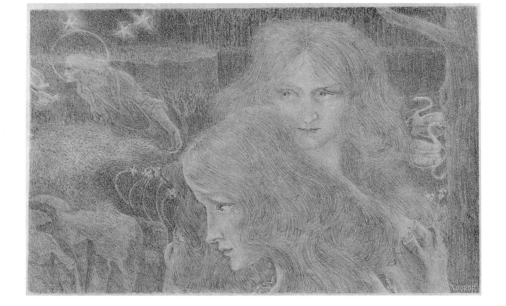

72

Jane Avril.
Henri de Toulouse-Lautrec. 1893.
Lithograph.
38.8 x 32.1 (15¼ x 12⅝)
Lautrec's monogram, lower left.
New York, The Metropolitan Museum
of Art, Inv. 23.30.3(1). Harris Brisbane
Dick Fund, 1923.

From *Le Café-Concert,* a series of twenty-two
lithographs, half by Lautrec and half by H. G.
Ibels, which were published by L'Estampe
Originale in an edition of fifty with a text by
Georges Montorgueil.

Bibl: Delteil 1920, no. 28; Ives 1974, pl. 92.

73

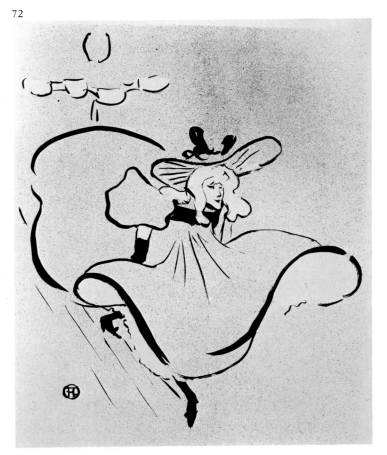

72

73

Miss Loïe Fuller.
Henri de Toulouse-Lautrec. 1893.
Lithograph, printed in black, hand-colored
and dusted with gold by the artist.
38.3 x 28.3 (15⅛ x 11⅛)
San Antonio, McNay Art Institute, Inv.
1974.51. Gift of Robert L. B. Tobin.

Published by André Marty in an edition of
fifty, and exhibited at the Salon de la Libre
Esthétique in 1894.

Bibl: *Echo de Paris,* Dec. 9, 1893, supplement,
illus.; Delteil 1920, no. 39 illus.; Schmutzler
1964, fig. 172; Adhémar 1965, no. 8.

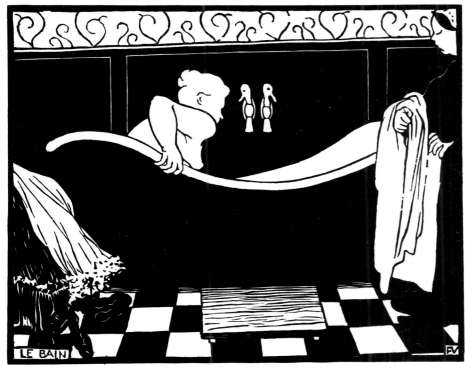

75
La Paresse (Indolence).
Félix Vallotton. 1896.
Woodcut.
17.8 x 20.8 (7 x 8⅛)
LA PARESSE, lower left. *FV,* lower right.
f vallotton and monogram in blue crayon,
lower right.
New York, The Museum of Modern Art,
Inv. 193.54. Larry Aldrich Fund.

Bibl: Vallotton and Goerg 1972,
pp. 182–83 illus.

Exh: Lawrence 1968; New York 1972;
New York 1974a.

74
Le Bain (The Bath).
Félix Vallotton. 1894.
Woodcut.
18.1 x 22.4 (7⅛ x 8⅞)
LE BAIN, lower left. *FV,* lower right.
f vallotton in blue crayon, lower right.
New York, The Museum of Modern Art,
Inv. 369.48. Gift of Victor S. Riesenfeld.

Shown in 1895 at the Salon de la Libre
Esthétique, Brussels.

Bibl: Vallotton and Goerg 1972, p. 157 illus.

Exh: New York 1974a.

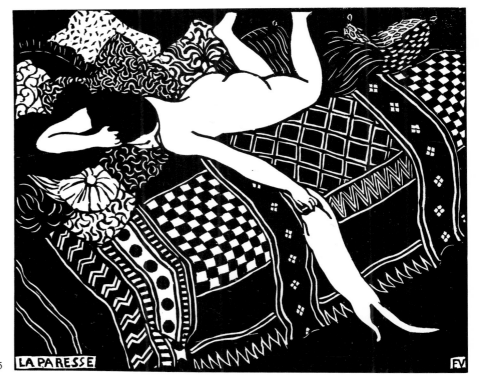

75

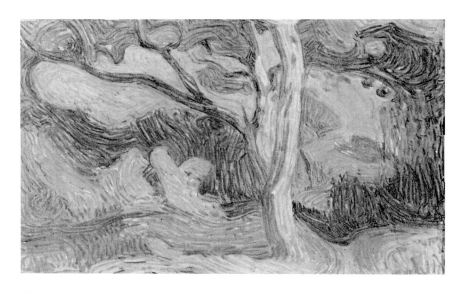

76

Catalogue des publications contemporaines figurant à l'exposition internationale du livre moderne organisée à l'art nouveau.
Designed and illustrated by Félix Vallotton.
Paris: Lahure, for L'Art Nouveau, 1896.
136 pages, with numerous vignettes; parchment binding, gilt-stamped. One of an edition of 75.
26 x 21.5 (10¼ x 8½)
Paris, Bibliothèque des Arts Décoratifs, Y650.

An exhibition selected by S. Bing of 1134 examples of the best contemporary European, oriental, and American book illustration and design. The oriental group included a number of Japanese books, with woodcut illustrations by Hiroshige and others, from Bing's own collection.

77

Etude de Jardin (Study of a Garden).
Henry van de Velde. 1892–93.
Pastel on paper.
30 x 45 (11¾ x 17¾)
Brussels, L'Ecuyer.

Bibl: Hammacher 1967, p. 334, no. 105, p. 27 illus.

Exh: Zürich 1958, no. 16; Hagen 1959, no. 48; Stuttgart 1963, no. 29; Brussels 1963b, no. 49; Munich 1964 (not listed in catalogue—exhibition label on back of frame); Brussels 1970, no. 23.

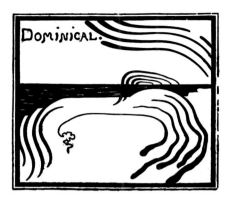

78
Proof of cover for *Van Nu en Straks*.
Henry van de Velde. 1893.
Wood engraving, printed in ocher
on Japanese paper.
12.5 x 18 (4⅞ x 7⅛)
Brussels, Archives Henry van de Velde,
E.N.S.A.A.V., Inv. 1731.

"M. Ch. Henry, professor at the Sorbonne,
claims (in *Quelques Aperçus sur l'Esthétique des
Formes*, Paris, 1895) that one can measure the
beauty of a line in a utilitarian object or in an
ornament. He has been unable to actually
demonstrate his theory, and it is doubtful that
he will ever be able to do so. But surely these
dogmas of form, which still for us constitute an
aesthetic, are the first gropings toward what
will one day be a science. . . . Likewise those
laws which Van de Velde's line unconsciously
follows will one day be revealed; and perhaps
then the expression of line will emerge, from a
new order of laws. Seurat sensed the existence
of these laws . . . but Seurat worked only with
nature. Van de Velde, who made regular and
conscious use of this means of expression, was
the first to understand that it would be most
effective outside the realm of nature. The
development of the idea can be traced in his
early works. In the woodcut for the cover of
Dominical, the ascending lines interrupted by
black areas draw the reader into the spirit of
the book, tinged with a melancholy joy. Sea,
shore, and clouds are still recognizable in the
schematic composition. But in the later
woodcut for *Van Nu en Straks* the object is

completely subordinated; although the origin
of the design is a sail puffed by the wind, there
is nothing left of this save the expressive
direction of lines, and the semblance of forward
movement that beautifully symbolizes the
hardy character of the progressive little
journal" (Meier-Graefe 1898, p. 7).

Bibl: Meier-Graefe 1898, p. 7; Schmutzler
1964, p. 16 illus.

Exh: Brussels 1963b, no. 72;
Paris 1971b, no. 47.

79
Dominical, by Max Elskamp.
Cover illustration and design by Henry van de
Velde. Antwerp: J. E. Buschmann, 1892.
Wood engraving on cover.
22.2 x 13.8 (8¾ x 5½)
Brussels, Bibliothèque Royale Albert Ier.

"The title-page of *Dominical* is one of the first
deliberately asymmetrical typographical
layouts in the history of book design. The
composition on the cover, an expressionistic
wave pattern of ebbing tide on the beach with
rays of the setting sun on the horizon . . . was
followed in 1893 by similar striking
abstractions for the periodical *Van Nu en Straks*
[cat. no. 78]. J. E. Buschmann was a poet and
one of the foremost Belgian writers, as well as
publisher and printer" (Garvey et al. 1970, pp.
69–70).

Bibl: *L'Art Décoratif* 1 (1898), p. 9 illus.;
Madsen 1956, p. 251 illus.; Fern 1959, pp.
31–32 illus.; Cassou et al. 1962, pp. 239–40
illus.; Schmutzler 1964, p. 138 illus.; Day
1965, pp. 25–26; Madsen 1967, p. 99 illus.;
Hammacher 1967, p. 210 illus.; Hofstätter
1968, pp. 137–38 illus.; Pevsner 1968, p. 57
illus.; Garvey et al. 1970, pp. 69–70.

Exh: New York 1960, no. 283;
Brussels 1962, no. 185.

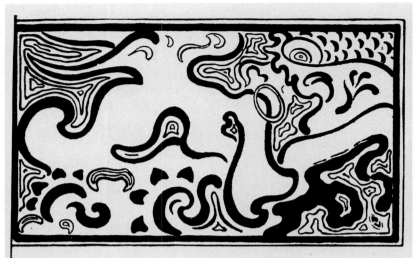

81
Déblaiement d'Art.
Henry van de Velde. Brussels: Mme. Veuve
Monnom, 1894.
Thirty-five pages, with ornamental letters and
culs-de-lampe.
14.7 x 16 (5¾ x 6¼)
Chicago, Wing Foundation,
The Newberry Library.

Van de Velde delivered the text of *Déblaiement
d'Art* as a lecture at the Salon de la Libre
Esthétique on March 6, 1894. It was
subsequently published in *Société Nouvelle* 118
(April 1894), before the appearance of the
small volume exhibited here.

Bibl: Madsen 1956, p. 253 illus.

80
Salutations, dont d'angéliques, by Max Elskamp.
Cover illustration and design by Henry van de
Velde. Printed by J. E. Buschmann, Antwerp.
Brussels: Paul Lacomblez, 1893.
Printed paper wrappers.
22.9 x 17.2 (9 x 6¾)
Brussels, Bibliothèque Royale Albert Ier.

"Van de Velde revered the art and teachings of
William Morris, yet in his own book
production radically split from his English
mentor, especially in his attitude towards

ornament. This cover with its bold and
rhythmical curvilinear design and the
unconventional lettering, which have a
movement of their own, are in perfect unity
but are entirely abstract. In 1895 *Salutations*
became part of *Triptyque de louange à la vie, selon
l'amour, l'espérance et la foi,* which also included
Dominical [cat. no. 79] and *En symbole vers
l'Apostolat*" (Garvey et al. 1970, p. 70).

Bibl: Day 1965, p. 25; Garvey et al. 1970,
p. 70; Jullian 1973, no. 169 illus.

Exh: Brussels 1962, no. 184.

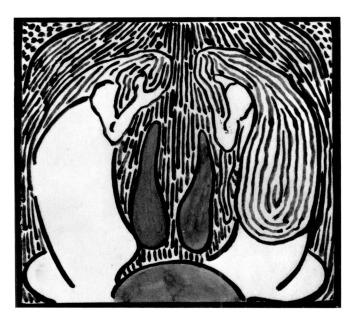

82
Project for an illustration.
Henry van de Velde. c. 1894.
India ink and red gouache on tracing paper.
11 x 11 (4⅜ x 4⅜)
Brussels, Archives Henry van de Velde,
E.N.S.A.A.V., Inv. 1734.

83
Monograms.
Henry van de Velde.
a) c. 1894. Grease pencil on gray paper,
mounted on gray cardboard.
10 x 14.5 (4 x 5¾)
b) c. 1895. Pencil on tracing paper, mounted
on cardboard.
11 x 6 (4⅜ x 2⅜)
c) c. 1894. Printed in black on paper, mounted
on cardboard.
10.5 x 10.5 (4⅛ x 4⅛)
Brussels, Archives Henry van de Velde,
E.N.S.A.A.V., Inv. 1600, 1606, 1643.

84
Monograms.
Henry van de Velde. c. 1894.
India ink on heavy paper, mounted on
gray cardboard.
12 x 10 (4¾ x 4); 12.5 x 9.5 (5 x 3¾);
12 x 14.5 (4¾ x 5¾); 9.2 x 12 (3⅜ x 4¾)
Brussels, Archives Henry van de Velde,
E.N.S.A.A.V., Inv. 1610–13.

Four variations on an intertwined *M* and *S*.

85
Lecture program, Section d'Art et
d'Enseignement populaire of the Maison du
Peuple.
Henry van de Velde. 1898.
Printed in black and red.
40 x 28.5 (15¾ x 11¼)
Brussels, Archives Henry van de Velde,
E.N.S.A.A.V., Inv. 1753.

When this lecture took place the Section d'Art
et d'Enseignement populaire was not yet
located in Horta's Maison du Peuple [cat. no.
543], which had been under construction since
1895 and was still incomplete. Henry van de
Velde, along with the socialist leaders Emile
Vandervelde and Jules Destrée, was one of the
founders of the Maison du Peuple's art section,
later to become the art section of the Belgian
Workers' Party. Among the other charter
members were the poet Emile Verhaeren and
the writer Georges Eekhoud.

86
Brochure for the Continental Havana
Compagnie, Berlin.
Henry van de Velde. 1900.
Printed pamphlet with cover in three colors.
20 x 14.2 (7⅞ x 5⅝)
Brussels, Archives Henry van de Velde,
E.N.S.A.A.V., Inv. 1754.

The brochure seen here, a price list for cigars
sold by Continental Havana, was created by
Van de Velde at the same time he designed the
interior and furnishings for the Berlin office of
the company (cat. no. 571).

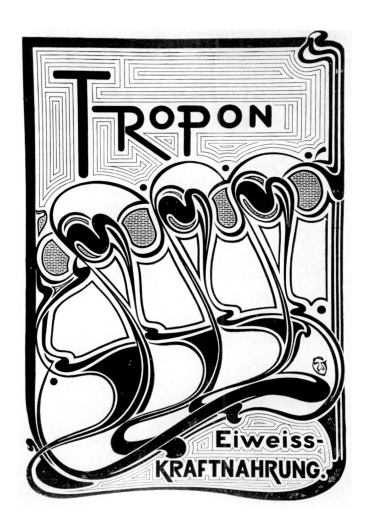

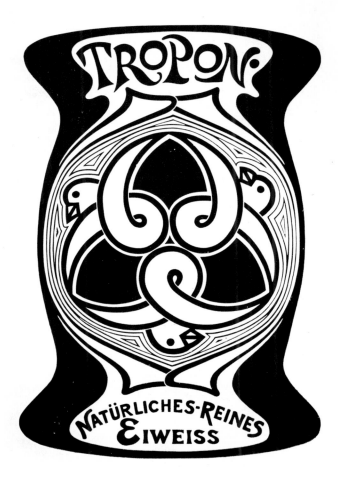

87
Advertising placards for
Tropon-Werke, Cologne.
Henry van de Velde. 1898.
Printed in black on heavy blue paper.
29 x 21.5 each (11⅜ x 8½)
Brussels, Archives Henry van de Velde,
E.N.S.A.A.V., Inv. 1874, 1875, 1876,
1879, 1880, 1881, 1882.

Bibl: Rheims 1966, fig. 539.

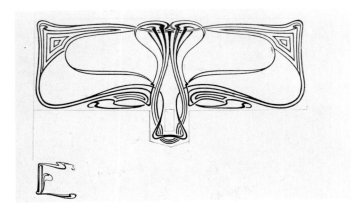

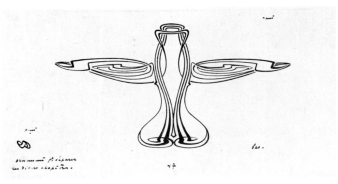

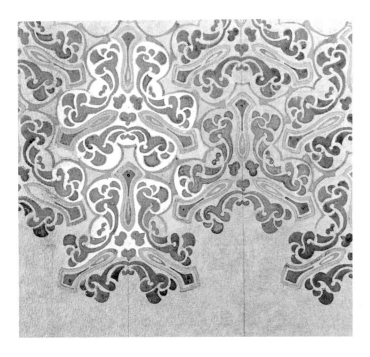

88
Design for vignettes for *Pan*.
Henry van de Velde. 1900.
India ink and zinc white on cardboard.
17 x 22.5 (6¾ x 8⅞)
Pour "Pan"/ Henry v. d. Velde fev. 1900.,
lower right.
Pencil annotations in German,
in another hand.
Hamburg, Museum für Kunst und Gewerbe,
Inv. E1968.284.

Pan, a quarterly journal of the arts founded by
Julius Meier-Graefe, was published in Berlin
from 1895 to 1900.

Exh: Hamburg 1963, no. 1043.

89
Design for vignettes for *Pan*.
Henry van de Velde. 1900.
India ink and zinc white on cardboard.
15.4 x 23.4 (6 x 9¼)
Haut and *ornement pr séparer/ les divers chapitres.*,
with vignette at lower left. *47,* center. *Haut/
bas,* at right. *cul de lampe/ "pr Pan" Henry v. d.
Velde/ 1900,* lower right. Pencil annotations in
German, in another hand.
Hamburg, Museum für Kunst und Gewerbe,
Inv. E1968.285.

Exh: Hamburg 1963, no. 1043.

90
Study for an ornamental pattern.
Henry van de Velde. c.1900.
Gouache on gold paper, mounted on
illustration board.
32 x 32 (12⅝ x 12⅝)
Brussels, Archives Henry van de Velde,
E.N.S.A.A.V., Inv. 1239.

Also illustrated in color.

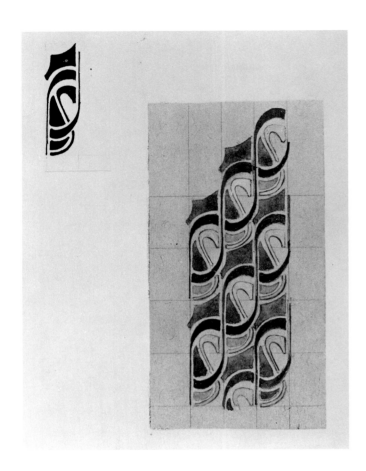

91
Study for an ornament.
Henry van de Velde. August 1902.
Watercolor and india ink on colored paper,
mounted on cardboard.
Brussels, Archives Henry van de Velde,
E.N.S.A.A.V., Inv. 1263.

92
Also Sprach Zarathustra, by
Friedrich Nietzsche.
Binding design, page design, and illustration
by Henry van de Velde; type designed by
Georges Lemmen. Printed by W. Druiglin.
Leipzig: Insel Verlag, 1908.
Title page, four full-page illustrations, and
numerous vignettes; printed in color; leather
binding, gilt-stamped.
37.2 x 24.8 (14⅝ x 9¾)
Chicago, Wing Foundation,
The Newberry Library.

Count Harry Kessler, a great friend of Van de
Velde, knew of the artist's admiration for
Nietzsche and of his desire to express it. Thus
it was on the count's suggestion that Insel
Verlag committed itself in 1898 to publishing
this edition of *Zarathustra.* During the ten
years that elapsed between the conception of
the book and its realization, Kessler
collaborated enthusiastically with Lemmen on
the creation of the typeface, and with Van de
Velde on questions of format and design.

Bibl: Hammacher 1967, pp. 154–57;
Garvey et al. 1970, p. 92; Brunhammer
et al. 1971, p. 90.

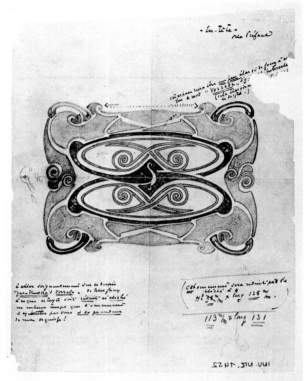

AMO

J'AIME LES FLEURS QUI SONT LES yeux de la Terre, qui s'ouvrent dès qu'Elle se réveille pour nous dire l'éclat de sa joie, simple et enfantine, la gravité de ses pensées lourdes et obsédantes et de ses désirs inassouvis, l'ironie de sa cruauté ou l'infinie douceur de sa bonté.

J'aime les arbres qui réussissent où nous avons échoué et réalisent en beauté, sans l'intervention d'aucun bon sentiment, par le seul miracle de leur parure et de leur silence, la lutte et le choc des efforts et de l'égoïsme qui sont pareils à ceux qui décident de notre destinée. Pas un juge prononce parmi eux le jugement hautain; pas un prêtre la promesse fallacieuse du pardon de la faute commise contre les autres; pas un docteur applique le remède, panse la plaie; pas un voisin jase, colporte le blâme ou la médisance ou la louange chargée d'envie.

Parmi eux, le plus fort impose — sans plus — son geste

96

93

94

95

90

93

Also Sprach Zarathustra: study for title page
ornament.
Henry van de Velde. 1906.
Pencil and gold highlights on tracing paper,
mounted on illustration board.
41 x 20 (16⅛ x 7⅞)
grandeur/ des carreaux/ aux autres/ feuilles and *doit
avoir 12.5 cm/ 13 cm,* lower right.
Brussels, Archives Henry van de Velde,
E.N.S.A.A.V., Inv. 1457.

Exh: Brussels 1963b, no. 83.

94

Also Sprach Zarathustra: design for
preface heading.
Henry van de Velde. 1906.
Pencil, ink, and gold highlights on tracing
paper, mounted on cardboard.
30 x 24 (11⅞ x 9½)
*à coller soigneusement sur le dessin/ "Zarathustra's
Vorrede" de telle façon/ à ce que le texte soit* réduit
et cliché/ *en même temps que l'ornement/ à exécuter
par vous* à la grandeur/ *de mon esquisse!,* lower
left. *En-tête de la préface* and *cet espace devra être
un peu élargi de façon à ce/ que le mot "Vorrede"
s'y . . . intercale/ (cela élargira . . . ,* upper
right. *cet ornement sera réduit par le/ cliché à/
Ht 95 m/m x larg 125 m/m. 113 m/m x larg 131,*
lower right.
Brussels, Archives Henry van de Velde,
E.N.S.A.A.V., Inv. 1452.

Exh: Brussels 1963b.

95

Also Sprach Zarathustra: proof of title page
and page 9.
Designed and illustrated by Henry van de
Velde; type designed by Georges Lemmen.
Leipzig: Insel Verlag, 1908.
Printed in gold and violet.
40.5 x 50 (16 x 19¾)
Brussels, Archives Henry van de Velde,
E.N.S.A.A.V., Inv. 1484.

Another proof in the Archives Henry van de
Velde is printed in gold and burnt sienna
(Inv. 1484; exhibited Brussels 1963b, no. 93,
and Paris 1971b, no. 67).

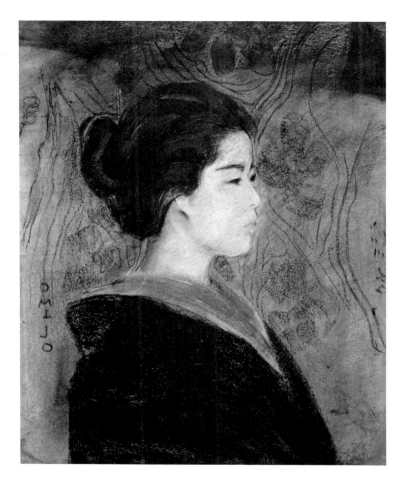

96

Proof of page from *Amo.*
Henry van de Velde. Weimar:
Cranach Press, 1915.
Printed in black with red initial letters.
38 x 33.4 (15 x 13⅛)
Houston, D. & J. de Menil Collection.

First published in German in 1909, Van de
Velde's short text was printed in French in *Art
et Technique* 1 (1913). Van de Velde designed
the French edition seen here, and directed the
printing of its 200 copies.

97

Omijo.
Théo van Rysselberghe.
Pastel on paper; original frame of carved
and gilt wood.
66 x 55 without frame (26 x 21⅝)
A mon ami G. de la Haut/ T. v. Rysselberghe in
green, lower left. *OMIJO,* vertically at left.
Japanese characters for "Omijo,"
vertically at right.
Brussels, L. Wittamer–de Camps.

Omijo was Van Rysselberghe's mistress. De la
Haut, the Brussels "aesthete" to whom the
painting was dedicated, refused it; about 1900
Van Rysselberghe sold it and several other
works to his friend Joseph Mommen, from
whose family the artist rented a studio.

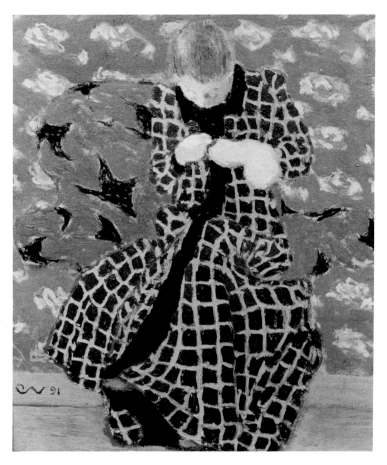

98
Almanach, cahier de vers, by Emile Verhaeren.
Cover design and illustration by Théo van
Rysselberghe. Printed by Mme. Veuve
Monnom. Brussels: Dietrich & Co., 1895.
Printed wrapper; four full-page illustrations
and numerous vignettes.
21 x 20.3 (8¼ x 8)
Brussels, L. Wittamer—de Camps.

Bibl: Uzanne 1898, p. 92 illus.; Uzanne 1899,
p. 38 illus.; Culot 1954, p. 16; Schmutzler
1964, p. 48 illus.; Garvey et al. 1970, pp.
72–73.

99
La Ravaudeuse (The Darner).
Edouard Vuillard. 1891.
Oil on board.
26.6 x 21.5 (10½ x 8½)
EV 91, lower left.
Paris, Centre National d'Art et de Culture
Georges Pompidou, Musée National d'Art
Moderne, Inv. AM3256P.

Bibl: Chastel 1946, p. 46, p. 48, p. 17 illus.;
Dorival 1954b, p. 172, fig. 1; Schweicher
1955, p. 3 illus.; Russoli 1966, pl. 1; Dugdale
1967, pl. 1.

Exh: Paris 1892; Paris 1938, no. 13;
Cardiff 1957, no. 79; London 1957, no. 21;
Munich 1968.

POSTERS

THE ART NOUVEAU POSTER
Alain Weill

In the late 1860s Jules Chéret made the first large lithographed posters. During this period of urban growth and upheaval, when Baron Haussmann was cutting broad avenues through medieval Paris, industrial development progressed rapidly in the circumstances of free enterprise and a speculative boom. With this industrial expansion it took the poster less than ten years to spread through France and win, little by little, the whole of Europe.[1]

The second half of the 19th century was also the time when a new generation turned against the academicism and historicism that had held sway in the fine arts. The poster appealed to these artists, both as a means of promoting their ideas and as a new genre in which the interests of art and industry were joined. Yet defining the Art Nouveau poster and the poster designer is not so simple. There are at least two ways, one touching on substance, the other on form.

The artists attracted to the new ideas (often inspired by the arts of the Orient, especially Japan), and opposed to academicism, did not all express themselves in the same way; in the history of art they were subsequently categorized as Nabis, Impressionists, Symbolists, and so on. But at the time they stood side by side, all showing works together in the same exhibitions; and for these exhibitions they designed posters. In the phrase coined by Octave Maus in 1884, these artists were "les croyants de l'Art Nouveau"—the true believers. But at the same time, the "Art Nouveau poster" brings to mind the works of Mucha, Grasset, Livemont, and their disciples—and the image of a woman with long hair, lost in a cloud of flowers.

Looking further, it is apparent that we are dealing with two different types of poster. The first type embraces works of widely varying form: they illustrate most of the art trends of the time, and in general were done by artists for expositions or events where they defended their ideas. The second type put the floral style, so popular in the 1890s, at the service of show-business entrepreneurs and industrialists.

These are the two currents we have attempted to illustrate. In addition a distinction must be made between Belgium and France. In France the commercial poster reached a high stage of development (the Paris Métro alone furnished thousands of places for them), but the avant-garde was not united. In Belgium, on the contrary, the avant-garde came together around La Libre Esthétique, but use of the poster was more limited.

In 1884 Octave Maus, a Brussels lawyer, created the Groupe des Vingt (to which twenty artists invited twenty others); in 1894 the group became La Libre Esthétique and continued its activities until World War I. Located in a small country which was in the vanguard of industrial and social progress, this circle became one of the prime movers of Art Nouveau in Europe. Bringing together painters, sculptors, musicians, and writers, it drew in all the innovators Europe had to offer. Lautrec and Beardsley were quickly invited to join, and Europe's finest talents became involved sooner or later. Its annual exhibitions between 1884 and 1914 were always publicized by at least one poster. Octave Maus and his friends generated enterprises that were to be echoed in France: one such was the Toison d'Or, a shop opened in 1895 by the son of Edmond Picard, which probably inspired Bing to open his L'Art Nouveau in Paris.

In France artistic activity was less concentrated, but there were two centers that brought together creative artists interested in postermaking. First there was *La Revue Blanche,* founded by the three Natanson brothers ("ceux qui revuent blanche").[2] Alfred Jarry, one of the contributors, coined the pun; through the magazine Jarry met Bonnard, whose poster for it (cat. no. 105) contained a portrait of Mme. Thadée Natanson. It was Bonnard who introduced Lautrec to lithography, whereupon the latter did a poster for *La Revue Blanche.* Vuillard, a friend of Bonnard, also frequented the same

circle. The involvement of these artists, here briefly noted, shows clearly the importance of the magazine.

The other center was the Salon des Cent. This was established in February 1894 by Léon Deschamps, editor-in-chief of *La Plume*, an avant-garde magazine devoted to literature and the arts. To publicize the salon, which was to include no more than one hundred works and show the most diverse group of artists, posters were designed by Lautrec, Grasset (cat. no. 119), de Feure (cat. no. 112), Mucha (cat. no. 129), Berthon (cat. no. 103), and Bonnard, and also by the Belgians Ensor, Evenepoel (cat. no. 116), Rassenfosse (cat. no. 135), and Van Rysselberghe. *La Plume,* which ran articles and even special issues on the poster artists, and the Salon des Cent are the principal sources for artistic posters of that period.

The Ordre de la Rose+Croix, instituted by the Sâr Peladan to restore "the cult of the ideal with tradition as its base and beauty as its means,"[3] also had its salon from 1892 to 1897: Schwabe, Aman-Jean, Point, Sarluis, and Etienne Moreau-Nélaton drew the posters (cat. nos. 134, 137). Delville created a Belgian counterpart, L'Art Idéaliste, in Brussels. Other groups started salons in the 1890s: in Brussels, Pour l'Art in 1891 and Le Sillon in 1893; in France, L'Art Indépendant, which opened its doors wide to Belgian poster artists.

Most of the salon posters are high-quality lithographs, the work of painters or designers whose one aim was to advance their ideas (except Mucha and Grasset for the Salon des Cent); they were publicity only by chance. Even Lautrec, the most productive among these artists, made only thirty-one posters in his lifetime, a good number of them for his friends, and the case was the same for many of the Belgians. The example of Maurice Siville, an art critic who ordered posters for his insurance company from Berchmans, Rassenfosse, and Donnay (cat. no. 114), was a rare exception.

In France posters came out in huge numbers. Chéret alone designed over a thousand; his disciples—Meunier, Pal, and Guillaume—did hundreds. Grasset, who began to apply his theories to the poster in 1892, was directly inspired by the Middle Ages. His works were often designed like stained-glass windows, and for the first time put on the walls a feminine type different from the alluring, smiling, dimpled "Chérette" Jules Chéret had made famous.

Sarah Bernhardt, the great actress, who was passionately interested in mystery and the esoteric, took great care in choosing her posters (as she did with her costumes and stage sets). She had Orazi do her first poster, and ordered one for her *Jeanne d'Arc* from Grasset, who made two versions (see cat. no. 118). At Christmas, 1894, she suddenly ordered a new poster for *Gismonda*; and Alphonse Mucha, working all alone for the printer Lemercier, set to work on a project which immediately won Bernhardt's enthusiastic approval. The finished poster, laden with oriental touches, had lettering designed in mosaic; it showed the actress swathed in damask, which she loved to wear, and holding a palm in her hand. From the day it appeared it had an enormous success, and *la grande Sarah* signed Mucha to a six-year contract. With the success of his theatrical posters Mucha found himself inundated with orders from industrialists, among them Job cigarette papers (two posters), Champagne Ruinart, Bières de la Meuse, Cycles Waverley, Cycles Perfecta, Nestlé's Foods, Cassan, Biscuits Lefèvre-Utile, and more. Working from photographs he gradually perfected his feminine type: a woman with Bernhardt's face but a heavier body, her hair wildly exaggerated, and surrounded by a kind of decoration that drew upon Byzantine mosaics, in which an abundance of flower design appears.[4]

With the opening of Bing's shop (1985) and Meier-Graefe's La Maison Moderne (1898), new artists had opportunities to show their wares. The most notable of the poster artists were de Feure, who also created a mysterious feminine type, and Orazi, who designed one of the most beautiful Art Nouveau posters (cat. no. 132) for Loïe Fuller, another great subject for illustrators at the time. Then other actresses, following Bernhardt's lead, wanted to see themselves depicted with disheveled hair surrounded by flowers. Suzy Degez called on Grasset, Liane de Pougy on Berthon (cat. no. 104). Bicycle manufacturers, who ordered the greatest number of posters, wanted theirs done in the same style: Omega and Griffiths went to Thiriet (cat. no. 138), Richard to Grasset. Rapidly, and with more or less talent and luck, a large number of *affichistes* copied the "Mucha style"—which sold the artist as well as the product.

In Belgium Privat-Livemont's career was similar to Mucha's. Of his numerous posters most are not artistic but commercial. Using the figure of a woman with long hair and a floral setting, he did posters for Absinthe Robette, Bec Auer, Bitter Oriental, Café Rajah (cat. no. 125), *La Réforme,* and others. In Belgium the use of the commercial poster expanded, and people like Meunier, Crespin, and Victor Mignot glorified cycles and soaps, or advertised a variety of events.

These documents were collected avidly as soon as they appeared, and were sold by specialized dealers (Sagot, Ar-

nould, Pierrefort in Paris, Dietrich in Brussels) who also commissioned posters. Hence a fairly large number have survived, giving us a good idea of the prodigious effervescence of the last two decades of the 19th century. In a few years academicism was rudely shaken up, and the posters for the groups which overthrew it, signed by artists who are famous today, remain as evidence of the struggle. From it emerged a new style which, especially with reference to decoration, is called Art Nouveau. It enjoyed a considerable vogue, and, particularly in France, counted hundreds of

skilled practitioners in the field of the poster.

In this exhibition we have tried to bring together the best examples of the two types of Art Nouveau poster. We felt that we could not properly hold to the customary definition, which is that of a style, a fashion; nor have we chosen to limit ourselves solely to the examples of this style most widely recognized as outstanding. Lastly, the poster was one thing in France, another in Belgium, and by our choice of examples we have sought to bring out both the differences between the two countries and the close bonds that united them.

1 Several works have been of value in preparing this article: Yolande Oostens-Wittamer, *L'Affiche Belge, 1892–1914* (Brussels: Bibliothèque Royale Albert Ier, 1975); Roger-H. Guerrand, *L'Art Nouveau en Europe* (Paris: Plon, 1965); Jane Abdy, *The French Poster: Chéret to Cappiello* (New York: Clarkson N. Potter, 1969); and the basic work for the study of the French poster, Ernest Maindron, *Les Affiches Illustrées* (Paris: G. Boudet, 1896).

2 Isidore Panmuphle, bailiff of the Tribunal Civil de la Seine, in drawing up an inventory of foreclosure in the case of one Doctor Faustroll noted among other valuable possessions "three engravings hanging on the wall, one poster by Toulouse-Lautrec *Jane Avril,* one by Bonnard *La Revue Blanche,* the portrait of the Sieur Faustroll by Aubrey Beardsley."

3 Joséphin Peladan, *Salon de la Rose+Croix, Règle et Monitoire* (Paris: Dentu, 1891).

4 For information about Mucha, see the works by his son Jiri: *Alphonse Mucha: His Life and Art* (London: Heinemann, 1966); *Alphonse Mucha: Posters and Photographs,* in collaboration with Marina Henderson and Aaron Scharf (London: Academy Editions, 1971); and *The Graphic Work of Alphonse Mucha* (London: Academy Editions, 1973).

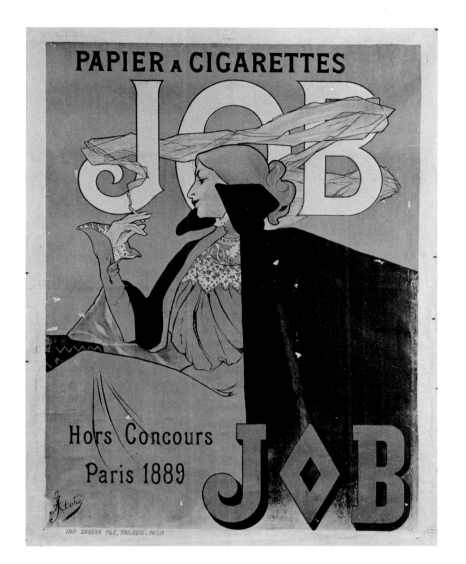

100
Job.
Atché. Toulouse and Paris: Imprimerie
Cassan Fils, 1899.
Color lithograph.
146 x 112 (57½ x 44)
Atché, lower left.
Paris, Bibliothèque des Arts Décoratifs,
Inv. 12356. Gift of Roger Braun.

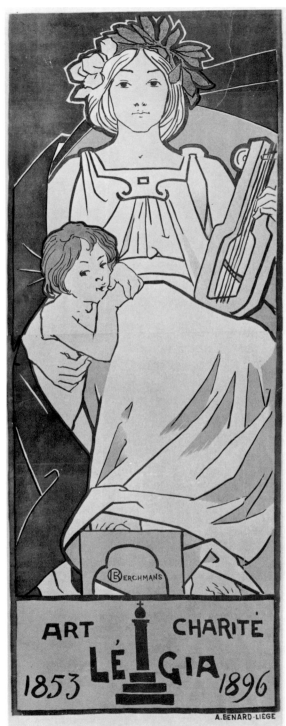

101

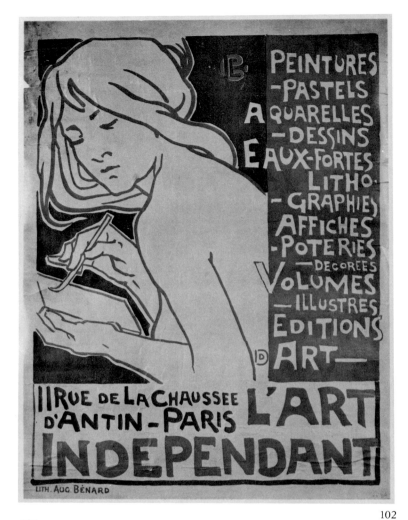

102

101
Légia Art et Charité.
Emile Berchmans. Liège: A. Bénard, 1896.
Color lithograph.
130.5 x 93.5 (51⅜ x 36¾)
Berchmans' monogram, lower center.
Brussels, L. Wittamer—de Camps.

102
L'Art Indépéndant
Emile Berchmans. Aug. Bénard, 1897.
Color lithograph.
65 x 49.5 (25⅝ x 19½)
Berchmans' monogram, at top.
Brussels, L. Wittamer—de Camps.

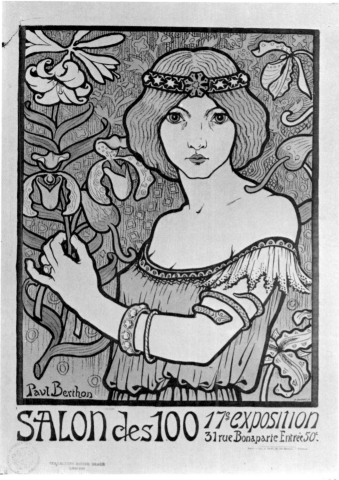

103

103
Salon des 100.
Paul Berthon. Paris: A. Davy, typography,
and A. Barret, lithography, 1895.
Color lithograph.
60.5 x 41 (23⅝ x 16⅛)
Paul Berthon, lower left.
Paris, Bibliothèque des Arts Décoratifs,
Inv. 9878. Gift of Roger Braun.

104
Liane de Pougy.
Paul Berthon. Paris: Imprimerie
Lemercier, 1895.
Color lithograph.
150 x 82 (59 x 32¼)
Paul Berthon, lower left.
Paris, Bibliothèque des Arts Décoratifs,
Inv. 12408. Gift of Georges Pochet.

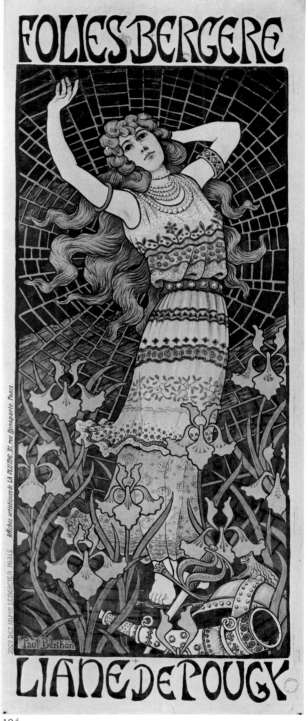

104

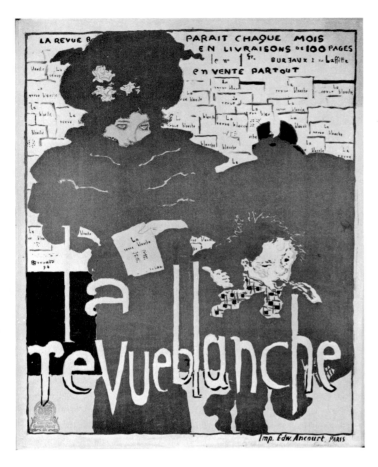

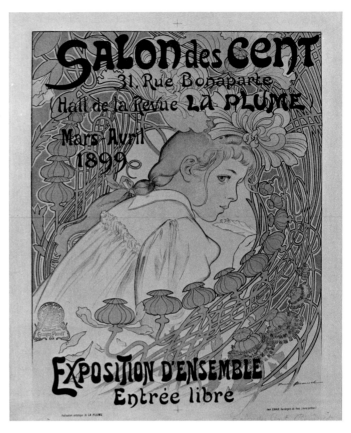

105
La Revue Blanche.
Pierre Bonnard. Paris: Imprimerie
Ancourt, 1894.
Color lithograph.
81 x 62.5 (31⅛ x 24⅝)
Paris, Bibliothèque des Arts Décoratifs,
Inv. 12537.

106
Salon des Cent.
Firmin Bouisset. Paris: Imprimerie
Chaix, 1899.
Color lithograph.
65 x 50 (25⅝ x 19¾)
Firmin Bouisset, lower right.
Paris, Bibliothèque des Arts Décoratifs,
Inv. 9873.

107
A la Toison d'or.
Gisbert Combaz. Liège: Aug. Bénard, 1895.
Color lithograph.
193.5 x 100.5 (76¼ x 39⅝)
Gisbert Combaz, lower left.
Brussels, L. Wittamer—de Camps.

108
La Libre Esthétique.
Gisbert Combaz. Brussels:
J. L. Goffart, 1899.
Color lithograph.
74 x 44 (29⅛ x 17⅜)
Gisbert Combaz 1899, lower right.
Brussels, L. Wittamer—de Camps.

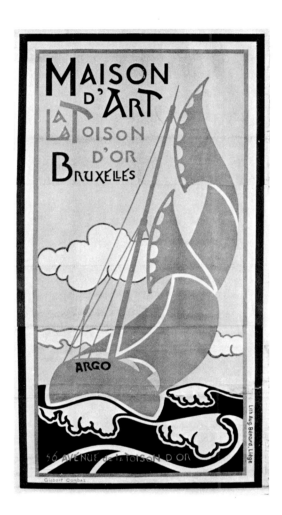

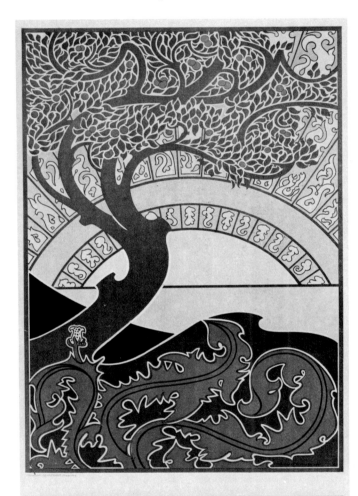

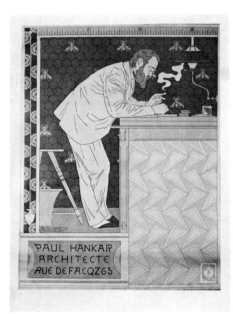

109

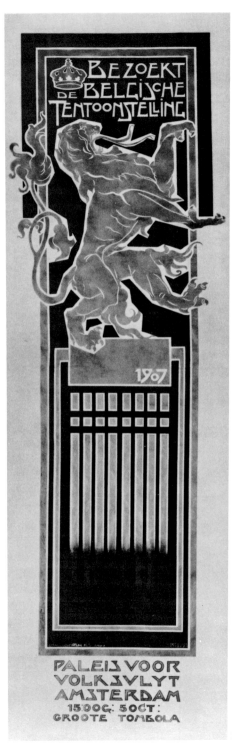

109
Paul Hankar.
Adolphe Crespin. Brussels: Imprimerie
Ad. Mertens, 1894.
Color lithograph.
54 x 40.5 (21¼ x 16)
A Crespin 94, lower left.
Brussels, L. Wittamer–de Camps.

110
Belgische Tentoonstelling.
Victor Creten. Brussels: J. Goffin Fils, 1907.
Color lithograph.
173.5 x 52 (68¼ x 20½)
Victor/ Creten, lower right.
Brussels, L. Wittamer–de Camps.

111
Le Journal des Ventes.
Georges de Feure. Paris: Imprimerie
Lemercier, 1897.
Color lithograph.
50 x 65 (19¾ x 25⅝)
de Feure, lower right.
Paris, Bibliothèque des Arts Décoratifs,
Inv. 12648. Gift of Georges Pochet.

112
Salon des Cent.
Georges de Feure. Paris: Imprimerie
Bourgerie, 1893.
Color lithograph.
39.5 x 60 (15½ x 23⅝)
De Feure's monogram, lower left.
Paris, Bibliothèque des Arts Décoratifs,
Inv. 12596.

113
Salons d'Art Idéaliste [photograph exhibited].
Jean Delville. Brussels: Imprimerie
Stevens, 1896.
Color lithograph.
123 x 73 (48⅜ x 28¾)
Brussels, L. Wittamer–de Camps.

110

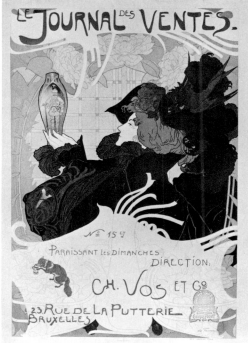

111

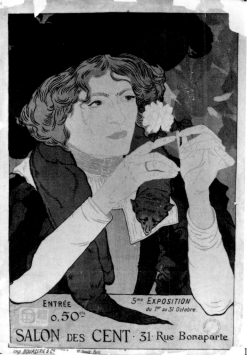

112

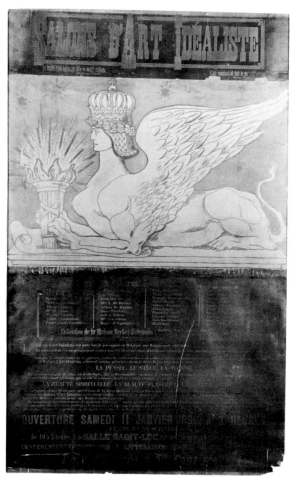

113

114
The Fine Art & General Insurance Company, Ltd.
Auguste Donnay. Liège: Aug. Bénard, 1897.
Color lithograph.
74 x 53.5 (29⅛ x 21)
Donnay's monogram, middle left.
Brussels, L. Wittamer–de Camps.

115
Lulu d'Alberghi.
P. Eler. Paris: Imprimerie Lemercier, 1898.
Color lithograph.
105 x 74.5 (41⅜ x 29⅜)
P. Eler. 98., lower right.
Paris, Bibliothèque des Arts Décoratifs,
Inv. 13903.

116
Salon des Cent.
Henri Evenepoel. Paris: Affiches
La Plume, 1899.
Color lithograph.
63 x 45 (24¾ x 17¾)
h. evenepoel., lower right.
Brussels, L. Wittamer–de Camps.

117
La Garonne.
Arthur Foäche. Toulouse and Paris:
Imprimerie Cassan, c. 1898.
Color lithograph.
72 x 54 (28⅜ x 21¼)
Foäche, lower left.
Paris, Bibliothèque des Arts Décoratifs,
Inv. 14450. Gift of Roger Braun.

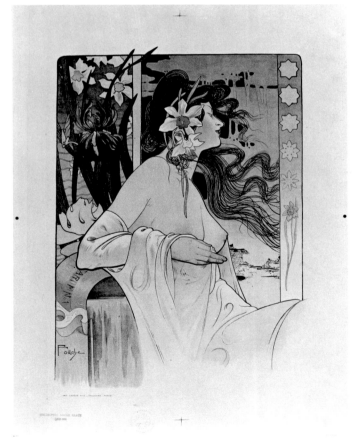

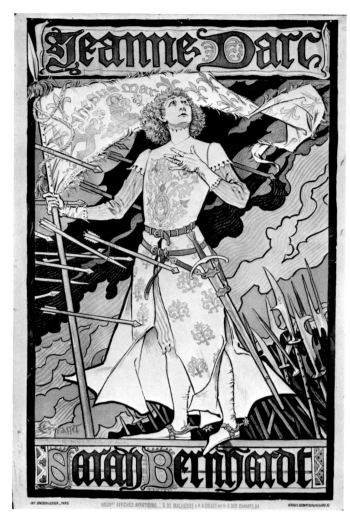

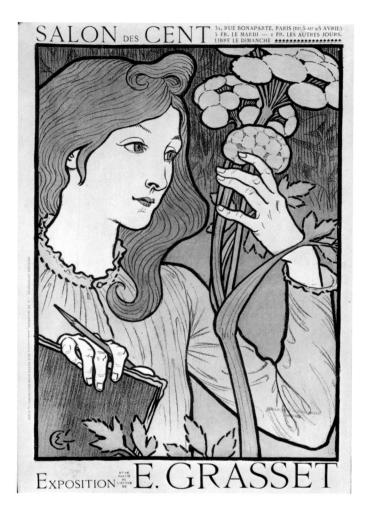

118
Jeanne d'Arc.
Eugène Grasset. Paris: Imprimerie
Draeger & Lesieur and Nouvelles Affiches
Artistiques, G. de Malherbe et
H. A. Cellot, 1890.
Color lithograph.
120 x 77 (47¼ x 30⅜)
Grasset, lower left.
Paris, Bibliothèque des Arts Décoratifs,
Inv. 2102.

119
Salon des Cent: Exposition E. Grasset.
Eugène Grasset. Paris: Affiches Artistiques, G.
de Malherbe, 1894.
Color lithograph.
61 x 41 (24 x 16⅛)
Grasset's monogram, lower left.
Paris, Bibliothèque des Arts Décoratifs,
Inv. 12581.

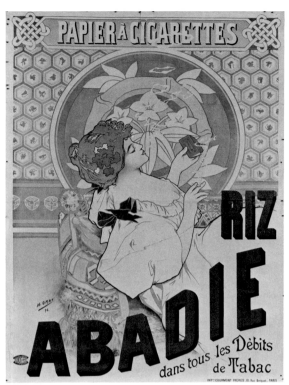

120

120
Abadie.
Henri Gray (pseudonym of Boulanger). Paris:
Imprimerie Courmont Frères, 1898.
Color lithograph.
140 x 99.5 (55⅛ x 39⅛)
H. Gray/ 98, lower left.
Paris, Bibliothèque des Arts Décoratifs,
Inv. 13842.

121
Exposition Le Castel Béranger.
Hector Guimard. Paris: Imprimerie de
Vaugirard, 1899.
Color lithograph.
90 x 130.5 (35½ x 51⅜)
Guimard's monogram, lower left.
Paris, Bibliothèque des Arts Décoratifs, Inv.
13558.

121

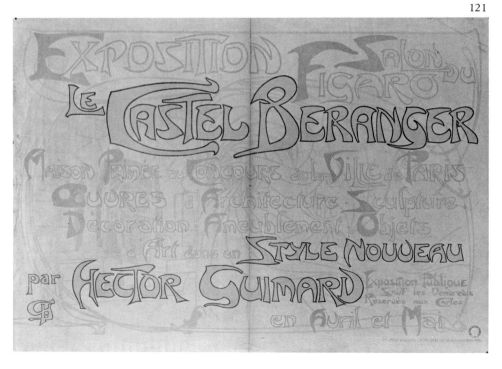

122

125

124

122
L. Vandevelde & Cie.
Georges Lemmen.
Color lithograph.
35.5 x 46.5 (14 x 18¼)
Brussels, L. Wittamer–de Camps.

123
Arnould.
Marcel Lenoir. Paris: Imprimerie Champenois.
Color lithograph.
65.5 x 44.5 (25¾ x 17½)
Marcel Lenoir, lower left.
Paris, Bibliothèque des Arts Décoratifs,
Inv. 12625.

124
Cercle Artistique de Schaerbeek.
Privat-Livemont. Brussels:
Trommer & Staeves, 1896.
Color lithograph.
111 x 82 (43¾ x 32¼)
Privat-Livemont/ 1896, lower center.
Brussels, L. Wittamer–de Camps.

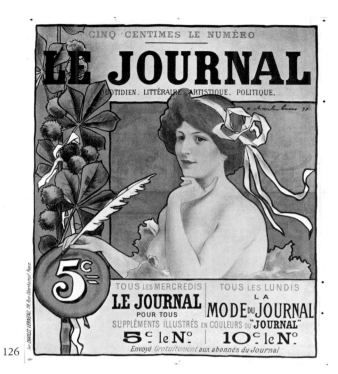

126

125
Rajah.
Privat-Livemont. 1899.
Color lithograph.
78 x 43.5 (30¾ x 17⅛)
Privat/ Livemont, lower left.
Brussels, L. Wittamer—de Camps.

126
Le Journal.
Charles Lucas. Paris: Imprimerie
Charles Verneau, 1897.
Color lithograph.
90.5 x 75 (35⅝ x 29½)
e charles lucas 97, upper right.
Paris, Bibliothèque des Arts Décoratifs,
Inv. 14447.

127
Rajah.
Henri Meunier. Brussels, Lille, and Paris:
J. E. Goossens, 1897.
Color lithograph.
59.5 x 75.5 (23½ x 29¾)
Henri/ Meunier/ 97, middle right.
Brussels, L. Wittamer—de Camps.

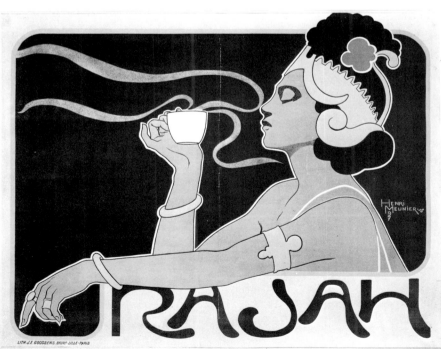

127

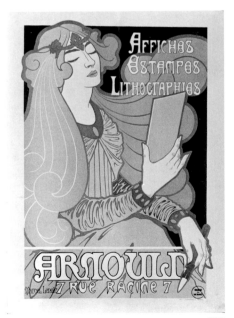

123

128
Médée.
Alphonse Mucha. Paris: Imprimerie
Champenois, 1898.
Color lithograph.
208 x 76 (81⅛ x 29⅞)
Mucha, lower left.
Paris, Bibliothèque des Arts Décoratifs,
Inv. 11148. Gift of Roger Braun.

129
Salon des Cent.
Alphonse Mucha. Paris: Imprimerie
Champenois, 1896.
Color lithograph.
64 x 43.5 (25¼ x 17⅛)
Mucha, lower left. *Mucha/ 5,* autograph,
lower right.
Paris, Bibliothèque des Arts Décoratifs,
Inv. 12281. Gift of Georges Pochet.

130
Vins des Incas.
Alphonse Mucha. Paris: Imprimerie
Champenois, c. 1899.
Color lithograph.
77.5 x 205 (30½ x 80¾)
Mucha, lower right.
Paris, Bibliothèque des Arts Décoratifs,
Inv. 12469. Gift of Georges Pochet.

131
La Monacale.
E. Muller. Paris: Imprimerie
de l'A.B.C., 1898.
Color lithograph.
130 x 70 (51⅛ x 27½)
E Muller/ 98, lower right.
Paris, Bibliothèque des Arts Décoratifs,
Inv. 14445.

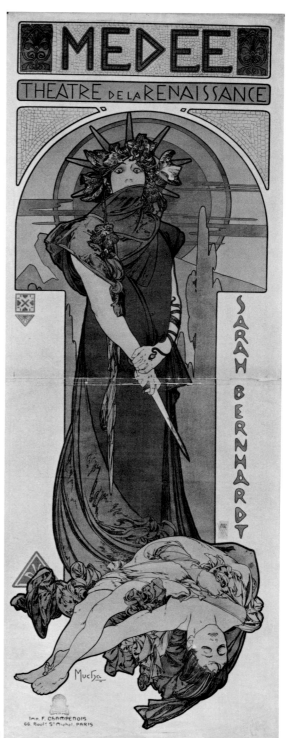

128

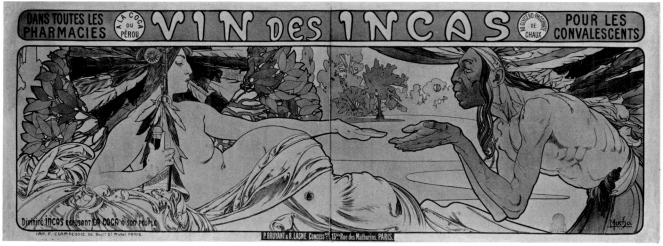

130

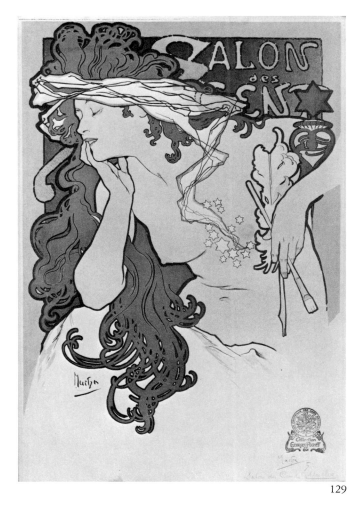

129

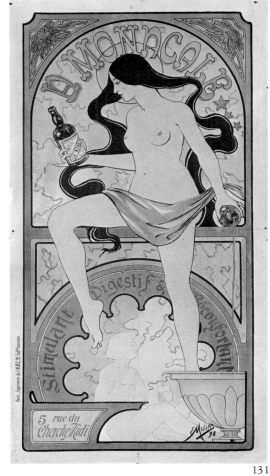

131

132
La Maison Moderne.
Manuel Orazi. Paris: J. Minot, Affiches
Artistiques, c.1905.
Color lithograph.
83 x 117.5 (32⅜ x 46¼)
Orazi's monogram, lower left.
Paris, Bibliothèque des Arts Décoratifs,
Inv. 14413. Gift of Georges Pochet.

133
Théâtre de Loïe Fuller. Exposition Universelle.
Manuel Orazi. Paris: Affiches Artistiques
Manuel Orazi, 1900.
Color lithograph.
201 x 60.5 (79⅛ x 23⅞)
Orazi's monogram, lower right.
Paris, Bibliothèque des Arts Décoratifs,
Inv. 13460.

Printed in three editions, in three
different color schemes.

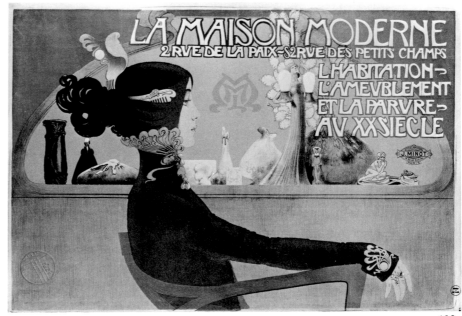

132

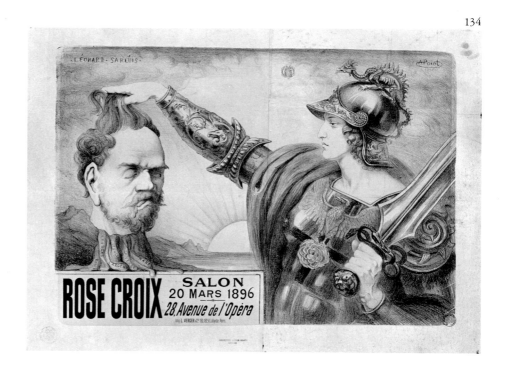

134

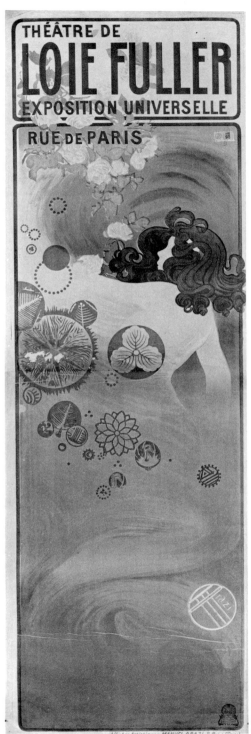

133

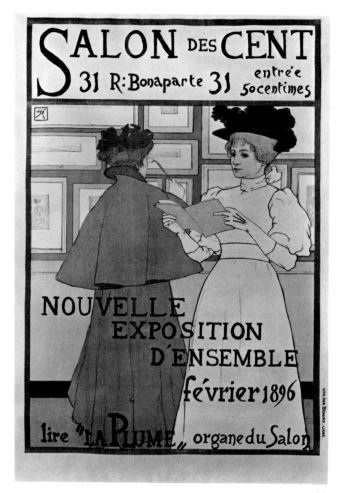

135

134
Salon Rose Croix.
Armand Point and Léonard Sarluis. Paris:
Imprimerie L. Verger, 1896.
Color lithograph.
77 x 105 (30¼ x 41⅜)
LEONARD SARLUIS, upper left.
APoint/ 1896, upper right.
Paris, Bibliothèque des Arts Décoratifs,
Inv. 14446. Gift of Roger Braun.

135
Salon des Cent.
Armand Rassenfosse. Liège:
Aug. Bénard, 1896.
Color lithograph.
66 x 50 (26 x 19¾)
Rassenfosse's monogram, upper left.
Brussels, L. Wittamer–de Camps.

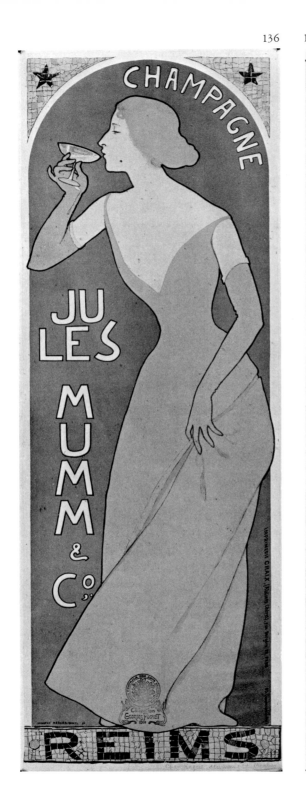

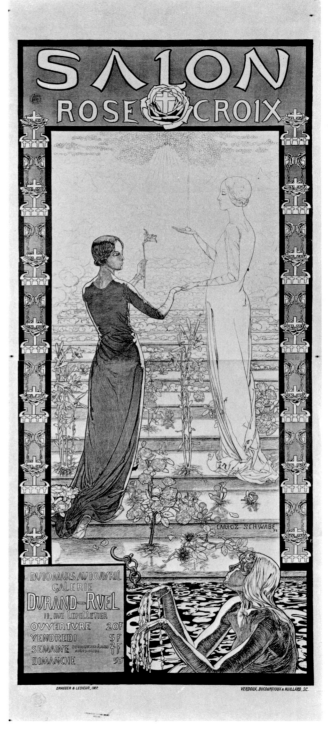

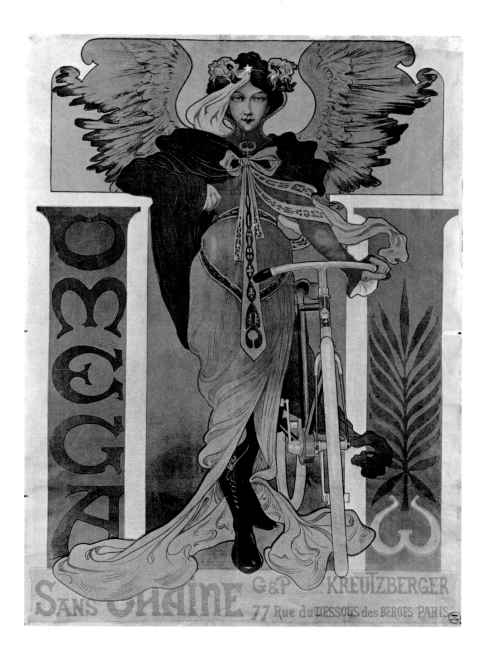

136
Champagne Jules Mumm.
Maurice Réalier-Dumas. Paris: Imprimerie
Chaix, 1895.
Color lithograph.
85 x 29.5 (33½ x 11⅝)
maurice REALIER-DUMAS 95, lower left.
Paris, Bibliothèque des Arts Décoratifs,
Inv. 14449. Gift of Georges Pochet.

137
Salon Rose + Croix.
Carlos Schwabe. Paris: Imprimerie
Draeger & Lesieur, 1892.
Blue lithograph.
184.5 x 81.5 (72⅝ x 32)
CARLOZ SCHWABE/92, lower right.
Paris, Bibliothèque des Arts Décoratifs,
Inv. 12864.

138
Omega.
Henri Thiriet.
Color lithograph.
140 x 99 (55⅛ x 39)
H. Thiriet, lower left.
Paris, Bibliothèque des Arts Décoratifs,
Inv. 9947.

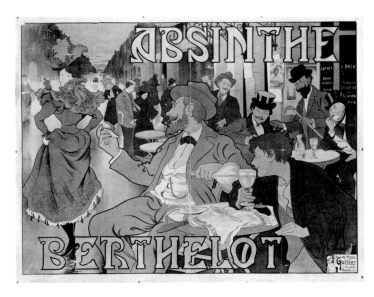

139
Absinthe Berthelot.
Henri Thiriet. Brussels: J. L. Goffart.
Color lithograph.
101 x 129.5 (39¾ x 51)
h. Thiriet, lower right.
Paris, Bibliothèque des Arts Décoratifs,
Inv. 12802.

140
Divan Japonais.
Henri de Toulouse-Lautrec. Paris: Imprimerie
Edward Ancourt, 1892.
Color lithograph.
81 x 62.5 (31⅛ x 24⅝)
HTLautrec (H, T, and *L* conjoined), lower
right.
Paris, Bibliothèque des Arts Décoratifs,
Inv. 12160. Gift of Georges Pochet.

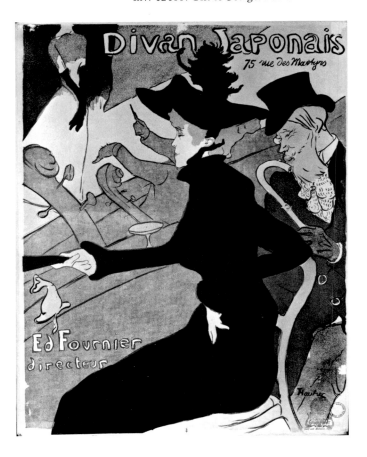

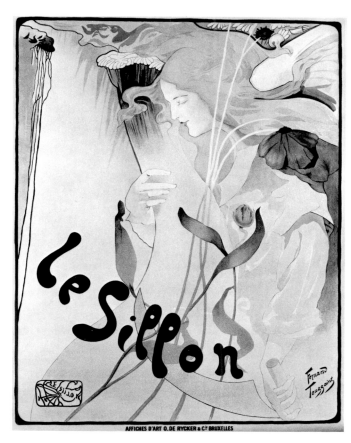

141
Le Sillon.
Fernand Toussaint. Brussels: Affiches
d'Art O. de Rycker, 1895.
Color lithograph.
103 x 80.5 (40½ x 31¾)
Fernand/ Toussaint, lower right.
Brussels, L. Wittamer–de Camps.

142
La Libre Esthétique.
Théo van Rysselberghe. Brussels: Imprimerie
Monnom, 1897.
Color lithograph.
100 x 74.5 (39⅜ x 29⅜)
Van Rysselberghe's monogram, upper left.
Brussels, L. Wittamer–de Camps.

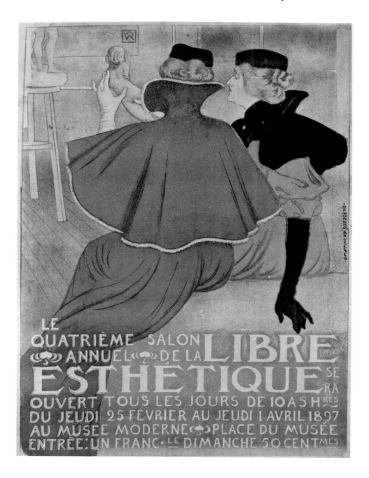

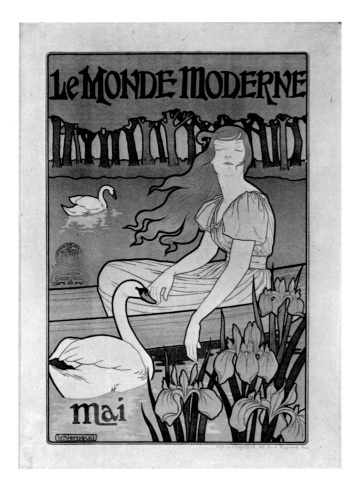

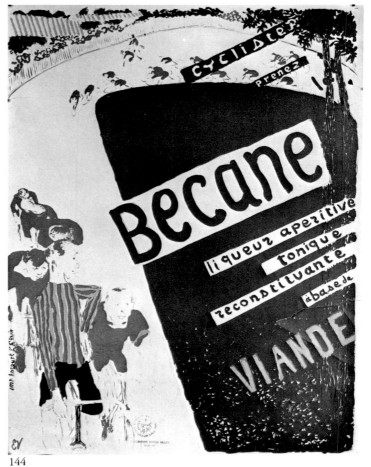

144

143
Le Monde Moderne.
Maurice Pillard Verneuil. Paris: Imprimerie
de Vaugirard, 1896.
Color lithograph.
63 x 41 (24¾ x 16⅛)
M P. Verneuil, lower left.
Paris, Bibliothèque des Arts Décoratifs,
Inv. 14423. Gift of Roger Braun.

144
Bécane.
Edouard Vuillard. Paris: Imprimerie
Ancourt, 1890.
Color lithograph.
81 x 61 (31⅞ x 24)
EV, lower left.
Paris, Bibliothèque des Arts Décoratifs,
Inv. 14448. Gift of Roger Braun.

SCULPTURE
AND
DECORATIVE
ARTS

ART NOUVEAU
AND THE
APPLIED ARTS IN BELGIUM
Jacques-Grégoire Watelet

A great rift cut the 19th century in two, completing the break between modern society and the *ancien régime*. Politically this rupture took the form of the European revolutions of 1848; but at the same time it gave rise to a revolution of thought and imagination which began in England with romantic exhortations, characteristic of the Gothic Revival, to return to nature and to represent it faithfully. Ruskin delighted in minute observation of nature, which he found perfectly transposed in Gothic architecture. A little later William Morris, stirred by the fervor of the Oxford Movement (he was then a scholar at the university), gave up his ecclesiastical studies and devoted himself entirely to the revival of the crafts. In the same years, in France, Viollet-le-Duc was discovering the internal logic of Gothic art through his work in restoring its monuments; he translated this logic with meticulous precision in his *Dictionnaire raisonné de l'architecture*. These two currents, which ran parallel although their motivation was quite different, sounded the death knell of academicism. At the same time they drew attention to the products made for use in daily life, the designs of which were soullessly eclectic or simply hideous ornament.

Over against these efforts the brutal new force of the machine reared itself, and not only revolutionized the process of production but profoundly affected popular taste. "It was not just that the machine had stamped out taste in industrial products," writes Nikolaus Pevsner; "by 1850 it seems that it had irremediably poisoned the surviving craftsmen. . . . The insensibility of the artist towards the beauty of pure shape, pure material, pure decorative pattern, is monstrous."[1] The first international exposition, held in London in 1851, demonstrated this clearly. Observers like the Comte de Laborde, the French government's farsighted delegate to the exposition, saw in this great display the possibility of a union between the two creative powers, the handicrafts and

the machine. This would demolish in a single stroke the wall that separated artists and craftsmen: "Besides," he wrote, "where does art end and industry begin? Are artists differently endowed by nature? Are their studies so different? And tell me, . . . where does the separation of industry start? Ghiberti was a bronzeworker, Benvenuto Cellini a goldsmith, Bernard Palissy a potter."[2]

While this penetrating insight gave a glimpse of the whole future career of design, it still saw the machine as a mere extension of the hand tool, and showed no awareness of the alienating power of this new, voracious force, nor of the frightful consequences to come from its domination by the great middle-class industrialists—like the grinding poverty of the working class. Ruskin hated the machine for producing such ugliness, but Viollet-le-Duc saw the locomotive as a masterpiece of contemporary creativity and praised it in the highest terms. Sensitivity in the making of things on the one hand, on the other the blindness of the machine—this is the dilemma which confronted the whole period of Art Nouveau. The hot controversy between Henry van de Velde and Hermann Muthesius at the Werkbund congress in Cologne in 1914 brought out clearly the two sides of the problem.

At this same time a new wind of inspiration stirred among the artists. Colonial conquest of the Orient by the great powers was making Eastern art known, and its products began to pour into Europe. London, Paris, and Brussels discovered them and were entranced. Liberty and Co. in London began as an oriental import shop. In Paris, Bing specialized in oriental prints before establishing his shop, L'Art Nouveau. La Maison Japonaise in Brussels was opened in 1866. Gustave Serrurier-Bovy started a decorating business in Liège in 1884, and imported objects from Japan and the Orient at large. This contact with the Far East, which influenced Van Gogh and Gauguin so strongly, complemented Ruskin's ideas and gave artists a new way of

looking at nature.

This brief survey of the general climate of the period would not be complete without touching upon the social background of a world in evolution. The first reaction of the socialist thinkers was that art ought to belong to everybody. The section on art of the Belgian Workers' Party, founded in 1891, expressed this wish: "In the future, we hope, art will be everywhere. Not only will it formulate in magnificent fashion the generous aspiration toward an ideal, but it will come down to the ordinary things of daily life and will accompany all human activity."[3] The object cannot stop at its own beauty; there is beauty only in things that are useful. Here again is the rationality of Viollet-le-Duc. William Morris wanted and wholeheartedly called for "an art for the people and by the people." Jean Lahor, one of his French disciples, came to realize that for the time being his desires had to be limited to "an art for the people for want of an art by the people."[4] The theory of art for art's sake was out of date. An art indifferent to daily life had no more than a purely aesthetic interest: consequently it ran the risk of being estranged from man's real experience of life.

The Aesthetic Movement placed England ahead of the Continent in the search for a new style, but subsequently it was in Belgium that this search was carried forward. Brussels was fast becoming a first-rate center for the propagation of the new ideas. The Groupe des Vingt, which became La Libre Esthétique in 1894, brought together the most advanced artists of the period under the shrewd and active guidance of Octave Maus.[5] At first composed of painters, sculptors, men of letters, and musicians, it soon opened its annual exhibitions to works of applied art. When the group elected the Antwerp artist Van de Velde to membership in 1888, it brought in a man who was about to burst the narrow confines of its exhibitions.

A painter first in the Impressionist and then the Pointillist style, Van de Velde soon felt an attraction to Van Gogh's art that was to precipitate a crisis in his career. While on his honeymoon he visited the home of Van Gogh's brother Théo in Bussum, and there saw the painter's works piled up in the attic. He was dazzled by the perfection to which Van Gogh had brought the art of painting, and it flashed upon him that that road was forever closed to him. He thereupon decided to devote himself entirely to the applied arts, and proposed that these be introduced in the exhibitions of Les Vingt. At first objects from England and France were timidly displayed, to be joined shortly by Belgian creations. The innovation was

important: it shifted the focus of interest to the arts so recently called "minor," and their relationship to the quality of everyday life.

Another Belgian, Gustave Serrurier-Bovy, had sensed the significance of what was happening in England even before Van de Velde, who acknowledged this frankly. Serrurier-Bovy, an architect who followed Viollet-le-Duc's directives rather than those of the academy, had crossed the Channel to take courses in the Schools of Handicrafts, and came back full of ideas about simple, sturdy, well-built house furnishings. He set out to design and construct his own, and at the time of the first Salon de la Libre Esthétique in 1894 he was the first to exhibit a complete set of household furnishings: he remodeled a section of the Musée des Beaux-Arts, putting in a study in which the furniture, draperies, wallpaper, lighting, and bric-a-brac combined to make a new ensemble. The following year he repeated the experiment with a workroom, which he called a "chambre d'artisan." Van de Velde, and after him Horta (in 1897) also exhibited sets of furniture at La Libre Esthétique.

Other painters and sculptors proceeded to create household objects. The painter Willy Finch became a ceramist, as Gauguin had done. Sculptors like Fernand Dubois and others exhibited statuettes, candelabra, and centerpieces. Painters and engravers covered walls with new posters. An exhibition reserved exclusively to applied art, "L'Oeuvre Artistique," opened at Liège in 1895. There for the first time the works of the Glasgow School and the first projects of a young French architect, Hector Guimard, were put on display. Certain industries paid heed to the renewed creativity: Finch's interest in ceramics began when he was asked to decorate pottery at the Boch factory in La Louvière, while the Cristalleries du Val-Saint-Lambert gave artists the opportunity to produce works in the new mode.

It was thanks to the prosperity Belgium enjoyed under King Leopold II that Art Nouveau found a favorable terrain there. The young country was driving ahead in every field—industry, research, commerce, a variety of businesses throughout the world—and the new ideas aroused no fear in a progress-minded, wealthy middle class. It was among these rich bourgeois, generous by nature and defenders of social reform movements, that Art Nouveau found its initiates and its clients; works like Horta's Maison du Peuple and Hôtel Solvay were the result. The personal influence of the sovereign made itself felt when he promoted the products of the Congo Free State by suggesting that they be used for new works of art. So, at the Antwerp exposition in 1894,

sculpture-objects in ivory and metal made by Philippe Wolfers were on display. This artist's works, and those of other sculptors who used the same techniques and materials, were also shown in 1897 at the Tervueren exposition, the colonial section of the Exposition Internationale held in Brussels. Hankar, Hobé, Serrurier-Bovy, and Van de Velde, all of them Art Nouveau architects and decorators, prepared the stands there. The person who suggested that new men be called on for this exhibition was Baron Van Eetvelde, secretary general of the Congo Free State; he was a friend of Octave Maus, and had Horta build his house. The new style of architecture became quite fashionable, so much so that even buildings of the traditional type were dressed up with "modern style" exteriors.

Each period has its own way of returning to nature. The Art Nouveau artist did not place himself before nature or in its atmosphere the way the Impressionists did. Rather, he immersed himself in it, identified with it, entered into the very heart of the plant: "I leave the leaf and the flower and take the stem," said Horta. Van de Velde, dreaming beside the North Sea, found in the mobility of the wave and the firmness of its outline a dynamic line that became a vital element in his experiments: "The line is a force," he said. To take the plant as the paramount source of forms for furniture, to apply the curves of stems stretching and bending with the pressure of the mounting sap—this is what the creative artists of the time proposed to do. This constructive force is found in the works of Serrurier-Bovy, Van de Velde, and Hankar, while Horta extended it in multidirectional dimensions which recall the knot of the branch or the bud. Painters used these curves and volutes in their posters and wallpapers. Several creators of objects continued to be influenced by the Symbolism of earlier years and by contemporary poetry. Yet if some of Philippe Wolfers' jewels may be related to a passage of poetry, still the structure of the jewel fits into the undulant, sinuous lines of a floral art; if the Medusa's head, the dragonfly, and the peacock are symbols, they are still held in a curvilinear setting which frames and supports them. The same sinuous line is seen in candelabra by Van de Velde and Fernand Dubois. No doubt one can see a similarity between these floral patterns and Japanese art, and these curves are not unlike those used by the Italian ornamentalists who created the Rococo style in France. Nevertheless the decisive factor was not this indirect influence, nor for that matter the grammars of ornament—those marching orders which all of them had had to learn. It was direct contact with nature

studied in detail, as we see in the thousands of drawings from life by Wolfers, that made it possible for the artists of the time to see reflections of their own work in the asymmetry of Japanese prints, and to relate their style to the volutes of Rococo. Even the woman often figuring in small sculptures is like a flower opening amidst a harmonious and liberating nature.

In the products of the furniture-makers linear treatment blends with the rigorous structural requirements of the architect. Hankar, Serrurier-Bovy, Horta, Hobé, Pompe, and Van de Velde were architects, the latter choosing to learn the art by himself. Their innovations included the employment of materials not previously in common use, like silky light or dark woods from the Congo, upon which played the gleam of worked metal. Jewelry also incorporated materials in new forms—ivory, uncut stones, and baroque pearls—to create unexpected juxtapositions, recalling a still virgin nature.

Art Nouveau artists, therefore, worked in freedom, yet kept to strict rules of procedure. Volutes and curves and baroque or asymmetrical materials must not mislead us. The logic is in the curve of the flower's stem itself, or in the dynamic force of the wave. This art "carries within it the stern will to tame movement and give it a harmonious balance."[6] The easiest comparison is with music: "The fluid development of musical structure expresses this equality between the liberal arts and the applied arts, or rather their interpenetration. We begin to understand the influence of a harmonious environment on the human being, and the social benefit brought about by the daily use of beautiful and functional objects."[7] If there is play between the sinuous line and the material, there is still an impassioned quest for a useful art, for the blending of the beautiful with the uses of every day.

To exhibit Art Nouveau objects today is to demand a twofold rereading by the viewer. The first supposes a fresh discovery of forms that until recently have been thought of as outmoded or even a bit ridiculous. The passage of time and a surfeit of the geometric and the abstract have reawakened interest in this art; we are probably better able than its contemporaries to read this network of supple but solid lines, for it no longer wears the halo of fashion. The time has come for analysis and more penetrating, more critical insights.

But seeing objects in an exhibition, out of their original context, calls for a second and still more difficult rereading. One or two pieces may allow us to judge the incisiveness of an artist's designs and the ingenuity of his constructions, but

the fact remains that we do not see them in their intended environment. And yet if there was ever a period when the ideal of the "work-as-a-whole"—*Gesamtwerk*—was faithfully adhered to, it was the period of Art Nouveau. Even the jewelry had to form an integral part of the attire of the ladies who frequented La Libre Esthétique, "elegant women whose coats of green velvet or mauve silk, peplums of orange muslin, ferronières, reticules, lilies sometimes carried like candles . . . were meant to bring toilettes à la Ruskin into accord with the modern setting in which they moved about."[8] In the perspective of the work-as-a-whole, the poster calls for the wall, furniture presupposes draperies, rugs, and wallpaper; the small object postulates the whole room. This must be kept in mind if the object is to be understood in its real context.

The magnificent wave of Art Nouveau in Belgium did not last long—fifteen or twenty years at the most. The end of a decadent romanticism or the beginning of a new era? A little of both, probably. However that may be, the fact remains that after the brilliant expositions in Turin in 1902 and Liège in 1905, the style was in the process of change. Curves were reduced, objects grew calmer and more clean-lined. Was it the influence of Vienna, manifested in Brussels when Hoffmann built the Palais Stoclet in 1905, that brought about this sudden turn? Was Belgium to be outstripped as the center of the new style? Perhaps this shift was foreshadowed when the Austrian Olbrich, himself influenced by the Scotsman Mackintosh, built the Mathildenhöhe colony in Darmstadt in 1901. Serrurier-Bovy had a premonition of this when he discovered the work—and wrote a sagacious criticism of it.[9] At the Liège exposition he showed some working-class furniture; very simple, built of birchwood, it could be taken apart and reassembled. As for Van de Velde, in 1908 he adopted a more geometric decoration for the Hohenhof house in Hagen. Wolfers abandoned jewelry for sculpture; and Hankar died in 1901. The later Art Nouveau was calmer, and reflected an effort to adapt to the changing social scene. For those who most valued quality of craftsmanship it already pointed towards the Art Deco style. For those more attracted to Constructivism it opened the way to a rational geometrization, which in turn led to functionalism in design.

All things considered, what is the real "input" of Art Nouveau to the development of art? Is it simply a marginal episode, or has it a place in a continuing current of renewal and creativity? The latter view now seems to prevail.

Textbook academicism, deteriorating into sterile Eclecticism, yielded to a restructuring of forms and a wave of prolific innovation. Of this the curve was not only the most visible element, but also the nervous system and the new structure, making it possible to go beyond imitation and to make craftsmanship again a part of production. Viollet-le-Duc's influence was beneficial for those who put it to good use: that is, not to imitate, but to study the secrets of crafts and return through them to an art of simpler purpose— making things for everyday use. It is important to emphasize this dual aspect of Art Nouveau—imaginative form and rational construction, deriving respectively from Ruskin and Viollet-le-Duc.[10] The breakdown of privilege and the abolition of the totalitarian power of the Beaux-Arts made room for an explosion of new experiments. Painters and sculptors reassessed the reasons for their aesthetic activity, and more than one of them opted for a radical change of direction. "Modernity," already evoked by Baudelaire and upheld in circles like Les Vingt, took the form of an abandonment of art for art's sake. This modernity sought to combine with social progressivism and to domesticate the machine artistically. The period was full of enthusiasm and rich in creative minds. In Belgium the First World War completed the obliteration of the last manifestations of Art Nouveau and broke the continuity between it and the following period. Yet we must repeat that in the realm of the applied arts this continuity exists.

In 1952 Van de Velde, an old man in his Swiss hermitage at Oberägeri, was stricken with fear when the Kunstgewerbemuseum in Zürich proposed a retrospective of 1900 art. "Would the public think," he wrote at that time to Johannes Itten, "that all these objects date from the period of 'infantile maladies,' and that few of the artists progressed beyond that stage? Can they be viewed in the perspective which connects them with what is current today in style and art?"[11] The exhibitions, already numerous, which have been devoted to this theme since then have shown that the apprehension of this apostle of Art Nouveau was without foundation.

The world changes, and with it the particulars of culture and daily life. Creativity endures. Beyond the obvious breaks—which, moreover, are intentional and real—it generates forms, whose affinities and relationships are revealed by the passage of time. The relationships may be unanticipated and unconscious at the time of their blossoming, but they are no less real for that. Art Nouveau does not escape this law: the works presented in this exhibition are there to prove it.

1 Nikolaus Pevsner, *Pioneers of Modern Design* (London: Penguin Books, 1960), pp. 42–43.

2 Comte Léon de Laborde, *Travaux de la commission française sur l'industrie des nations: Exposition universelle de 1851* (Paris, 1856), p. 418.

3 Jules Destrée and Emile Vandervelde, *Le socialisme en Belgique* (Paris: Girard, 1898), p. 235.

4 Jean Lahor, *L'Art pour le peuple à défaut de l'art par le peuple* (Paris: Larousse, c. 1902).

5 See Madeleine-Octave Maus, *Trente années de lutte pour l'art* (Brussels: L'Oiseau Bleu, 1926), and the exhibition catalogue *Le Groupe des XX et son temps* (Brussels: Musées Royaux des Beaux-Arts de Belgique, 1962).

6 Stephan Tschudi Madsen, *L'Art Nouveau* (Paris: Hachette, 1967), p. 15

7 Francine-Claire Legrand, *Le Symbolisme en Belgique* (Brussels: Laconti, 1971), p. 208.

8 Octave Maus, "La Lanterne magique" (1918), quoted in Maus, *Trente ans,* p. 179.

9 Gustave Serrurier-Bovy, "A Darmstadt," *L'Art Moderne,* no. 10 (1902), pp. 35–36, 52–53.

10 See Nikolaus Pevsner, *Ruskin and Viollet-le-Duc: Englishness and Frenchness in the Appreciation of Gothic Architecture* (London: Thames and Hudson, 1969).

11 "Ein Brief von Henry van de Velde" in the exhibition catalogue *Um 1900: Art Nouveau und Jugendstil* (Zürich: Kunstgewerbemuseum, 1952), p. 5.

THE CREATORS
OF
ART NOUVEAU IN FRANCE
Yvonne Brunhammer

It is undeniable that Art Nouveau is more closely related to decorative art than to architecture, painting, or sculpture. Yet there is Art Nouveau architecture, Hector Guimard being its best and most famous representative in France, and there are pictures and sculptures in which themes and characteristics of the 1900 style appear. The social and aesthetic history of the second half of the 19th century enables us to understand why the decorative arts were favored, and how close bonds developed between decorators, craftsmen, and practitioners of the so-called major arts.

The 19th-century renewal of the plastic arts began with Delacroix and his contemporaries. The "modern" artist born of the political upheavals of the late 18th century tended to free himself from the recent past, and to reach back to the tradition of the Middle Ages; he also discovered the Orient, in the wake of the colonial wars. With the generation of Daumier and Courbet art entered the era of realism. The painter no longer strove to represent the "eternal truths of religion or morality," but to speak to his own time. Impressionism marks this break. Affirming the value of sensation *per se,* the artist achieved a new expression outside of old aesthetic ideals or the constraints of historicism.

The Great Exhibition of 1851 in London had launched the idea that works of art belonged not to a particular nation but to the whole world. The artists who met through the international exhibitions, who traveled and maintained relations with their foreign contemporaries, thought less and less of national boundaries. After 1874, the year the "Impressionist" painters held their first show, new groups and movements followed one after the other, each translating in its own way its relations with comtemporary life, which changed and evolved with increasing speed. The Neo-Impressionists radicalized the Impressionist way of seeing, applying scientific discoveries in the field of optics. The Symbolists, on the contrary, took their place in the literary and mystical movement widespread in Europe, turning their backs on imitating nature and giving priority to imitating the essence or spirit of nature, the idea, which determines the form and is above it. Intent upon "representation of the world by resonance and mystery,"[1] Symbolism involved or was influenced by painters and illustrators as diverse as Gustave Moreau, Puvis de Chavannes, Odilon Redon, Edmond Aman-Jean, Georges de Feure, Eugène Grasset, and Lucien Lévy-Dhurmer, as well as Gauguin, Maurice Denis, Paul Ranson, and lastly Aristide Maillol before he turned entirely to sculpture. Symbolism was something in the atmosphere of the time rather than a movement or a school. Its beginnings may perhaps date back to 1864, the year that Gustave Moreau scored a public success at the salon with his *Oedipus and the Sphinx*, more than two decades before Jean Moréas published his Symbolist manifesto in *Le Figaro* (1886).[2]

Between these two dates the situation of the decorative arts changed considerably in France. Decorative artists were locked in an impasse resulting from the rapid advance of industrial methods, to which they adapted without rethinking their work. This situation of the "arts applied to industry" was general all through Europe. Whether it went by the name of Historicism or Eclecticism, the trend was toward pastiche, or else pure and simple copying of the decorative styles of the past. At the international expositions held in Paris in 1867 and 1878 decorative artists found themselves confronted with a new range of choices—not only the works of their fellow professionals throughout the world, but those of men engaged in every modern activity—architecture, painting, sculpture, industry in all its phases, and agriculture. By prominently featuring domestic architecture and decoration, the expositions had contributed to a renewed interest in these fields. The artists, anxious to respond to the demand and produce furniture or other objects for mass

consumption, were swayed by contradictory motives; curiously, they rejected industrial methods, which alone could have served their purposes, and turned instead to the handicrafts, perhaps under the influence of Ruskin's and William Morris' writings.

Industrial production is based on the principle of division of labor, which artists regarded as a brake on their inventiveness. "The century now drawing to a close," said Emile Gallé in 1900, "has had no popular art, by which I mean art applied to utilitarian objects and executed spontaneously and joyously by the artisans themselves at their crafts." He observes that "the slavish imitations of the past, copies in which the trace of the past is absent, its symbols, created in other times, being beyond our comprehension and responding to other needs and another conception of life, [are the result] of the age of industrialism, of too much division of labor, of its organization far from the home and the hearth, from the family and its natural environment, in a poisonous, artificial atmosphere."[3] Artists in the second half of the 19th century all felt the need of following the fabrication of an object from its conception through to the final touches.

The discovery of the arts of Japan and the expositions in 1867 and 1878 played a stimulating role which went beyond their aesthetic influence. Japan attached the same worth to the handcrafted object, and particularly to ceramic ware, as did the Occident to painting or sculpture. In Japan the object is charged with a symbolic intention. The potter who turns the bowl destined for the tea ceremony is no ordinary craftsman; he is the best and most respected artist in the land. This attitude confirmed French artists in their idea that the renewal of the decorative arts depended on handicraft production. It is easy to imagine how painters, engravers, and sculptors, enchanted and influenced by Japanese art, were tempted to become potters, glassworkers, goldsmiths, or weavers, or at least to furnish sketches for the objects and decorations executed in the studios that opened in increasing numbers in Paris and its *banlieue*, in Nancy and Limoges.

One of the first artists to do this was Félix Bracquemond the engraver, who made his discovery of Japanese prints as early as 1856. He created several plates for Théodore Deck, made engravings of birds and flowers inspired by Hokusai for the ceramist Eugène Rousseau, and finally took charge of the workshop founded by Charles Haviland in Auteuil. There, from 1872 to 1881, he set up one of the centers where the new French ceramic was developed: he was influenced both by Japanese techniques and shapes and by the Impressionist vision of naturalistic decoration. Paul Gauguin also became interested in ceramic work, as well as in objects carved out of wood. Bracquemond introduced him to Ernest Chaplet in 1886. "Charmed by my sculpture," Gauguin wrote to his wife, "he asked me to make some things this winter, whatever I liked; they would be sold and we would share the proceeds evenly."[4] Gauguin's stay at the workshop in the rue Blomet, and the financial setbacks suffered there, are well known. The fact that a painter of this rank took up a handicraft technique in the 1880s marks a turning point in the contemporary decorative arts—a development which was to be extended and commercially exploited by Samuel Bing and Julius Meier-Graefe toward the end of the century.

In Gauguin's hands a pot became a sculpture-object[5] enriched with complex undertones. Rupert Carabin also dreamed up and produced sculpture-objects, handmaking and handcarving furniture, chairs, mirrors, and pin trays. With Seurat and Signac a cofounder of the Salon des Indépendants in 1884, he was working on realistic figurines when a collector to whom he had expressed a desire to make furniture commissioned a bookcase. We are in 1889: at the Exposition Universelle, Emile Gallé himself succumbed to Eclecticism when he proposed a cabinet "in gray and black oak," and a large neo-Renaissance table, as well as a "console in ebony with bronze, and island woods inlaid and carved"—a piece which, in spite of its decoration of orchids and insects, showed that Fourdinois' influence was still all-powerful.[6] With his bookcase Carabin broke with a tradition that went back to the 16th century. Since the Renaissance a piece of furniture had been architecture, and from architecture had taken its structure and ornament. Carabin thought differently. For him furniture was sculpture, and its function should be revealed in sculptural terms. In this first attempt (cat. no. 215) we find elements to which he remained faithful in the best of his work—priority given to wood, use of wrought iron for hardware and of sculpture for structural elements and ornament, symbolism in figures and bas-reliefs. He invented his own laws of balance and relation with a fascinating freedom that recalls Gaudí's imaginativeness in the Park Güell and the bestiary on the porch of the Sagrada Familia.

It is not surprising that an art as independent as Carabin's scandalized the public and the critics when it was presented at the salon of the Société Nationale des Beaux-Arts in 1891.[7] Nor does Carabin belong with the artists whose work regained popularity in the 1960s due to the new wave of interest in Art Nouveau. It is true that he felt himself a stranger to the Franco-Belgian movement at the end of the

century. He was familiar with the work of Van de Velde and Serrurier-Bovy through the Salon de la Libre Esthétique, in which he took part. He had little use for Horta, "who introduced the macaroni style which, when Guimard brought it to Paris, arrested the French movement launched by some few artists four or five years earlier."[8] Carabin may have been thinking of Alexandre Charpentier and Victor Prouvé, who were among the artists who had gone over to the decorative arts and had exhibited decorative works at the official salon.

The development of Art Nouveau was so diverse that its practitioners often did not acknowledge each other and occasionally opposed each other. Like Gauguin, Carabin stayed free of the kind of design that reduced the new style to a system of curves inspired by nature. But if the 1900 style represents the breaking down of barriers between the different branches of art, a wholesale renewal of the conception of the object and its forms, and an ornamentation inspirited with symbolic undertones, Carabin was one of its torchbearers.

Interest in decorative art increased because of the exhibitions devoted to it and the importance allotted to it in the salons at Paris and Brussels and in the world's fairs. Most of the Symbolist painters tried their hand at decorative techniques. Gustave Moreau had projects executed by Paul Grandhomme the enameler (cat. no. 40); Lévy-Dhurmer did ceramics with Clément Massier in Golfe-Juan (cat. no. 424); Grasset designed furniture, stained-glass windows, and posters; Georges de Feure was one of the decorators regularly engaged by Samuel Bing. All of them, or almost all, illustrated texts for their poet and writer friends, or drew vignettes and cover designs for the magazines that were being launched.

With the Nabis, decorative art ceased to be a fringe activity: it became an accepted type of plastic expression. They laid claim to Gauguin, in whom Maurice Denis recognized "the Master, the undisputed Master." "At the time we were hardly aware of the savor of his exoticism, the almost barbarous refinements of his Impressionism. In him we saw only the ultimate example of Expression through Decoration."[9] Decorative applications were in line with the Nabis' conception, derived from Puvis de Chavannes, of art as ornament, and with their faith in its social role. Their aesthetic was valid for every form of art, and their number included artists in every medium. An initial core of painters—Paul Sérusier, Maurice Denis, Pierre Bonnard, K.-X. Roussel, Edouard Vuillard, and Paul Ranson—was joined by a sculptor, Georges Lacombe; a theater decorator, René Piot; musicians, among them Pierre Hermant; theater people like Lugné-Poë and Antoine; and lastly foreign artists, including Meyer de Haan, Jan Verkade, and Mögens Ballin.

To Maurice Denis, the theorist of the group, we owe the profession of faith that committed the Nabis to the art of wall decoration—tapestry, stained glass, wallpaper. "Remember that a picture, before being a war-horse, a nude woman, or some kind of anecdote, is essentially a planar surface covered with colors assembled in a certain order."[10] With Bonnard decorative art was only marginal, rather related to Japanese influence—for instance his decoration of folding screens (cat. no. 206). On the other hand it was an essential part of Paul Ranson's work. His cartoons for tapestries, together with Maillol's, are the best Art Nouveau creations in a genre somewhat neglected in the period: Les Femmes en blanc and Le Tigre have the sinuous graphic quality and the taste for vegetation as ornament which are basic to the 1900 style. Maurice Denis worked in practically all the decorative techniques, but painting always held first place. As gifts to his fiancée he painted a fan and a lampshade (cat. nos. 287, 288), and he designed projects for interiors, furniture, stained glass, wallpaper, and ceramics. The Nabi painters were in the first rank of the artists whom Samuel Bing, and later Meier-Graefe, called upon for designs for furniture and various objects. Like the Symbolists, they also illustrated books and designed posters.

When the "pioneers" of Art Nouveau—Bracquemond in Paris, Emile Gallé in Nancy—began to show their wares, decorative art did not yet enjoy the position it attained with the 1889 exposition. "The word 'decorative' wasn't yet on the tip of everybody's tongue in talk among artists or just ordinary people," wrote Maurice Denis in 1903 in an article on Gauguin.[11] But a change took place with the organization of the great expositions and the opening of the salons, which determined the relations between the different forms of art. Painters, sculptors, and architects thought it no loss of face to engage in a decorative art. Majorelle, Grasset, Georges de Feure, all great furniture designers, were trained as painters; Charpentier and Jean Dampt began as sculptors. Henri Cros, looking for a way to get his sculptures into circulation, rediscovered the technique of pâte de verre. Rodin gave models to the Manufacture de Sèvres and to Jean Carriès the potter, who had just abandoned a brilliant career as a sculptor to work in stoneware. For architects, and particularly for Hector Guimard, the problem presented itself in terms of the

close interrelationship between container and contents, between external structure and internal arrangement down to the smallest detail. The result was a plastic unity rarely achieved in architecture.

A number of artists and craftsmen took up several techniques simultaneously or in succession. Emile Gallé, founder of the Ecole de Nancy, is mainly known for "inventing" Art Nouveau glassware as early as 1878, but he also produced ceramics and furniture. Jacques Gruber, also of Nancy, designed furniture before becoming a master glassworker. Georges Hoentschel, the decorator responsible for the pavilion of the Union Centrale des Arts Décoratifs at the 1900 exposition, also worked in stoneware, first with Carriès and then with Grittel. René Lalique, perhaps the most inventive jeweler of all time, worked only in glass from 1914 on. On the other hand, some craftsmen chose to limit themselves to one technique and to master it completely, especially when it required a long and often frustrating apprenticeship, as is the case with ceramics. Among these were Ernest Chaplet and Auguste Delaherche: the quality and diversity of their work fully justify the choice they made.

After 1890 Art Nouveau became a fad—a "snobisme," Maurice Denis later called it.[12] Thanks be for the *snobisme* that broke through the barriers between the arts and gave us such a profusion of fine works! The newborn movement was rich in promise: it laid the foundations of a teaching which, through Henry van de Velde and Josef Hoffmann, led to the creation of the Weimar Bauhaus.

"Architects, sculptors, painters, we must all get back to the crafts! Then there will be no 'professional art.' There is no essential difference between the artist and the craftsman: the artist is a higher order of craftsman. . . . Therefore let us create a new guild of craftsmen, without the false pride that throws a barrier up between craftsman and artist. Let us want, plan, and create together the new structure of the future, in which architecture, sculpture, and painting will be united, and will rise toward the heavens from the hands of millions of craftsmen, the crystal symbol of a new faith." The terms of the manifesto with which Walter Gropius announced the creation of the Bauhaus in 1919 are well known. Now a new light shines upon them: the affiliation with Art Nouveau is clear, whatever aesthetic opposition there may be.

"Around 1900, a magnificent gesture—Art Nouveau. We shed the tatters of an old culture."[13] We owe this statement of position to Le Corbusier, who although he shared with his contemporaries an abhorrence for the forms of Art Nouveau decoration, nevertheless sensed the real importance of the movement and its consequences. In 1925, just before the opening of the Exposition des Arts Décoratifs, he wrote: "There was a superb effort, a considerable courage, a very great hardihood, a veritable revolution. In 1900 a fire was kindled in the mind. It was then that people began to talk about Decorative Art. And skirmishes broke out: great art, minor arts. Two camps."[14]

It is in this perspective that we now see the 1900 period: a privileged time, a moment when men united to strive toward a common goal, to create a new art.

1 Jean Cassou, "The Climate of Thought," in *The Sources of Modern Art* (London: Thames and Hudson, 1962), p. 55.
2 Francine-Claire Legrand, foreword to the exhibition catalogue *Peintres de l'imaginaire* (Paris: Grand Palais, 1972), p. 15.
3 Emile Gallé, "Le Décor symbolique," an address delivered before the Académie de Stanislas, May 17, 1900. Printed in the academy's *Mémoires,* 5th ser., vol. 17, and in *Ecrits pour l'Art* (Paris: Librarie Renouard, H. Laurens, 1908), p. 226.
4 *Lettres de Gauguin à sa femme et à ses amis*, ed. Maurice Malingue (Paris, 1946), no. 38, p. 88. The letter is undated, but Malingue considers it to have been written toward the end of May 1886. Gauguin goes on to tell his wife that Bracquemond had bought from him "with enthusiasm a picture for 250 francs," and had put him in contact with "a ceramist who plans to make art vases." And he adds, "Maybe I'll get something out of this in the future. Aubé used to work for him; his pots made a living for him and this is even more important." After his marriage in 1873 Gauguin had lived in the house of Jean-Paul

Aubé (1837–1916), one of Bracquemond's coworkers in the Auteuil workshop. In 1882 he did a pastel (now in the Musée du Petit-Palais) portraying Aubé and his son at work there; see the exhibition catalogue by Jean and Laurens d'Albis et al., *Céramique Impressioniste; L'Atelier Haviland de Paris-Auteuil, 1873–1882* (Paris: Société des Amis de la Bibliothèque Forney, 1974), no. 98.
5 In his correspondence with his wife, Gauguin insisted that his work should be considered "sculpture-céramique" (*Lettres,* no. 14, p. 97).
6 Alexandre-Georges Fourdinois (1799–1871), one of the outstanding sculptors and furniture-makers in the Second Empire, was purveyor by appointment to the Empress Eugénie, for whom he made furniture in the style called "Louis XVI–Impératrice." His son Henri-Auguste, born in 1830, came into his father's business in 1860, and produced furniture that showed the influence of a variety of styles.
7 The salons of both the Société Nationale des Beaux-Arts in Paris and Les Vingt in Brussels accepted the decorative arts beginning in 1891. According to Carabin's notes (unpublished), the artists who pressed

for this change in Paris included among others Dalou, Carrière, Rodin, Besnard, and Puvis de Chavannes.

8 Quoted from Carabin's notes. See Yvonne Brunhammer, "Un Oublié de l'Art Nouveau: Rupert Carabin," in the exhibition catalogue *L'Oeuvre de Rupert Carabin, 1862–1932* (Paris: Galerie du Luxembourg, 1974), pp. 1–13.

9 Maurice Denis, *Théories, 1890–1910: Du Symbolisme et de Gauguin vers un nouvel ordre classique* (Paris: Bibliothèque de l'Occident, 1912), p. 165.

10 Ibid., p. 1. The article from which this quotation was taken was originally published in the August 1890 issue of *Art et Critique,* a journal directed by Jean Jullien, a dramatist and friend of Lugné-Poë.

11 Ibid., p. 165.

12 Ibid.

13 Le Corbusier, introduction to *Le Corbusier et Pierre Jeanneret Oeuvre complète 1910–1929* (Zürich: Girsberger, 1929).

14 Le Corbusier, *L'Art décoratif d'aujourd'hui* (Paris: Grès, 1925), p. 135.

L'ART NOUVEAU BING
Yvonne Brunhammer

Samuel Bing, going to the United States in 1893 to visit the Chicago world's fair, was retained by the French government "to give an account of American art and what might come of it in the future."[1] Bing brought together his impressions, "brief notes of a tourist interested in such matters,"[2] in a volume entitled *La Culture Artistique en Amérique*, which he published in 1895. Eighty years later his views still strike one as surprisingly perceptive. The chapter devoted to the industrial arts goes well beyond a mere listing of facts to emphasize the conditions required for a situation favorable to industrial design: "The full and entire rehabilitation of this category of art, which . . . purposes to enhance all the familiar objects of daily life with its prestige; the organization of large establishments in which many different branches of decorative art can be concentrated in the pursuit of a predetermined end . . . ; a moral bond, a tacit collaboration, uniting scattered efforts; . . . a strict subordination of questions of mere embellishment to those concerning the organic structure of things; the deep-seated conviction that every object made for use should draw its beauty from the rhythmic coordination of its lines, which must first and foremost serve the practical purpose for which it is made; the ardent application . . . of the most highly perfected processes; the organization of model workshops . . .; in a word, the rule [is] to keep up, always and come what may, with the perpetual metamorphoses of the time, the day, the present hour."[3]

In short, here were the basic principles of the art schools and associations that would be in the forefront of creative effort in 20th-century industry. "There is an axiom to the effect that the machine is the predestined enemy of art," Bing wrote in this same chapter (which must be read attentively if his ambitions in the field of contemporary art are to be understood). "At last the time has come to take a stand against these ready-made ideas. Provided that fine models, well thought out and logically adapted for manufacture in quantity, are made available, the machine can become an important factor in the improvement of public taste."[4] Henry van de Velde said the same thing in fewer words in 1894, "Art must conquer the machine,"[5] and the ideas advanced by Le Corbusier in 1925, when he attacked the idea of *decorative art* which would score a victory at the exposition of "Arts Déco" in Paris, are in the same vein.

In the United States Bing saw Louis Comfort Tiffany, whose work in glass he admired—the stained glass used in household decoration, the glass mosaics set in lighting fixtures, the vases made out of opaque, mat material "which has the feel of a silken, delicate skin,"[6] or out of a translucent paste laced with "fine threads and bands of colors, like the delicate shades seen in the skin of fruit, in the petal of a flower, the veins of an autumn leaf."[7] Tiffany's activity did not stop there, and it was no accident that Bing got so interested in a kind of organization whose aim was to meet all the requirements of indoor furnishing and decoration: "The establishment of a large art workshop . . . marshaling under one roof an army of craftsmen representing all the needed skills—glassworkers and jewel setters, metalworkers, embroiderers and weavers, casemakers and toolers, gilders, jewelers and cabinetmakers, all working to give bodily form to the conceptions painstakingly worked out by a group of directing artists united by a shared current of ideas."[8] His trip to the United States had in several respects been a revelation to Bing, who years before had had a major part in making known and popularizing Japanese art in France. In 1895 he transformed the shop where he dealt in Far Eastern antiques into a contemporary art gallery to which he gave a name that would become synonymous with the movement—L'Art Nouveau.

Samuel Bing's story is now fairly well known due to recent studies by two American historians, Robert Koch[9] and Ga-

briel Weisberg.[10] He was born in Hamburg in 1838, and worked there in a ceramics factory until the war of 1870. In 1871 he went to France and set up his own business. Following a journey to China and Japan he opened a second shop in which he sold objects imported from the Far East. The shop in the rue Chauchat quickly became a meeting place for lovers of Japanese art, among them Philippe Burty, Théodore Duret, Louis Gonse, the Goncourts, and Roger Marx the critic. Bing's role was no longer that of a mere tradesman. At the Exposition Universelle of 1878 he presented his own collection of Japanese art, thus helping to make an art only recently discovered in the West known to a larger public. From May 1888 to April 1891 he published a monthly magazine devoted to Japanese arts and industries, with the foremost Japan enthusiasts of the time as contributors. *Le Japon Artistique* was the work of a man in love who wanted to share his passion by setting before the eyes of amateurs a kind of graphic encyclopedia drawn from all branches of art and the most diverse periods of a culture. His aim was also to instruct, and so to raise the level of French industrial production by offering artists, craftsmen, and industrialists "examples worthy in every respect of being followed, not of course to undermine the foundations of our old aesthetic edifice, but to add one more strength to all those that we have appropriated, down through the centuries, to bolster our national genius."[11] Instead of leaving industry to get its ideas from the trashy goods that the Japanese fad was throwing on the market, Bing chose to show the best there was, using engraving and printing processes worthy of admiration even today.

Bing launched the Galeries de l'Art Nouveau on Thursday, December 26, 1895, at eight o'clock in the evening, and the opening gave concrete reality to the ideas born of his study of art in America. The first Salon de l'Art Nouveau brought together the best contemporary creative artists in France and abroad. Its catalogue is a genuine compendium in which the merchant's remarkable flair is apparent: he fixed his choice at once at the international level. The painters whose participation he secured belonged to the Nabi group—Maurice Denis, Bonnard, Vuillard, Sérusier, Ranson, Lacombe. We also find the names of Pissarro, Signac, Cross, Carlos Schwabe, Toulouse-Lautrec, Albert Besnard, Théo van Rysselberghe, Khnopff, Beardsley, and others. There were some paintings, pastels, and watercolors, but most were decorative paintings—mural panels, ceilings, screens. At this first salon Bing also showed his interest in prints and illustrated books, which he put on view in an important exhibition the following year. The poster section

brought together Americans—Bradley, Penfield, Cox, Hollebone, Chambers, Woodbury, and Gifford—and British, among them Beardsley and the Glasgow School artists, Mackintosh, Herbert MacNair, and the Macdonald sisters. Sculpture was represented at the first salon by Bourdelle, Rodin, Pierre Roche, Charpentier, Jean Dampt, Camille Claudel, Fix-Masseau, and the Belgians Constantin Meunier and Victor Rousseau. The cover of the catalogue was embossed with one of Pierre Roche's "gypsographs." In the field of the decorative arts Bing's choice was just as outstanding: it embraced ceramics by Bigot, Albert Dammouse, Dalpayrat and Lesbros, Massier, Delaherche, and Emile Müller; glassware by Cros, Gallé, the German Koepping, and the American Tiffany; jewelry by René Lalique; wallpapers (mostly English); and lighting fixtures.

Nevertheless the two strong points of the Salon de l'Art Nouveau were stained glass and furniture. In the United States Bing had discovered the potentialities of colored glass in Tiffany's windows, made out of marbled, mottled, iridescent, and opalescent glass. Bing revealed his genius as an entrepreneur when he conceived the idea of recruiting European painters to make cartoons, and having these executed in Tiffany's studios, in the unique material which the American master had invented. Thus he was able to present a remarkable group of seventeen stained-glass windows after the designs of Ranson, Roussel, Bonnard, Vuillard, Ibels, Toulouse-Lautrec, Vallotton, Grasset, and Sérusier: almost all trace of them is lost, the exception being two or three now hidden away in private collections.

Furniture was entrusted to Henry van de Velde except for the bedroom, which Bing had reserved for Maurice Denis. Correspondence between Bing and the painter reveals a disagreement between the two men. Denis thought he was to do the whole room, decorations and furniture. Bing, on the other hand, wanted him to do the decorations, but to use furniture by Gallé, "with floral ornamentation, but much simpler, more open, less intricate and less symbolic than the models his exhibitions have accustomed us to."

Further on Bing alludes to "models with a certain lack of finish, however artistic they may be, which, all things considered, would look a little out of place in the environment presently in process of formation at L'Art Nouveau. Vast as my premises may look, they are very limited in proportion to our program, and will only allow the presentation of a single model room. The living rooms, dining room, etc., are gradually acquiring a certain air of elegance. And just as a perfect consistency of style must reign in each room, you will

131

agree with me in the thought that the ensemble must also form a harmonious whole."[12] Bing clearly imposed these same conditions on Van de Velde, although such conformity ran counter to the functional aesthetic of the furniture in the latter's own house, Bloemenwerf.

Bing's aesthetic authority asserted itself in subsequent years, when he established studios in which artists of his choice worked to carry out a program which laid claim to "the old French tradition," while enriching it with "a lively spirit of modernity."[13] He engaged Eugène Gaillard, Edward Colonna, and Georges de Feure, and with them put together a complete interior installation, the furnishings and decoration of which were essentially those of his pavilion, Art Nouveau Bing, at the exposition of 1900. The pavilion—a triumph of feminine qualities and elegance, with a fragrance of the Rococo and a touch of the Baroque that tied it in with French tradition—showed the extent of the aesthetic compromise which Bing had been forced to accept since the days of the first Salon de l'Art Nouveau. The pursuit of a new way freed of the past was left to his compatriot Meier-Graefe, who in 1898 opened La Maison Moderne on the rue de la Paix and undertook quantity production of objects for ordinary use.

Samuel Bing's role, however, is still of the highest importance. His greatest merit is, no doubt, to have crossed frontiers and allowed artists from different countries to participate in works undertaken in common. He helped to make both Japanese and American art known in Europe. Thus the glassware of Tiffany, Gallé, and Koepping was brought together, and pottery by Grueby and Rookwood was set side by side with that of Delaherche and Dammouse—contacts that were fruitful in both directions. Bing conceived an industrial order ahead of its time and its aesthetic options.

1 Samuel Bing to Henri Roujon, Directeur des Beaux-Arts, November 1896. Published as a preface to Bing's *La Culture Artistique en Amérique* (Paris, 22 rue de Provence, 1895). A translation by Benita Eisler of Bing's book, accompanied by several of his articles, has been published with an introduction by Robert Koch under the title *Artistic America, Tiffany Glass, and Art Nouveau* (Cambridge, Mass.: MIT Press, 1970).
2 Ibid.
3 Bing, *La Culture Artistique,* pp. 107–108.
4 Ibid., p. 106.
5 Henry van de Velde, "Cours d'arts d'industrie et d'ornementation," Extension Universitaire de Bruxelles, second lesson (1894). Quoted by Robert-L. Delevoy in the exhibition catalogue *Henry van de Velde 1863–1957* (Brussels: Palais des Beaux-Arts, 1963), p. 35.
6 Bing, *La Culture Artistique,* p. 90.
7 Ibid., p. 90.
8 Ibid.
9 Robert Koch, "Art Nouveau Bing," *Gazette des Beaux-Arts* (1959), pp. 179–90; see also note 1 above.
10 Gabriel P. Weisberg, "Samuel Bing: Patron of Art Nouveau," *Connoisseur* (Oct. 1969), pp. 119–25, (Dec. 1969), pp. 294–99, (Jan. 1970), pp. 61–68; "Samuel Bing: International Dealer of Art Nouveau," *Connoisseur* (Mar. 1971), pp. 200–205, (Apr. 1971), pp. 275–83, (May 1971), pp. 49–55, (July 1971), pp. 211–19; "Bing Porcelain in America," *Connoisseur* (Nov. 1971), pp. 200–203.
11 Samuel Bing, "Programme," *Le Japon Artistique* (May 1888), p. 5.
12 Samuel Bing to Maurice Denis, August 30, 1895, Archives Nabis, Saint-Germain-en-Laye.
13 Quoted in René Puaux, "L'Art Nouveau Bing," introduction to the catalogue *Oeuvres de Georges de Feure* (Paris: L'Art Nouveau, c. 1903).

SCULPTURE AND DECORATIVE ARTS:

SOURCES AND COMPARISONS

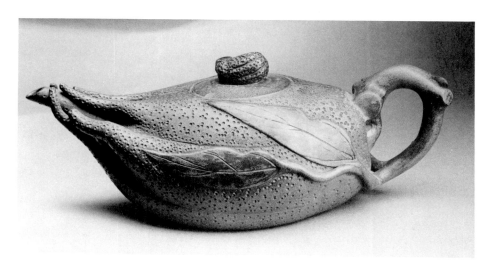

145
Teapot.
Chinese. Ch'ing Dynasty, 18th century.
Unglazed stoneware (I-Hsing ware).
Height 9.5 (3¾)
Kansas City, Nelson Gallery–Atkins Museum,
Inv. 54–61. Gift of Mrs. M.R. Sickman.

146
Cup.
Chinese. Ch'ing Dynasty.
Carnelian; wooden base.
Height 12.7 (5)
Kansas City, Nelson Gallery–Atkins Museum,
Inv. 51–56/22. Gift of Mrs. Massey Holmes.

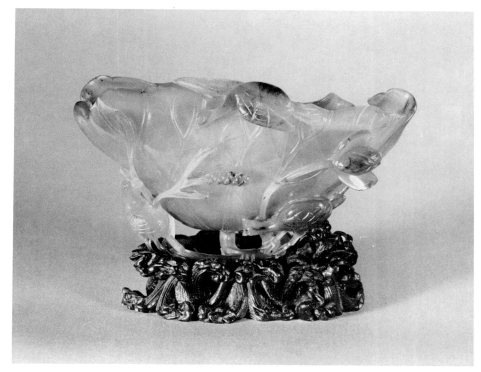

147
Bowl.
Chinese. Late Ming Dynasty,
16th–17th century.
Pale gray-green nephrite; wooden base.
Height 17.2 (6¾)
Kansas City, Dr. Maxine T. Brillhart.

148
Sprinkler bottle.
Persian. 18th century.
Light blue pattern-molded glass.
Height 33.6 (13¼)
The Corning Museum of Glass, Inv. 51.1.62.

Designed to hold costly attar of roses, which
could be poured drop by drop from its spout,
the sprinkler bottle originated in 16th-century
Persia and later became fashionable throughout
Europe. Its exotic and elegant shape,
suggesting the cobra poised to strike, was a
source of inspiration to numerous Art Nouveau
glassmakers, most notably Tiffany (Wichmann
1972, pp. 43–44).

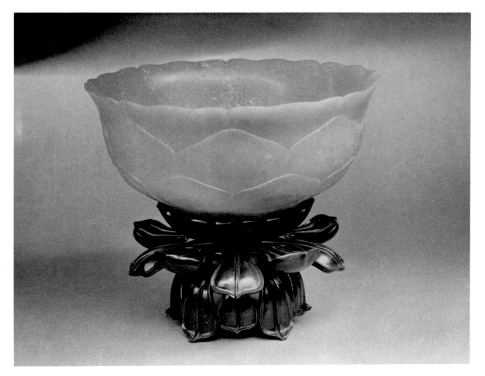

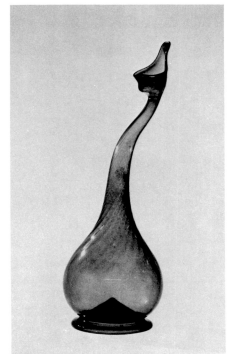

149
Vase.
American, late 19th century.
Clear and green glass; wheel-cut decoration.
Height 31.5 (12⅜)
X 3023, etched on bottom. *Tiffany Favrile Glass,* on label on bottom.
Baltimore, The Walters Art Gallery,
Inv. 47.381.

According to Robert Koch, paper labels were all that was used to identify most Tiffany works from 1892 to 1895. And though the mere presence of such a label is not evidence enough for attribution, the decoration of the vase shown here is quite similar in form and technique to that of a vase published in an 1896 booklet called *Tiffany Favrile Glass* (Koch 1971, pp. 41, 43).

150
Vase.
Chinese. Ming Dynasty.
Porcelain with relief decoration.
Height 14.9 (5⅞)
Kansas City, Nelson Gallery–Atkins Museum,
Inv. 34–237/73. Gift of Mrs. Jacob L. Loose.

151
Wine bottle.
Japanese. c. 1870.
Glazed stoneware (Kinkazan ware,
Mino Province).
Height 18.7 (7⅝)
Kansas City, Nelson Gallery–Atkins Museum,
Inv. 32–58/3.

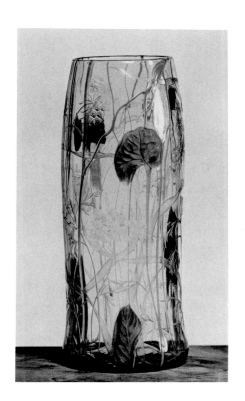

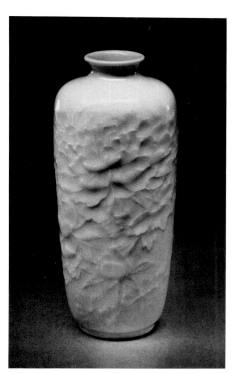

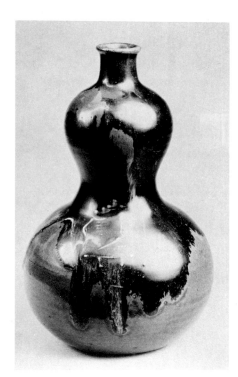

152
Plate.
Decoration designed by Félix Bracquemond for
Haviland & Co., Limoges. 1874.
Molded earthenware with relief and painted
underglaze decoration.
Diameter 41 (16⅛)
B in relief, lower left. *9bre 74*,
painted on bottom.
H & C°/L, imprinted on bottom.
Limoges, J. and F. d'Albis Collection.

Formerly in Charles Haviland's private
collection. There are in existence at least two
other plates of the same model which are
decorated in different colors.

Exh: Paris 1974a, no. 20.

Also illustrated in color.

153
Plate.
Decoration by Félix Bracquemond for
Haviland & Co., Limoges. c. 1875.
Porcelain with impressed decoration; pale
celadon glaze.
Diameter 22.2 (8¾)
Assiette Nenuphar/ No. 3127, and *10f Piece ou
100f la doz.,* imprinted in red on bottom.
H & C°., imprinted in green on bottom.
New York, The Metropolitan Museum of Art,
Inv. 23.31.15. Gift of George
Haviland, 1923.

To achieve the decoration on this and the
following piece, Bracquemond's design was
etched on a metal plate; a relief cast was made
from the etched plate and then impressed on
the porcelain form. *Nenuphar* refers to the form
of the plate itself.

Bibl: Weisberg et al. 1975, p. 161.

154
Plate.
Decoration by Félix Bracquemond for
Haviland & Co., Limoges. c. 1872–80.
Porcelain with impressed decoration.
Diameter 18.7 (7⅜)
H & C°./L, imprinted in green on bottom.
New York, The Metropolitan Museum of Art,
Inv. 23.31.22. Gift of George Haviland, 1923.

Exh: Cleveland 1975, no. 201.

155
Plate.
Decoration designed by Félix Bracquemond for
Haviland & Co., Limoges; manufactured by
Barluet et Cie., Creil Montereau, for
Haviland. 1879.
Earthenware with painted underglaze
decoration in blue, green, pink, yellow,
and dark blue.
Diameter 25.4 (10)
B., painted at bottom of decoration. *CREIL/
B & Cie/ MONTEREAU/ MODELE/
HAVILAND & Co/ A/ PARIS,*
imprinted on back.
Paris, Musée des Arts Décoratifs,
Inv. 16823/7. Gift of La Marquise
Arconati-Visconti, 1910.

Part of a reedition of a series of plates which
became known as the "Art Nouveau" service,
because Bracquemond's design of flowers and
ribbons anticipated characteristic Art Nouveau
motifs. The original series was executed at
Haviland in porcelain, with underglaze slip
decoration on a form by Albert Dammouse
(d'Albis et al. 1974, no. 139).

Bibl: Madsen 1956, p. 174, p. 175 illus.;
Madsen 1967, p. 85, p. 86 illus.; d'Albis et al.
1974, no. 139.

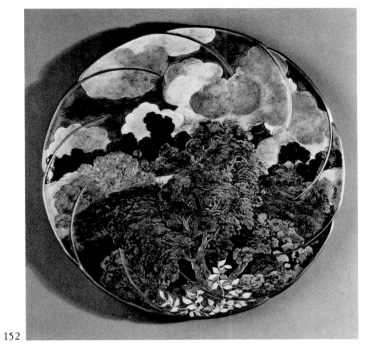

152

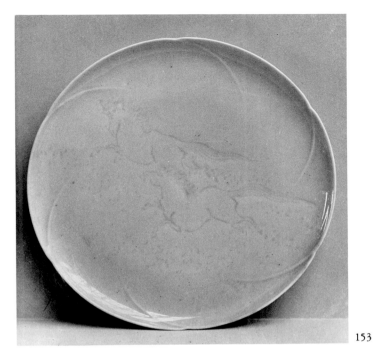

153

154

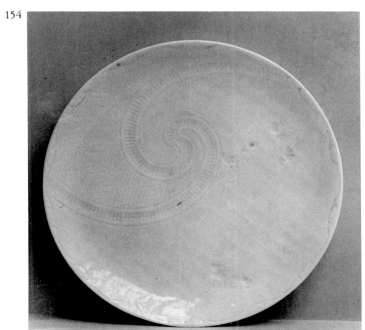

155

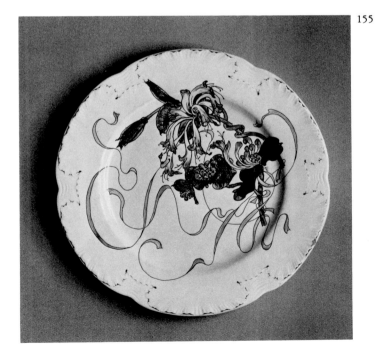

156
Rocking chair.
Carlo Bugatti.
Wood covered with yellow-tinted parchment;
decoration in colored pencil.
89.8 x 37.3 x 41.6 (35⅜ x 14⅝ x 16⅜)
Bugatti, in ink on inside of right rear leg.
Paris, Collection Félix Marcilhac.

157
Plate.
Théodore Deck. c.1860–70.
Faience; painted underglaze decoration in
cobalt blue and turquoise with black outlines.
Diameter 29.8 (11¾)
TH.DECK (*T* and *H* conjoined),
impressed on bottom.
Paris, Musée des Arts Décoratifs, Inv. 7313.
Gift of Jules Maciet, 1892.

The decoration is directly inspired by the
so-called Damascus ceramics, which were made
in the 15th and 16th centuries either in Syria
or Asia Minor.

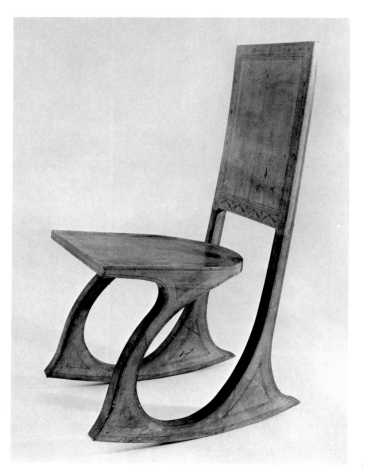

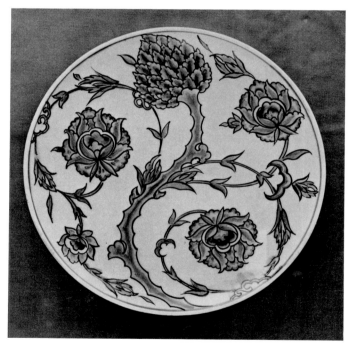

158
Vase.
Emile Diffloth at University City
Pottery. 1910.
Porcelain; blue and white crystalline glaze on
off-white ground; twelve bosses around the
shoulder.
Height 19 (7½)
The American Women's League in a circle with
U-C/1910 in center, imprinted in olive on
bottom. *ED* intertwined and *13*, imprinted in
green on bottom.
Private collection.

159
Vase.
Taxile Doat at University City Pottery. 1914.
Porcelain; overall pale celadon crystalline
glaze, partially outlined in red-brown, on
cream ground.
Height 25.1 (9⅞)
U C/19, TD intertwined, and *14*, painted in
green on bottom.
Private collection.

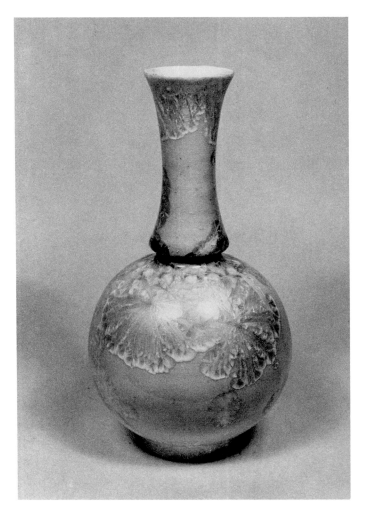

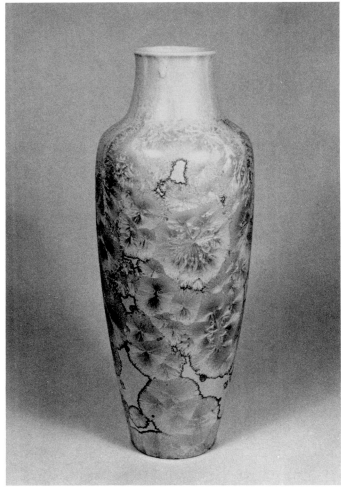

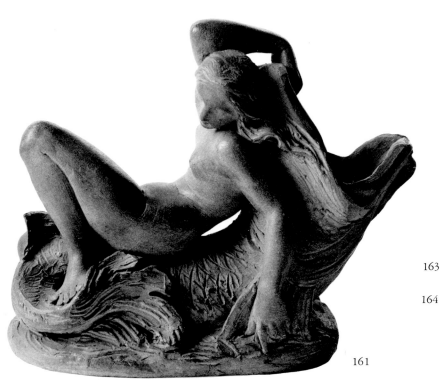

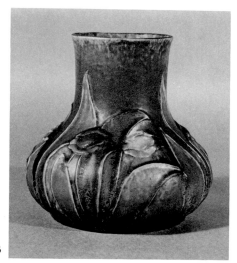

163

164

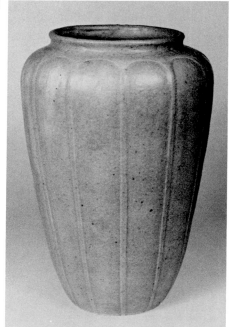

161

160
Armchair.
Otto Eckmann. c. 1900.
Stained gaboon and maple; leather upholstery.
74 x 47 x 49 (29⅛ x 18½ x 19¼)
Darmstadt, Hessisches Landesmuseum,
Inv. Kg. 62:80.

Bibl: *Deutsche Kunst und Dekoration* 3
(1898–99), p. 110 illus.; Ahlers-Hestermann
1941, p. 68 illus.; Kohlhaussen 1955, pp.
565, 567; Cremona 1964, fig. 295; Bott
1973, no. 480.

Exh: Ostende 1967, no. 86.

161
Woman with Dolphin.
Jean-Jacques Feuchère. 1844.
Terra-cotta.
Height 18 (7⅛)
Feuchère. 1844, incised at base.
Paris, Musée des Arts Décoratifs, Inv. 19078.

162
Side chair.
Designed by Antoni Gaudí. c. 1905–1907.
Replica by Casa Ribas Seva, Barcelona. 1957.
Oak.
75 x 53.3 x 38.7 (29½ x 21 x 15¼)
New York, The Museum of Modern Art,
Inv. 74.58.

The original chair was designed for the Casa
Battló, Barcelona. In 1957 the Amigos de
Gaudí commissioned the replica for the Gaudí
retrospective at the Museum of Modern Art.

Bibl: Bossaglia 1972, p. 38 illus. (original).

140

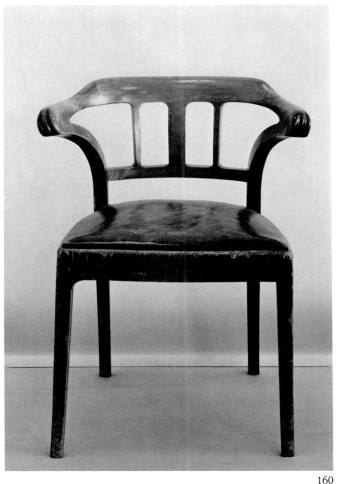

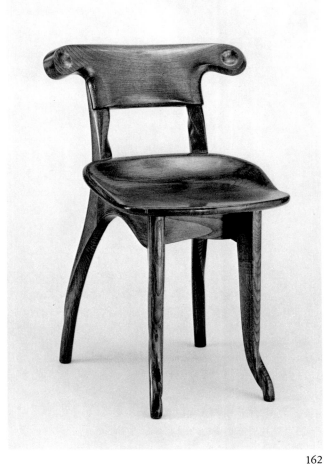

160

162

163
Vase.
Grueby Pottery. c.1899–1910.
Earthenware with modeled decoration; deep
green and yellow mat glazes.
Height 21.9 (8⅝)
GRUEBY POTTERY BOSTON U.S.A. in a
circle, and illegible number, impressed on
bottom. *MCJ* conjoined, incised on bottom.
X, painted on bottom.
New York, private collection.

Bibl: Frangiamore 1973, pp. 40–41 illus.;
Kovel 1974, p. 51 illus.

Exh: Princeton 1972, no. 193.

164
Vase.
Executed by Lillian Newman at Grueby
Pottery. c.1898–1903.
Earthenware with relief decoration;
yellow-orange mat glaze.
Height 18.6 (7⅜)
GRUEBY FAIENCE CO. BOSTON U.S.A.
surrounding a lotus flower, *118,* and *N* in a
circle, impressed on bottom.
Private collection.

Bibl: Saunier 190lb, p. 206 illus.

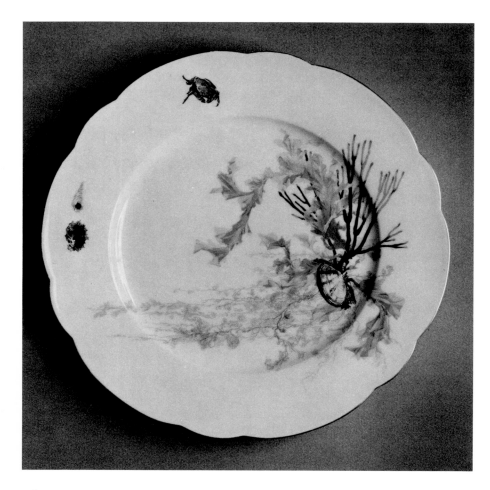

166

Armchair with adjustable back.
Designed by Josef Hoffmann. c. 1900–1906.
Bentwood, probably beech, with red
mahogany stain.
109.5 x 65.2 x 81 (43½ x 25¾ x 31⅛)
The Art Institute of Chicago, Inv. 1971.743.
Gift of Renée Harth Thompson in memory of
her father, John Charles Harth.

Probably manufactured by Thonet, Vienna.

Bibl: Adams n.d.

167

Armchair.
Designed by Charles Rennie Mackintosh.
c. 1905.
Wood, lavender glass, and fabric.
Height 119.4 (47)
Sydney and Frances Lewis Collection.

From the music room of Hous'hill, Glasgow,
the residence of Miss Cranston and her
husband, Major Cochrane.

Bibl: Pevsner 1950, p. 113; Macleod 1968,
p. 121; Howarth 1952, pl. 46.

Exh: London 1968, no. 248.

165

Plate from the series *Plantes Marines*.
Designed by Pallandre for Haviland & Co.,
Limoges. Before 1876.
Porcelain with decal decoration touched up by
hand.
Diameter 25.5 (10)
Limoges, J. and F. d'Albis Collection.

At Haviland two methods were used to transfer
an artist's designs onto porcelain. In one the
design, with careful notations as to the colors
to be used, was engraved on copper, printed,
and transferred to the piece. A painter then
filled in the indicated colors. The above plate,

however, is an early example of the more
economical but technically more demanding
process of chromolithography, in which the
design was engraved (by Jochum in this case)
onto lithographic stones. Since each color
required a different stone, such pieces were
often touched up by hand to obtain a richer
variety of color (d'Albis et al. 1974). The
absence of marks indicates a date prior to
1876, when Haviland began marking.

Bibl: Dubouché 1876, p. 56; Young 1878.

Exh: Paris 1876; Philadelphia 1876.

168

Chair [photograph exhibited].
Designed by Arthur Heygate Mackmurdo.
c. 1883.
Mahogany.
London Borough of Waltham Forest, William
Morris Gallery.

Like Mackmurdo's title page for *Wren's City
Churches* (cat. no. 10), the decorative back
panel of this chair is considered to be one of the
earliest instances of fully developed Art
Nouveau design.

Bibl: Madsen 1956, p. 276 illus.; Schmutzler
1964, fig. 297; Madsen 1967, p. 72 illus.

168

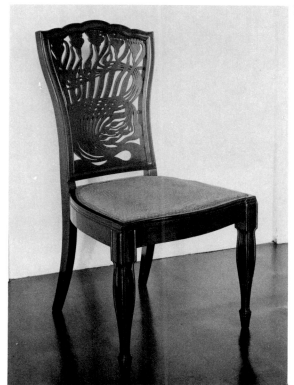

167
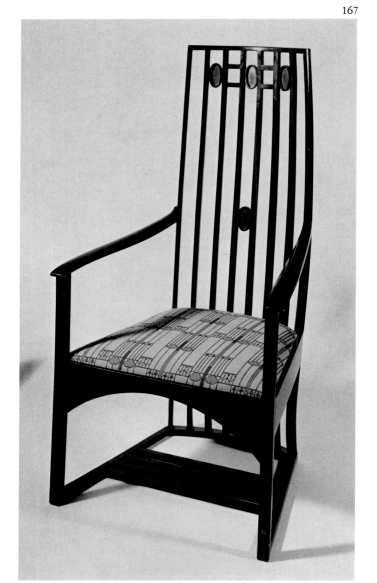

166
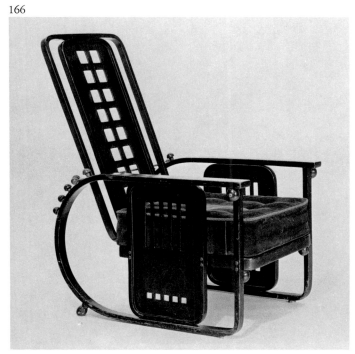

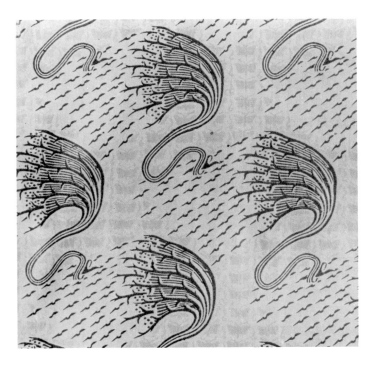

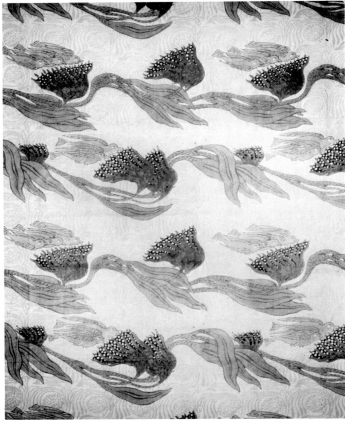

169
Thorns and Butterflies. Fabric.
Designed by Arthur Heygate Mackmurdo.
c. 1884.
Cretonne; printed in dark red, green, and
ocher on natural ground.
76.2 x 39.4 (30 x 15½)
London Borough of Waltham Forest, William
Morris Gallery.

Bibl: Madsen 1956, p. 159 illus.; Wilson
1961, p. 138 illus.; Schmutzler 1964,
fig. 278.

Exh: London 1952, no. L18b.

170
Cromer Bird. Fabric.
Designed by Arthur Heygate Mackmurdo.
c. 1884.
Cretonne; printed in two shades of yellow
ocher and pink on cream ground.
87.6 x 80 (34½ x 31½)
London Borough of Waltham Forest, William
Morris Gallery.

The letters *CG*, for Century Guild, are
incorporated into the design. Founded by
Mackmurdo in 1882, the Century Guild of
Artists intended "to render all branches of art
the sphere no longer of the tradesman but of
the artist. It would restore building,
decoration, glass-painting, pottery, wood
carving and metal to their right place beside
painting and sculpture." Although the Guild
itself was disbanded in 1886, its magazine,
The Hobby Horse, continued publication
through 1892.

Bibl: Schmutzler 1955, pl. 28; Wilson 1961,
p. 138 illus.; Schmutzler 1964, fig. 2; Madsen
1967, p. 82 illus.

Exh: Zürich 1952; New York 1960, no. 189;
Hagen 1968, no. 106.

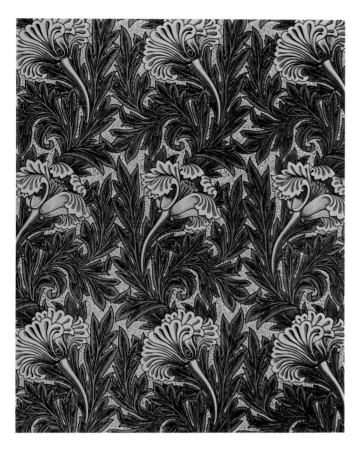

171
Tulip. Fabric.
Designed by William Morris. 1875.
Printed cretonne.
135 x 93 (53⅛ x 36⅝)
MORRIS & COMPANY and *449 OXFORD
STREET*, on right edge.
Hamburg, Museum für Kunst und Gewerbe,
Inv. 1973.144.

Bibl: Henderson 1967, p. 155, pl. 52; Pevsner
1968, p. 26 illus.; Aslin 1969, pl. 29.

Exh: Hamburg 1974.

172
Side chair.
Richard Riemerschmid. 1899.
Oak; leather upholstery.
Height 78 (30¾)
New York, The Museum of Modern Art,
Inv. 112.60.

Bibl (similar example): *L'Art Décoratif* 2
(1899), p. 123 illus.; *Deutsche Kunst und
Dekoration* 4 (1899), p. 527 illus.; Schmutzler
1964, fig. 209; Pevsner 1968, p. 172 illus.

Exh: Dresden 1899; New York 1960, no. 236.

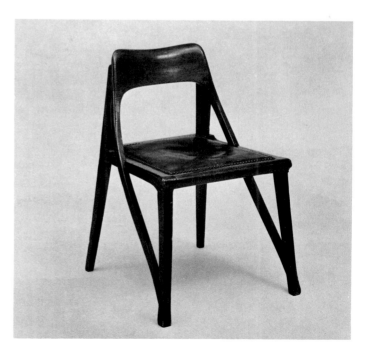

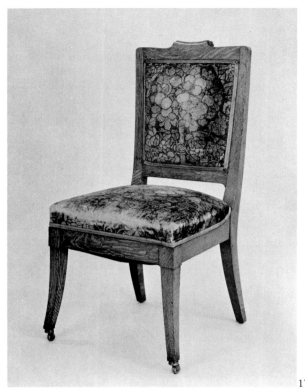

174

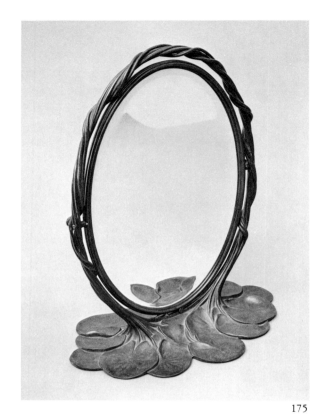

175

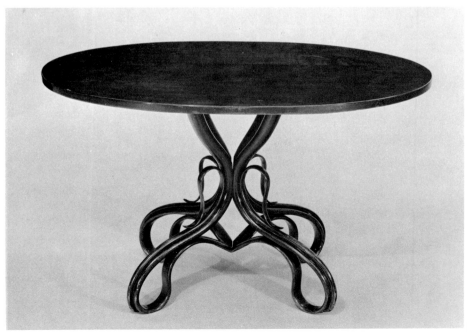

173

173
Table.
Michael Thonet. c. 1860–65.
Beech with mahogany stain.
75.5 x 120 x 77 (29¾ x 47¼ x 30⅜)
3-, carved under top.
The Art Institute of Chicago, Inv. 1970.31.
Gift of Mrs. Samuel O. Rautbord.

174
Side chair.
Louis Comfort Tiffany. c. 1905.
Oak with original upholstery.
109.2 x 49.8 x 58.4 (43 x 19⅝ x 23)
The Art Institute of Chicago, Inv. 1973.772.
Gift of Mrs. Philip K. Wrigley.

Commissioned for the Chicago home of
William Wrigley.

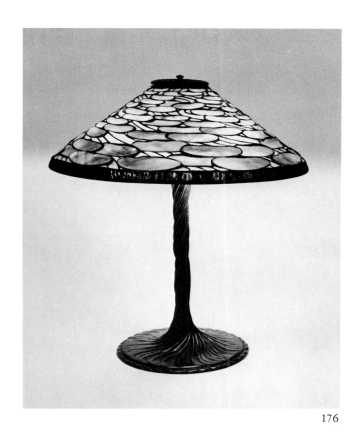

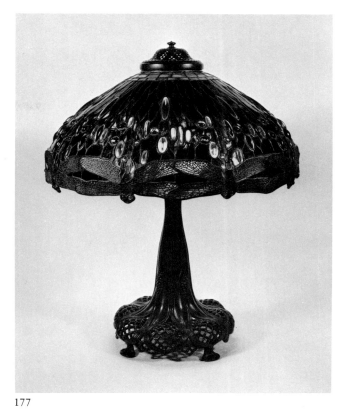

176

177

175
Table mirror.
Louis Comfort Tiffany.
Bronze and glass.
Height 51.2 (20⅛)
TIFFANY STUDIOS, stamped center back.
Houston, private collection.

176
Table lamp with lily-pad shade.
Louis Comfort Tiffany. c. 1900.
Bronze; green and white glass.
Height 60 (23⅜)
Sydney and Frances Lewis Collection.

177
Table lamp with dragonfly shade.
Louis Comfort Tiffany. c. 1899–1900.
Bronze; red and yellow glass.
Height 74 (29⅛)
Sydney and Frances Lewis Collection.

Clara Driscoll's dragonfly lampshade design won a prize in Paris at the Exposition Universelle, 1900.

Bibl: Koch 1964, pl. iv.

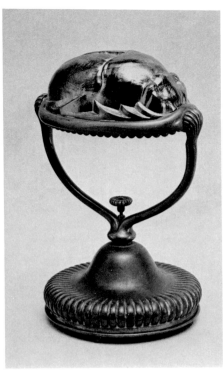

179
Vase.
Louis Comfort Tiffany.
Blown iridescent blue glass.
Height 32.3 (12¾)
R5632/L.C.T., etched on bottom.
Houston, private collection.

180
Vase.
Louis Comfort Tiffany.
Blown glass; opalescent peach at base, clear and green on base and stem, and translucent white at top.
Height 50.8 (20)
L.C.T./W1873, etched on rim of base.
Houston, private collection.

178
Scarab lamp.
Louis Comfort Tiffany. c. 1892–1902.
Bronze; iridescent blue-green glass.
Height 22.2 (8¾)
TIFFANY STUDIOS/NEW YORK, Tiffany's trademark, and *S1427*, stamped on bottom.
Houston, private collection.

Bibl: Koch 1971, p. 29 illus. (similar example).

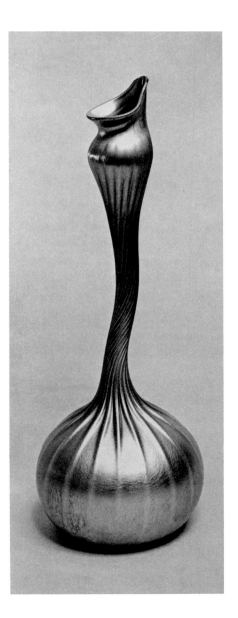

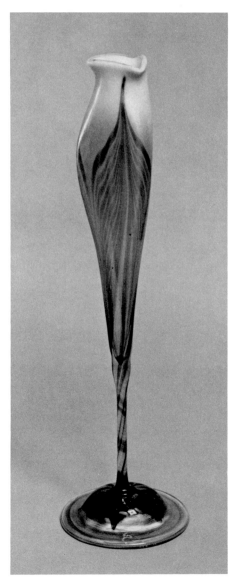

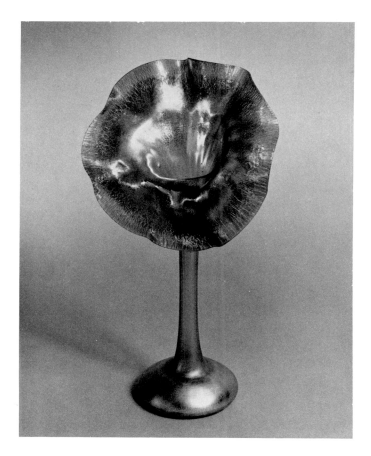

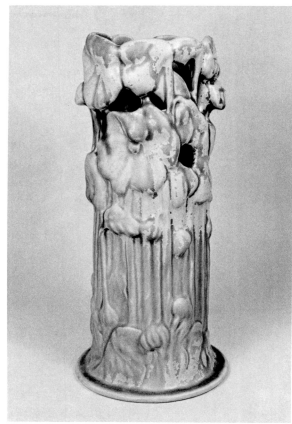

181
Jack-in-the-pulpit vase.
Louis Comfort Tiffany.
Blown iridescent gold glass.
Height 54.8 (21½)
L.C.T./ Y1802, etched on bottom.
Houston, private collection.

182
Vase.
Louis Comfort Tiffany.
Earthenware with relief and excised decoration;
green and blue mat glaze.
Height 27.6 (10⅞)
P 1261[7?], *L.C.T. Favrile Pottery,* and *LCT*
intertwined, incised on bottom. *Tiffany Favrile
Glass —Registered Trade Mark*, printed on paper
label.
Private collection.

183
Vase.
Louis Comfort Tiffany.
Molded stoneware; old ivory mat glaze with scattered specks of blue.
Height 19.7 (7¾)
LCT intertwined, incised on bottom. *L.C.T. Favrile/ Pottery/ P1331*, etched in glaze on bottom.
New York, private collection.

184
Vase.
Louis Comfort Tiffany. c. 1905–19.
Molded stoneware with relief decoration; green mat glaze.
Height 20.3 (8)
LCT intertwined and 7, incised on bottom.
New York, private collection.

The same form, placed on the end of a long stem, was executed by Tiffany in bronze as a candle holder.

Bibl: Evans 1974, pl. 1.

185
Gourd vase.
University City Pottery. c. 1910–14.
Porcelain; crystalline green, blue, brown, white, and olive glaze.
Height 23.5 (9¼)
Private collection.

186
Gourd vase.
University City Pottery. 1912.
Molded porcelain; glossy green glaze with accents of brown and blue.

Height 16.8 (6⅝)
U.C./ 1912, incised on bottom.
New York, private collection.

From the estate of Edward G. Lewis, the founder of University City Pottery.

Bibl: Evans 1974, p. 287 illus.

187
Vase.
Anna Marie Valentien at Rookwood Pottery. 1901.
Earthenware with relief decoration; pale green satin mat glaze.
Height 6.7 (2⅝)
RP with fourteen flames, *I,* and *161Z,* impressed on bottom. *AMV,* incised on bottom.
Private collection.

188
Dos Cabezas (Two Heads). Vase.
Artus Van Briggle. 1901.
Earthenware with relief decoration; brown mat glaze.
Height 19.7 (7¾)
Conjoined *AA* in a rectangle, and *VAN BRIGGLE/ 1901/ II/ 70,* incised on bottom.
Private collection.

Formerly in the collection of Artus and Anne Van Briggle, this vase was part of the first group offered for sale at Van Briggle Pottery, in December 1901. It is perhaps the original vase of this design, which later became shape number sixteen of Van Briggle's repertoire.

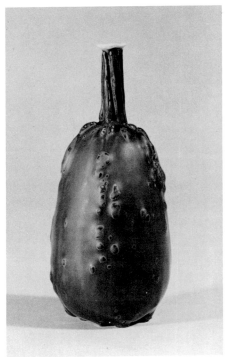

186

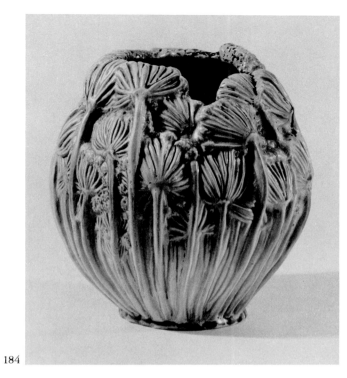

184

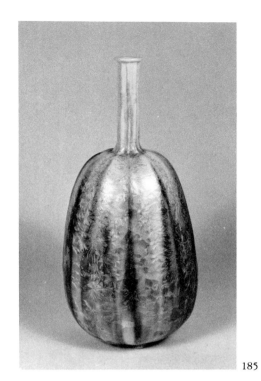

185

187

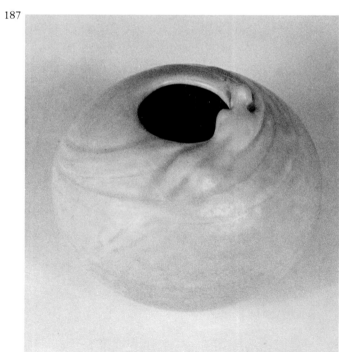

188

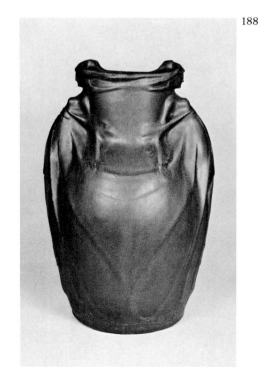

151

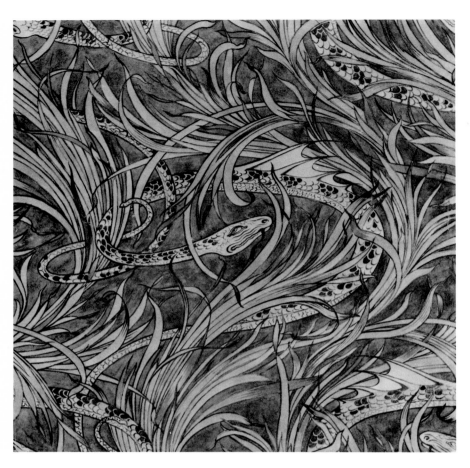

189
Serpent d'eau (Water Snake). Design for
wallpaper.
Charles F. A. Voysey. c. 1896.
Colored washes on paper.
44 x 42 (17⅜ x 16½)
London, Royal Institute of British Architects..

Bibl: *Studio* 7 (1896), p. 212 illus.; Cassou
et al. 1962, fig. 243; Pevsner 1968, p. 68
illus.

SCULPTURE AND DECORATIVE ARTS:

BELGIUM AND FRANCE

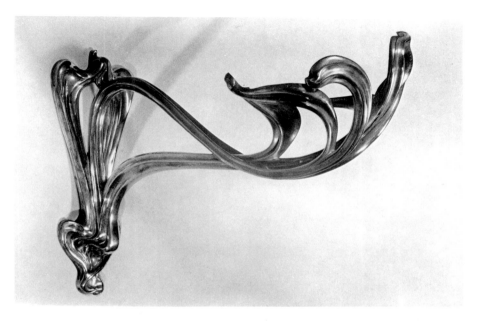

190
Wall mount for an oil lamp.
French. c. 1900.
Brass.
Height 28 (11)
Berlin, Kunstgewerbemuseum Staatliche
Museen Preussischer Kulturbesitz,
Inv. 00.665.

Purchased by the museum at the Exposition
Universelle in Paris, 1900.

Bibl: Scheffler 1966, no. 41, p. 39 illus.

Exh: Paris 1900.

191
Two sets of door handles.
French.
Bronze.
Length 16.5 each (6½)
New York, private collection.

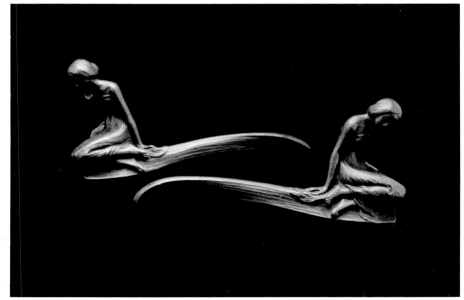

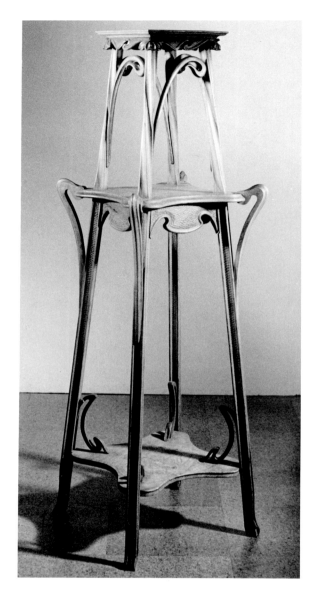

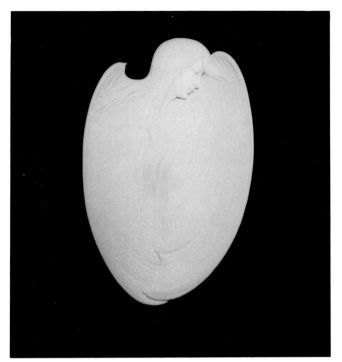

193
Visiting-card holder.
Artist unknown.
Carved ivory.
Length 14.6 (5¾)
New York, private collection.

Exh: New York 1967.

192
Pedestal.
French.
Wood, with traces of gilding.
Height 129.8 (51⅛)
Chrysler Museum at Norfolk,
Inv. DAF.71.100.

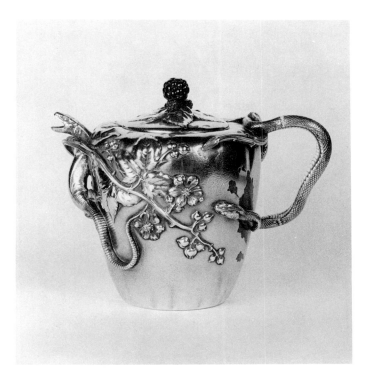

195
Teapot.
Bapst et Falize. c. 1888–89.
Silver and vermeil, hammered and chased;
purple and green glass; ivory in handle.
Height 14.5 (5¾)
BAPST ET FALIZE/ORFEVRES, stamped on
bottom. French assay mark and master's mark
of Falize, stamped on bottom and inside lid.
Paris, Musée des Arts Décoratifs, Inv. 23868.
Bequest of Mlle. Corroyer, 1923.

Part of a tea service which also includes a tray,
sugar bowl, and cream pitcher. The entire
service was exhibited in 1889 at the Exposition
Universelle in Paris.

Bibl: Champier 1903, pl. 79.

Exh: Paris 1889, Paris 1933, no. 1107; Paris
1960, no. 852.

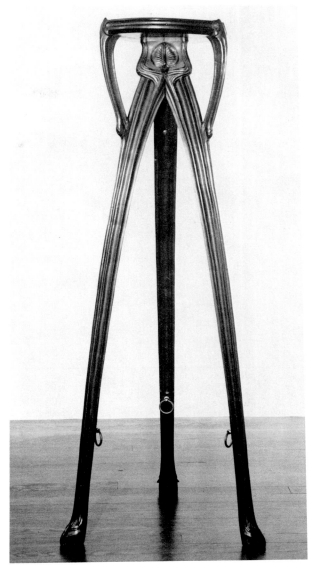

194
Pedestal.
Designed by Emile André. Before 1903.
Mahogany.
Height 131.5 (51¾)
Mr. and Mrs. Herbert D. Schimmel.

The same model, but executed in oak, was
shown at the Exposition Ecole de Nancy
(Paris 1903).

Bibl: Mannoni 1968, p. 27 illus.

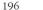

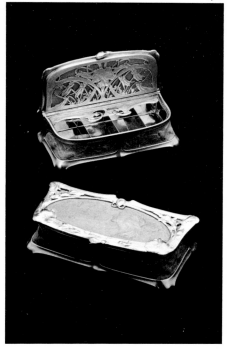

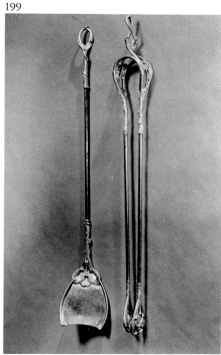

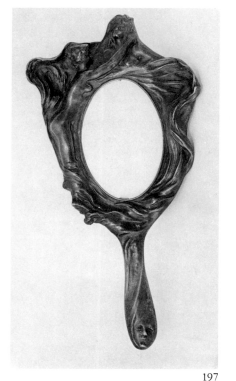

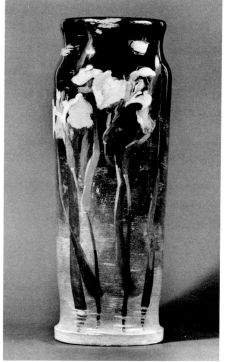

196
Stamp box.
Wood carved by Edmond Becker; metalwork by Frédéric Boucheron. c. 1900–1901.
Boxwood and gold.
3.2 x 11.1 x 5.4 (1¼ x 4⅜ x 2⅛)
Becker's monogram, incised at upper right of front panel. *BOUCHERON PARIS*, engraved on bottom.
New York, private collection.

Bibl: *Revue de la Bijouterie* 11 (1901), p. 232 illus.; Molinier 1901, p. 189.

Exh: New York 1967.

197
Hand mirror.
Attributed to Joseph Bernard. c. 1900.
Bronze.
Height 36.7 (14½)
Bernard J, engraved on back.
Darmstadt, Hessisches Landesmuseum, Inv. Kg. 61:4.

Bibl: Bott 1973, no. 238 illus.

198
Iris vase.
Aristide Bézard at the Marlotte Manufacture.
Earthenware with underglaze slip decoration.
Height 31 (12)
Bézard, scratched in glaze below decoration.
B.M./MARLOTTE. S.M., painted on bottom. *12,3*, incised on bottom.
Paris, Cazalis-Sorel Collection.

199
Fire irons.
Design attributed to Louis Bigaux; execution to Eugène Baguès. c. 1899–1900.
Gilt bronze and iron.
Height 83 (32⅝) and 84 (33)
Berlin, Kunstgewerbemuseum Staatliche Museen Preussischer Kulturbesitz, Inv. 00.673–74.

Purchased by the museum in 1900 at the Exposition Universelle, Paris.

Bibl: Scheffler 1966, no. 40, p. 38 illus. (attributed there to Bigana and Raguès).

Exh: Paris 1900.

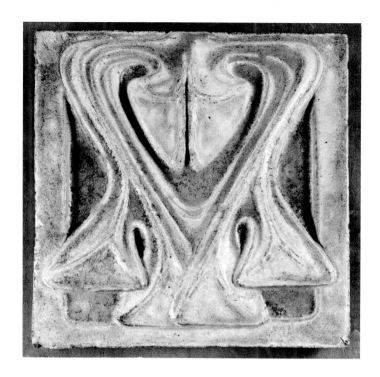

200
Revetment tile: frieze element.
Designed by Henri Sauvage; executed by
Alexandre Bigot. c. 1900.
Molded stoneware with relief decoration;
blue-gray glaze.
33 x 33 x 5 (13 x 13 x 2)
Paris, Musée des Arts Décoratifs, Inv. 43207.
Gift of Marie de Beyrie, 1971.

Bibl: Bigot 1902, p. 14, fig. 74.

201
Plate.
Executed by Alexandre Bigot. c. 1897.
Stoneware with relief decoration; glazed blue
and ocher with crystalline passages.
Diameter 24.8 (9¾)
Bigot, impressed on bottom. *D 142*, incised on
bottom.
Paris, Collection Félix Marcilhac.

Perhaps designed by Alexandre Charpentier, to
whom is attributed the design of a similar plate
in the collection of the Musée des Arts
Décoratifs, Paris (Inv. 8565. Gift of Jules
Maciet, 1897).

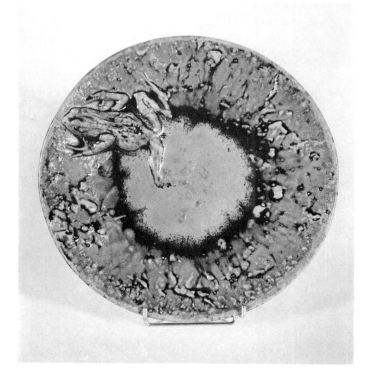

202 204

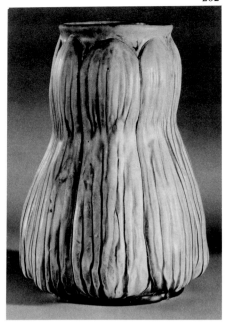 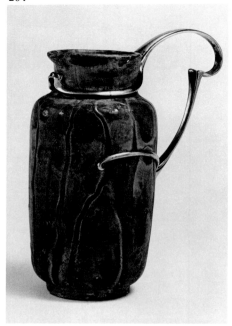

204
Mounted pitcher.
Pitcher by Alexandre Bigot. 1895. Mounting designed by Edward Colonna. c. 1898–99.
Stoneware; green mat glaze with overflows; mounting in silver gilt.
Height 20.1 (7⅞)
A. Bigot/ mai 95, incised on bottom of pitcher.
Paris, Musée des Arts Décoratifs, Inv. 15227.
Gift of Marcel Bing, 1908.

Colonna's design for the mounting was undoubtedly commissioned by S. Bing, whose shop L'Art Nouveau opened its doors in 1895 in Paris.

Bibl: Rheims 1964, pl. 15.

Exh: Paris 1960, no. 802.

202
Vase.
Alexandre Bigot. c. 1894–95.
Stoneware with relief decoration; glazed light gray with dark veining and turquoise flecks outside, ocher and green inside.
Height 25.2 (9⅞)
A. Bigot, incised on bottom.
Cologne, Gertrud and Dr. Karl Funke-Kaiser Collection.

According to Hans-Jörgen Heuser (1974, p. 199), this piece was thrown by Bigot himself. It is dated by comparison with pieces in the Kunstgewerbemuseum, Berlin, and the Museum für Kunst und Gewerbe, Hamburg.

Bibl: Heuser 1974, p. 199.

Exh: Cologne 1974, no. 145.

203
Two revetment tiles: frieze elements.
Designed by Henry van de Velde; executed by Alexandre Bigot. c. 1900.
Molded stoneware with relief decoration; green glaze.
17 x 20 x 2 each (6¾ x 7⅞ x ¾)
Paris, Musée des Arts Décoratifs, Inv. 43206.
Gift of Yvette Barran, 1971.

203

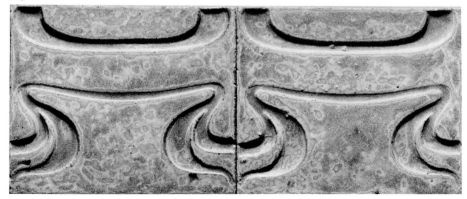

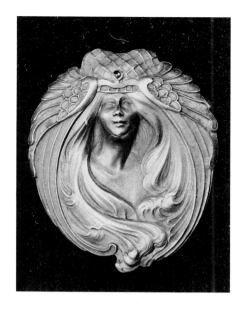

206
Promenade des nourrices, frise des fiacres
(Promenade of Nursemaids, Frieze of Horse Cabs).
Screen.
Pierre Bonnard; printed by Molines. c. 1897.
Four chromolithographed panels; 110 copies,
40 mounted.
137.2 x 45.7 each panel (54 x 18)
PB, lower right of third panel.
Mr. and Mrs. Derald H. Ruttenberg.

Lithographed after a painted screen which
Bonnard completed in 1894 (Rewald 1948,
p. 65 illus.; Dauberville 1965, no. 125 illus.).

Bibl: Selz 1959, pp. 56–57 illus.; Soby et al.
1964, p. 31; Schmutzler 1964, fig. 167;
Wichmann 1972, p. 125; Ives 1974, pl. 69.

Exh: New York 1975a.

205
Pendant.
Designed by Marcel Bing. c. 1900–1901.
Chased gold with blue and green enamel; a
ruby cabochon.
4.9 x 3.9 (1¾ x 1½)
French assay mark and master's mark
(illegible), stamped on loop.
Paris, Musée des Arts Décoratifs,
Inv. 15280B. Gift of Marcel Bing, 1908.

From S. Bing's L'Art Nouveau.

Bibl: *Revue de la Bijouterie* 14 (1901), p. 49
illus.; Meusnier 1901, pl. 17.

Exh: Paris 1901, Salon SNBA.

206

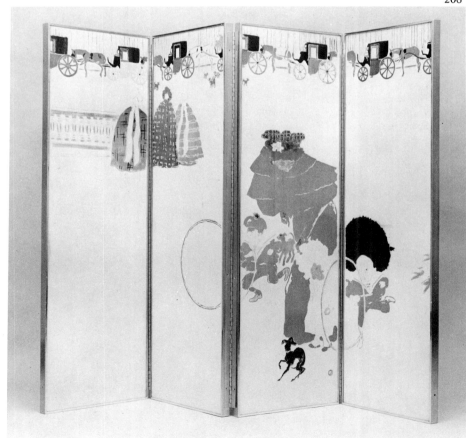

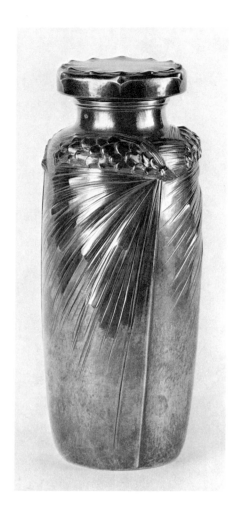

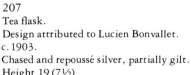

207
Tea flask.
Design attributed to Lucien Bonvallet.
c. 1903.
Chased and repoussé silver, partially gilt.
Height 19 (7½)
French assay mark and master's mark with
initials *A G*, stamped on inside of cover and on
neck.
Paris, Musée des Arts Décoratifs, Inv. 21623

Our attribution of this piece is based on the
records of the Musée des Arts Décoratifs,
which acquired it from Bonvallet's widow in
1919, the year of his death. The flask is also
similar in style and technique to works
exhibited by Bonvallet at the salons of 1903
and 1904.

Bibl: Clouzot 1921, pl. 13.

208
Pin tray.
Maurice Bouval. c. 1898.
Bronze with patina.
Height 20 (7⅞)
M. Bouval, on base.
Paris, Cazalis-Sorel Collection.

Bouval, a regular contributor to the salon of
the Société des Artistes Français, exhibited in
1899 a bronze pin tray entitled *Femme au pavot*
(*Woman with Poppy*), possibly this piece.

Bibl: Rheims 1964, pl. 33 (another casting).

209
Les Lianes (Lianas). Fabric.
Manufactured by E. Bouvard et Cie., Lyons.
c. 1900.
Liseré silk tabby; white, golden yellow, and
pale green on green ground.
135 x 130 (53⅛ x 51⅛)
Paris, Musée des Arts Décoratifs, Inv. 13786.

208

210

Pluie d'or (Golden Rain). Fabric.
Manufactured by E. Bouvard et Cie., Lyons.
c. 1900.
Liseré silk tabby; gold, green, and blue on
turquoise ground.
180 x 130 (70⅞ x 51⅛)
Paris, Musée des Arts Décoratifs, Inv. 13788.

Bibl: Mannoni 1968, p. 33 illus.

Exh: Paris 1943, no. 154.

211

Plumes de paon (Peacock Feathers). Fabric.
Manufactured by E. Bouvard et Cie., Lyons.
c. 1900.
Liseré silk tabby; green, golden yellow, and
blue on blue ground.
130 x 130 (51⅛ x 51⅛)
Paris, Musée des Arts Décoratifs, Inv. 13789.

Bibl: *L'Art Décoratif* 8 (1906), p. 110 illus.;
Mannoni 1968, p. 34 illus.

210
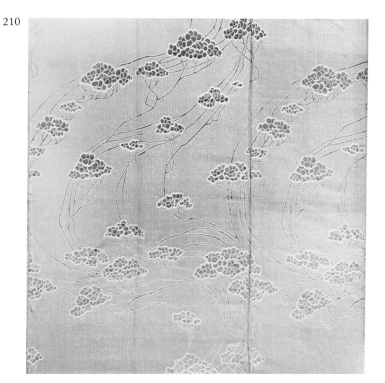

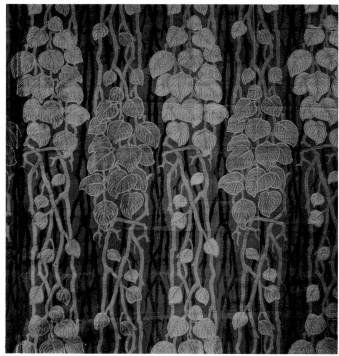

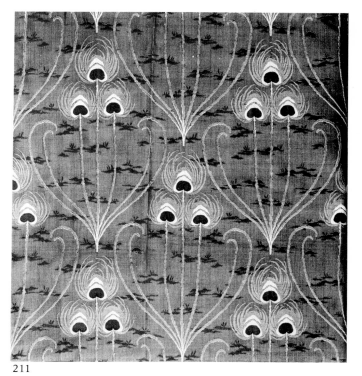

209 211

213

212

212
Vase.
Jules-Paul Brateau. c. 1905.
Lavender, green, and white *pâte de verre*.
Height 6.3 (2½)
Jules Brateau, on gold label on bottom.
Chrysler Museum at Norfolk, Inv.
GEFBr.68.1. Joan Foy French Collection.

Bibl: Grover 1970, pl. 123.

213
Persian bottle.
Joseph Brocard. 1884.
Pale yellow glass with gold and multicolored
enamel.
Height 30 (11¾)
Brocard F. (Fils), enameled on bottom.
Paris, Musée des Arts Décoratifs, Inv. 369.
Gift of the artist, 1884.

Brocard, whose imitations of oriental
glasswork first gained recognition in Paris at
the universal expositions of 1867 and 1878,
again showed examples of his work in this
mode at the exhibition in Paris sponsored by
the Union Centrale des Arts Décoratifs in
1884, at the Palais de l'Industrie. Since this
bottle was given to the Musée des Arts
Décoratifs at the end of 1884, it seems likely
that it was among the works he exhibited that
year.

Exh: Paris 1884; Munich 1972, no. 200.

214
Satinpod bowl.
Joseph Brocard. 1885.
Glass with pale green sealed oxides, clear
enamel, and gold accents.
Height 8 (3¼)
Paris, Musée des Arts Décoratifs, Inv. 13063.

Bibl: Polak 1962, p. 32, pl. 15b;
Bloch-Dermant 1974, p. 24.

Also illustrated in color.

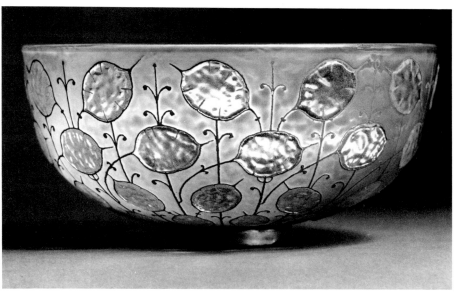

214

215
Bookcase.
Rupert Carabin; wrought-iron details executed
by A. Servat. 1889–90.
Carved walnut and wrought iron.
300 x 210 (118⅛ x 82⅝)
R. Carabin, carved on left at top.
Paris, Galerie du Luxembourg.

The figures are allegorical representations of a
Reader, Truth, and Reflection above and
Ignorance below right, with the masks of
Vanity, Greed, Intemperance, Anger,
Stupidity, and Hypocrisy below left.
Carabin was twenty-seven when Henry
Montandon asked him to build a bookcase.
Along with the commission, his first for a
piece of furniture, came an advance of 4,000
francs and the freedom to design as he chose.
Materials alone cost him 3,700 francs; the
bookcase took eleven months in all to build,
but as Carabin said later, "It was
wonderful. . . . What did it matter that the
profit was small. I was able to realize my idea.
That was the important thing" (quoted in
Brunhammer et al. 1974, p. 2). The Salon des
Indépendants, who claimed to be free of the
rigid criteria of the older salons, nevertheless
refused to accept the bookcase in 1890, leaving
Carabin to enter it in the inaugural section of
decorative arts at the Société Nationale des
Beaux-Arts salon of 1891.

Bibl: Geffroy 1890, pp. 43–49, p. 45 illus.;
Marx 1890; Darzens 1895, pp. 261–62;
Saunier 1900a, p. 165 illus.; Carabin 1910,
illus.; Brunhammer et al. 1974, pp. 2–3;
Brunhammer 1974, p. 53 illus.; Duret-Robert
1975, fig. 4.

Exh: Paris 1891, Salon SNBA; Paris 1974b,
no. 1.

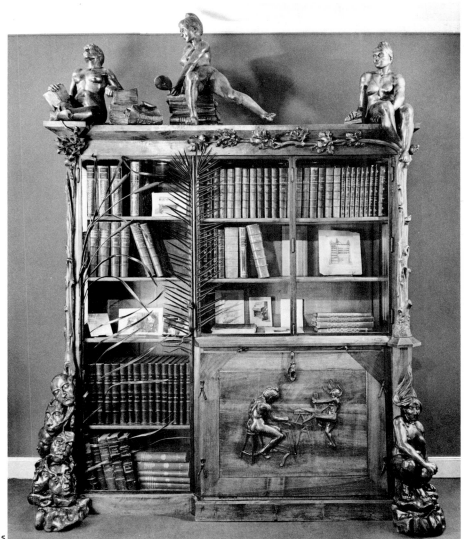

215

216
Chair.
Rupert Carabin. 1895.
Walnut.
Height 72 (28⅜)
Carabin 1895, behind seat.
Paris, Mme. Robert Walker.

Bibl: *Décoration Ancienne et Moderne* 4 (1895),
pl. 20; Frantz 1896, p. 458 illus.; *L'Art
Décoratif Moderne* (1896–97), p. 85 illus.

Exh: Paris 1896, Salon SNBA; Paris 1934b;
Paris 1974b, no. 16.

217
Loïe Fuller.
Rupert Carabin. 1896–97.
Bronze.
Height 19.5 (7⅝)
R. Carabin, on back of base.
Mr. and Mrs. Herbert D. Schimmel.

One of a series of six studies by Carabin of this
famous dancer. They were exhibited at the
Société Nationale des Beaux-Arts salon in
1897, where the unnamed critic of *The
International Studio* saw them: "M. Carabin,
who shows both taste and ability in his ring in
gold, iron and silver, and in his stoneware, has
gone hopelessly wrong over his trinket-box and
his mirror-frame in worked copper. However,
we need not insist upon this unfortunate
mistake, but rather console ourselves with
these six little bronze dancing figures, which
recall with infinite charm the ineffaceable
memory of Loïe Fuller" ("Decorative Art at the
Champ de Mars," p. 43).

Bibl: *International Studio* 2 (1897), p. 43;
Gazette des Beaux-Arts (1897), p. 247; Geffroy
1897, p. 378; Coquiot 1907, p. 27.

Exh: Paris 1897, Salon SNBA; Paris 1933;
Paris 1934b; Paris 1974b, no. 77.

218
L'Araignée (The Spider). Pin tray.
Rupert Carabin. 1908.
Carved and polished walnut.

Height 18.5 (7¼)
R. Carabin 1908, incised on base.
Paris, Musée des Arts Décoratifs, Inv. 15966.

Acquired from the artist at the salon of the
Société Nationale des Beaux-Arts, 1909.
Carabin treated this theme several times over
the years.

Bibl: Brunhammer et al. 1974, no. 12 illus.

Exh: Paris 1909, Salon SNBA; Paris 1934b,
no. 97; Tokyo 1975, no. 8.

219
Cane handle.
Rupert Carabin. 1903–1904.
Silver and a moonstone.
Height 13 (5⅛)
R. Carabin, engraved on extension of figure's
legs.
Paris, Galerie du Luxembourg.

The handle has never been mounted on a cane.

Exh: Paris 1904, Salon SNBA; Paris 1934b;
Paris 1974b, no. 168.

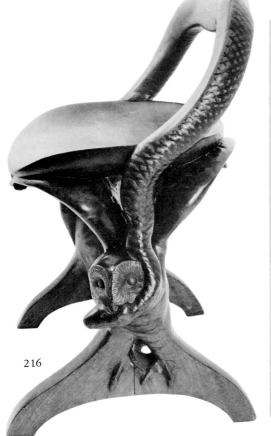

216

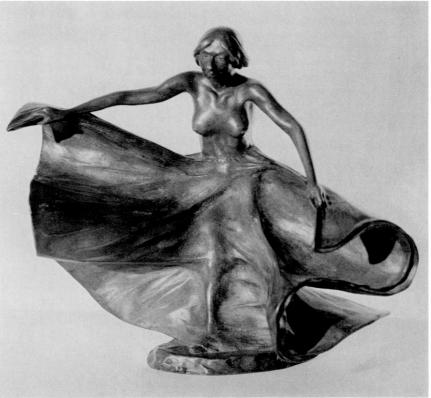

217

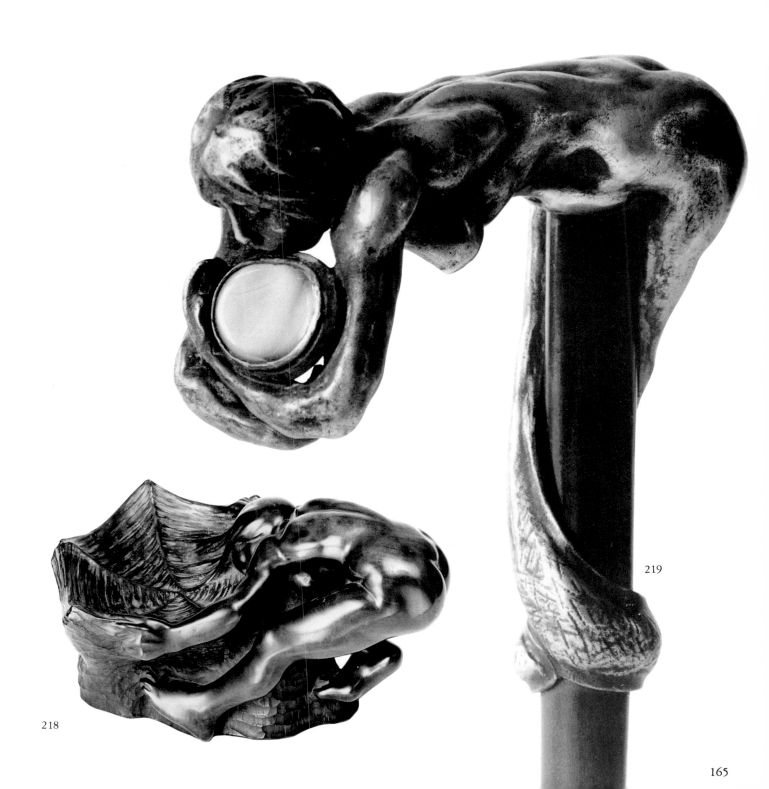

218

219

221

222

220

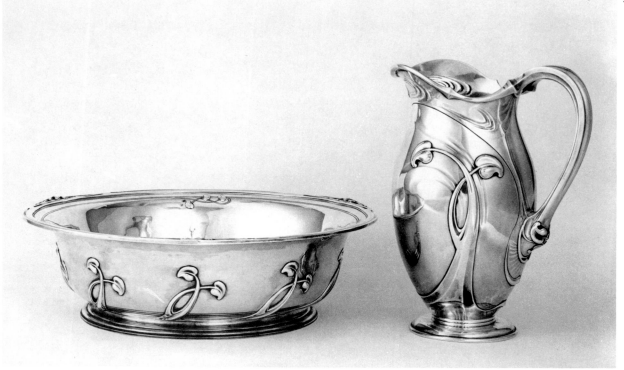

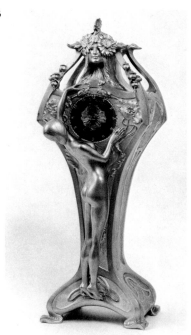

220
Ewer and basin.
Cardeilhac. c.1900.
Chased and repoussé silver.
Ewer: Height 33.5 (13¼)
Basin: Height 13.2 (5¼)
Master's mark, French assay mark, and
CARDEILHAC/PARIS, stamped on bottom
of each piece. *A*, stamped on bottom of basin.
Y627, engraved on bottom of basin.
Paris, Musée des Arts Décoratifs, Inv. 28740.
Gift of Paul Morel, 1933.

221
Gourd vase.
Jean Carriès. c.1890.
Stoneware with relief decoration; glazed dark
brown, green, and blue.
Height 30 (11⅞)
Jean Carriès, incised on bottom.
Düsseldorf, Collection Hentrich, on loan to
the Hetjens-Museum, Deutsches
Keramikmuseum.

Exh: Düsseldorf 1974, no. 10.

222
Vase.
Jean Carriès. c.1890–94.
Stoneware; glazed green and gray with gold
accents on brown and rust ground.
Height 13.5 (5⅜)
Paris, Musée des Arts Décoratifs, Inv. 34680.
Gift of the Comtesse de Caqueray, 1942.

Exh: Saint-Amand-en-Puisaye 1967.

Also illustrated in color.

223
Clock.
Louis Chalon; executed by E. Colin & Cie.,
Paris. c.1897.
Gilt and silver-plated brass.
Height 32.2 (12⅝)
LR9535, on back. *L. Chalon, 2*, and a
monogram, on lower border of right side. *E.
Colin & Cie, Paris,* stamped lower left back.
Darmstadt, Hessisches Landesmuseum,
Inv. Kg. 64:171.

Bibl: Bott 1973, no. 239 illus.

224
Vase.
Form designed by Ernest Chaplet for Haviland
& Co.; decoration by Edouard Dammouse.
c.1885–86.
Stoneware covered with white slip; pale green
ground with blue, green, yellow, coral, and
turquoise slip decoration, under- and
overglaze; touches of gold.
Height 21.6 (8½)
H & Co./30 in a rosary (Chaplet's mark),
impressed on bottom. *ED. DAMMOUSE,* in
gold on side.
New York, The Metropolitan Museum of Art,
Inv. 23.31.12. Gift of George Haviland,
1923.

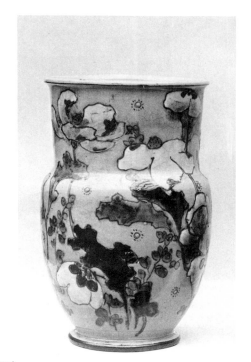

224

225
Pitcher.
Ernest Chaplet; thrown by Albert Kalt.
c. 1886.
Stoneware; blue, red, white, and gold
decoration on chamois-colored ground.
Height 29.2 (11½)
A rosary (Chaplet's mark), impressed on
bottom. *A.K./29*, incised on bottom.
Paris, Galerie du Luxembourg.

Albert Kalt, one of the twenty-odd painters
and sculptors who worked in Chaplet's rue
Blomet studio, was known primarily as a
decorator. However, the location of his
signature here, on the bottom rather than on
the side, would indicate that he threw this
pitcher. According to Laurens d'Albis, the

molds in which such brown stoneware pieces
were thrown were usually made from forms
that Chaplet had designed.

226
Vase.
Ernest Chaplet. 1889.
Thick-walled porcelain; *sang-de-boeuf* flambé
glaze.
Height 53.5 (21)
E within a rosary (Chaplet's mark) and *1889*,
painted in black on bottom.
Paris, Musée des Arts Décoratifs, Inv. 5695.

Acquired from the artist in 1889 at the
Exposition Universelle, Paris. This vase is a

landmark in Chaplet's oeuvre. Its form,
executed on an exceptionally large scale, was
taken directly from a shape called *mei-p'ing*,
created in the Sung Dynasty. The vase is
dated—a rarity with Chaplet. Furthermore, its
copper-red *sang-de-boeuf* glaze, also of Chinese
inspiration, is remarkably beautiful.
According to Jean d'Albis (d'Albis 1976),
Chaplet's research on this Chinese red glaze
began in 1884. Another vase in the collection
of the Musée des Arts Décoratifs (Inv. 4100),
one of his early and less than successful
attempts dated 1884, bears witness to the
technical difficulties encountered in pursuit of
a copper-red glaze. The vase exhibited here, a
crowning achievement of five years' research,

225 226

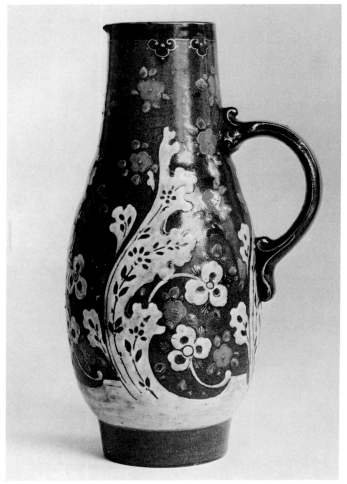

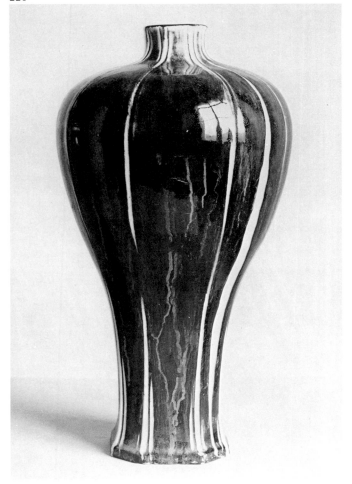

was among the group which earned Chaplet a gold medal at the 1889 Exposition Universelle. "Ses flammés exécutés toujours sur des formes étudiées et parfaitement appropriées présentent exactement les mêmes effets que ceux du vieux Chine" (Loebnitz 1891, p. 216).

Exh: Paris 1889; Munich 1972, no. 1428.

227
Vase.
Ernest Chaplet. c. 1891–92.
Thick-walled porcelain, hand-thrown; flambé glaze, turquoise on the exterior, copper-red overflows on the interior.

Height 9 (3½)
A rosary (Chaplet's mark), impressed on bottom.
Paris, Musée des Arts Décoratifs, Inv. 7261.

Acquired from the artist at the salon of the Société Nationale des Beaux-Arts in 1892.

Exh: Paris 1892, Salon SNBA; Brussels 1963a, no. 446; Paris 1964, no. 479.

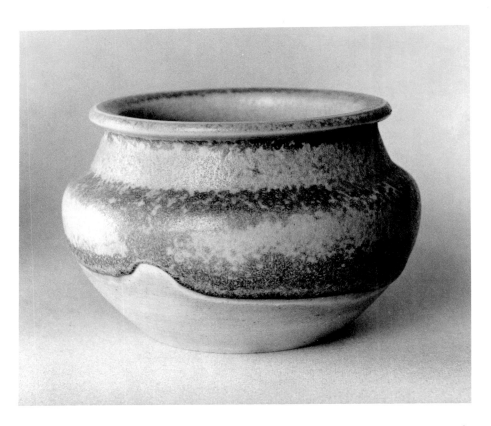

228
Doorknob and escutcheons from the series *La Musique*.
Alexandre Charpentier. c. 1892.
Bronze with light brown patina.
Escutcheons: 8 x 35.5 together (3⅛ x 14)
Knob: Diameter 7.7 (3)
Alexandre Charpentier, bottom left of right escutcheon.
Paris, Musée des Arts Décoratifs, Inv. 7572, 7573.

Executed by the Maison Fontaine, from whom the pieces were acquired in 1893. There is a similar set in the Hessisches Landesmuseum, Darmstadt (Bott 1973, nos. 240–41).

Bibl: Saunier 1894, p. 553 illus.; Nocq 1895, opp. p. 48 illus.; *Revue des Arts Décoratifs* 20 (1900), p. 355 illus.

Exh: Paris 1893, Salon SNBA; Paris 1900.

229

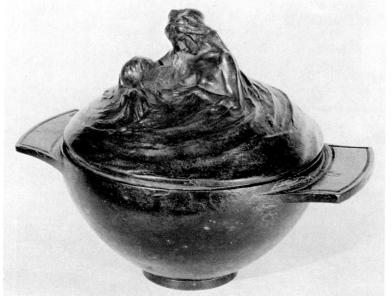

229
Covered bowl.
Alexandre Charpentier. c. 1892–93.
Bronze.
Height 14.3 (5⅝)
A. Charpentier, on back of lid. *J. Petermann Bruxelles*, stamped on bottom of bowl.
Mr. and Mrs. Herbert D. Schimmel.

A copy in pewter, in the collection of the Musée des Arts Décoratifs, Paris (Inv. 7736), was purchased at the 1893 salon of the Société Nationale des Beaux-Arts.

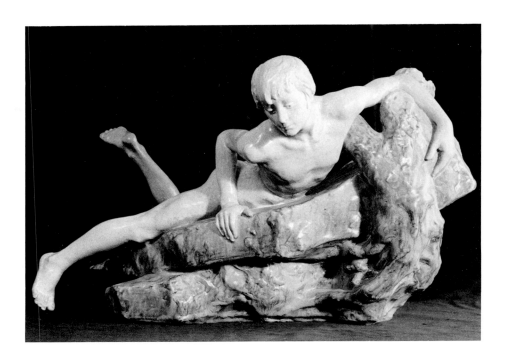

230
Narcissus.
Designed by Alexandre Charpentier; executed by Emile Müller. c. 1896–97.
Molded stoneware; glazed gray-green on the figure, turquoise and olive on the base.
Height 33.7 (13¼)
Alexandre Charpentier and *Grès Emile Muller*, incised on back of base. Circular seal on point of base. *IVRY, EMILE MULLER* in a circle, *PARIS*, and *152B2*, impressed on bottom.
Chrysler Museum at Norfolk,
Inv. CA.66.31.F.

Intended for a fountain.

Bibl: *Revue des Arts Décoratifs* 17 (1897), opp. p. 296 illus.

Exh: Paris 1897, Salon SNBA.

231
L'Enseignement des Arts (Instruction in the Arts).
Alexandre Charpentier. c. 1899.
Silver.
32 x 25 (12⅝ x 9⅞)
Charpentier's monogram, lower right.
Paris, Musée des Arts Décoratifs, Inv. 9172.

Mounted on a binding of Volume 19 of *Revue des Arts Décoratifs* (1899). Fifty deluxe copies, with Charpentier's plaque in silver, were offered for sale by the publishers of the magazine. The binding was also executed in a larger quantity with the plaque in embossed leather.

Exh: Paris 1960, no. 839; Tokyo 1975, no. 12.

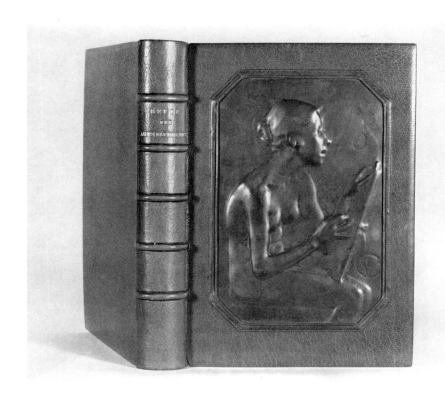

232

Music stand.
Designed by Alexandre Charpentier.
c. 1900–1901.
Waxed hornbeam, with rotating top.
122 x 44 (48 x 17⅜)
Paris, Musée des Arts Décoratifs,
Inv. 13064B.

Part of an ensemble including two music
stands and a *meuble à quatuor* (illustrated
below)—a large cabinet which housed the
instruments of a quartet—all designed by
Charpentier and exhibited at the salon of the
Société Nationale des Beaux-Arts in 1901.
Pevsner describes this piece as "a pure example
of the three-dimensional Art Nouveau curve,
spatially ingenious and functionally dubious"
(1968, p. 83).

Bibl: *Revue des Arts Décoratifs* 21 (1901), pp.
202–204 illus.; *L'Art Décoratif* 3
(1900–1901), p. 158 illus.; *Art et Décoration* 9
(1901), p. 198 illus.; Gerdail 1901, p. 158;
Mourey 1907; Olmer 1927, p. 27; Madsen
1956, p. 382 illus.; Cassou et al. 1962,
fig. 255; Brunhammer 1964, p. 164; Barilli
1966, pl. 40; Barilli 1967a, p. 263 illus.;
Mannoni 1968, p. 36 illus.; Pevsner 1968, p.
83 illus.; Sterner 1975, p. 50 illus.

Exh: Paris 1901, Salon SNBA; Paris 1933, no.
1031; Zürich 1952, no. 15; Paris 1960, no.
838; New York 1960, no. 57; Turin 1961;
Brussels 1963a, no. 423; Ostende 1967, no.
81; Tokyo 1968a, no. 62; Tokyo 1975,
no. 13.

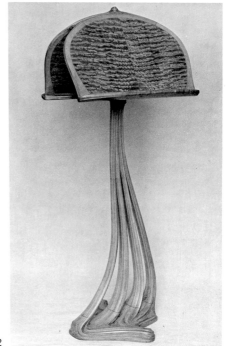

232

233

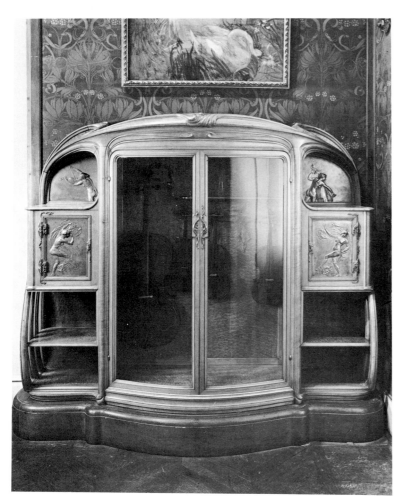

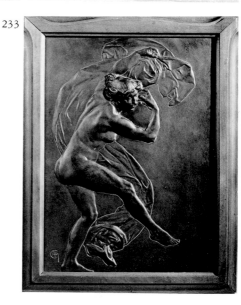

233

Plaque.
Alexandre Charpentier. c. 1900.
Bronze; original wooden frame.
35.9 x 25.1 (14⅛ x 9⅞)
Charpentier's monogram, lower left.
Marxen am Berge, Maria and Dr. Hans-Jörgen Heuser.

Cast from the same mold as one of the four plaques which decorate Charpentier's *meuble à quatuor* (Paris, Musée des Arts Décoratifs, Inv. 13064A).

234

Les Masques (The Masks). Vase.
Designed by Joseph Chéret for the Manufacture de Sèvres. 1898.
Porcelain with relief decoration; glaze modulated from blue at the base through white to pale yellow at the top.
Height 56.5 (22¼)
Joseph Chéret, incised at base. *AD 98*, stamped at base. *S 98* in an oval, imprinted inside.
Paris, Musée des Art Décoratifs. Dépôt de la Manufacture de Sèvres, Inv. 127−45.

Other examples are in the Funke-Kaiser collection and in the Musée National de Céramique, Sèvres.

Bibl: *Revue des Arts Décoratifs* 12 (1892−93), opp. p. 8 illus.; ibid., 13 (1894−95), opp. p. 196 illus.; *L'Art Décoratif Moderne* (1894−95), p. 85.

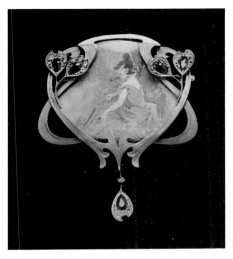

235

Brooch.
Watercolor by Jules Chéret; mounting by Fonsèque & Olive, Paris. c. 1900.
A watercolor miniature on paper; mounting in gold set with rubies and diamonds.
5.1 x 4.1 (2 x 1⅝)
Chéret, on miniature.
New York, private collection.

Exh: New York 1967.

235

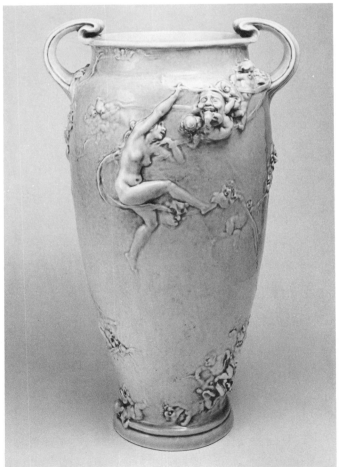

234

236
Chalice.
Designed by Eugène Bourgouin for Christofle.
c. 1904.
Silver-plated and partially gilt bronze.
Height 24 (9½)
E. Bourgouin, engraved on base.
Paris, Musée des Arts Décoratifs,
Inv. 11325A.

Acquired in 1904 from Bourgouin. The angels
on the stem represent Faith, Contemplation,
Prayer, and Suffering.

Exh: Paris 1904, Salon SNBA.

237
Fabric.
Designed by Edward Colonna. c. 1899–1900.
Silk and cotton brocade.
145 x 130 (57⅛ x 51¼)
Hamburg, Museum für Kunst und Gewerbe,
Inv. 1900.365.

The material used to upholster Colonna's
drawing-room furniture shown at Bing's
pavilion in the Exposition Universelle, 1900,
where it was purchased by the museum.

Bibl: *Revue des Arts Décoratifs* 20 (1900), p. 284
illus.; Verneuil 1900, p. 115 illus.; Weisberg
1971c, p. 52 illus.

Exh: Paris 1900; Hamburg 1974.

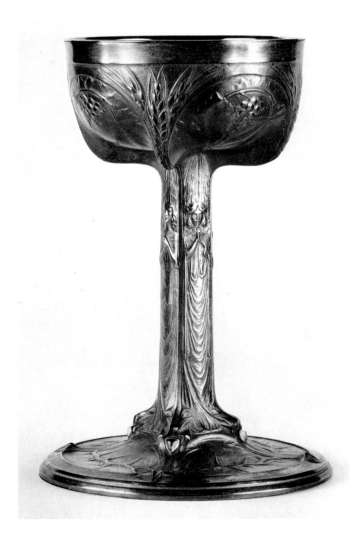

238
Side chair, armchair, and settee.
Designed by Edward Colonna. c. 1899–1900.
Brazilian rosewood; original printed velvet
upholstery.
Side chair: 89 x 48.5 x 37 (35 x 19⅛ x 14½)
Armchair: 99.5 x 65 x 50 (39⅛ x 25⅝ x 19¾)
Settee: 99 x 113 x 49 (39 x 44½ x 19¼)
Brussels, L'Ecuyer.

Part of an ensemble of drawing-room furniture
created by Colonna for S. Bing's pavilion at the
1900 Exposition Universelle, Paris. The pieces
on view there were upholstered in a different
material.

Bibl (similar examples): *Revue des Arts
Décoratifs* 20 (1900), opp. p. 280 illus.; *Art et
Décoration* 7 (1900), pp. 114, 116 illus.;
Osborn 1900, pp. 573–75 illus.; *International
Studio* 11 (1900), p. 179 illus.; Weisberg
1970, p. 62 illus.; Weisberg 1971c, pp.
49–51 illus.

239
Pendant.
Designed by Edward Colonna. c. 1898–99.
Green translucent enamel on gold; two
baroque pearls.
5.5 x 3.5 (2⅛ x 1⅜)
French assay mark, stamped on loop.
Paris, Musée des Arts Décoratifs, Inv.
15280A. Gift of Marcel Bing, 1908.

Designed for S. Bing's L'Art Nouveau.

Bibl: *Art et Décoration* 6 (1899), p. 10; Riotor
1900, pp. 176–77 illus.; *L'Art Décoratif* 2
(1900), p. 112 illus.

Exh: Paris 1899, Salon SAF.

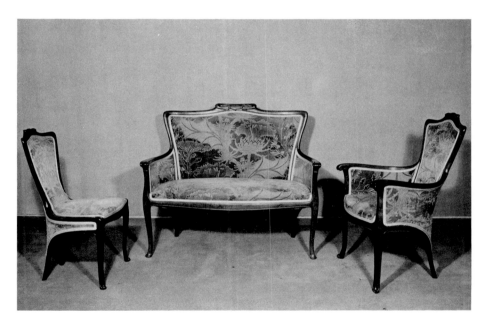

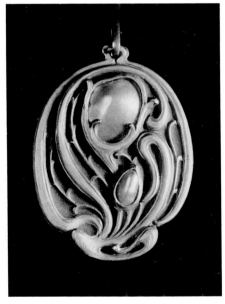

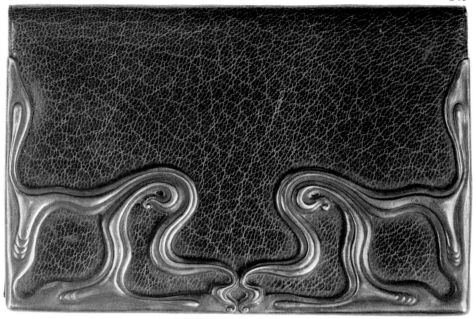

240
Case for visiting cards.
Designed by Edward Colonna. c.1898.
Brown morocco and chased silver.
7 x 10.5 (2¾ x 4⅛)
L'ART NOUVEAU—PARIS, stamped in gold
on inside.
Paris, Musée des Arts Décoratifs, Inv. 15276.
Gift of Marcel Bing, 1908.

Designed by Colonna for L'Art Nouveau.

Bibl: *Dekorative Kunst* 2 (1898), p. 127 illus.

241
Sugar spoon.
Designed by Edward Colonna. c.1900.
Chased and gilt copper.
Height 14.5 (5¾)
Paris, Musée des Arts Décoratifs, Inv. 15282.
Gift of Marcel Bing, 1908.

Designed by Colonna for S. Bing's L'Art
Nouveau. A similar sugar spoon is illustrated
in *L'Art Décoratif* 2 (1899–1900), p. 173, as
having been shown at the Paris Exposition
Universelle of 1900 (Riotor 1900).

Bibl: *Magazine of Art* (1904), p. 264 illus.

242
Vase.
Designed by Edward Colonna. c.1901.
Porcelain with relief and incised decoration
under a transparent straw-colored glaze.
Height 30 (11⅞)
Colonna's monogram, Bing's L'Art Nouveau
monogram, and *LEUCONOE*, imprinted in
blue-green on bottom.
Paris, Musée des Arts Décoratifs, Inv. 15233.
Gift of Marcel Bing, 1908.

Designed by Colonna for S. Bing's shop L'Art
Nouveau, and executed at Limoges by G.D.A.

241

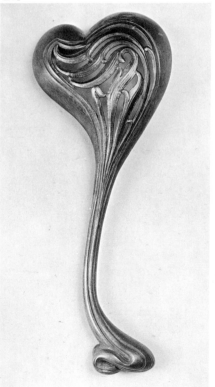

242

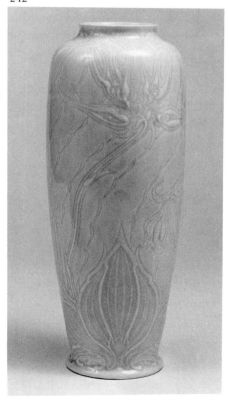

243

Study for a bookcase.
Attributed to Edward Colonna. c. 1898–1903.
Watercolor and pencil on paper.
26.2 x 20.7 (10¼ x 8⅛)
Dessin A/ Acajou ou noyer 2000./ Citronnier
2600,/ 2 m x 1.40, at top.
Paris, Musée des Arts Décoratifs, Inv.
CD2683. Gift of Marcel Bing, 1919.

One of a group of studies for furniture and
interiors made by Georges de Feure, Edward
Colonna, and Eugène Gaillard for S. Bing's
L'Art Nouveau. Two among them (including
cat. no. 278) bear de Feure's monogram. The
rest are unsigned, but attributions may be
made through comparisons with known works
of the three artists or with works found in the
Album de références de L'Art Nouveau
(Bibliothèque des Arts Décoratifs, Inv. LL35).
Here Colonna's style is evident in certain
details: the curves of the base and top, the
pattern of the glass, the design of the drawer
pulls, and the mounting of the vase in the
niche.

244

Study for a bookcase.
Attributed to Edward Colonna. c. 1898–1903.
Watercolor and pencil on paper.
26.2 x 21 (10⅜ x 8¼)
Dessin B/ Acajou ou noyer 2500/ Citronnier
3250./ 2.10 x 1.50, at top.
Paris, Musée des Arts Décoratifs, Inv.
CD2682. Gift of Marcel Bing, 1919.

A variant of the preceding study, having only
one door with colored glass. Among the
Tiffany-style vases on the shelves is a piece by
the German Karl Koepping (1848–1914). The
decorative moldings at the top and base of the
bookcase recall certain motifs of the "Victor
Hugo" bookcase (no. 282 in the *Album de
références de L'Art Nouveau*), the study for which
was also part of Marcel Bing's 1919 donation
(Inv. CD2684).
 Exhibited and published here for the first
time to our knowledge, this project and the
preceding one seem never to have been
executed. The inscriptions on the drawings
give technical information—dimensions,
kinds of woods and their prices. Colonna's style
is more evident in this study than in the
former: compare, for example, the motifs of
the base with the handle of the spoon by
Colonna (cat. no. 241).

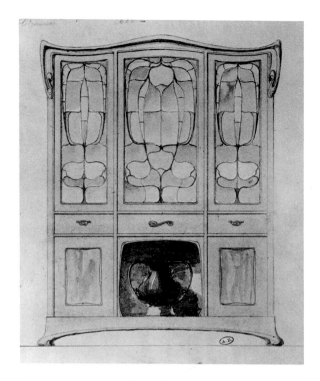

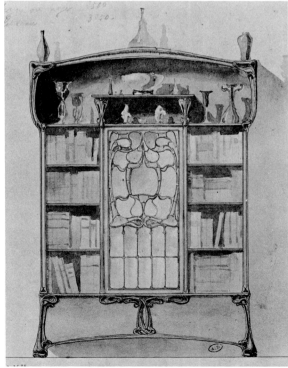

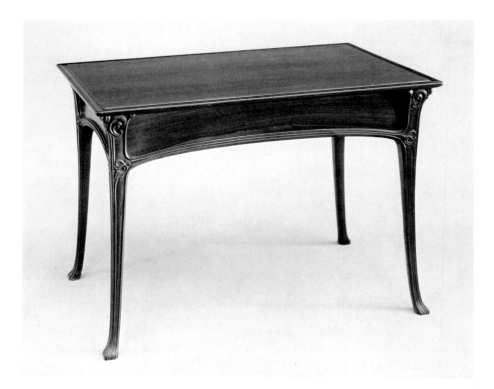

245
Table.
Designed by Edward Colonna. c. 1899–1900.
Brazilian rosewood.
72.4 x 99.7 x 59.7 (28½ x 39¼ x 23½)
New York, The Metropolitan Museum of Art,
Inv. 26.228.4. The Edward C. Moore, Jr.,
Gift Fund, 1926.

The prototype was designed as part of a
drawing-room ensemble shown in Bing's
pavilion at the Paris Exposition Universelle,
1900. Other examples are in the collections of
the Kaiser Wilhelm Museum, Krefeld,
Germany, the Victoria and Albert Museum,
London, and the Musée des Arts Décoratifs,
Paris.

Bibl (similar examples): *International Studio* 11
(1900), p. 169 illus.; Madsen 1956, p. 374
illus.; Weisberg 1970, p. 62 illus.; Weisberg
1971b, p. 275 illus.; Weisberg 1971c, p. 49
illus.

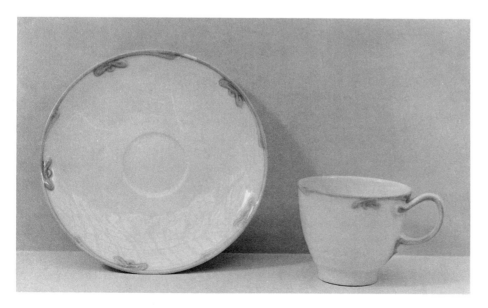

246
Cup and saucer.
Designed by Edward Colonna. c. 1899.
Porcelain with green underglaze relief
decoration and incised decoration.
Cup: Height 6.7 (2⅜)
Saucer: Diameter 12.7 (5)
l'Art/Nouveau/Bing, imprinted on bottom of
saucer.
New York, The Metropolitan Museum of Art,
Inv. 26.248.8,9. Gift of R. Haase, 1926.

Designed for Bing's L'Art Nouveau; executed
at Limoges.

Bibl: Weisberg 1971e, p. 201 illus. (similar
example).

247
Side chair.
Designed by Edward Colonna. c. 1899–1900.
Brazilian rosewood; original damask
upholstery with silver and gold design on a
rose ground.
87.6 x 42.8 x 38.1 (35¼ x 16⅞ x 15)
New York, The Metropolitan Museum of Art,
Inv. 26.228.5. The Edward C. Moore, Jr.,
Gift Fund, 1926.

The prototype for this chair was created as part
of the furnishings for a drawing room,
designed entirely by Edward Colonna, and
exhibited in 1900 at S. Bing's pavilion at the
Exposition Universelle. The fabric used for the
upholstery is shown as cat. no. 237.

Bibl (similar examples): Mourey 1900, p. 262
illus.; Soulier 1900, p. 44 illus.; *Deutsche Kunst
und Dekoration* 6 (1900), pp. 573, 578 illus.;
International Studio 11 (1900), p. 169 illus.;
Weisberg 1970, p. 62 illus.; Weisberg 1971c,
pp. 51–52 illus.

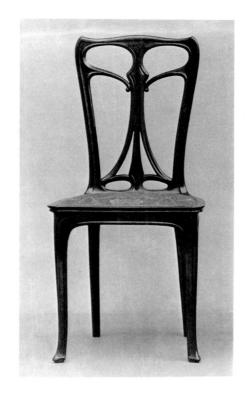

248
Bottle.
Attributed to Omer Coppens. c. 1895.
Earthenware with underglaze slip decoration;
green glaze.
Height 31.5 (12⅜)
Brussels, L'Ecuyer.

249
Iris. Fabric.
Designed by Bohl; manufactured by Cornille
Frères, Lyons and Puteaux. c. 1900.
Liseré silk satin, brocaded; tones of garnet,
green, and yellow on white ground.
140 x 130 (55⅛ x 51⅛)
Paris, Musée des Arts Décoratifs, Inv. 10688.

Bibl: *Art et Décoration* 10 (1901), p. 98 illus.;
Revue des Arts Décoratifs 21 (1901), p. 331
illus.; Mannoni 1968, p. 34 illus.

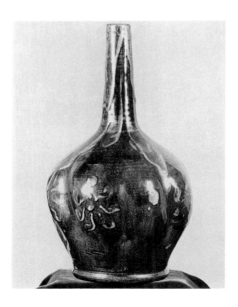

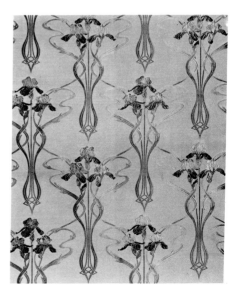

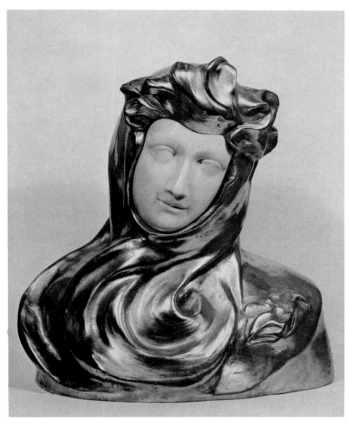

250

Vase.
Henri Cros.
Multicolored *pâte de verre*, molded in two
sections.
Height 23 (9)
Paris, Musée des Arts Décoratifs, Inv. 21182.
Peytel Donation, 1919.

Bibl: Vaillat 1908, p. 27 illus.; Belfort 1967,
pp. 182–85, p. 186 illus.; Duret-Robert
1974, illus.

Exh: Paris 1960, no. 855.

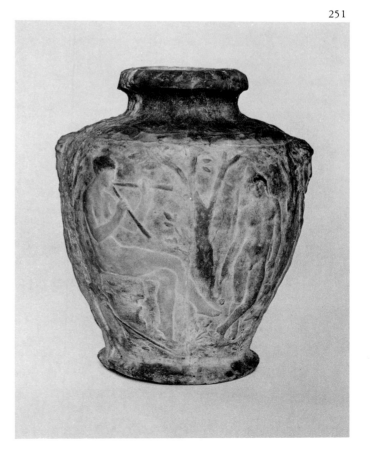

250
Orchidée (Orchid).
Arthur Craco. 1894.
Gilt bronze and ivory.
Height 39 (15⅜)
ART. CRACO/ 1894, on back at right.
J. PETERMANN FONDEUR/ BRUXELLES,
stamped on back at left.
Brussels, L'Ecuyer.

Ivory from the Belgian Congo was first
imported into Belgium in 1893. To encourage
its use, King Leopold II offered gifts of ivory to
several promising sculptors of the day, who
were delighted with the possibilities of this
new material. Their early efforts, including the
piece shown here, were exhibited in 1894 at
the Exposition Universelle in Antwerp.

Exh: Antwerp 1894; Brussels-Tervueren 1897.

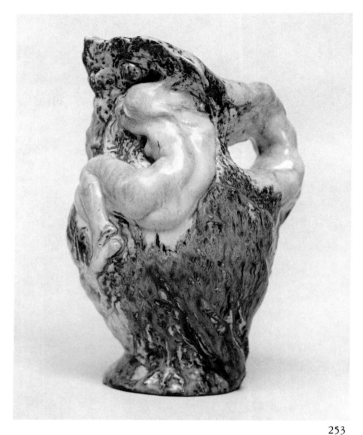

252
Pitcher.
Pierre Adrien Dalpayrat. c. 1905.
Stoneware with incised decoration; copper-red
and copper-blue flambé glaze.
Height 40 (15¾)
Dalpayrat, painted on bottom.
Mr. and Mrs. Herbert D. Schimmel.

252

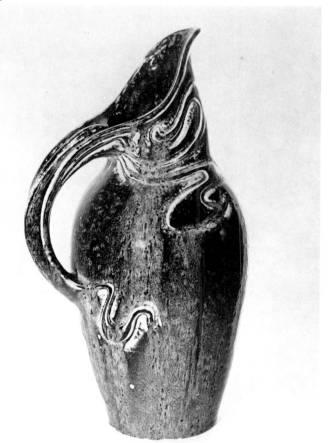

253

253
La Nuit (Night). Pitcher.
Pierre Adrien Dalpayrat and Adèle Lesbros.
1893–94.
Molded stoneware, hand finished; blue, red,
and green flambé glaze.
Height 27.3 (10¾)
A pomegranate (Dalpayrat's mark), impressed
on bottom.
New York, private collection.

Formerly in the collection of Philippe Wolfers,
who acquired the vase around 1895 through an
exchange with Dalpayrat.

Bibl: *Revue des Arts Décoratifs* 15 (1894–95),
p. 200 illus.

Exh: Paris 1894.

254
Vase.
Pierre Adrien Dalpayrat. c. 1905.
Molded stoneware with red, blue, and
turquoise flambé glaze.
Height 48 (18⅞)
Dalpayrat, in india ink on bottom.
Düsseldorf, Collection Hentrich, on loan to
the Hetjens-Museum, Deutsches
Keramikmuseum.

Exh: Düsseldorf 1974, no. 36.

255
Vase.
Albert Dammouse. c. 1892–99.
Stoneware; dark blue, yellow-green, and red
glaze with black outlines on off-white ground.
Height 68.5 (27)
A Dammouse S (Sèvres) in a circle, impressed on
bottom.
Paris, Musée des Arts Décoratifs, Inv. 9356.

Purchased from the artist at the Exposition
Universelle in Paris, 1900.

Exh: Paris 1900.

256
Cup.
Albert Dammouse. c. 1909.
Thin-walled *pâte de verre*, opaque mauve,
yellow, and green-yellow.
Height 9 (3½)
A Dammouse S (Sèvres) in a circle, on bottom.
Paris, Musée des Arts Décoratifs, Inv. 17385.

Acquired from the artist at the salon of the
Société Nationale des Beaux-Arts, 1910.

Exh: Paris 1910, Salon SNBA; Paris 1964,
no. 503; Ostende 1967, no. 431.

Also illustrated in color.

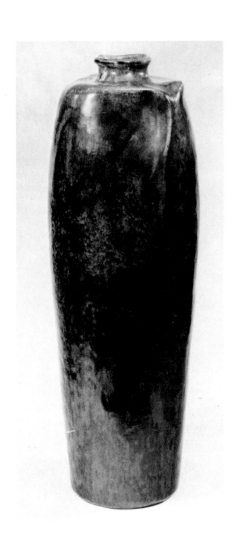

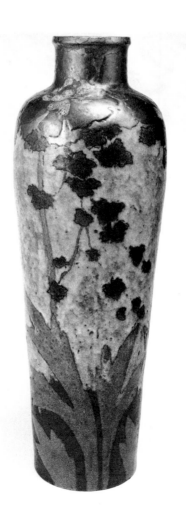

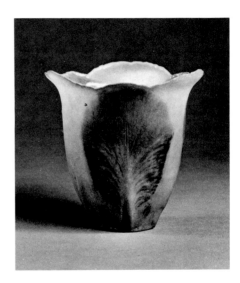

257
Vase.
Albert Dammouse. c. 1901.
Thin-walled *pâte de verre*, opaque turquoise,
cobalt blue, and green.
Height 12 (4¾)
A Dammouse S (Sèvres) in a circle, on bottom.
Paris, Musée des Arts Décoratifs, Inv. 10271.

Acquired from the artist at the salon of the
Société des Artistes Français, 1902.

Bibl: Sandier 1901, p. 60 illus.; Polak 1962,
p. 33, pl. 16; Rheims 1964, pl. 77.

Exh: Paris 1902, Salon SAF; Paris 1960,
no. 860.

258
Mounted vase.
Vase by Verreries Daum; mounting by Maurice
Guerchet. c. 1897–98.
Transparent and light blue cased glass;
wheel-cut decoration; mounting in chased
silver and vermeil.
Height 13.5 (5⅜)
DAUM, cross of Lorraine, and *Nancy*,
engraved and gilt on bottom. Master's mark
and French assay mark, stamped on upper and
lower parts of mounting. *GUERCHET/ 30/
Bard Malesherbes* and *GUERCHET*, stamped at
base of mounting.
Paris, Musée des Arts Décoratifs, Inv. 8745.

Purchased from Maurice Guerchet in 1898.

Bibl: Bloch-Dermant 1974, p. 134 illus.

Exh: Paris 1960, no. 862.

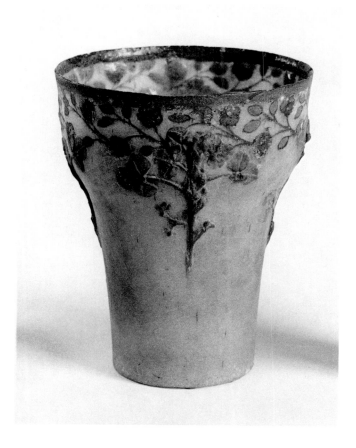

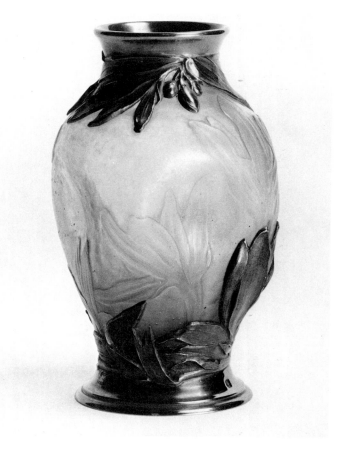

259
Crocus vase.
Designed by Louis Fuchs; executed at Verreries
Daum. c. 1898–99.
Opaline white, pink, and green cased glass;
wheel-cut decoration.
Height 15 (5⅞)
Daum/Nancy, cross of Lorraine, and *d'après L.
Fuchs*, engraved and gilt on bottom.
Paris, Musée des Arts Décoratifs, Inv. 9074.

Fuchs' design received an award at the second
competition sponsored by the Société
Nationale des Arts Décoratifs, preliminary to
the Paris Exposition Universelle, 1900.

Bibl: Jourdan 1899, p. 114 illus.;
Bloch-Dermant 1974, p. 134 illus.

Exh: Paris 1933, no. 1862; Paris 1960, no.
863; Ostende 1967, no. 432; Tokyo 1975, no.
23.

260
Bottle with stopper.
Verreries Daum. c. 1900.
Clear glass with flashed layers of red and black;
engraved, wheel-cut, and gilt decoration.
Height 11.1 (4⅜)
Daum, cross of Lorraine, and *Nancy*, engraved
and gilt on bottom.
New York, The Metropolitan Museum of Art,
Inv. 29.25.3ab. Gift of Charles B. Hoyt,
1929.

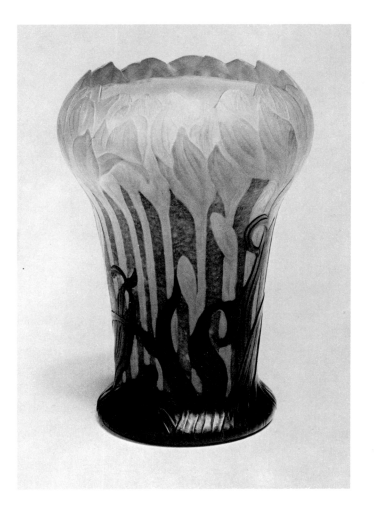

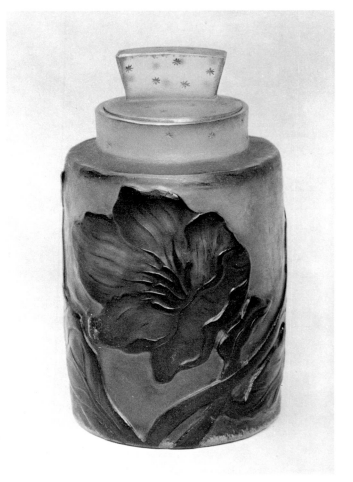

261
Vase.
Verreries Daum. 1900.
Cased glass with sealed oxides of yellow, green,
and purple-red; wheel-cut decoration.
Height 43 (16⅞)
Daum Nancy, engraved on bottom.
Paris, Musée des Arts Décoratifs, Inv. 42774.
Gift of Jacques and Michel Daum, 1969.

Bibl: Bloch-Dermant 1974, p. 154 illus.

Exh: Paris 1969, no. 38; Tokyo 1975, no. 24.

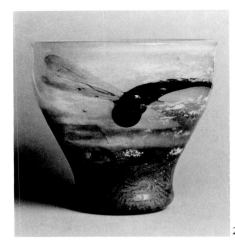
262

262
Dragonfly vase.
Verreries Daum. 1900.
Cased glass with sealed oxides and an
application.
Height 19.6 (7¾)
Paris, Musée des Arts Décoratifs, Inv. 42776.
Gift of Jacques and Michel Daum, 1969.

Exh: Paris 1969, no. 52.

Also illustrated in color.

263

263
Berluze bottle.
Verreries Daum. 1902.
Cased glass with fired-on enamels and
applications; etched decoration.
Height 36.5 (14⅜)
Daum/Nancy and cross of Lorraine, painted in
gold on bottom. *2047*, engraved on bottom.
Paris, Musée des Arts Décoratifs, Inv. 42777.
Gift of Jacques and Michel Daum, 1969.

Berluze is the name the Daums gave to this
particular form of vase with a long thin neck.

Exh: Paris 1969, no. 25.

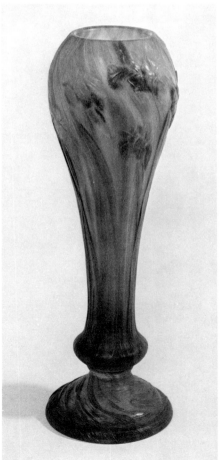

261

265
Gourd vase.
Verreries Daum.
Blown glass with fired-on enamels and
applications.
Height 30 (11¾)
DAUM/NANCY with cross of Lorraine,
wheel-cut on side.
Paris, Musée des Arts Décoratifs, Inv. 36315.
Gift of Jacques Daum, 1950.

According to Michel Daum, the decoration
on this piece and cat. no. 266, achieved by
firing on powdered enamels or oxides of
different colors, was called *vitrification* by the
Daums.

Bibl: Rheims 1964, pl. 46; Bloch-Dermant
1974, p. 154 illus.

Exh: Paris 1951, no. 792; Paris 1960,
no. 864; Ostende 1967, no. 434.

264
Bowl.
Verreries Daum.
Dark green, russet, and clear cased glass;
wheel-cut decoration.
Height 18.4 (7¼)
Daum, cross of Lorraine, and *Nancy*, engraved
on bottom.
Chrysler Museum at Norfolk, Inv.
GEFD.68.1. Gift of Walter P. Chrysler, Jr.

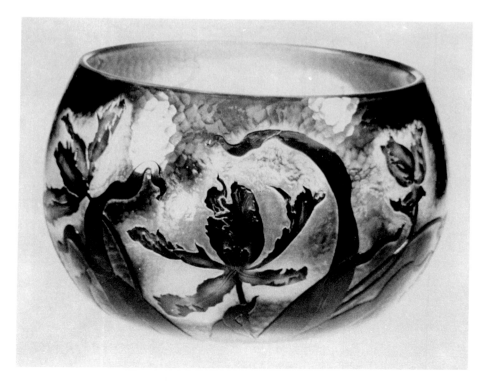

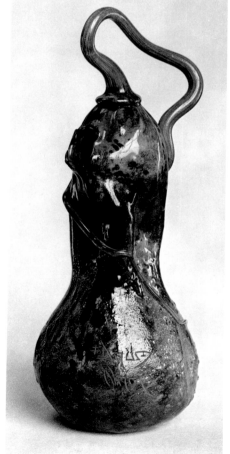

267

Match-holder.
Designed by Marie Gautier; executed by
Emile Decoeur. c. 1906–1907.
Stoneware; green and yellow glaze.
Height 7.4 (3)
MARIE GAUTIER, incised along bottom of
right leg. A clover (Decoeur's mark),
impressed twice on bottom.
Paris, Musée des Arts Décoratifs, Inv. 14926.
Gift of Jules Maciet, 1908.

Bibl: Bénédite 1908, p. 137 illus.

Exh: Paris 1907, Salon SNBA.

266

Gourd vase.
Emile Decoeur. c. 1905.
Stoneware with relief decoration; dark blue,
red, and gray satin glaze.
Height 32.1 (12⅝)
Decoeur, painted on bottom. A clover
(Decoeur's mark), impressed on bottom.
Private collection.

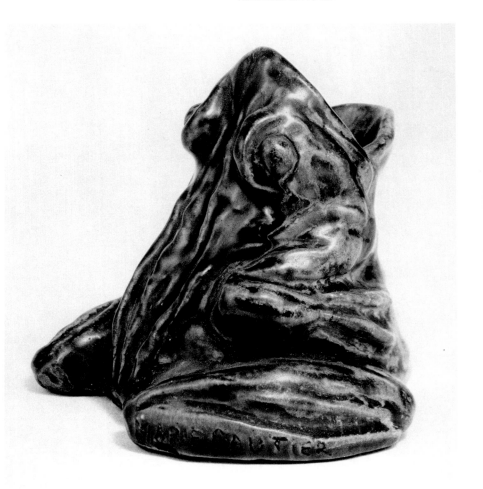

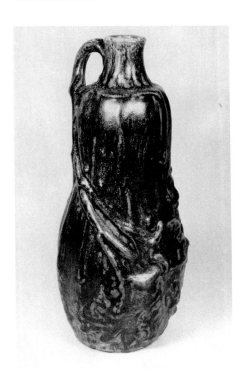

268
Vase.
François Décorchemont. c. 1903.
Stoneware with relief decoration; transparent glaze on the body of the vase, dark ocher glaze on the handles.
Height 28.2 (11⅛)
Decorchemont in a circle and *47*, impressed on bottom.
Paris, Collection Félix Marcilhac.

Bibl: Duret-Robert 1973, fig. 2.

Exh: Düsseldorf 1974, no. 48.

269
Vase.
François Décorchemont. 1912.
Thick-walled yellow and emerald green *pâte de verre*, with air bubbles.
Height 17.5 (6⅞)
Decorchemont in a circle, at base.
Paris, Musée des Arts Décoratifs, Inv. 18501.

Purchased from the artist at the salon of the Société des Artistes Décorateurs, 1912. This is model number eight, created in 1912, according to Décorchemont's records.

Bibl: Polak 1962, p. 33, pl. 17; Duret-Robert 1973.

Exh: Paris 1912, Salon SAD; Paris 1964, no. 505; Ostende 1967, no. 440; Tokyo 1975, no. 121.

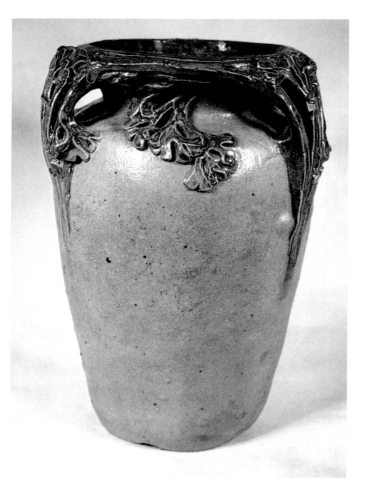

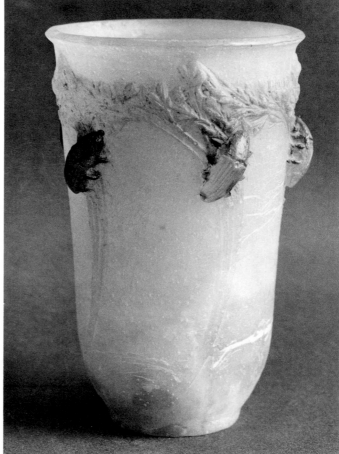

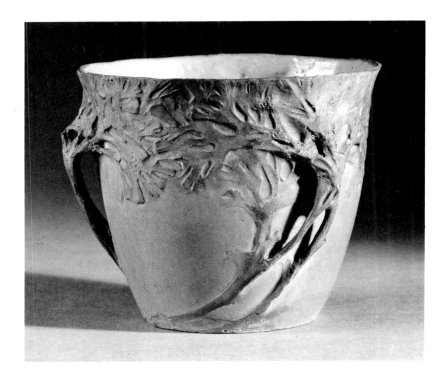

270
Cup.
François Décorchemont. 1906.
Thin-walled turquoise *pâte de verre*.
Height 8.7 (3⅜)
DECORCHEMONT in a circle, on bottom.
1906, handwritten in ink on bottom.
Paris, Musée des Arts Décoratifs, Inv. 36421.

Bibl: Rheims 1964, pl. 78.

Also illustrated in color.

271
Candelabrum.
Designed by Georges de Feure. c. 1901–1902.
Silver-plated bronze.
Height 26 (10¼)
DE FEURE, engraved on bottom.
Paris, Musée des Arts Décoratifs, Inv. 15220.
Gift of Marcel Bing, 1908.

Designed for Bing's L'Art Nouveau.

Bibl: *L'Art Décoratif* 4 (1902), p. 110 illus.;
Art et Décoration 12 (1902), p. 61 illus.;
Deutsche Kunst und Dekoration 11 (1902–1903),
p. 169 illus.

Exh: Paris 1902, Salon SNBA; Turin 1902;
Turin 1961.

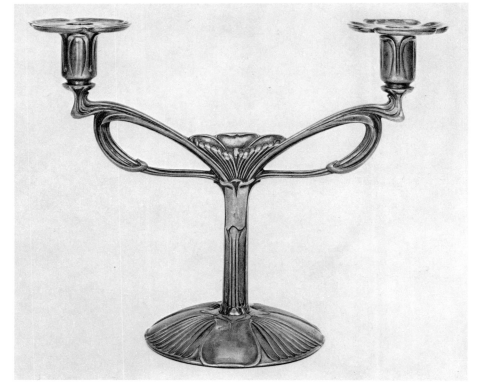

272

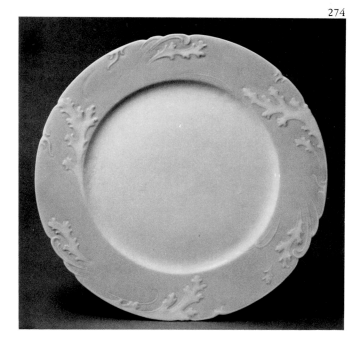

274

273

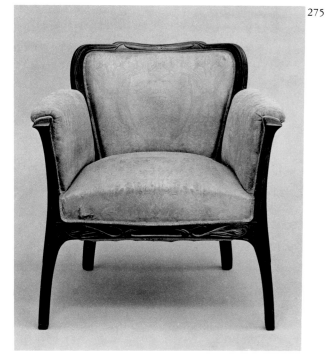

275

272
Fabric.
Designed by Georges de Feure. c. 1899–1900.
Reinforced silk satin.
146 x 125 (57½ x 49¼)
Hamburg, Museum für Kunst und Gewerbe,
Inv. 1900.362.

Designed for the sitting room in Bing's
pavilion at the Paris Exposition Universelle of
1900, and purchased there by the museum.

Bibl: Mourey 1900, p. 263 illus.; Verneuil
1900, p. 116 illus.; *L'Art Décoratif* 2 (1900),
p. 222 illus., p. 226 illus.; Osborn 1900,
pp. 563–67 illus.; *L'Art Décoratif* 3 (1901),
pp. 24–25 illus.

Exh: Paris 1900; Hamburg 1974.

273
La Neige (Snow). Vase.
Designed by Georges de Feure. c. 1901.
Porcelain with painted underglaze decoration.
Height 20.3 (8)
De Feure's monogram and *LEUCONOE*,
imprinted on bottom.
Paris, Musée des Arts Décoratifs, Inv. 15239.
Gift of Marcel Bing, 1908.

Manufactured by G.D.A. (Gérard-
Dufraisseix-Abbot), Limoges, for
L'Art Nouveau.

Bibl: *L'Art Décoratif* 3 (1901), p. 121 illus.;
Puaux 1903a, p. 316 illus.; Kahn 1902, p.
26.

Exh: Paris 1902, Salon SNBA; Paris 1903.

Also illustrated in color.

274
Plate.
Designed by Georges de Feure. c. 1901–1904.
Porcelain with relief decoration; pale green
border.
Diameter 21.6 (8½)
New York, The Metropolitan Museum of Art,
Inv. 26.228.13. The Edward C. Moore, Jr.,
Gift Fund, 1926.

Manufactured for Bing's L'Art Nouveau by
G.D.A., Limoges. In a 1900 letter to the firm
concerning the decoration of a line of ceramics
shown at the Exposition Universelle, Bing
noted that "the green borders seem to be the
only ones that sell. So please change as much of
my order for pink borders as is still possible"

(July 3, 1900; Gérard-Dufraisseix-Abbot
archives, Limoges).

275
Armchair.
Designed by Georges de Feure. c. 1899–1900.
Pearwood; original tan and pale green
upholstery.
77.5 x 67.3 x 50.8 (30½ x 26½ x 20)
New York, The Metropolitan Museum of Art,
Inv. 26.228.2. The Edward C. Moore, Jr.,
Gift Fund, 1926.

The prototype for this chair was part of a suite
of sitting-room furniture de Feure created for
Bing's pavilion at the Paris Exposition
Universelle, 1900. The ensemble shown
there was in gilded wood; its upholstery
matched the fabric on the walls.

Bibl (similar example): *Deutsche Kunst und
Dekoration* 6 (1900), p. 588 illus.; *L'Art
Décoratif* 2 (1900), p. 218 illus., p. 220 illus.;
International Studio 9 (1900), p. 79 illus.;
Weisberg 1970, p. 65 illus.

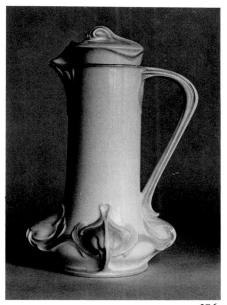

276

276
Chocolate pot.
Designed by Georges de Feure. c. 1901–1902.
Porcelain, with relief decoration glazed pink
and green.
Height 27.5 (10⅞)
De Feure's monogram, Bing's L'Art Nouveau
monogram, and *LEUCONOE*, imprinted on
bottom.
Paris, Musée des Arts Décoratifs, Inv. 15246.
Gift of Marcel Bing, 1908.

Manufactured at Limoges for L'Art Nouveau.

Bibl: *L'Art Décoratif* 4 (1902), p. 347 illus.;
Art et Décoration 12 (1902), p. 27 illus.; *L'Art
Décoratif pour Tous*, no. 42 (1903), p. 9 illus.;
Madsen 1956, p. 375 illus.; Madsen 1967,
p. 151 illus.; Sterner 1975, pp. 66–67 illus.

Exh: Paris 1902, Salon SNBA; Ostende 1967,
no. 341.

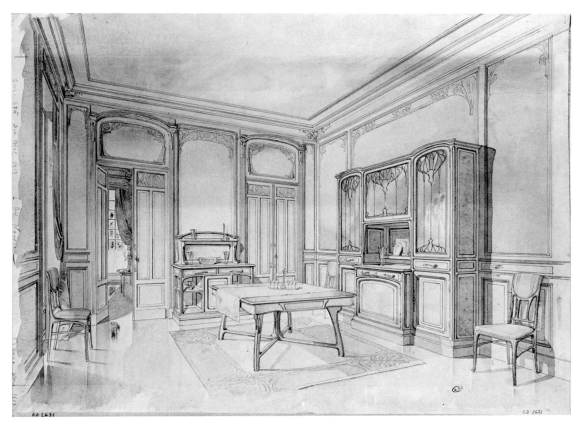

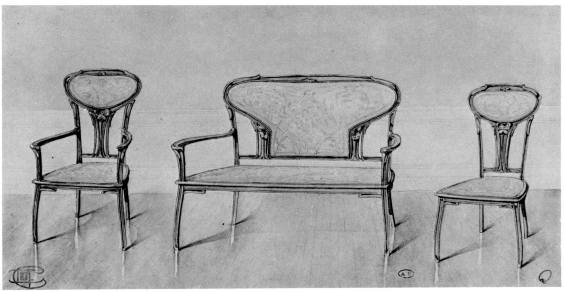

277
Study for a dining room.
Attributed to Georges de Feure.
c. 1898–1905.
Ink and gray wash, with white gouache
highlights.
37.5 x 50 (14¾ x 19⅝)
Paris, Musée des Arts Décoratifs, Inv.
CD2671. Gift of Marcel Bing, 1919.

One of two interiors among a group of
twenty-four projects created for S. Bing's L'Art
Nouveau by de Feure, Eugène Gaillard, and
Edward Colonna (others are shown as cat. nos.
243, 244, 278). The second study for an
interior— a boudoir in blue and gold—is
unsigned, but it is illustrated in *Oeuvres de
Georges de Feure* (Paris: L'Art Nouveau,
c. 1903). The decorative theme of both
interiors, the poppy flower, appears often in
the work of de Feure, notably in the
sitting-room suite which he designed for
Bing's pavilion at the Paris 1900 Exposition
Universelle. The study shown here is, to our
knowledge, previously unpublished. Although
it is not signed, comparison with the boudoir
in blue and gold and with a study for a buffet
which bears de Feure's monogram (Paris,
Musée des Arts Décoratifs, Inv. CD2681A)
makes the attribution to de Feure seem
plausible.

278
Study for a settee and two chairs.
Georges de Feure. c. 1898–1905.
Watercolor and pencil on paper.
17.7 x 33.3 (7 x 13⅛)
De Feure's monogram, lower left. *Q* in pencil,
lower right.
Paris, Musée des Arts Décoratifs, Inv.
CD2673. Gift of Marcel Bing, 1919.

Of the design projects for L'Art Nouveau, this
is one of two which are signed, both of them
with the de Feure monogram. The poppy
flower, a characteristic motif in de Feure's
work, appears here in the carved decoration of
the chairs and settee. This design was
apparently never executed.

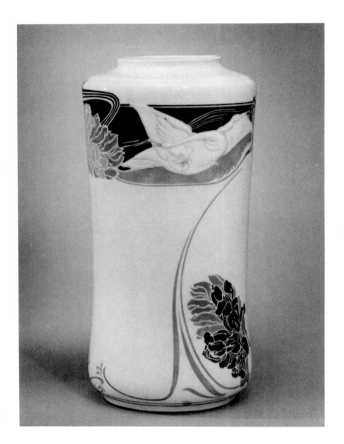

279
Vase.
Designed by Georges de Feure.
c. 1901–1902.
Porcelain with relief and incised decoration,
painted blue, pink, and green.
Height 31.8 (12½)
De Feure's monogram, Bing's L'Art Nouveau
monogram, and *LEUCONOE,* imprinted on
bottom.
New York, The Metropolitan Museum of Art,
Inv. 26.228.9. The Edward C. Moore, Jr.,
Gift Fund, 1926.

Manufactured by G. D. A., Limoges, for L'Art
Nouveau. The word *Leuconoë* appears
frequently on ceramics designed for Bing; its
significance is unknown.

Bibl: *Art et Décoration* 12 (1902), p. 26 illus.;
Puaux 1903a, p. 316 illus.

Exh: Paris 1902, Salon SNBA.

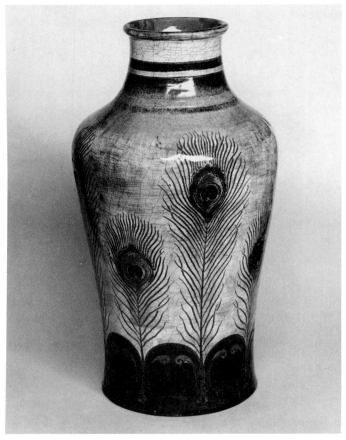

280
Four studies for carpets.
Attributed to Georges de Feure.
c. 1898–1905.
Gouache on paper; mounted and framed
together.
20 x 15 each (7⅞ x 5⅝)
Paris, Musée des Arts Décoratifs,
Inv. CD2697a-d. Gift of Marcel Bing, 1919.

There are six such studies in the Cabinet des
Dessins of the Musée des Arts Décoratifs.
These four are in tones of blue, mauve, and
green; the two others are in reds and pinks. All
were for Bing's shop L'Art Nouveau.

281
Peacock vase.
Auguste Delaherche. c. 1888–89.
Stoneware with incised decoration; blue and
green glaze with traces of red on white ground;
crackled lead overglaze.
Height 43 (16⅞)
AUGUSTE DELAHERCHE in a round mark
and *1634*, impressed on bottom.
Paris, Musée des Arts Décoratifs, Inv. 5700.

Acquired from the artist at the Exposition
Universelle in Paris, 1889. There is another
copy, with *1630* impressed on the bottom and
different glazes, in the Musée Adrien
Dubouché, Limoges (Inv. 4988).

Bibl: *Revue des Arts Décoratifs* 20 (1900), p. 355
illus.; Champier 1903, pl. 175; Marx 1906, p.
p. 55 illus.; Grasset 1909, p. 136 illus.

Exh: Paris 1889; Paris 1907a, no. 125.

 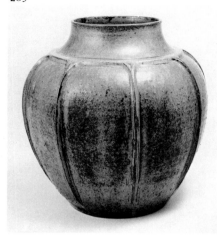

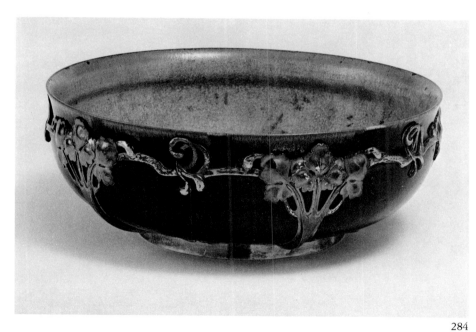

284

282
Vase.
Auguste Delaherche. 1890.
Stoneware with incised decoration; rose, blue, and gray glaze.
Height 15.8 (6⅛)
AUGUSTE DELAHERCHE in a round mark and *3797,* impressed on bottom.
Paris, Musée des Arts Décoratifs, Inv. 5931.

Acquired from the artist in 1890. A comparable but much larger piece is in the Musée Adrien Dubouché, Limoges.

Exh: Paris 1960, no. 868.

283
Vase.
Auguste Delaherche. c. 1891–92.
Stoneware with applied relief decoration; yellow-brown glaze.
Height 31 (12¼)
AUGUSTE DELAHERCHE in a round mark with *255* in center, impressed on bottom.
Paris, Musée des Arts Décoratifs, Inv. 14808.
Gift of the artist, 1908.

Made at Héricourt, where Delaherche spent his vacations in 1891 and 1892. The austerity of the form and glaze shows the influence of the local pottery.

284
Mounted bowl.
Bowl by Auguste Delaherche; mounting designed by Lucien Bonvallet and executed at Cardeilhac. c. 1901.
Hand-thrown stoneware; flambé glaze, yellow-green on the interior, dark brown on the exterior; mounting in silver gilt.
Diameter 20.6 (8⅛)
Auguste Delaherche in elongated mark and *3283,* impressed on bottom of bowl. Master's mark, French assay mark, and *CARDEILHAC/ PARIS*, stamped on bottom of mounting.
Paris, Musée des Arts Décoratifs, Inv. 10041.

Purchased from Cardeilhac, 1902.

Bibl: Demaison 1902, p. 207 illus.

Exh: St. Louis 1904.

285
Vase.
Auguste Delaherche. c. 1901–1902.
Porcelain; rust and citrine flambé glaze.
Height 12.4 (4⅞)
A D and a sprig of clover, painted in green on bottom.
Paris, Musée des Arts Décoratifs, Inv. 10285.

Purchased from the artist at the salon of the Société Nationale des Beaux-Arts, 1902.

Exh: Paris 1902, Salon SNBA; Brussels 1963a, no. 458; Ostende 1967, no. 337; Munich 1972, no. 1303.

286
Bowl.
Auguste Delaherche. c. 1913–14.
Porcelain with excised and relief decoration.
Height 8 (3⅛)
Aug. Delaherche and date code, painted in gray-green on bottom.
Paris, Musée des Arts Décoratifs, Inv. 19723.

Well after 1900 Delaherche was still using decorative motifs which could be considered Art Nouveau; there is a bowl with narcissus decoration in the Musée Départemental de l'Oise, of the same style and technique as this one, dated as late as 1928 (Beauvais 1973, no. 180). The piece shown here was acquired from the artist in 1914 at the salon of the Société Nationale des Beaux-Arts.

Exh: Paris 1914, Salon SNBA.

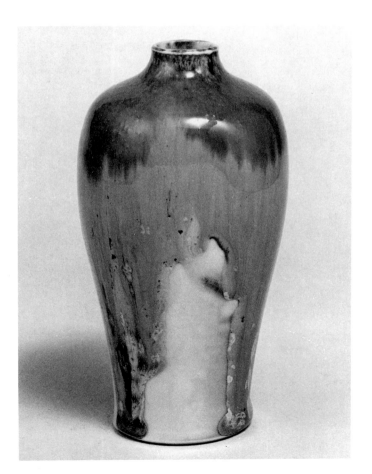

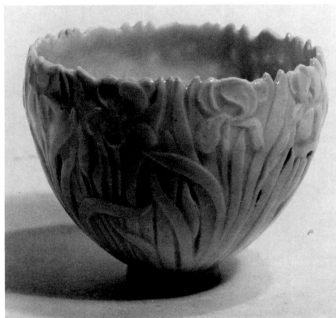

287
Fan.
Maurice Denis. 1891.
Gouache on paper, mounted on a painted
wooden frame.
Height 30 (11¾)
17 NOV 91, vertically at left, with drawing of
Maurice Denis' face below. *MARTHE*,
vertically at right.
Saint-Germain-en-Laye, Musée Symbolistes et
Nabis. Formerly in the collection of Maurice
Denis.

Given by the artist to his fiancée, Marthe, on
her twentieth birthday. His journal entry on
that date reads, "How, at the sight of the fan,
she turned round to her mother and hid herself
to cry. She is twenty years old today: joy of our
common heart! O God, you have not given me
back the gift of tears, but I am so hopeful now"
(Denis 1957, p. 89).

Bibl: Denis 1957, p. 89.

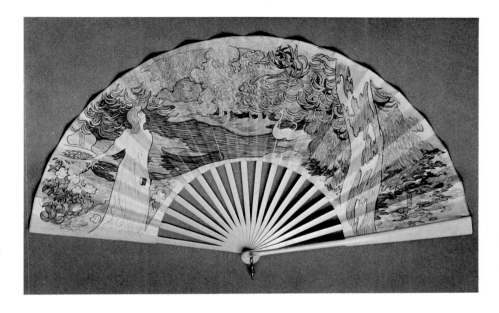

288
Erlkönig (The Elf-King). Lampshade.
Maurice Denis. 1893.
Gouache on paper.
Height 17.3 (6¾)
Denis' monogram, vertically at right.
17/Nov/93, at left. *Erlkönig*, bottom center.
Private collection.

Made for the twenty-first birthday of Marthe
Meurier, whom Denis had married in June
1893. The theme was that of a song Marthe
often sang, Schubert's *Erlkönig*.

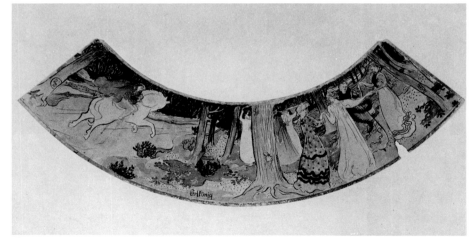

288

289
Wallpaper.
Maurice Denis. 1893.
Color lithograph.
90.5 x 49.8 (35⅝ x 19⅝)
New York, The Museum of Modern Art,
Inv. 250.52.

Exh: New York 1960, no. 77.

290
Ring.
Georges de Ribaucourt. c. 1902.
Gold and an amethyst.
Diameter 2.7 (1⅛)
French assay mark, stamped on inside.
Paris, Musée des Arts Décoratifs, Inv. 32625.
Gift of Mme. de Ribaucourt, 1937.

Bibl: *L'Art Décoratif aux Expositions*, pl. 141;
Ernould-Gandouet 1970, p. 48 illus.

Exh: Paris 1902, Salon SAF; London 1961, no.
664; Brussels 1963a, no. 434; Amersfoort
1972, no. 59; Tokyo 1975, no. 81.

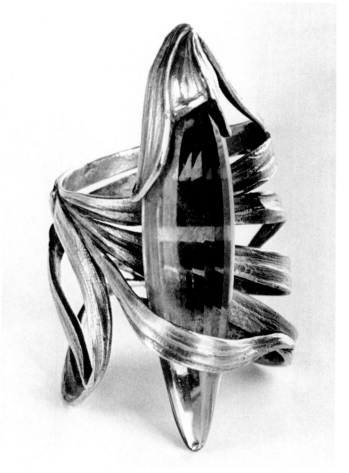

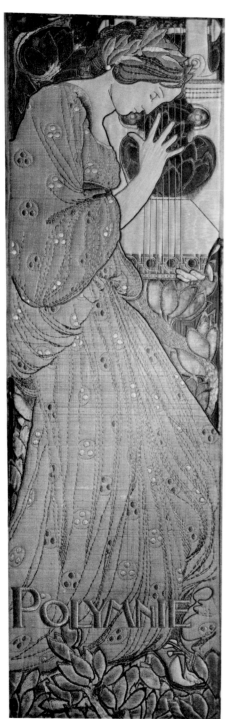

291

291

Polymnie.
Attributed to Hélène De Rudder.
Silk embroidery with velvet and silk appliqués on canvas; beige-brown, yellow, pink, and yellow-green.
141 x 42.7 (55½ x 16¾)
POLYMNIE, embroidered at bottom.
Brussels, L. Wittamer—de Camps.

One of the nine Muses, Polymnia is usually associated with lyric poetry, and was sometimes referred to as the mother of Orpheus.

292
Cup.
Georges Despret.
Dark green *pâte de verre*.
Height 23.3 (9⅛)
G. Despret 682, engraved on bottom.
Paris, Mme. Robert Walker.

Formerly in the collection of the artist's family.

292

293
Figurine.
Georges Despret. c. 1900.
Opalescent and pink *pâte de verre* with white,
yellow, blue, and green mottling.
Height 24.6 (9¾)
Despret, incised on back of base.
The Corning Museum of Glass, Inv. 66.3.22.

Obviously inspired by Tanagra figurines.

294
Pax. Paperweight.
Taxile Doat. 1901.
Porcelain with *pâte sur pâte* (underglaze slip)
decoration.
Diameter 9.8 (3⅞)
TDoat (*T* and *D* intertwined), *1901*, and
Sèvres, incised and painted in green on bottom.
Marxen am Berge, Maria and Dr. Hans-Jörgen
Heuser.

Doat made several paperweights with similar
allegorical representations such as *Industrie*, *La
Mer*, and *La Vague*.

295
Gourd vase.
Taxile Doat.
Porcelain with relief decoration; salmon and
chartreuse overflows.
Height 18.4 (7¼)
TDoat (*T* and *D* intertwined) and *Sèvres*,
painted on bottom.
New York, Lillian Nassau.

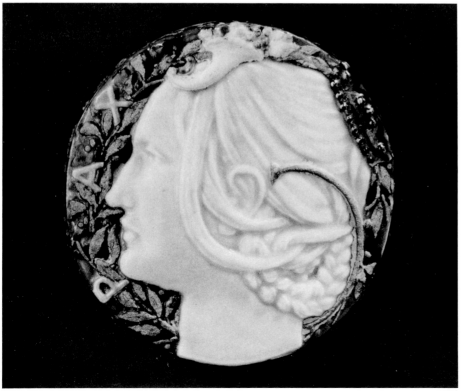

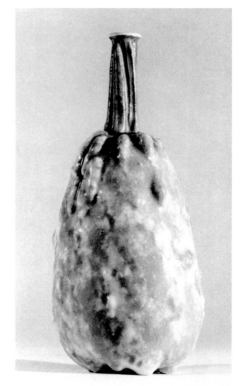

294

295

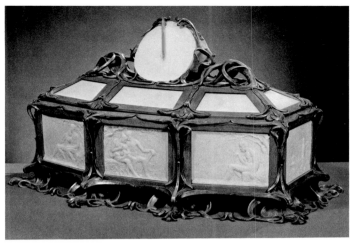

296
Coffre de mariage (Wedding Casket).
Fernand Dubois. Before 1897.
Ivory, silver, gesso, and exotic hardwood.
20.5 x 69.4 x 45.5 (8⅛ x 27¼ x 17⅞)
Brussels, Musées Royaux d'Art et d'Histoire,
Inv. Sc. 62.

Acquired by the Musée Royale de l'Afrique
Centrale in 1897. Probably the two gesso
medallions were intended for miniature
portraits of the bride and bridegroom.

Bibl: Maus 1897, p. 130 illus.

Exh: Brussels-Tervueren 1897; Tervuren
1967, no. 17.

297
Candelabrum.
Fernand Dubois. c. 1898.
Silver-plated metal.
Height 52.5 (20⅝)
Dubois' monogram and *Fernandubois*, at base.
Brussels, Commune de Saint-Gilles, Musée
Horta, Inv. SM 16.

Bibl: *L'Art Décoratif* 1 (1899), p. 32 illus.
(similar example); *Art et Décoration* 12 (1902),
p. 75 illus.

Exh: Turin 1902.

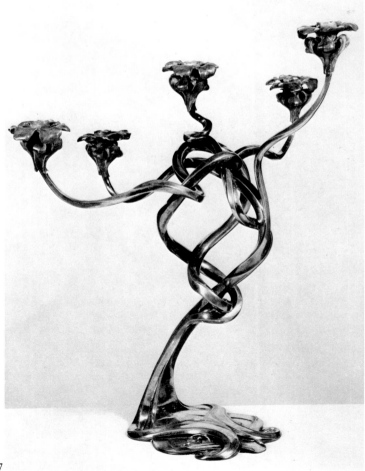

297

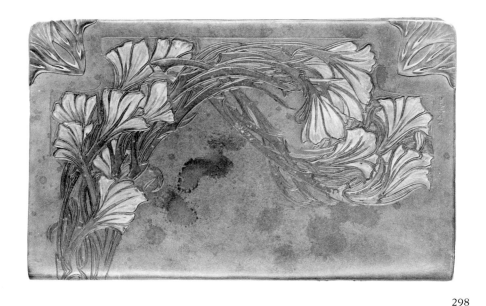

298

298
Case for writing paper.
Designed by Maurice Dufrêne. c. 1900–1901.
Embossed leather, painted mauve and green;
silver mounts.
42.3 x 26.7 x 1.7 (16⅝ x 10½ x ⅝)
M. DUFRENE, incised lower right.
Paris, Musée des Arts Décoratifs, Inv. 9654.

Acquired from the artist, 1901; probably
designed by Dufrêne for La Maison Moderne.
The leatherwork has been attributed to Henry
Jolly (Sterner 1975, p. 62).

Bibl: Sterner 1975, p. 62, p. 65 illus.

299
Mounted vase.
Vase designed by Maurice Dufrêne; executed
by Pierre Adrien Dalpayrat for La Maison
Moderne. Mounting designed by Lucien
Bonvallet; executed at Cardeilhac. c. 1899.
Hand-thrown stoneware with relief decoration;
red, blue, and green flambé glaze on yellow
ground; mounting in silver.
Height 24.7 (9¾)
M. DUF (incomplete), incised on bottom of
vase. Monogram of La Maison Moderne,
impressed on bottom of vase. Master's mark,
French assay mark, and *CARDEILHAC/
PARIS*, stamped on bottom of mounting.
Paris, Musée des Arts Décoratifs, Inv. 9148
(vase), 9244 (mounting).

The vase was purchased at La Maison Moderne,
unmounted, in 1899. The museum then
commissioned a mounting, designed by
Bonvallet, from the firm of Cardeilhac, and in
1900 the mounted vase was exhibited in the
pavilion of the Union Centrale des Arts
Décoratifs at the Exposition Universelle, Paris.
In 1904 it was among the works sent to the
Louisiana Purchase Exposition in St. Louis.

Bibl: *Revue des Arts Décoratifs* 20 (1900), opp.
p. 216 illus.; Vitry 1905, p. 102 illus.

Exh: Paris 1900; St. Louis 1904.

Also illustrated in color.

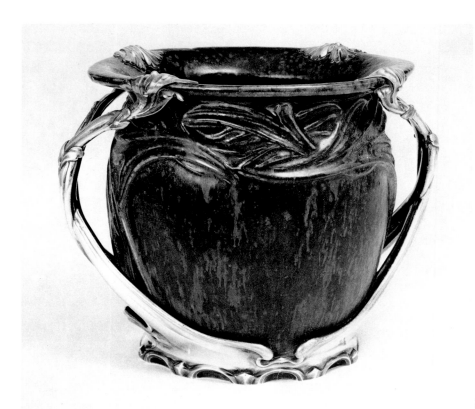

299

300
Chocolate pot.
Designed by Maurice Dufrêne. c. 1901–1902.
Porcelain; relief decoration glazed blue and
pink; silver hinge.
Height 21.3 (8⅜)
M. Dufrêne, incised on bottom.
Paris, Collection Félix Marcilhac.

Probably designed for La Maison Moderne.

Bibl: *Art et Décoration* 12 (1902), p. 24 illus.

Exh: Paris 1902, Salon SAF.

301
Peacock vase.
Jean Dunand. c. 1912–13.
Repoussé copper, with patina and silver
encrustations.
Height 39.5 (15½)
JEAN DUNAND, engraved on bottom.
Paris, Musée des Arts Décoratifs, Inv. 19140.

Acquired from the artist at the salon of the
Société des Artistes Décorateurs, 1913. A vase
of similar form and size, but with a decoration
of ferns, was exhibited at the same salon
(Verneuil 1913, p. 90 illus.) and is now in a
private collection, Paris.

Bibl: Verneuil 1913, p. 90 illus.;
Brunhammer 1966a, no. 820; Brunhammer
1973, p. 11 illus.

Exh: Paris 1913, Salon SAD; Munich 1972,
no. 285; Tokyo 1975, no. 125.

300

301

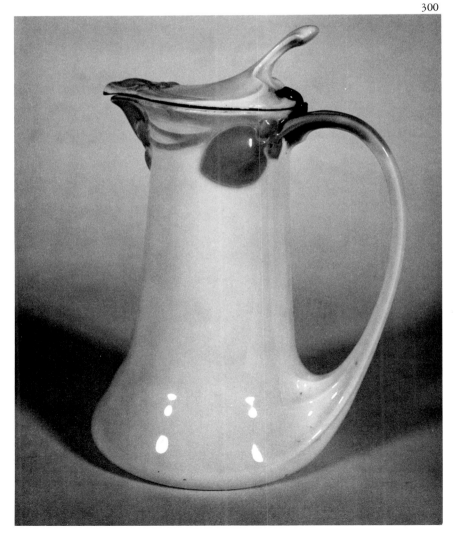

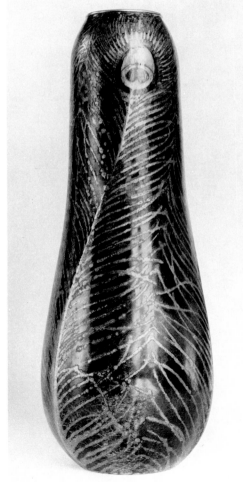

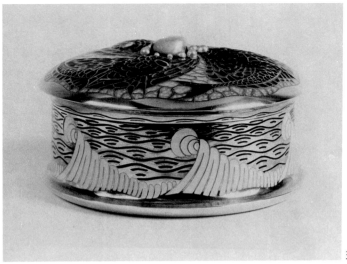

303
Ring tray.
Eugène Feuillâtre. c. 1900–1901.
Silver and plique-à-jour enamel.
12 x 16.5 x 9.5 (4¾ x 6½ x 7⅝)
FEUILLATRE, engraved on snakes' tails.
Paris, Mme. Robert Walker.

Bibl: *Magazine of Art* (1901), p. 497 illus.;
Verneuil 1902, p. 100 illus.; Vaizey 1971,
p. 18 illus.

Exh: Paris 1901, Salon SAF.

302

302
Powder box.
Eugène Feuillâtre. c. 1900.
Silver with champlevé and plique-à-jour
enamel; pearls.
Height 7 (2¾)
Master's mark, stamped on edge.
Darmstadt, Hessisches Landesmuseum,
Inv. Kg. 66:2.

Bibl: Bott 1973, no. 222 illus.

Exh: Ostende 1967, no. 215.

303

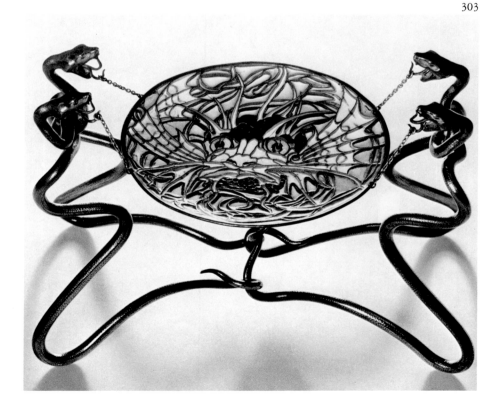

304
Plate.
Willy Finch.
Earthenware with underglaze slip decoration;
glazed yellow and dark brown.
Diameter 35.8 (14⅛)
A-W-F/ No. 57, incised on bottom.
Brussels, L'Ecuyer.

305
Vase.
Willy Finch.
Earthenware with underglaze slip decoration;
glazed siena and yellow. Lead rim and lining
probably added later.
Height 30 (11¾)
-A-W-F-, incised on bottom.
Brussels, L'Ecuyer.

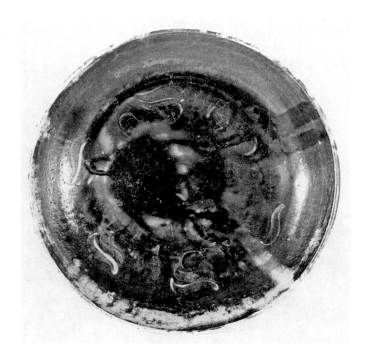

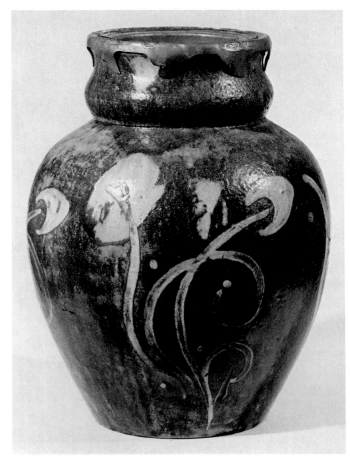

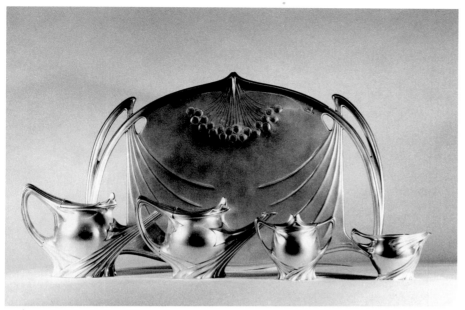

306

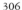

306
Coffee service.
Designed by Paul Follot. c. 1900–1903.
Silver-plated metal.
Tray: 42.5 x 61.6 (16¾ x 24¼)
Follot, engraved on each piece.
New York, Lillian Nassau.

Possibly manufactured by La Maison Moderne
after Follot's model. Several copies of this
service are known today.

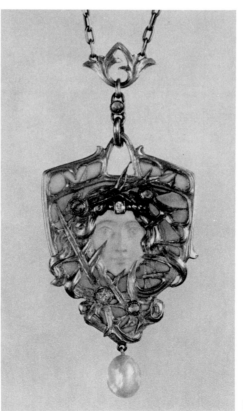

307

307
Pendant.
Designed by Alphonse Mucha; executed by
Georges Fouquet. c. 1900.
Gold, diamonds, emeralds, polychrome
enamel, and a baroque pearl.
8.4 x 3.6 (3¼ x 1⅜)
Fouquet's mark, stamped on back.
Darmstadt, Hessisches Landesmuseum,
Inv. Kg. 65:C328.

The same woman's head appears in a *parure de
corsage* by Mucha which was illustrated in *The
Studio* (special winter number, 1902, French
section, p. 7). A similar piece, also designed
by Mucha and executed by Fouquet, is shown
in *L'Art Décoratif* 3 (1900), p. 7.

Bibl: Mucha 1965, p. 175 illus.; Bott 1972,
p. 202; Bott 1973, no. 156 illus.

Exh: London 1963.

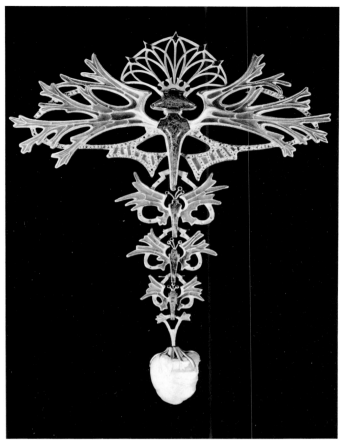

308

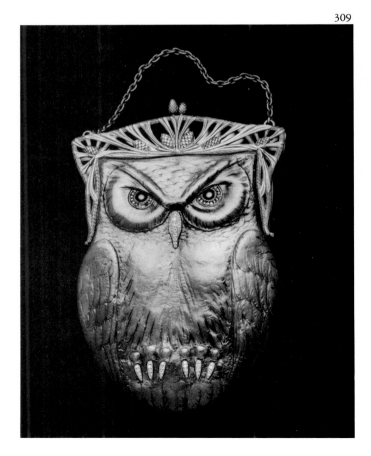

309
Handbag.
Paul Frey for Lacloche Frères, Paris. c. 1895.
Light brown tooled leather; diamonds, rubies,
and black striped onyx; gold frame, clasp, and
chain.
23 x 13.3 (8 x 5¼)
LACLOCHE FRERES —PARIS, stamped
inside clasp. Master's mark of Frey, stamped
on ring. French assay mark, stamped inside
near hinge.
New York, private collection.

A similar purse, but without jewels, is
illustrated in Henri Vever's *La Bijouterie
française au XIXe siècle*, vol. 3, p. 583.

309

308
Brooch.
Designed by Charles Desrosiers; executed by
Georges Fouquet. c. 1900.
Gold, green enamel, diamonds, agate, rubies,
and a baroque pearl; hinged in four places.
15.5 x 12.3 (6⅛ x 4⅞)
G. FOUQUET, engraved on back. *3455*,
engraved on pin of clasp. French assay mark
and master's mark, stamped on top edge.
Master's mark, stamped on pin of clasp.
Paris, Collection Michel Périnet.

Bibl: Seyden 1901, opp. p. 9 illus.; *L'Album
d'Art* (1904), p. 14 illus.

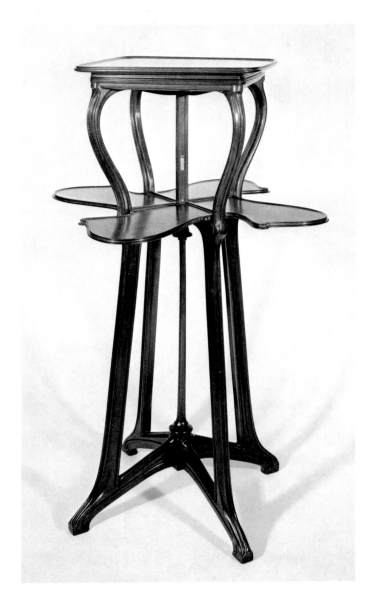

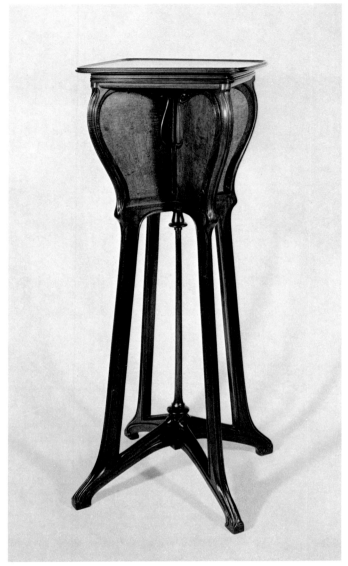

310
Tea table.
Eugène Gaillard. c. 1901.
Mahogany; four small leaves and removable top
tray.
Height 109.2 (43)
Sydney and Frances Lewis Collection.

No. 439 in the *Album de références de L'Art*

Nouveau, a photographic inventory of Bing's
shop which is now in the collection of the
Bibliothèque des Arts Décoratifs, Paris.

Bibl: *Art et Décoration* 11 (1902), p. 22 illus.

Exh: Richmond 1971, no. 29.

311
Side chair.
Eugène Gaillard. 1906.
Brazilian rosewood; original silk upholstery.
95 x 41 x 41 (37⅜ x 16⅛ x 16⅛)
Paris, Musée des Arts Décoratifs, Inv. 14802.

Acquired from the artist in 1908, this chair is
upholstered in the *pluie d'or* pattern (cat. no.
210), which was woven in Lyons by Bouvard et
Cie.

Bibl: De Félice 1906, p. 204 illus.; *L'Art
Décoratif* 10 (1908), p. 6 illus.; Madsen 1956,
p. 376 illus.; Bossaglia 1972, p. 42 illus.

Exh: Paris 1906, Salon SAD; Paris 1960,
no. 912; Turin 1961; Brussels 1963a, no. 429;
Munich 1964, no. 803; Tokyo 1975, no. 36.

312
Side chair.
Eugène Gaillard. Before 1900.
Mahogany; leather upholstery.
93.5 x 42 x 41 (36¾ x 16½ x 16⅛)
Paris, Musée des Arts Décoratifs, Inv. 31483.
Gift of the artist, 1934.

According to Gaillard, this was the first chair
style he designed and executed for Bing's L'Art
Nouveau.

Bibl: De Félice 1906, illus.; Seyden 1921,
pl. 2; Barilli 1966, p. 92, pl. 39; Mannoni
1968, p. 23 illus.

Exh: Paris 1906, Salon SAD; Paris 1960,
no. 907; Brussels 1963a, no. 424; Munich
1964, no. 802; Ostende 1967, no. 91; Tokyo
1975, no. 35.

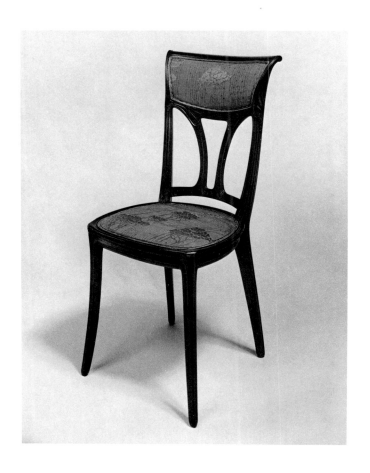

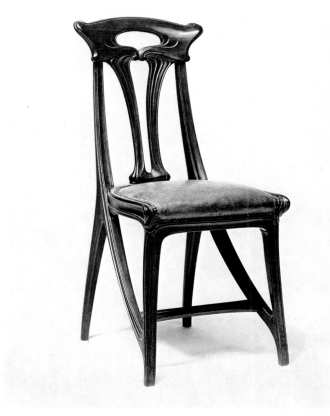

313

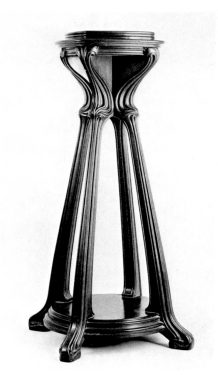

313
Pedestal.
Eugène Gaillard. c. 1901–1902.
Mahogany.
125 x 55 x 55 (49¼ x 21⅝ x 21⅝)
Paris, J. P. Christophe.

Bibl (similar examples): *Art et Décoration*
11 (1902), p. 24 illus.; Madsen 1956, p. 370
illus.

315
Parasol handle.
Lucien Gaillard. c. 1899–1900.
Cast silver with brown patina, partially gilt.
Height 8 (3⅛)
LUCIEN GAILLARD PARIS and French assay
mark, stamped near lower end.
Berlin, Kunstgewerbemuseum Staatliche
Museen Preussischer Kulturbesitz,
Inv. 00.639.

Purchased by the museum at the Exposition
Universelle in Paris, 1900.

Bibl: Scheffler 1966, no. 13.

Exh: Paris 1900.

314
Fabric.
Designed by Eugène Gaillard. c. 1899–1900.
Printed white cotton.
146 x 81 (57½ x 31⅞)
Hamburg, Museum für Kunst und Gewerbe,
Inv. 1900.359.

Designed for the walls of the bedroom shown
at S. Bing's pavilion in the Paris Exposition
Universelle, 1900, and purchased there by the
museum.

Bibl: Weisberg 1970, pp. 63–64 illus.

Exh: Paris 1900.

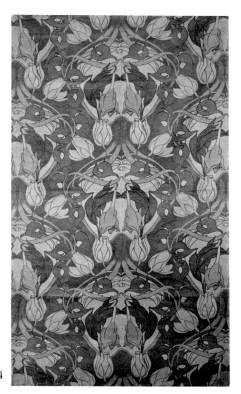

314

315

316
Hairpin.
Lucien Gaillard. c. 1905–1906.
Carved horn with gold in the form of maple seeds.
15.9 x 11.4 (6¼ x 4½)
L. GAILLARD, engraved on pin. French assay mark, stamped on lower gold form.
Paris, Musée des Arts Décoratifs, Inv. 12899.

Bibl: Rheims 1964, pl. 47.

Exh: Paris 1906, Salon SAF; New York 1960, no. 99.

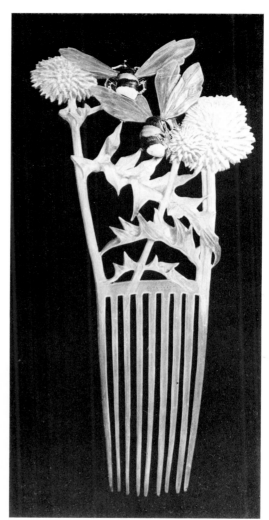

317

316

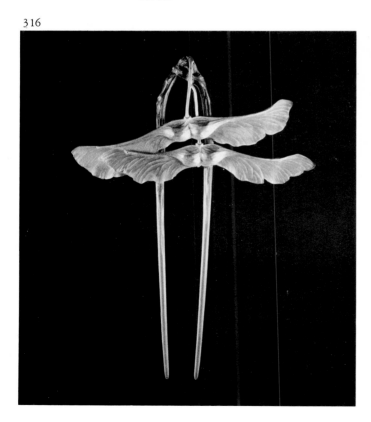

317
Comb.
Lucien Gaillard. c. 1903–1904.
Carved horn; transparent enamel on chased gold.
Height 18 (7⅛)
L. GAILLARD, engraved on bridge above teeth.
Paris, Musée des Arts Décoratifs, Inv. 11322.

Bibl: *L'Art Décoratif* 6 (1904), p. 17 illus.; Rheims 1964, pl. 47; Champigneulles 1972, p. 232 illus.

Exh: Paris 1904, Salon SAF; London 1961, no. 318; Brussels 1965, no. 13; Tokyo 1975, no. 38.

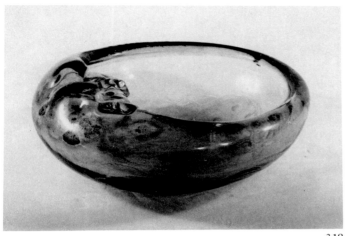

319

Vase with cornflower decoration.
Emile Gallé. c. 1884.
Transparent pale blue glass; polychrome
enamel decoration.
Height 25 (9⅞)
déposé/ Emile Gallé/ à Nancy and *EG* with cross
of Lorraine, engraved on bottom.
Houston, Menil Foundation, Inv. 75–32DJ.

Purchased June 1975 in the flea market of the
place du Jeu de Balles, Brussels. An example of
the first type of vase Gallé designed for
production in series, this vase is also, because
of its pale blue color, one of the *clair de lune*
pieces.

318

318

Lunaria. Bowl.
Emile Gallé. 1883–84.
Transparent pale blue cased glass; yellow and
black sealed oxides; molded, with wheel-cut
decoration.
Diameter 11.5 (4⅜)
Gallé, engraved on bottom. *LUNARIA*,
engraved on rim.
Cologne, Gertrud and Dr. Karl Funke-Kaiser
Collection.

One of the *clair de lune* pieces, whose pale
blue color, achieved with cobalt oxide,
was probably inspired by a Chinese ceramic
glaze of the same name that was reserved for
royal use. The title, *Lunaria,* a reference to
the moon shape of the rim, is also the generic
name of the satinpod plant, a motif which
appears in the decoration. The Victoria and
Albert Museum has a piece whose form is the
same, but whose color and cut decoration are
different (Inv. C278–L926). Two other works
of the same form are known; one of them, from
the collection of Richard Dennis, London,
having neither signature nor decoration,
somehow made its way out of Gallé's workshop
in an unfinished state.

Bibl: Hakenjos 1976, p. 188, no. 105.

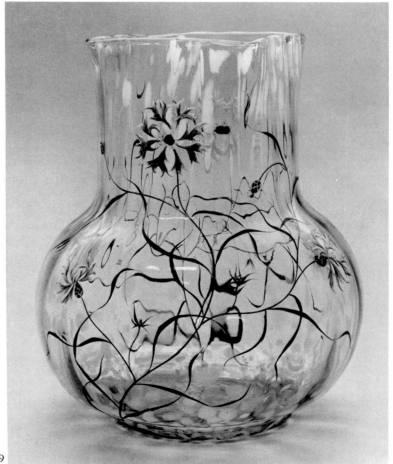

319

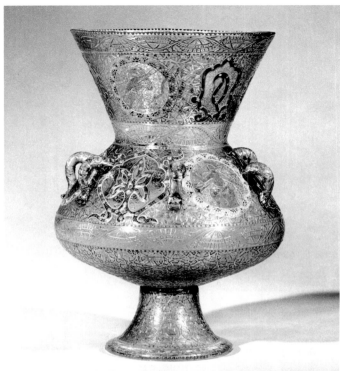

321
Bowl.
Emile Gallé. 1884.
Clear cased glass with sealed black oxides and gold leaves; four applied glass cameos, white and polychrome enamel, and gilt.
Height 7 (2¾)
EM GALLE. NANC. and *EG* with cross of Lorraine, engraved and gilt in one medallion.
Paris, Musée des Arts Décoratifs, Inv. 378.

Purchased from Gallé in 1884, probably at the eighth Exposition des Industries d'Art, *La pierre, le bois de construction, la terre, et le verre*, sponsored by the Union Centrale des Arts Décoratifs and held at the Palais de l'Industrie in Paris. This bowl was one of the works sent by the Musée des Arts Décoratifs to the World's Columbian Exposition in Chicago, 1893.

Bibl: Demoriane 1960, p. 36, fig. 2; Hakenjos 1973, p. 723, no. 86; Bloch-Dermant 1974, p. 56 illus.

Exh: Chicago 1893.

320
Mosque lamp.
Emile Gallé. c. 1884.
Clear glass; etched, enameled, and gilt decoration.
Height 21.6 (8½)
E. Gallé, engraved on rim of base. *E. Gallé Nan* and *E. Gallé Nancy*, engraved on bottom.
The Corning Museum of Glass, Inv. 69.3.9.

An example of Gallé's "Islamic" work from the period after 1882. Here he took his technique of enameling on glass from Arab and Venetian models, and his decorative motifs from Persian miniatures of the 15th and 16th centuries. Such strict adherence to traditional form, rare in Gallé's oeuvre, appears more frequently in the work of Brocard or Auguste Jean.

Bibl: *Journal of Glass Studies* 12 (1970), p. 181 illus.; Hakenjos 1973, p. 724, no. 88.

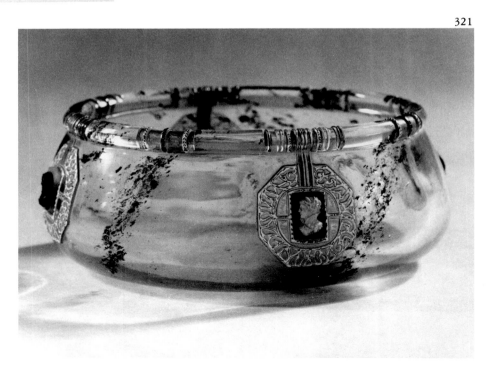

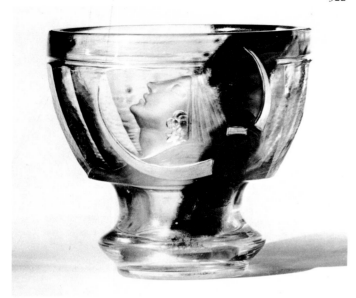

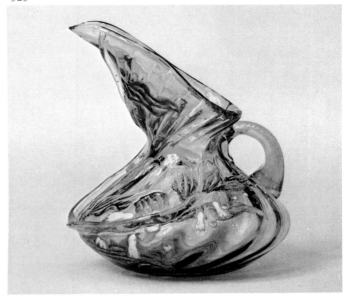

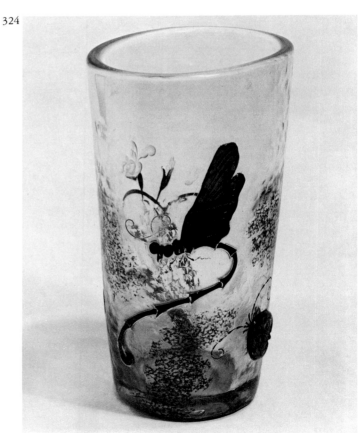

322

La Nuit, le Silence, le Sommeil (Night, Silence, Sleep). Vase.
Emile Gallé. 1884.
Clear cased glass with sealed black oxides;
wheel-cut and engraved decoration.
Height 11.1 (4⅜)
Escalier de Cristal/Paris with *E*, cross of
Lorraine, and *G*, engraved at base. Collection
Magda Taylor, on loan to The Corning
Museum of Glass, Inv. L95.3.60.

The only known variant of a piece shown in
1884 at the eighth Exposition des Industries
d'Art, sponsored by the Union Centrale des
Arts Décoratifs, Paris. The original model,
whose whereabouts are unknown, was
illustrated in the *Revue des Arts Décoratifs* 5
(1884–85), between pages 260 and 261. Its
decoration was surely designed by Victor
Prouvé. His original drawing, also lost, was
reproduced in several periodicals around the
turn of the century.

Bibl: O'Neal 1960, p. 135 illus.; Hakenjos
1973, p. 734, no. 106.

323
Pitcher.
Emile Gallé.
Molded amber glass with blue, green, white, and red enameled decoration.
Height 17.5 (6⅞)
Cristallerie/ Emile Gallé/ Nancy, painted on bottom.
Houston, The Museum of Fine Arts, Inv. 73–150. Gift of J. Brian and Varina Eby.

324
Les Ephémères. Vase.
Emile Gallé. 1887.
Clear cased glass with sealed black oxides, and pieces of colored glass applied to the surface; engraved, wheel-cut, and enameled decoration.
Height 22 (8⅝)
Emile Gallé fect. Nancy in a cartouche, and *EG* with cross of Lorraine, engraved on bottom.
Paris, Musée des Arts Décoratifs, Inv. 3591.

A variant on the theme is illustrated in *L'Art du Verre en France, 1860–1914*, p. 100 (Bloch-Dermant 1974).

Bibl: Marx 1911, opp. p. 232 illus.; Cassou et al. 1962, pl. 42; Dennis 1966, fig. 9; Pevsner 1968, p. 53 illus.; Hakenjos 1973, p. 742, no. 122.

Exh: Paris 1960, no. 921; Tokyo 1975, no. 41.

325
Orphée et Eurydice. Vase.
Emile Gallé. 1888–89. Figures designed by Victor Prouvé.
Clear cased glass with dark red and brownish-black sealed oxides; wheel-cut, engraved, and gilt decoration.
Height 26.5 (10½)
Qvis et me inqvit, miseram, et te perdidit Orphev Qvis tantvs fvror? En itervm crvdelia retro Fata vocant, condit qve natantia lvmina somnvs virg., with crosses of Lorraine, engraved and gilt on band at shoulder. *Ne retournez plus/ En arrière/ Ce serait me perdre deux fois/ et pour toujours*, a crown, and *AE* conjoined, engraved and gilt on body of vase. *Vitrarius faciebat Emil Gallé/ Lotharings. Nanceüs E*, with cross of Lorraine, and *G/ Effigies inv. amicus V - Prouvé/ Nan./ egregius pictor*, and glassmaker's tools, engraved and gilt on bottom.
Paris, Musée des Arts Décoratifs, Inv. 11975.

Bibl: *Gazette des Beaux-Arts* (1889), p. 580 illus.; Henrivaux 1889, p. 179 illus.; Appert and Henrivaux 1894, p. 9, fig. 4; Havard 1894, p. 67 illus.; Henrivaux 1897, p. 613, fig. 368; Henrivaux 1911, p. 585; Rosenthal 1927, fig. 8; Hakenjos 1973, p. 745, no. 128; Bloch-Dermant 1974, p. 77 illus.; Duret-Robert 1974, illus.

Exh: Paris 1889; Paris 1951, no. 774; Paris 1960, no. 922; Paris 1964, no. 500.

325

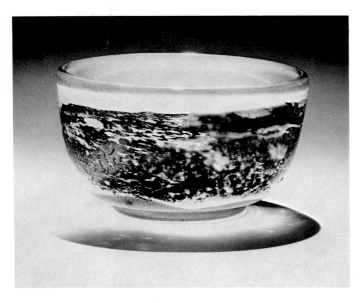

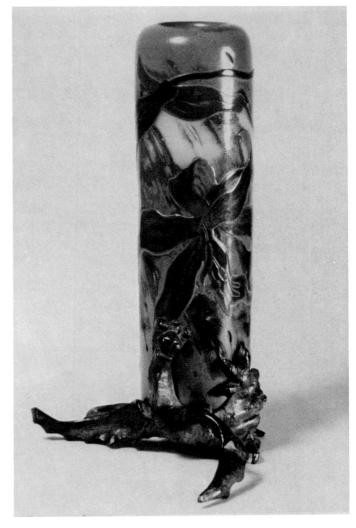

326

La Nature. Bowl.
Emile Gallé. 1899.
Cased glass, amber, creamy yellow, and dark
blue; green-gray marquetry decoration.
Height 14 (5½)
Gallé, engraved on side.
The Corning Museum of Glass, Inv. 54.3.33.

An almost identical bowl is in the collection of
Robert Walker, Paris; still another version,
illustrated in Pazaurek 1901, p. 87, was
exhibited at the 1900 Exposition Universelle
and at Dresden in 1901. The prototype, a
larger bowl now in the Musée de la Ville de
Cognac (Inv. 40.1.24), was also shown at the
Exposition Universelle. These bowls are rare
examples of an abstract tendency in Gallé's
works. The source of their decoration is most
evident in the large bowl at Cognac: there,
inspired by Jules Michelet's *La Mer* (1861) and
La Montagne (1867), Gallé used mottled and
stained inclusions to represent earth, sea, and
sky, the three spheres of the physical world.
The ambiguous shapes in marquetry are
intended as general symbols of human and
animal life.

327

Lilium martagonum (Turk's-cap Lily).
Mounted vase.
Vase by Emile Gallé. c. 1895.
Cased glass, light and dark red on transparent
green, with white passages; etched and
wheel-cut decoration; mounting in bronze.
Height 20 (7⅞)
Cristallerie de Gallé, etched on bottom. *Modèle*
et décor déposé, engraved on bottom.
Chrysler Museum at Norfolk, Inv. GEFG.
70.7.

An example of Gallé's *demi-riche* line, a series of
limited editions of vases, flacons, bowls, and
plates, all with similar decoration. Such pieces
are found in public and private collections all
over the world.

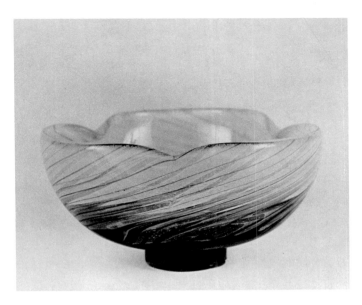

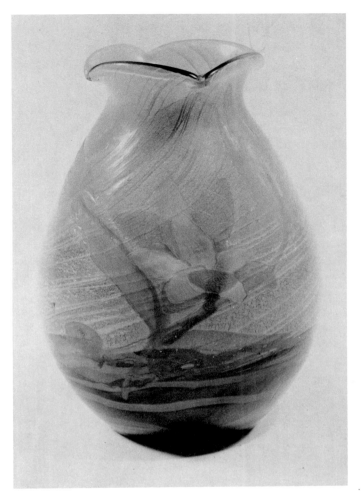

328
Bowl.
Emile Gallé. c.1898.
Cased glass, white, violet, red, and green;
sealed irregular threads and ribbons.
Height 7 (2¾)
Gallé, engraved on side.
Kunstmuseum Düsseldorf, Collection
Hentrich, Inv. P1970–205.

Bibl: Grover 1970, no. 232 illus.; Hilschenz
1973, no. 199 illus.

Exh: Düsseldorf 1963, no. 86; Munich 1964,
no. 813.

329
Narcisse (Daffodil). Vase.
Emile Gallé. 1900.
Cased glass with sealed threads in amber,
yellow, blue, and green; marquetry decoration
in white, yellow, and pink; wheel-cut
decoration.
Height 25 (9⅞)
G——, engraved on side. *L. C. Tiffany Favrile
3761,* engraved on bottom.
Mr. and Mrs. James Caldwell.

Gallé's signature has been erased and a
fraudulent Tiffany signature added. A similar
piece, made for the 1900 Exposition
Universelle and exhibited at Dresden the
following year, is illustrated in Pazaurek 1901,
p. 86.

330
Vase.
Emile Gallé. 1897.
Cased glass, opaque yellow and amethyst, with lower layers of brown and green drawn up in threads toward the top; marquetry and wheel-cut decoration.
Height 11.5 (4½)
Gallé Etude, engraved and gilt on side.
Kunstmuseum Düsseldorf, Collection Hentrich, Inv. P1970–202.

Bibl: *Deutsche Kunst und Dekoration* 3 (1898–99), p. 143 illus.; Grover 1970, no. 303 illus.; Hilschenz 1973, no. 200 illus.

Exh: Düsseldorf 1963, no. 82; Munich 1964, no. 810; Munich 1969, no. 75.

331
Les douleurs passées (Bygone Sorrows). Vase.
Emile Gallé. 1900.
Cased black and clear glass with sealed gold and platinum leaves; marquetry decoration in yellow, brown, violet, and dark blue; wheel-cut and engraved decoration; some mat areas.
Height 14 (5½)

Les feuilles des douleurs passées/ Maurice Maeterlinck, engraved at top. *Gallé,* engraved on bottom.
Kunstmuseum Düsseldorf, Collection Hentrich, Inv. P1970–213.

Another version is in a private collection in Paris (Bloch-Dermant 1974, p. 63 illus.). A third version, now lost, was purchased in 1900 at the Exposition Universelle for the Museum für Kunst und Gewerbe, Hamburg (Inv. 1900.329). All three are examples of Gallé's *verres parlants,* or "talking glass," which he introduced in 1884 at an exhibition sponsored by the Union Centrale des Arts Décoratifs. The vase shown here should be seen as a symbol of *vanitas,* of the impermanence of earthly things. Gallé, who thought of himself as a Symbolist working in glass, greatly admired Maeterlinck's poetry and used it frequently on his glass after 1892, when the Belgian poet's works first appeared in Paris.

Bibl: Grover 1970, no. 325 illus.; Hakenjos 1973, no. 211 illus.; Hilschenz 1973, no. 220 illus.

Exh: Munich 1969, no. 66.

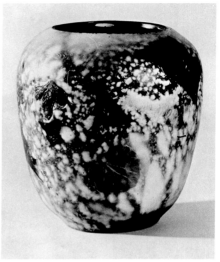

331

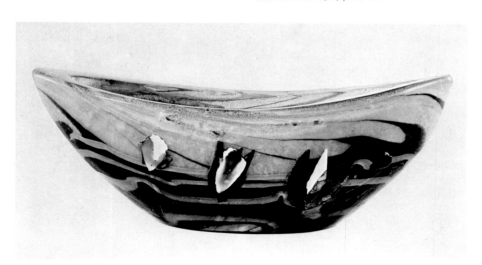

330

332
Africana. Mounted vase.
Vase by Emile Gallé. 1900. Mounting
designed by Lucien Bonvallet and executed at
Cardeilhac. 1901.
Glass with polychrome marquetry decoration
and *patinage* (texturing); mounting in silver.
Height 35 (13¾)
AFRICANA, engraved on neck. *Mais nous
luttons/ Esprits/ Nous vaincrons/ Bien nous même/
Victor Hugo*, engraved on side.
Exposn 1900/ Oeuvre de Gallé, engraved at base,
Master's mark, French assay mark, and
CARDEILHAC/ PARIS, stamped on bottom
of mounting.
Paris, Musée des Arts Décoratifs, Inv. 27982.
Bequest of Raymond Koechlin, 1931.

Part of Gallé's entry to the Exposition
Universelle in Paris, 1900; the purchaser
commissioned the mounting in 1901. The vase
was broken on loan in 1972 and repaired the
following year by Jean Michel André.

Bibl: Demaison 1902, p. 201 illus.

Exh: Paris 1900; Tokyo 1968b, no. 213;
Munich 1972, no. 1232.

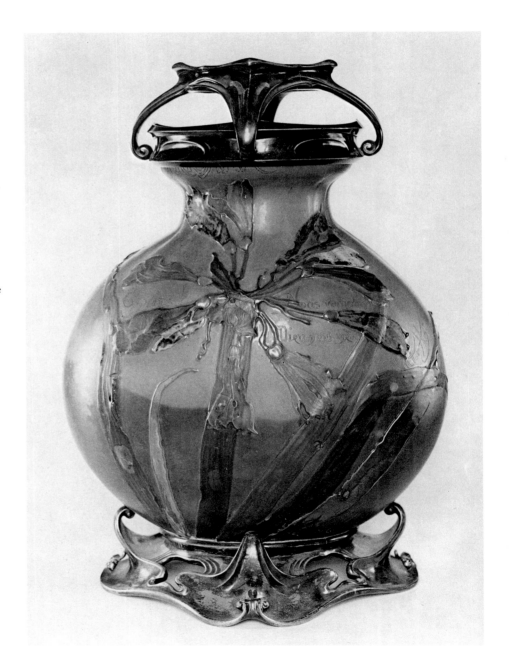

333

Cattleya. Vase.
Emile Gallé. 1900.
Transparent glass, partially cased with brown,
gray-green, and red glass; sealed oxides;
applications and wheel-cut decoration.
Height 22 (8⅝)
Gallé, engraved on side.
Cologne, Gertrud and Dr. Karl Funke-Kaiser
Collection.

A characteristic example of Gallé's *verres
sculptés,* or sculpted glass. The prototype was
designed for the 1900 Exposition Universelle;
several other versions, differing from this one
in color and applied ornament, are known
today. All have decoration in the form of the
cattleya, a type of orchid.

Bibl: Hakenjos 1976, no. 187.

Exh: Hanover 1969.

334

La Vérité (Truth). Lamp.
Emile Gallé. c. 1900.
Light green and orange cased glass with sealed
white threads; bronze base.
Height 43 (17)
La vérité s'allumera comme une lampe, in relief
around bottom of stem. *Gallé,* engraved on
stem. *Gallé,* on bottom of base.
Brussels, L'Ecuyer.

As a passionate Dreyfusard, Gallé wrote
articles for the Paris and Nancy newspapers
between 1898 and 1901, and even carried on
the campaign for justice in his works in glass.
The vase shown here bears the inscription
"Truth will shine forth like a lamp"; others
from this period read "We shall rise, at last, to
the light," "Idea, thou shalt not be
extinguished," and "Love the Idea in all its
aspects, Power, Truth, Liberty, Peace, Justice,
Innocence."

Bibl: Gallé 1900, p. 333 illus.; Grover 1970,
no. 224 illus.

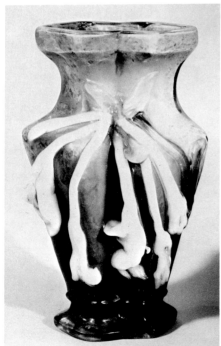

333

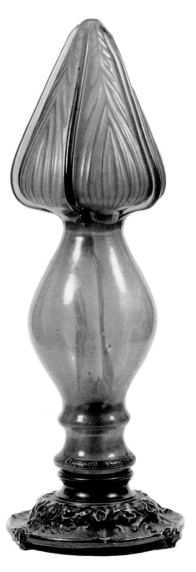

334

335
L'Hippocampe (The Seahorse). Vase.
Emile Gallé. 1901.
Modeled cased glass, green, brown, red, and amber; applications; surface partially oxidized.
Height 19 (7½)
Joseph Reinach Emile Gallé 1901 in a cartouche, engraved on bottom. *vitam impendere Vero,* engraved on side.
Paris, Musée des Arts Décoratifs, Inv. 24556.
Bequest of Joseph Reinach, 1925.

As one of the founders of the Ligue des Droits de l'Homme in Nancy, Gallé was in constant contact with the leading personalities of the pro-Dreyfus movement, among them Emile Zola, Louis Havet, and Joseph Reinach. Reinach, a writer and a politician, was secretary of the Dreyfusards and published a chronicle of the affair in several volumes. In tribute to his efforts Gallé presented him with the vase shown here, inscribed with an appropriate quotation from Juvenal.

Bibl: Rheims 1964, pl. 39.

Exh: Munich 1972, no. 1200; Tokyo 1975, no. 46.

336
Vase.
Emile Gallé. 1899.
Cased yellow glass with sealed oxides in gray-white, blue, and green; marquetry and wheel-cut decoration.
Height 28 (11)
Etude/Gallé 1899, engraved on bottom.
BENI SOIT LE COIN SOMBRE OV S'ISOLE MON COEUR, around the base.
Paris, Musée des Techniques, Conservatoire National des Arts et Métiers, Inv. 13398–2.
Gift of Emile Gallé, 1901.

A vase of similar form but with decoration of lily of the valley is illustrated in Bloch-Dermant 1974, pp. 88, 116.

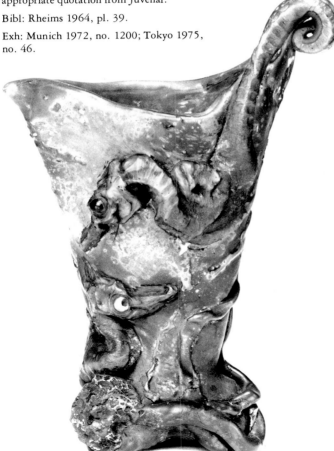

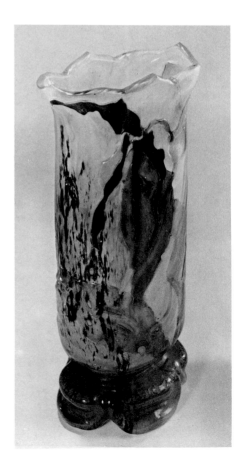

337
Dragonfly vase.
Emile Gallé. 1904.
Cased opaque white glass with marbling;
applications in brown, blue, and yellow;
wheel-cut decoration.
Height 20 (7⅞)
Paris, Musée des Techniques, Conservatoire
National des Arts et Métiers, Inv. 13815.

Bibl: Henrivaux 1905, p. 125 illus.; *Catalogue Officiel* 1908, p. 273; Henrivaux 1911, p. 585; *La Nature* 31 (1913), p. 211, fig. 6; Polak 1962, fig. 8a; Hakenjos 1973, p. 825, no. 285; Bloch-Dermant 1974, p. 84 illus.

338
Les Iris ou Flambe d'eau. Vase.
Emile Gallé. 1900.
Polychrome cased glass with sealed oxides;
applications and wheel-cut decoration.
Height 39.2 (15⅜)
Gallé, engraved on side.
Paris, Musée des Techniques, Conservatoire
National des Arts et Métiers, Inv. 13398–1.

The prototype, made for the Exposition
Universelle of 1900, is now in the Musée de
l'Ecole de Nancy. Two other versions are
known today, one in a private collection,
Frankfurt, the other in the Gertrud and Dr.
Karl Funke-Kaiser Collection, Cologne
(Hakenjos 1976, no. 183).

Bibl: *Catalogue Officiel* 1908, p. 273; Rosenthal 1927, pl. 10.

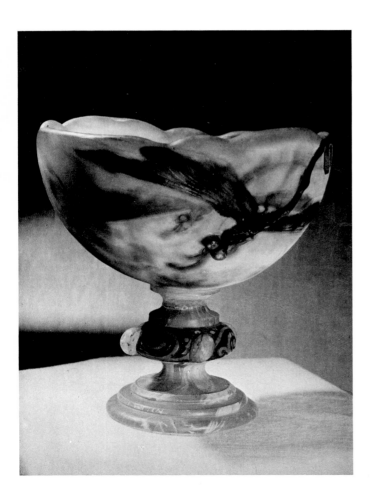

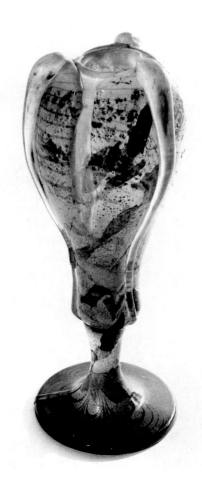

339
Vase.
Emile Gallé.
Glazed earthenware with painted polychrome
decoration.
Height 14.6 (5¾)
Em Galle/ Fayenceri/ Nancy, painted on bottom.
Houston, private collection.

340
Table.
Emile Gallé. 1900.
Wood with marquetry decoration of water
plants, after a theme of Maurice Bouchor.
73.7 x 100.3 x 52.1 (29 x 39½ x 20½)
*Emile Gallé. La musique de l'eau, des feuilles et du
ciel. Maurice Bouchor. L'exposition 1900,* inlaid
on bottom tier.
Mr. and Mrs. James Caldwell.

A table called *A fleur d'eau*, with the same
decoration but slightly different form, was
illustrated in *Revue des Arts Décoratifs*
21 (1901), p. 10.

339

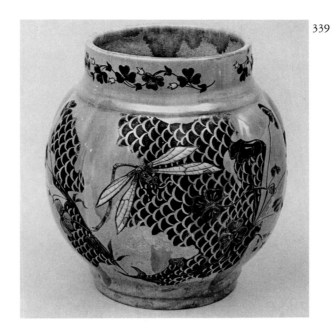

340

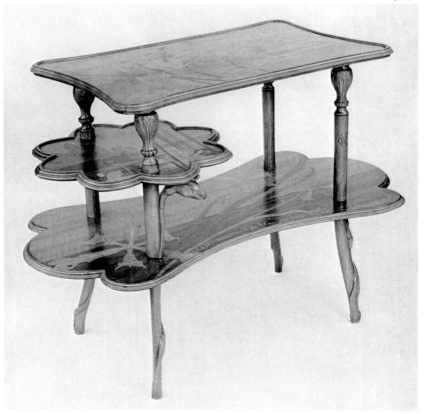

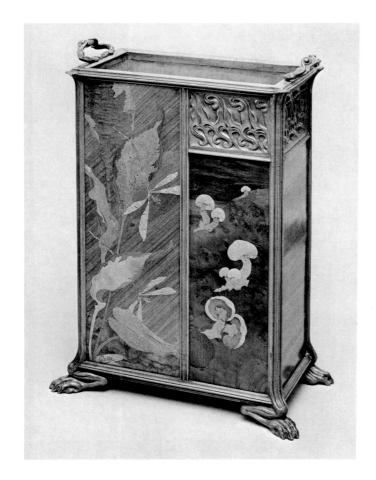

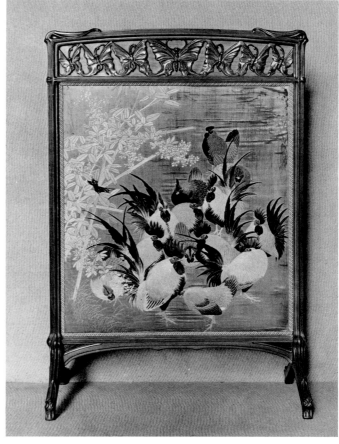

341
Umbrella stand.
Emile Gallé.
Wood with marquetry decoration; bronze
handles.
74.8 x 53.2 x 26.6 (29⅜ x 21 x 10½)
Gallé, inlaid at lower left of front.
Houston, private collection.

342
Fire screen.
Emile Gallé. c. 1901–1902.
Walnut and embroidered silk.
121.5 x 80.5 (47⅞ x 31⅝)
Paris, Musée des Arts Décoratifs, Inv. 41827.
Gift of the heirs of Mme. Chardin, 1968.

Part of the furnishings of the residence of
Edouard Hannon, 1 avenue de la Jonction,
Brussels.

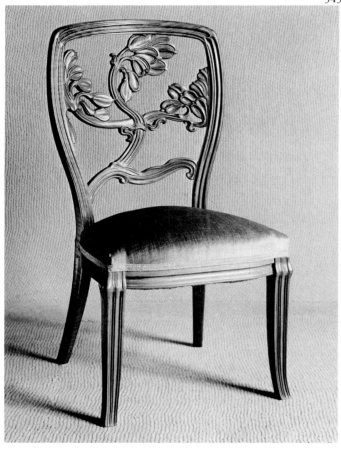

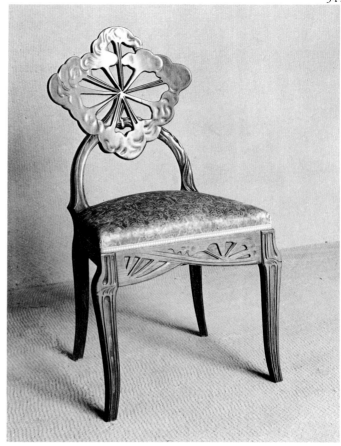

343
Dining-room chair.
Emile Gallé. c. 1901–1902.
Walnut; pink plush upholstery.
102.5 x 50 x 47 (40⅜ x 19⅝ x 18½)
Gallé, carved on left rear leg.
Paris, Musée des Arts Décoratifs, Inv. 41807.
Gift of the heirs of Mme. Chardin, 1968.

One of a set of twelve from the residence of
Edouard Hannon, 1 avenue de la Jonction,
Brussels. For symmetry, the design of the back
was reversed on half the chairs.

Bibl: *L'Art Décoratif* 5 (1903), p. 212 illus.

Exh: Paris 1903, Salon SNBA.

344
Side chair.
Emile Gallé. c. 1902.
Beechwood; upholstered in cut velvet, pale
yellow on pale pink.
95 x 48 x 43 (37⅜ x 18⅞ x 16⅞)
Gallé, carved on left rear leg.
Paris, Musée des Arts Décoratifs, Inv. 41824.
Gift of the heirs of Mme. Chardin, 1968.

From the residence of Edouard Hannon, 1
avenue de la Jonction, Brussels. Gallé took the
decoration of this chair and its matching settee
and footstool from a Japanese sword-guard
with an umbel motif (Charpentier 1972,
p. 131). Another copy, now in the Musée de
l'Ecole de Nancy, was exhibited at the
Exposition Ecole de Nancy (Paris 1903) as part
of a suite of bedroom furniture with umbel
decoration.

Bibl (similar examples): Leroy 1903, p. 177
illus.; Mannoni 1968, p. 8 illus.; Charpentier
1972, p. 131 illus.

Exh: Paris 1903, Salon SNBA (similar
example); Tokyo 1975, no. 48.

345
Pitcher.
Paul Gauguin. 1886–87.
Red stoneware with slip decoration; brown glaze and gold highlights.
Height 16.5 (6½)
Paris, Musée des Arts Décoratifs, Inv. 16983.
Bequest of Ernest Chaplet, 1910.

Exhibited at the Exposition Universelle of 1900 with the following notice: "Paul Gauguin—a pitcher with relief decoration, executed by M. Chaplet, 1887, belonging to M. Chaplet." But the clumsy execution suggests that it was in fact modeled by Gauguin and merely fired by Chaplet.

Bibl: Bodelsen 1959, p. 333, fig. 6; Bodelsen 1960, pp. 17, 33n, 36n; Gray 1963, pp. 16–20, p. 145 illus.; Charpentier 1964, p. 30 illus.; Brunhammer 1964, p. 30 illus.; Rheims 1964, pl. 71.

Exh: Paris 1900; Paris 1910, no. 179; Paris 1960, no. 960; Paris 1964, no. 480.

346
Vase with Breton scenes.
Paul Gauguin, on a form by Ernest Chaplet. 1886–87.
Chocolate-colored stoneware; decoration in colored glazes with incised outlines and lines in gold.
Height 28.8 (11⅜)
P Go, in gold on lower edge of decorated zone. A rosary (Chaplet's mark) and *21*, impressed on bottom.
Brussels, Musées Royaux d'Art et d'Histoire, Inv. 6756.

Purchased at the Salon de la Libre Esthétique in Brussels, 1896. Gray (1963, p. 158) considers the decorative technique a refinement of Deck's *émaux cloisonnés*: the forms are outlined with a greasy resist and filled in with colored glazes.

Bibl: Berryer 1944; Bodelsen 1959, pp. 324–44; Gray 1963, pp. 158–59 illus.; Schmutzler 1964, figs. 118–19; Verdier 1968, p. 46; Bossaglia 1972, p. 61 illus.

Exh: Brussels 1896, no. 77; New York 1960, no. 113; Brussels 1962; London 1966b; Saint-Gilles 1973; Brussels 1975.

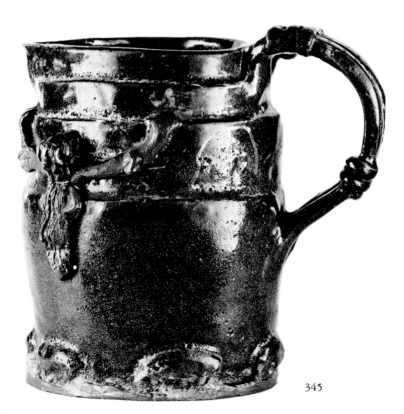

345

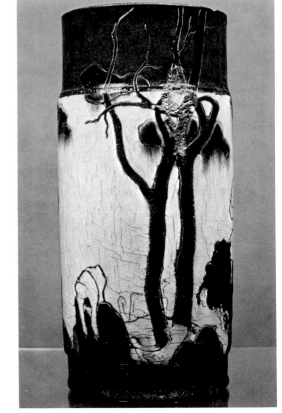

346

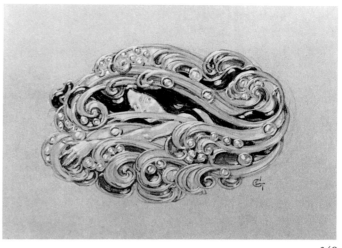

348

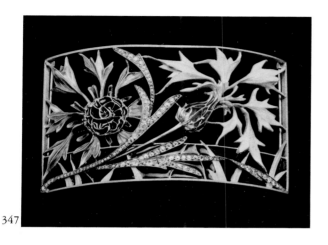

347

349

347
Buckle for a dog-collar necklace.
L. Gautrait. c. 1900.
Gold, enamel, and diamonds.
4.4 x 7.6 (1¾ x 3)
L. GAUTRAIT, engraved on back. French
assay mark, stamped at top.
New York, private collection.

348
Design for a brooch.
Eugène Grasset. c. 1899.
Watercolor and pencil on paper.
17.8 x 22.6 (7 x 8⅞)
Grasset's monogram, lower right.
New York, Cooper-Hewitt Museum of
Design, Smithsonian Institution,
Inv. 1954–41–1.

Bibl: Bénédite 1900b, p. 70 illus.; Steingraber
1956, no. 333 illus.

Exh: Syracuse 1964.

349
Poésie. Design for a pendant.
Eugène Grasset. Before 1900.
Watercolor, white gouache, and pencil on gray
paper.
32.5 x 25 (12⅞ x 9⅞)
New York, Cooper-Hewitt Museum of
Design, Smithsonian Institution,
Inv. 1958–13–1.

Grasset's design was executed by Maison
Vever; see cat. no. 498.

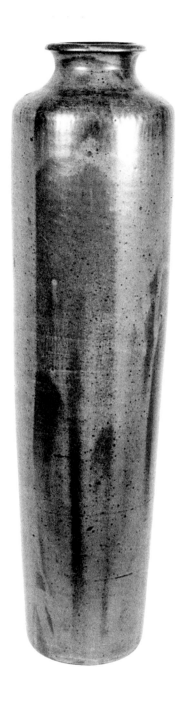

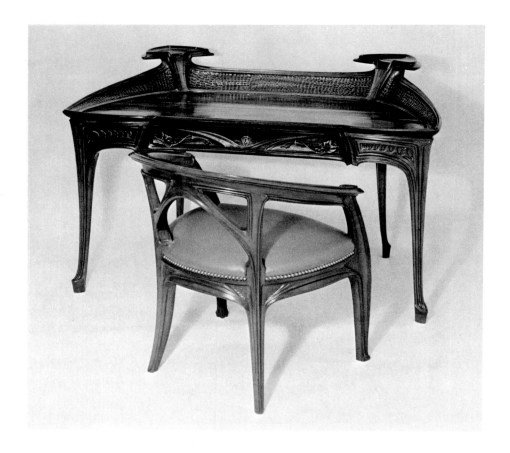

350
Vase.
Emile Grittel.
Stoneware; red-brown and olive-brown glaze.
Height 69.9 (27½)
E. Grittel, painted in black on bottom. *g*,
incised on bottom.
Private collection.

351
Desk and chair.
Jacques Gruber.
Mahogany; bronze fittings and leather
upholstery.
Desk: 94 x 134 x 80 (37 x 52¾ x 31½)
Chair: 80 x 78 x 54 (31½ x 30⅜ x 21¼)
Jacques Gruber/Nancy, on top of desk.
Sydney and Frances Lewis Collection.

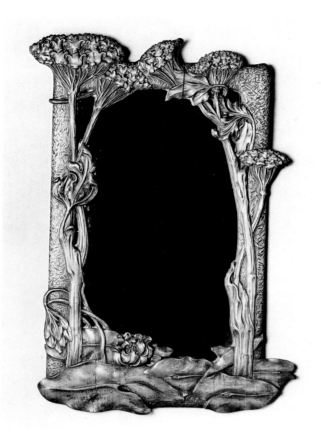

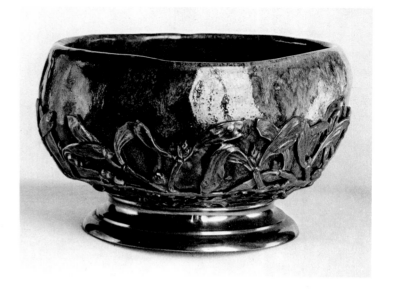

352
Mirror.
Jacques Gruber.
Wood and glass.
99 x 66 (39 x 26)
Jacques Gruber, incised lower left.
Paris, private collection.

353
Mounted bowl.
Chinese; mounting by Maurice Guerchet.
Hand-built stoneware with green glaze;
mounting in silver gilt.
Height 6.8 (2⅜)
Master's mark, French assay mark, and
GUERCHET/30/Bard MALESHERBES.
stamped on base of mounting.
Paris, Musée des Arts Décoratifs, Inv. 8717.

Exh: Munich 1972, no. 1235.

354

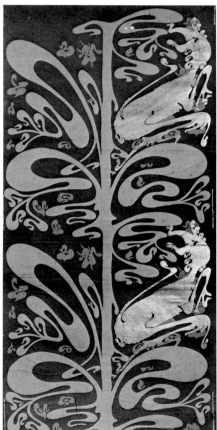

356
Wallpaper.
Designed by Hector Guimard. c.1896.
Printed; turquoise, yellow, pale salmon, and ocher on salmon ground.
83 x 50 (32¾ x 19¾)
Paris, Bibliothèque Forney.

Printed by Le Mardelé, Paris; intended for the bedrooms of the Castel Béranger.

Bibl: *Castel Béranger*, pl. 41.

Exh: Paris 1967, no. 382; New York 1970, no. 53; Paris 1971b, no. 116; Münster 1975, no. 26b.

355

354
Design for a stool.
Hector Guimard. 1894.
Pencil on paper.
55 x 71 (21⅝ x 28)
Hotel de Mr Jassedé, across top. *Tabouret Gr d'Exécution*, lower left. *15 aout 94/ Hector Guimard*, lower right.
Paris, Musée des Arts Décoratifs.

Designed for the Hôtel Jassedé, 41 rue Chardon-Lagache, Paris, which was built in 1893. The diagonal supporting element, a principle Guimard also used in his facade for the Ecole du Sacré-Coeur in Paris (1895; cat. no. 612), was taken directly from Viollet-le-Duc's *Entretiens sur l'architecture*.

Exh: Paris 1971b, no. 185; Münster 1975, no. 4.

355
Wallpaper.
Designed by Hector Guimard. c.1896.
Printed; ocher, white, and gold on blue-gray ground.
102 x 50 (41⅛ x 19⅝)
Paris, Bibliothèque Forney.

Printed by Le Mardelé, Paris; intended for the anterooms of the Castel Béranger.

Bibl: *Castel Béranger*, pl. 37; Soulier and Soulier 1899, p. 43.

Exh: Paris 1967, no. 381; New York 1970, no. 52; Paris 1971b, no. 115; Münster 1975, no. 26a.

357
Wallpaper.
Designed by Hector Guimard. c. 1896.
Printed; gray, dark green, and ocher on
earth-yellow ground.
75 x 50 (29½ x 19⅝)
Paris, Bibliothèque Forney.

Printed by Le Mardelé, Paris; intended for the
dining rooms of the Castel Béranger.

Bibl: *Castel Béranger*, pl. 47; Boileau 1899,
p. 129 illus.

Exh: Paris 1967, no. 383; New York 1970,
no. 54; Paris 1971b, no. 117; Münster 1975,
no. 26c.

358
Wallpaper.
Designed by Hector Guimard. c. 1896.
Printed; ocher red, ocher, and olive green on
glossy lime ground.
98 x 50 (38½ x 19⅝)
Paris, Bibliothèque Forney.

Printed by Le Mardelé, Paris. Possibly
intended for the Castel Béranger.

Exh: Paris 1967, no. 384; New York 1970,
no. 56; Paris 1971b, no. 118; Münster 1975,
no. 26d.

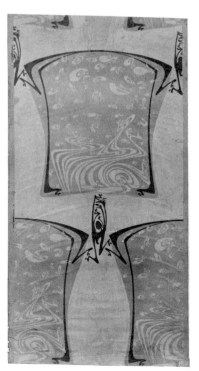

358

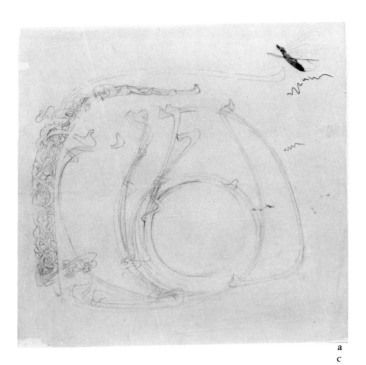

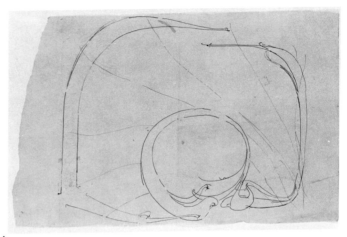

a

b

c

d

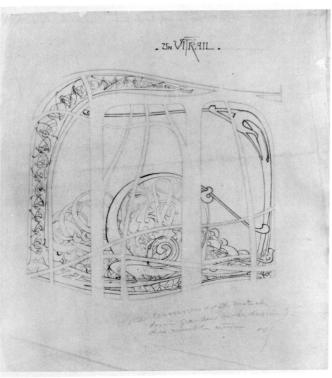

. Un VITRAIL .

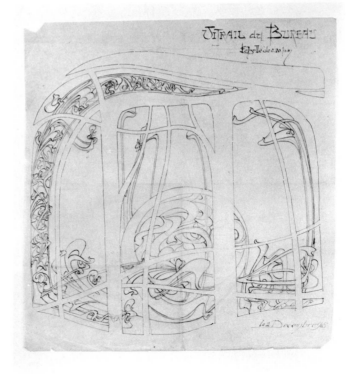

VITRAIL du BUREAU

232

e

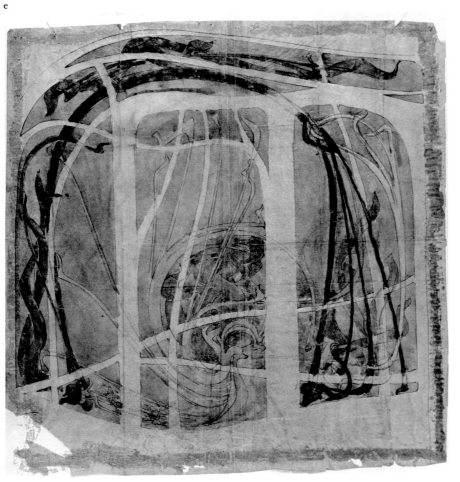

359
Five studies for a stained-glass panel.
Hector Guimard. 1898.
a) Pencil on tracing paper.
42 x 43.3 (16½ x 17⅛)
b) India ink and red ink on tracing paper.
31 x 46 (12⅛ x 18⅛)
c) Pencil, india ink, red and green ink on
tracing paper.
53 x 47 (20⅞ x 18½)
UN VITRAIL, above. *me commencer de suite des/
dessin grandeur sur le dessin Gr/ du meuble même*,
lower right. Signature illegible.
d) Pencil, india ink, and blue ink on tracing
paper.
40 x 37.8 (15¾ x 14⅞)
VITRAIL DE BUREAU./ Echelle de 0.20 p.m.,
above. *Le 2 Décembre 98*, lower right.
e) Pencil, red ink, and watercolor on tracing
paper, mounted on heavy paper.
39.6 x 38.5 (15⅞ x 15⅛)
Paris, Musée des Arts Décoratifs.

Studies for the panel of a door which separated
the vestibule and the design studio in
Guimard's office suite in the Castel Béranger.

Exh: Paris 1971b, no. 142; Münster 1975,
no. 23.

a

b

c

234

360
Five studies for a detail of a stained-glass panel.
Hector Guimard. c. 1898.
a) Pencil on tracing paper.
16.5 x 17 (6½ x 6¾)
b) Pencil, india ink, and blue ink on tracing
paper.
19 x 15 (7½ x 5⅞)
c) Pencil on tracing paper.
20.8 x 21 (8⅛ x 8¼)
d) Pencil, india ink, and blue ink on tracing
paper.
17 x 17 (6¾ x 6¾)
A, at top.
e) Pencil on tracing paper.
20.8 x 30 (8¼ x 11¾)
Paris, Musée des Arts Décoratifs.

Sketches for the central motif of the preceding
window design; mounted together.

Exh: Paris 1971b, no. 143; Münster 1975,
no. 24.

d

e

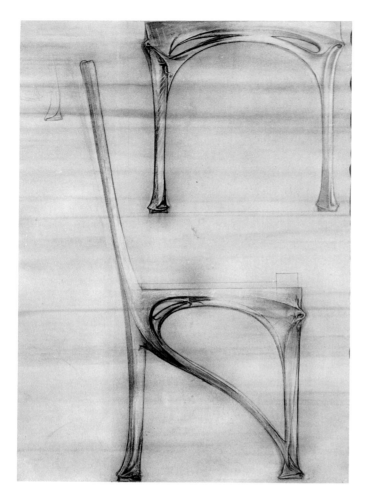

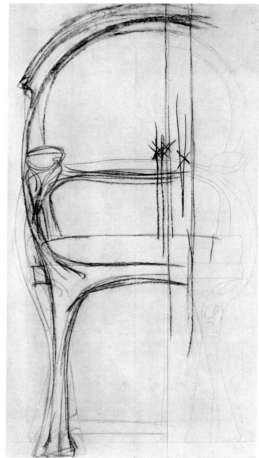

361
Design for a side chair.
Hector Guimard. c. 1899.
Pencil, charcoal, and chalk on heavy paper.
110 x 75 (43⅜ x 29½)
Paris, Musée des Arts Décoratifs.

Designed for the Maison Coilliot, Lille.

Exh: New York 1970, no. 43; Paris 1971b,
no. 205; Münster 1975, no. 44.

362
Design for an armchair.
Hector Guimard. c. 1899–1900.
Pencil and charcoal on heavy paper.
100 x 54 (39⅜ x 21¼)
Paris, Musée des Arts Décoratifs.

Designed for the Maison Coilliot.

Exh: New York 1970, no. 39; Paris 1971b,
no. 203; Münster 1975, no. 42a.

363
Fireplace and buffet [photograph exhibited].
Designed by Hector Guimard. c. 1899–1900.

Still in the Maison Coilliot, Lille, for which
they were designed. The enormous buffet, in
fruitwood with panels of enameled glass,
surrounds a fireplace of blue and yellow glazed
lava.

Bibl: Fabre 1901, p. 287, p. 300 illus.

Exh: Paris 1971b, no. 201; Münster 1975, no.
40.

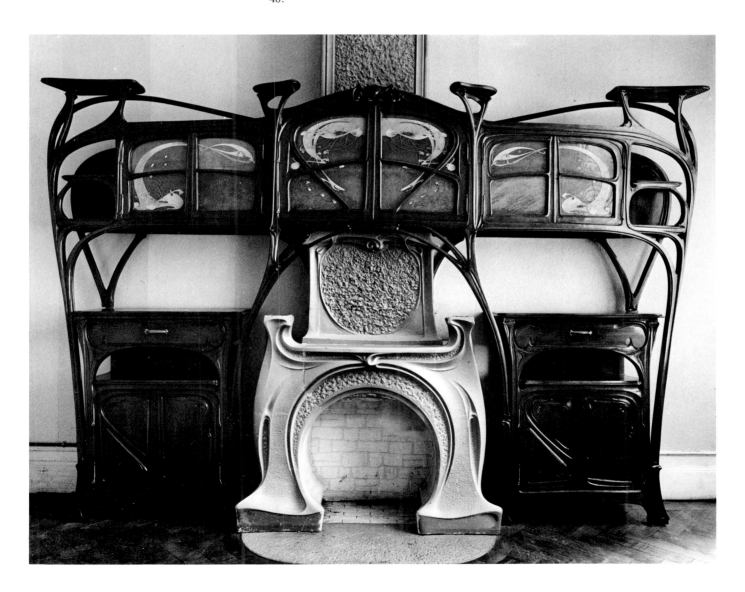

364
Upholstery.
Designed by Hector Guimard. c.1898–1900.
Printed moleskin.
24 x 45.5 (9½ x 17⅞)
Paris, Blondel and Plantin Collection.

Used to cover the back of one of the seats in the
Humbert de Romans Concert Hall (cat. no.
617). After that building's demolition, about
forty of the seats sold for salvage were installed
in a movie theater in the French provinces,
where they remained until the recent
destruction of the theater. The cast-iron frames
for the seats were the same as those shown in
Guimard's *Fontes Artistiques* (cat. no. 700).

365
Vase.
Designed by Hector Guimard. Before 1902.
Bronze with brown patina.
Height 14.5 (5¾)
Guimard's monogram, near base. *R.C.* twice
and *309*, stamped on bottom.
Paris, Mme. Robert Walker.

366
Studies for three friezes and two panels.
Hector Guimard. 1902.
Watercolor and gouache on five pieces of
paper, mounted together on heavy brown
paper with outlines in yellow watercolor.
61 x 48.6 (24 x 19⅛)
1902, upper right of mounting, masked by
frame.
Paris, Musée des Arts Décoratifs, Inv.
CD2694. Gift of Mme. Hector Guimard,
1948.

Probably mounted by Guimard.

Exh: New York 1970, no. 63; Paris 1971b,
no. 124; Münster 1975, no. 77.

367
Design for a fireplace.
Hector Guimard. c. 1903.
Pencil, charcoal, and chalk on paper.
107 x 109 (42⅛ x 42⅞)
Tout le côté rustiqué La ligne délimite une partie
moins rustiquée *pour permettre d'arriver à une*
surface unie, down left side. *Lave/ Mettre une*
tablette, upper right. *0.375*, center. *Vide 0.75*,
lower right.
Paris, Musée des Arts Décoratifs.

Executed in lava with a central panel of glazed
stoneware, this fireplace is still in situ in the
Maison Coilliot, Lille.

Exh: New York 1970, no. 12; Paris 1971b,
no. 210; Münster 1975, no. 48.

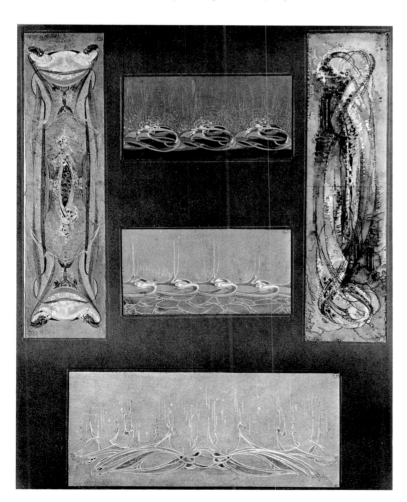

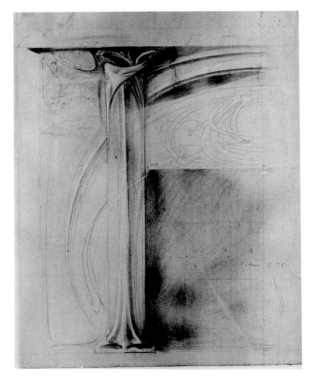

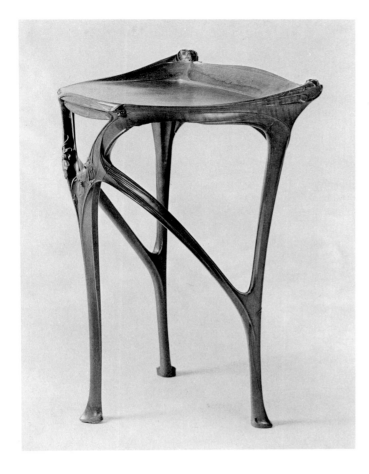

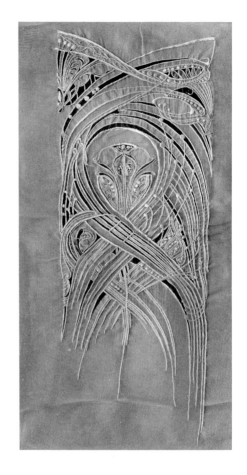

368
Side table with sliding tablet.
Designed by Hector Guimard. c. 1904–1907.
Pear wood.
76 x 53 x 46 (29⅞ x 20⅞ x 18⅛)
Hector Guimard, incised on top.
Paris, Musée des Arts Décoratifs, Inv.
32650. Gift of Mme. Pézieux on behalf of
Mme. Léon Nozal, 1937.

Part of the furnishings designed by Guimard
for the Hôtel Nozal. Guimard himself kept a
similar table, unsigned, which is now in the
collection of the Museum of Modern Art, New
York.

Bibl: Madsen 1956, p. 380 illus.; Schmutzler
1964, fig. 271; Brunhammer 1964, p. 165,
fig. 7; Brunhammer 1966b, p. 127; Huyghes
and Rudel 1969, p. 159, fig. 512; Blondel and
Plantin 1970, p. 38 illus.

Exh: Zürich 1952; Paris 1964, no. 171;
Ostende 1967, no. 103; New York 1970, no.
32; Paris 1971b, no. 229; Münster 1975, no.
95; Tokyo 1975, no. 55.

369
Dress ornament.
Designed by Hector Guimard.
Cream-colored silk tabby; machine embroidery
in white and ivory silk; parts of design painted
light tan with black details.
68.6 x 45.7 (27 x 18)
New York, The Metropolitan Museum of Art,
Inv. 49.85.11. Gift of Mme. Hector
Guimard, 1949.

370
Standing frame with photograph of Guimard.
Designed by Hector Guimard. 1907.
Silvered brass.
26.5 x 17 (10½ x 6¾)
Hector Guimard 1907, lower right of frame.
New York, Cooper-Hewitt Museum of
Design, Smithsonian Institution,
Inv. 1956–76–6A,B. Gift of Mme. Hector
Guimard, 1956.

Exh: New York 1960, no. 126; New York
1969; New York 1970, no. 35.

371
Cane [photograph exhibited].
Designed by Hector Guimard. c. 1909.
Wood and silver.
Formerly in the collection of Alain Blondel and
Yves Plantin. Stolen from an exhibition in
1975.

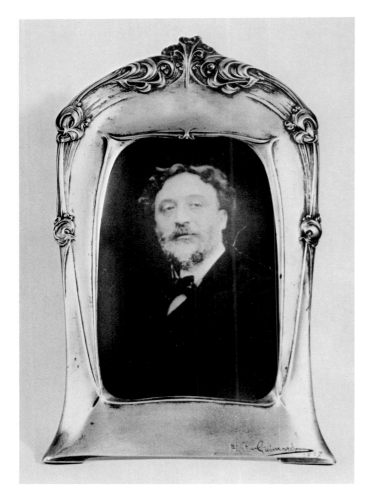

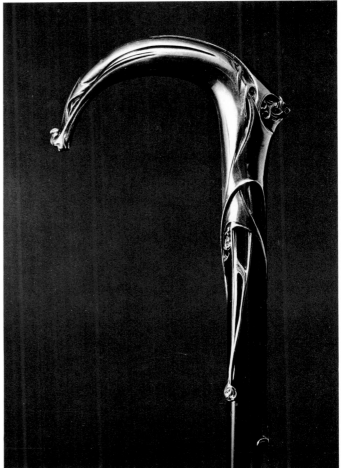

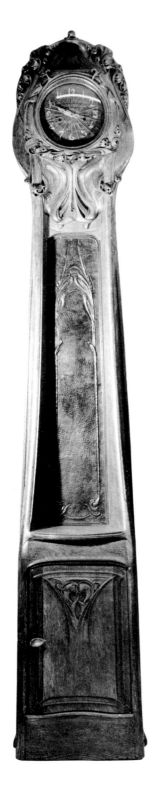

372
Grandfather clock.
Designed by Hector Guimard. 1910.
Wood and copper.
239 x 43.2 x 22.9 (94⅛ x 17 x 9)
Hector Guimard, 1910, at base.
New York, Lillian Nassau.

It was sometimes Guimard's practice when he designed furniture to have two copies made of each piece. One he would sign and date; the other, unsigned, he would keep for himself. His copy of the piece shown here was among the furnishings of his home at 122 avenue Mozart. It was later given by Mme. Guimard to the Musée des Arts Décoratifs in Paris (Inv. 36080).

Bibl (unsigned version): Gelbert 1910, p. 333; Lenning 1951, no. 50; Brunhammer 1964, p. 165, fig. 9; Barilli 1966, p. 92, p. 93 illus.; Mannoni 1968, p. 52 illus.; Blondel and Plantin 1970, p. 34 illus.; Graham 1970, p. 22 illus.

Exh (unsigned version): Paris 1910, Salon SAD; Paris 1960, no. 982; Brussels 1963a, no. 420; Paris 1971b, no. 242.

373
Side chair.
Designed by Hector Guimard. c. 1912.
Cherry; plush upholstery.
111 x 45 x 43 (43¾ x 17¾ x 17)
New York, The Museum of Modern Art, Inv. 312.49. Gift of Mme. Hector Guimard, 1949.

From Guimard's house, 122 avenue Mozart; probably part of the bedroom furnishings.

Bibl: Drexler and Daniel 1959, p. 12, p. 13 illus.

Exh: New York 1970, no. 47; Paris 1971b, no. 232.

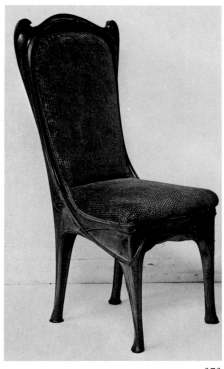

373

374
Chair.
Designed by Paul Hankar. c. 1900.
Oak, walnut, and leather.
113 x 58 x 48 (44½ x 22⅞ x 18⅞)
Ghent, Museum voor Sierkunst, Inv. 812.

According to Marcel Wolfers, this chair was one of a pair Hankar designed for the villa he built at La Hulpe for Philippe Wolfers (c. 1898–1900).

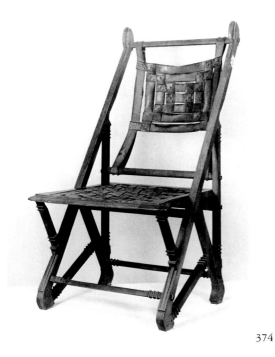

374

375
Design for a detail of a dining-room table.
Paul Hankar. 1898.
Watercolor and pencil on heavy paper.
75 x 118.5 (29½ x 46⅝)
Brussels, Musées Royaux d'Art et d'Histoire,
Bibliothèque, Hankar doc. 83813.

Part of the furniture made for the residence of
Henri Renkin, 138 rue de la Loi, Brussels. The
house, built by Hankar, was demolished in
1962 and the furniture was dispersed.

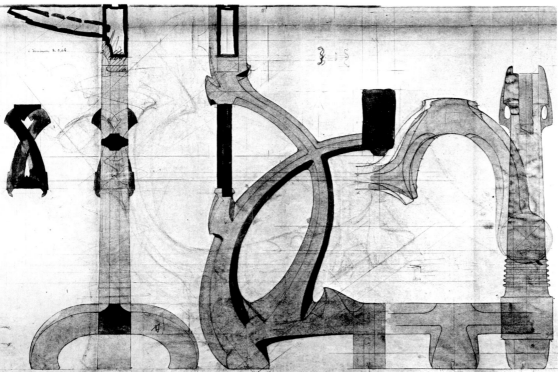

375

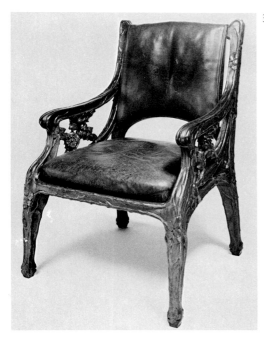

376

376

Armchair.
Georges Hoentschel. c. 1899–1900.
Carved Algerian sycamore; original pigskin
upholstery.
102 x 55 x 65 (40⅛ x 21⅝ x 25⅝)
Paris, Musée des Arts Décoratifs, Inv. 9405.

One of an ensemble of four armchairs and a
large table—furnishings for the Salon du Bois
in the pavilion of the Union Centrale des Arts
Décoratifs at the Exposition Universelle of
1900. For the Salon du Bois Hoentschel
designed paneling, built-in vitrines, and
furniture, all executed in Algerian sycamore,
with carved decoration inspired by the
branches and flowers of the wild rose. Most of
the woodwork and furnishings are now
installed in the Salle 1900 of the Musée des
Arts Décoratifs, Paris; the rest are in the
Museum für Kunst und Gewerbe, Hamburg.

Bibl: *Art et Décoration* 8 (1900), p. 30 illus.;
Revue des Arts Décoratifs 21 (1901), p. 8 illus.;
Olmer 1927, pl. 17; Devinoy and Jarry 1948,
pl. 336; Madsen 1956, p. 385 illus.;
Brunhammer 1966b, p. 163; Mannoni 1968,
p. 15 illus.; Sterner 1975, p. 49, p. 48 illus.

Exh: Paris 1900; Paris 1933, no. 1027; Zürich
1952; Paris 1960, no. 104; Tokyo 1968a,
no. 77; Tokyo 1975, no. 59.

377

Vase.
Georges Hoentschel.
Stoneware with tool marks; green overflow
glaze on yellow and ocher ground; gold touches
at the neck and on the handles.
Height 9.2 (3⅝)
Hoentschel's monogram, impressed on
bottom.
Paris, Musée des Arts Décoratifs, Inv. 10202.

Acquired from the artist, 1902. Both this vase
and the following one take their form from the
Japanese tea caddy. The gold, here used purely
ornamentally, was also inspired by Japanese
ceramics, in which gold was used for repair.

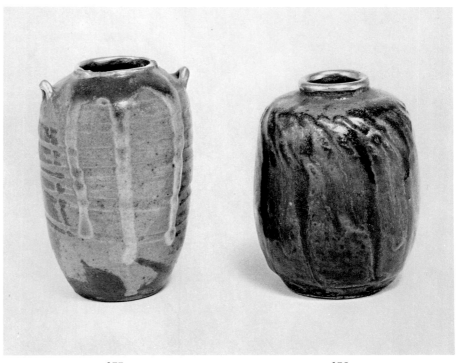

377 378

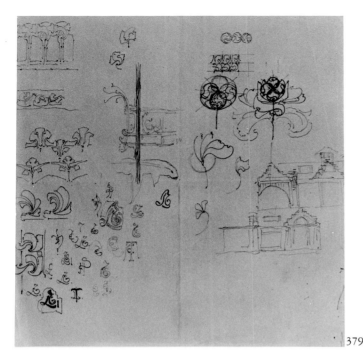 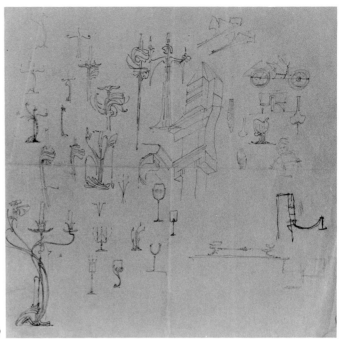

379

378
Vase.
Georges Hoentschel.
Stoneware with incised decoration; green and
brown overflow glaze on yellow ground; gold
touches at the neck.
Height 8.4 (3¼)
Hoentschel's monogram, impressed on
bottom. *G*, incised on bottom.
Paris, Musée des Arts Décoratifs, Inv. 10198.

Acquired from the artist, 1902.

379
Sketches of candelabra, architectural details,
and an automobile.
Victor Horta.
Pencil on paper, recto and verso.
22.2 x 21.2 (8¾ x 8⅜)
Brussels, L. Wittamer–de Camps.

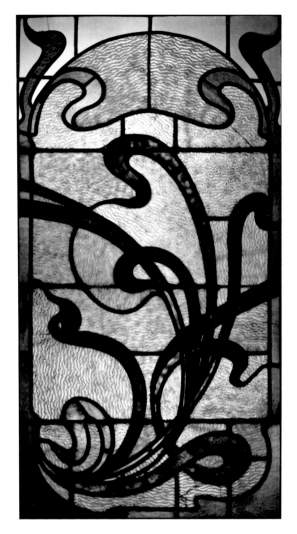

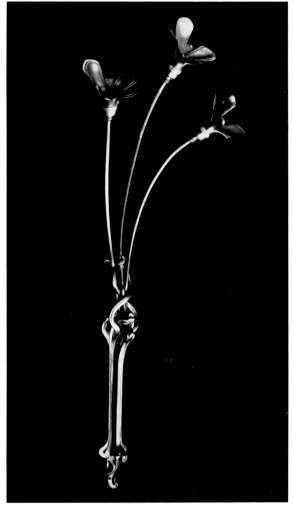

380
Panel of a stained-glass window.
Designed by Victor Horta. 1894.
Lead; yellow, red, and opaline white stained glass.
102.2 x 52.1 (40¼ x 20½)
Brussels, L. Wittamer—de Camps.

Originally in the Frison residence, Brussels, built by Horta in 1894.

Also illustrated in color.

381
Wall lamp from the entryway to the Hôtel Solvay.
Designed by Victor Horta. c. 1894.
Gilt bronze.
Height 128.5 (50⅝)
Brussels, L. Wittamer—de Camps.

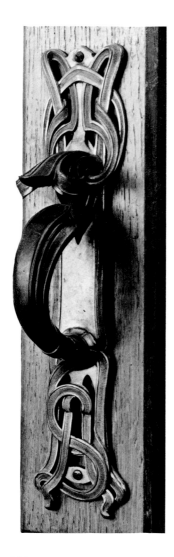

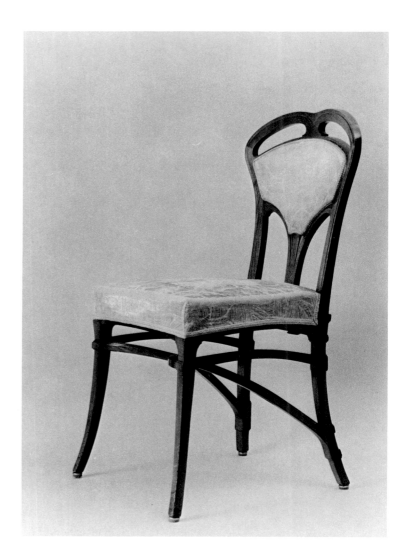

382
Door latch.
Designed by Victor Horta. c. 1894.
Chased and gilt bronze.
28 x 6.5 x 6 (11 x 2½ x 2⅜)
13, stamped on back.
Brussels, L. Wittamer–de Camps.

From the Hôtel Solvay; Armand Solvay's initials are incorporated in the design of the plaque.

383
Side chair.
Designed by Victor Horta. c. 1894.
Mahogany; original upholstery of silk velvet.
88 x 41 x 44.5 (34⅜ x 16⅛ x 17½)
Brussels, L. Wittamer–de Camps.

Part of a suite of furniture from the living room of the Hôtel Solvay.

384
Side chair.
Designed by Victor Horta. c. 1894.
Fruitwood; original upholstery of blue and
yellow velvet brocade in a peacock design.
92.5 x 44.5 x 44 (36⅜ x 17½ x 17⅜)
Brussels, L. Wittamer—de Camps.

Part of a suite of two side chairs, four
armchairs, and two settees from the living
room of the Hôtel Solvay.

385
Photograph stand.
Designed by Victor Horta. c. 1895–1900.
Gilt bronze.
145.5 x 49.5 x 48 (47¼ x 19½ x 18⅞)
Brussels, L. Wittamer—de Camps.

Part of the furnishings designed for the Hôtel
Solvay.

Bibl: Rheims 1964, pl. 70; Borsi and
Portoghesi 1969, pl. 65.

Exh: New York 1960, no. 141; Ostende 1967,
no. 112.

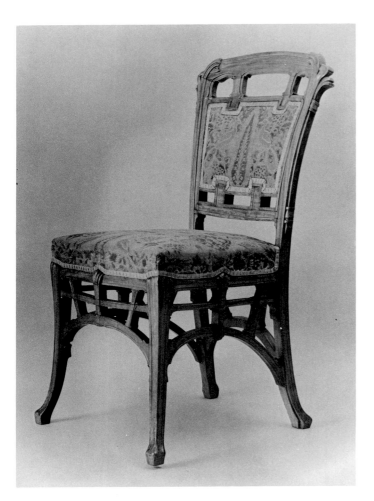

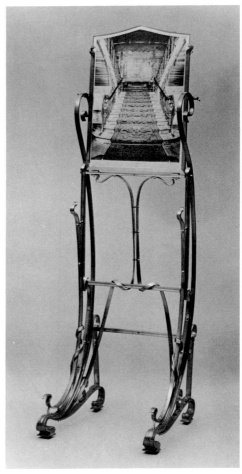

386
Design for a stained-glass window.
Victor Horta. 1895.
Ink and colored pencil on tracing paper.
10.2 x 18.5 (4 x 7¼)
*Vitrail formant Lambrequin/ au Château de La
Hulpe*, lower left. *68*, upper left. *1895/ Victor
Horta*, lower right.
Brussels, L. Wittamer–de Camps.

Intended for the Château Solvay at La Hulpe,
for which Horta designed some renovations.

387
Study for a balustrade of a staircase.
Victor Horta. 1896.
Pencil and india ink on tracing paper.
7.8 x 23.6 (3⅛ x 9⅜)
*1896/ Rampe d'escalier/ Hôtel de M.W./ à
Bruxelles*, center.
Brussels, L. Wittamer–de Camps.

Study for the Hôtel Winssinger. Today only
the facade of this residence remains as it was
built. This drawing was a gift from Horta to
Sander Pierron, whose widow later presented it
to M. and Mme. Wittamer–de Camps.

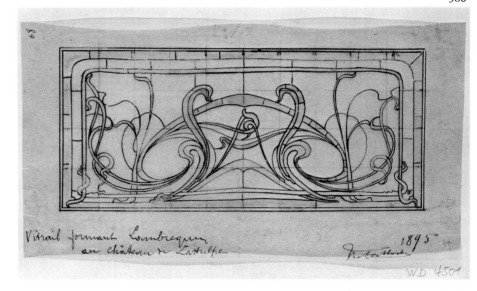

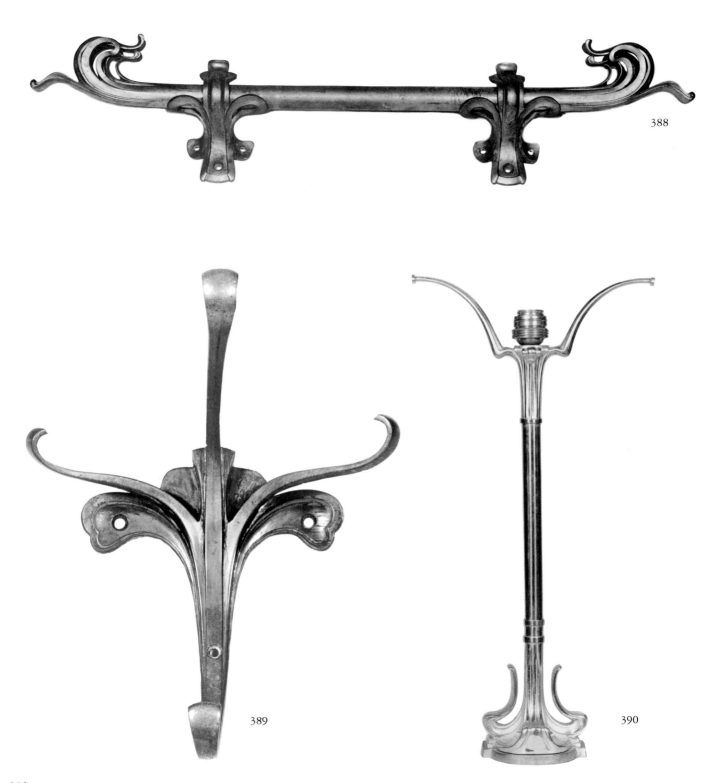

388

389

390

250

388
Bar for hanging paintings.
Designed by Victor Horta. c. 1898–1900.
Chased and gilt bronze.
11.7 x 59.2 (4⅝ x 23⅜)
Brussels, Jean Delhaye.

A detail from Horta's home, 25 rue
Américaine, Brussels. Horta installed such
bars in the houses he designed so that holes
would not have to be made in the painted
canvas which covered the walls.

389
Coat hook.
Designed by Victor Horta. c. 1898–1900.
Gilt bronze.
Height 26 (10¼)
Brussels, Jean Delhaye.

Made for Horta's own residence at 25 rue
Américaine, Brussels.

390
Lamp base.
Designed by Victor Horta. c. 1898–1900.
Bronze, recently regilt.
Height 49.8 (19⅝)
Brussels, Jean Delhaye.

One of the table lamps from Horta's own
residence, 25 rue Américaine, Brussels.

391
Armchair.
Designed by Victor Horta. c. 1901–1902.
Maple; recently reupholstered.
99.5 x 64.5 x 54.2 (39¼ x 25⅜ x 21⅜)
Brussels, L. Wittamer–de Camps.

Made for the Esposizione Internazionale d'Arte
Decorativa Moderna at Turin. This chair
remained in Horta's personal collection.

Exh: Turin 1902.

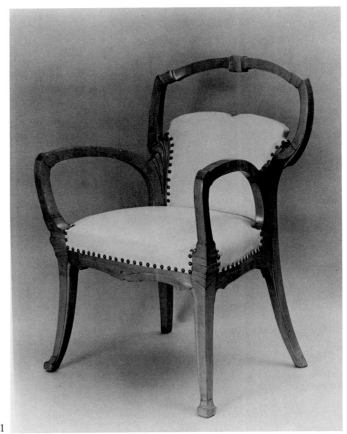

391

392

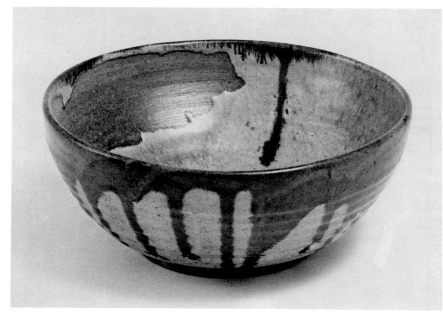

392
Bowl.
Paul Jeanneney. c. 1899.
Stoneware; gray glaze with blue overflows.
Height 7.3 (2⅞)
Jeanneney, incised on bottom.
Paris, Musée des Arts Décoratifs, Inv. 9334.

Acquired from the artist at the Exposition Universelle, 1900.

Exh: Paris 1900.

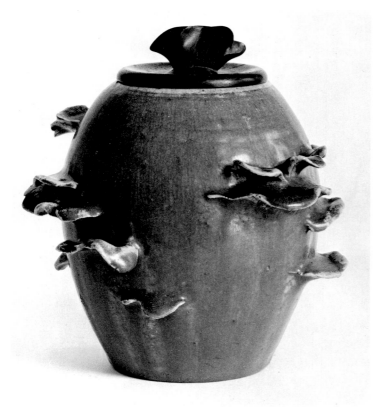

393

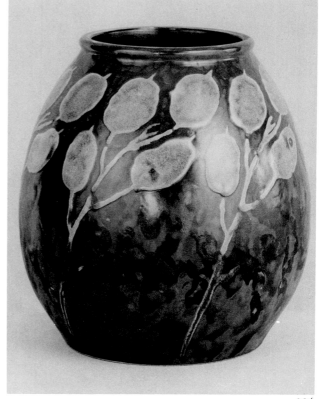

394

393
Covered jar.
Paul Jeanneney. Before 1897.
Stoneware with relief decoration in the form of
bracket fungi; chamois-colored glaze; wooden
top.
Height 16.5 (6½)
Paris, Galerie du Luxembourg.

Sold in 1920 at the Jeanneney estate sale,
Saint-Amand-en-Puisaye.

Bibl: Soulier 1897, p. 90 illus.

394
Satinpod vase.
Kéramis.
Stoneware, glazed green and blue on brown
ground; mustard-yellow slip decoration.
Height 17.5 (6⅞)
Grès/Kéramis/D652/D, incised on bottom
900, impressed on bottom.
Ghent, Museum voor Sierkunst, Inv. 1487.

395
Table lamp with concealed inkwell.
Charles Korschann.
Gilt bronze.
Height 48.3 (19)
Charles Korschann—Paris in a circle, and *Arts/
Louchet/Ciseleur* in a circle, stamped on back of
base.
Sydney and Frances Lewis Collection.

Exh: Richmond 1971, no. 79.

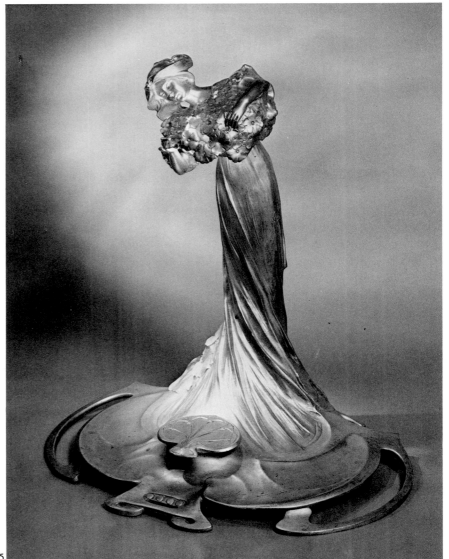

395

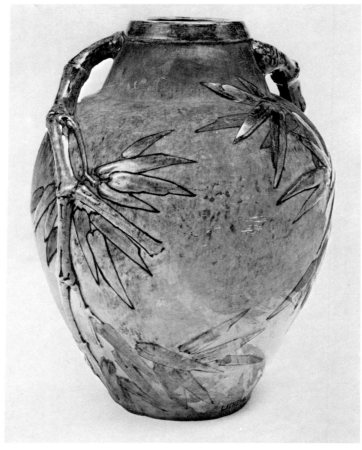

396

396
Vase.
Edmond Lachenal. c. 1893–94.
Earthenware with relief decoration; painted underglaze decoration in blue, black, and white; mat surface in some places as a result of application of acid to the overglaze.
Height 35.5 (14)
LACHENAL, painted at base. LACHENAL GT, impressed on bottom.
Paris, Musée des Arts Décoratifs, Inv. 7991.

Purchased from the artist, 1894. A similar piece was shown at the World's Columbian Exposition in Chicago, 1893. This vase was part of the group sent by the Musée des Arts Décoratifs to the Louisiana Purchase Exposition in St. Louis, 1904.

Bibl: *Revue des Arts Décoratifs* 14 (1893–94), p. 325 illus.; *Revue des Arts Décoratifs* 15

(1894–95), p. 6 illus.; *Revue des Arts Décoratifs* 16 (1895–96), opp. p. 370 illus.; *Revue des Arts Décoratifs* 17 (1897), p. 371 illus.; *Revue des Arts Décoratifs* 20 (1900). p. 217 illus.

Exh: Paris 1900; St. Louis 1904; Paris 1960, no. 1023.

397
Iris bracelet.
René Lalique. c. 1897.
Gold, opal sections, and violet champlevé enamel; five sections.
Length 17.8 (7)
LALIQUE, stamped near clasp. Master's mark and French assay mark, stamped on clasp.
New York, private collection.

The pencil and gouache design (private collection, Paris) has the sections arranged in a different order.

Bibl: Marx 1899, p. 16 illus.; Bénédite 1900a, p. 243 illus.; Rücklin 1901, vol. 2, pl. 168.2; Vever 1908, p. 707 illus.; Barten 1973, no. 1239.

Exh: Paris 1897, Salon SAF; New York 1967.

398
Dryad among Willows. Pendant.
René Lalique. c. 1897–98.
Gold; champlevé and plique-à-jour enamel.
8 x 5.7 (3⅛ x 2¼)
LALIQUE, stamped on bottom left edge.
New York, private collection.

The original design, now lost, was published in *Art et Décoration* in 1899 (Marx 1899, p. 20 illus.).

399
Pendant.
René Lalique. c. 1897–98.
Gold; white and green enamel; blue
plique-à-jour enamel.
5.7 x 3.8 (2¼ x 1½)
LALIQUE, stamped on bottom edge.
New York, private collection.

The pencil and ink design for this piece (Paris,
private collection) also shows the chain
designed to accompany it.

Exh: New York 1967.

Also illustrated in color.

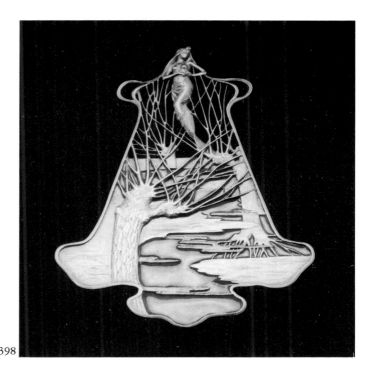

398

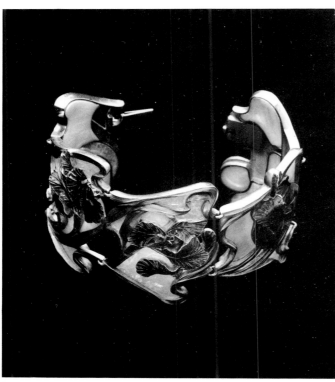

397

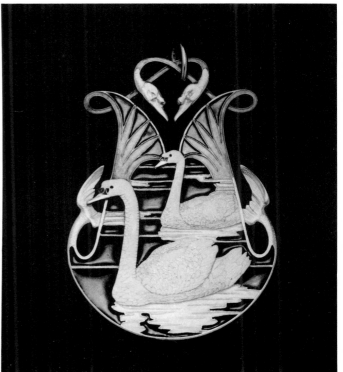

399

255

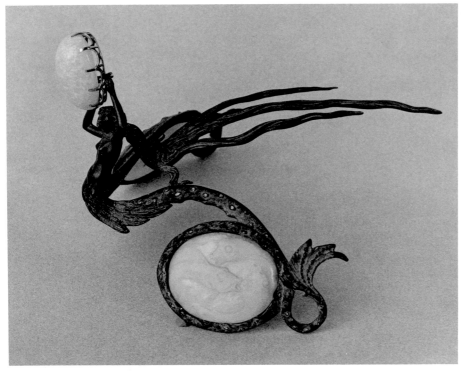

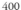

401
Sylphide. Buckle for a dog-collar necklace.
René Lalique. c. 1897–98.
Gold, plique-à-jour enamel, and diamonds.
5 x 8 (2 x 3¼)
LALIQUE, stamped at top.
New York, private collection.

Later converted to a brooch.

Exh: New York 1967.

400
Diadem.
René Lalique. c. 1897–98.
Bronze with green patina; emerald cabochons;
two opals carved in low relief; one large opal
cabochon in a gold setting.
Height 14.9 (5⅞)
LALIQUE, stamped on back.
Paris, Musée des Arts Décoratifs, Inv. 34374.
Gift of the Comte de Ganay in memory of the
Comtesse de Behague, 1939.

Bibl: Vever 1898, p. 173; Bénédite 1900a,
pp. 204–205 illus.; Riotor 1903, p. 59;
Barilli 1966, fig. 27; Barten 1973, no. 12;
Sterner 1975, p. 56, p. 59 illus.

Exh: Paris 1960, no. 1036; Munich 1964,
no. 940; Brussels 1965, no. 59.

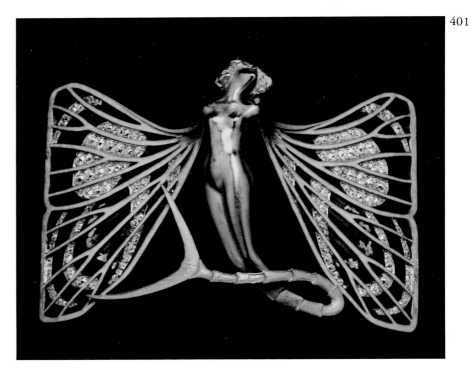

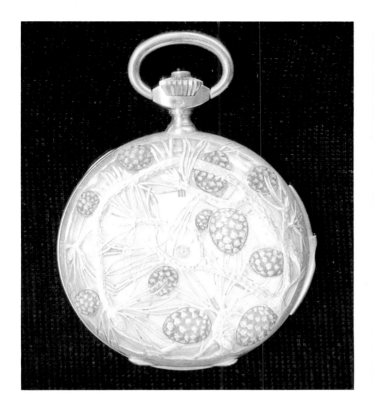

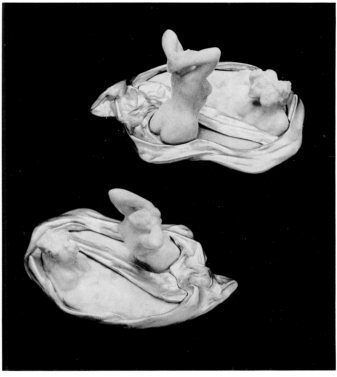

402
Case for a pocket watch.
René Lalique. c. 1898–1900.
Chased gold; pale blue plique-à-jour enamel
and dark green enamel.
Diameter 5.3 (2⅛)
French assay mark, stamped on winding crown
and on inside.
Paris, Musée des Arts Décoratifs, Inv. 9370.

Purchased from the artist in 1900 at the
Exposition Universelle, Paris.

Bibl: Ernstyl 1900, p. 118 illus.; Bénédite
1900a, p. 239 illus.; Bouyer 1901a, p. 40
illus.; Vever 1908, p. 718 illus.; Rheims
1964, pl. 44; Barten 1973, no. 1494.

Exh: Paris 1900; London 1961, no. 515;
Brussels 1965, no. 56; Amersfoort 1972, no.
48; Tokyo 1975, no. 61.

403
Les Baigneuses (The Bathers). Brooch.
René Lalique. c. 1899.
Gold and ivory.
Length 5.7 (2¼)
LALIQUE, stamped on bottom.
New York, private collection.

Exh: New York 1967.

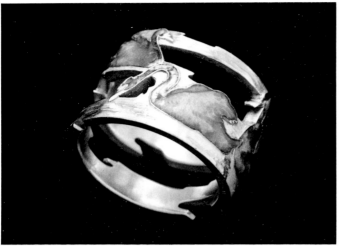

404

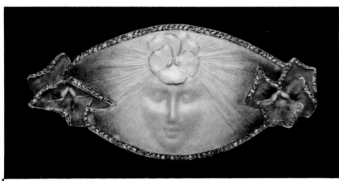

405

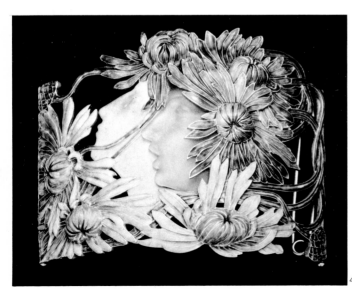

406

404
Ring.
René Lalique. c. 1898–99.
Gold; blue and white champlevé enamel.
Diameter 2 (¾)
LALIQUE, stamped on bottom.
New York, private collection.

The design for this ring was illustrated in *Art et Décoration* 6 (1899), p. 20.

Bibl: Bénédite 1900a, p. 201 illus.; Henri and Magne 1922, p. 159, fig. 101; Barten 1973, no. 1298.

Exh: New York 1967.

405
La Pensée (The Pansy/ The Thought). Brooch.
René Lalique. c. 1899–1901.
Gold, blue enamel, and diamonds.
2.7 x 5.7 (1⅛ x 2¼)
LALIQUE, stamped on bottom edge.
New York, private collection.

A variant version, executed as a pendant, is in a private collection, Paris.

Exh: New York 1967.

Also illustrated in color.

406
Narcisse. Buckle for a dog-collar necklace.
René Lalique. c. 1899–1900.
Gold, enamel, and molded glass.
6 x 7.6 (2⅜ x 3)
LALIQUE, stamped on bottom edge.
New York, private collection.

A similar buckle showing a single profile surrounded by thorn-apple flowers rather than chrysanthemums was illustrated in the *Gazette des Beaux-Arts* (1901), plate preceding p. 80.

Exh: New York 1967.

407
Bacchanale. Parasol handle.
René Lalique. c. 1899–1901.
Carved bone and gold.
Height 10.8 (4¼)
LALIQUE, engraved on top of handle. Master's
mark, stamped on arm of figure.
New York, private collection.

Recently converted to a seal. Another almost
identical version is in the Museu Caluste
Gulbenkian, Lisbon (Inv. 1161).

Bibl: Poppenberg 1903, no. 495.

Exh: New York 1967.

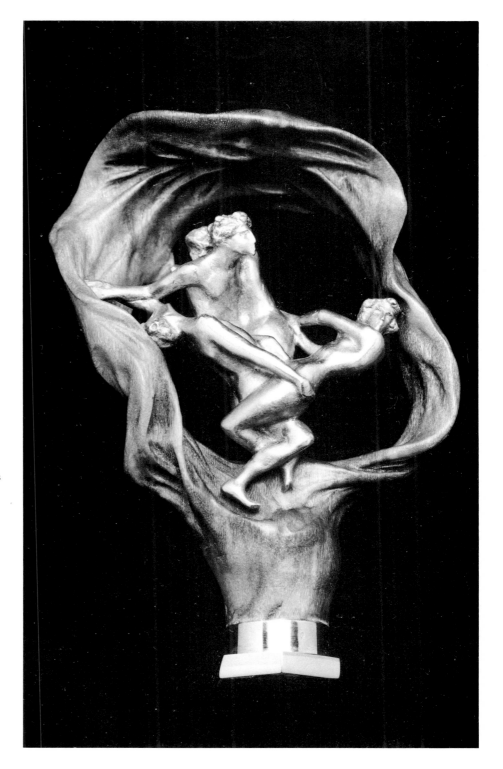

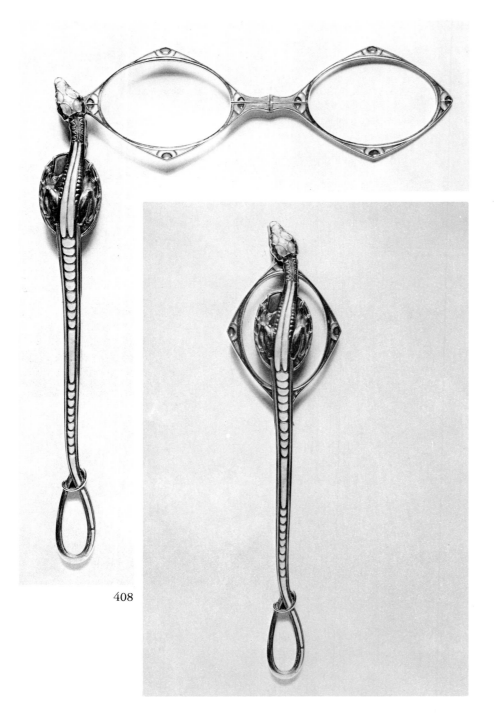

408

408
Lorgnette.
René Lalique. c. 1899–1901.
Chased gold; green champlevé enamel; yellow
and blue plique-à-jour enamel.
Height 16 (6⅜)
LALIQUE, stamped on handle.
Paris, Musée des Arts Décoratifs, Inv. 28865.
Gift of La Baronne Félix Oppenheim, 1933.

Bibl: Rheims 1964, pl. 44; Battersby 1969,
fig. 42; Barten 1973, no. 1544.

Exh: Paris 1937, no. 1312; Paris 1960, no.
1037; London 1961, no. 518; Paris 1964, no.
349; Brussels 1965, no. 48; Amersfoort 1972,
no. 51; Tokyo 1975, no. 60.

409
Clematis *devant de corsage*.
René Lalique. c. 1899–1901.
Gold; silver; transparent brown, orange, and
light turquoise enamel; hinged in three places.
15.6 x 6.8 (6¼ x 2⅝)
LALIQUE, stamped on right. Master's mark
and two French assay marks, stamped on back.
Paris, Collection Michel Périnet.

Bibl: *Art et Décoration* 12 (1902), p. 36 illus.;
L'Art Décoratif 4 (1902), p. 145 illus.; *L'Album
d'Art* (1904), p. 4 illus.; Barten 1973, no.
996.

Exh: Paris 1902, Salon SAF.

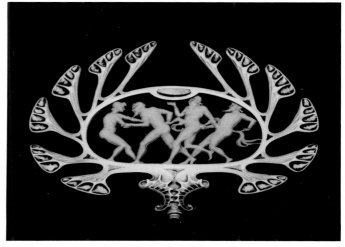

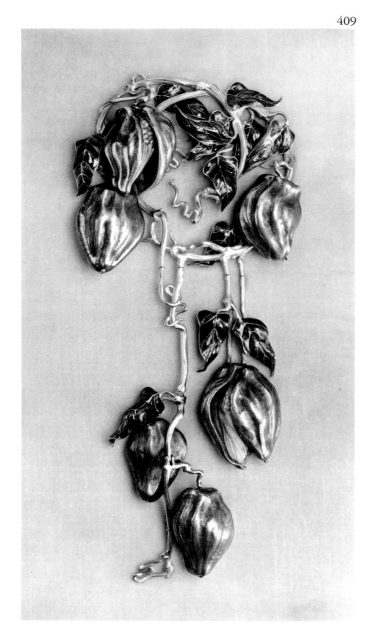

410
Finial.
René Lalique. 1900.
Gold, enamel, and black opal.
6 x 9.5 (2⅜ x 3¾)
LALIQUE, stamped near bottom.
New York, private collection.

Bibl: Neveux 1900, p. 134 illus.

Exh: New York 1967.

411
Chalice.
René Lalique. c. 1900–1902.
Silver and opaline glass.
Height 18.7 (7⅜)
LALIQUE, engraved at base.
Houston, private collection.

Two other copies are known (Paris, Musée
Galliera, Inv. 579; Darmstadt, Hessisches
Landesmuseum, Inv. Kg. 66:100).

Bibl (various examples): Bouyer 1902, pp.
54–55 illus.; Rheims 1966, no. 572, p. 424;

Bott 1973, no. 228 illus.; Barten 1973,
no. 1711.

412
Handbag.
René Lalique. c. 1901–1903.
Gray suede with silver embroidery in silk;
silver clasp.
22.2 x 19 (8¾ x 7½)
LALIQUE, stamped on clasp mounting.
French assay mark, stamped near hinge.
New York, private collection.

Bibl (similar example): Karageorgevitch 1903,
p. 220 illus.; *L'Art Décoratif* 5 (1903), p. 31
illus.; *Art et Décoration* 14 (1903), p. 221
illus.; Verneuil 1903, p. 221 illus.; Barten
1973, no. 1579.

Exh: Paris 1903, Salon SAF.

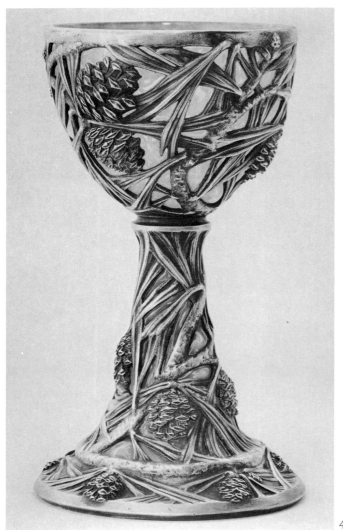

411

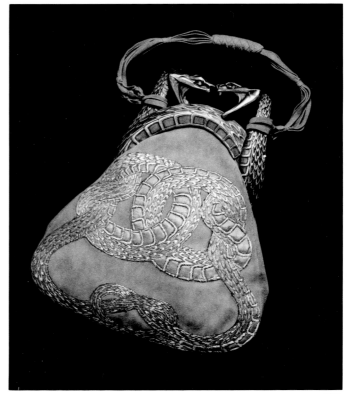

412

413
Flagon.
René Lalique. c. 1901–1903.
Chased and repoussé silver; brown enamel; ivory.
Height 32.3 (12¾)
LALIQUE, stamped on edge of lip. French assay mark, stamped inside cover.
Paris, Collection Michel Périnet.

Drawings exist of two variant versions (Paris, private collection). The group of figures at the shoulder, which like the others seems to have been inspired by Rodin, was executed separately in bronze on a larger scale (Paris, Collection Michel Périnet). An earlier flagon in bronze and glass (Frankfurt am Main, Museum für Kunsthandwerk) varies from this one in details of form and decoration.

Bibl: Barten 1973, no. 1714.

414
Thistle brooch.
René Lalique. c. 1903–1904.
Gold; molded and carved crystal; pale blue, dark blue, and opaline blue enamel.
5.5 x 14.5 (2¼ x 5¾)

LALIQUE, stamped on bottom edge. Master's mark, stamped on pin. French assay mark, stamped on pin and back of clasp.
Paris, Collection Michel Périnet.

The working design for this piece, in pencil, ink, and gouache, is in a private collection, Paris. It is accompanied by a second drawing showing detailed studies of the gold portions.

Bibl: Barten 1973, no. 1065.

414

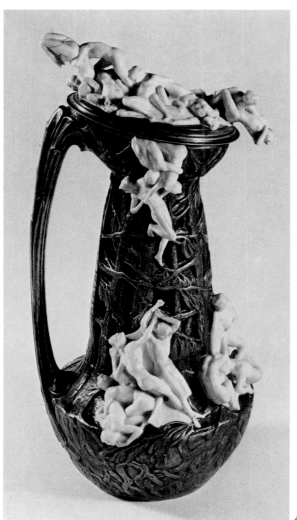

413

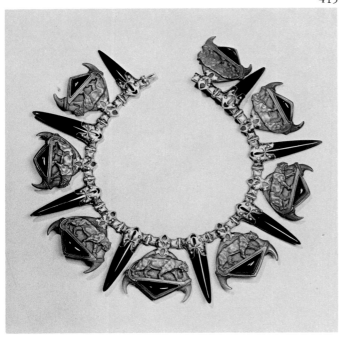

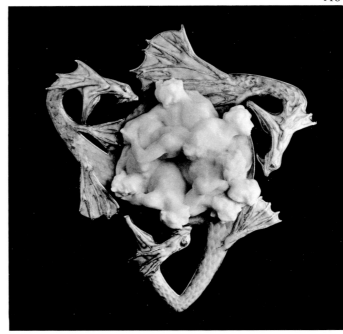

415
Necklace.
René Lalique. c. 1903–1904.
Gold, horn, tortoiseshell, and brown crystal.
Diameter 23.3 (9¼)
LALIQUE, stamped on clasp.
Baltimore, The Walters Art Gallery,
Inv. 57–938.

Purchased at the Louisiana Purchase
Exposition, 1904.

Bibl: Randall 1966, p. 499 illus.; Barten
1973, no. 349.

Exh: St. Louis 1904.

416
Brooch.
René Lalique. c. 1903–1905.
Gold, pale blue and pale pink champlevé
enamel, and ivory.
9.5 x 8.2 (3¾ x 3¼)
LALIQUE, stamped on right edge. Master's
mark and French assay mark, stamped on back.

Paris, Collection Michel Périnet.

The neck of the bottom dragon was made
slightly longer to hold a triangular pendant in
the form of another dragon head. Although the
pendant is now lost, it is known from a
detailed pencil, ink, and gouache study in a
private collection in Paris. The ivory figures,
which seem to have been inspired by Rodin,
strongly resemble another group forming the
center of an ivory and crystal brooch of about
the same date which is illustrated in *Art et
Décoration* 18 (1905), pp. 179, 184.

Bibl: Barten 1973, no. 1092.

Also illustrated in color.

417
Wineglass.
René Lalique. c. 1910–15.
Clear glass; etched decoration.
Height 17.8 (7)
Lalique France, engraved on bottom.

New York, The Metropolitan Museum of Art,
Inv. 23.173.1. The Edward C. Moore, Jr.,
Gift Fund, 1923.

418
Box.
René Lalique. c. 1910–15.
Dark green pressed glass; silver hinges and
clasp.
7.7 x 17.8 x 10.5 (3 x 7 x 4⅛)
R. LALIQUE, on edge of cover.
The Corning Museum of Glass, Inv. 73.3.41.

An identical piece is in the collection of the
Hessisches Landesmuseum, Darmstadt (Inv.
Kg. 62:19).

Exh: Boston 1975.

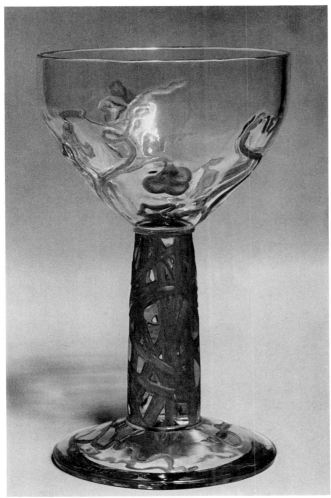

417

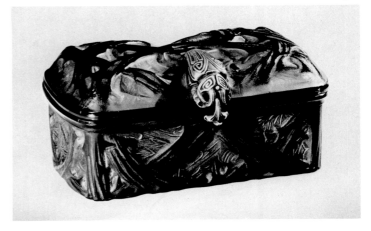

419
Fire screen.
Designed by Abel Landry; executed by Ballauf
et Petitpont for La Maison Moderne.
c. 1905–1906.
Bronze.
76.4 x 72 (30⅛ x 28⅜)
Houston, private collection.

Bibl: De Félice 1906, p. 208 illus.

Exh: Paris 1906, Salon SAD.

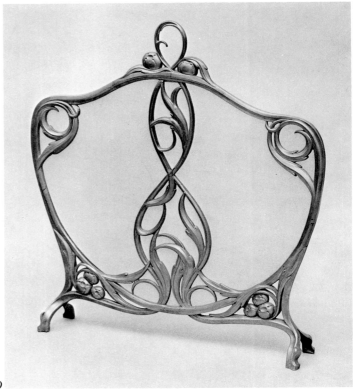

419

420
Löie Fuller. Lamp.
Raoul Larche.
Bronze.
Height 33 (13)
Raoul Larche, at base. *Siot-Decauville/ Fondeur/ Paris*, stamped at base.
New York, Lillian Nassau.

421
Löie Fuller.
Raoul Larche.
Gilt bronze.
Height 46.3 (18¼)
Raoul Larche, at front of base. *Siot-Decauville/ Fondeur/ Paris*, stamped on top surface of base.
Berkeley, University Art Museum.

Exh: Santa Cruz 1974.

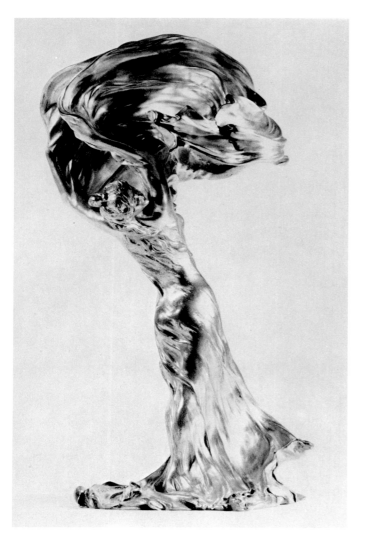

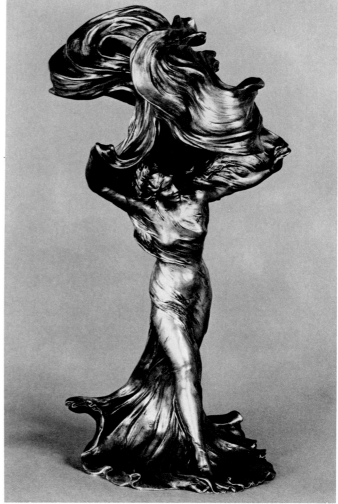

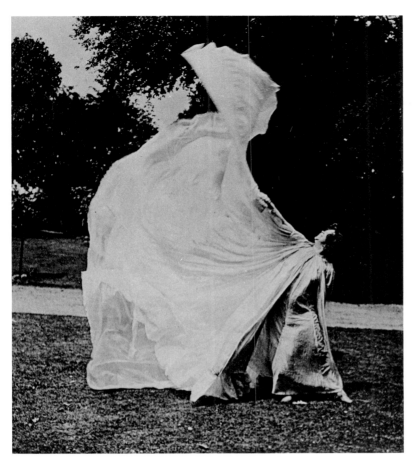

Loïe Fuller.

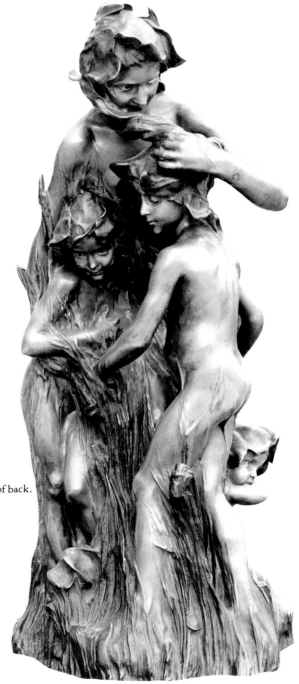

422
Les Violettes.
Raoul Larche. c. 1901–1902.
Bronze.
Height 81 (31⅞)
RAOUL LARCHE, at lower right of back.
Paris, Collection Félix Marcilhac.

Bibl: Dayot 1902, p. 117 illus.

Exh: Paris 1902.

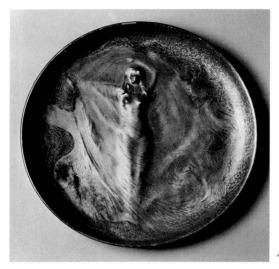
424

423
Vase.
Legras & Cie. c. 1910.
Cased glass, ocher, green, lavender, and buff;
etched decoration.
Height 42 (8⅛)
Legras and *SD* intertwined, etched near base.
Chrysler Museum at Norfolk, Inv.
GEFGr.64.1. Joan Foy French Collection.

424
Plate.
Designed by Lucien Lévy-Dhurmer; executed
by Clément Massier. c. 1890–95.
Stoneware with relief decoration; luster glaze.
Diameter 48.5 (19⅛)
Clément Massier Golfe Juan (A.M.), impressed
on bottom.
Paris, Laurence and Barlach Heuer.

Bibl: Battersby 1969, p. 35, pl. 29.

Exh: Sèvres 1971a, no. 195; Paris 1973, no.
47.

425
Flambeau.
Designed by Lucien Lévy-Dhurmer; executed
by the firm of Falize. c. 1910–14.
Bronze and alabaster.
Height 180.3 (71)
New York, The Metropolitan Museum of Art,
Inv. 66.244.22. Harris Brisbane Dick Fund,
1966.

One of a set of four from a dining room whose
furnishings were designed entirely by
Lévy-Dhurmer.

Bibl: Forthuny 1919, pp. 291, 293 illus.

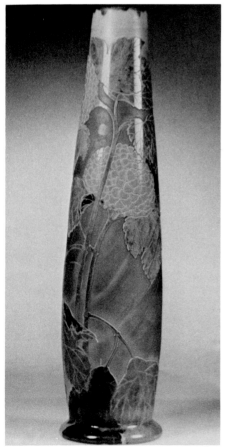

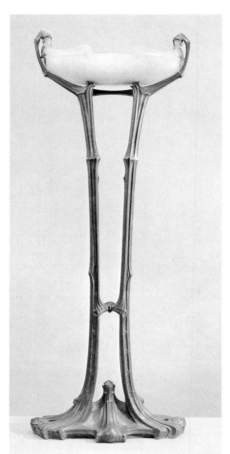

423

425

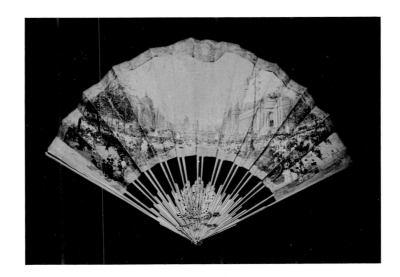

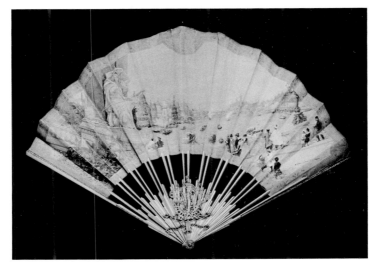

426
Fan.
Painted by Luigi Loir. 1900.
Watercolor on paper, mounted on a gold frame
set with diamonds.
32.2 x 47 (12⅔ x 18½)
Loir Luigi 1900, lower right on front (side set
with diamonds). *Loir Luigi*, lower right on
back.
New York, private collection.

Created to commemorate the Exposition
Universelle in Paris, 1900. One side of the
frame bears the seal of the city of Paris in gold
and rose diamonds; the watercolor shows a
view of the Seine from the Pont Alexandre III,
with the two towers of the Trocadéro in the
center background. The watercolor on the
reverse depicts the Petit Palais and the Grand
Palais. The dome of Les Invalides is visible in
the distance.

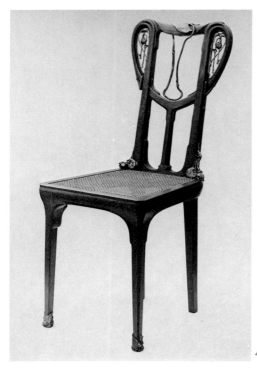

427

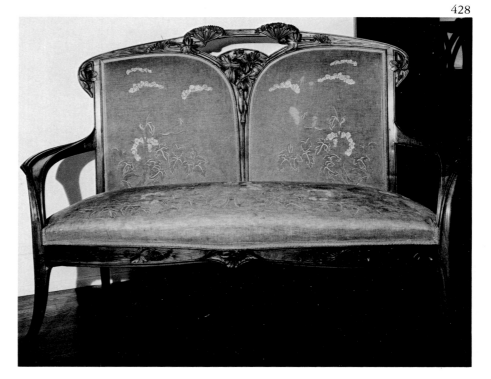

428

427
Side chair.
Louis Majorelle. Before 1900.
Walnut with caning; gilt bronze mounts.
93.5 x 37.5 x 39 (36¾ x 14¾ x 15⅜)
Ghent, Museum voor Sierkunst, Inv. 730.

428
Settee.
Louis Majorelle. Before 1900.
Walnut; original upholstery.
113.7 x 157.5 x 59.7 (44¾ x 62 x 23½)
Mr. and Mrs. Herbert D. Schimmel.

429
Armchair.
Louis Majorelle. Before 1900.
Walnut; original upholstery.
106.7 x 71.1 x 53.3 (42 x 28 x 21)
Mr. and Mrs. Herbert D. Schimmel.

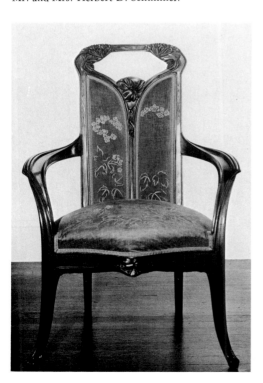

430
Desk chair.
Louis Majorelle. c. 1900.
Mahogany; original leather upholstery.
75 x 74 x 53 (29½ x 29⅛ x 20⅞)
Paris, Musée des Arts Décoratifs, Inv. 37497.
Gift of M. Chanbon, 1955.

Exh: Brussels 1963a, no. 37; Tokyo 1975, no.
71.

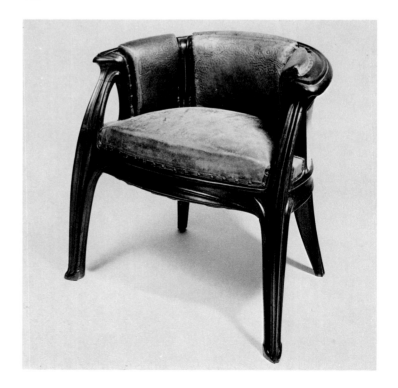

431

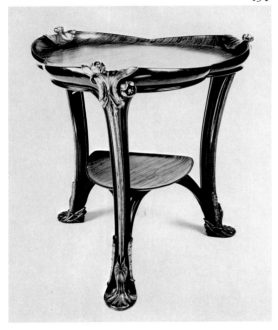

432

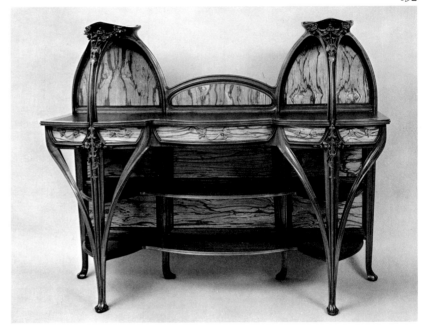

431
Table.
Louis Majorelle. c. 1901–1902.
Mahogany with tamarind veneer; gilt bronze
mounts.
85 x 95 x 95 (33½ x 37⅜ x 37⅜)
Paris, Musée des Arts Décoratifs, Inv. 10317.

Purchased from the artist at the salon of the
Société des Artistes Français, 1902. Majorelle
often used the waterlily as a decorative motif
for mounts and fittings on his furniture.
Another copy of the table was exhibited at the
Exposition Ecole de Nancy (Paris 1903).

Bibl: Madsen 1956, p. 352 illus.;
Brunhammer and Ricour 1958, p. 654 illus.;
Cassou et al. 1962, p. 254 illus.; Schmeck
1962, p. 55 illus.; Viaux 1962, pl. 38; Barilli
1967a, pl. 37; Mannoni 1968, p. 58 illus.;
Pevsner 1968, p. 83 illus.

Exh: Paris 1902, Salon SAF; St. Louis 1904;
Paris 1960, no. 1119; Brussels 1963a, no.
376; Ostende 1967, no. 131; Tokyo 1975, no.
72.

432
Sideboard.
Louis Majorelle.
150 x 175.5 x 50 (59 x 69⅛ x 19¾)
Wood and slate.
Houston, private collection.

The slate top replaced the original one in
marble, which was broken.

433
Fire screen.
Screen by M. Melchior; frame attributed to
Emile Gallé. c. 1900.
Walnut and tooled leather with peacock-blue
and green enamel.
99.1 x 67.3 (39 x 26½)
M. Melchior, incised at lower right of leather
panel.
Sydney and Frances Lewis Collection.

Exh: Richmond 1971, no. 52.

434
Gourd bottle.
André Methey. 1902.
Stoneware with relief decoration; green glaze.
Height 27.7 (10⅞)
A Methey and *CA/ no 2792*, incised on bottom.
Paris, Musée des Arts Décoratifs, Inv. 10898.

Acquired from the artist in 1903. Other
versions in the Funke-Kaiser and Marcilhac
collections (cf. Cologne 1974, no. 155, and
Düsseldorf 1974, no. 92).

Bibl: Clouzot 1922, pl. 1; Rheims 1964, pl.
16.

Exh: Paris 1960, no. 1124; Ostende 1967, no.
377.

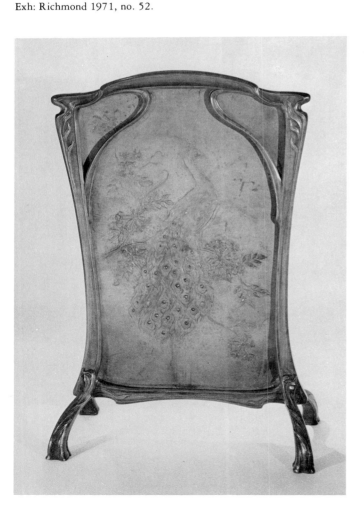

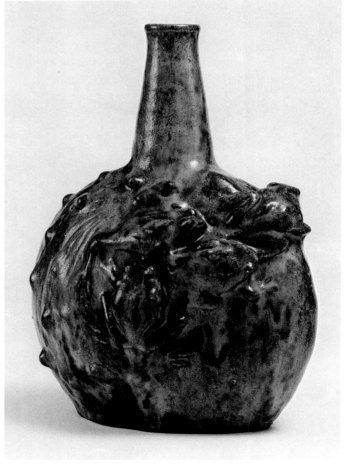

435
Vase.
Eugène Michel. c. 1900.
Cased crystal, amethyst on clear crackled;
modeled and wheel-cut decoration.
Height 22.6 (8⅞)
E. Michel, engraved at base.
Paris, Musée des Arts Décoratifs, Inv. 14393.
Gift of Mme. Michel, 1907.

Bibl: Polak 1962, p. 23, pl. 29;
Bloch-Dermant 1974, p. 44 illus.

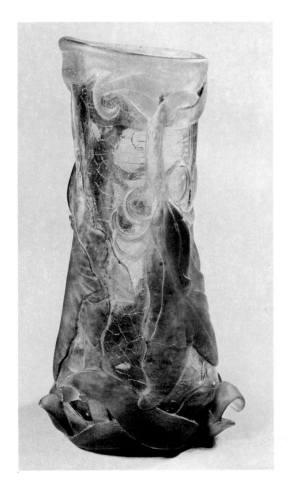

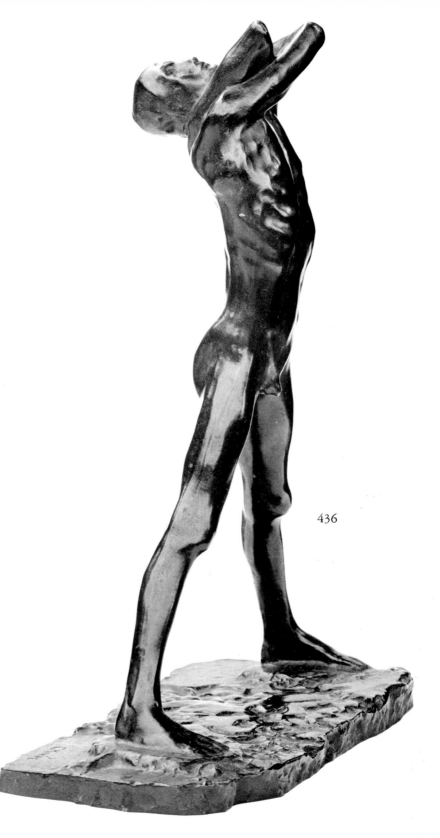

436

436
L'Adolescent I.
George Minne.
Bronze.
Height 42 (16½)
G. MINNE, at base.
Brussels, L'Ecuyer.

437
Vase.
Joseph (and Pierre?) Mougin. c. 1900–10.
Stoneware with relief decoration; blue-gray and pale orange glaze.
Height 24.1 (9½)
France in a rectangle and *GRES/MOUGIN/NANCY* in an oval, impressed on bottom.

273, incised on bottom.
New York, private collection.

438
Vase.
Designed by Alfred Finot; executed by Joseph and Pierre Mougin. c. 1900–1906.
Stoneware with relief decoration; brown, blue-white, white, and green mat glaze and glossy green glaze.
Height 19 (7½)
A Finot/2938 Sculp./J. & P. Mougin/Ceram, incised on bottom. *A. Finot*, incised on side.
New York, private collection.

Bibl: *La Lorraine*, December 1, 1900, illus.

438

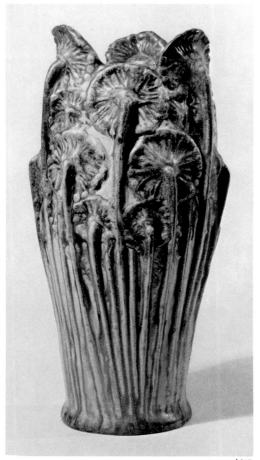

437

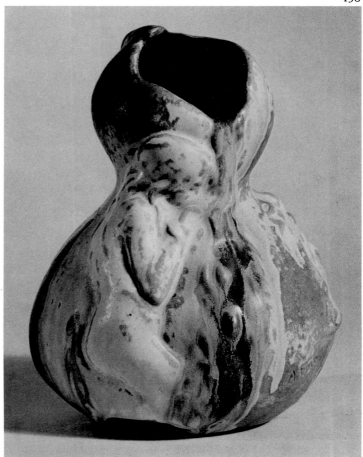

439
Bust.
Alphonse Mucha. c. 1899.
Silvered and gilt bronze; lapis lazuli finial.
Height 70 (27½)
MUCHA, on right. *BRONZE garanti au titre—Paris* surrounding an emblem, stamped on left side.
Paris, Mme. Robert Walker.

Encouraged by Rodin, Mucha became interested in sculpture and between 1895 and 1903 worked in the studio of his downstairs neighbor, the sculptor Auguste Seysses (1862–1946). Seysses in fact executed at least one bronze for Mucha, a bust which was part of the furnishings of Georges Fouquet's jewelry boutique and is now in the collection of the Musée des Arts Décoratifs, Paris (Inv. 38135). The bust shown here, undoubtedly inspired by Sarah Bernhardt, figures in Mucha's designs for the Fouquet shop. Four castings are known.

Exh: Turin 1902; Brussels 1974, no. 82.

440
Stool.
Designed by Alphonse Mucha. c. 1900–1901.
Walnut; original gilt leather upholstery.
42 x 36 x 36 (16½ x 14⅛ x 14⅛)
Paris, Musée des Arts Décoratifs, Inv. 32476B.

Like the display table shown as cat. no. 441, this stool was part of the furniture designed for Georges Fouquet's jewelry boutique, and was acquired by the museum upon the liquidation of the shop in 1936.

Bibl: Sterner 1975, p. 50, p. 49 illus.

Exh: Paris 1933, no. 1026; Zürich 1952; Paris 1961; London 1963; Tokyo 1968, no. 91.

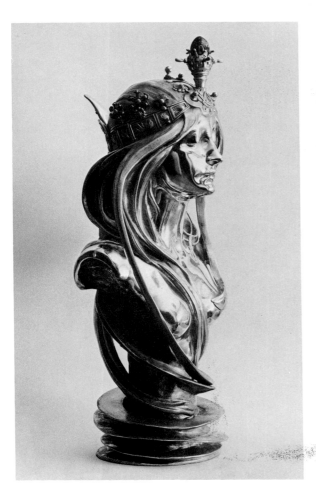

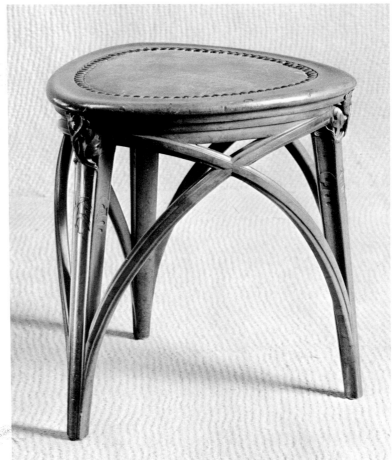

441
Display table.
Designed by Alphonse Mucha. c. 1900–1901.
Fruitwood with leather top; bronze mounts
with green patina.
76 x 115 x 68.5 (29⅞ x 45¼ x 27)
Paris, Musée des Arts Décoratifs, Inv.
32476A.

Part of the furnishings from Georges Fouquet's
jewelry boutique on the rue Royale, for which
Mucha designed a fabulous interior and
exterior decorative scheme: "The workshop, lit
by the permanent glow of furnaces, became a
natural source of light, illuminating from
behind a bronze peacock whose spread tail
formed the back wall of the shop and glittered
with countless eyes of colored glass. The
furniture, carved in simple lines, was of rare
woods, there was a fountain with goldfish and
a bronze nude, stained glass panneaux in the
walls and a mosaic floor" (Mucha 1966, p.
264). This table and the stool shown as cat. no.
440 were acquired by the museum on the
liquidation of Fouquet's shop in 1936; the
storefront and much of the remaining furniture
are now in the collection of the Musée
Carnavalet, Paris.

Exh: Paris 1933, no. 1026; Paris 1961;
London 1963; Tokyo 1968b, no. 91.

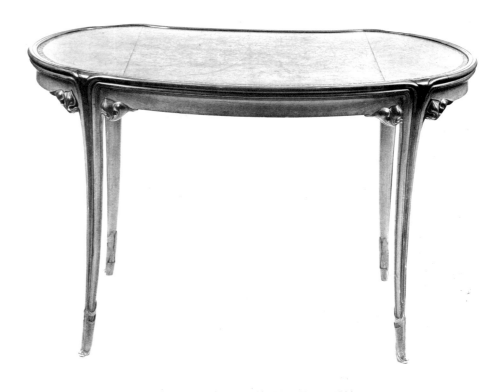

442
Femme à la marguerite (Woman with Daisy).
Decorative panel.
Designed by Alphonse Mucha.
Printed velvet.
58 x 80 (22¾ x 31½)
Paris, Bibliothèque Forney.

Exh: Paris 1966, no. 212; Brussels 1974, no.
81.

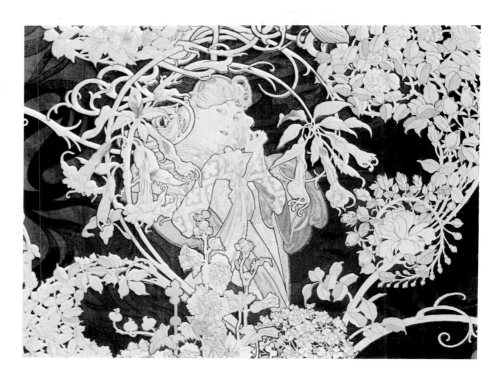

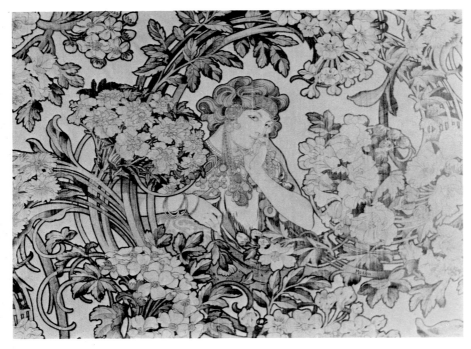

443
Femme parmi les fleurs (Woman among Flowers).
Decorative panel.
Designed by Alphonse Mucha.
Printed velvet.
65 x 80 (25⅛ x 31½)
Paris, Bibliothèque Forney.

Exh: Paris 1966, no. 213; Brussels 1974, no. 80.

444
Vase.
Designed by James Vibert; executed by Emile Müller.
Stoneware; beige, iridescent red, and turquoise glaze.
Height 21.6 (8½)
REPRODUCTION/ INTERDITE/ IVRY/ PARIS, and *E [MIL] E MULLER* in a circle, impressed on bottom. *J VIBERT/ Emile Muller*, incised on side.
New York, private collection.

Bibl: Rheims 1964, fig. 378.

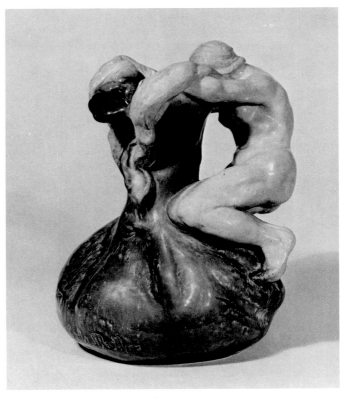

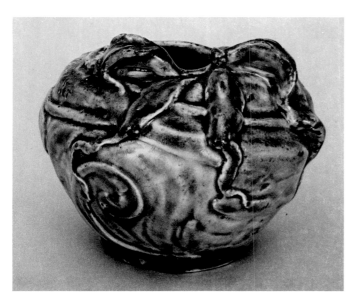

446
Vase.
Cristallerie de Pantin: Stumpf, Touvier,
Viollet & Cie. c. 1901.
Cased glass, green on clear; etched decoration.
Height 29.5 (11⅝)
Cristallerie de Pantin surrounding intertwined
STV and *&C*.
Chrysler Museum at Norfolk, Inv.
GEFP.70.1. Jean Outland Chrysler
Collection.

Bibl: Hilschenz 1973, p. 353 illus. (similar
example).

446

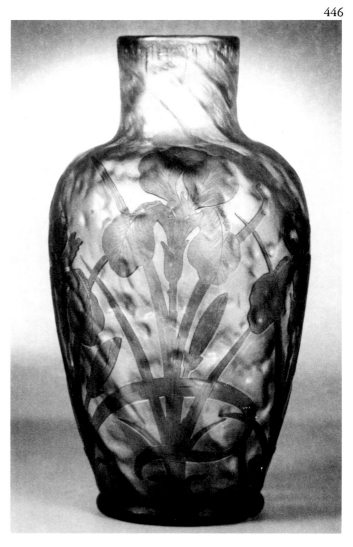

445
Bowl.
Designed by Philippe Wolfers; executed by
Emile Müller. 1897.
Molded stoneware with green glaze.
Height 11.1 (4⅜)
Wolfers/ E. Muller, incised on shoulder. *No. 2/
g/ T.2/ 120*, incised on bottom. *1897/ 6*,
written in ink on bottom.
Brussels, L. Wittamer—de Camps.

According to Marcel Wolfers, a representative
of the firm of Emile Müller approached his
father, Philippe Wolfers, at an exhibition of
the latter's works in about 1897. The elder
Wolfers gave permission for several of his
bronze cachepots to be used as models for
editions in ceramic. The piece shown here, a
result of that agreement, was probably
modeled after cat. no. 507.

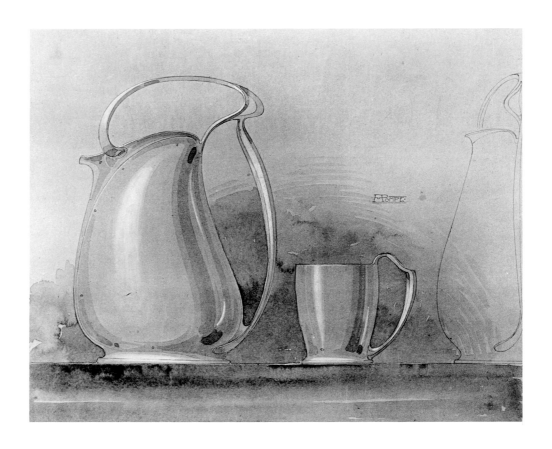

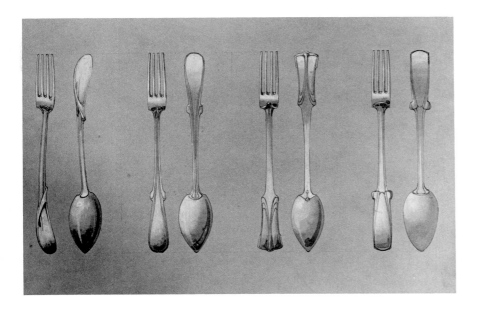

447
Study for a pitcher and mug.
Antoine Pompe. c. 1900.
Sepia ink, watercolor, and white gouache on paper.
33 x 37 (13 x 14½)
Brussels, Archives d'Architecture Moderne.

Exh: London 1974a.

448
Study for flatware.
Antoine Pompe. c. 1900.
Sepia ink, sepia wash, and white gouache on heavy gray paper.
31 x 47 (12 x 18½)
Brussels, Archives d'Architecture Moderne.

Designed for the jewelry firm headed by Pompe's father.

Exh: London 1974a.

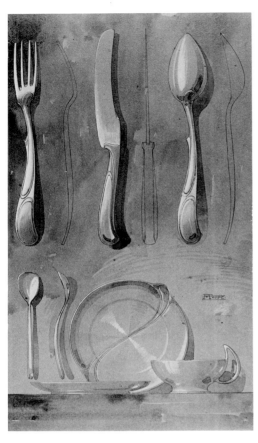

450
Study for a tea service.
Antoine Pompe. c. 1900.
Sepia ink, watercolor, and white gouache on paper.
42.5 x 57 (16¾ x 22½)
A. Pompe, center right. *A. Pompe/ Architecte/ Bruxelles*, stamped lower right. *1905*, lower right.
Brussels, Archives d'Architecture Moderne.

The stamp and date were added later by the artist.

Exh: London 1974a.

449
Study for pewter tableware.
Antoine Pompe. c. 1900.
Sepia ink, watercolor, and white gouache on paper.
46 x 27.5 (18⅛ x 10⅞)
A. Pompe, middle right.
Brussels, Archives d'Architecture Moderne.

Designed for the jewelry firm headed by Pompe's father.

Exh: London 1974a.

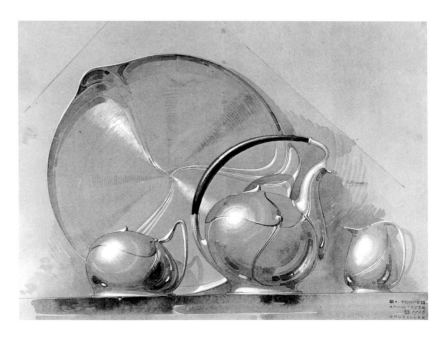

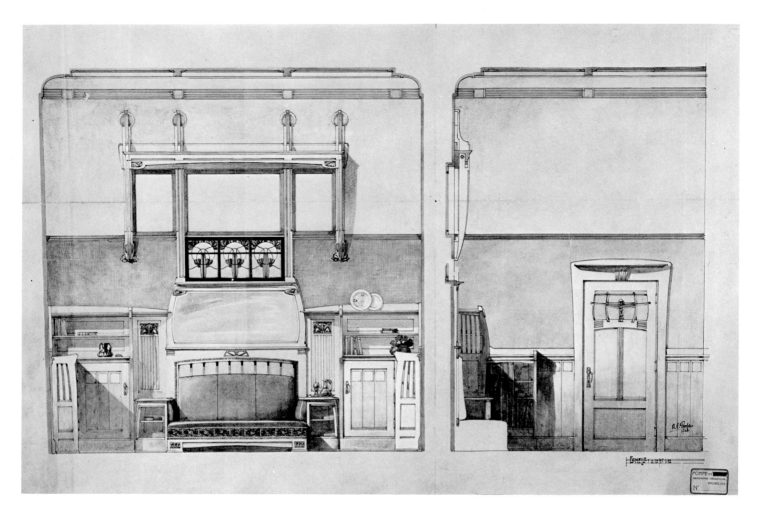

451
Study for a library/sitting room.
Antoine Pompe. 1902.
Sepia ink, watercolor, and white gouache on
heavy beige paper.
63 x 83 (24⅞ x 32¾)
A. C. Pompe/ 1902 and *Echelle: 0.10 pr 1.00*,
lower right.

Brussels, Archives d'Architecture Moderne.

Designed by Pompe at the request of Georges
Hobé, an architect and cabinetmaker from
Brussels, this interior was executed and
exhibited at Turin in 1902.

Exh: London 1974a.

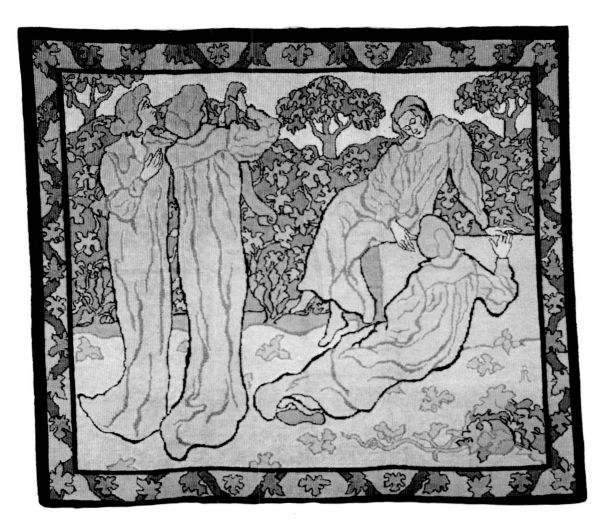

452
Wall hanging.
Designed by Paul Ranson; executed by France
Ranson. c. 1895.
Wool embroidery on canvas.
180 x 202 (70⅞ x 79¾)
Ranson's monogram, lower right.
Darmstadt, Hessisches Landesmuseum, Inv.
Kg. 65:56.

France Ranson was the unofficial hostess of the
Nabis, by whom she was called "La Lumière du
Temple." She executed about a half dozen of
her husband's tapestry designs in needlepoint
between 1890 and 1898.

Bibl: Bott 1973, no. 474 illus.

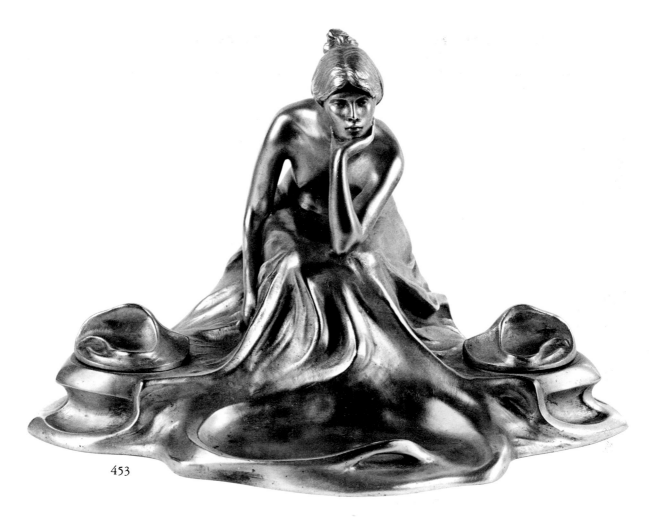

453

453
Inkwell.
Aloïs Reinitzer. c. 1901–1902.
Chased and gilt bronze.
Height 15 (5⅞)
Paris, Cazalis-Sorel Collection.

Bibl: *L'Art Décoratif aux Expositions* (1902), pl. 175.

454
Loïe Fuller.
Théodore Rivière.
Bronze.
Height 27.8 (11)
Fonte surplâtre, on left side of base.
THEODORE RIVIERE, on right side of base.
Houston, private collection.

A marble version of this statue, perhaps that in the collection of the Musée des Arts Décoratifs, Paris, was illustrated in *L'Art Décoratif* 4 (1902), p. 137.

455
Loïe Fuller.
Pierre Roche.
Bronze with dark brown patina, mounted on black marble base.
Height 54.5 (21½)
PIERRE ROCHE, on left side of base. *E. Genet/ 44 bis avenue de Chatillon*, stamped on back.
LOIE FVLLER, on face of base.
Paris, Musée des Arts Décoratifs, Inv. 27955.

Gift of the Massignon children in memory of their mother, Mme. Pierre Roche, 1931.

The date of this piece is unknown. However, Roche exhibited a terra-cotta *Loïe Fuller* at the salon of the Société Nationale des Beaux-Arts in 1894 (Geffroy 1895, p. 305), and a bronze of the same title at the SNBA salon of 1901 (Geffroy 1903, pp. 399–400).

Bibl: Vitry 1904, p. 123 illus.; Montagu 1963, p. 122, no. 132; Schmutzler 1964, fig. 169; Hammacher 1967, p. 66 illus.

Exh: Paris 1931, no. 678; Zürich 1952, no. 21; Paris 1957, no. 158; New York 1960, no. 238; Ostende 1967, no. 206; Tokyo 1968a, no. 144; Tokyo 1975, no. 82.

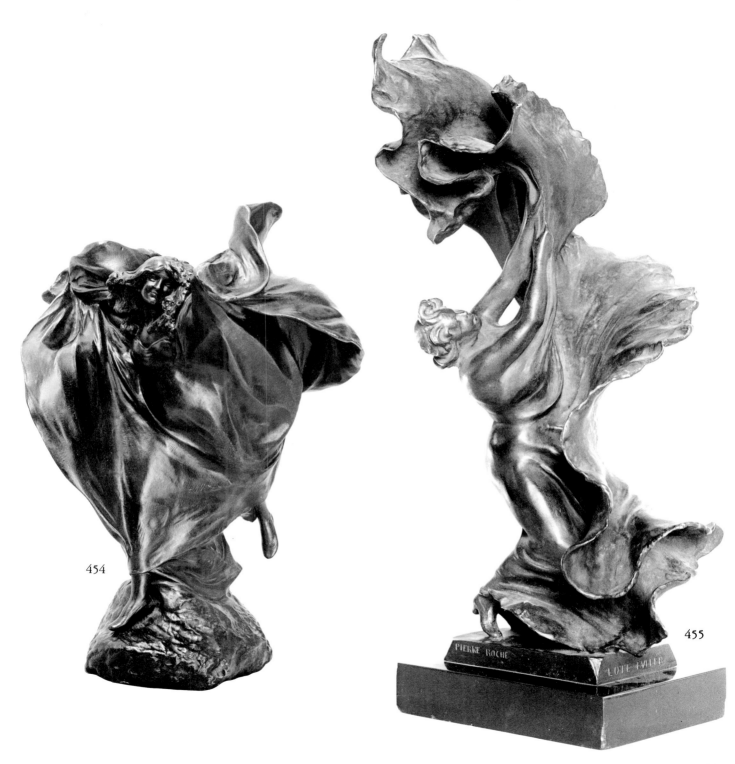

454

455

PIERRE ROCHE LOIE FULLER

456
Fugit Amor (Fugitive Love).
Auguste Rodin.
Bronze.
48.3 x 81.3 x 30.5 (19 x 32 x 12)
A. Rodin, on base. *E. Gruet Jne., Paris*,
stamped on base.
New Brunswick, N.J., Rutgers
University Fine Arts Collection, Inv.
1243. Gift of Hans Arnold, 1959.

A representation of Paolo and Francesca, one of
the groups of figures from Rodin's famous
Gates of Hell. The first casting was made
c. 1880–82; this copy is believed to be a later
recasting, c. 1917.

Bibl: Rutgers 1966, pp. 76–77 illus.

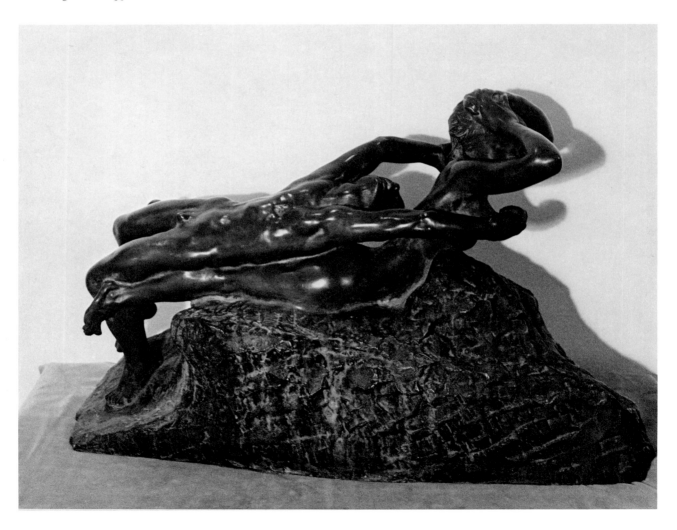

457
Tête de douleur (Head of Sorrow).
Auguste Rodin. By 1882.
Bronze with patina.
Height 22.2 (8¾)
A. Rodin, on back of neck at right. *Alexis Rudier/ fondeur/ Paris*, stamped on back.
The Art Institute of Chicago, Inv. 1924.813.
Gift of Robert Allerton.

Bibl: Bénédite 1918, p. 5; *Worcester Art Museum Bulletin* 14 (July 1923), p. 37 illus.; Elsen 1963, p. 66 illus.

Exh: Lafayette 1967.

458
Plaque.
Auguste Rodin. c.1907–1908.
Bronze with patina.
30 x 26.5 (11¾ x 10½)
Paris, Musée des Arts Décoratifs, Inv. 15359.
Gift of Maurice Fenaille, 1908.

Proof in bronze of a stone bas-relief decorating one of the newel posts of the staircase in the entrance hall of M. Fenaille's residence, 19 rue de la Ferme, Neuilly.

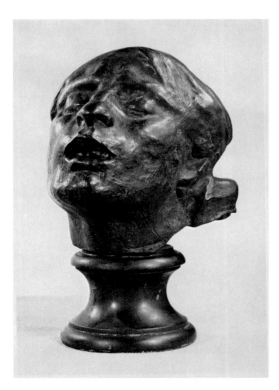

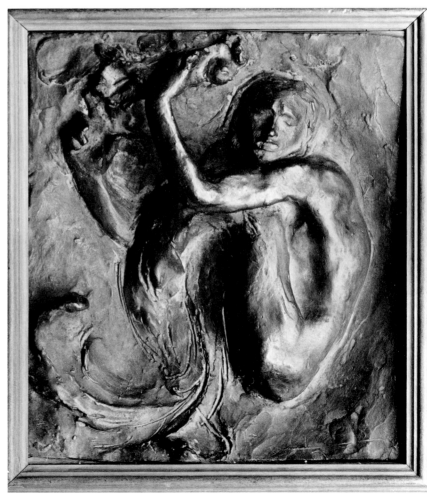

459
Vase.
Eugène Rousseau. Executed by Appert Frères,
Clichy. c.1878–85.
Cased glass, clear and green; engraved and
enameled decoration.
Height 27.1 (10⅝)
E. Rousseau/Paris, etched on bottom.
Baltimore, The Walters Art Gallery, Iny.
47.381.

Bibl: Rosenthal 1927.

Exh: Cleveland 1975, no. 233.

460
Vase.
Eugène Rousseau. c.1884.
Cased glass, brown with traces of red on
opaque white; wheel-cut and engraved
decoration.
Height 16 (6¼)
E. ROUSSEAU Paris, engraved on bottom.
Paris, Musée des Arts Décoratifs, Inv. 625.
Acquired from the artist, 1885.

Bibl: Polak 1956, p. 81 illus.; Polak 1962,
pl. 1.

Exh: Tokyo 1975, no. 83.

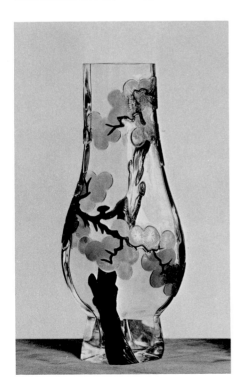

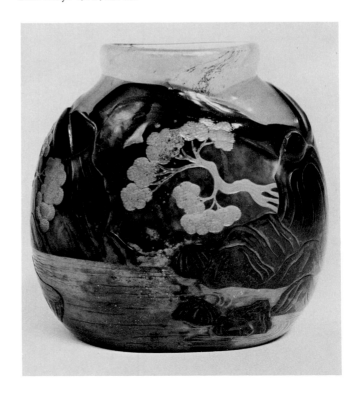

461
Jardinière.
Eugène Rousseau. 1884.
Molded opaque jade-colored glass, partially
cased with red; wheel-cut decoration.
Height 14 (5½)
Paris, Musée des Arts Décoratifs, Inv. 627.

Acquired from the artist in 1885, this is one of
the objects sent by the Musée des Arts
Décoratifs to the World's Columbian
Exposition in Chicago, 1893.

Bibl: Cassou et al. 1962, pl. 231; Pevsner
1968, p. 50 illus.

Exh: Chicago 1893; Paris 1960, no. 1216;
Ostende 1967, no. 480; Munich 1972, no.
1195.

Also illustrated in color.

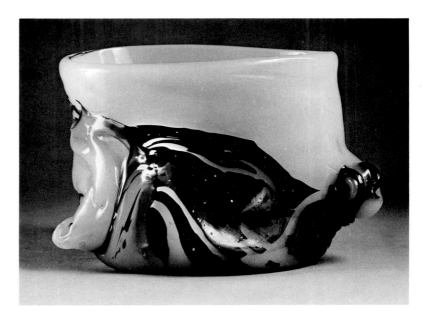

462
Homme Accroupi (Crouching Man).
Victor Rousseau. c.1905.
Bronze.
Height 19 (7½)
Victor Rousseau, on base. *FONDERIE NATLE
DES BRONZES/J. PETERMANN/ST.
GILLES BRUXELLES*, stamped on base.
Brussels, L'Ecuyer.

According to M. Weynans, who is preparing
an exhibition at the Galerie L'Ecuyer of
Rousseau's work, this is a unique casting.

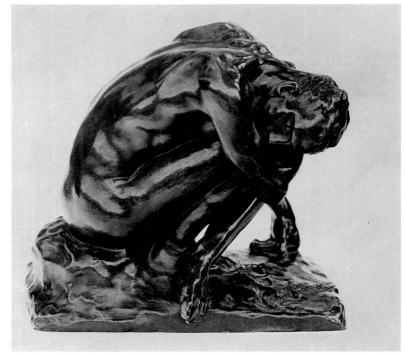

463 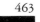 464

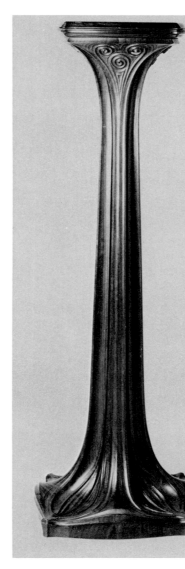

463
Vase.
Cristallerie Schneider. c. 1910.
Cased glass, opaque russet shading to
translucent white; lavender application.
Height 39.9 (15¾)
Schneider, engraved at base.
Chrysler Museum at Norfolk, Inv.
GEFSc.72.3. Gift of Walter P. Chrysler, Jr.

464
Pedestal.
Pierre Selmersheim. c. 1900.
Padouk wood.
Height 111 (43¾)
Paris, Musée des Arts Décoratifs, Inv. 16920.

The pedestal, a very common form in Art
Nouveau furniture, was used to display vases,
plants, or pieces of sculpture. After the First
World War its use practically disappeared.

Exh: Paris 1961; Tokyo 1975, no. 84.

465
Side chair.
Gustave Serrurier-Bovy. Before 1900.
Mahogany inlaid with maple; upholstered in
embroidered velvet.
90 x 43 x 42 (35½ x 17 x 16½)
Liège, Musée de l'Art Wallon.

466
Table.
Gustave Serrurier-Bovy. 1899.
Light mahogany.
100 x 98.5 x 55 (39⅜ x 38¾ x 21⅝)
Namur, Galerie d'Art.

Exh: Namur 1958, no. 36; Ostende 1967, no.
147.

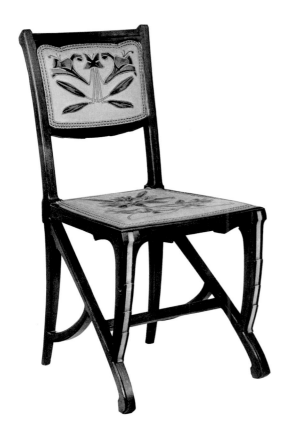

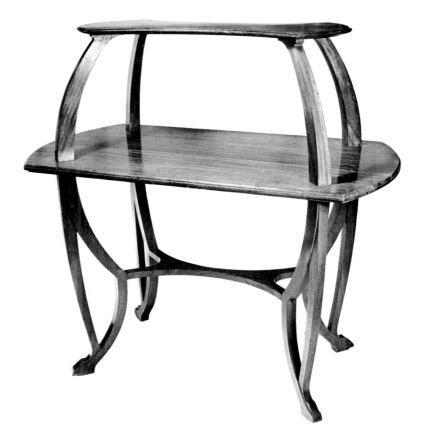

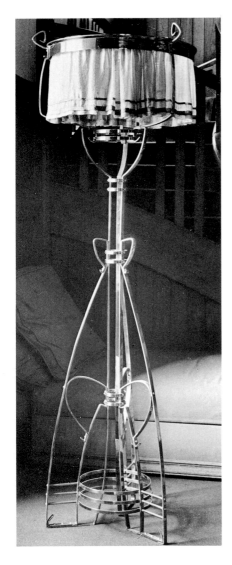

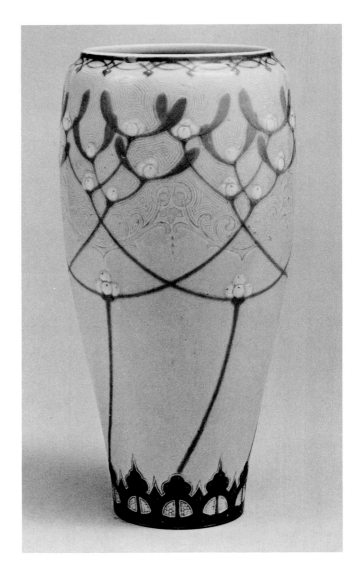

467
Floor lamp.
Designed by Gustave Serrurier-Bovy; executed by Dulong. c. 1903–1904.
Brass; original shade.
Height 175 (68⅞)
France, Mr. and Mrs. Trillat-Felgères.

There is a study for a similar lamp in the archives of the Musée de la Vie Wallonne, Liège.

468
Vase with mistletoe decoration.
Designed by Mlle. Bogureau; executed at the Manufacture de Sèvres. 1898–99.
Porcelain with incised and relief decoration; white, green, and chamois-colored underglaze, straw-yellow overglaze.
Height 28.7 (11¼)
S.98 in an oval, and *décoré à Sèvres 99* in a circle, imprinted on bottom.

Paris, Musée des Arts Décoratifs. Dépôt de la Manufacture de Sèvres, Inv. 120.57.

Bibl: *Art et Décoration* 7 (1900), p. 188 illus.; Saunier 1900b, p. 10 illus.

Exh: Paris 1900.

292

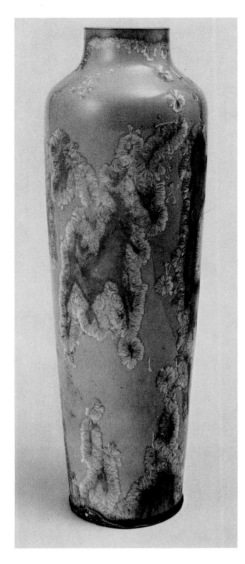

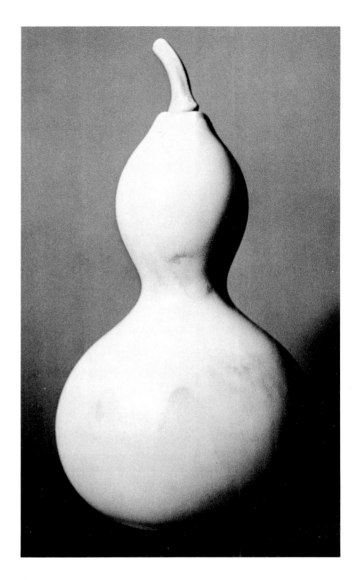

469
Vase.
Manufacture de Sèvres. 1901.
Porcelain with lavender-blue crystalline glaze.
Height 40.5 (17¾)
S 1901 in a triangle, imprinted on bottom. *C
1901 3 PN*, incised on bottom.
Paris, Musée des Arts Décoratifs. Dépôt de la
Manufacture de Sèvres, Inv. 59.67.

470
Gourd vase.
Manufacture de Sèvres. 1901.
Porcelain with light beige glaze; stopper with
crystalline beige glaze.
Height 16.1 (6⅜)
S 1901 in a triangle, imprinted on bottom.
PC-10-1901/PN, incised on bottom.
Paris, Collection Félix Marcilhac.

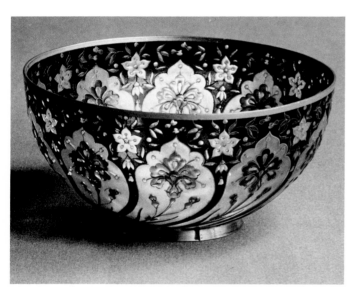

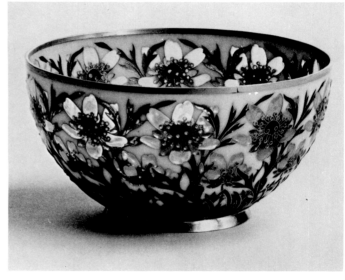

471
Bowl.
Fernand Thesmar. c. 1890.
Gold with multicolored plique-à-jour enamel.
Height 5 (2)
Thesmar's monogram, incorporated into
design on bottom.
Paris, Musée des Arts Décoratifs, Inv. 6269.
Acquired from the artist, 1891.

Bibl: *Revue des Arts Décoratifs* 13 (1892), opp.
p. 14 illus.; Champier 1896b, opp. p. 376
illus.; Rheims 1964, pl. 80.

Exh: Paris 1892, Salon SNBA.

472
Bowl.
Fernand Thesmar. 1900.
Gold with multicolored plique-à-jour enamel.
Height 5 (2)
Thesmar's monogram and *1900*, incorporated
into design on bottom.
Paris, Musée des Arts Décoratifs, Inv. 32564.

Bibl: Rheims 1964, pl. 79.

Exh: Nancy 1963, no. 3.

473
Catherine. Cane.
Georges Tonnellier. 1901.
Chased silver and wood.
Head: Length 9.7 (3¾)
G. TONNELLIER 1901/M. DE WALEFFE,
engraved around base.
Brussels, L. Wittamer–de Camps.

The writer Maurice de Waleffe, whose name is
engraved on the head, dubbed the cane
"Catherine" and always carried it with him.

Exh: Brussels 1965, no. 73; Ostende 1967,
no. 586.

474
Crocus vase.
Designed by Adolphe Truffier; executed by
Alphonse Debain. c. 1899–1900.
Repoussé silver and blue enamel.
Height 21 (8¼)
Master's mark and French assay mark, stamped
at base.
Brussels, L. Wittamer–de Camps.

Bibl: Vitry 1900; *Revue de la Bijouterie* 16
(1901), p. 130 illus.

Exh: Paris 1900; Paris 1901, Salon SAF.

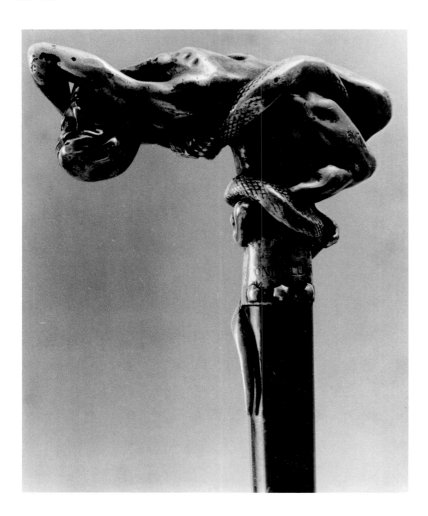

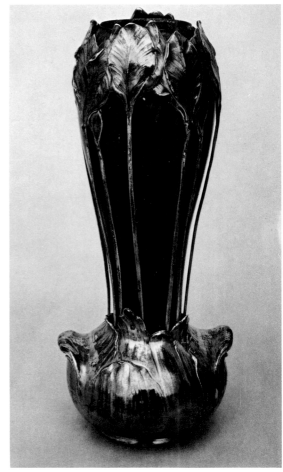

475
Wineglass.
Val-Saint-Lambert; design of decoration
attributed to Henry van de Velde. c. 1898.
Clear crystal; wheel-cut decoration.
Height 18.3 (7¼)
Brussels, L'Ecuyer.

Bibl: *L'Art Décoratif* 3 (1898), p. 130 (drawing
illustrated).

476
Vase.
Form designed by Léon Ledru; design of
decoration attributed to Henry van de Velde;
executed at Val-Saint-Lambert. c. 1902.
Cased crystal, plum on lime green; wheel-cut
decoration.
Height 29 (11⅜)
Brussels, L'Ecuyer.

An identical piece in the collection of the
Cristalleries du Val-Saint-Lambert is dated
1902 (Philippe 1974, p. 216 illus.). Around
1900 other decorations were executed on this
same form (ibid., p. 200 illus.).

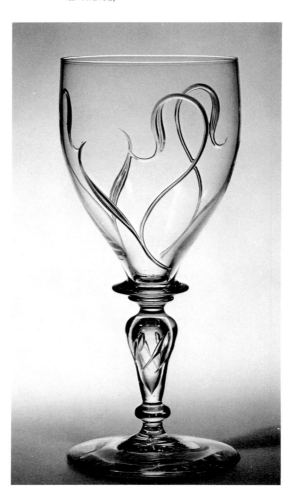

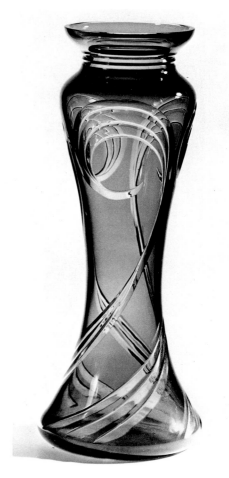

477

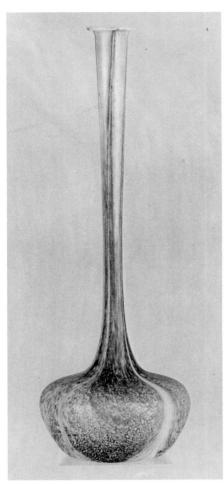

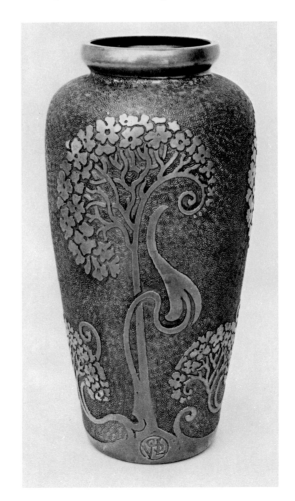

478
Vase.
Val-Saint-Lambert.
Bronze with blue crystal on the interior.
Height 17.7 (7)
Val-Saint-Lambert monogram, at base.
Brussels, L. Wittamer–de Camps.

477
Vase.
Val-Saint-Lambert. c. 1905.
Cream-colored opaque glass; brown fired-on
decoration.
Height 42.6 (16⅜)
Val-Saint-Lambert monogram, on bottom.
Ghent, Museum voor Sierkunst, Inv. 1497.

A vase similar in both form and decoration is in
the collection of the Hessisches
Landesmuseum, Darmstadt (Inv. Kg. 65:1).

479
Sphinx mystérieux.
Charles van der Stappen. 1897.
Ivory and silver-plated brass; onyx base.
Height 56.5 (22¼)
Ch. Van der Stappen 1897, at back of base.
Brussels, Musées Royaux d'Art et d'Histoire,
Inv. Sc. 73.

Acquired by the Congo Free State, Musée
Royale de l'Afrique Centrale, in 1897.

Bibl: *International Studio* 2 (1897), p. 202;
Maus 1898, p. 57 illus.; Verhaeren 1898, p.
298 illus.

Exh: Brussels-Tervueren 1897; Tervuren
1967, no. 31.

480
Wallpaper.
Designed by Henry van de Velde. 1893.
Printed by Schulfaudt, Brussels. 1894–95.
Printed in shades of blue-green.
59 x 47 (23¼ x 18½)
Brussels, Archives Henry van de Velde,
E.N.S.A.A.V., Inv. 3933.

Bibl: *L'Art Décoratif* 1 (1898), p. 10.

Exh: Brussels 1963b, no. 70; Paris 1971b,
no. 52.

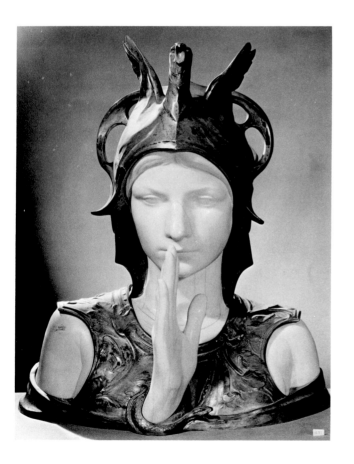

481
Wallpaper.
Designed by Henry van de Velde. 1893.
Printed by Schulfaudt, Brussels. 1894–95.
Printed; green pattern on gray ground.
59 x 48 (23¼ x 18⅞)
Brussels, Archives Henry van de Velde,
E.N.S.A.A.V., Inv. 3938.

Intended for a study.
". . . his preoccupation was to create a
personal and definitive decorative form. . . .
In his latest works, these attempts have gone as
far as possible without compromising the
purity of the forms. The bedroom wallpaper
exhibited at the Arts and Crafts salon, with its
lines drawn downward as though sinking
away, expresses fatigue, while the proud
uplifting of the lines [in the above paper] is
certainly suitable for the decoration of a study"
(Meier-Graefe 1898, p. 8).

Bibl: *L'Art Décoratif* 1 (1898), opp. p. 10
illus.; Schmutzler 1964, endpapers.

Exh: Brussels 1963b, no. 68; Paris 1971b,
no. 51.

482
Side chair.
Designed by Henry van de Velde. 1895–96.
Oak, with rush seat.
Height 94 (37)
New York, The Museum of Modern Art, Inv.
111.60.

Made for the artist's house in Uccle.

Bibl: *Art et Décoration* 1 (1897), p. 62 illus.;
L'Art Décoratif 1 (1898), p. 16 illus., p. 35
illus.

Exh: New York 1960, no. 286.

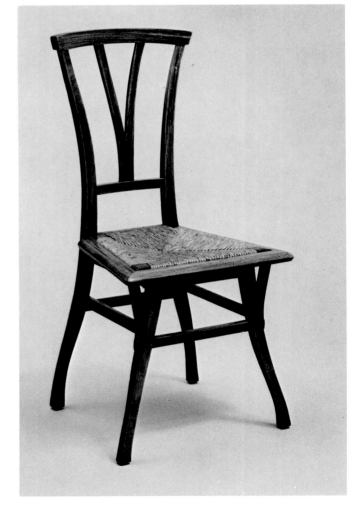

483
Ornament for the hem of a dress.
Designed by Henry van de Velde. c. 1896–98.
Pale yellow silk gossamer with rose gossamer
appliqués and embroidery.
15 x 230 (5⅞ x 90¾)
Zürich, Museum Bellerive, Collection of the
Kunstgewerbemuseum, Inv. 1958–85.

Made for Maria van de Velde. Formerly in the
collection of Henry van de Velde, Oberägeri,
Switzerland.

483

485

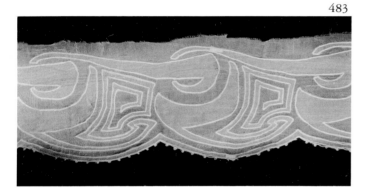

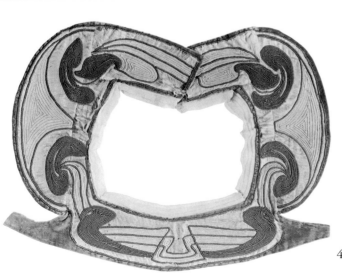

484

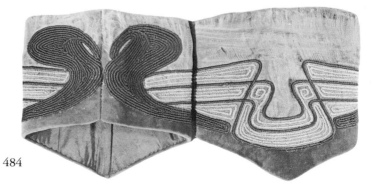

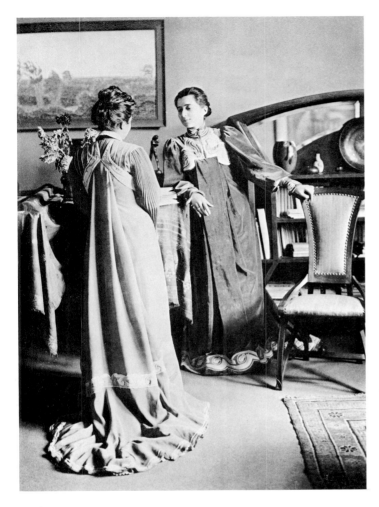

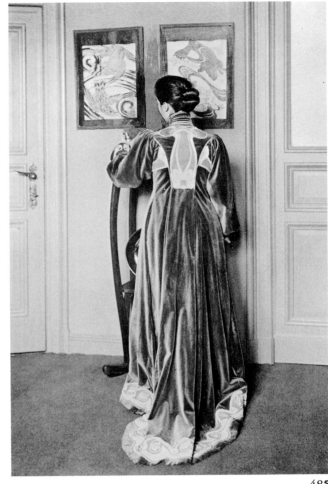

485

484
Two cuffs and a collar.
Designed by Henry van de Velde. c. 1896–98.
Brown velvet with appliqués of pale green silk
chiffon; embroidery in yellow and brown.
Collar: Width 45 (17¾)
Cuffs: Diameter 26 each (10¼)
Zürich, Museum Bellerive, Collection of the
Kunstgewerbemuseum, Inv. 1958–82.2–4.

Made for a dress worn by Maria van de Velde.
Formerly in the collection of Henry van de
Velde, Oberägeri, Switzerland.

Bibl: Gysling-Billeter 1975, no. 256 illus.

Exh: Krefeld 1900; Zürich 1958; Hagen 1963.

485
Two women's gowns [photographs exhibited].
Designed by Henry van de Velde. 1900.
Brussels, Archives Henry van de Velde,
E.N.S.A.A.V., Inv. 5250, 5251, 5252.

Three black-and-white photographs by Franz
Kullrich (Berlin, 1901), which were published
as illustrations to an album of women's dresses,
with a preface by Maria van de Velde and cover
design by her husband.

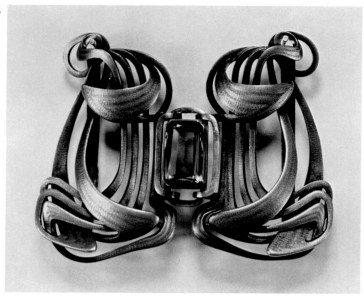

486

486

Belt buckle.
Designed by Henry van de Velde. c. 1898.
Silver and an amethyst.
8 x 10 (3⅛ x 3⅞)
Van de Velde's monogram, stamped twice on back.
Hagen, Henry-van de Velde-Gesellschaft, on loan to the Karl Ernst Osthaus Museum, Inv. H4/30.

Bibl: Hammacher 1967, p. 126 illus.

Exh: Brussels 1970.

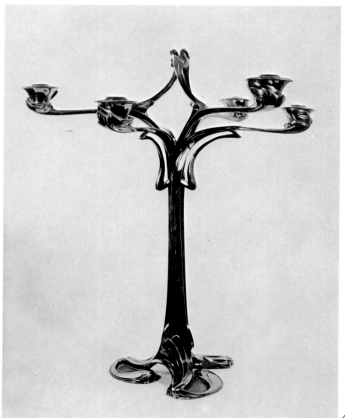

487

Candelabrum.
Designed by Henry van de Velde. c. 1898–99.
Silver-plated bronze.
Height 58.5 (23)
Brussels, Musées Royaux d'Art et d'Histoire, Inv. 6868.

Purchased from the artist in April 1900 shortly after it was exhibited at La Libre Esthétique.

Bibl: *Deutsche Kunst und Dekoration* 5 (1899–1900), p. 13 illus.; Maus 1900a, p. 173 illus.; Rheims 1964, pl. 95; Hammacher 1967, p. 217 illus.; Hüter 1967, pp. 93–95, p. 94 illus.

Exh: Munich 1899 (similar example); Brussels 1900; Brussels 1963b, no. 170; Ostende 1967, no. 261; Paris 1971b, no. 99; Brussels 1973, no. 501.

487

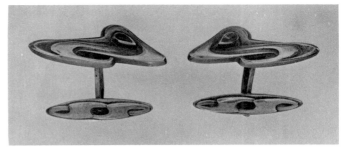

488
Cane.
Designed by Henry van de Velde.
Wood with silver head and tip.
Head: 5.5 x 3 (2⅛ x 1⅛)
Van de Velde's monogram, stamped on head.
Paris, Mme. Robert Walker.

The artist's personal cane, acquired from his
son, Théo van de Velde.

Exh: Brussels 1963b, no. 212A; Brussels
1970, no. 77.

489
Cufflinks.
Designed by Henry van de Velde; executed by
Theodor Müller.
Chased silver with sapphire and aquamarine
cabochons.
Height 3 (1⅛)
Van de Velde's monogram and *TM*, stamped
on back.
Hamburg, Museum für Kunst und Gewerbe,
Inv. 1952.36b–c.

Theodor Müller was the court jeweler in
Weimar.

Bibl: Rickert 1960, p. 229.

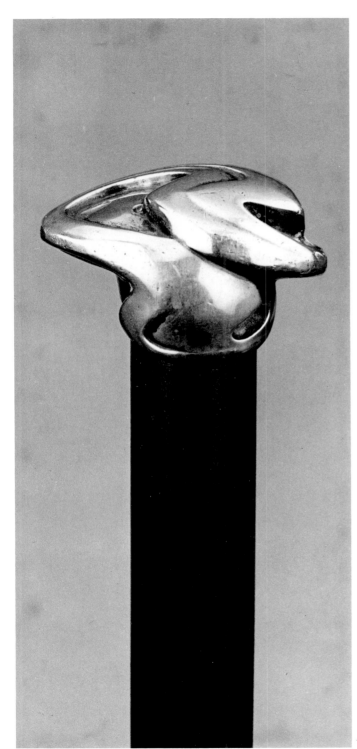

488

490
Design for dessert flatware.
Henry van de Velde. c. 1902.
Pencil on tracing paper.
32 x 22 (12⅝ x 8⅝)
Brussels, Archives Henry van de Velde,
E.N.S.A.A.V., Inv. 4101.

490

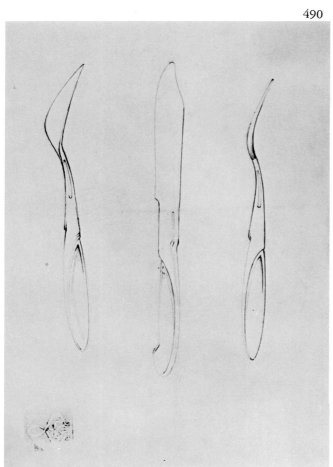

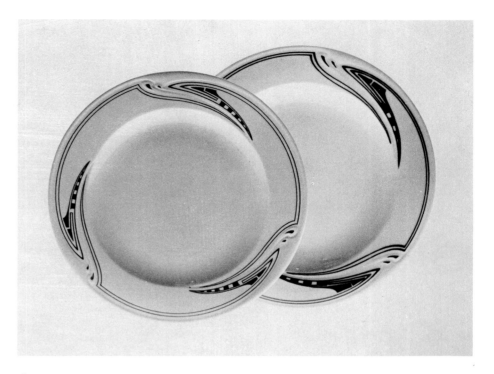

491
Studies for a plate.
Henry van de Velde. c.1903.
Black and red ink on tracing paper, mounted
together on cardboard.
28 x 37 each (11 x 14½)
Kgl. Porzelan-Manufactur/ Meissen/ I, upper
right of left drawing. *Kgl. Porzelan.
Manufactur./ Meissen./ IV.*, upper right of right
drawing.
Brussels, Archives Henry van de Velde,
E.N.S.A.A.V., Inv. 1253, 1254.

492
Plate.
Designed by Henry van de Velde; executed at
the Königliche Porzellanmanufaktur, Meissen.
c.1905.
Porcelain with relief and gold underglaze
decoration.
Diameter 23 (9)
Crossed swords (the Meissen mark) and Van de
Velde's monogram, imprinted on bottom.
Zürich, Museum Bellerive, Collection of the
Kunstgewerbemuseum, Inv. 1971–1.

Bibl: Gysling-Billeter 1975, no. 295 illus.

Exh: Dresden 1906.

493
Plate.
Designed by Henry van de Velde; executed at
the Königliche Porzellanmanufaktur, Meissen.
c.1905.
Porcelain with relief and blue underglaze
decoration.
Diameter 26.5 (10½)
Crossed swords (the Meissen mark) and Van de
Velde's monogram, imprinted on bottom.
Zürich, Museum Bellerive, Collection of the
Kunstgewerbemuseum, Inv. 1973–82.

Bibl: Gysling-Billeter 1975, no. 295 illus.

Exh: Dresden 1906, p. 113.

494

Chocolate service.
Designed by Henry van de Velde; executed at the Königliche Porzellanmanufaktur, Meissen. 1904.
Porcelain with painted underglaze decoration.
Pot: Height 16 (6¼)
Cups: Height 10.3 each (5⅛)
Dessert dishes: Diameter 21.2 each (8⅜)
Sugar bowl: Height 7 (2¾)

Tray: Length 46.8 (18⅜)
Crossed swords (the Meissen mark), on bottom.
Starnberg, Dr. Siegfried Wichmann.

Bibl: Hammacher 1967, p. 152 illus.

Exh: Paris 1960, no. 1281; Stuttgart 1963, no. 124; Brussels 1963b, no. 248.

495

Four stoves [photographs exhibited].
Designed by Henry van de Velde; executed by the firm of Schmidt, Weimar. 1904.
Brussels, Archives Henry van de Velde, E.N.S.A.A.V., Inv. 5000.

Van de Velde's stoves were usually designed for specific interiors, although Schmidt executed a few portable models. Those shown here, which bring to mind the first jukeboxes, are representative of the artist's early Weimar style. The heating element has been made the central ornament of an oversized plastic composition.

Bibl: Madsen 1956, p. 125 illus.

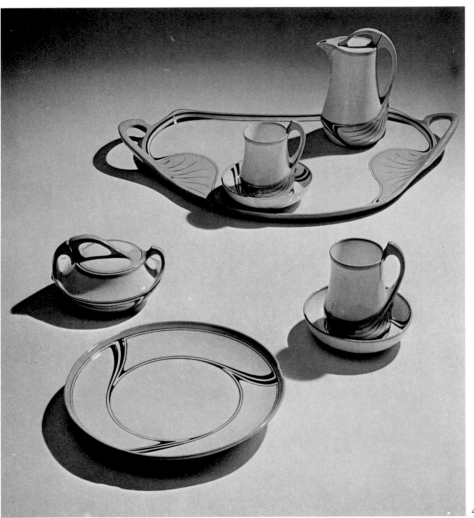

494

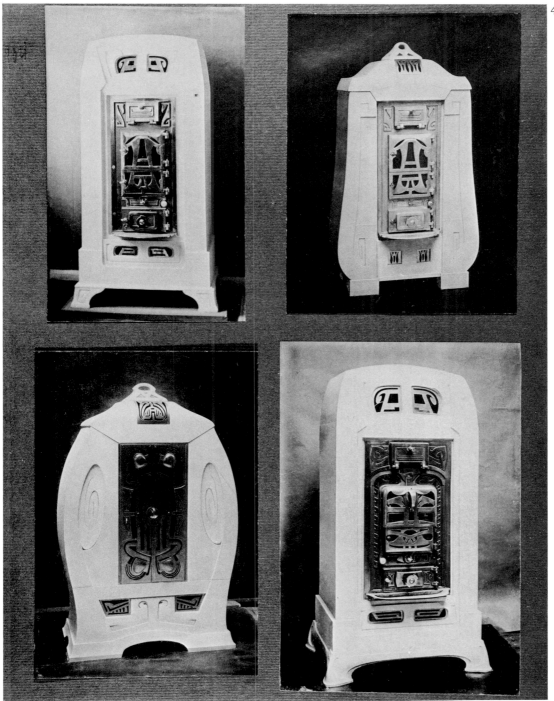

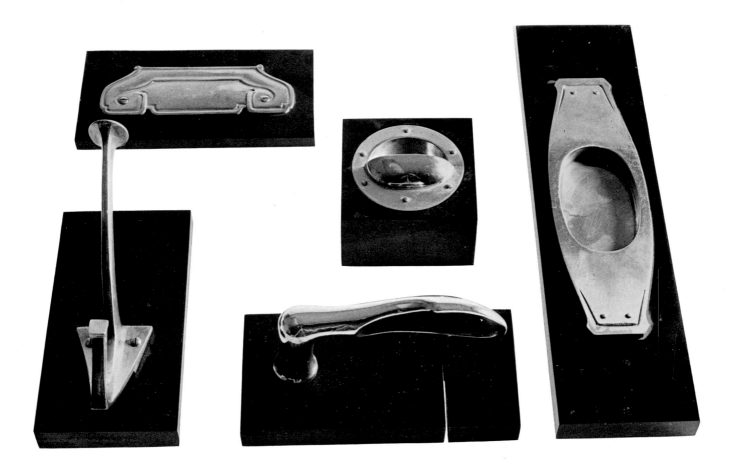

496
Door handle, coat hook, door fitting, door
pull, pull for a sliding door.
Designed by Henry van de Velde.
c. 1904–1907.
Brass; door handle chromed.
Door handle: Length 18 (7⅛)
Coat hook: Height 15.5 (6⅛)
Door fitting: Width 11 (4½)
Door pull: Diameter 6 (2⅜)
Pull for sliding door: Height 18 (7⅛)
Zürich, Museum Bellerive, Collection of the
Kunstgewerbemuseum, Inv. 1958–91.1–5.

Bibl: Gysling-Billeter 1975, no. 273 illus.

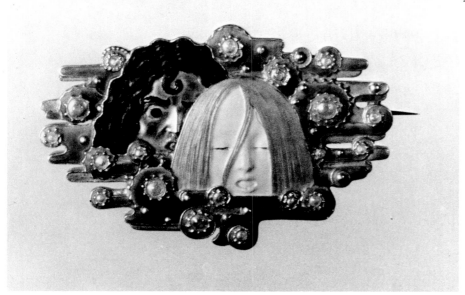

497

Apparition. Brooch.
Designed by Eugène Grasset; executed at
Maison Vever. 1900.
Gold; ivory; blue, turquoise, and lime mat
enamel.
3 x 5 (1¼ x 2)
VEVER, stamped on bottom edge. French
assay mark, stamped on clasp and bottom
edge. *2267*, engraved on clasp. Master's mark
(illegible), stamped on bottom edge.
Paris, Musée des Arts Décoratifs, Inv.
24516A. Gift of Henri Vever, 1924.

Bibl: Bénédite 1900b, p. 82 illus.; Ernstyl
1900, p. 152; Meusnier 1901, pl. 1; Geffroy
1901, p. 52; *Revue de la Bijouterie* 9 (1901), p.
152 illus.; Saunier 1902, p. 220 illus.; Vever
1908, p. 669 illus.

Exh: Paris 1900; Brussels 1963a, no. 438;
Munich 1964, no. 1106; Brussels 1965, no.
83; Amersfoort 1972, no. 45; Tokyo 1975,
no. 93.

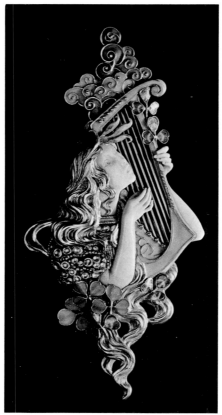

498

498

Poésie. Pendant.
Designed by Eugène Grasset; executed at
Maison Vever. 1900.
Gold; ivory; mauve and green enamel.
11.4 x 5.3 (4½ x 2⅛)
VEVER PARIS—E. GRASSET—1900,
engraved on back. *2257*, engraved on back and
scratched through. French assay mark and
illegible master's mark, stamped on loop.
Paris, Musée des Arts Décoratifs, Inv. 12746.

Vever executed the pendant from Grasset's
design (cat. no. 348) and exhibited it in 1900
at the Exposition Universelle, Paris; it was
acquired from Maison Vever in 1906.

Bibl: Bénédite 1900b, p. 70 illus.; Vever
1908, p. 668 illus.; Rheims 1964, pl. 53.

Exh: Paris 1900; Paris 1933, no. 1949;
London 1961, no. 351; Brussels 1963a, no.
442; Munich 1964, no. 1109; Amersfoort
1972, no. 46.

499
Perfume bottle.
Maison Vever. c. 1900.
Carved rock crystal; gold with green and
yellow enamel.
Height 11 (4⅜)
French assay mark, stamped on hinge. *No 40,*
engraved on inside of cover.
Paris, Musée des Arts Décoratifs, Inv.
24509A. Gift of Henri Vever, 1924.

500
Buckle.
Maison Vever. c. 1900.
Gold and enamel.
5.1 x 8.3 (2 x 3¼)
VEVER-PARIS, engraved on bottom.
New York, private collection.

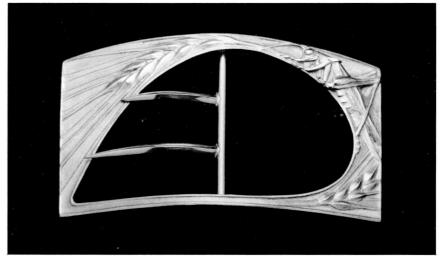

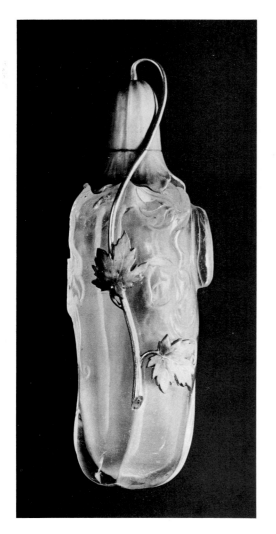

501

Vénus Dormante (Sleeping Venus). Pendant.
Maison Vever. 1900.
Gold, enamel, and diamonds; a baroque pearl;
carved ivory figure. Break at right shoulder
disguised with a band of platinum and
diamonds.
11.4 x 3.8 (4½ x 1½)
VEVER-PARIS, engraved on side.
New York, private collection.

There is an identical piece, without the
disguised repair on the arm, in the Musée des
Arts Décoratifs, Paris (Inv. 24524). One of the
two was exhibited in 1900 at the Exposition
Universelle, Paris.

Bibl: *Art et Décoration* 8 (1900), p. 79 illus.;
Revue des Arts Décoratifs 21 (1901), p. 18 illus.;
Revue de la Bijouterie 9 (1901), p. 142 illus.;
L'Art Décoratif 5 (1903), p. 55 illus.; Vever
1908, p. 672 illus.

Exh: New York 1967.

502

Mistletoe comb.
Maison Vever. 1900.
Shell; lime green enamel on chased gold;
artificial pearls.
17 x 10 (6¾ x 4)
Paris, Musée des Arts Décoratifs, Inv. 9372.

Purchased from the artist in 1900 at the
Exposition Universelle, Paris.

Bibl: *International Studio* 14 (1901), p. 28
illus.; Germain 1901, p. 141 illus.; Meusnier
1901, pl. 7; Rheims 1964, pl. 47.

Exh: Paris 1900; Paris 1957, no. 161; New
York 1960, no. 295; Brussels 1965, no. 84;
Tokyo 1975, no. 95.

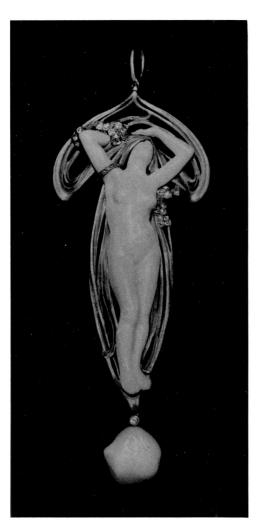

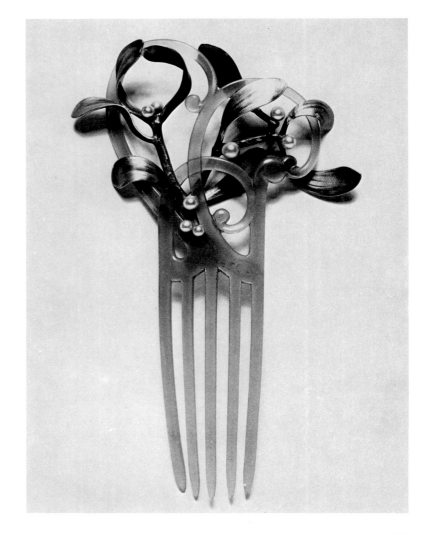

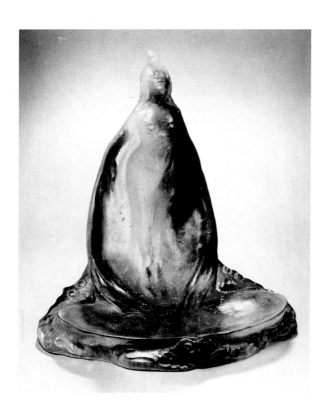

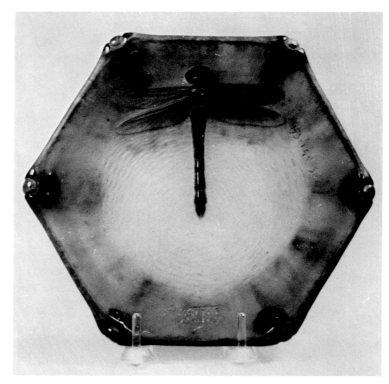

503
Pin tray.
A. Walter.
Blue *pâte de verre*.
Height 20 (7⅞)
A Walter Nancy, on rim of bowl. *J. Moug.,*
at rear.
Kunstmuseum Düsseldorf, Collection
Hentrich.

The signature indicates that this piece was
modeled after a ceramic by Joseph Mougin.

504
Ashtray.
Designed by Henri Bergé for A. Walter.
After 1908.
Blue, green, white, black, and brown
pâte de verre..
Diameter 19.7 (7⅞)
A Walter/ Nancy and *H Bergé Sc* (*H* and *B*
intertwined), inside rim.
Chrysler Museum at Norfolk, Inv.
GEFW.70.7. Jean Outland Chrysler
Collection.

505
Six studies.
Philippe Wolfers. 1895–98.
Pencil, watercolor, and gouache on paper;
mounted together in a frame designed
by the artist.
76 x 113 with frame (29⅞ x 44½)
From left to right, top to bottom: *PhW*——/
2/31/96, lower right. *PhW*——/ *16/9/96*,
lower right. *1.7.*, Wolfers' monogram, and

98, lower right. *30.5.*, Wolfers' monogram,
and 98, lower right. *19.6.*, Wolfers'
monogram, and 95, lower left. *15.11.*,
Wolfers' monogram, and 97, lower right.
Vieusart, Marcel Wolfers.

According to Marcel Wolfers, his father
Philippe may have framed these drawings in
1898 for exhibition at the Cercle Artistique,
where many of his works were shown.

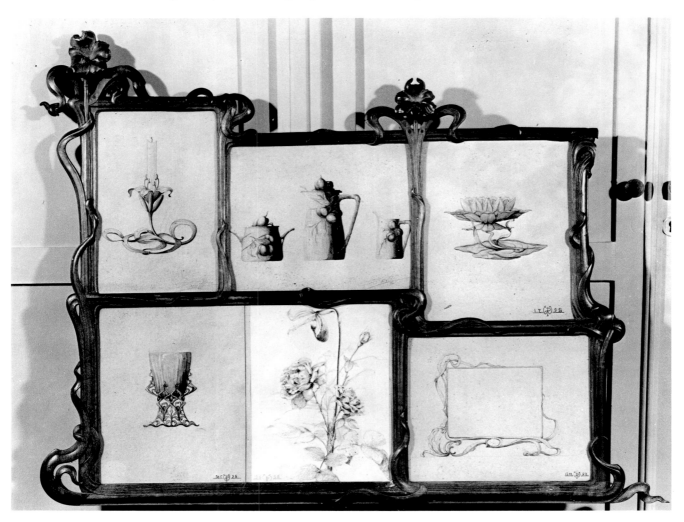

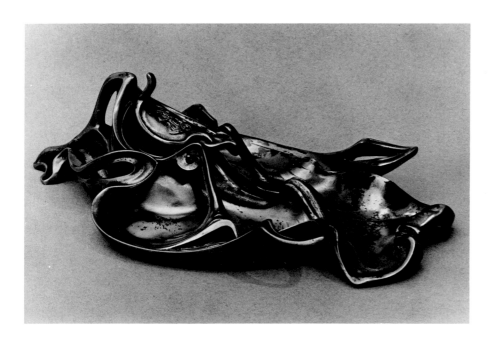

506
Inkwell.
Philippe Wolfers. c. 1895–1900.
Gilt bronze.
9.8 x 35.5 x 21 (3⅞ x 14 x 8¼)
Wolfers' monogram, engraved on edge.
Brussels, L. Wittamer–de Camps.

The inkwell of Armand Solvay, whose initials are incorporated into the design of the lid. This piece has been exhibited and illustrated several times as the work of Victor Horta, an attribution undoubtedly arising from Horta's celebrated association with the industrialist, for whom he built and furnished the Hôtel Solvay, Brussels, beginning in 1894.

Bibl: Madsen 1956, p. 48 illus.; Schmutzler 1964, fig. 3; Madsen 1967, p. 157 illus.

Exh: New York 1960, no. 144.

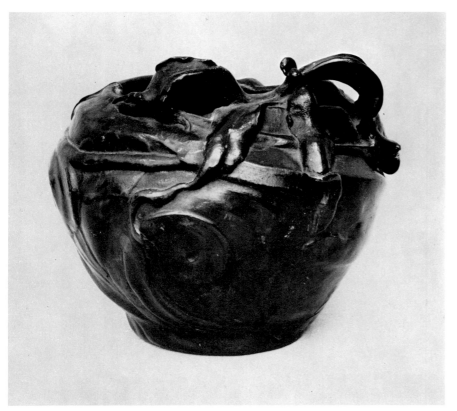

507
Bowl.
Philippe Wolfers. c. 1896.
Bronze with green patina.
Height 15.5 (6⅛)
PW, engraved at base.
Brussels, L. Wittamer–de Camps.

Found at the flea market in the place du Jeu de Balles, Brussels, this piece is undoubtedly the model for the bowl manufactured by Emile Müller (cat. no. 445).

508
Bud vase.
Philippe Wolfers and Val-Saint-Lambert;
mounting by Philippe Wolfers. 1896.
Cased green and clear crystal; mounting in
silver.
Height 20.9 (8¼)
Master's mark, *800* in a rectangle, and
no. 212, stamped on bottom of mounting.
Brussels, L. Wittamer–de Camps.

One of a pair.

Bibl: Philippe 1974, pl. 22a.

Exh: Ostende 1967, no. 278.

509
Chrysanthemum vase.
Philippe Wolfers. 1898.
Silver with yellow, green, and mauve enamel;
inlaid mother-of-pearl sections.
Height 18.2 (7⅛)
Wolfers' monogram, engraved and enameled at
base. Wolfers' monogram and
EX. UNIQUE as a seal, impressed on bottom.
Brussels, L. Wittamer–de Camps.

Made for Wolfers' exhibition, 1898.

Bibl: *Catalogue des Exemplaires Uniques* (1898),
no. 1; Pierron 1900, p. 231 illus.; Whitby
1901, p. 324, p. 323 illus.; *Deutsche
Goldschmiedezeitung* (April 1902), illus.;
La Gerbe 1 (July 1899), illus.

Exh: Turin 1902; Ostende 1967, no. 272.

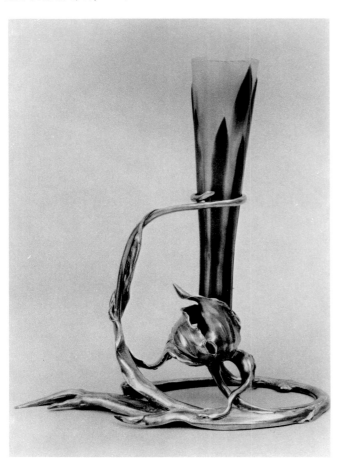

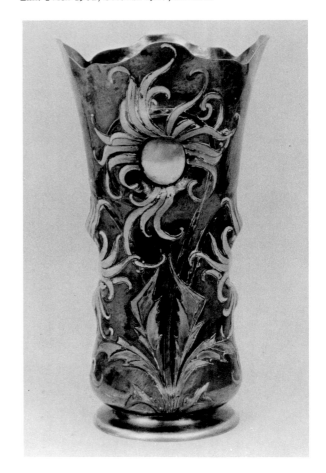

510
La Nuit (Night). Vase.
Philippe Wolfers. 1898.
Copper with blue, pink, and red enamel;
mounting in silver.
Height 16 (6⅜)
Brussels, L. Wittamer–de Camps.

Bibl: Pierron 1900, p. 230 illus.

Exh: Ostende 1967, no. 271.

511
Salamander vase.
Philippe Wolfers and Val-Saint-Lambert.
1899.
Molded yellow, blue, and raspberry crystal;
mounting in silver.
Height 32 (12⅝)
PWolfers (*P* and *W* intertwined), engraved at
top.
Brussels, L. Wittamer–de Camps.

Bibl: Philippe 1974, p. 209, pl. 22c.

512
Goblet.
Philippe Wolfers. c. 1899.
Silver; pale blue, green, and siena
plique-à-jour enamel.
Height 12.5 (4⅞)
PWolfers (*P* and *W* intertwined)/ *EX.
UNIQUE*, engraved on bottom.
Ghent, Museum voor Sierkunst, Inv. 1451.

One of a pair. According to a certificate by

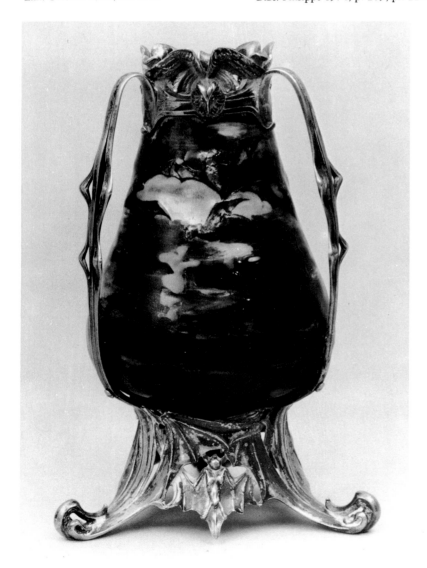

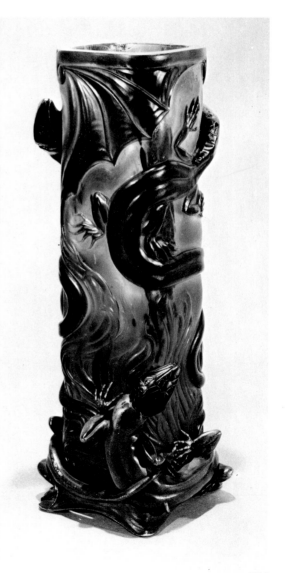

510

511

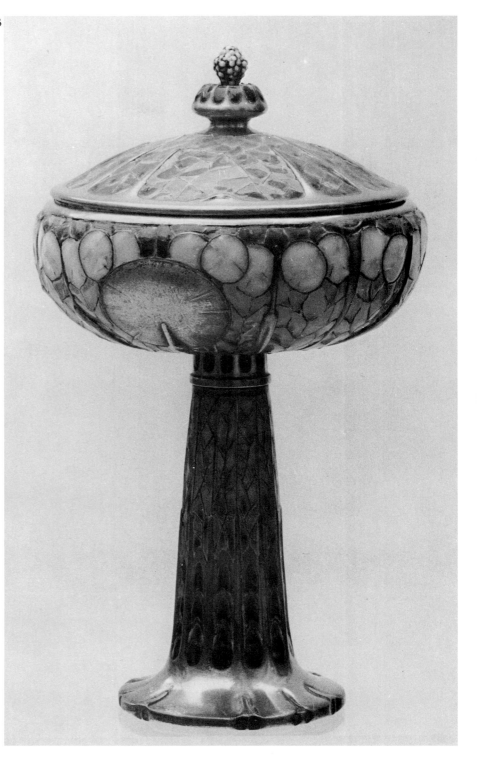

Marcel Wolfers in the files of the Museum voor
Sierkunst, this piece and its companion, as
well as a pair of chalices (see cat. no. 513),
were purchased from the artist in 1899 by a
Mme. Neyt; the museum acquired them in
1920 at the Neyt collection sale. All four
pieces originally had a light patina of gold.

Bibl: *Collection Adolphe Neyt*, no. 665, p. 51.

Also illustrated in color.

513
Covered chalice with satinpod decoration.
Philippe Wolfers. c. 1899.
Silver; blue, green, pale green, orange, and
yellow plique-à-jour enamel; green and yellow
champlevé enamel.
Height 20.4 (8)
Ghent, Museum voor Sierkunst, Inv. 1452.

One of a pair, and acquired with a pair of
goblets (see cat. no. 512).

Bibl: *Collection Adolphe Neyt*, no. 666, p. 51.

Exh: Brussels 1972, no. 8.

512

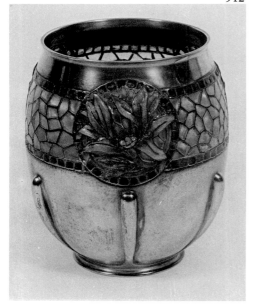

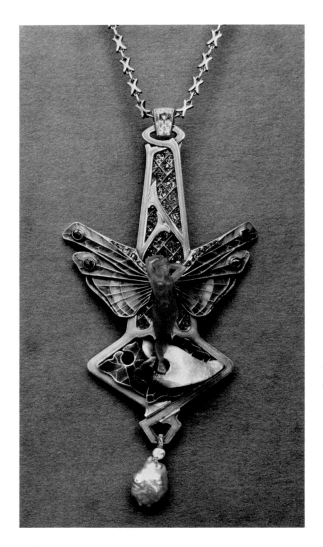

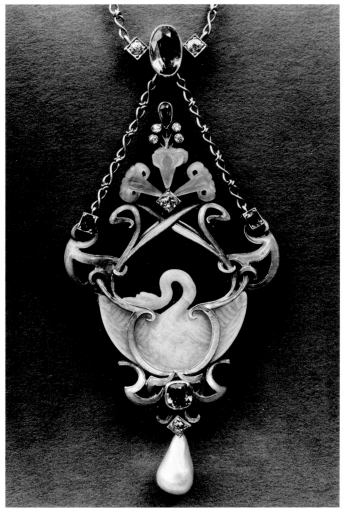

514
La Nuit (Night). Pendant.
Philippe Wolfers. 1899.
Carved carnelian and opal sections; a baroque
pearl; gold with cloisonné and plique-à-jour
enamel, set with diamonds and ruby
cabochons.
9.2 x 5.5 (3⅝ x 2⅛)
P.W. Ex. unique, engraved on back.
Brussels, L. Wittamer–de Camps.

Bibl: *Revue des Arts Décoratifs* 20 (1900),
p. 230 illus.; Hughes 1964, pl. 176.

Exh: Brussels 1899; Brussels 1965, no. 99;
Ostende 1967, no. 294; Paris 1972, no. 273;
Milan 1973, no. 9.

Also illustrated in color.

515
Cygne et Jacinthe (Swan and Hyacinth). Pendant.
Philippe Wolfers. 1900.
Gold with green enamel; carved carnelian and
iridescent stone; diamonds, rubies, a green
tourmaline, a pink tourmaline, and a
baroque pearl.
Height 10.5 (4⅛)
Brussels, L. Wittamer–de Camps.

Bibl: Molinier 1901, p. 189 illus.

Exh: Brussels 1965, no. 97; Ostende 1967,
no. 296; Milan 1973, no. 10.

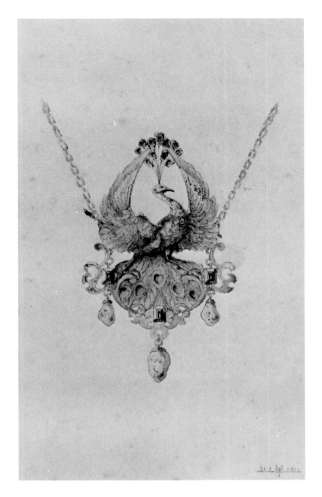

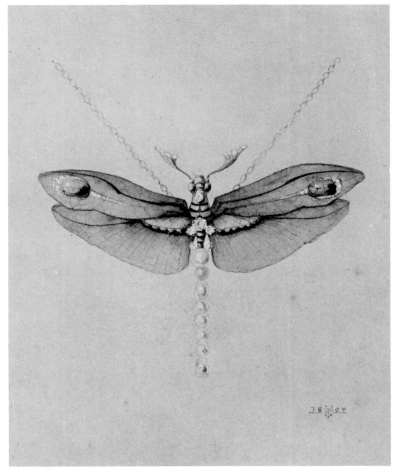

516
Design for a peacock pendant.
Philippe Wolfers. 1901.
Colored pencil on paper.
25.3 x 16 (10 x 6¼)
31.7., Wolfers' monogram, and *1901*,
lower right.
Vieusart, Marcel Wolfers.

The working design for a pendant which is
now in a private collection in Antwerp.

Exh: Milan 1973, no. 6.

517
Design for a dragonfly pendant.
Philippe Wolfers. 1904.
Colored pencil on paper.
20 x 17.3 (7⅞ x 6¾)
7.2., Wolfers' monogram, and *04*,
lower right.
Vieusart, Marcel Wolfers.

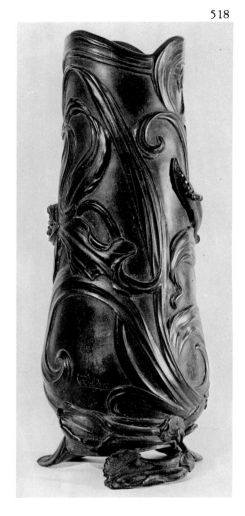

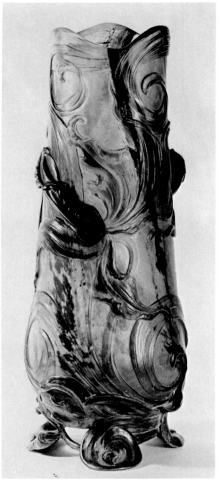

519
Orchidée (Orchid). Mounted vase.
Philippe Wolfers and Val-Saint-Lambert.
Cased crystal, cranberry on pale green on clear,
with sealed oxides; wheel-cut decoration;
mounting in gilt bronze.
Height 39.3 (15½)
PWolfers (*P* and *W* intertwined), engraved
near base.
Brussels, L'Ecuyer.

According to Marcel Wolfers, his father
Philippe would model a form, cast it in
bronze, and give the bronze to the
Val-Saint-Lambert glassworks as a model. At
Val-Saint-Lambert the vase would be blocked
out in glass and returned to Philippe Wolfers,
who then did the fine cutting himself. As with
most of Wolfers' work, this is a unique piece.
The bronze model (cat. no. 518) is still in the
collection of Marcel Wolfers.

Bibl: Philippe 1974, p. 210 illus.

Also illustrated in color.

518
Model for *Orchidée*.
Philippe Wolfers.
Bronze.
Height 39 (15⅜)
PWolfers (*P* and *W* intertwined), near base.
Vieusart, Marcel Wolfers.

Model for the vase executed with the
collaboration of the Val-Saint-Lambert
glassworks (see cat. no. 519). Another copy of
the model, also in bronze, is in the collection
of L. Wittamer–de Camps, Brussels.

Bibl: Philippe 1974, p. 210 illus. (the
illustration is of a drawing of the model; its
signature is incorrectly represented).

ARCHITECTURE

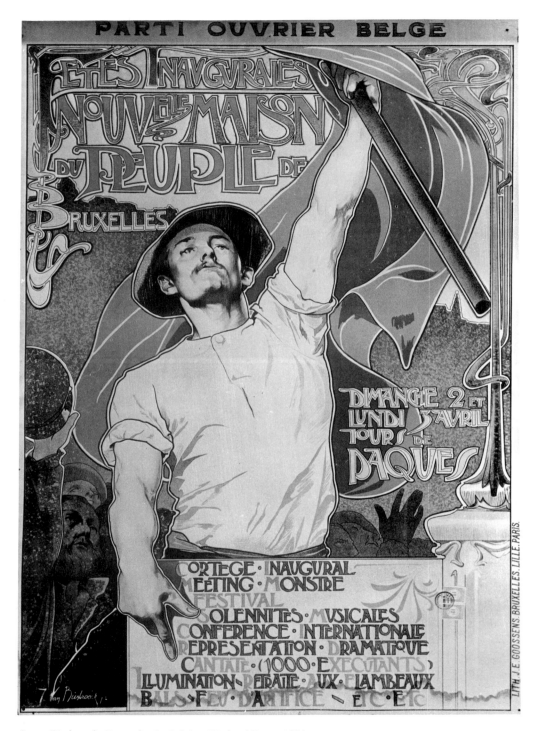

J. van Biesbroeck. Poster for the Belgian Workers' Party. 1899.

ART NOUVEAU ARCHITECTURE IN BELGIUM: RED STEEL AND BLUE AESTHETIC
Maurice Culot

If the past is often distorted in retrospective accounts, it is in works dealing with the history of contemporary architecture that we must look for the widest divergence between rhetorical pronouncements and the realities of spaces enclosed within walls. The architecture of the past century has too often been analyzed by historians in a way that conceals the value of the sources of documentation. The leading men of the modern movement and their hagiographers have quite naturally tried to conceal or minimize the importance of references that might prompt questions about the orthodoxy of their procedures. How many architects have wanted, as their written memoirs indicate, to secure a place in history interpreted as proving that architecture must go from ornament to bareness, from complexity to simplicity, from the individual to the collective! How many archives have disappeared or been deliberately destroyed by artists disappointed or resigned! The desire to wipe out the traces of a past now in disfavor could lead a master like Horta to the ultimate solution, the auto-da-fé of thousands of original plans and designs.

If the past is to be examined not with a theoretical bias, but rather to find actual determinants for the formation of the languages and landscapes of architecture, the importance of prosaic, day-to-day developments cannot be overlooked. More specifically, anyone who wants to judge the breadth and originality of the Art Nouveau phenomenon in Belgium must bring to light the whole range of the architecture included in the categories of traditional art, official art, and avant-garde art in its various aspects—from art for art's sake to socially conscious art. If Brussels is thought of as one of the capitals of Art Nouveau, this is due not so much to a handful of buildings by Horta as to the efflorescence of decoration which spread through the whole city like a pernicious ivy and transcended the personalities of a few individuals and even an avant-garde art movement. It was a particular kind of efflorescence, and its obsessive and singular character can be explained only in relation to the recent past of the country, its economic climate, social conditions, political conflicts, and ideological struggles.

The years 1892–93 are generally recognized as historically significant. This was when Horta built a house—so revolutionary in design that it was called a "maison-manifeste," an architectural manifesto—for Tassel, an engineer and member of the Société Solvay. Hankar, then thirty-four years old, broke with the prevalent historicism in the building of his own combination house and studio. Van de Velde, a painter-turned-architect, did his enigmatic woodcuts for the magazine *Van Nu en Straks*. But Tassel's blind confidence in Horta, an architect who was just making his start; Hankar's facade, which showed Japanese influence although he had been trained in the Flemish Renaissance and Gothic styles; and Van de Velde's woodcuts, the first experiments with an abstract, linear writing, were three departures stemming directly from a process of social change, the pivotal events of which occurred around 1885.

SOCIAL PROTEST

The economic crisis which struck Europe in 1884 was particularly severe in Belgium, since the condition of the working class was worse there and the density of population greater than in any other Continental country. Between 1850 and 1900 the population rose from 150 to 230 per square kilometer. The Liberal government fell in 1884, and with it disappeared the regime under which the country had lived since winning independence from the Dutch in 1830. The Catholics established themselves solidly in power, and the socialists began to gain strength.

The Belgian Workers' Party (Parti Ouvrier Belge) was

founded in 1885, the fruit of twenty years of effort. An awakening of class consciousness, influenced by ideas propagated at the First International, was evidenced in 1867 but did not survive the dissensions within the International and the worldwide reaction provoked by the suppression of the Paris Commune. The penal code was revised in 1867, however, and workers were guaranteed the right to strike. But what an illusory right it was, in view of the fact that the promulgators of the socialist idea were forced to hold "black meetings" at which the speakers, hidden by the darkness of night, talked through lengths of stovepipe to disguise their voices, and the workers themselves were threatened with dismissal if they attended these meetings.

Continuous economic contacts were taking place between the United States and Belgium, the latter country exporting both glass products and prefabricated metal houses.[2] From 1870 on, the manufacture of mirrors increased considerably. Their high quality and reasonable cost opened up new possibilities for their use in architecture. Alban Chambon, who built the Théâtre de la Bourse in 1885, multiplied effects of perspective by covering the walls with mirrors. Hankar executed some surprising store windows in which the beveled edges of the polished panes fitted into woodwork cut in irregular, sinuous shapes. Horta and Saintenoy erected large store buildings with wholly glassed-in facades.

A large number of glassblowers from the Charleroi region went to the United States to work at their trade. These contacts explain the introduction of "knighthood" into the industrial area of southern Belgium: the glassblowers who came back from America were steeped in the principles of the Knights of Labor, a secret society founded in 1869 to defend workers' rights. In 1882 these artisans established a Belgian branch of the Knights of Labor (Local 3628, the Assemblée des Verriers à Vitres Belges, or Eurêka), and in 1885 the organizer of Local 300 in Pittsburgh went to Charleroi to interest the miners in starting their own organizations. The Belgian units of the Knights of Labor were to play a leading role in the formation of the Belgian Workers' Party, and most of them joined ranks with the new party in 1895.

On March 25, 1886, riots broke out in the Charleroi region, but were suppressed by the army with unheard-of brutality. The rank injustice of this action moved some few young intellectuals to quit their social milieu and join the new Workers' Party; among them were three lawyers, Jules Destrée, Emile Vandervelde, and Max Hallet. All three eventually became intimate friends of Henry van de Velde, and it was they who persuaded the executive committee of the party to give Victor Horta the commission for the Maison du Peuple in Brussels; Max Hallet later engaged Horta to draw the plans for his residence on the avenue Louise.

The riots of 1886 sparked socialist action in Belgium. From that time on, demonstrations followed one after the other. In August 1887 thirteen thousand miners, and in 1890 eighty thousand demonstrators, paraded through the streets of Brussels to demand universal suffrage. A general strike was announced, then canceled upon receipt of promises from Parliament. Two general strikes, however, were called. The first, in 1902, was a failure because it was launched in a period of economic prosperity; it drained the strikers' relief funds without really threatening the national economy. The second, in 1903, was decisive, and forced Parliament to agree to the principle of universal suffrage—tempered, it is true, by the plural vote, which gave extra votes to the middle-class electorate.

The upshot of the economic crisis of 1884 and the organization of the forces of labor was an acceleration of industrial and financial concentration which displaced family or individual management. Stimulated principally by the Société Générale, a financial establishment created in 1822 for the purpose of providing capital to young and growing mechanized industries, the number of corporations rose from 201 in 1857 to 1158 in 1900. Control over the business world passed into the hands of new men fired with the spirit of progress: mostly they were engineers and former colonials who had taken part in building the Congo Free State, setting up steel mills in Russia, or constructing the Peking-Hankow railroad line. These were the people who became Horta's most enlightened clients and had complete confidence in him—the Van Eeteveldes, the Solvays, the Aubecqs, the Tassels. Intelligent and energetic, they set the development of capitalism upon a new road. Belgium was never richer than it was on the eve of World War I: orders flowed in, and industrial activity overran the national boundaries to spread through the entire world.

SOCIALISM AND ART NOUVEAU

When, after the riots of 1886, the directors of the Belgian Workers' Party extended a welcome to young intellectuals, deserters from the liberal middle class, they recognized that the presence of these recruits was an unhoped-for stroke of luck for the future of socialist action. They therefore felt no hesitancy about elevating men like Destrée, Furnémont, and

Vandervelde to positions of importance, although the rank and file preferred their leaders to come from the working class rather than from the bourgeoisie. The learning, eloquence, and writings of these men brought the party a badly needed power of logic. But there was more involved than the struggle against social inequalities. The charter of the Workers' Party stated clearly that the march forward towards the society of the future was to be accompanied by intellectual as well as material transformations, and that all these developments must proceed on an equal footing and be fostered with equal care.

As things turned out, however, the field of combat was exclusively that of bettering material conditions. Cultural policy was rarely discussed, and the executive committee tacitly left it to their intellectual recruits to define the party line in that area. In the many lectures, newspaper articles, and books which the champions of the Workers' Party devoted to the problem of the relation of art to socialism, the appeal was always to the exaltation of beauty rather than to the definition of a socialist art.[3]

This attitude was justified for two reasons. The first pertained to strategy: by encouraging the proletariat to appreciate works of art, the party intended to show that socialists were not benighted barbarians who might be expected to sacrifice the nation's cultural heritage on the altar of revolution. The second reason pertained to culture itself. When they talked of art, the Destrées and Vandeveldes and Hallets were not referring to a mere abstraction, nor solely to the works of the artistic past. Implicitly they associated the notion of a progressivist art with the efforts of their artist friends—the Van de Veldes, Hortas, Meuniers, Verhaerens, Maeterlincks—to free contemporary art from academicism. Here we must remind the reader that when, in 1885 and thereabouts, some of the most thoughtful young intellectuals directed their interest to socialism and politics while others chose to engage in the fight for the renewal of the arts, this was not a rift but a manner of specialization.

So it was that at the dawn of the 20th century the aesthetic ideas of the Belgian Workers' Party rested entirely on the friendship between its young intellectual leaders and the avant-garde artists, notably those of the Groupe des Vingt, its successor La Libre Esthétique, and L'Art Moderne. And because these artists were enthusiastic about Art Nouveau, their socialist friends came out for architecture in the modern style. Thus the plans for the Maison du Peuple are Victor Horta's work, and thus Louis Bertrand, a socialist deputy mayor, saw to it that most of the public buildings in his commune—schools, swimming pool, low-cost housing—were of Art Nouveau design.[4] Although we cannot quite call Art Nouveau the official socialist style, there can be no doubt that it was given preference by the party: Henry van de Velde, for instance, was put in charge of the party's graphics, while the socialist leader Emile Vandervelde wrote in favor of the new style.[5]

However, basing an aesthetic approach on relations of friendship between the leaders of a party and a select group of artists, even if these were the most creative of their time, inevitably led to a dead end. A vibrant, forward-looking socialist aesthetic could develop only in the context of a wide, continuous, and contentious democratic debate. In fact, socialist thought on the subject petrified rapidly, the end result being a new academicism. One of the most disastrous effects of this was the indifference of socialists toward the whole problem of urban space, which, because they have failed to make it an object of thoughtful analysis, does not impress them even today as a prime field of combat for the class struggle.

From its beginnings, Art Nouveau architecture appealed to a clientele that was more open and dynamic than the *grande bourgeoisie*: engineers, lawyers, and artists were more receptive to new ideas by the very nature of their professional activities. By putting its stamp of approval on Art Nouveau, the Workers' Party confirmed and accentuated this cleavage, which found concrete expression in the Brussels street scene in a way that no one expected. Building became a medium for the expression of ideology. Freethinkers, socialists, and liberals had their buildings done in Art Nouveau style. Catholics on the other hand chose Gothic Revival or Flemish Renaissance. They condemned Art Nouveau on the ground that its sinuous curves appeared to be the mark of a totally pagan lubriciousness, and forbade its teaching in the architectural schools of Saint-Luc.

The Proud, Fecund Luxury of Bengal Architecture

The extreme tension that invigorated the artistic and political avant-garde toward the end of the 19th century drew much of its strength from a reaction to the intellectual climate of the 1880s. In a memoir of his years as a law student Jules Destrée conveys the feeling of that climate. On his shelves current magazines stood next to the works of Zola, Taine, and Baudelaire. A large etching by Rops hung on his wall. In the evening he went to the places then in fashion, the

Vauxhall and the Eden Théâtre, as much to sit and talk as to see the show. He belonged to the Chapitre, a small literary group which at the time was only a timid beginning, but which foreshadowed what Les Vingt, L'Art Moderne, and La Libre Esthétique were to be a few years later. The time, however, was out of joint, and it was easy to fall into the fashionable pessimism that such writers as Dostoevsky incited.[6]

The first gust of fresh air came from the Far East, when Japanese imagery raised hopes that art could be stripped of its furbelows. Destrée, now a socialist lawyer, decorated his office walls with the same prints that Hankar the architect hung in his studio.[7] Monograms engraved by Henry van de Velde, and the wrought iron and cabinetwork of the house Hankar built for himself in 1893, reveal a graphic style clearly influenced by Japanese art.

So, in the early 1890s, two movements, one political and the other cultural, finally pierced the fog of materialism which had driven young intellectuals to take a pessimistic view of life in general. On the one hand there was socialism with its ideals and its strategy of action; on the other hand there was the budding Art Nouveau, which opposed an organic art to the revivals and labored compositions of Eclecticism.

Rarely have opinions and critical analyses on an architectural style been so divergent as those regarding Art Nouveau. A majority of the historians who wrote in the period between the two world wars, while they recognized that Art Nouveau had broken with tradition, have considered it an eccentricity, a hiatus in the evolution of architecture. Since World War II the problem has been reexamined, and more thorough analysis has thrown light on the factors that favored the blossoming of this style. But if the ebullition of ideas characteristic of the 1880s made an ideal crucible for the shaping of a new style of architecture, by itself it does not suffice to explain a popularity so great that the face of a city like Brussels was profoundly changed in the space of less than ten years.

If the style was to flourish it needed first a suitable urban structure. Belgian cities with their communal divisions, and Brussels in particular, made such urbanization and uniformity as was achieved in Paris practically impossible. The terrain that favored the development of Belgian Art Nouveau architecture was the narrow building site about twenty feet wide, fronting along a street. Even Horta, who built for the richest clients, usually had to set his houses within such a limited space. This restriction, however, challenged the imagination: the originality of the plans of the Tassel and Van Eetvelde houses is a direct outcome of this division of land into narrow, elongated parcels. In addition to this type of site limitation, which favored the multiplication of small properties, there was the intensely individualistic character of the householders, who, as heirs to a long tradition of communal liberties, were strongly attracted to a style that allowed so much daring and fantasy.

It was Art Nouveau's very popularity that caused its rapid decline. From the point of view of building technique the style could have lasted until just before World War I, but it fell into disuse shortly after 1905, and the building crafts reverted to all the "Louis" styles in their work with iron, wood, and stone. Art Nouveau in becoming popular, moreover, reversed Horta's equation: the latter developed his elegant spaces behind relatively simple facades, while the homes of the commercial bourgeoisie were given facades in an exuberant modern style, with an interior that was often banal.

In practice their owners left the sumptuous residences built by Horta only a few years after occupying them, moved out of the city, and isolated themselves on estates laid out in the suburbs. The coming of the automobile facilitated this exodus of the rich. And as the aristocracy abandoned the city, the critics, who only the day before had extolled Art Nouveau to the skies, now began to treat it with disdain. The style died of its own popularity. Thereafter the town was given over to unbridled speculation. The aristocracy, who no longer lived there, had lost interest in preserving and adding to its beauties.

Generally speaking, historians point out relationships between the iron structures of the 19th century, the theories of Viollet-le-Duc, and the exposed structural elements characteristic of Art Nouveau. But, granted that Viollet-le-Duc's logic and the iron-and-glass architecture of the international expositions stirred the imagination of architects like Horta and Guimard, this a posteriori judgment still needs to be refined.

The 19th century witnessed two achievements of epic proportion: the conquest of new territories and the conquests of science. From the point of view of risks incurred, the story of the lives of the first great engineers is comparable to that of the pioneers who pressed forward into uncharted lands, and their work may even be more truly significant than the over-mythicized "winning of the West."

Jules Verne's engineer, a castaway on a desert island, might singlehandedly reconstruct civilization, but the 19th

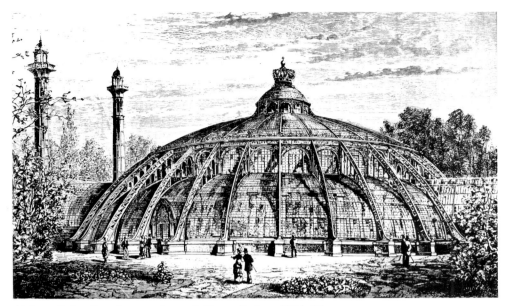

Alphonse Balat. Greenhouse at the royal château, Laeken. 1874–76.

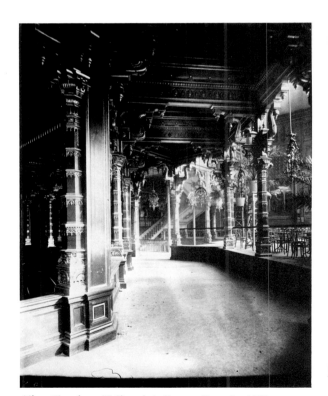

Alban Chambon. Théâtre de la Bourse, Brussels. 1885.

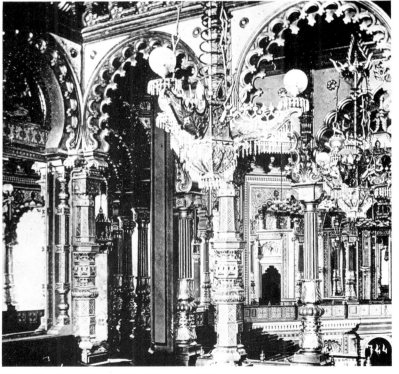

Alban Chambon. Eden Théâtre, Brussels. 1880.

century never confused the roles of the architect and the engineer: the former beautified the city, the latter constructed bridges, laid out railroads, put mines in working order. When Balat built the greenhouses at the château of Laeken,[8] he did not for a moment imagine that iron and glass would one day be used in so ostentatious a way for private dwellings. In fact, when he went to see the Tassel house built by Horta, a former pupil of his, he was revolted, and never forgave the younger man for having betrayed architecture by putting stained glass and bare iron in a domestic building. And when Jobard wrote, in 1847, that the *ordre métallurgique* was at hand,[9] he was not suggesting that metal be used to simplify architecture, but that the potentialities of the new material be exploited to achieve more complex architectural wonders—the sort of things that painters alone had until then dreamed up. Chambon, building his theaters in Brussels, London, and Amsterdam, was simply following Jobard's advice, using the possibilities of contemporary technology to produce palaces out of the *Thousand and One Nights.* The critics, moreover, greeted Chambon's accomplishments in the same terms Jobard had used thirty-five years earlier in his predictions.[10]

In the 1880s Brussels finally lost its Neoclassical, provincial dignity, and built fairy castles in order to escape from a civilization dominated by materialism. Everything seemed put together to create a dreamland, to ease flight into the unknown: the profusion of plants, oriental decors, star-studded cupolas, mirrors, expanses of glass, canopies, electric lights, even the curves of Thonet's chairs . . . all reminiscent of the narcotic high. Indeed people were trying drugs: in 1889, for instance, Van de Velde and his friend, the poet Max Elskamp, experimented with hashish. As for the poets, they imitated Baudelaire. Iwan Gilkin's *La Nuit* was a rejoinder to the *Fleurs du Mal,* but his descriptions are even darker; he was attacking the vices of the city, its jaded sophistication, its pessimism, and his Catholic concept of sin lent the poem a tragic mood.

But the works of Chambon, designed to gratify the taste for novelty of a wealthy, carefree aristocracy, did not have this demonic brilliance. His vast metal-and-glass umbrellas, his theaters with their wide promenades and their glass-enclosed, heated foyers, created an ambience which satisfied the fondness for exoticism in a completely new and grandiose way. Stained glass became the fad, succeeding the vogue for covered arcades that had raged during the first half of the century.[11] Similarly, the purpose of the greenhouses at the royal château was not so much botanical as social; they were

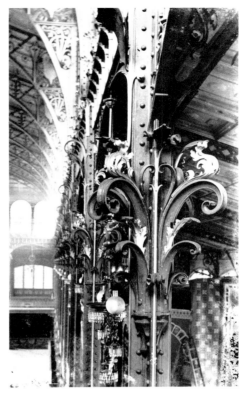

Alban Chambon. Palais d'Eté, Brussels. 1894.

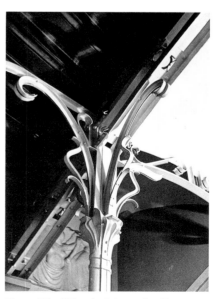

Horta. Hôtel Tassel. Column detail.

built for the sake of prestige, to provide a place for social functions, concerts, and a pleasant promenade. So strong was the taste for glassed-in structures that a church built entirely of iron and glass was adjoined to the royal greenhouses.[12]

MIDDLE-CLASS SOCIAL LIFE

The thirteen years or so preceding the historic year 1893, when Victor Horta literally exploded the conventional space of the private residence, were the time when middle-class social affairs also found a new environment, moving from public areas to private space. As proof that Horta's architecture represented a departure in style one need only point to the distance separating it from the eclecticism of a period which distributed styles according to the relative dignity of the rooms, from the Louis XVI boudoir to the Empire drawing room.[13] But to talk about Horta's work as representing a break with a style of living or a forward step toward social functionalism would be an exaggeration, to say the least.

In Horta, the man of the hour, the middle class discovered an artist who knew how to provide novel, original places where people of means could live as pleasantly as possible. A significant comparison can be made between the interior arrangements in Chambon's buildings and those in Horta's private houses. The fluidity of spaces, generally recognized as one of the major characteristics of Horta's architecture, is present in the theaters Chambon built some ten years earlier, where spatial continuity unified the different floors of the building, the monumental staircase, the auditorium and its promenades, and the foyers prolonged by lush gardens that were covered with expanses of glass. Plants in profusion, electric lighting, and mirrors were also arranged to create this feeling of unity rather than to set the different areas apart.

Contemporary press descriptions of these theaters, now all demolished, could apply quite as well to the houses Horta later built for the Solvays and the Van Eetveldes—but with a difference. In Horta's work garish display gave way to refined elegance, soft gradations of paint and stained glass supplanted blue domes studded with gold stars, marble replaced stucco, the Art Nouveau line drove out oriental decoration; yet the same spatial fluidity was retained. If it is true, as the Chevalier de Wouters de Bouchout held in his *L'Art Nouveau et l'Enseignement* (1903), that stage presentations had a fundamental influence on the taste of the worldly

bourgeoisie in their choice of building styles,[14] then it must be equally true that Chambon's sumptuous theaters had a decisive effect in these matters.

In 1885 idlers stood around theater entrances to see the V.I.P.'s of society, the arts, and politics, and to gawk at the ladies and their finery. After the bloody riots of 1886, the demonstrations for universal suffrage that followed, and the general strikes, it occurred to the wealthy that they should flaunt their riches less openly. Social gatherings were held thereafter behind the walls of private homes, whose entrances and exits, cloakrooms, grand staircases, and drawing rooms had to match the appurtenances and luxury of the theaters. Horta understood what the middle class wanted and was admirably equipped to supply it. Behind the sober look of his facades, space was the show. And if, when he wrote his memoirs in 1940, the old architect made clumsy efforts to prove that his first concern was with the functional aspect of architecture, this was because he knew he was being watched by the moralistic censors of a functionalism which did not acknowledge that gala social affairs were an honorable function. Caring much for his honors, the old man hid his talents as a theatrical producer and posed as a pioneer of functionalism, hoping thus to assure his future reputation.

THE IMPOSSIBLE THEORY

As for Henry van de Velde, he, as an artist, had long been prey to the anguish of doubt. He came to architecture by a series of detours, and because he was self-taught, he felt a crying need for reassurance. Paradoxically, he comes through clearly as a person—and an attractive one—only when seen through his blunders, misgivings, and contradictions.

This painter-turned-architect was never at ease in the third dimension. And besides its heaviness, his architecture shows that it is overworked. Van de Velde's vision in space was so limited that when he was studying a project he ordinarily took as his starting point a building by a colleague or one seen on a journey. But they were used only as aids to his imagination: the result was never a pastiche.

The Werkbund Theater, built in Cologne in 1914, is a case in point. This building, which has become a classical illustration in architectural manuals, looks like the most perfect example of Van de Velde's theory of line,[15] the linear dynamographic ornament *which above all represents the movement prompted by internal activity*.[16] Yet the design of this building did not result from theoretical speculation about

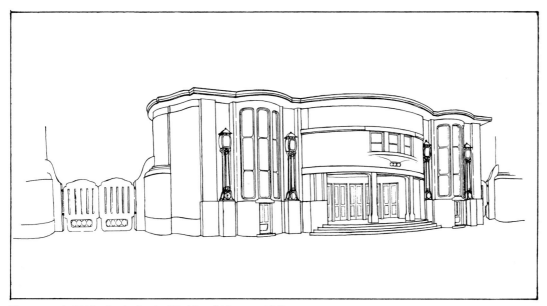

Henry van de Velde. Study for the Werkbund Theater. 1913.

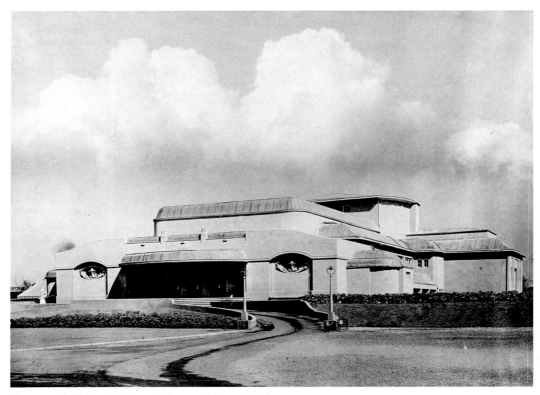

Henry van de Velde. Werkbund Theater, Cologne. 1914.

linear ornament. On the contrary, the preliminary studies for the theater reveal a progressive development that began with a series of sketches in the Viennese style, in the manner of Hoffmann. Step by step, Van de Velde grafted his theoretical concerns upon these preliminary sketches, and when the process of assimilation was complete all traces of the sources of inspiration had practically disappeared. The disparity between his architecture and his methodological writings was a constant with Van de Velde, but there was not a question of divorce. Indeed, the genius of this architect is contained whole and entire in this conflict. In the last phase of his career, when Van de Velde developed his theory of pure form, intellect triumphed over sentiment. The artist finally conquered his own contradictions; but the architectural result of this victory was disappointing if not mediocre.

In the city as it was in 1880—already cut off from nature by its growth beyond the walls—Chambon had depended upon the advance of technology to recreate a "nature" all the more exuberant and exotic because it was to provide an element of contrast to urban rigidity. Horta had mastered and directed this spirit for the use of an enlightened middle class; Van de Velde strove to give the Art Nouveau line social and philosophical significance. However, while the contents, style, and typographic presentation of his *Formules de la beauté architectonique moderne* delight the mind, the formulas themselves defy any practical application. To assimilate them Van de Velde would have needed an extraordinary ability to synthesize, a spatial vision which—oh, irony of fate!—Horta, his rival and archenemy, alone possessed.

In 1902, the year Van de Velde summed up his thought and research since 1891 in the concise formula "the line is a force"[17]—thus making it possible for Art Nouveau to become a style in and of itself—certain of the most talented young Belgian architects turned away abruptly and radically from curves and volutes, whether naturalistic or abstract. Emile van Averbeke made this switch in Antwerp, and Léon Sneyers, one of Paul Hankar's most brilliant pupils, in Brussels. Sneyers had just exhibited an Art Nouveau drawing room in Turin which received very favorable notices, but he paid little attention to the laurels awarded him. He was more interested in the Austrian pavilion by the architect Ludwig Baumann, and went through the Viennese architectural magazines eagerly, studying at length the plates reproducing the works of W. Vochem, Oskar Felgel, and Wunibald Deininger.[18] Back in Brussels, Sneyers came forward as the apostle of the Sezession style—this three years before the Austrian Josef Hoffmann built the Palais Stoclet. At the expositions in Milan, Venice, and Liège he built pavilions which bore a surprising resemblance to the one done by Josef Olbrich in Vienna in 1897. Soon he opened a Sezession gallery in Brussels, as Joseph Urban did later on in New York. Neither of these shops was a commercial success, but both had influence on the formation of the Art Deco style.

It is easy to discern the impact of the Sezession style in the United States, particularly in the skyscrapers built between 1923 and 1939.[19] Its influence in Belgium, however, has not yet been systematically investigated by art historians, a number of significant facts notwithstanding. For instance, in the years around 1915 students in the professional schools were executing decorative works which followed Viennese cartoons and drawings by Klimt. In 1920 Mallet-Stevens, the architect, published a collection of plates entitled *Une Cité Moderne*; the projects represented are simply pastiches of the Palais Stoclet. In 1926 L.-H. De Koninck, the most accomplished among the Belgian functionalist architects, gave his drawings of facades a Viennese flavor in order to obtain permits to erect communal administration buildings more easily. Similarly, the visionary architect René Braem in 1927 drew plans for edifices inspired by Hoffmann's architecture.

Why this lapse on the part of the historians? The answer may be that they have a bias toward the more "masculine" forms of architecture. In contrast to what happened in the United States, where the Sezession style, filtered through Art Deco, was expressed in skyscrapers, in Belgium its influence was limited to domestic architecture—villas, houses, small apartment buildings. The charm, the smiling fantasy, the freshness of the Sezessionist approach looked weak and even affected to the aggressive young architects and theorists of the avant-garde, who dreamed of having done with the styles for once and for all. In such an atmosphere the Viennese style could be ignored by the critics, who considered it lacking in virility and force. Yet its place in the evolution of Belgian architecture is indisputable. Only when its significance is examined can the complete story of Art Nouveau in Belgium be written.

1 Blue was the color of the Liberal Party. (A popular Liberal journal of the period was named *Le Petit Bleu.*) Red, of course, denotes the socialists.

2 In the October 1849 issue of the *Journal de l'Architecture,* published in Brussels, we read: "Belgian industry does not lag behind in following up opportunities in the most distant countries. Metallurgical establishments have exported iron houses to California, where they are admired by all who see them. In several localities in Belgium houses, dwellings, and stores are being built to be shipped to California; in M. Pauwels' workshops in Brussels a superb residence has been constructed, which might well be built for occupancy in the capital. It took this industrialist only twelve days to build it . . . ; it was put aboard at Antwerp, with a staff and complete furnishings, to serve as a residence in San Francisco" (no. 10, pp. 162–64).

3 See, for instance, Jules Destrée, "Socialisme et Art," in *Révolution Verbale et Révolution Pratique,* a lecture delivered to the Étudiants Collectivistes of Paris on June 13, 1902. It and other speeches by Destrée were published under the title *Sémailles* (Henri Lamertin, 1913), pp. 2–18.

4 Louis Bertrand, a leading figure in Belgian socialism, deputy mayor of the commune of Schaerbeek, awarded the building of all the new communal schools to the architect Henry Jacobs (1864–1935), a pupil of Horta.

5 Emile Vandervelde, *Essais Socialistes* (Paris, 1906).

6 Regarding his reading of Dostoevsky, Destrée tells how he found pleasure in perusing that author's "indictments against reason." Traveling in Italy in 1886 he notes in his diary: "The decadence of individuals is pitiful; the decadence of societies is as marvellous as a sunset" (quoted in Richard Dupierreux, *Jules Destrée* [Brussels: Lahor, 1938], p. 46).

7 Destrée published a work entitled *Imagerie Japonaise* in 1888, several years before the Goncourt brothers' studies on Japanese art, which had a compelling influence on the taste of the period.

8 The architect Alphonse Balat (1819–95) built the greenhouses of the royal château at Laeken from 1874 to 1886. Victor Horta entered his studio as a probationer in 1884.

9 "At last we move under full sail into the metallurgical order, which will present differences sharper than those that distinguish the Tuscan from the Gothic order. . . . All the architectonic masterpieces of the *Thousand and One Nights,* hitherto relegated to albums and memory-books, are realizable in iron and cast iron. Even the haunting biblical nightmares of the painter Martin, the mysterious brahmanic compositions of the erudite Condère, and the elegant arabesques of Midolle the engineer can be rendered in cast-iron lace, bright with stained glass." From a review of the 1847 exposition published in the Brussels *Journal de l'Architecture,* no. 4 (April 1848), p. 3.

10 "Don't expect us to define his architecture . . . it's simply 20th century. It's a pagoda if you like, a mosque if you prefer, an Alhambra if that suits you better. It's an Alcazar, the delight of Moorish kings and of lots of others who are neither kings nor Moors. It's a composite Eden, motley, teeming, kaleidoscopic, multicolored, appended to the architectural movement of a time that has no architecture because it has all the architectures, the movement of an electric, ever-changing age that injects criticism even into its art. Stunning fantasy of a composite, cosmopolitan art, artificial, brilliant improvisation that responds to the fever and paroxysm of the moment. It is surely the setting that goes best with modern ballets, exhibitions of *tableaux vivants,* the perilous leaps of gymnasts, the somersaults of acrobats, the lies of Bengal lights, the trumperies of gas, the impostures of electric light. A theater spangled, starry, rouged, light-headed, fanciful, adorable, and absurd, that looks as if it had been made of dancers' skirts, athletes' jerseys, and the tinseled tights of lion-tamers" ("La première au Théâtre de la Bourse," *L'Etoile Belge,* Dec. 31, 1885).

11 This vogue led to the building of the elegant Galeries Saint-Hubert in Brussels in 1846, following plans drawn in 1837 by the architect Jean-Pierre Cluysenaar (1811–80).

12 The iron church in the royal demesne at Laeken was built in 1892–93 on Alphonse Balat's plans.

13 De Wouters de Bouchout, *L'Art Nouveau et l'Enseignement* (Malines, 1903), p. 8.

14 Ibid., p. 9.

15 "Die Linie" appeared in *Die Zukunft* (Berlin), Sept. 6, 1902.

16 "In Nature's creations we can discover all the secrets which the new architectural line will reveal to us in the near future. . . . Nature proceeds by continuity, connecting and linking together the different organs that make up a body or a tree; she draws one out of the other without violence or shock. . . . This line will be expressive in the manner of the line that determines the shape of trees as well as that of the bodies of humans and animals" (Van de Velde, *Les Formules de la beauté architectonique moderne* [Weimar, 1916], p. 81).

17 "The relations between form and ornament cannot be other than *complementary.* . . . They are relations of structure, and the function of the line, which establishes them, is to suggest the thrust of an energy, where the line of the form bends without an evident cause for the bend. . . . This function consists in *structuring* the form, not in *decorating* it. . . . In fact, the structural-linear, dynamographic ornament . . . is the image of the play of internal forces which we sense in all forms and materials. It is these activities that seem to have called forth the form and fixed its appearance" (ibid., pp. 64–65).

18 Léon Sneyers (1877–1949) owned an important collection of documents on Viennese architecture. His library included a set of J. Olbrich's posters and copies of the magazine *Der Architekt.* He copied several of Wunibald Deininger's projects which had appeared in this magazine, making slight changes in them.

19 The influence of the Sezession style on New York skyscrapers has been analyzed by Cervin Robinson and Rosemary Haag Bleter in *Skyscraper Style* (New York, 1975).

ARCHITECTURE:
BELGIUM

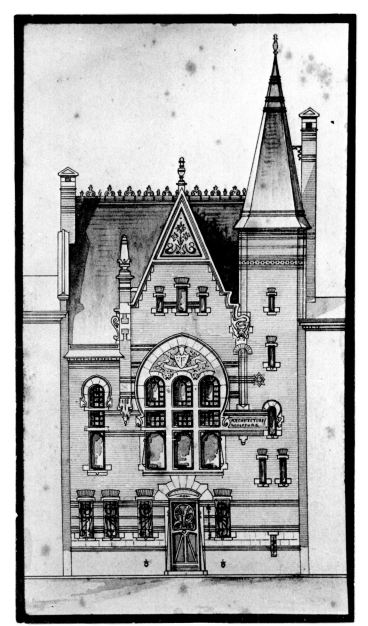

520

JOSEPH BASCOURT
b. 1863, d. 1927.

Joseph Bascourt completed his architecture studies at the Antwerp academy as a night student, working as a clerk and a foreman for a brick mason to support himself. In 1889 he won notice when his design for a press club took first prize in a competition sponsored by the Société Royale des Architectes. Soon after, his marriage to a daughter of the architect Vereecken brought him into the wealthy circles of Antwerp. Commissions began pouring in.

A virtuoso of historic styles, Bascourt was described by a contemporary newspaper as knowing "how to inject a touch of genuine modernism while respecting the classical canons." The construction of the Zurenborg section in Antwerp enabled him to exercise his talents fully. Between 1894 and 1906 he built more than twenty-five dwellings there for the Société Anonyme de la Construction du Quartier d'Est d'Anvers; the majority still exist. The taste of the middle-class businessmen for pretentiousness and eclecticism reached new heights in Zurenborg, where the houses, clustered together in groups of two or more behind "Gothic Venetian" or "neo-Greek" facades, are now considered to be among the city's architectural curiosities. Although historic styles predominated in Zurenborg, there were Art Nouveau

333

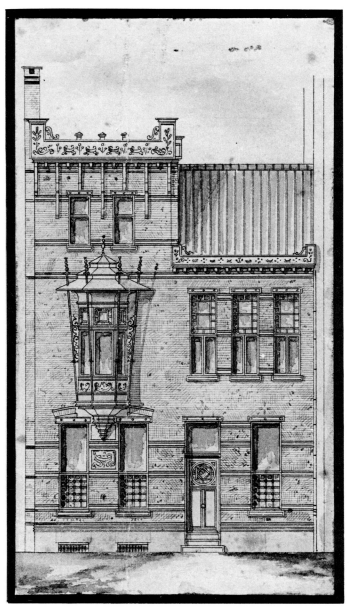

b

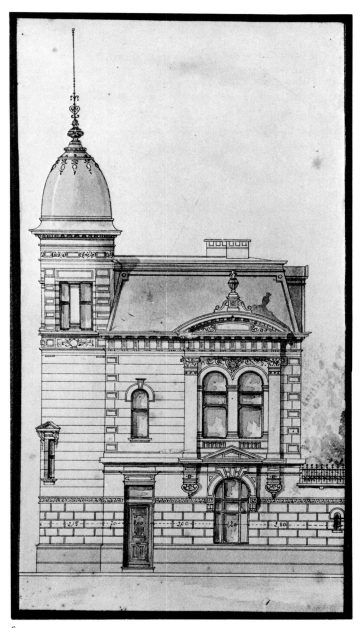

c

buildings as well. The architecture of La Libre Esthétique, developed in Brussels by Horta, Blérot, and Strauven, was "improved and enriched" by Antwerp architects.

Bascourt was one of the few to develop an original and personal Art Nouveau style, which was influenced by Arab architecture. In Zurenborg, at a main intersection, he created a group of four corner houses in glazed brick, with oriels and mosaics on the theme of the four seasons. Besides his Art Nouveau buildings there, Bascourt also built a two-family home called "Euterpia," a bit of bravura in the Neoclassical style.

Bascourt's own home was reminiscent of the English architect John Soane's house, as much in the manner in which its facades were handled as in its interior decoration. Located on the rue Saint-Vincent in Antwerp, the house is like a small museum. Its rooms, all decorated differently, are organized around a hall in the Empire manner and include an oriental living room.

Joseph Bascourt never embraced the International Style. To his death in 1927 he remained faithful to the eclectic style he had developed, later adapting and simplifying it to suit the needs of a clientele less fortunate than the wealthy merchants of Zurenborg.

520
Designs for three facades executed in Antwerp.
Joseph Bascourt.
India ink heightened with watercolor;
mounted together on cardboard.
a) Residence at the corner of the Dolfijnstraat and the Tweelingenstraat. c. 1897.
20.5 x 11 (9⅞ x 4⅜)
b) Maison Kolteren, rue du Transvaal (Zurenborg). c. 1897.
17.8 x 9.3 (7 x 3⅝)
c) Residence. c. 1900.
20.5 x 11 (9⅞ x 4⅜)
Brussels, Archives d'Architecture Moderne.

Bascourt, who subscribed to the French architecture and design journals, seems here to have been influenced by the ornamental vocabulary of Guimard, for certain decorative elements resemble those illustrated in the album *Le Castel Béranger* (1898; cat. no. 48).

Bibl: "L'Architecte Joseph Bascourt," *Le Matin* (Antwerp), March 7, 1927; *Tijdschrift voor Architektuur en Beeldende Kunsten* 9 (1970), special number.

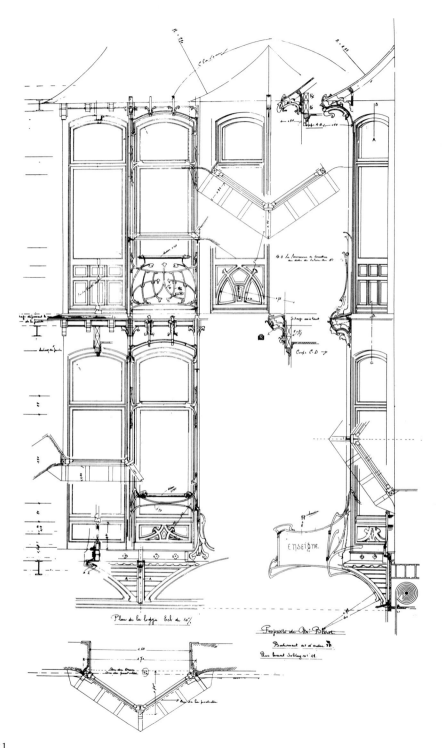

521

ERNEST BLÉROT

b. Brussels 1870, d. Elzenwalle 1957.

Blérot was one of the most unusual and interesting of the architects who shaped Art Nouveau in Brussels. His brief but busy career can be divided into three periods.

In the first, from 1899 to 1901, Blérot built the 17 residences that line an entire side of the rue Vanderschrick in Saint-Gilles, 11 houses in the new Saint-Boniface section, and 15 other buildings in various new suburbs south of Brussels. The series of facades on the rue Vanderschrick is unique in Brussels for its great architectural variety and exceptional plastic articulation. Blérot, both architect and builder, but with no substantial backing, kept going simply by selling the houses as he finished them; by varying the style of the facades he could satisfy the middle-class buyer's desire for a house different from his neighbor's. The division of the street into lots served an economic need, and building house by house also permitted Blérot to resolve the problem of adjustment of floor levels along the slope of the street.

The second period in Blérot's career, 1901–1908, saw the construction of his own home. A corner house like Horta's Hôtel Aubecq and Brunfaut's Hôtel Hannon, it was among the most remarkable of that genre to be built in Brussels. The house was destroyed in 1962.

After 1908, Blérot almost completely abandoned his private practice, perhaps finding it difficult to make the transition from Art Nouveau to another style. For a number of years, however, he continued working in the Art Nouveau manner on a single large project, the reconstruction of the château of Elzenwalle, near Ypres, which belonged to his wife's family and had been shelled in World War I. Apart from this effort he confined himself to maintaining and remodeling those of his buildings he still owned. A passion for mechanics led him to design several automobiles, radically transformed from the commercial models on which they were based. Sadly, most of Blérot's papers and documents were lost in the sale and subsequent demolition of his home.

521

Design for an oriel.
Ernest Blérot. c. 1900.
India ink on tracing paper.
116.5 x 58.5 (45⅞ x 23)
Brussels, private collection.

For an apartment building at 12 rue Ernest-Solvay, one of eleven Blérot built in Saint-Boniface, Ixelles, a newly urbanized neighborhood of Brussels.

Bibl: Borsi and Wieser 1971, p. 61.

522

Design for a fireplace: section, elevation, and plan.
Ernest Blérot. 1901.
India ink on tracing paper.
76 x 65 (30 x 25⅝)
Brussels, private collection.

For a house at 42 rue de la Vallée, Brussels. The decorative motif, an arch over the fireplace, imposes symmetry on what is actually an irregular form. One of the side panels is stationary, while the other opens into a closet.

522

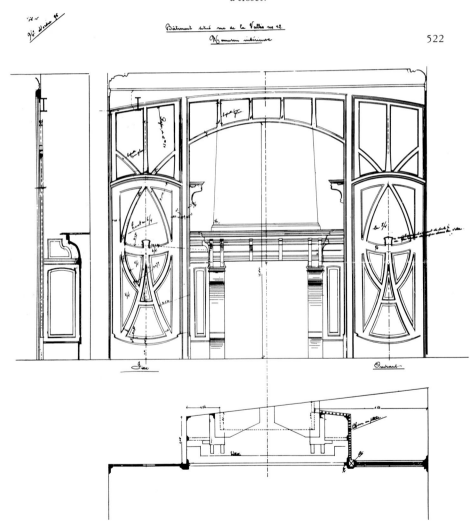

Jules Brunfaut

b. Brussels 1852, d. Brussels 1942.

A native of Brussels, Brunfaut began his architectural studies at the Ecole du Génie Civil in Ghent, then worked four years in the studio of the architect Henri Beyaert, where he met Paul Hankar. From 1881 to 1882, after a stay in Paris, he traveled to Italy.

A prolific architect who was very much in vogue, Brunfaut did not appreciate Art Nouveau; only one of his buildings was designed in the style, and that at the request of an old friend, Edouard Hannon. For Hannon he built an Art Nouveau house on an exceptional piece of land at the intersection of the avenue Brugmann and the rue de la Jonction, Brussels. Victor Horta and Ernest Blérot were inspired by similar sites to create architectural tours de force, the Hôtel Aubecq and Blérot's own home; compared to these, Brunfaut's building is quite restrained.

Both on the facade and on the interior, it was obvious that he did not want to wander too far from academic canons. On the exterior, the static composition of the facade, reinforced by horizontal bands of stone, counteracts the building's Art Nouveau character. Inside, he showed his skepticism toward the new style by commissioning the decoration of the hall from the French artist P. A. Baudouin, who painted frescoes in the style of Puvis de Chavannes. Brunfaut's desire to escape the limitations of a style he considered to be essentially in poor taste is further demonstrated by his choice of the most refined furnishings—windows by Tiffany, furniture by Gallé. As Franco Borsi noted, "Even when he yielded to fashion Brunfaut accepted only the classics."

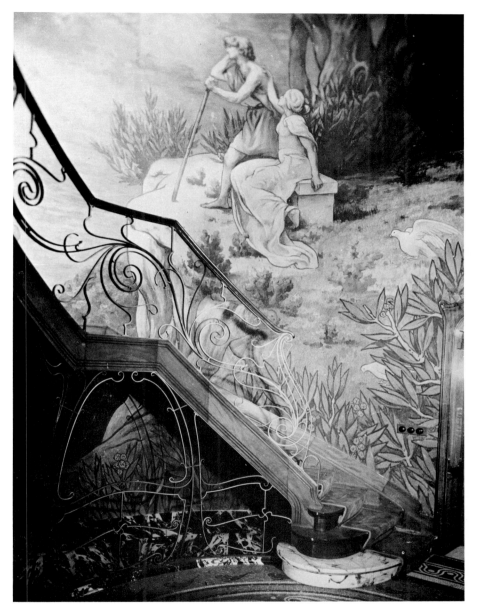

523

Residence of Edouard Hannon, at the corner of the avenue Brugmann and the rue de la Jonction, Brussels. Hall and main stairway. Jules Brunfaut. 1903.

P. A. Baudouin painted the stairwell frescoes in 1909; the furniture and decoration were by Emile Gallé (see cat. nos. 342–44). "The large dining room, the winter garden, and the large stairway reveal an extraordinary naturalistic richness: a proliferation of corymb flowers, hazelnuts, and umbels, climbing squirrels on the lamps, and rainbow-colored reflections from the Tiffany windows. But this pursuit of a joyful liveliness did not quite displace the traditional concept of furnishings, for the woodwork, cornices, and tapestries play the same role as in the Louis XV tradition" (Borsi and Wieser 1971, p. 50).

Bibl: Saintenoy 1950; Borsi and Wieser 1971, p. 50.

337

PAUL CAUCHIE

b. Ath, Belgium, 1875, d. 1952.

When Cauchie built his combined home and studio on the rue des Francs in Brussels, he had a precise goal: to win the prize in the annual "L'Art à la Rue" (Street Art) contest for the originality of his facade. The style of decoration Cauchie chose followed a tradition in which Paul Hankar had excelled several years earlier. In 1896 Hankar in association with the painter Adolphe Crespin had won a similar prize for a bakery whose facade was entirely painted. And on the numerous studio-homes he designed for his friends, Hankar always left space for frescoes and sgraffito decoration.

The originality of Cauchie's house, however, lay in its antiarchitectural character: its facade was conceived as a painting behind which the artist arranged the parts of the building. To get the effect of a tower in the style of Hankar, Cauchie used vertical woodwork after the manner of Mackintosh and Voysey.

Called an "artist-decorator" in a biographical note published in 1904, Cauchie had first studied architecture at the Antwerp academy. He left in order to study under the painter Jean Portaels (1818–95), a director of the Brussels academy who was instrumental in reviving mural painting in Belgium. In Portaels' studio Cauchie acquired a taste for sgraffito; he afterwards used the technique to decorate a number of facades in Brussels, Antwerp, and Ath. He also produced numerous Art Nouveau projects in the field of the applied arts—posters, wallpaper, furniture, embroidery, tapestries, and mosaics—while his architectural background is evident in the interior designs he created for private homes.

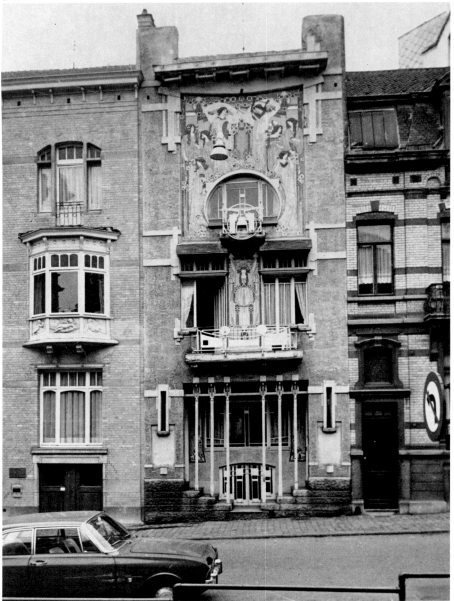

524
Studio and home of the architect, 5 rue des Francs, Brussels. Facade.
Paul Cauchie. 1905.

Bibl: Borsi 1974, fig. 126.

525
Home and studio of the architect. Detail of the facade.
Paul Cauchie. 1905.

The caryatid, which bears a cartouche inscribed *Par nous, pour nous* (By us, for us), serves to integrate the architectural composition and the pictorial theme.

526
Home and studio of the architect. Detail of the facade.
Paul Cauchie. 1905.

The group of women around the window, executed in sgraffito, probably represent the nine Muses.

527
Studio and home of the architect. The dining room.
Paul Cauchie. 1905.

The furniture and interior frescoes are by Cauchie; Charles Rennie Mackintosh's influence is quite evident in all the furnishings.

525

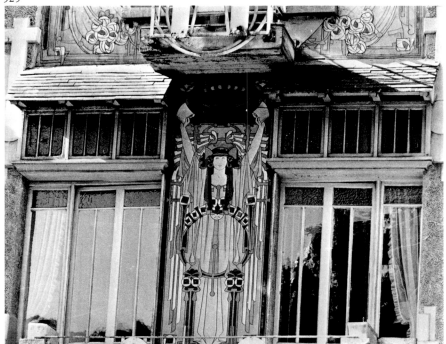

527

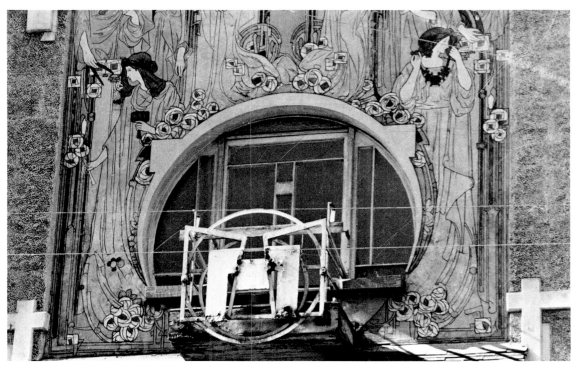

526

ALBAN CHAMBON

b. Varzy (Nièvre), France, 1847, d. 1928.
A youthful familiarity with the Loire valley
châteaux inspired Chambon's vocation as an ar-
chitect. He first studied sculpture and then
attended the Ecole des Beaux-Arts in Paris. In
1868 he moved to Belgium. After working for
several years there as a designer, he was commis-
sioned to build the Eden Théâtre in Brussels
(1880), the Park-Schouwburg in Amsterdam
(1883), and the Théâtre de la Bourse in Brussels
(1885); from 1885 to 1888 he built no fewer
than five theaters in London. All featured vast
lobbies with exotic decoration in "the beautiful
modern Hindu style, combining the elegance of
Moslem art with sumptuous luxury in the capri-
cious lines of Bengal architecture" (*L'Etoile
Belge,* June 14, 1880).

In 1894 Chambon directed the construction
and decoration of the Métropole Hotel in Brus-
sels; from 1894 to 1900 he built the first villas
at the new beach of Westende, an enterprise of
the senator and financier Otlet; and from 1898
to 1906 he transformed, enlarged, and deco-
rated the Kursaal in Ostende. Leopold II gave
him his full support and honored him with
several commissions. At this time there were
probably about 200 workers employed in
Chambon's studios.

In his many public buildings Chambon sys-
tematically used stoneware and glazed bricks,
both for aesthetic reasons and as protection
against fire. Metal structures were usually left
visible, and often had cast-iron decorative
motifs. Besides his architectural designs Cham-
bon also created a number of urban planning
projects, most notably the Mont des Arts at the
request of Leopold II. But World War I, and
the profound social and political changes that
followed, effectively ended his career.

528
Kursaal, Ostende. Elevation of the west facade.
Alban Chambon. 1901.
Watercolor [photograph exhibited].
Brussels, Archives d'Architecture Moderne.

Under the corner tower of the west facade
Chambon built a pavilion dedicated to Leopold
II. He had the work done without consulting
the communal council, who discovered the
"surprise" the very day the king was to
dedicate the pavilion.

The July 5, 1902, issue of the newspaper
Le Carillon gave a brief description of the

pavilion's architecture: "Its walls are entirely of
rare marble, while six polished granite
columns support the vaulted ceiling and the
tower above it. In the middle, a double basin
of Scottish granite is filled with ornamental
plants. The ceiling is decorated with a painting
of Architecture revealing her beauty, her eyes
turned toward the bust of the king, and around
the ceiling's periphery there are representations
of famous monuments, ancient and modern:
St. Paul's in London, the Palais de Justice in
Brussels, Notre-Dame de Paris, a Roman arch,
Trajan's column in Rome, the Parthenon in
Athens, and an Egyptian pyramid."

Bibl: "Les Travaux de l'aile Ouest du Kursaal,"
Echo d'Ostende, Nov. 2, 1901.

529
Kursaal, Ostende. Elevation of the sea facade.
Alban Chambon. 1903.
Printed, and heightened with wash and
gouache; mounted on wood support.
51 x 114 (20 x 44⅞)
Bruxelles le 18 Juin 1903 / A. Chambon / arch,
lower right.
Brussels, Archives d'Architecture Moderne.

The first Kursaal at Ostende, a simple
greenhouselike structure, was replaced by a
larger building designed by the architect
Naert. Through successive transformations
from 1898 to 1906, Chambon in his turn so
modified the existing building that *L'Etoile
Belge* could write, "Naert . . . would no longer
recognize his work. Perhaps he would say, as
others have, that the originality of his concept
has disappeared, that unity has given way to a
proliferation of details, and that his imitation
of an Arab mosque has been replaced by a
monument to the modern aesthetic" (May 16,
1906). Although the Kursaal survived the First
World War, it was completely destroyed
during World War II. A contemporary journal
described its interior: "A magnificent double
stairway, all in white and purple marble with
copper banisters, leads to a rotunda in Indian
style much like that of the palaces of Madura,
brilliant in its pale rose and gold decoration
and numerous stained-glass windows. This
rotunda, decorated with ornamental plants,
functions as both a conservatory and
promenade. Columns support the vaulted
ceiling (of the Italian Renaissance grand hall);
above the second entablature, there is graceful
curved corbeling in the style of the Baths of
Diocletian in Rome. . . . Urns made of rare
marbles fill the niches in the courtyards. An

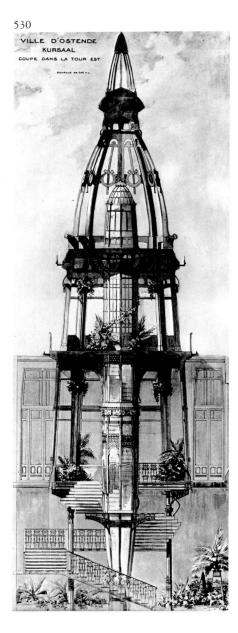

530

VILLE D'OSTENDE
KURSAAL
COUPE DANS LA TOUR EST

unusual winter garden, built of iron and
decorated with stoneware, provides the perfect
finishing touch for this magnificent palace"
(*Messager de Bruxelles,* Aug. 22, 1900).

530
Kursaal, Ostende. Section of the east tower.
Alban Chambon. July 1904.
Printed, and heightened with gouache;

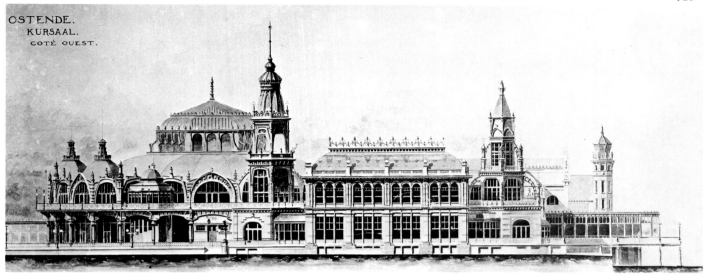

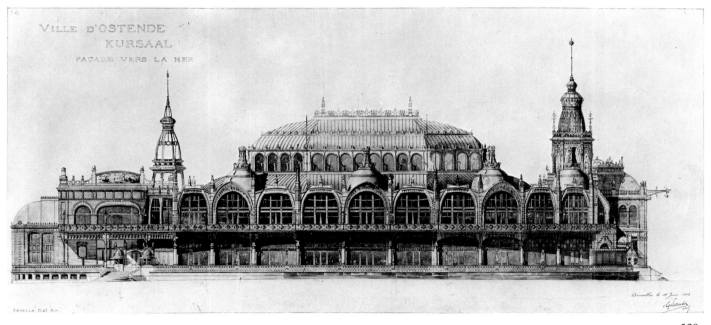

529

mounted and framed.
141 x 55 (55½ x 21⅜)
Juillet 1904/ Chambon, lower right.
Brussels, Archives d'Architecture Moderne.

From the top balcony, one of the highest
points in Ostende, visitors could admire the
panoramic view of the coast.

341

PAUL HANKAR

b. Frameries (Hainaut), Belgium, 1859,
d. Brussels 1901.

Trained by his father as a stonecutter, Paul Hankar worked from 1878 to 1894 in the studio of the Brussels architect Henri Beyaert, where he was exposed to Beyaert's taste for the Gothic and Flemish Renaissance styles. Two major influences are present in Hankar's work: historicism and the tenets of Viollet-le-Duc on the one hand, orientalism—as it was transmitted through prints and magazines of Japanese art—on the other. Hankar's custom of rendering his architectural drawings in colored washes, and his systematic division of planar surfaces with frames, bears witness to the importance of this oriental influence.

In contrast to Horta, Van de Velde, and Pompe, Hankar was not preoccupied with spatial unity or fluidity of spaces. More a decorator than an architect, he treated interior spaces like isolated boxes: connecting spaces, halls, and stairwells were residual rather than organic. He composed facades like collages; each decorative element—particularly the cast iron—was treated with exceptional care, but each one was also treated independently. This formula had the advantage of avoiding the costly and complex joints between wood and iron typical of Horta's architecture, enabling Hankar to design a number of stores with large glazed windows framed by curving lines of woodwork.

Hankar died on January 19, 1901. He left almost no writings, but a large number of marvelous drawings are preserved at the library of the Musées Royaux d'Art et d'Histoire. Although most of his buildings have disappeared today due to the intense urbanization of Brussels in recent years, a shift of popular opinion in favor of turn-of-the-century architecture has made possible the preservation of the shop-window on the rue Royale and three other buildings.

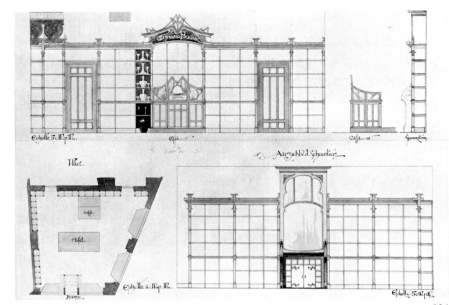

531

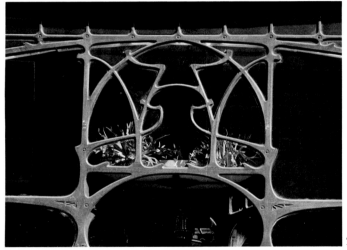

534

531
Designs for the Magasins Wynand-Fockink, rue Royale, Brussels.
Paul Hankar. 1897.
India ink and pencil on heavy paper, heightened with watercolor.
65 x 70.5 (25⅝ x 27¾)
Brussels, Musées Royaux d'Art et d'Histoire, Bibliothèque, Hankar doc. 83816.

The building has been demolished.

532
Home and studio of the painter Bartholomé, 151 avenue de Tervueren, Brussels. Facade.
Paul Hankar. 1898.
The building was demolished c. 1950.

"It was in the studio-home of the painter Bartholomé, a medieval tower house, . . . that Hankar obtained an unequaled freedom of expression by inserting into a soberly proportioned facade a majestic fan-shaped window, highlighted by the oriental touch of the small balcony" (Borsi 1974, p. 35).

"In this turbulent adventure called Art Nouveau, which according to the writings of Goncourt combined rationalism and aesthetics, Paul Hankar did artistic architecture. He built mainly for intellectuals, painters, and sculptors: homes, studios, furnishings for artists. This was his way of conceiving functionalism" (de Maeyer 1963, p. 11).

533
Showroom of the Compagnie Générale des Céramiques d'Architecture, rue d'Arenberg, Brussels. Designs for exterior lighting.
Paul Hankar. 1899.
India ink on paper, heightened with watercolor.
70 x 104 (27½ x 41)
Brussels, Musées Royaux d'Art et d'Histoire, Bibliothèque, Hankar doc. 83816.

The building has been demolished.

534
Magasin Niguet, 13 rue Royale, Brussels. Detail of the display window.
Paul Hankar. 1899.

"Hankar achieved great liberty in the decoration and furnishings of public establishments like the grill room of the Grand Hotel, the restaurant Au Chien Vert, or the store of the shirtmaker Niguet. In substance this liberty depended on few elements, above all on the appearance of curving lines in the heart of a reticular division of squares or rectangles reminiscent of the English tradition" (Borsi and Wieser 1971, p. 39). The shop is now occupied by a florist.

535
Magasin Senez-Sturbelle, 161 rue Neuve, Brussels. Study for an iron support for a gas lamp.
Paul Hankar. 1899.
Red and blue pencil on tracing paper.
82.5 x 103.5 (32½ x 40¾)
Brussels, Musées Royaux d'Art et d'Histoire, Bibliothèque, Hankar doc. 83816.

The chocolate shop, completed in 1900, has since been demolished.

536
Villa of Philippe Wolfers, La Hulpe. Study for pillars and grilles of the rear entrance gate.
Paul Hankar. 1900.
India ink and pencil on paper, heightened with watercolor.
70 x 92 (27½ x 36¼)
Brussels, Musées Royaux d'Art et d'Histoire, Bibliothèque, Hankar doc. 83816.

Hankar designed a number of artists' houses. This study is part of a group of documents relating to the small country house he created for his friend Philippe Wolfers, the Brussels jeweler and sculptor. The villa was later demolished.

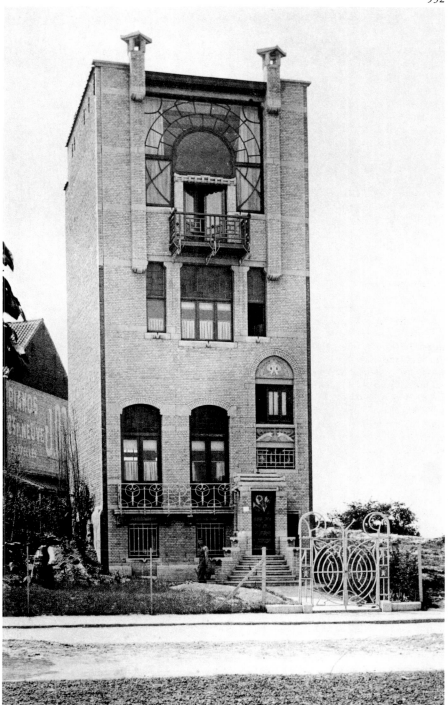

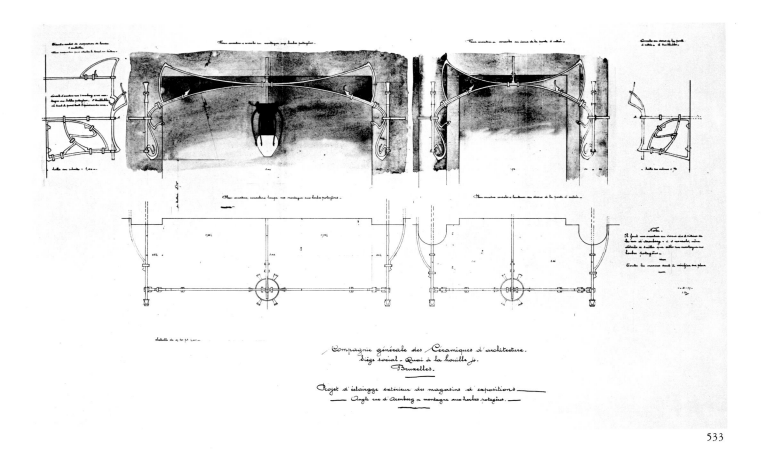

Compagnie générale des Céramiques d'architecture.
Siège social - Quai à la houille 54.
Bruxelles.

Projet d'éclairage extérieur du magasins d'expositions
Angle rue d'Arenberg à montagne aux herbes potagères.

533

535

536

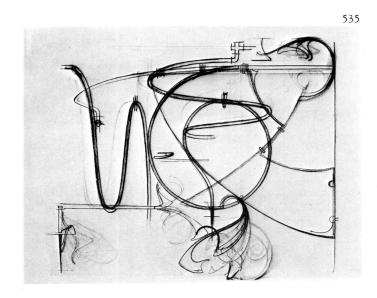

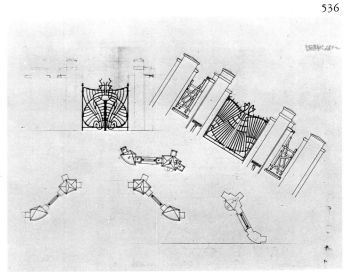

VICTOR HORTA

b. Ghent 1861, d. 1947.

At the age of seventeen Victor Horta went to Paris, accompanied by a close friend of Théo Van Gogh. He was called home suddenly only two years later by the death of his father, a cobbler in Ghent, but the brief stay in Paris had confirmed his vocation as an architect. "Paris stimulated my artistic sensibility," he wrote later. "No scholarly teaching could have instilled in me such enthusiasm as I felt—and still feel—when I see or read about her monuments. . . . Paris taught me to test my enthusiasm about art, made me understand what an enormous amount of knowledge I needed to draw closer to the great buildings that had attracted me as a candle attracts moths."

In 1881 Horta enrolled at the Brussels academy, and after receiving his diploma in architecture was accepted as an intern by Alphonse Balat (1818–95), architect of the royal greenhouses at Laeken. Drawn again to Paris by the Exposition Universelle of 1889, Horta discovered there vast halls whose spaces were defined by membranes of iron and large expanses of glass. However, neither the constructive discipline of his master Balat, nor his discovery in Paris of the extraordinary scale possible in glass-and-iron construction, nor his assiduous reading of Viollet-le-Duc (from whom he garnered the principle of structural honesty)— none of these things alone explains the development of an architecture and a concept of space which broke so radically with the architecture of the period.

An innovator, but still primarily a designer of residential architecture, Horta had to persuade his rich clientele to abandon traditional styles, do away with old furniture, and accept the presence of windows, columns, and metal beams even in their formal parlors. To accomplish this the architect made his source of inspiration the aspirations of his clients. The new industrial bourgeoisie satisfied its desire for novelty in a taste for exoticism: it was fascinated by the decor typical of the new casinos, theaters, and lobbies—rooms that glittered like Ali Baba's cave, lavishly garnished with green plants and decorated in a modernized "Hindu" style. Horta proposed to transpose the luxury of such stylish places to private residences. But to a clientele that could have been seduced by affected decors, decorative plants, and draperies, he suggested instead the distinction of rare marbles, subtle gradations of color, arabesques in metal, and undulating woodwork. He captured the festive spirit in a noble decor.

Horta's creative power was at its zenith from 1893 to 1903, a period when he designed more than thirty major projects. Most of those that were built have been either destroyed or significantly altered today. His achievements began in 1893 with the residence of the engineer Emile Tassel. The Hôtel Tassel was a sort of architectural manifesto built for a friend who, after hesitating over a traditional plan—three rooms set along a corridor, typical of homes in Brussels—decided to give Horta total freedom. He designed a building of two independent sections whose floors were staggered in height but joined by galleries that overlooked the entire construction. A whiplash line flowing over the walls, floors, ceilings, and windows united all parts of the building from the entry hall to the roof. If Horta owed his vocation as an architect to his encounter with the monuments of Paris, Hector Guimard owed the revelation of his style to a visit to Horta and the Hôtel Tassel. Inspired by what he had seen, Guimard returned to Paris and modified his plans for the facade of the Castel Béranger.

In 1894 the industrialist Armand Solvay commissioned "the most expensive architect in town" to design and build a house on the avenue Louise with a facade 15 meters long. Two vertical light wells introduced light into the very heart of the house, diffusing it through the stained-glass wall of the suspended winter garden and through the great expanse of stained glass over the main staircase. The facade curved in to create space for a large balcony where the Solvay family could watch the horsemen returning from the races. Construction on the Hôtel Solvay lasted four years, and the interior finishing was completed only in 1904, ten years after the house was begun. Horta notes in his memoirs that "it would be an exaggeration to pretend that my work progressed as fast as that of my colleagues. . . . Usually the problem lay not with my plans but with the foundry, which did not furnish materials on time. Since the building was entirely framed in iron, the lack of a few girders would hold up the entire project. . . . This reputation as a dawdler actually served me well, . . . for I was so overloaded with projects that it would have been impossible to take on any more."

A year after receiving the Solvay commission Horta was asked to design the new Maison du Peuple for the Belgian Workers' Party. Although the choice of an architect associated with expensive residential projects might seem surprising, in fact many socialist leaders of the period came from important bourgeois families. Such was the case with Hallet and Furnémont,

the friends who proposed Horta's name. And the choice of Horta enhanced the prestige of the Workers' Party, just then experiencing its first political successes, by showing it to be at the forefront of the social and cultural avant-garde.

Horta took six months to develop the plans for the Maison du Peuple, and three more to get them to scale; fifteen designers collaborated on the project. On the ground level he put the great cafe and all the stores of the cooperative. The cafe's monumental size was emphasized by a ceiling that exposed a network of metal beams arranged according to the force lines of the structure. The second and third floors housed the offices, while the fourth was reserved for the 1500-seat auditorium. For obvious reasons of stability Horta chose to realize this auditorium in as lightweight a construction as possible. To withstand the effects of wind, an important consideration, he created a strong but light shell composed of metallic ribs.

The famous facade with its "wall of glass" was demolished in 1965. Franco Borsi has noted that the facade's transparency served as a symbol to the working classes of their reconquest of the right to space and light; it represented, furthermore, a material guarantee of the indispensable alliance between technology and social progress. Horta seemed to foresee the building's demolition when he wrote in 1940, "The Maison du Peuple was enlarged without my assistance, and it was painted and repainted without a thought given to how it looked in the beginning, It wasn't able to grow along with the party. If it were to be redone, it would have to be given a whole new look: it no longer fulfills the needs of a party that dominates the others. Yesterday's banner is not today's. If the building is demolished, I would scarcely be surprised; the same fate has overtaken a number of my other works."

After the Maison du Peuple Horta completed several other significant projects. In the Hôtel Van Eetvelde he attempted to avoid the corridor plan usually imposed by a deep, narrow site, designing instead an entrance passage set at an oblique angle to the front door. This led to a central solarium illuminated by a light well. For O. Aubecq Horta created a residence, begun in 1899, in which he revealed the richness of a baroque genius and abandoned strict discipline for organic expressionism. His design for the A l'Innovation department store, begun in 1900, was the architect's swan song. The splendid glass cage Horta devised to sell more things and sell them better was later transformed by the store's owners, who put a facade of decorative elements over the original facade. The

building was destroyed by fire in 1967.

From 1903 to the end of his career Horta's creativity diminished. He became absorbed in his work as an architectural consultant to several department stores, and in the planning of several projects—a train station, a hospital, a museum of fine arts. Although their interest today is primarily historical, they nevertheless reveal Horta's unfailing mastery of organic space. The facade of one project, the Palais des Beaux-Arts in Brussels (1920–28), reveals similarities with the style of Frank Lloyd Wright, whose buildings Horta had visited while touring in America from 1916 to 1918.

At the end of his life, in 1940, Horta wrote his memoirs. Because he attempted there to justify his actions to a younger generation of architects working in the International Style, some of the theories he presents differ significantly from those which actually guided him during his creative period. Regrettably, the disfavor in which the advocates of the International Style held Art Nouveau led Horta, like many of his colleagues, to destroy his archives. In 1945 he sold for recycling nearly two tons of records and architectural designs.

Horta's Maison du Peuple was demolished in 1965, despite an international campaign of protest. It is quite possible that few of his buildings would have survived without the efforts of Jean Delhaye, Horta's fervent disciple and himself an architect, who has labored for the past thirty years to preserve this superb architectural heritage. Delhaye is responsible as well for the creation of the Musée Horta, opened in 1969 and housed in the two adjacent buildings which were formerly the studio and home of Victor Horta.

537
Residence of Emile Tassel, 6 rue Paul-Emile Janson (formerly 12 rue de Turin), Brussels. Period photograph of the facade.
Victor Horta. 1893–95.

"When the work was finished, the stonecutters, out of spite, ruined the bases and capitals of the columns on the mezzanine. The public was amused. . . . There were those who found it novel; others, the majority, criticized or pitied; still others felt nothing. . . . The world of architects gave unanimous echo. . . . After they laughed, they had to ask questions: Why a door, why two little windows? For an entryway giving access to a cloakroom and lavatory on one side and to a waiting room on the other—three things unheard of in ordinary

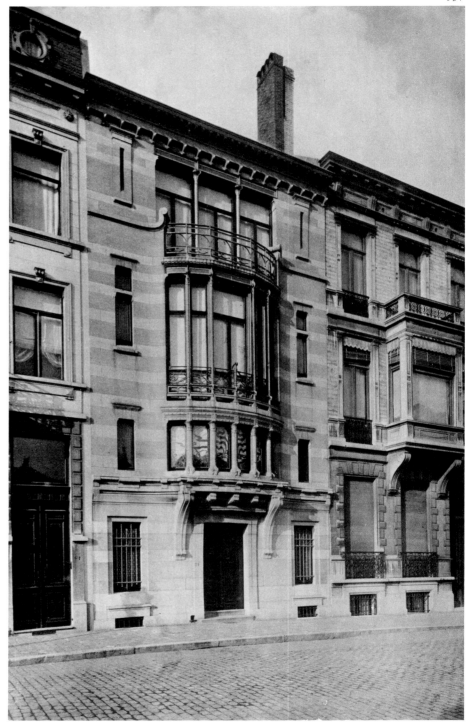

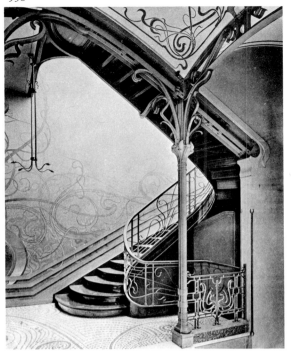

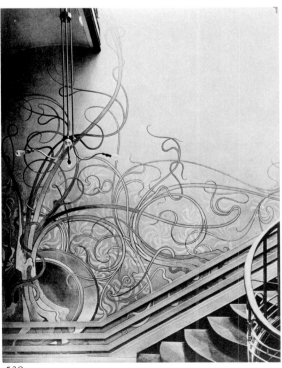

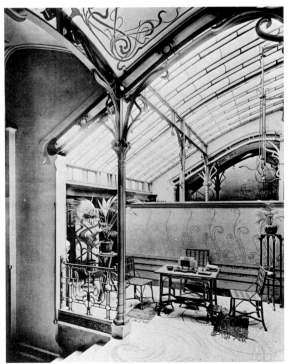

plans, yet so useful. . . .

"Why a mezzanine? For a darkroom [Tassel was an avid amateur photographer], and for a smoking room where everyone could gather before and after the lectures, which were illustrated with photographs that were projected onto the rear wall of the salon and dining room, where the audience sat.

"Why the large oriel window on the second floor? Simply because it was the principal element of the most important room in the house, the office of the master.

"And why this, and why that? As it was for the house, so it was for the furnishings, but even the least question had its answer. . . . Criticism of the architecture died away in the face of reason" (Horta, Memoirs).

538
Hôtel Tassel. Period photograph of the staircase leading from the ground-floor hall. Victor Horta. 1893–95.

"Here is the 'Horta line' in mad exuberance. . . . It whips across . . . ground, walls, and ceiling, breaks out of capitals, runs down flights of stairs, spreads through the branches of the chandeliers, creeps across the window

538

539 540

leading. It lashes around everywhere, wraps around, intertwines, unties itself, as flexible as a liana—a liana tamed however by geometry. Whether it developed with Mackintosh's line or preceded it, descended from Toorop or hearkened back to the sources, this line was born in the ambiance of the period. Still Horta gave it its special quality, made it split the air like a coachman's whip. Certainly the line alone did not create the 1900 style—but it was the style's fundamental theme" (Delevoy 1971, p. 22).

539
Hôtel Tassel. Period photograph of mural decoration in the stairwell.
Victor Horta. 1893–95.

540
Hôtel Tassel. Period photograph of the ground-floor conservatory, seen from the hall.
Victor Horta. 1893–95.

A light well provides natural illumination to the glass ceiling.

541
Residence of Armand Solvay, 224 avenue Louise, Brussels. Facade as it is today.
Victor Horta. 1894–98.

The ground level of the facade has been transformed, and the interior light wells covered over. The winter garden has also been dismantled.

Horta's design for the ground floor of the Hôtel Solvay provided space for a private reception office for the master of the house, as well as a large cloakroom directly off the entrance hall. "On the street side of the second floor [was] a living room fifteen meters long, with an exterior balcony made for viewing the return from the races—which unfortunately were stopped just after the house was finished. That had been one of the main reasons for choosing the avenue Louise. Who would believe it today?

"A double flight of stairs in green marble, complementing the color of the glass ceiling above, led from the first floor to the second. On the third floor, Monsieur and Madame's private offices and bedrooms; on the fourth floor, rooms for the children; on the fifth, rooms for the servants. A house like other houses . . . except that its interior characteristics were exposed metal construction, and the glass partitions which

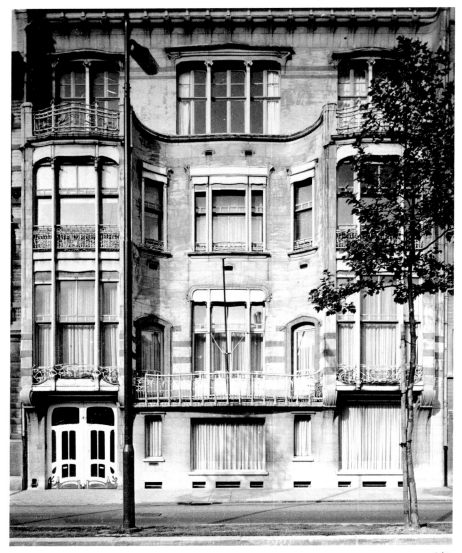

541

allowed a view of the whole interior on the occasion of evening receptions—although the view could also be cut off by drawing light curtains over the partitions.

"Whoever knew the interior arrangement couldn't deny the utility of the two big oriels on the facade, made necessary by the large dimensions of the rooms. Naturally the house was furnished and decorated according to my plans—even the piano, which I designed with the help of Gustave Lyon at Pleyel" (Horta, Memoirs).

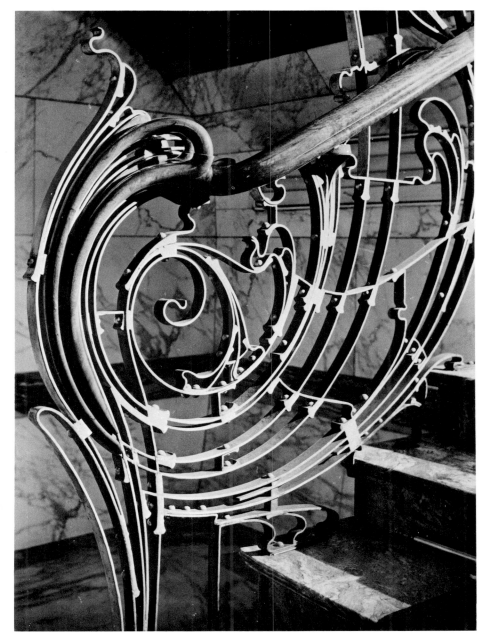

542

542
Hôtel Solvay. Detail of the banister.
Victor Horta. 1894–98.

543
Maison du Peuple of the Belgian Workers'
Party, place Emile Vandervelde, Brussels.
Period photograph of the rue Stevens facade.
Victor Horta. 1895–99.
The building was demolished in 1965–66.

"They chose me to build the Maison du
Peuple, because they wanted something
expressive of my aesthetic style. The choice was
not at all political. My friends and I simply had
the same ideas, and there was no question of
interest—we were 'reds' without having
thought about Marx or his theories. . . . The
old workers and new intellectuals agreed on my
name unanimously. I was very touched the day
that a three-person delegation came to ask me
to plan their Maison du Peuple. . . . I was
overburdened with work at the time, but,
nonsense! I was young, I could manage it. . . .
Besides, I could see immediately that the work
would be interesting: to build a palace, which
wouldn't be a palace but a 'house' where air and
light, too long excluded from workers' hovels,
would be the luxuries. The house would lodge
the administrative offices, cooperative offices,
political and professional meeting rooms, and a
cafe where the price of drinks would be in
keeping with the directors' desire to combat
alcoholism, still a great problem among the
people. There would be conference rooms for
instruction and, to crown it all, an immense
auditorium for political meetings and the
party's congress, as well as for the musical
programs and theatrical events the members
would produce" (Horta, Memoirs).

544
Maison du Peuple. Period photograph of the
main facade: the "wall of glass."
Victor Horta. 1895—99.

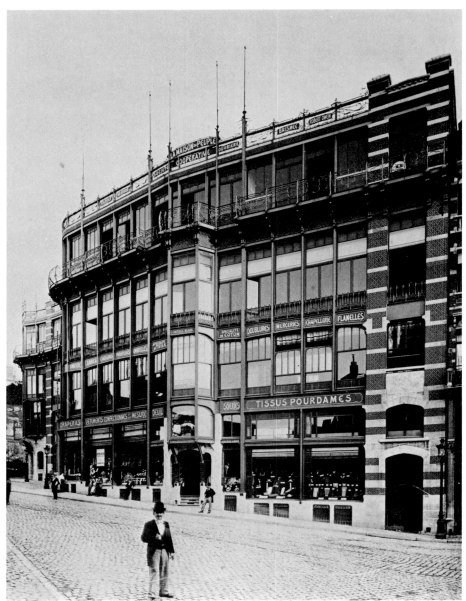

543

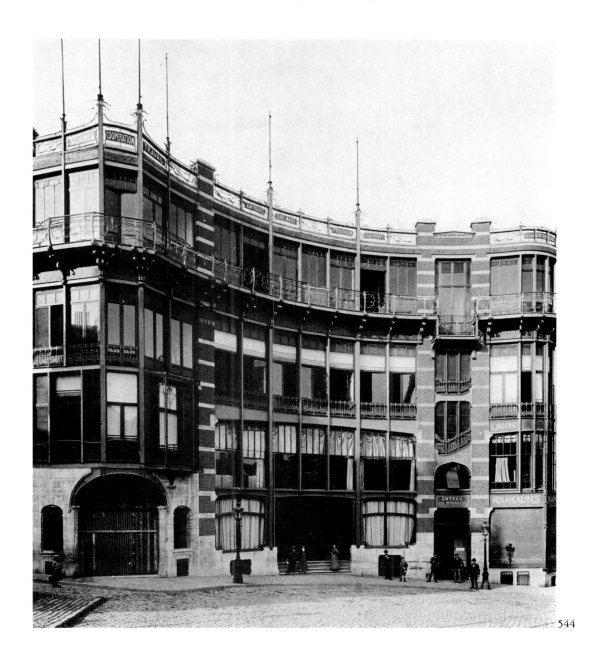

544

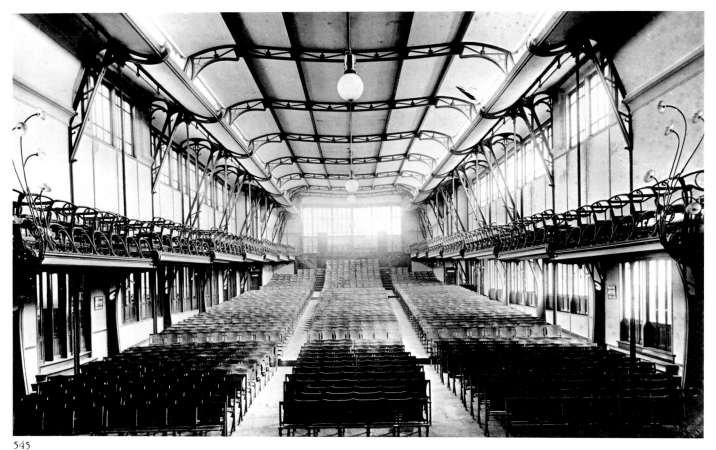

545

545
Maison du Peuple. Interior of the auditorium.
Victor Horta. 1895—99.

"Here the important features are the horizontal
ceiling and the steeply inclined floor, which
was raised again near the far end to break the
sound reverberations. The public was quite
satisfied with this arrangement, believing that
it was done to improve their view of the stage.
The building in section resembled the Mansard
form; it was lighted by vertical windows which
allowed suspension of a double gallery from the
framework. As for the fine acoustics, they were
achieved by means of a cornice gallery . . .
[and by] the ceiling, which was curved in order
to return sound to the seats" (Horta, Memoirs).

546
Maison du Peuple. Structural detail of the
auditorium.
Victor Horta. 1895—99.

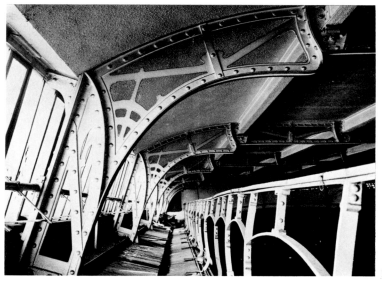

546

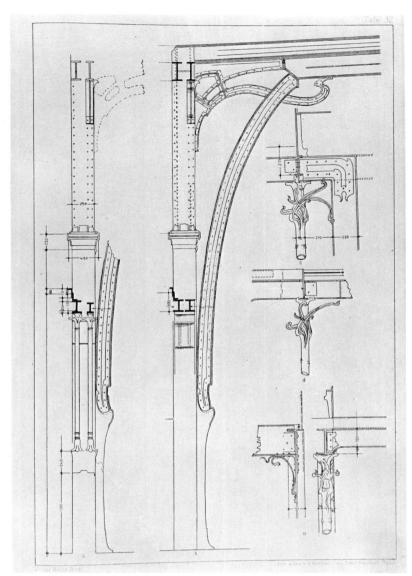

547

547
Maison du Peuple. Designs for construction details [photographs exhibited].
Victor Horta. 1895–99.

At left, structural ironwork for the ground-floor cafe.

548
Residence of Edmond van Eetvelde, 4 avenue Palmerston, Brussels. Interior view from the dining-room entrance.
Victor Horta. 1895–97.

Here the living room is visible through the columns of the central hall separating the two sections of the building. The light well which originally carried natural light to the hall was covered over during a recent remodeling; the stained-glass dome is now artificially lighted.

Horta writes, "Van Eetvelde first had army duty in China, but the king summoned him home to appoint him administrator for the Congo. 'I want a home for my family,' he told me. 'My life style is like everyone else's. I must receive guests, thus I must have a large living room and as big a dining room as you can manage; the upper levels will be occupied only by the family so a formal staircase won't be necessary.'

"Van Eetvelde was the type of person you greeted with indifference but parted from with regret. I decided that with him my imagination could run free, so I presented him with the boldest plans I had made up to that point. The site was divided into five almost equal parts—one for the gardens, one for the dining room, one for the living room, one for the glassed-in hall that separated the dining room from the living room at the center of the house, and the rest for the stairways and closets. From the street entrance it was a dozen steps to the level of the hall. A second flight of steps led to the dining room, and across the hall was the formal living room" (Horta, Memoirs).

353

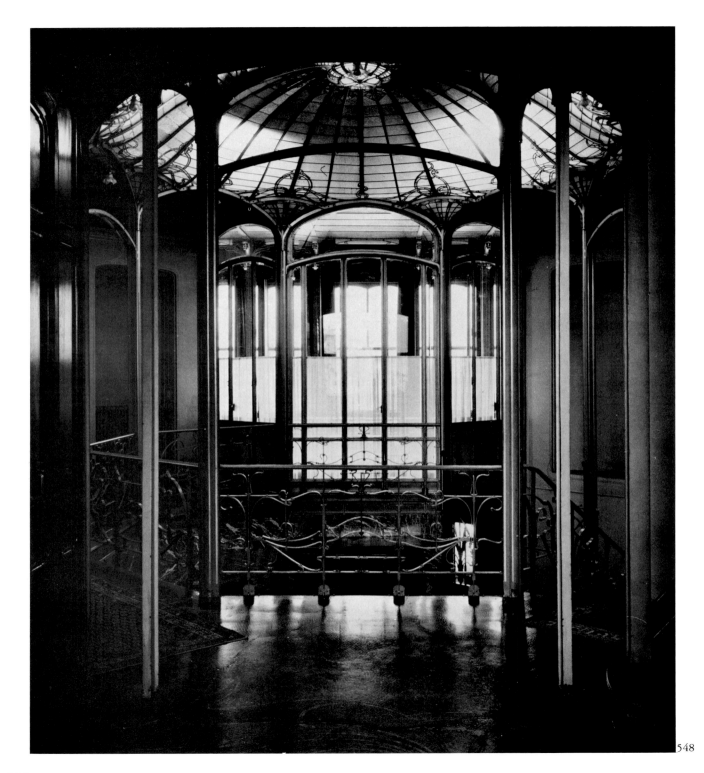

548

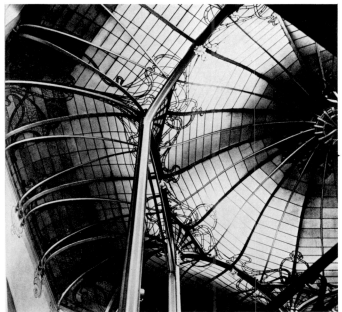

549
Hôtel Van Eetvelde. Detail of the stained-glass dome.
Victor Horta. 1895—97.

550
Hôtel Van Eetvelde. Detail of a capital.
Victor Horta. 1895—97.

551
Residence of Georges Deprez—van de Velde, 3 avenue Palmerston and 14 rue Boduognat, Brussels. Entrance, rue Boduognat.
Victor Horta. 1895—97.

The building was remodeled several times by Horta himself.

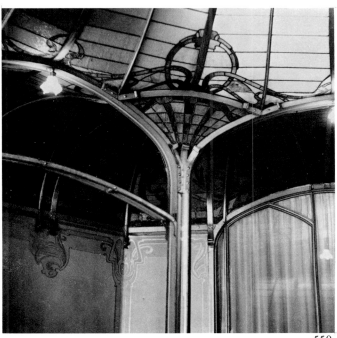

550

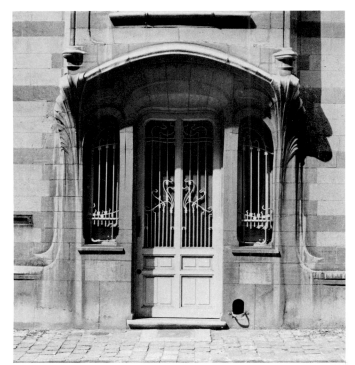

551

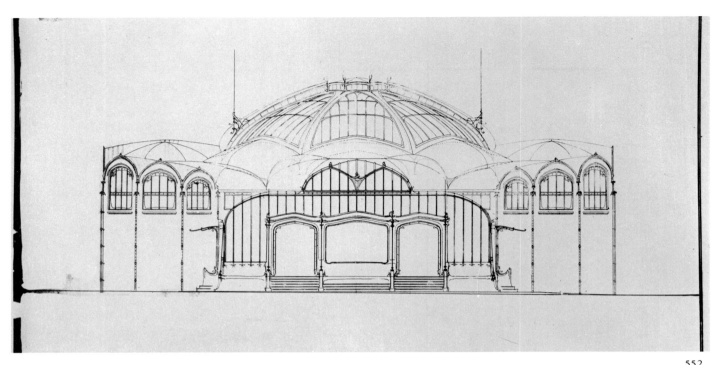

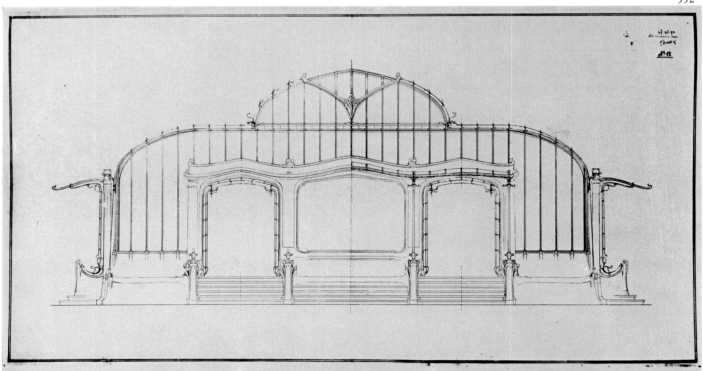

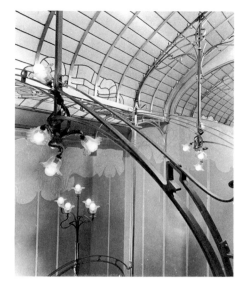

552

Two studies for the pavilion of the Congo Free State at the 1900 Exposition Universelle, Paris [photographs exhibited].
Victor Horta. 1898–99.

"Horta had conceived a work built completely of iron and glass. Of pure and rigorous line, it would have been an exceptional addition to the exhibition. . . . [But] people were afraid that the size of the building would arouse the jealousy of other nations; a variant version of the project, with reduced dimensions, was proposed. Finally the order came to suspend work. 'It cost as much to stop the project as it would have to execute it,' wrote Horta, 'but Leopold II wasn't one to revoke his orders.' Nothing remains of Horta's project except several designs—sections, facades, and a few details—on badly yellowed paper" (Borsi and Portoghesi 1970, p. 92).

553

Home and studio of the architect (now the Musée Horta), 25 rue Américaine, Brussels. Detail of the facade: brackets of the third-floor oriel.
Victor Horta. 1898.

554

Home and studio of the architect. Two details of the stairwell ceiling.
Victor Horta. 1898.

"For those who understood it, the lesson of Viollet-le-Duc was to show how the Middle Ages used stone and brick to their full potential. Horta understood it and applied it to metal. But it would be wrong to think he used metal only for its structural or plastic qualities, for Horta was above all else a master of architectural spectacle. The staircases of the Hôtel Solvay and the Hôtel Van Eetvelde, the abrupt enlargement of the entryway to the drawing room of Horta's house, and the entire interior composition of the Hôtel Tassel—all are the works of a true showman" (Puttemans 1968, p. 276).

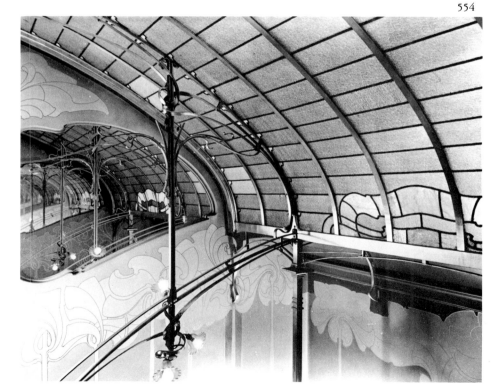

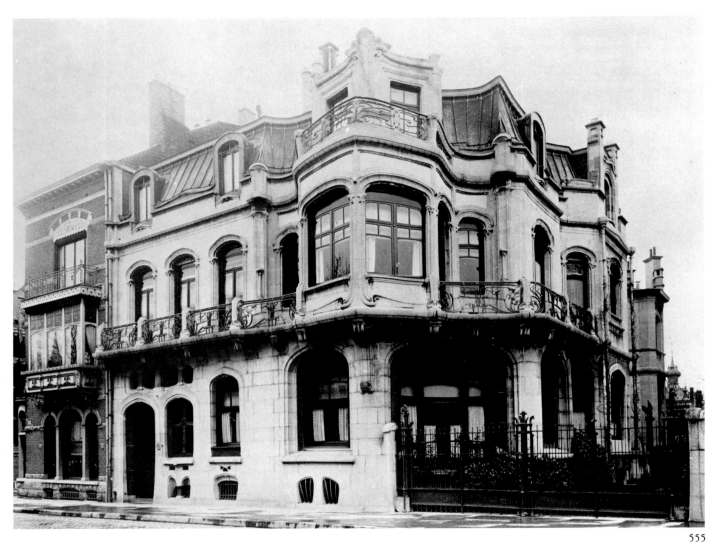

555

Residence of O. Aubecq, 520 avenue Louise,
Brussels. Facade.
Victor Horta. 1899–1902.
The building was demolished in 1949.

"Aubecq, a friend of both Tassel and Solvay
and one of the lawyer Frison's clients, was thus
directly connected with Horta's circle.
Nevertheless, Horta's relations with him were
not easy, for Aubecq was a difficult and
demanding man. He had considered several
architects before settling on Horta, whom he
called and told: 'Here is my program, here is
my plan.' Horta took the plans and drew them
precisely as Aubecq had wanted, scrupulously
respecting his client's desires. When he
returned to present them to the Aubecq family
he was received enthusiastically, for the plans
exactly suited their wishes. Aubecq then asked
Horta, 'Won't you say something?' 'I have
nothing to say; I carried out your plans.' 'Does
the project please you?' In response, Horta
took the plans and tore them up. The architect
later regained the family's confidence and won
the total liberty that was a necessary condition
to his work. One of Aubecq's desires was to
keep his own furniture; Horta, however, could
not permit the use of any furnishings in his
interiors except those of his own design. He
therefore designed the rooms in such a way as
to render impossible the use of Aubecq's
traditional furniture" (Borsi and Portoghesi
1970, pp. 96–98).

556

Hôtel Aubecq. Detail of stained-glass dome
over the staircase.
Victor Horta. 1899–1902.

556

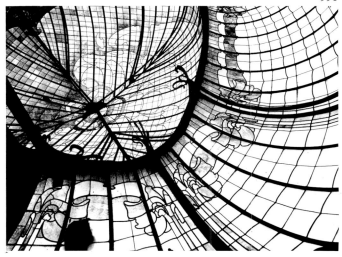

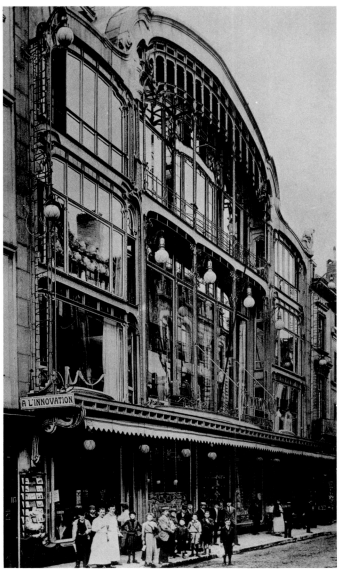

557

558

557
A l'Innovation department store. Facade after
the 1967 fire.
Victor Horta.

558
A l'Innovation department store, rue Neuve,
Brussels. Period photograph of the facade.
Victor Horta. 1900–1903.
The building was destroyed by fire in 1967.

"The construction program for A l'Innovation
was extremely simple: from the outside attract
the passerby in to become a buyer, and once he
was in the 'cage,' oblige him to concentrate his
attention on even the smallest bit of
merchandise. . . . Displaying the merchandise
became the principal object of the architect,
who aimed above all to give the customer a
comprehensive view. This affected even the
building materials, as it left little room for the
supports of the galleries and dictated the use of
iron and steel. Such material was hardly new,
of course, but it was still rarely used in any
artistic form. The public was quite hostile to
it. They saw only its industrial use and simply
could not understand it from an artistic point
of view" (Horta, Memoirs).

359

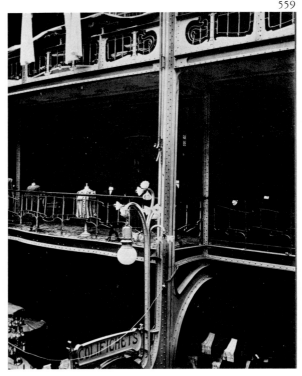

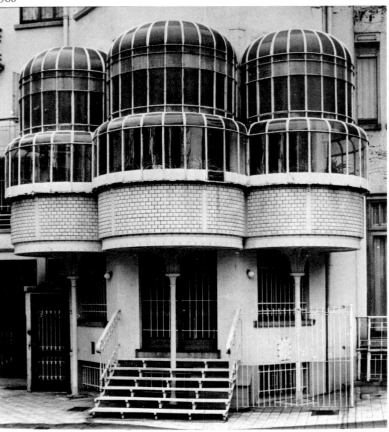

559
A l'Innovation department store. Period
photograph of a pillar.
Victor Horta. 1900–1903.

"One might think today that the glass
elements, and the way the pillars supporting
the gallery curved to enlarge the glass ceiling,
were simply the architect's fantasy. Far from it;
these areas of glass ensured the maximum
distribution of natural light, providing the
conditions in which the public wanted to see
the merchandise, whose appearance would be
distorted by artificial light" (Horta, Memoirs).

560
Residence of Max Hallet, 346 avenue Louise,
Brussels. Detail of the rear facade.
Victor Horta. 1902–1905.

"On the back facade, conceived as usual with
extreme simplicity and strict rationality,
Horta's imagination burst forth in a creation
that could be called futuristic. Instead of
normal windows, glass cells shaped like
mushrooms jut out from the bay window. To
solve the problem of heating Horta had special
radiators built with pipes curved to follow the
surface of the three windows" (Borsi and
Portoghesi 1970, pp. 104–105).

ANTOINE POMPE
b. Brussels 1873.
Pompe's career bears several similarities to the
careers of Charles Voysey and the California
architects Bernard Maybeck and the Greene
brothers: all had to wait until the last years of
their lives to see their work justly appreciated,
and all refused to be labeled pioneers of the
modern movement in architecture. Holding
that functional architecture as it was defined by
Le Corbusier and his colleagues at CIAM had
taken a dead-end path, Pompe in his numerous
polemical writings attacked those who proposed
to turn dwellings into "machines à habiter."
But by forcibly defending complexity at a time
when the slogan was used as a weapon Pompe
condemned himself to disregard. His work was
rediscovered only at the end of the 1960s, when
he was over ninety and had destroyed a large
part of his documents, designs, and projects.

Like Henry van de Velde, Pompe came late to architecture; he produced his first work at thirty-seven, after experimenting with such different occupations as metal engraver, blacksmith, rug designer, industrial designer, and architectural draftsman. Having been educated at the Munich Kunstgewerbeschule, he shared with Van de Velde an appreciation of German culture, whose paradoxical tendencies—the spirit of discipline, the sense of intimacy in domestic architecture, and the taste for mystery—greatly attracted him.

A vast difference in social milieu, however, separated him from Van de Velde. Pompe, who did not have a background of economic and cultural advantages, based his architectural practice on diligence, modesty, and a love of the profession. With rare exceptions his clients were members of the *petite bourgeoisie*. Van de Velde, who came from a cultivated bourgeois family, threw aside tradition, developed his intellectual speculations, and, thanks to enlightened patrons, found practical fields of application for his theories.

Between 1895 and 1905 Pompe designed jewelry, cast-iron grillwork, signs, tableware, flatware, furniture, and tapestries in the Art Nouveau style. However, none of these projects were executed. Victor Horta called on him several times to design interior perspectives for his houses and once asked him to draft the technical plans of a project, never executed, for the Congo pavilion at the Paris Exposition Universelle of 1900. Although several of Pompe's architectural works reflect his admiration for Wright, he was principally influenced by English and German domestic architecture.

Today aged 103, Antoine Pompe spends his days peacefully in a suburb of Brussels. Ever the creator, he is currently perfecting numerous patented inventions like the extraordinary "patin-cycle," an individual transportation vehicle resembling something between a bicycle and roller skates.

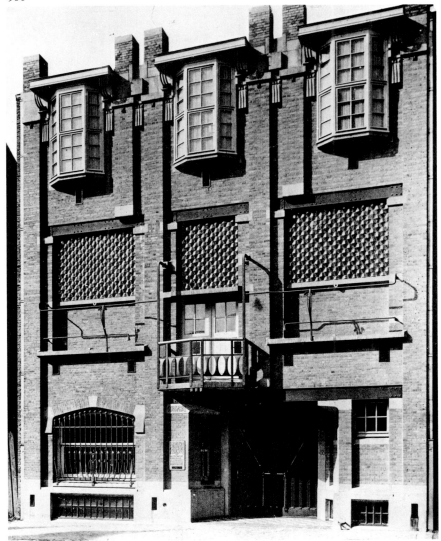

561

Orthopedic clinic of Dr. Van Neck, 53 rue Wafelearts, Brussels. Facade.
Antoine Pompe. 1910.

In placing one ventilator shaft over the metal lintel of the entry bay, and two over the lintels of the gymnasium, the architect clearly emphasized their nonstructural character while using them in a surface composition with the structural pilasters.

"Characteristics: base in Euville stone;

masonry of gray Denain bricks; woodwork enameled white; ironwork painted blue. A recessed porch, whose ceiling is illuminated at night, receives and shelters the visitor. In the wrought-iron door the artist displays all the resources of the builder's art, especially in the rational and original structure of the panels, whose braces assure rigidity while serving at the same time as the door handles. The hollow glass bricks that light the big gymnasium on the second floor are perfect insulators against the sun's rays, noise, and temperature variations. The balcony, made of iron tubing and hammered sheet metal, is light despite its

appearance of solidity. It is removable and thus allows the moving of large objects. To facilitate the cleaning of the windows on the outside, the balcony is flanked by simple narrow ledges with guardrails. Three oriels light the private rooms of the third floor. The side windows open laterally to permit rapid ventilation of the bedrooms. All the rooms are provided with air intakes and ventilators to remove stale air" (*Art et Technique* 1–2 [1914–15]).

Bibl: *Art et Technique* 1–2 (1914–15); Culot and Terlinden 1969; Culot and Delevoy 1973.

ALBERT ROOSENBOOM

b. Brussels 1871, d. Brussels 1943.

After finishing his studies at the Brussels academy in 1896, Albert Roosenboom worked in Horta's offices. His personal contribution to Art Nouveau is limited to one building that he constructed in 1900 only a few steps from Horta's famous Hôtel Tassel. Roosenboom's facade is one of the most beautiful and refined Art Nouveau productions in Brussels. Although the house shows the influence of Horta—its bay window recalls that of the Hôtel Tassel— Roosenboom avoided the master's severity without falling into vulgarity or plagiarism. The house reflects the distinction of its maker.

Architectural history has rarely witnessed such radical transitions as those that occurred at the beginning and end of the Art Nouveau movement. What separates the observer of 1920 from that of 1900 is not so much social change or technical progress, but rather the former's inclination to scorn the world of the latter. Young architects who were hailed as innovators in 1900 were regarded with disdain only a few years later; many of them, the majority, could not survive the transition. Horta retained his mastery of design but lost his creative momentum; Blérot, more radical, would not betray a style he had so dearly loved and chose to quit architectural practice altogether; in Liège Jaspar preached a vernacular architecture inspired by local tradition; others went to Holland or Vienna. Only Roosenboom dared turn deliberately to the past. In an article entitled "Par Horreur du Moderne-Style" he wrote, "You ask me, dear sir, how, after having submitted like so many others to the influence of Art Nouveau, I came to be working with the 18th century. It happened one day while I was walking among the ruins of the château at La Motte. I knew a bit of its history and that of several of its last guests before the Revolution. There I learned to understand the beauty of this architecture. Since I had also read and reread the famous novel by the Abbé Prévost, I imagined I saw Manon in this knightly setting; though I lived for only an instant in the splendor of her time, I felt so much of its poetry and charm that the memory of the château's elegant silhouette and the dreamlike setting turned my taste toward this past, still so near to us" (Roosenboom 1910). An architect of unquestioned talent, not caring to polemicize and highly attentive to detail, Roosenboom continued until 1940 to construct marvelous edifices in the style of Louis XV.

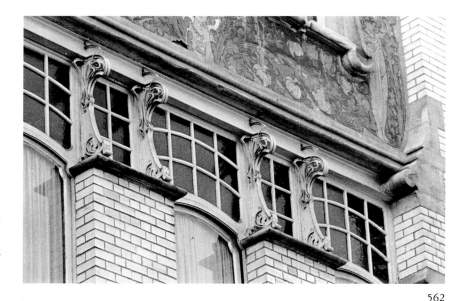

562

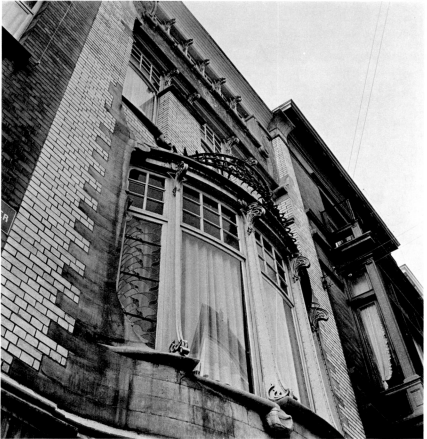

562

Residence, 83 rue Faider, Brussels. Two details of the facade.
Albert Roosenboom. 1900.

"Here certain features—the even composition, the colorful mural covering the top story, and the conspicuous party walls that give the building the character of a tower-house—are reminiscent of Hankar. They combine beautifully with the curve of the bay window, which is modeled on the Hôtel Tassel. In fact more than one element has been borrowed from Horta: the splaying of the building's base, for instance, and the stone relief details on the bay window" (Borsi 1974, p. 53).

PAUL SAINTENOY

b. Brussels 1862, d. Brussels 1952.
Paul Saintenoy, like Horta one of the most conscientious architects of his generation, created only a few buildings in the Art Nouveau style. He never allowed himself to be pigeon-holed, preferring always to suit the style of his architecture to the context in which it was placed.

The Old England department store, located next to a lovely group of Neoclassical buildings on the place Royale, posed an obvious problem of integration. Saintenoy's solution was extremely simple: a facade made entirely of iron and glass. He thus anticipated Horta's design for the A l'Innovation store by two years, and at the same time satisfied his client's need to attract and retain the customer's interest by flooding the merchandise with natural light. A daring floor plan allowed the display counters to be rearranged freely. To this Saintenoy added a further innovation, a tea room on the top floor with a view of the city below.

563

Old England department store, 80 rue Montagne de la Cour, Brussels. Period photograph of the facade.
Paul Saintenoy. 1899.

The building is currently threatened with destruction.

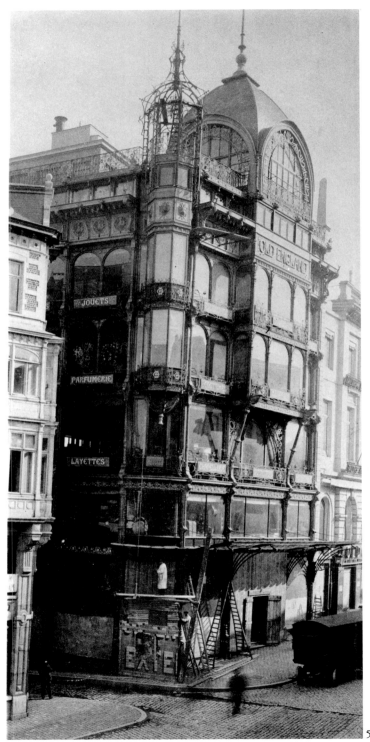

563

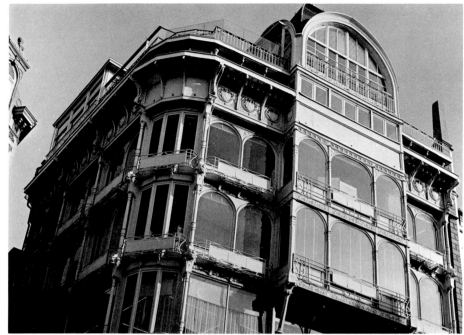

564

564
Old England department store. The facade as it appears today.
Paul Saintenoy. 1899.

F. SMET-VERHAS

Among the architects of the Antwerp school led by Joseph Bascourt, Smet-Verhas was surely one of the most eccentric. His buildings were frequently anecdotal: here, for instance, the window in the shape of a ship's prow jutting into the street was inspired by his client's profession.

In the facades of the private residences he built in the lavish Zurenborg section Smet-Verhas' taste for grandiloquence was pushed to an extreme; some of his compositions there, following the example set by the house called "The Battle of Waterloo," were even inspired by epic themes.

565
Residence of a ship owner, corner of the Schildersstraat and the Plaatsnijdersstraat, Antwerp. Detail of the facade: oriel in the shape of a ship's prow.
F. Smet-Verhas. c. 1900.

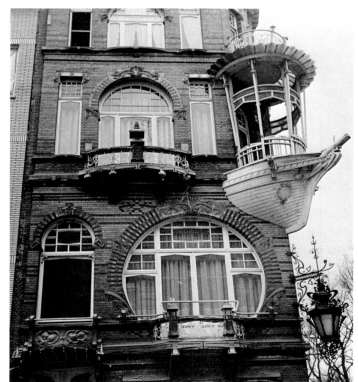

565

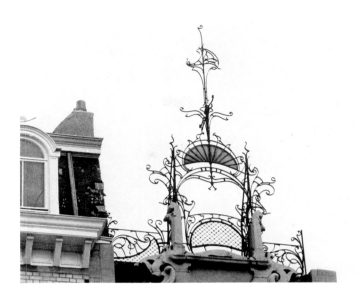

567

GUSTAVE STRAUVEN

b. Schaerbeek, Belgium, 1878,
d. Faverge, France, 1919.

In 1899, after having worked for two years for Horta, Strauven opened his own studio. Although his clientele was less wealthy and prestigious than Horta's, the impossibility of using such noble materials as stone, marble, and precious wood or of being assisted by talented artists and decorators did not prevent Strauven from working in the Art Nouveau style. In order to disguise the fact that he built on tiny lots with common materials—brick and standardized ironwork—Strauven developed an aesthetic of extravagance. To the harmony and tautness of Horta's facades, the result of speculative thought and refined technique, he opposed a bursting force, a force enhanced by the recessed areas whose shadows accentuate the graphic structure of the facade. The house of the painter Saint-Cyr, built in 1903 on the square Ambiorix, Brussels, on a patch of ground less than twelve feet wide, constitutes his masterpiece. The dynamic of the structure is reinforced with a crown of cast iron whose tendrils wave in the sky.

Strauven, like Ernest Blérot, developed an architecture which, while it was not the high point of Art Nouveau, nevertheless aroused popular admiration by its virtuosity and created a taste for a type of architecture that was to profoundly change the face of Brussels. Wounded on the battlefields of the Marne, he died in 1919 in a French hospital.

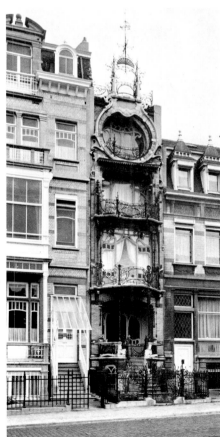

566

566
Residence of the painter Saint-Cyr, 11 square Ambiorix, Brussels. Facade.
Gustave Strauven. 1903.

567
Saint-Cyr residence, Brussels. Detail of the facade.
Gustave Strauven. 1903.

EMILE VAN AVERBEKE

b. Berchem, Belgium, 1876, d. 1946.

Emile van Averbeke was the oldest child in a family of ten. He studied architecture at the Antwerp academy, interrupting his studies to help support his family, then from 1892 to 1897 worked in Antwerp for the German architect Emiel Thielens. In 1898 he collaborated with the architect Van Asperen on the Liberal Party's Maison du Peuple, "Help U Zelve" (Help Yourself): although the plan and overall conception of the building can be attributed to Van Asperen, the facade is undoubtedly Van Averbeke's. His design reveals various influences—Horta and Hankar, Bascourt and Viollet-le-Duc—while the remarkable grillwork, brackets, and metal decoration are strongly reminiscent of Mackintosh.

It was undoubtedly Van Averbeke's old friend and employer Thielens who introduced him to Julius Hoffmann, the German publisher. Between 1900 and 1903 several of Van Averbeke's projects were reproduced in color in Hoffmann's famous collection *Moderne Bauformen*, among the works of such noted architects as Sauvage, Voysey, and Baillie Scott. *Moderne Bauformen* and similar publications made Van Averbeke familiar with the Viennese school of architecture, particularly the work of Wunibald Deininger, and led him to develop a hybrid style somewhere between the lyricism of Art Nouveau and the stylization of Viennese geometry. Later, around 1910, his interest turned to Holland, his style becoming rather heavy under the influence of Berlage; after World War I his architecture reflected the styles of both Dudok and Wright.

The feminine image is a recurring theme in Van Averbeke's Art Nouveau designs. It appears everywhere: in the stained-glass windows of homes; in sgraffito murals; in the delightful book illustrations he created for Scalden, Antwerp's art society; even in the decorative panel of a piano. His architecture during the period from 1898 to 1901, before the Viennese influence, could also be considered feminine, for compared to Horta's firm, determined designs his lines seem evanescent and delicate.

568
The Liberal Party's Maison du Peuple, "Help U Zelve" (Help Yourself), Antwerp. Detail of the facade.
Emile van Averbeke. 1898.

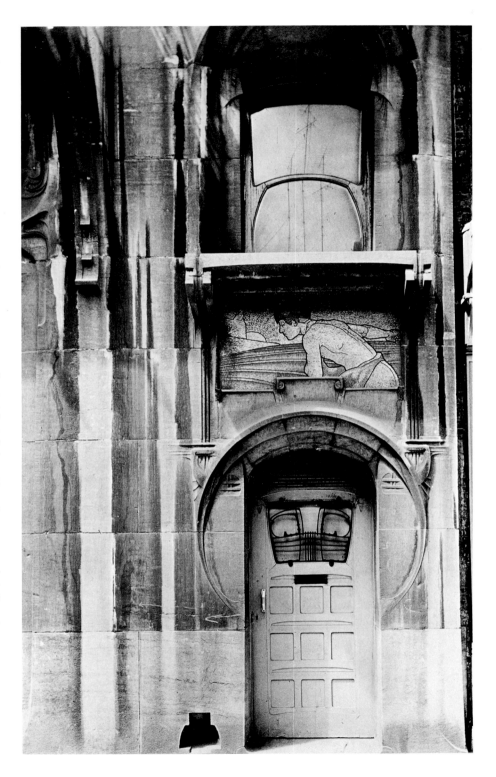

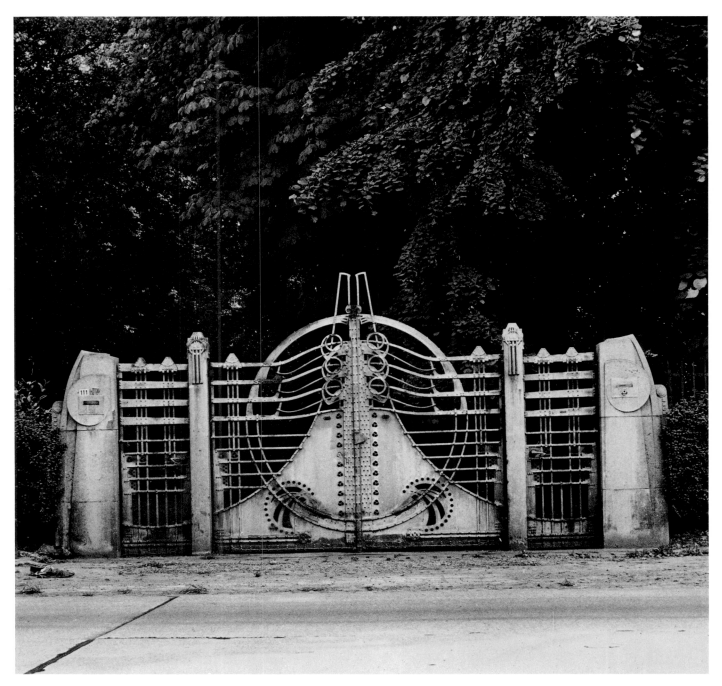

569
Entrance gate to a country house at
Kortenberg, near Brussels.
Emile van Averbeke. 1903.

HENRY VAN DE VELDE
b. Antwerp 1863, d. Oberägeri,
Switzerland, 1957.

Henry van de Velde was a contemporary of
Behrens, Horta, Garnier, Mackintosh, Poelzig,
Pompe, and Sauvage. Of a classical tempera-
ment tinged with romanticism, he was a fervent
follower of Schopenhauer, a humanitarian pre-
occupied very early by social and community
problems, a theorist and man of action, and an
apostle of the functional aesthetic and "pure
form." Van de Velde exercised a decisive influ-
ence over architecture and the applied arts be-
tween 1900 and 1925, especially in Germany.

Coming from a middle-class Flemish family,
Van de Velde was attracted by music, literature,
and painting before becoming interested in ar-
chitecture. In 1881 he took painting courses at
the academy in Antwerp, then studied under
Carolus-Duran in Paris from 1884 to 1885. It
was here that he met the Impressionist painters
and Symbolist poets; he was especially influ-
enced by Seurat, whose theory of divisionism
seemed to Van de Velde to include a spatial
concept that could open up new pathways for
architecture. Upon his return to Antwerp he
collaborated in the foundation of the cultural
circle Als ik Kan (Van Eyck's motto) in 1886
and of L'Art Indépendant, an association of
young Neo-Impressionist painters, in 1887.
From 1889 on he participated in the activities of
the famous avant-garde Brussels group Les
Vingt, where he was exposed to Synthetism and
the writings of Gauguin. Through the painter
Willy Finch he discovered the English Arts and
Crafts Movement and learned of William Mor-
ris' courageous activities on behalf of socially
concerned art.

For the important literary journal Van Nu en
Straks, with which he was associated during the
early 1890s, Van de Velde created a layout that
was revolutionary by virtue of its new typog-
raphy and its ornaments, engraved on wood in a
style derived from Gauguin. This work, which
contributed significantly to the revival of book
manufacture in Belgium, marked the begin-
ning of his shift toward the applied arts. In
1892 and 1893 he created an embroidered
mural tapestry, La Veillée des anges, whose source
can be found in the work of Emile Bernard.
From 1893 on, following William Morris
example, he gave up painting altogether and
dedicated himself to book illustration and the
decorative arts. He produced furniture, his first
three-dimensional work, in 1894, and this
proved to be the final step before his involve-
ment in architecture.

After his marriage to Maria Sèthe in 1894 he
constructed his own house, Bloemenwerf
(1895), at Uccle near Brussels. Conceived as an
organic whole, and completely fitted out with
woodwork, hardware, furniture, rugs, curtains,
table service, crystal, and silver in a unified style
of English inspiration, the house conformed to
theories the young Van de Velde (he was thirty-
three at the time) had presented in various pub-
lications: Déblaiement d'Art, 1894; L'Art futur,
1895; Aperçus en vue d'une synthèse d'art, 1895.
One finds in these writings a rationalism which
holds that the process of fabrication should be
made visible, "proudly and frankly," in every
domain; an uncompromising logic in the use of
materials; and the rejection of ornament in-
spired by nature or by past styles. However, this
consciousness of constructive function and of
utility, this ambition to break away from all
dead tradition, and this fundamental ratio-
nalism remained subject to a persistent sen-
timentality, for Van de Velde's thinking was
affected by German Romanticism. "Where the
creations of German, Austrian, or Dutch artists
are concerned," he wrote later, "we were all
much more closely attached than we thought to
a sort of romanticism that prevented us from
considering form without ornament." The cult
of linear ornament and the fluid line was rein-
forced in Van de Velde's case by his enthusiastic
adherence to the Neo-Romantic theory of Em-
pathy, promulgated by Theodor Lipps in 1903.

In any event the originality of his work im-
pressed the art historian Julius Meier-Graefe
and the merchant S. Bing, who in time were to
make it internationally known. In 1895 Bing
invited Van de Velde to furnish four rooms of
the shop he was opening in Paris under the sign
of "L'Art Nouveau." The robust curved furni-
ture that resulted, very close to the style intro-
duced in 1894 by Gustave Serrurier-Bovy of
Liège, aroused enthusiasm at the exhibition of
applied arts held in Dresden in 1897. From then
on, Van de Velde's road was marked out: he
would make his career in Germany. But before
he left Belgium in 1899 he designed the interior
for La Maison Moderne, the store Meier-Graefe
had founded in Paris; Meier-Graefe introduced
him as well to the Pan group in Berlin, where he
received many commissions—the Hohenzollern
Kunstgewerbehaus, the store of the Continental
Havana Compagnie, the Haby hairdressing sa-
lon, and the Esche house at Chemnitz—mean-
while pursuing his theoretical activities.

During the winter of 1900–1901 he went on
a speaking tour in Germany to present his ideas
(published in 1902 under the title of Kunst-

gewerbeliche Laienpredigten). Thanks to Karl
Ernst Osthaus, Van de Velde completed and
fitted out (1900–1902) the Folkwang Museum
in Hagen—exhibition rooms, display cases,
doors, stairways, ramps, windows, moldings,
and furniture. Its firmly stated plastic quality
and curvilinear ornament exemplify a stage of
Art Nouveau and mark the culmination of Van
de Velde's initial period, which ended in 1906
with the presentation of a sitting room at the
Dresden exposition.

Serving as artistic advisor to the Grand Duke
of Saxe-Weimar from 1901, Van de Velde di-
rected the foundation and construction of the
Kunstgewerbeschule at Weimar in 1906, thus
beginning the second phase (1906–14) of his
fruitful career. The school was an ideal situation
for him to practice his pedagogical vocation and
to apply a new teaching method based on the
immediate cultivation of sensitivity and the
constant reliance on inventiveness, without any
reference to the past or to the study of former
styles. This method generated a variety of new
forms which were seized upon at once by Ger-
man industry. "One day we will be forced to
realize that these objects with their rational
forms prepared the way for rational architecture
and contributed greatly to its dissemination
throughout the world. Their principles, more-
over, are the same as those upon which the new
architecture would be based" (Van de Velde
1933, p. 11). The buildings at the Weimar
school were in themselves an emphatic expres-
sion of Van de Velde's thought and develop-
ment. While maintaining his attachment to
classical construction processes and principles,
he showed there a surer sense of space and vol-
ume; he brought back the straight line, purified
the ornament, and emphasized the plastic qual-
ity which was to dominate the famous Werk-
bund Theater.

Built for the Cologne exhibition in 1914,
this capital work, now no longer in existence,
was a brilliant response to the requirements of
the dramatic art of the time. With a symme-
trical plan and a heavy, traditional shell (whose
profile was nevertheless original), it contained
numerous innovations: a tiered amphitheater,
an independent proscenium, a semicircular rear
stage wall, and above all a tripartite stage. Van
de Velde, who had become the friend of Gordon
Craig and Max Reinhardt, had meanwhile de-
veloped the first plans (1911) for the Théâtre des
Champs-Elysées in Paris.

World War I opened the third and last phase
of the master's career (1914–57). In 1917 he
went to Switzerland, where he won the friend-

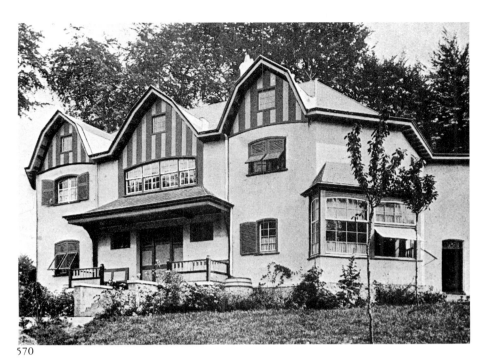

570

ship of Romain Rolland and E. L. Kirchner; in 1921 he moved to Holland, where the Kröller-Müller family commissioned him to draw up plans for a museum he would later reshape into a masterpiece—a perfectly pure, sober, harmonious structure free of any grandiloquence (1937–54). The adaptation of the building to its site at Otterlo and to its function is exemplary: built on one level, it has central and secondary corridors, and natural lighting.

Van de Velde returned to Belgium in 1925. Thanks to the support of the minister of state Camille Huysmans, he had the opportunity in 1926 to repeat his experiment at Weimar by founding the Institut Supérieur des Arts Décoratifs at La Cambre, Brussels (now the Ecole Nationale Supérieure d'Architecture et des Arts Visuels). He served as the school's director for ten years.

Van de Velde also taught architecture at the University of Ghent from 1926 to 1936. In 1947 he settled at Oberägeri in Switzerland, where he devoted his time to writing his memoirs. His work was always dominated by his ardent, combative, penetrating writings. His thinking is summarized in *Formules de la beauté architectonique moderne* (Weimar, 1917), an adaptation of which was published in 1923 under the title *Formules d'une esthétique moderne*.

This work is to early 20th-century architecture what Maurice Denis' *Théories* (1890) are to the painting of the same period. R.-L. D.

570
Bloemenwerf, Van de Velde's residence, 80 avenue Vanderaye, Uccle. Photograph, c. 1896.
Henry van de Velde. 1895–96.

The building materials used are French white stone and Dutch yellow brick, while the wood sections of the gables are green and gray.

"The unusual and irregular plan of Bloemenwerf is typical of the architect's aesthetic. Van de Velde succeeded in designing a building that, with the exception of the entry hall, has no rectangular rooms. The center of the house is a stairwell. On both floors all the rooms open onto the hall, a very different arrangement from the classic Belgian house. . . . The contour of the house seems really to enclose the contents and creates a feeling of intimacy. . . .

"On his first visit in 1897 Kessler was especially struck, not with the richness of the interior, but with its purity. Everything there was light and wholesome. Madame Van de Velde, whom he noted was a lovely blonde, walked about in Pre-Raphaelite gowns inspired by Morris. Other visitors were impressed by the harmony, the simplicity, the somewhat sad gray tones. A Blüthner grand piano sat next to Seurat's exquisitely serene painting *Dimanche à Port-en-Bessin*, a pen-and-ink sketch by Van Gogh, and a portrait of Maria by her brother-in-law Van Rysselberghe.

"Van de Velde created special furniture and wallpaper for this setting. Bloemenwerf was the source of an important movement that was to be propagated by those who saw the house and left it captivated and inspired: the Parisian art dealer Samuel Bing, the art critic Julius Meier-Graefe, Count Harry Kessler, Edouard von Bodenhausen, and Karl Ernst Osthaus" (Hammacher 1967, pp. 102–104).

571
Continental Havana Compagnie store, Berlin. Three period photographs of the interior. Henry van de Velde. 1898–99.

The interior, furnishings, and graphics (see cat. no. 86) for the Berlin office of the Continental Havana Compagnie were entirely designed by Van de Velde.

In an article appearing in the January 1900 issue of *Innendekoration*, Max Osborn noted that certain of Van de Velde's works showed the influence of the decorative quality of line in primitive art. Beginning in 1893, Jan Toorop in Holland had shown works that incorporated this use of linear ornament. According to Osborn, Van de Velde had been subconsciously influenced by the primitive objects and images introduced into Belgium by way of the colonies. He found proof of this in the bizarre character of some of Van de Velde's decorative works, especially in the handling of the great wooden archways of the interior bays in the Keller and Reiner art gallery, Berlin (1897), and those in the Continental Havana store. In the art gallery the pieces of wood on the archways were too large and gave one the impression of being in a prehistoric temple. The Berliners, quick to poke fun, dubbed Van de Velde's style in the gallery "Mammuth-Stil." Van de Velde cleverly avoided such oppressive heaviness in the Continental Havana store, where the somewhat exotic element he introduced was especially welcome, since the store specialized in the sale of tropical products, cigars and tobacco.

Although line was Van de Velde's unifying dynamic element, he at times used color to

harmonize different parts of his rooms, for
which his early career as a painter was very
helpful. Here, however, probably for financial
reasons, Van de Velde had difficulty creating a
synthesis between the lower parts of the walls,
lined with furniture and decoration, and the
unadorned upper parts. In an awkward attempt
to accomplish this he used a stenciled fresco
that repeated a motif of stylized clouds of
smoke.

572
Folkwang Museum (now the Karl Ernst
Osthaus Museum), Hagen. Entry hall. Henry
van de Velde. 1900–1902.

In 1898 the banker and collector Karl Ernst
Osthaus commissioned the Berlin architect
Karl Gerard to design a building that would
house his collections and his living quarters at
the same time. The bulk of the work on
Gerard's neo-Renaissance building was already
completed when in 1900 Osthaus read an
article Meier-Graefe had published in 1898 in
the magazine *Dekorative Kunst*. He
enthusiastically sought out Van de Velde in
Brussels and asked him to continue the fitting
out of his museum-home. Van de Velde
accepted reluctantly, for Gerard's style was just
what he had fought against in his work and
writing, and neither the facade nor the
majority of the interior spaces could be
modified.

In this limited framework, Van de Velde
managed to achieve a unified artistic creation
and mask the oppressiveness of Gerard's
architectural style. The most remarkable part
of the building is without doubt the entry hall
of the museum. Here Van de Velde covered the
existing metal columns and brick arches with
stucco, which, thanks to his mastery of line,
gave the impression of a dynamic relationship
like that of the limbs to the body. His
handling of the problem becomes even more
impressive when one considers that he had
originally intended to leave the columns as
they were, but was forced to stucco them in
order to give greater security against fire.

Bibl: Osthaus 1920, pp. 18–27; Van de Velde
1962, p. 186; Hüter 1967, pp. 100, 171–76;
Hammacher 1967, pp. 179–80, 185–86
illus.

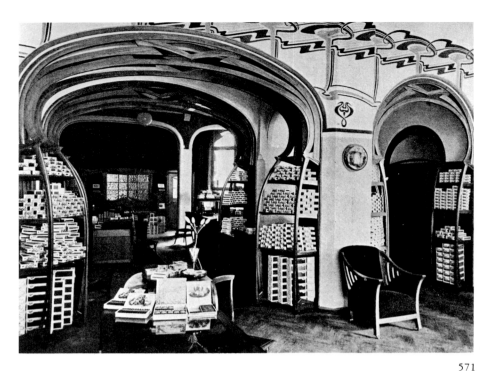

571

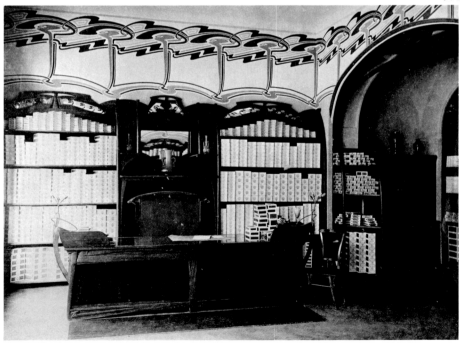

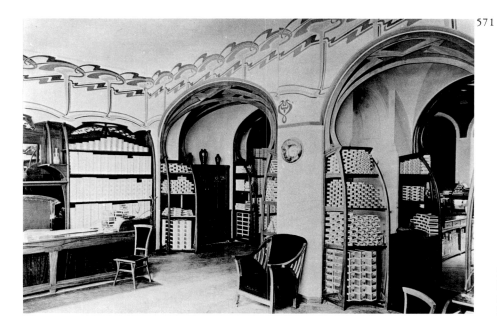

571

573
Folkwang Museum, Hagen. Detail of a column
in the entrance hall.
Henry van de Velde. 1900—1902.

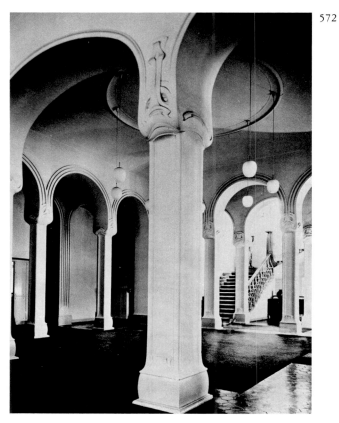

572

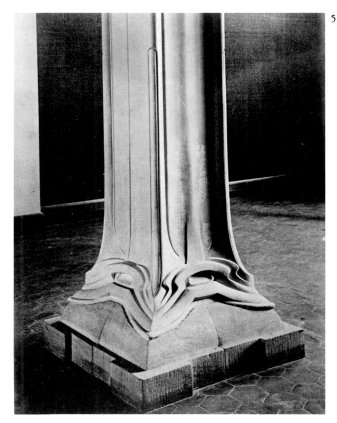

573

574

Villa of Herbert Esche, Chemnitz, Germany.
Henry van de Velde. 1902.

The first villa built in Germany by Van de
Velde, who also designed the interior and
furnishings.

Bibl: Osthaus 1920, pp. 30–31; Lenning
1951, p. 40; Van de Velde 1962,
pp. 144–45; Hüter 1967, pp. 118–20,
figs. 138–45.

574

575

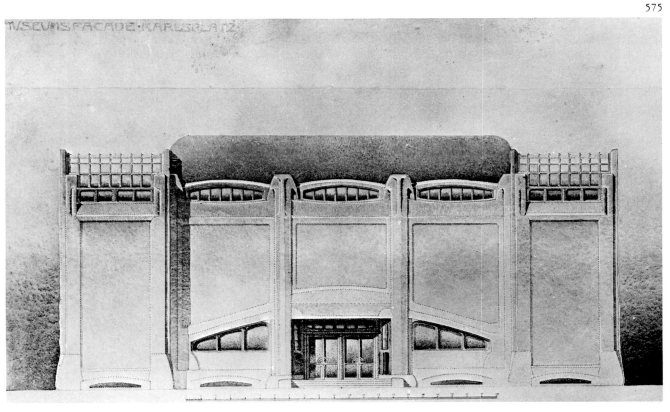

575

Study for a museum of fine arts, Weimar.
Elevation of the Karlsplatz facade.
Henry van de Velde. 1903–1904.
Watercolor on illustration board.
51 x 72.5 (20 x 28½)
Brussels, Archives Henry van de Velde,
E.N.S.A.A.V., Inv. 4391.

In March 1903 the handicrafts collection of the
city of Weimar, along with the institute that
housed it, became the property of the Grand
Duke of Saxe-Weimar and was transformed
into the grand-ducal museum of Arts and
Crafts. Later that same year, in December, the
museum became the headquarters of the
Deutschen Künstlerbundes, the artists' union
recently founded in the area. Count Harry
Kessler, named president of the union's
administrative council, decided to construct a
new museum and commissioned plans from
Van de Velde, whose work at the Folkwang
Museum in Hagen was of course known to
him. A Finn, Sigurd Frosterus, was associated
with Van de Velde in these studies.

In May 1904 the plans and a model were
presented to the grand duke. The project was
to include apartments and business spaces as
well, to absorb to some extent the cost of
building the museum. Van de Velde himself
had reservations about the project; he feared
that mixing the functions of the buildings
increased the risk of fire. In 1905, he began a
second project with plans for a museum alone.
About the same time, however, Count Kessler
left the union presidency, which killed the
project.

Among the restraints imposed on Van de
Velde was the necessity to retain and
incorporate into the new structure an existing
facade in Venetian style and an attached
exhibition hall. Van de Velde planned to
surround the old area with three wings, leaving
an open interior space that would make the
original facade visible from the museum's entry
hall. The plans for the museum were developed
in a symmetrical way around the central patio;
the bays on either end of the vaulted entry on
the Karlsplatz sheltered the two stairways.
Natural lighting particularly interested Van de
Velde, who planned, among other ways of
lighting precious objects, to have display cases
built into the bay windows of the
Bürgerschulstrasse facade.

Bibl: Hüter 1967, pp. 176–78, fig. 199.

Exh: Paris 1971b, no. 79.

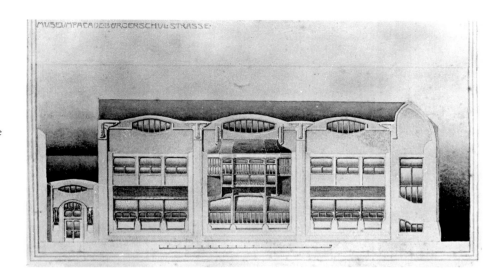

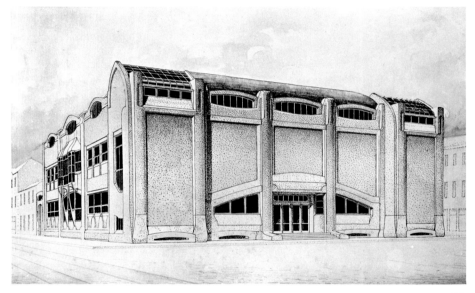

577

576
Study for a museum of fine arts, Weimar.
Elevation of the Bürgerschulstrasse facade.
Henry van de Velde. 1903–1904.
Watercolor on illustration board.
51 x 72.5 (20 x 28½)
Brussels, Archives Henry van de Velde,
E.N.S.A.A.V., Inv. 4392.

Bibl: Hüter 1967, pp. 176–78, fig. 200.

Exh: Paris 1971b, no. 79.

577
Perspective study for a museum of fine arts,
Weimar. Second project.
Henry van de Velde. 1905.
India ink and wash on cardboard.
51 x 72.5 (20 x 28½)
Brussels, Archives Henry van de Velde,
E.N.S.A.A.V., Inv. 4390.

Bibl: Hüter 1967, pp. 176–78.

Exh: Paris 1971b, no. 78.

578
Perspective study for the Louise Dumont
Theater.
Henry van de Velde. 1904–1905.
Watercolor on paper.
53 x 74.5 (20⅞ x 29⅜)
Brussels, Archives Henry van de Velde,
E.N.S.A.A.V., Inv. 4380.

Commissioned by a famous actress who hoped
to create a National Theater of German
Dramatic Art, the Louise Dumont Theater was
among Van de Velde's earliest theater projects.
It was to be located near Weimar, but was
never executed.

Bibl: Van de Velde 1962, pp. 255–58;
Hammacher 1967, p. 287; Hüter 1967,
p. 111; Sharp and Culot 1974, pp. 27–31,
75, 79, p. 30 illus.

Exh: Brussels 1963b, no. 222; Oslo 1970;
Paris 1971b, no. 81; London 1974, no. 31.

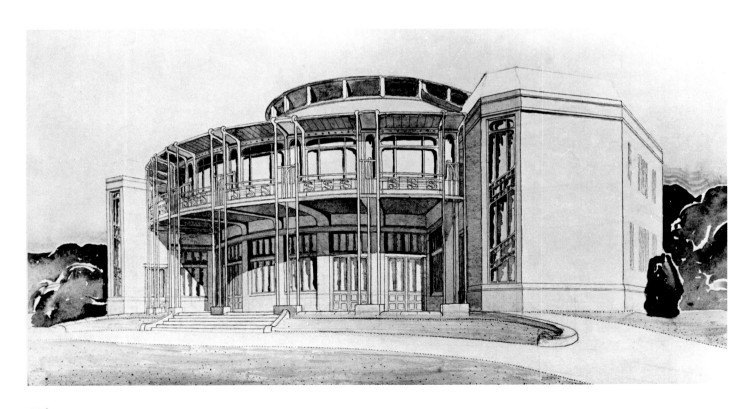

579
Kunstschule, Weimar. Two views of the wing
completed in 1911.
Henry van de Velde. 1904–11.

From 1860 there existed at Weimar a private
art school that was particularly known for its
painting department. The school held classes
in an old barn until 1902, when it became a
public school; plans were made then to
gradually modernize it and enlarge it without
interrupting the courses in progress. In June
1904 the studios situated along the avenue de
Belvédère were remodeled according to Van de
Velde's plans. Construction on new buildings
for the art school was not begun till February
1911. Between 1904 and 1906 new buildings
for the school of decorative arts, designed by
Van de Velde, were constructed on a site across
from the art school.

"What Van de Velde created at first was not
a school but a type of laboratory: the
Kunstseminar, founded in October 1902. . . .
In 1907 the first students entered the
Kunstgewerbeschule, where he was able to
develop on a large scale the ideas that had been
the basis for the founding of the seminar,
which was to be discontinued. But the state
subsidy was insufficient and allowed financing
of only two studios. Fortunately Van de Velde
was of the generation that could still count on
private funds. Thus the responsibility both for
financing and for material organization fell
upon Van de Velde, on foundations and on
private assistance. . . .

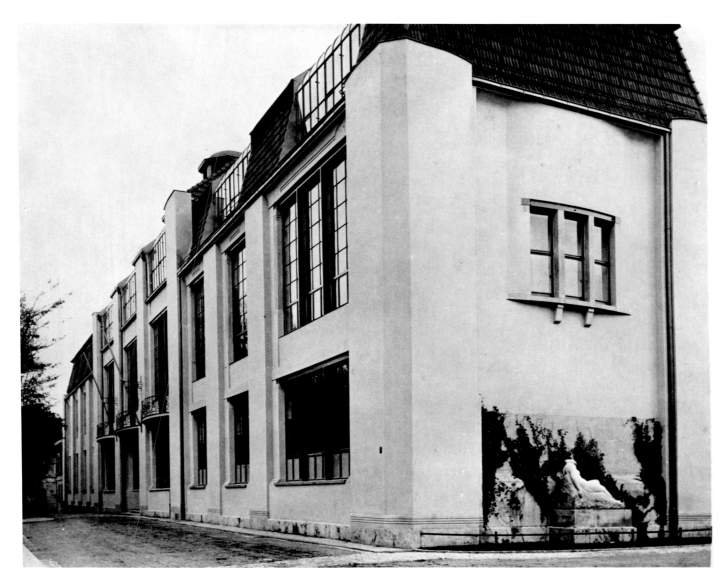

"If Weimar stood out, it was because Van de Velde inspired it with his own enthusiasm and intensity of spirit. Weimar therefore won a name for itself; in 1911 the young Le Corbusier came to see and study what was being done there. In reality, however, the situation was not as easy as it appeared; Van de Velde endured significant resistance and efforts to undermine his position, a transient faculty whose talents were not always first-class, and an unbelievable burden on the creator himself, for an incredible amount of energy and dedication were required simply to maintain acceptable standards. In 1910 he sounded the alarm and insisted on courses in elementary architecture, wood engraving for book illustrations, printing, batik, calligraphy, weaving, and the history of the aesthetic of industrial arts. But by this time Van de Velde's position no longer enabled him to obtain what he wanted. . . .

"When he resigned, discouraged and exhausted, on July 25, 1914, the three names he mentioned as possible successors revealed his shrewdness and the breadth of his vision: Gropius, Obrist, Endell" (Hammacher 1967, pp. 220–25).

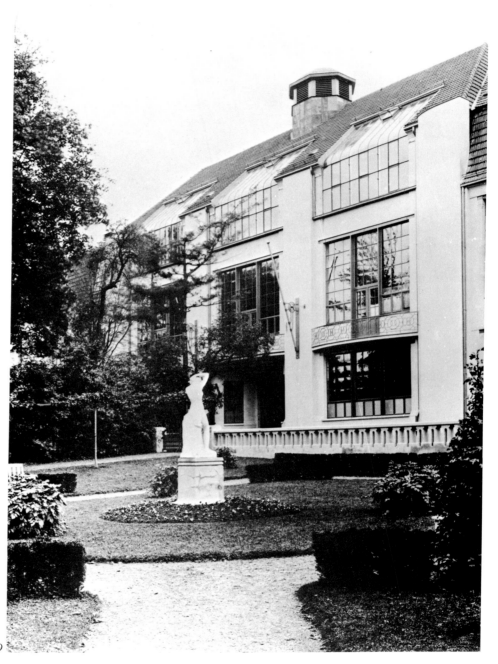

579

PAUL VIZZAVONA

b. Paris 1881, d. Sanary-sur-Mer,
France, 1956.
Born in Paris of a Corsican family, Paul Viz-
zavona was an intern under Charles Garnier and
Emile Bertone before moving in 1903 to Brus-
sels, where he worked in Horta's studios. By the
time he began his own practice in 1906 he was
well known in liberal circles and was able to
acquire a clientele rapidly. Between 1906 and
1914 he built more than thirty buildings in
Brussels, as well as numerous villas at the fash-
ionable new beach resort of Westende. Vizzavo-
na's architecture shows a strong French influ-
ence. In his attempt to wed Art Nouveau and
the Louis XV style he borrowed freely from
Horta's handling of architectural detail—an ac-
tion justly protested by Horta, who accused him
of plagiarism.

A talented lecturer and writer, Vizzavona
contributed throughout his life to numerous
journals and periodicals, most notably the fa-
mous liberal newspaper *Le Petit Bleu* in Brussels.
Upon the declaration of war in 1914 Vizzavona
left Belgium for the south of France, where he
continued his career as an architect.

580
Residence, 97 rue Franz Merjay, Ixelles,
Brussels. Detail of the facade.
Paul Vizzavona. 1907.
The building was demolished in 1972.

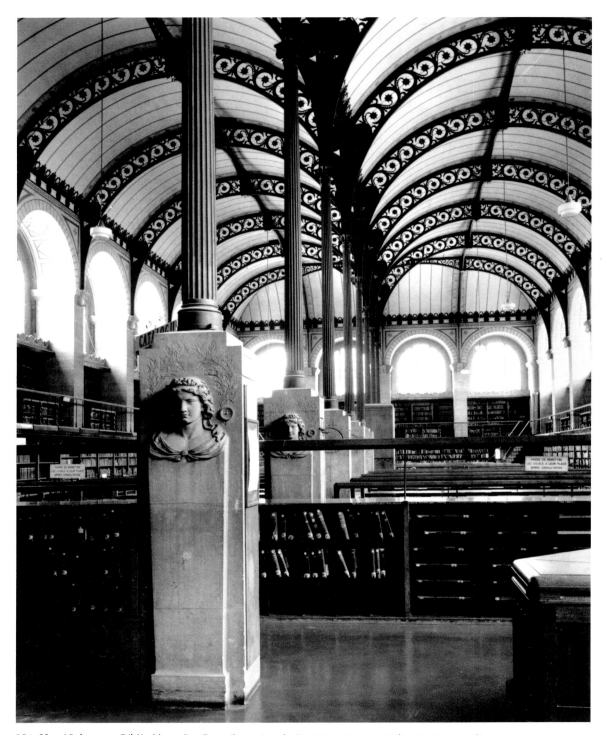

581. Henri Labrouste. Bibliothèque Ste-Geneviève, place du Panthéon, Paris 5. 1843–50. Main reading room.

ART NOUVEAU ARCHITECTURE
IN FRANCE
François Loyer

Is there an Art Nouveau architecture in France? The question may well be asked in view of the scarcity of available documentation on the subject. In fact there is no documentation except what was provided by Hector Guimard, that exceptional individual who was so aware of his originality that he gave his production the resounding title "Style Guimard."

The fact that we see so little of what can be called Art Nouveau *architecture* is not surprising, considering that this style originated in the decorative arts, and particularly in the industrial arts (glassmaking and pottery). It was essentially an art of decoration, useful to the painter of china, the goldsmith, the cabinetmaker. In principle it had little or nothing to do with architecture—just as Rococo, properly speaking, had not produced an architecture in France, where the monumental, classical tradition certainly seems to have held its own.

Eclecticism.[1] The first problem is to establish the criteria by which we may define Art Nouveau architecture. The usual position is that it consisted solely of decoration—and floral decoration at that—added to a building: where there is no decoration, or any other than foliation, there is no Art Nouveau. Hence little is said about certain aspects of Horta's work (the vestibule of the Hôtel Solvay, for instance), or about the turnabout of Henri Sauvage.

Another way of looking at architecture is to focus on the problem of space, at least in the period we are concerned with. The interest devoted to the treatment of space is one of the characteristics of the architecture of our time, the roots of which reach deep into the 19th century so far as France is concerned, and even into the 18th for England. It is obvious that the Industrial Revolution entered the picture here; yet modern architecture—by which we mean the art of the industrial period, from the Second Empire to our own

day—is definable more by the novelty of the plastic language of forms and spaces than by its rather slow technological development, and not at all by social evolution.

Let us look again at Horta's Hôtel Solvay. The most interesting aspect of this building is the fluidity of its interior spaces and the powerful contradiction between the rigidity of the formal scheme and the mobility of space, light, and color. The decoration of the structure is conceived in integral relation to the principal scenario, a "spatial narrative" developed through time as the fourth dimension resulting in a *spectacle of form* rather than form itself.[2] Here the unity of form and ornament make this house a major example of Art Nouveau. But when the ornamentation is not integral—as in Alphonse Balat's greenhouses at the royal château of Laeken, for example—it is far more difficult to judge whether or not the result can be called Art Nouveau.

It is a striking fact that Madsen, Pevsner, and Schmutzler,[3] the leading historians of Art Nouveau, concerned themselves with architecture only under the aspect of decorative art. This led them to judgments that are superficial when they are not completely erroneous. And much might be said about the fundamental error of interpretation into which Hitchcock[4] falls when he categorizes the Eclectic artists by the styles to which they make reference.

One must go beyond the confusions of Eclecticism in order to understand the architecture of the end of the 19th century. The mutual opposition of its styles is only superficial, and conceals an effort to reassert the significance of built spaces. If the clothing comes with the body, this is only a formal accident in the emergence of a new kind of architecture from earlier styles. Emil Kaufmann, a remarkable historian, saw immediately and intuitively the close bond connecting Ledoux and Le Corbusier:[5] the whole history of the 19th century lies between these two, in a continuum from Romanticism to Art Nouveau.

Birth of a New Architecture. Our story will begin at the break with Neoclassicism in the reign of Louis Philippe. The generation of Hittorf, Duc, and Labrouste marks the real line of rupture. L. J. Duc (1802–79) built the Colonne de Juillet in the place de la Bastille in 1840–41.[6] The great facade of the Palais de Justice in Paris (1857–68) and the Vestibule de Harlay to which it leads are also his work: he emphasized their distance from the Neoclassical tradition by exaggerating their monumentality, by altering the profile and proportion of moldings and generally adopting a stylistic treatment that accentuates formal tension and harsh contrast.

Jacob Ignaz Hittorf (1792–1868), better known than Duc,[7] is recognized for the importance of his studies on polychromy as a means of renewing the stylistic basis of Neoclassicism. Nevertheless the sharp contrast between the gigantic facade of the Gare du Nord (1863) and the breadth and airy lightness of the metal skeleton which supports the spacious glass roofing over the station platforms has never received the attention it deserves.

Henri Labrouste (1801–75) completed the break with tradition in his two major achievements, the Bibliothèque Ste-Geneviève (1843–50; cat. no. 581) and the Bibliothèque Nationale (1858–68). It is surprising that so much emphasis has been put on his use of a new building material—iron—and so little on the originality of the great spaces in the two reading rooms. At the Bibliothèque Ste-Geneviève the wide expanse of the reading room centers on the row of cast-iron columns dividing the two bays, which are generously lighted by the glass walls that surround them. It is a work of astounding inventiveness. The main reading room of the Bibliothèque Nationale also shows the architect's originality. The room makes use of the multiple domes typical of Seljuk Turkish mosques. The domes further define the square spaces marked out by their slender supports. The scale is truly daring: the internal height is sixty-five feet, while the floor area is approximately 12,500 square feet.

Labrouste's work is also that of a great decorator who by simplification of the vocabulary of Neoclassicism accomplished the tradition's complete renewal. The disturbing aspect of the busts of Hermes in the Bibliothèque Ste-Geneviève expresses this renewal: the statue's immobile beauty beneath the abrupt joining of the stone base with the iron column forms a juxtaposition that is fundamentally anticlassical, yet whose logical perfection is indisputable. The foliated scrolls in the iron arches there, and the strange bases of the heaters in the Bibliothèque Nationale, are part of this language, which deviated more and more with each

succeeding work from the sources upon which it supposedly drew for inspiration. Another example is the curious drapery in carved stone which covers the corridor walls in the entrance of the Bibliothèque Nationale.[8]

OFFICIAL ART AND MODERN ART

The crisis of academicism. The great architecture of the Second Empire was built on the foundations laid by Labrouste's generation. As in other fields of creative endeavor, conflict broke out between official art and modern art. The stalwarts of academicism were Charles Rohault de Fleury (1801–75) in the Neoclassical tradition (Chambre des Notaires, place du Châtelet, 1855; Grand Hôtel du Louvre, place du Palais-Royal, 1858); Hector-Marie Lefuel (1810–80), who did the extensions of the Louvre (1852–76); and Félix Duban (1797–1870), with the Palais des Etudes of the Ecole des Beaux-Arts (1834). The Ecole des Beaux-Arts, with its international influence, was the stronghold of this official tendency. Opposed to it was the Gothic or "antiquarian" trend, dominated by the powerful personality of E. E. Viollet-le-Duc (1814–79). His lectures at the Ecole des Beaux-Arts, which were incorporated in the *Entretiens sur l'architecture,*[9] marked the high point of this conflict.

Eclecticism. To reduce the art of the Second Empire to a caricature of that kind would, however, lead to a very faulty understanding of the subject. Between the emphatic art of the establishment and the formal logic of the theorist there were all sorts of other expressions, and these properly speaking constitute Eclecticism. Antoine Bailly (1810–92), Théodore Ballu (1817–85), Gabriel Davioud (1823–81), and Charles Garnier (1825–98) cannot be classified simply as Neoclassical academics.

Eclectic art is founded on a profoundly ambivalent relationship to history—a fact essential to a clear definition of the distinctive contribution of Art Nouveau. It is to Robert Venturi's credit that he showed the nature of this relationship in different periods, as resting both upon reference to a model and at the same time upon distortion of the model.[10] Thus Garnier's Opéra in Paris can be considered a monument of Neoclassicism; Daniel Rabreau[11] has pointed out its reference to Palladio's Basilica in Vicenza, and the extraordinary ambiguity which stresses the relationship and at the same time alters it. This Garnier did by borrowing from other models (Sansovino's Library in Venice, Gabriel's Garde-meuble on

582. J.A.E. Vaudremer. St-Pierre-de-Montrouge, avenue du Maine and avenue Général-Leclerc, Paris 14. 1864–72. Detail of gables and gutters.

582

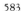

583

583. J.A.E. Vaudremer. Notre-Dame d'Auteuil, place d'Auteuil, Paris 16. 1875. Transept crossing with *confessio* choir and apsidal chapel of the Virgin.

the place de la Concorde), by tampering with relations of scale between parts, and by the lavish use of color and relief.

An echo of this distortion of models is found in the cool art of Victor Baltard (1805–74); Les Halles, the central market buildings in Paris (1854–66), are recognized as a work of genius, not only because of Baltard's use of iron (on the contrary, the hybrid technology of wrought and cast iron employed there would seem rather lacking in boldness), but also for the quality of the immense interior volumes, which are filled with soft light from the skylights and glass louvers while at eye level the gas lamps flare. The space recalls that of a mosque, and suggests Sinan's buildings in Istanbul.[12]

The "Modern" School. The experiments undertaken by the Eclectics in the handling of volume—distortion of scale or of light, disarticulation of the linkage between spaces—very clearly defined the "modern" school of the Second Empire, with architects like J. A. E. Vaudremer (1829–1914), Louis-Auguste Boileau (1812–96), and Paul Sédille (1836–1900), all of whom were working at the time of the changeover from the Second Empire to the Third Republic. Vaudremer's church of St-Pierre de Montrouge, 14e (1864–72; cat. no. 582), was unanimously considered a masterpiece in its time. The clarity of the spaces, their rigorous definition (inspired by Ottonian architecture), and

the logic of the building materials (differentiation between structural and infill components, and the prominence given to the decorated terra-cotta gutters) combine to make it a monument of architectural rationalism.

Here religious art acts as a catalyst for the latent emotionalism of rationalist architects. The model established by Louis-Auguste Boileau with his church of St-Eugène (1855) played upon the contrast between the compactness of the interior space and the subtle divisions of the vault structure. The success of this prototype was so great that we have every reason to see its derivatives in Pierre Bossan's (1814–88) astonishing basilica at Fourvière near Lyons (1872–96), one of the most important examples of Eclecticism in France, and in the religious architecture of Antoni Gaudí. We refer here not only to the chapel of Jesús-María in Tarragona (1877–82), which is a direct copy of Boileau's church, but also to that "total spectacle," the Sagrada Familia in Barcelona, whose relationship to Fourvière should not be overlooked.[13]

We come to Paul Sédille in connection with still another religious structure, the basilica of Ste-Jeanne d'Arc at Bois-Chenu near Domrémy (1881–1926). An interior route connects the crypt, here on the ground level, with the lofty nave above, then with the vaulted choir which terminates the apse and with the light-filled west chapel in the tower, which overlooks the valley through a balcony—a sequence that strongly affects the emotions of the spectator. We call attention to this basilica deliberately in preference to some of Sédille's best buildings in Paris[14] and to the well-known Au Printemps department store (1881–89), which have already won their meed of praise.[15]

Since Sédille was not alone in his experiments with construction in glass and steel, we may include the work of Paul Abadie (1812–84) and Lucien Magne (1849–1916) among the modern trends in architecture. After directing the restorations at Angoulème and Périgueux, Abadie—an imaginative restorer who was not very faithful to his models—was chosen to design the basilica of the Sacré-Coeur in Montmartre (1876–1910); Magne was his successor. The basilica's central block of space rises to an enormous height (the dome is 277 feet above the floor) and is pressed in by the squat lateral chapels which seem weighed down by the crushing force of a violent, obscure pressure from without.

This is a *symbolistic* rather than a symbolic architecture: it is not the architectural sign that prevails so much as the emotional effect, which goes beyond the normative, reassuring references of history. So these productions find their place in the antechamber of a coming Art Nouveau. Not by

accident was Pierre Séguin, one of the best Parisian sculptor-*ornemanistes* of the beginning of the present century, Abadie and Magne's collaborator for the choir and campanile of the Sacré-Coeur.

Other architects—Jean-Charles Formigé (1845–1926), designer of the Beaux-Arts pavilion at the exposition of 1889 and architectural consultant for the construction of the elevated Métro (the two viaducts of Grenelle and Austerlitz are his), Louis-Charles Boileau *père* (1837–1910), to whom we owe the department store Au Bon Marché (1885) and, as early as 1864, the interesting cast-iron and reinforced-concrete church at Le Vésinet; and Ferdinand Dutert (1845–1906)—belonged to this same world, applying, by means of more and more frequent recourse to industrial materials, the lessons Labrouste's plastic experiments had taught some forty years before. In the gallery of the Musée de l'Histoire Naturelle (1881), Dutert managed to surpass, like Sédille at Au Printemps, the stylistic handicap of traditional Neoclassical architecture.

TOWARD AN ART NOUVEAU

Art Nouveau is like another offshoot of this trend, reappearing after the long underground course of its maturation. The filiation with Viollet-le-Duc is evident; the theorist of a new art became its prophet as soon as liberation from the classical system of ornament was accomplished. Architects like Pierre-Joseph de Perthes (1833–98), with his basilica of Ste-Anne in Auray (1865–77), and Pierre Bossan at Fourvière were seeking a model: they looked for it in the Early Christian style of Rome or in the Romano-Byzantine of Syracuse,[16] from which they drew the inspiration for their most improbable inventions in the matter of furniture and decoration. And it seems that all of a sudden at the turn of the century, what they had been looking for crystallized, due to the threefold influence of Viollet-le-Duc, Ruskin, and William Morris.

Viollet-le-Duc at Pierrefonds. Although the importance of Viollet-le-Duc's theoretical studies (essentially the *Entretiens sur l'architecture* and the *Dictionnaire de l'architecture*)[17] is now generally acknowledged, his work as an architect has perhaps not yet been given the recognition it deserves. This work was by no means limited to his activity as a restorer, exceptional as his competence in that field may have been. Pierrefonds in particular is almost always thought of as a

584. E.E. Viollet-le-Duc. Château de Pierrefonds, Oise. 1857–70. Detail of interior courtyard: great stairway, entrance, and staircase of northeast pavilion.

585. E.E. Viollet-le-Duc. Château de Pierrefonds, Oise. 1857–70. Bench with movable back in waxed oak.

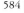

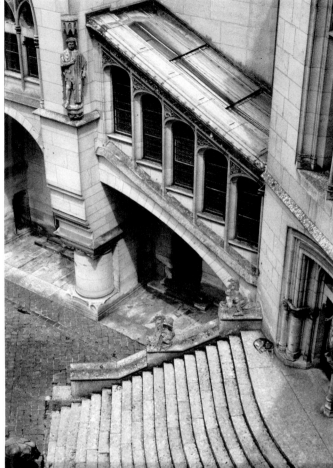

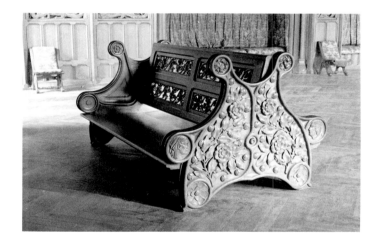

pastiche of elements designed to please the bourgeois taste of the empress or to demonstrate Viollet-le-Duc's theories on fortification in a very imaginative way. Yet Pierrefonds has a prominent place in the history of the Gothic Revival. It can be regarded as the model for a large number of later buildings, and for this reason ought to be given fresh consideration. Restored between 1857 and 1870, the castle should be looked upon as an original work, and this not only for its fantastic silhouette (imitated in the castles of King Ludwig II of Bavaria), but also for its spatial and ornamental inventiveness. The sketch for a diagonal entryway published in the *Entretiens* (believed by one author to have been a source for Horta)[18] is well known, but it is seldom related to the

entryway of the northeast pavilion at Pierrefonds, finished in 1868 (cat. no. 584). There a wide flight of steps in the corner leads to a diamond-shaped vestibule situated a half level above the courtyard; a straight flight of stairs, built onto the facade of the north wing, goes off to the left and leads to a colossally heavy windowed porch.

As he did in the theoretical texts of the *Entretiens*, Viollet-le-Duc gave as much attention to ornament as to architecture at Pierrefonds. The ensemble of polychrome decoration in the interior dates from 1865 to 1869. The systematic use of flat colors, outlined contours, and stenciled ornament is unusual enough to deserve special mention, for these elements were the prototype of French Neo-Gothic as a whole

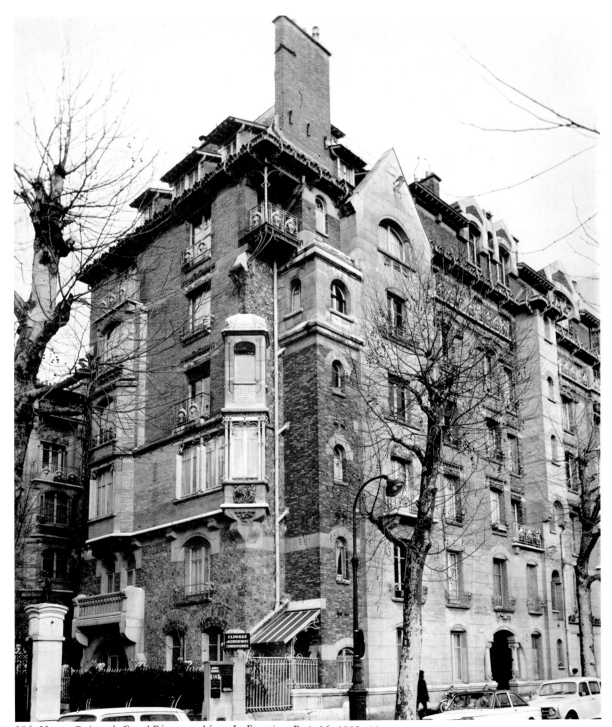

586. Hector Guimard. Castel Béranger, 14 rue La Fontaine, Paris 16. 1895–98.

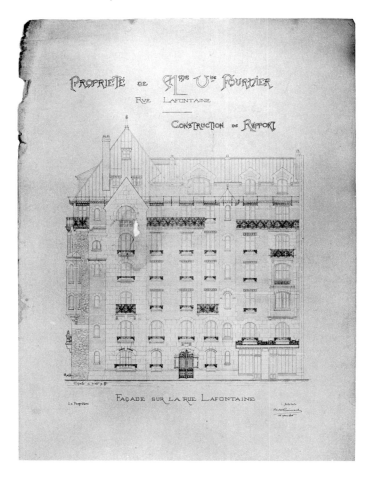

fr
PROPRIETÉ DE Mme Vve FOURNIER
RUE LAFONTAINE

CONSTRUCTION DE RAPPORT

FAÇADE SUR LA RUE LAFONTAINE

587. Hector Guimard. Original design
for the facade of the Castel Béranger.

—and this at precisely the time when William Morris, whose firm was launched in 1861, produced his principal creations. It is disconcerting to see how paneling and furniture made at Pierrefonds before 1870 can be confused with Art Nouveau productions; the same is true for the wrought-iron candelabra in the Salle des Preux or the celebrated "reversible bench" (cat. no. 585) in the great hall, with the window seats that complement it.

The Transformation of Hector Guimard. It was the extraordinary experience of a Neo-Gothic freed of all convention that set in motion the stylistic renewal of the art of 1900. This is clearly demonstrated by the production of Hector Guimard (1867–1942). His Maison Roszé, 34 rue Boileau, 16e (1893), still owes much to the picturesque Italianism taught in the academy. Then came the shock of his trip to London and Brussels in 1895, and the brusque change of style which

is apparent in the Ecole du Sacré-Coeur (1895; cat. nos. 611, 612)[19] and especially the renowned Castel Béranger (1895–98; cat. no. 586). The first elevations for the facade of the Castel Béranger were entirely Neo-Gothic (cat. no. 587), but after his Brussels visit Guimard revised the design of the facades—proof of the impact of Horta's system of decoration at the beginning of his career.

Guimard's oeuvre was primarily that of a designer—he was in fact a remarkable one, and one of history's great creators of furniture. But certain of his architectural efforts stand out for the exceptional success of their spatial organization: such buildings as the Humbert de Romans Concert Hall (1898–1901; cat. no. 617), the Castel Henriette at Sèvres (1899–1900; cat. no. 619), the house he built for himself (1909–12; cat. no. 625), and the Hôtel Mezzara, 60 rue La Fontaine, 16e (1911). In each case the architect's work is distinguished, not only for the sensitive modeling of the

facade and the elegant relationships of the materials, but for the brilliant organization of internal space, which, despite the apparent complexity of the volume, reveals subtle variations in the arrangement of each area in function of its nature and purpose.

Guimard and Lavirotte Compared. Comparison of Guimard's work with that of Jules Lavirotte (1864–1924), done in the same years, enables us to determine how far the fusion of space and ornament had been carried by the former, giving his work the delicacy and pliancy that transformed floral ornament into a new organism.

Take, for example, Guimard's Castel Béranger. In its first (Neo-Gothic) formulation its aesthetic was entirely that of contrast and disarticulation—the aesthetic of Eclecticism. Its elements include a variety of building materials (dressed stone, opus incertum, glazed ceramic, iron, slate, and white and colored brick, both glazed and unglazed); well-balanced asymmetry, following the laws laid down by Viollet-le-Duc; surface relief in the wall, here turning picturesque, notably in the lateral facade; and variation of the shape and size of openings to express interior space distribution. All these elements contribute to the obscurity of the form: they enrich perception while delaying the possibility of making a synthesis out of so many items of information.

How is it then that the disorderly look of the volumes, belonging to the aesthetic of the picturesque, does not result in the disintegration of the form? First of all, the facade's composition is remarkable for its graphic and plastic character. The interplay of line and relief is orchestrated according to an ascending dynamic that culminates in the vertical accent of the chimney at the corner. This creates the effect of a prow, which is what Guimard wanted it to do.

But what brings this kaleidoscopic facade together more than anything else is the decoration, including the polychromy. The choice of materials defies all formal analysis. They were selected for their purely pictorial qualities—mottled white, grayish yellow, pale emerald green, pink with touches of brick red, the sea green of the painted metal pieces. This harmony of light colors shades off into different values by an artful exploitation of the texture of each material. Their tactile variety—the smooth surface of the dressed stone, the graphic orthogonal network of the brick, the areas of rubblework whose uneven surface multiplies shadows—thus turns into a whole gamut of light and shade.

Thereafter ornament could be introduced at every critical point, to tone down transitions, link volumes together, establish continuity of planes or lines.[20] This had been the function of moldings in the Flamboyant and Rococo styles, rejecting the analytical and separative character of the classical 13th- or 16th-century molding. So it is not so much the vocabulary—the alphabet, if you like—but the handwriting that changes with the aim in view: to unify the form or to dissolve its unity; to make each element of the composition visible and autonomous, or, on the contrary, to attempt to synthesize the whole by a kind of gigantic fusion of the parts. That is the real break separating Art Nouveau from the rationalist architecture of the second half of the 19th century, even if the latter is tinged with a symbolism which sometimes has disquieting echoes.

Guimard's entire development between 1895 and 1911, and even until 1928–29, moved toward purification of the elements brought into play, and resulted in their constantly improved fusion. The earliest works of Jules Lavirotte, also considered one of the masters of French Art Nouveau, date from 1897 and 1898. Among them is the little-known building at 151 rue de Grenelle, 7e. Its interior courtyard, decorated with glazed polychrome brick, is a lively scene indeed, but the street front is still treated in a conventional neo–Louis XV manner—bay windows on squinches, balconies on the second and fifth stories, and rocaille decoration in very heavy relief, the whole rather soft and with a stubborn symmetry in which the lintels of the windows and the supports of the balconies are incorporated. This conventional facade is hardly distinguishable from the current production of the period, and the same can be said of the corner building at 134 rue de Grenelle and 37 rue de Bourgogne (1903); the sculpture, however, is interesting. Lavirotte here appears as the pure product of the Neobaroque of the Ecole des Beaux-Arts, using his talent to turn out speculative buildings in series.

This was hardly a promising debut; but not far away is the small house of the Liceo Italiano at 12 rue Sédillot, 7e (1899), in which we find a discrete asymmetry (playing on its contrast with the balanced symmetry of the composition as a whole) and a tasteful use of wrought iron in the shape of whiplash lianas—a touch of Japonisme. The house behind it, at 3 square Rapp (1899–1900; cat. nos. 588, 589), seems to have caught the spirit of the Castel Béranger, the winner in that year's facade competition, with respect to polychromy and diversity of materials. Yet the aesthetic is still that of a protuberant Neobaroque loaded with textbook references to the French Michelangelesque of the Henri IV–Louis XIII period. The secondary elements—ironwork, ceramic,

588

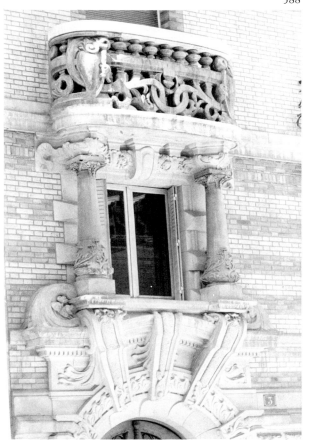

590

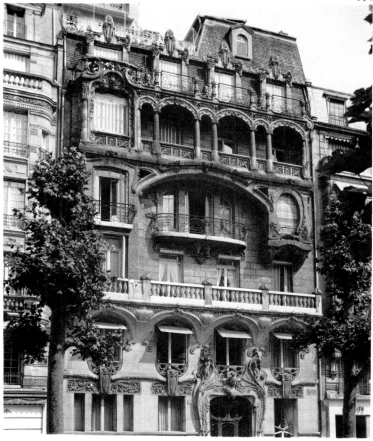

588. Jules Lavirotte. Apartment building, 3 square Rapp, Paris 7. 1899–1900. Window above entrance, with stoneware executed by Bigot.

589. Jules Lavirotte. Apartment building, 3 square Rapp, Paris 7. 1899–1900. Vestibule.

590. Jules Lavirotte. Apartment building, 29 avenue Rapp, Paris 7. 1901.

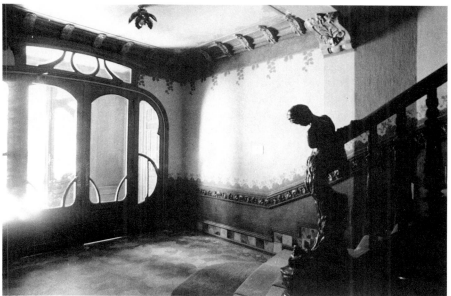

589

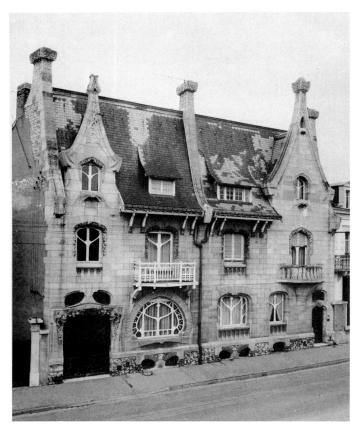

591. Emile André. Residence, 92 and 92
bis Quai Claude-le-Lorrain, Nancy. 1903.

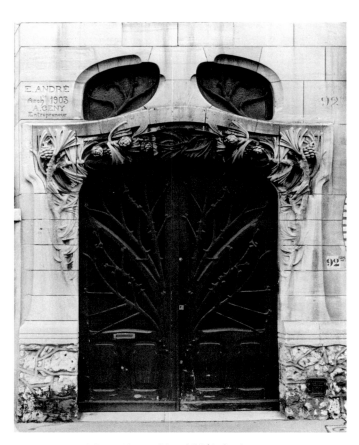

592. Emile André. Residence, 92 and 92 *bis* Quai
Claude-le-Lorrain, Nancy. 1903. Entrance at 92 *bis*.

cabinetwork—alone are interesting; in them the floral inspiration is much freer, although the handling of the entrance portal smacks of the Neo-Gothic, and the stoneware pieces in the balconies make no secret of their Classical origin. The most remarkable feature is the vestibule together with the staircase and its windows of tinted, frosted glass. The walls, covered with canvas-lined fabric, have a charming painted border in the form of a frieze of domestic animals that was derived directly from the Neo-Gothic, perhaps even from Pierrefonds, where animal friezes are included in the carved paneling.

The well-known building at 29 avenue Rapp (1901; cat. no. 590) is just as incongruous. The Neobaroque styling has indeed disappeared, but the composition is something to wonder at. Above a lower level in dressed stone, where stoneware on the lintels and doorframe disguises elements of

concrete, rise the three principal stories, completely faced with stoneware tiles from Bigot's workshop. Since the building regulations did not allow two symmetrical bay windows, the fourth story is adorned with a large protuberance upon which rests the arcade of the covered loggia of the next story. The tectonic exaggeration is carried so far that an enormous arch connects the facade's two projections, and the small axial balcony beneath it is supported by a pair of brackets in the shape of bulls' heads.

Lavirotte was more interested than Guimard in new construction techniques, notably the use of concrete covered by a stoneware revetment, which he employed on the Ceramic Hotel, 34 avenue de Wagram, 8e (1904), and on the buildings at 14 and 16 rue d'Abbeville, 10e (1902). (The building at 9 rue Claude-Chahu, 16e [1903], designed by Charles Klein and using Emile Müller's green-tinted ceramics with

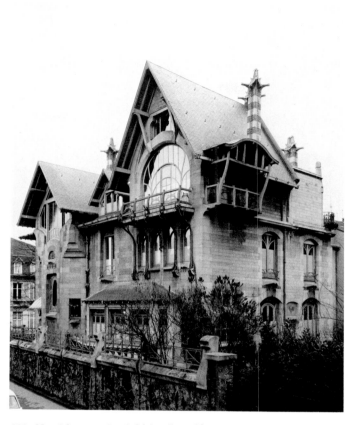

593. Henri Sauvage. Louis Majorelle residence,
1 rue Louis-Majorelle, Nancy. 1901.

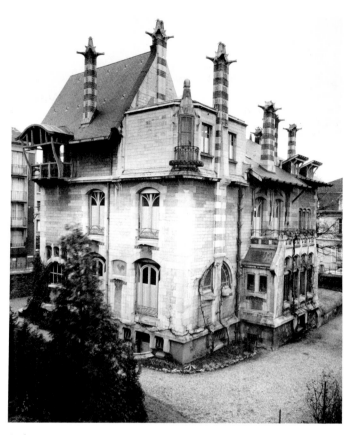

594. Henri Sauvage. Louis Majorelle residence,
1 rue Louis-Majorelle, Nancy. 1901. Garden facade.

Neo-Gothic thistle decoration, was the only one constructed entirely according to this principle.) Lavirotte's excessive decorative inventiveness may not have served the cause of Art Nouveau very well; the new style—which the public knew only from his avenue Rapp building and Guimard's Métro entrances—had aroused controversy at its first appearance. This may be why Lavirotte produced conventional and original works in the same years and why he called on certain more favored artists like Léon Binet, who decorated the facade of the building at 23 avenue de Messine and the contiguous one at the corner of the rue de Messine, 8e (1908), to work with him.

L'Ecole de Nancy. The contrast between Lavirotte and Guimard is of much significance for Parisian Art Nouveau, which was far from a unified school and just as far from being entirely accepted by a public more accustomed to the bourgeois art of the traditional apartment building. What was being built throughout the country followed almost entirely the aesthetic of Eclecticism at a time when that style was producing its best works. Nancy, however, was the exception to this rule.

The history of Nancy is in part the story of Emile Gallé, of his passion for botany and his discovery of Japanese art when he went to London in 1872. Gallé's influence was the moving force behind the school of Nancy and had a strong influence on Victor Prouvé, the brothers Daum, Louis Majorelle, Eugène Vallin, and others. Here architecture simply followed the movement, accommodating itself to the revolution in the decorative industrial arts after this had affected every other branch of production—glassworking, cabinetmaking, ironworking, goldsmithing, and bookbinding.

595. Charles Plumet. Apartment building,
50 avenue Victor-Hugo, Paris 16. 1911.

596. Charles Plumet. Apartment building, 50 avenue
Victor-Hugo, Paris 16. 1911. Residence at back of courtyard.

Eugène Vallin (1856–1922), at first a cabinetmaker, gradually turned to architecture, progressing from the Vauxelare store at 13 rue Raugaff (1901), in which the woodwork still shows strong traces of the Flamboyant, and the aquarium in the garden of the Musée de l'Ecole de Nancy (1906), to the fine building at 86 rue Stanislas (also 1906), and the house at 22 rue de la Commanderie. H. Wessenburger, who spent his whole career in Nancy, fell into the same pattern in a rather banal way, with the Bergeret house, 38 rue Lionnois (1903), and the Hôtel Wessenburger, 24 boulevard Charles V (1904). Emile André also went along with the trend, building a charming house at 92 and 92 *bis* Quai Claude-le-Lorrain (1903; cat. nos. 591, 592) whose elegant sculpture is in the form of fir branches.

The most interesting of the buildings in Nancy, however, is Louis Majorelle's residence (1901; cat. nos. 593, 594), the

product of a close collaboration between the renowned cabinetmaker and his Parisian architect, Henri Sauvage (1873–1932), who at that time was one of the best Art Nouveau designers. The two differed as personalities, but their synthesis of architecture and decoration accomplished here what Guimard at the same time was achieving by himself.[21]

ARCHITECTS AND ORNEMANISTES IN PARISIAN ART NOUVEAU

Besides the "stars" of French (or, more exactly, Parisian) Art Nouveau and the exceptional case of Nancy, there were other artists who are usually considered second-rate when they are not neglected altogether. These include such architects as

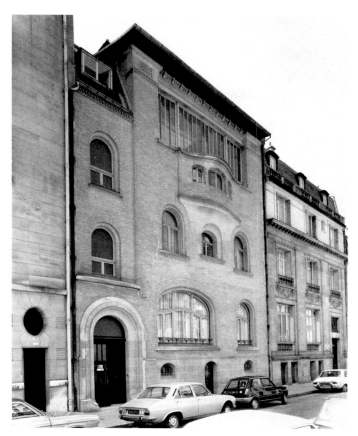

597. Charles Plumet. Artist's studio, 21 rue Octave-Feuillet,
Paris 16. 1908.

Charles Plumet, Louis Sorel, Du Bois d'Auberville, Eugène
Chifflot, Charles Letrosne, and Xavier Schoellkopf, as well as
ornemanistes like René Binet, J. Rispal, Pierre Séguin, and
Léon Binet.

Plumet and Sorel. Charles Plumet (1861–1928?), with
Alexandre Charpentier a member of the group Les Six, is
certainly the most interesting of these people. His impor-
tance was recognized as early as 1903–1904, years that
witnessed the reaction against the "excesses" of Art Nou-
veau. Raymond Escholier wrote in *Le Nouveau Paris*[22] about
"renewed tradition" in connection with Plumet, contrasting
his work with the fantastic tendencies of Jules Lavirotte,
whom he condemns.

The earliest of Plumet's known work,[23] the building at 67
avenue Malakoff (now Raymond-Poincaré), 16e, was exe-

cuted in 1895 in association with Pierre and Tony Selmer-
sheim: the link with Viollet-le-Duc is thus direct, since the
Selmersheim brothers had worked under him. The better-
known buildings at 50 avenue Victor-Hugo (cat. nos. 595,
596) and 39 avenue Victor-Hugo were much later (1911 and
1913), as was the townhouse in the avenue du Bois de
Boulogne (since demolished). On the other hand the small
studio at 21 rue Octave-Feuillet, 16e (1908; cat. no. 597),
and the two buildings at 15 and 21 boulevard Lannes
(1906)—and probably those at nos. 11 and 55, though they
are not signed—show that his aesthetic was fully formed
before 1910. His was a sober vocabulary of large blocks of
dressed stone, finely modeled but almost without decoration
except for the balconies, the columns with segmental arches,
and the shell-shaped surrounds of the dormer windows in the
attic stories. Plumet was still very active after 1914. His
office building at 33 rue du Louvre (1914) may look rather
commonplace, but the building at 34 avenue Montaigne, 8e
(1927), and the two at 3 and 7 rue Raffet, 16e (1929), fine
examples of a sober, measured Art Deco style, are far better.

Very little is known so far of Louis Sorel's work. There are
the former Sadla house at 48 boulevard Raspail and 29 rue de
Sèvres, 6e (1912), mentioned by Escholier as one of the best
examples of the new architecture, and the fine building at
7 rue Le Tasse, 16e (cat. nos. 598, 599), which dates from
1905. Sorel's art is all delicacy in the modeling, entirely
lacking effects of molding design but playing on the plastic-
ity of the upper elements—top stories with oriels and un-
dulating roofs that make the best possible use of the rounded
profile proposed by the Hénard *règlement* of 1902.[24] His
production represents a "cleansing" as compared with that of
Guimard, who, born designer that he was, did not achieve
the same quality except in his later works, such as the group
of buildings of the Villa Agar (1911) at 17–21 rue La
Fontaine, 8 and 10 rue Agar, and the corner of 1 rue Agar and
43 rue Gros, 16e.

Du Bois d'Auberville. To put Du Bois d'Auberville on the
same footing as Plumet and Sorel would be to overestimate
him. These latter two were the recognized champions of a
reforming tendency in Art Nouveau during the ten years
preceding World War I, and they were certainly no strangers
to the swing toward Art Deco that began in 1920. (Plumet,
for one, seems to have taken this turn in his stride, while
Guimard never quite succeeded, his interesting experiments
in the rue Henri-Heine and the square Jasmin notwithstand-
ing.) Du Bois d'Auberville enjoyed no such great renown

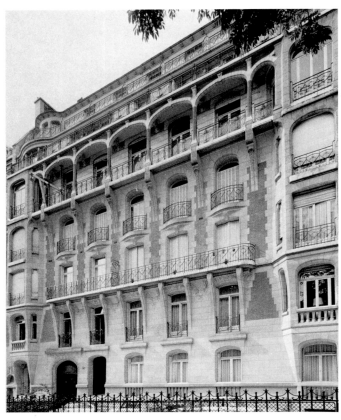

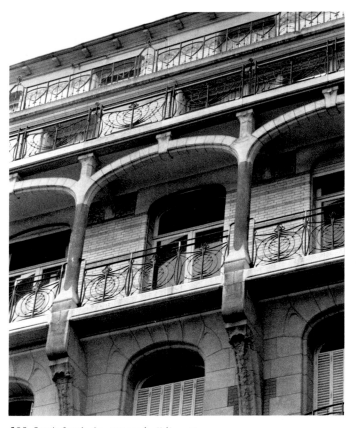

598. Louis Sorel. Apartment building, 7 rue Le Tasse, Paris 16.
1905. Facade in white stone, red brick, and glazed brick.

599. Louis Sorel. Apartment building, 7 rue
Le Tasse, Paris 16. 1905. Facade detail.

even in his own time, and one may wonder whether his success was not in some part due to Pierre Séguin's collaboration.[25]

The most remarkable of his buildings is a large edifice with a concrete attic story which he constructed on the Chaussée de la Muette at 1–5 avenue Mozart and 34 rue Bois-le-Vent, 16e (1907–1908; cat. nos. 600, 601, 602), with Pierre Séguin as sculptor. In 1910 he did a building (cat. no. 603) at 19 rue Octave-Feuillet (next door to Plumet's studio) at the corner of the rue Alfred-Dehodencq, where he also built a small residence at no. 3. At the present moment we know no more about him.

The building on the Chaussée de la Muette is notable for its great concrete roof, its turrets, and its silhouetted chimneys, with touches of Japonisme in the details. The extremely tall facade that faces on a side street is a fantastic construction formed of narrow brick walls which extend the party walls to support the chimney-bases and thrust out into the void above a series of set-back stories; iron railings join these projecting walls. The very beautiful ornamental detail consists simply of rose-tree and chestnut foliage carved into the surface of the stone or molded into the cast iron of the balconies.

The building in the rue Octave-Feuillet is no less interesting, thanks to the immense figure of a peacock, wings spread, which fills the arch over the portal, and to the undulation of stone and concrete waves at the base of the attic. A bad restoration, however, has reduced the effectiveness of this latter component.

Chifflot and Letrosne. Eugène Chifflot's work is comparable to that of Du Bois d'Auberville, although at times it is colder.

Chifflot also used Pierre Séguin for the large corner building at 90 boulevard Raspail and 42 rue de Fleurus, 6e (1907). When he worked alone the outcome, unfortunately, was sometimes less attractive: for example, the buildings at 79 boulevard Raspail, 6e (1911), 26 boulevard Raspail, 7e, and 147 boulevard Haussmann, 8e (1912). This is not true of Charles Letrosne, whose work deserves to be much better known. Some of it can be seen at the Vincennes Zoo. He built the Etablissement Thermal at Vichy and several residences and other buildings in Paris, such as those at 59 avenue Malakoff, 16e (1911), and 63 avenue Kléber, 16e (1913). His style is stripped of the excesses of Art Nouveau floral ornamentation; it consists of dry, tight, powerfully expressive shapes.

Schoellkopf. Xavier Schoellkopf[26] is so unlike the architects we have reviewed in style and personality that it is not so easy to include him among Art Nouveau architects. He had a passion for a disturbing rusticity, with enormous bosses à la Giulio Romano that arouse a feeling of uneasiness. Examples of his work are the house built on the boulevard Berthier for the *chanteuse* Yvette Guilbert (a building which has since been demolished), or the large building at 29 boulevard de Courcelles, 8e (1902; Rouillière, sculptor), the dressed-stone wall of which is entirely rusticated, presenting a smooth surface only in the rounded frames of the bays, with their soft, receding moldings.[27]

The Ornemanistes. There is good reason to include the *ornemanistes* in a discussion of Art Nouveau architects and buildings, since they not only served as decorators but also, at times, determined the whole feeling of the building, setting its architectural as well as its ornamental development. Moreover the sudden appearance of the *ornemaniste's* signature on facades is a notable feature of this period. (The architect's signature, sporadic during the July Monarchy and the Second Empire, became a constant in the 1890s, occasionally accompanied by that of the sculptor, and even of the contractor, who thus did his own advertising.)

Among the decorators who assumed the role of architect René Binet (1866–1911) is the most important, as proved by a surprising album of original drawings that is now preserved in the Cabinet des Estampes of the Bibliothèque Nationale.[28] He was the designer of the lovely Porte de la Concorde at the 1900 Exposition Universelle and acted as adviser for the reconstruction of the Pont Notre-Dame (three projects in 1901, 1903, and 1907, executed in 1913 by Le Guen the

architect), for which he designed the lamps.[29] His best-known work is the addition to the Au Printemps department store on the boulevard Haussmann, 9e (1911), adjoining the section built by Sédille, the general lines of which he followed while completely revising the decoration. Binet's work is only partially Art Nouveau; his taste for geometric design and the obvious influence of Mackintosh in some details make him a modern artist. Yet it is interesting to note how difficult it is to draw the line between these two styles.

As for Pierre Séguin, he was first and foremost a sculptor, as he proved in his collaboration with Du Bois d'Auberville and Chifflot. He also worked in 1903–1905 with Georges Pradelle on the residence in the rue d'Orléans, Neuilly; on the fine building at 5 rue de Luynes and square de Luynes, 7e (embellished with grilles by Emile Robert); and on a building in the rue du Chemin-vert, 10e. Lastly, with Burret, he did the house on the Champ de Mars at 16 avenue Elisée-Reclus and allée Adrienne-Lecouvreur, 7e (the excessive use of picturesque effects makes the architecture tedious), and (with Armand Sibien) the large, beautiful building at 77 avenue Paul-Doumer, 16e.[30]

The only works known to us of J. Rispal—perhaps a less original artist than those already reviewed—are Barbaud & Bauhain's building at 12 rue du Renard, 4e (1901; Syndicat de l'Epicerie), and the much finer A. Bluyssen building at 40 avenue du Président-Wilson, 16e (c. 1908–1909).

Léon Binet, namesake of the other great *ornemaniste* René Binet, is no better known at present than Rispal. Besides his work with Lavirotte, he collaborated with the architect Germain Roth on the handsome building at 12 rue Pierre-Demours and 15 rue Marcel-Renault, 17e (1911); with Théo Petit as architect and Henri Bouchard as sculptor on the group (cat. no. 604) at 132 rue de Courcelles and 80 avenue de Wagram, 17e (1907; the buildings continue along the rue Jouffroy and the rue Cardinet). He also worked with Louis-Henri Boileau *fils* and Hervé Tauzin on the Hôtel Lutétia at the corner of 23 rue de Sèvres and 45–47 boulevard Raspail, 6e (1910); the hotel's location across from buildings by Louis Sorel and Gustave Goy (see below) is significant, and as a group the buildings provide a summary of the trends of the period. Lastly Binet's work is seen on the building at 55 Quai d'Orsay, 7e (1913), which is much more modern in style.

Théo Petit, mentioned above, cuts a small figure in French Art Nouveau, and owes his place not so much to his own talents as to his collaborators. In 1905 he called upon E. Derré[31] for the somewhat sentimental bas-relief on the second story of the two buildings at 276 and 280 boulevard

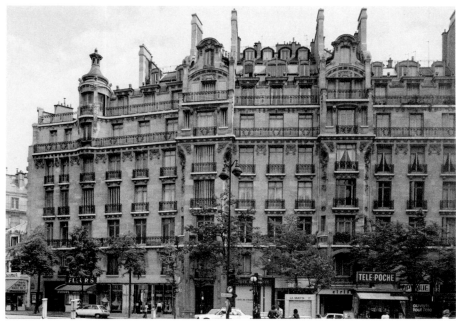

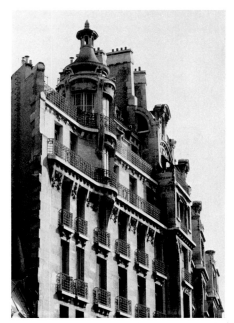

600

601

Raspail, 14e, thus beginning an association with artists—sculptors or decorators—from which the building in the avenue de Wagram (cat. no. 604) eventually resulted. Probably Théo Petit is also responsible for the curious edifice of the Magasins Réunis at 30 avenue des Ternes and 2 avenue Niel, 17e. Here the exposed structure in reinforced concrete is fairly similar to that of the upper part of the avenue de Wagram building, despite conventional elements, like the corner rotundas in the manner of Sédille, and the sparser decorative detail. Comparison of this store building with the one Paul Auscher constructed, also entirely of reinforced concrete, in 1904 for Félix Potin at 104 rue de Rennes, 6e, makes it possible to gauge the internal evolution of Art Nouveau between 1900 and 1914. We see that the style had come back, in a way, from Auscher's "whiplash" treatment to an aesthetic more Neo-Gothic in appearance, but above all more modern in its formal rigidity and the tendency toward the isolation of the decorative elements—despite recourse, as fervent as ever, to ironwork, mosaics, and stoneware.

We should bring in one more artist who also tried his hand at architecture, but this time for his own use: René Lalique, the master jeweler and glassworker, whose Neo-Gothic residence at 40 Cours-la-Reine (now Albert-Ier), 8e (1902), is a variation on the architecture of the Nancy school. The door in cut crystal is famous, as is the forged iron of the staircases. Otherwise the building is not especially interesting, but it provides a precise measure of the encyclopedic ambition that characterized the great artists of the early 20th century. Like the Renaissance masters they put their hands to every form of plastic expression, their goal being a synthesis of the arts—the supreme result of the effort at unification to which the stylistic system of Art Nouveau bears witness.

POPULARIZATION AND DECADENCE IN BOURGEOIS ART

The Art Nouveau style finally became popular for middle-class housing in its sumptuous form, that of great dressed-stone facades, adorned and sculpted. At first it was accepted rather timidly, but gradually it was included among the decorative possibilities available to a good practitioner, on the same footing as neo–Louis XV and neo–Louis XVI—

600. Du Bois d'Auberville. Apartment
building, Chaussée de la Muette
at 1–5 avenue Mozart and 34 rue
Bois-le-Vent, Paris 16. 1907–1908.
Facade on avenue Mozart.

601. Du Bois d'Auberville. Apartment
building, Chaussée de la Muette
at 1–5 avenue Mozart and 34 rue
Bois-le-Vent, Paris 16. 1907–1908.
Upper stories in reinforced concrete.

602. Du Bois d'Auberville. Apartment
building, Chaussée de la Muette
at 1–5 avenue Mozart and 34 rue
Bois-le-Vent, Paris 16. 1907–1908.
Upper stories on rue Bois-le-Vent.

603. Du Bois d'Auberville. Apartment
building, 19 rue Octave-Feuillet,
Paris 16. 1910. Entrance.

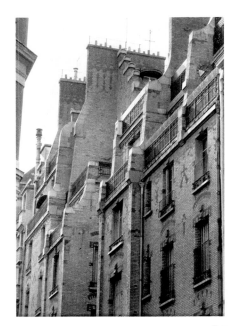

602

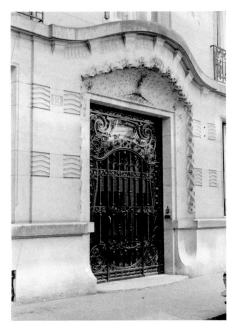

603

both of which, be it said, were a far cry from the styles to which they refer.

The first experiments were only derivations from avant-garde Art Nouveau, among them Jacques Rouché's residence at 1 rue Henri-Rochefort and the rue de Prony, 17e (1908; Barberis & de St-Maur, architects; William Lemit, sculptor; ironwork by Brandt); the buildings at 27 and 27 *bis* Quai Anatole-France, 7e (1902; Brouwers, architect); a building designed by L. Bénouville at 46 rue Spontini and rue du Général-Appert, 16e (c. 1902–1904; cat. no. 605); that at 48 avenue du Président-Wilson, 16e (1908; Charles Adda, architect; A. Laoust, sculptor); the Institut de Paléontologie Humaine, 21 boulevard St-Marcel, 1 rue René-Panhard, and 20 rue des Wallons, 13e (1912; Pontremoli?, architect); and E. Chastel's building for the society La Démocratie (which published Marc Sangnier's *Le Sillon*), at 32 boulevard Raspail, 7e (1909–10).[32]

But experiments like those above may also represent an entirely original development of Art Nouveau in the style of the facades of Paris buildings. This is evident in the later works of Paul and Charles Wallon, especially the noteworthy building at 71 boulevard Raspail, 6e (1909), with its upper parts in glazed green brick; of Henri Preslier, at 6 and 8 rue Huysmans, 6e (1913); of René Degeorge, at 61 boulevard des Invalides and 2 avenue Constant-Coquelin, 7e (1914–16); and of Raoul Brandon, at 1 and 2 rue Huysmans, 6e (1919).

The style became fashionable and the movement caught up a whole generation of architects, who almost simultaneously and somewhat accidentally made a synthesis of Laloux's Neobaroque and the Art Nouveau aesthetic. Of the latter they kept only the floral decoration and the taste for areas of transition in the ornament. Their production was extremely abundant. It was stimulated by the official facade competitions, by means of which the city's architectural inspectors set the norms and controlled the aesthetic ordained by the *réglements*.

Numerous architects were more or less clearly affected by Art Nouveau ideas, among them Octave Courtois-Suffit, with buildings at 62 rue de la Tour, 16e (1901), and 18 rue de Grenelle, 7e (1902); Deneu de Montbrun, at 6–8 avenue Théophile-Gauthier, 16e (1904), the Villa Jeanne d'Arc, 32

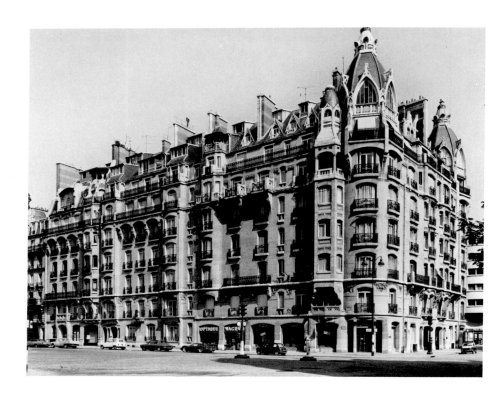

604. Léon Binet, in collaboration with Théo Petit and Henri Bouchard. Apartment building, 132 rue de Courcelles and 80 avenue de Wagram, Paris 17, 1907.

rue La Fontaine, 16e (1905), 21 avenue Théophile-Gauthier (1907), and 23 avenue Théophile-Gauthier (1908; Deneu de Folleville, sculptor); A. Jalabert, at 3 rue Chernoviz, 16e (1910), and 23–27 boulevard Garibaldi, 15e (1910); Lecourtois, at 25 rue de la Pompe, 16e (1911); F. A. Bocage, at 6 rue de Hanovre, 9e (with Bigot as ceramist), 15 rue de Téhéran, 8e (1910), 4 Chaussée de la Muette, 16e (1910), and 5–9 avenue Daniel-Lesueur and 6–10 avenue Constant-Coquelin, 7e (1913); and Gustave Goy, at 41 rue du Renard, 1er (1905), and the group at 15 rue de la Chaise, 39 and 41 boulevard Raspail, 12–18 rue de Sèvres, and 1 and 2 rue Récamier, 7e (1908–1909).

From Art Nouveau to Neobaroque. Gustave Goy's production, with the odd note of geometric patterning, shows a Neobaroque tendency. Closer still to this trend, and much in favor in the period before World War I, was the work of Alexandre Fournier at 10 and 12 rue Eugène-Labiche, 16e (1910; Henri Bouchard, sculptor); that of Albert Vèque, who in 1913 built two large groups of buildings, one on the avenue Frémiet and the rue des Eaux, the other to the north on the square Raynouard, 16e, where the floral decoration is

reduced to a proliferation of vines; and lastly that of E. Mourzelas, at 44–48 rue Vercingétorix, 14e (1913). The war dealt a mortal blow to these architects, whose careers were completely disrupted. Vèque retired to a villa on the Côte d'Azur, Mourzelas became a building manager; neither of them ever again had an opportunity to build, due both to the recession that followed the war (which deeply affected the construction industry) and to changing taste.

"Official" Art Nouveau. The mixture of styles—official art and Art Nouveau—goes back, curiously enough, to the unlikely collaboration of René Binet and Henri Deglane (1855–1931) in the competition for the Grand Palais at the time of the 1900 exposition: this, no doubt, explains the originality of the Grand Palais' interior metal framework and of its decoration, the sketches for which were Binet's.[33] Another official architect, Georges Chédanne (1861–1940), turned wholeheartedly to Art Nouveau with the elegant Elysée Palace Hotel (now occupied by the Crédit Commercial de France) at 103 avenue des Champs-Elysées, 8e (1899; Picard, Baralis, Gasq, and Lefebvre, sculptors); the metal building for the *Parisien Libéré*, 124 rue Réaumur, 2e (1903);

and the Hôtel Mercédès (now Kléber-Colombes), avenue Kléber and rue de Tilsit, 16e (1903–1904; Boutry, Gasq, and Picard, sculptors). For the residence, recently demolished, at 2–8 rue de la Faisanderie and 79–81 avenue Foch, 16e, Chédanne obtained the collaboration of two sculptors, Gasq and Derré. (Gasq, who worked in his native city of Dijon, is a neglected figure in the history of Art Nouveau.) Chédanne became the representative of the new style outside of France when he built the embassy in Vienna (1901–1909), which spread the message of French art.[34]

As we have just seen, hotel building was the area in which this hybrid, official-cum-modern style had its greatest development. In addition to Chédanne's two hotels, we ought to mention the astonishing Hôtel Plaza-Athénée, the work of Victor Laloux (1850–1937), whose skylights in the Gare d'Orsay and the suave Louis XV style of the vaults over its entrance had already flirted with Art Nouveau in 1899, as if the time of Eclecticism was past! We have referred above to the better-known Hôtel Lutétia, by Louis-Henri Boileau *fils*—a remarkable product of the turning point between 1910 and 1914 when architects were assimilating Art Nouveau. All these hotels, by the way, were sharply criticized by Raymond Escholier, who preferred the purer art of Plumet. After a few cutting remarks about the Lutétia he commends only one building, the Royal Palace Hotel by Constant Lemare, 8 rue de Richelieu, 1er (1908), as exemplifying the simplified style of 1900 that he so zealously promoted.

Eclectic Art Nouveau. When we say that Art Nouveau, popularized and "officialized," wound up by becoming a conventional style in Parisian building on the same basis as the historic styles, we can find no better proof of the statement than two speculative blocks of buildings in the sixteenth arrondissement—Charles Labro's group on the rue Louis-Boilly (1912)[35] and Henri Petit's on the avenue Mercédès (now Colonel-Bonnet; 1910). In each case the architect made promiscuous use of the styles at his disposal —Louis XV, Louis XVI, and Flamboyant Gothic, all three then very much à la mode—and crossed them with Art Nouveau details. The mixture is perhaps not very convincing, but it is pleasant enough.

1910 and After. About 1910, however, there was a change in the current production. The heavy, animated art of the great post-Haussmann facades departed little by little from the aesthetic of 1900—just when the "official" art merged with

it. Heterogeneous elements coming from the schools of Glasgow and Vienna were introduced. Without going down as far as Le Maresquier's mediocre production (the Rotonde Félix Potin, rue Réaumur and boulevard Sébastopol), we may mention isolated examples like the building at 2 rue Balny d'Avricourt, 17e (1910; Caignard de Mailly & Guéritte, with the collaboration of Rispal the *ornemaniste*); at 10 rue Balny d'Avricourt and 83 avenue Niel, 17e (1906; Eugène Bidard); at 2 rue du Colonel-Moll and rue des Acacias, 17e (Randon de Rollier); at 9–11 rue Massenet, 16e, 22 rue des Vignes, and 2–6 rue Alfred-Bruneau, 16e (1906 and 1910; Henri Cadilhac); at 63–67 avenue Niel, 17e (1913; Aristide Daniel); and on the rue Jean-Richepin, 16e (also by Daniel).

One of the most noteworthy works of the period just before World War I is the large building at 67 boulevard Raspail, 6e, built in 1913 by Léon Tissier with Henri Bouchard as sculptor, right beside the impressive building by Wallon. Here the concrete attics are sheathed in brick and brown tile. The sculpture becomes at once soft and heavy, and the floral ornament is reduced. More and more it was the spirit of Van de Velde that prevailed in the search for a kind of discreet urbanity, while leaving room for some powerful pieces of monumental allegorical sculpture. The transition to the 1920s was going ahead by degrees.

The remarkable thing is that all this developed simultaneously with the hybrid Art Nouveau–Eclectic style. The line separating the trends becomes vague when we are dealing with an ornamental style turned conventional, but we are struck by the fact that the years around 1910 mark this turnabout at the very time when the most commonplace work completely "digested" the values of Art Nouveau and exploited them shamelessly in a banal, repetitive style. We refer to the work of such architectural offices as A. Sélonier, Gustave Rives,[36] L. Salvan, Charles Lefebvre, Duval & Gonse, Dureau & Orième, Henri Tassu, A. Walwein, Weber, and Michaud.

A Popular Style. Led by Parisian architecture itself, we have come rung by rung down the ladder of quality from the innovative works of an artist like Guimard to the humdrum buildings of the architectural offices; and the curious fact is that in this architecture, supposedly so foreign to Art Nouveau, we have found traces of a deep and durable survival of that style. Admittedly we are observing a Parisian phenomenon: the study of regional movements would demonstrate a much greater resistance to any evolution of style, with the resulting restriction to Paris and Nancy of the

development we have followed.

The fact remains, however, that Art Nouveau affected life-styles throughout France, even if it was only by the diffusion of industrial models in pottery or other objects. And beginning in the years between 1905 and 1910, partly because of the world's fairs, it became a popular style, as Art Deco did later on, infiltrating every branch of artistic production. This infiltration often came through mass production, and was the result of a slow degeneration of motifs. The Eclectic tradition remained alive until after the First World War, which explains the difficulty of analyzing the influence of Art Nouveau outside of its major works.

IN SEARCH OF A MODERN ARCHITECTURE

The extreme success of Art Nouveau suggests that it was perhaps not so clean a break with tradition as its promoters made it out to be. Its compromises quickly watered down its content, leading very soon to its rejection by the artistic elite, who wearied of this fashionable phenomenon.

Thus it happened that various divergent trends developed very early. Certain architects were able to go beyond the revolution in decoration; they aimed at getting down to the essential problem, which was to revolutionize the *content* of architecture. Frantz Jourdain, Anatole de Baudot, and Louis Bonnier thus belong rather marginally to Art Nouveau, to which they brought their personal thinking as they tried to overcome what they considered to be the contradiction between the new style and its ornamentation.

Frantz Jourdain. The large La Samaritaine department store (cat. no. 606) was built by Frantz Jourdain (1847–1937) in 1905. The building shows relationships both to the earlier work of Paul Sédille and to Louis Sullivan's last buildings in Chicago (e.g., the Carson, Pirie & Scott store, 1899–1901 and 1903–1904). Jourdain retained Sullivan's broad panes of glass framed only by the metal skeleton, here without any revetment. At first he kept Sédille's general plan and the principle of light wells housing the monumental staircases (this followed the example set by L.-A. Boileau in 1885 at Au Bon Marché), as well as the exterior silhouette dominated by corner rotundas with domed roofs. These roofs, parabolic in profile and ending in oriental-style, compound-curve lanterns, were covered with a luxuriant vegetation in wrought iron. All this disappeared when the extension was built in 1930.[37] Large mosaics like those at Au Printemps showed

the store's principal wares in a decorative scheme with garlands of flowers; the mosaics still exist, but have been painted over. Jourdain went further than Sédille, however, when he left the metal skeleton of the building exposed on the inside, simply decorating it here and there with unobtrusive wood coverings or wrought-iron ornaments. The woodwork is in varnished plywood: comparison could be made with Van de Velde's contemporary creations. Jourdain also outdid Sédille by using thick plates of glass, translucent like the windows, in place of plank flooring. If Au Printemps was a revel of light, La Samaritaine was even more so. Daylight poured down through the floors, supplemented by light from a profusion of electric fixtures that were styled after Horta's, in harmony with the pillars of the metal structure to which they were attached in clusters.

Unfortunately this exceptional achievement had no successor. Frantz Jourdain himself turned his back on it, partially destroying his work when the building was enlarged in the interval between the two wars. In fact La Samaritaine was at once the crowning point and the last example of this art of transparency and light. It was an art based on the technological perfection of industrial materials, and all the efforts of the late 19th century had been directed toward achieving it.

Anatole de Baudot. The story of Anatole de Baudot (1834–1915) is completely different. He may be considered the spiritual heir of Viollet-le-Duc, with whom he and Labrouste studied. As a member of the Commission des Monuments Historiques and inspector general for diocesan buildings, he pursued an official career entirely devoted to restoration. At the same time he was a critic of repute, an active professor (beginning in 1887 he held the chair of French medieval and Renaissance architecture at the Ecole du Trocadéro), and a busy union organizer (charter member, then president of the Union Syndicale in 1894).

Baudot, first of all an academic, nevertheless was the architect for several buildings, including the church of St-Lubin in Rambouillet (1866; cat. no. 607), in which he applied Viollet-le-Duc's structural theories; the Lycée Lakanal in Sceaux (1882); and the Lycée Victor-Hugo in Paris (1894–96). For this last building he experimented with the use of reinforced concrete (the Cottancin system, patented in 1889), at the time a revolutionary construction process. Applying the same system he built a church, St-Jean de Montmartre (1894–99 and 1902–1904; cat. no. 608)—the structure of which was so advanced that he was taken to court by the church administration, who feared that the building

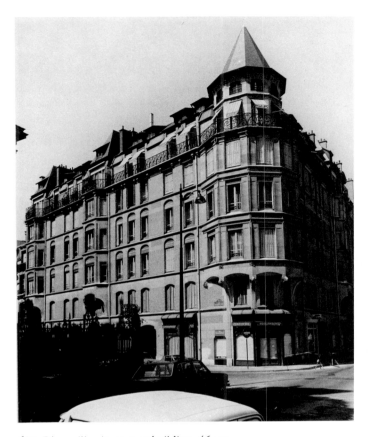

605. Bénouville. Apartment building, 46 rue
Spontini and rue du Général-Appert, Paris 16.

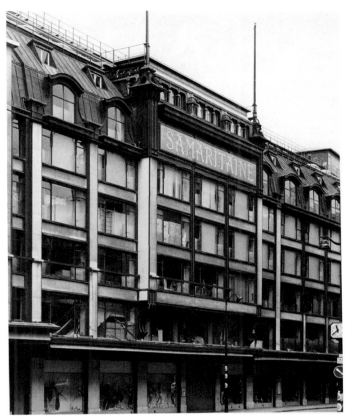

606. Frantz Jourdain. La Samaritaine, department
store, rue de la Monnaie, Paris 1. 1905. Facade as it appears today.

would collapse. Baudot was forced to suspend work for nearly three years before he finally prevailed.[38]

St-Jean de Montmartre shows an obvious Gothic inspiration; but a relationship has been pointed out on the one hand with Viollet-le-Duc's study for the Mausoleum of the Duchesse d'Albe, and on the other hand with Pier Luigi Nervi's work. Baudot carried the principles of skeletal construction to the utmost limit by making use of the monolithic properties of concrete. This architecture, consisting essentially of the supporting members of the skeleton, is a long way from Art Nouveau but close to Viollet-le-Duc: to Baudot, the ribbed vaults of the late Middle Ages suggested the beginnings of a new system of construction (the system is applied in our time in the three-dimensional structures of Frei Otto, for instance).

Baudot, however, gave much attention to the envelope of his buildings in such matters as the surface treatment of the concrete and the infilling of the walls. For infill material he used brick, and to give some life to the concrete he conceived the idea of embedding either pellets of *pâte de verre* or lozenges of stoneware (usually furnished by Bigot) in the wet cement. The result was a polychrome architecture, at times a bit exotic in its references, but based principally on the remarkable association of color with the light which comes through the great expanses of glass the ribbed structure made possible. In this treatment Baudot followed Boileau's example, at least as much as Gaudí did: Boileau's "synthetic cathedral" was the model for many experiments.[39]

Louis Bonnier. Another one of Art Nouveau's branches was the work of Louis Bonnier (1856–1946), who was not interested in technical innovation but rather in devising economical

607. Anatole de Baudot. St-Lubin, Rambouillet.
1866. Nave with domical vaults resting on
cast-iron pillars without exterior buttresses.

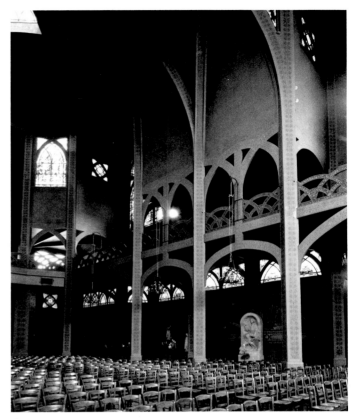

608. Anatole de Baudot. St-Jean de Montmartre, place
des Abbesses, Paris 18. 1894–99, 1902–1904. Nave
with two transepts, each capped by a concrete dome.

solutions with social applications—e.g., to housing problems. Bonnier was both a great builder of schools and an urbanist associated with Eugène Hénard and Marcel Poëte in the transformation of Paris.[40] For the Jouy-Rouve dispensary in Belleville and the school group in the fifteenth arrondissement (rue Sextus-Michel', rue du Dr.-Finlay, rue Emeriau, and rue de Schutzenberger; 1912), he used brick in simple forms, embodying at times a slightly picturesque aesthetic.

To Bonnier belongs most of the credit for the construction of the first blocks of low-cost housing (H.B.M.'s—*habitations à bon marché*—ancestors of the present H.L.M.'s), and particularly for the concept of "urbanisme d'îlot" (district planning) on which they are based. The undertaking paralleled the first housing experiments in other countries. There they took the form of garden cities, but France remained faithful to the tradition of collective housing, using a standard range of building types à la Haussmann.

As for the intensely interesting area of social housing construction prior to 1914, we regret that the subject has not yet been researched, and little information is available. We do know that the stylistic ideas of Mackintosh, Voysey, and Ashbee carried over into this type of construction in the form of a discreet but not at all imitative regionalism. The first low-cost housing certainly followed the lead of Art Nouveau, a point that could easily be proved by closer study of a few such buildings.

The Development of Henri Sauvage: The End of Art Nouveau. We now come back to Henri Sauvage and the turn that took him away from Art Nouveau. The well-known building at 26 rue Vavin, 6e (1912; cat. no. 609), and the Piscine des Amiraux, 26 rue des Amiraux, 18e (1924), are only the prototypes of a

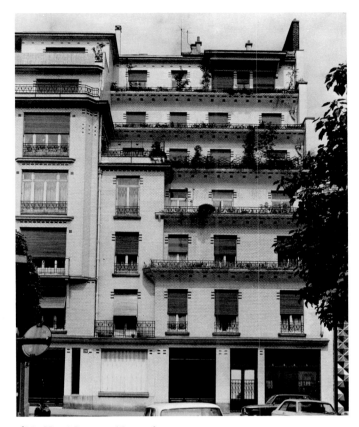

609. Henri Sauvage. Terraced apartment
building, 26 rue Vavin, Paris 6.
1912. Detail of facade in white ceramic.

system of tiered construction with superimposed terraces,
applying the methods of prefabrication to arrive at an entirely
new type of mixed individual and collective housing. Henri
Sauvage's thought was shaped (passing through many
theoretical studies) by Camillo Sitte's analyses of medieval
urban space and Louis Bonnier's and Marcel Poëte's writings
on Paris.[41] Out of the synthesis of all these lines of thought
was born a new philosophy of housing which pulled architec-
ture in the direction of urbanism much more than that of
decoration. As Sauvage in his old age saw it, Art Nouveau
ornamentation, of which he had been a very skillful designer,
was only a formal response to the real problem of architec-
ture: the architect had to go further, even at the cost of
sacrificing the charm of ornament to harsh economics.

The same sort of thinking, though less systematic and
conclusive, was at that time in the minds of architects like

François Lecoeur (1872–1934), who built the Bergère tele-
phone exchange (1912); Auguste Perret (1874–1954), in his
epic clash with Van de Velde over the Théâtre des Champs-
Elysées (1911–13); and Tony Garnier (1869–1948) in
Lyons, with the Abattoirs de la Mouche (1909–13) and the
Stade Olympique (1913–19). It may well be said that by that
time Art Nouveau was dead. A new wave of rationalism
invaded architecture, relegating the art of movement and life
to the storehouse of a historical, obsolete romanticism.

1 The first historian of Eclecticism, and the only one who so far has
 really dealt with it in the French context, is Louis Hautecoeur, who
 treats the subject in the last volume of his monumental *Histoire de
 l'architecture classique en France*, vol. 7, *1848–1900* (Paris: A. Picard,
 1957).
2 This is what we undertook to prove in our article "L'Espace d'Horta,"
 L'Oeil, no. 194 (Feb. 1971), pp. 14–19, with regard to the Solvay
 house.
3 S. Tschudi Madsen, *The Sources of Art Nouveau* (New York and Oslo,
 1956); Jean Cassou, Emile Langui, and Nikolaus Pevsner, *The Sources
 of Modern Art* (London: Thames and Hudson, 1962); Robert
 Schmutzler, *Art Nouveau* (New York: Harry N. Abrams, 1964). For
 French architecture add to these three basic works the excellent short
 treatise by M. Emery, *Un Siècle d'architecture moderne: 1850–1950*
 (Paris, 1971), and, for illustration alone, Maurice Rheims, *L'Art
 1900 ou le style Jules Verne* (Paris, 1965). A few Paris buildings have
 been published by M. Lesbrères, "Maisons 1900 de Paris," *Bizarre*,
 no. 123 (1963), special number.
4 Henry-Russell Hitchcock, *Architecture, Nineteenth and Twentieth Cen-
 turies* (Baltimore: Penguin Books, 1963).
5 Emil Kaufmann, *Von Ledoux bis Le Corbusier* (Vienna, 1933).
6 As a rule buildings without an address or with an address but without
 the name of a city are located in Paris. In all other cases the city where
 the building is located is specified at least in the context.
7 Cf. K. Hammer, *Hittorf, ein Pariser Baumeister* (Stuttgart, 1968).
8 The new mode of decoration took more extreme forms with certain
 architects who worked on apartment houses, among them B.
 Tremblay, who in 1856 built the one at 34 rue de l'Arcade, 9e, and;
 in 1858, the two which form the corner of the rue St-Séverin and the
 boulevard St-Michel (nos. 5 and 8). The ornamental snails and
 stylized foliage on these facades do not belong to any known style.
9 E. E. Viollet-le-Duc, *Entretiens sur l'architecture*, 2 vols. (Paris, 1863
 and 1872).
10 Robert Venturi, *Complexity and Contradiction in Architecture* (New
 York: Museum of Modern Art, 1966).
11 Daniel Rabreau, "'Ce cher XIXe' ou Palladio et l'éclectisme pari-
 sien," *Revue des Monuments Historiques*, no. 2 (1975), pp. 56–65.
12 We find the same enormous scale in the choir of Baltard's church of
 St-Augustin (1860–71)—a gigantic amplification of the Ravenna
 model or of the Sainte-Chapelle at Aix—whose furnishings progress
 evenly in scale to culminate in the majestic baldachin but are
 nevertheless dwarfed in relation to the volume.

13 Linking Gaudí and Bossan together may seem heretical if their common sources—architectural publications and religion, especially Marian devotion—are not taken into account. They shared a knowledge of the utopian work of L.-A. Boileau, whose *La Cathédrale Synthétique* appeared in 1886; see B. Foucart, "'La Cathédrale Synthétique' de Louis-Auguste Boileau," *Revue de l'Art,* no. 3 (1969), pp. 49–66. For the religious aspect, the philosophy of the medieval cathedral can be found of course in Ruskin's works, but more particularly, for France, in Joris-Karl Huysmans' *La Cathédrale,* published in 1898. It might be said that Gaudí made a synthesis of the thought of Viollet-le-Duc (from the *Dictionnaire de l'architecture*), Huysmans' writings, and Boileau's and Bossan's works. Out of this heterogeneous mixture the Sagrada Familia was born.

14 28 boulevard Malesherbes; 6 rue Roquépine (1862); 26 rue de Laborde (1864); 58 rue de Lisbonne (1877); 11 and 11 *bis* rue Vernet (1879–80).

15 Sédille is not well known, despite his importance in the 1880s. As in the case of Vaudremer, a good monograph on his work would be very useful.

16 The abrupt emergence of the Neoclassical tradition goes back to Hippolyte Lebas (1782–1867), whose church of Notre-Dame de Lorette shows the inspiration of the Early Christian basilicas of Rome for the first time. In his studio Lebas had as students Henri Labrouste, Léon Vaudoyer, Charles Garnier, Léon Ginain, Louis-Jules André, Pierre Bossan, and Pierre de Perthes. He may therefore be considered the earliest initiator of the renewal of French architecture in the 19th century: the anticlassical character of his references opened the way for the renovation of architectural ornament.

17 See note 9 above. The *Dictionnaire raisonné de l'architecture française du XIe au XVIe siècle* was published from 1854 to 1868.

18 Franco Borsi and Paolo Portoghesi, *Victor Horta* (Brussels, 1970), p. 113, regarding the Tournai museum: the reference concerns Viollet-le-Duc's seventeenth *Entretien,* fig. 4.

19 At the present time the Ecole du Sacré-Coeur, abandoned since 1973, is threatened with demolition.

20 The problem of unity and diversity, of interconnection or independence of parts, has been set forth in masterful fashion by Emil Kaufmann in *The Architecture of the Age of Reason* (Cambridge, Mass., 1955). Kaufmann's theory about Neoclassicism makes it possible to account for Eclecticism in its entirety, as belonging to the same trend of culture. Thus our analysis is, so to speak, a prolongation of Kaufmann's thought. Another echo of the same point of view is found in a paper by Daniel Rabreau, unfortunately not published, on the relation between Gabriel and the "official" art of the early 20th century.

21 The grand staircase in the rotunda of the Galeries Lafayette, boulevard Haussmann and rue de la Chaussée d'Antin, 9e (removed in 1974, although the rotunda remained intact) is generally attributed to Majorelle. Actually it was the work of the architect Chanat, who built the extension of the Galeries Lafayette in 1912; it was executed by an ironsmith from Nancy who was familiar with Majorelle's ideas.

22 Raymond Escholier, *Le Nouveau Paris: La Vie artistique de la Cité moderne* (Paris, c. 1913). The testimony of a contemporary critic, this book is a fundamental source for Parisian Art Nouveau and its development in the 1910s. It touches on the artistic production of the period as a whole and on the effort at synthesis which characterized it.

23 The building at 270 boulevard Raspail and 1 rue Schoelcher, 14e, is absolutely identical with the one in the avenue Raymond-Poincaré and probably should be attributed to Plumet. This building also dates back to c.1895. The curious Neo-Gothic structure, decorated with terra-cotta elements, that Plumet built in 1893 at 3 and 3 *bis* rue Léonce-Cosnard and 2 *bis* rue de Tocqueville, 17e, is considered here only as one of his sources.

24 Eugène Hénard (1849–1923), architect and urbanist, evolved the theory of the *avenue à redents*, a theory he was able to implement in the rectangular meander pattern of the facades on the boulevard Raspail (unfinished since the Second Empire). Together with Louis Bonnier he furnished the ideas for the *réglement* of 1902. On this subject see E. Hénard, *Etudes sur les transformations de Paris,* 8 fascicules (Paris, 1903–1909), *Les Espaces libres de Paris* (Paris, 1909), and *Rapport sur l'avenir des grandes villes* (London, 1910); and L. Bonnier, *Rapport sur la Révision des ordonnancements de la voie publique* (Paris, 1909).

25 As the building at 6 rue Vineuse, 16e (1909), would seem to prove, the poverty of imagination expressed in an economical *petit-bourgeois* neo–Louis XVI style lowers Du Bois d'Auberville to the rank of the most mediocre architects.

26 Following most authors on the subject we spell the name "Schoellkopf," although it appears as "Schoellropf" in an inscription on the first-story cornice molding of the building at 29 boulevard de Courcelles, 8e.

27 This emphatically rusticated style—it might be called "grotesque" in the first meaning of the word—is used again on two strange buildings in the seventeeth arrondissement, at 49 avenue des Ternes (here the squinches under the balconies are adorned with thick folds like the skin of an elephant) and especially at 29 avenue Mac-Mahon. The latter recalls the Renaissance palaces in Florence by the prominence of the bossage, but the mark of Art Nouveau (with a strong hint of Rococo) is seen in the delicacy of the ornamental carving of bouquets and masks which is introduced on this colossal structure. The work might be by Schoellkopf in a slightly earlier period, under the influence of the academy.

28 Binet's album of drawings gives all the details of the beautiful Porte de la Concorde at the exposition of 1900. It also contains sketches for the metal framework of the Grand Palais, and a series of exotic projects (including one for a marionette theater) that reveal an exceptional talent. Unfortunately the extant works do not do full justice to Binet, who was restrained by his respect for Sédille's work in the one instance, by the historic site in the other. A facsimile publication of the volume of drawings would add much to our knowledge of French Art Nouveau and its relation to architecture.

29 Binet's influence on ironwork reaches into the 1930s through Art Deco, as we can see from the fine ensemble of lighting fixtures in the square in front of the church of Ste-Thérèse in Lisieux (L. M. Cordonnier, architect; begun in 1929) and particularly in the chapels of Ste-Thérèse and Ste-Jeanne d'Arc in the parish church of Notre-Dame, Alençon, where the quality of the ironwork and mosaics is outstanding.

30 After World War I, Séguin turned to the restoration of the historic monuments destroyed by the war. This is why we have the complete

photograph album of the paneling carved by Séguin for the great hall of the Hôtel de Ville in Arras between June 1931 and June 1932 (Pierre Paquet, architect).

31 E. Derré was not only the Symbolist sculptor of the "Chapiteau des Baisers" in the Luxembourg Gardens; his collaboration with Théo Petit and Georges Chédanne lines him up with the Art Nouveau *ornemanistes*. Rheims made a mistake in publishing the building at 276 boulevard Raspail as being located at 103 avenue des Champs-Elysées.

32 The privileged relations of Art Nouveau with Neo-Gothic are illustrated by this list of works, most of them derived from the Neo-Gothic. From a sociological point of view, Art Nouveau's clientele was limited to the international artistic elite, who were impressed by the architectural manifestoes of its beginnings; later it reached a middle-class clientele desirous of being recognized as avant-garde. Art Nouveau, both in monuments to science and in monuments to politics, was tainted with a supposed "modernity," to such a degree that outside of the sumptous boulevard Raspail it touched only the new quarters of the city—and the new classes—in the seventh and fifteenth arrondissements (the sixteeth and seventeenth remained faithful to the Louis XV and Louis XVI modes, though "modernized").

33 Binet and Deglane won the prize in the competition for the Grand Palais, but Binet gave up building it in order to concentrate on the monumental Porte de la Concorde (Hautecoeur, *op. cit.,* vol. 7, p. 465). The pity is that this work, only an ornament for the exposition, was not preserved.

34 The appropriation of Art Nouveau by the most official sort of academicism is typified by the figure of Jules M. Boussard (1844–1923), an Eclectic committed to the cult of the Renaissance. He was also an excellent architect and built a number of buildings, among them the one at 7 place des Ternes, 17e (1881–82), with its immense circular courtyard, and the series at 40, 42, 41, 43–45 rue Ribéra and 1–5 rue Dangeau, 16e (1894). For the structures at 78–80 avenue Mozart, rue Jasmin, rue de l'Yvette, and rue de la Cure, 16e (1898), as for the Louvre telephone exchange (1890), he yielded to the fascination of sea-green glazed brick, and, in the latter case, of entirely exposed metal framework, a surprisingly daring achievement at the time. In his later buildings at 4 and 6 rue Jasmin (1911, 1914), the overloaded decoration closely approaches the redundant style of Lavirotte—yet is not lacking in charm.

35 After 1914 the same Charles Labro worked in the "Neoclassical–Art Deco" style (Chaussée de la Muette and rue d'Andigné, 16e), of which Le Maresquier and Henri Dubouillon were the other proponents. The style was much appreciated by the clientele in the western *quartiers* of Paris.

36 Gustave Rives built the Grands Magasins Dufayel, boulevard Barbès and rue de Clignancourt, 18e, between 1890 and 1900. The monumental doorway on the rue André-del-Sarte is a surprising evidence of the slightly saponified style of the official art of the time, well suited to Dufayel, a low-cost furniture merchant whose specialty was bedroom suites in the foulest *rocaille.*

37 The extension of La Samaritaine on the Quai du Louvre by Frantz Jourdain and Henri Sauvage, done in 1930, signals an outright renunciation of their past history, if only in the ruthless "cleaning up" that Jourdain carried out on the facade of the 1905 building. He tore down the corner rotundas and all the wrought-iron decoration, and washed out the color of the polychrome mosaic.

38 Our information is taken from Françoise Boudon, "Recherche sur la pensée et l'oeuvre d'Anatole de Baudot," *Architecture, Mouvement, Continuité,* no. 28 (March 1973), special number.

39 See note 13 above. Baudot's ideas were of such originality that we have few applications of them except for his study drawings, most of which remained in the theoretical stage. Perhaps the only building that comes close to realizing his aesthetic is the Gare de Rouen-Etat (completed by Adolphe Dervaux in 1928), but the actual building is fairly conventional; there is, for instance, no polychrome decoration behind the great stone facade. The only official offspring of Baudot's thinking and practice, which were so drastic in their novelty that they were not completely understood by his contemporaries, would include the following buildings: two residences in reinforced concrete by Paul Guadet—the recently demolished Carnot house at 8 avenue Elisée-Reclus, 7e (1907; entirely covered with dark blue stoneware by Bigot), and the Guadet house at 95 boulevard Murat, 16e (1912), whose facade is decorated with ceramic lozenges; the residence of Henri Deneux, at 185 rue Belliard, 18e (1913); and several less skillful constructions by Joachim Richard at 40 rue Boileau, 16e (1908), and 16 rue de Montevideo, 16e (1915).

40 See note 24 above. See also L. Bonnier and Marcel Poëte, *Enquêtes sur l'expansion de Paris,* 2 vols. (Paris, 1916). Marcel Poëte is also the author of *Introduction à l'urbanisme* (Paris, 1929), and *Une vie de cité, Paris de sa naissance à nos jours,* 4 vols. (Paris, 1924–31).

41 Camillo Sitte is the author of *Der Stadtbau nach seinen Künstlerischen Grundsätzen* (Vienna, 1889; French translation entitled *L'Art de bâtir les villes,* Paris, 1918), which treats urban space in the medieval town and develops the idea of the continuity of the urban fabric. His studies had a fundamental impact on the development of urbanistic thought at the turn of the century. Furthermore they directly inspired many of Henri Sauvage's projects as he sought to go beyond the conflict between the collective and the individual, and had something to do with the picturesque styling of garden cities. In its concern to put some life into urban space, the Paris *réglement* of 1902 is also a reflection of this "gospel of urbanism" at the opening of the century. In the name of rationality the functionalist theories of the 1930s opposed this vision of the urban landscape, considering it sentimental.

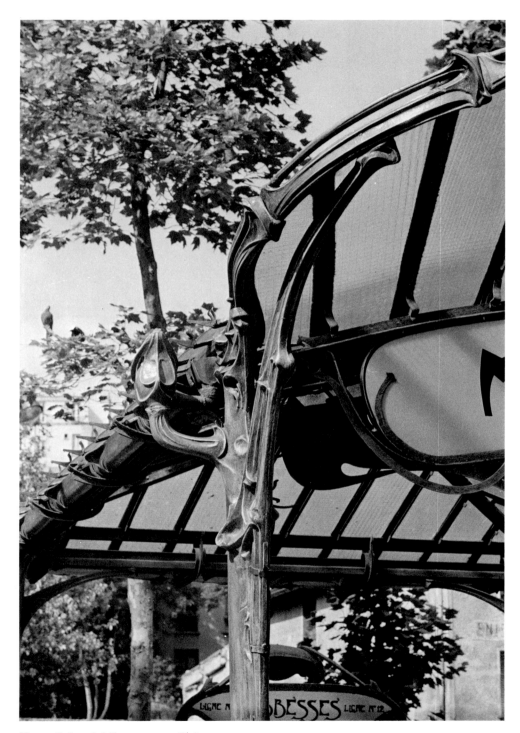

Hector Guimard. Métro entrance, Paris.

ORNAMENTAL CAST IRON IN GUIMARD'S ARCHITECTURE
Alain Blondel, Yves Plantin

In 1907 Hector Guimard designed a cover for the catalogue of his ornamental ironwork; the title, set in lettering also of his design, was *Fontes Artistiques pour Constructions, Fumisterie, Articles de Jardins, et Sepultures* (Ornamental cast iron for buildings, fireplace fittings, garden fixtures, and tombs). Thus he enumerated everything to which external ornamentation could be applied. And under this list, in a cartouche, he added "Style Guimard." Without a text, the catalogue's cover was an adequate preface for the presentation of a considerable volume of work spread over seven years (1900–1907); and the label "Style Guimard" was a good gauge of his ambition.

The catalogue demonstrated an organization of the art of ornament that fulfilled Guimard's theory of total architecture. Studying his work, one is impressed by the all-inclusive concept evidenced in his constructions, from the choice of a site to the arrangement of the smallest details. In the brochure for his "Pavillon Style Guimard" at the 1903 Exposition de l'Habitation, he stated: "The arts related to housing can live and develop only to the degree that they issue from and remain subject to a completely established general aesthetic. Every renovation, every new departure in detail, will perish at birth unless it is an integral part of the ensemble, i.e., of the architecture."

Builders in the second half of the 19th century saw the different possibilities inherent in metal; Guimard, attracted at first to the most varied materials, soon concentrated on the special qualities of cast iron. He used it in 1895 in the Ecole du Sacré-Coeur (cat. no. 611), supporting the second floor with a series of oblique cast-iron columns in a manner Viollet-le-Duc had proposed. The modeling of these columns already showed a sculptural conception that went beyond mere ornament to convey the feeling of static forces. In 1896 the Castel Béranger (cat. no. 586) gave Guimard an opportunity to experiment further with iron. In addition to balconies and decorated gutters he executed a number of other components in cast iron, including the famous drinking fountain in the courtyard; and in 1900 he used cast iron exclusively for his Métro entrances, which enabled him to change the appearance of the Paris street within a few months. Whereas other builders working with cast iron reproduced the architectonic forms of wrought iron or stone, Guimard respected the nature of the material itself, and sought to make its appearance correspond to its particular characteristics. Only a moldable material allowed such freedom of design, permitting him to model the curves and reliefs of vegetation while adhering to a carefully elaborated structural scheme.

Still in 1900, Guimard designed a radiator grille (cat. no. 663) and auditorium seats (cat. no. 364) for the Humbert de Romans Concert Hall: these were the earliest models in his catalogue of cast iron. Three years later he had a chance to carry out his ideas for a variety of balconies and other accessories in a building on the avenue de Versailles. Delighted with the results, Guimard multiplied his designs until he had done everything that could be done for the house, the garden, and even for the cemetery. So it was that he was able to publish an impressive catalogue, containing over two hundred models, in 1907.

With this ornamental cast iron the pretext of usefulness yielded to a genuinely sculptural concept. Sometimes the sculpture is linear, as in the radiator grille mentioned above, but the scrollwork acquired a third dimension by the overlapping of lines: the swift upward movement of the tracing is suggested in a palmette (cat. no. 634) in which the curves end in a swirl that centrifugal force seems to have filled out with matter. The cast iron faithfully reproduced the intricacies of the original flourish. Jardinières, vases, fence spikes, even andirons, all derive directly from statuary art and must be judged as such. The monumental jardinière on a

pedestal (cat no. 695) definitely gives this impression, but the most spectacular piece is a fence spike (cat. no. 683): the subject seems insignificant, but it proves that Guimard had something in mind other than a mere ornament for a railing. What he was attempting here was microsculpture—from every angle the object looks different, confirming the impression that the form is conceived entirely in space. Given its small size, designing the piece to be cast in iron was a gamble—or proof of unusual modesty. It would be easier to imagine it worked in a precious metal.

The originals from which the pieces were cast were carefully chased and polished, which explains the sharp edges, the clean spaces, and the fine grain of the "skin." Guimard showed some few specimens at the Salon des Artistes Décorateurs in 1907, amidst elaborate and unique pieces of furniture, jewelry, and fine crafts. Such painstaking finish might seem inconsistent with the type of wholesale production that Guimard certainly had in mind. Yet the idea of standardization was not new to him, as witness the modular components made for the Métro in 1900. This system of production, Guimard thought, should put a touch of unaccustomed luxury in streets and public buildings. He was quickly disillusioned. We can imagine how other architects and contractors would balk at having such imposing accessories point up the anonymity of their facades. So, against his will and with few exceptions, Guimard was practically the only client for his own models. As its name all too clearly indicated, the "Style Guimard" could be put to use only by its creator. His work, as photographs of the interior of his residence reveal, was a closed, self-sufficient whole: the "art objects" not by his own hand are insignificant at best. To have them otherwise would have risked creating a painful imbalance.

Guimard's was the opposite of an eclectic, versatile mind. After 1896, the decisive year when he chose his course (in the midst of the multiple influences of a nascent Art Nouveau), he never stopped affirming and developing his own characteristics. He paid no attention to opinion, changes of fashion, or the bored indifference of his contemporaries to his "extravagances." In the course of his development he gradually and systematically obliterated traces of other styles—Gothic, Rococo—that might influence him. Abstract ornament, in his mature art, was pure invention; it owed nothing to other styles, nor to nature, to which he still appealed in 1898 in order to win approval for the expressive sculpture of his interiors and the flowing curves of his furniture. Jealous of the personal universe he had organized, he could not be the founder of a school. He had imitators but never trained pupils of his own; those who worked with him did no more than execute his designs. Guimard was anything but the theorist of a new art (as Gallé was in Nancy, though in a limited and ephemeral way); rather he was an incredibly productive despot who never trusted anyone but himself. So, when the time called for a style of its own, he responded by proposing . . . the Style Guimard. His publication in 1898 of a complete decorative program in the album *Le Castel Béranger*—subtitled *L'Art dans l'Habitation Moderne*—was its first manifestation. His genius may be measured by the risk he took.

Guimard's attempt to create a style—an ambition so enormous that it was doomed to failure from the beginning—can nevertheless be considered an effort to reconcile art and industry. Theoretically, industrial methods indeed made it possible to carry out such a project and assure its rapid distribution. Previously the flowering and withering of a style had taken time, usually the duration of a reign; but modern analysis of the notion of style transformed what was almost a natural necessity into an abstract concept, which the system of mass production hastened to make widely available, and therefore all too short-lived. Since this phenomenon was new to history, Guimard could not have known of the curse connected with speed of manufacture and distribution.

Viewed in this perspective, the publication of the catalogue of his ornamental cast iron was equivalent to the writing of a testament. Guimard was then only forty years old, yet most of his work was already behind him. Of course he continued to be active after 1907, but it is undeniable that his prodigious creative energy had flagged: the final great effort of his career was the building of his own house in 1910, and he made it something of a museum for his models.

Guimard and his art were one, and he would not repudiate his earlier work as other architects of his generation did when, about 1909, the vogue of Art Nouveau faded. On the last building he constructed in Paris, in 1928, he still used the same elements: he was the last Art Nouveau architect, as he had been, in France, the first.

GUIMARD'S ARCHITECTURE

610
Maison Paul Hankar, Brussels; house in Uckfield, England.
Hector Guimard. 1894–95.
Two watercolors on Canson paper, mounted together on black cardboard.
45.7 x 14.7 (18 x 5⅞)
Hotel de Monsieur Paul Hankar / a Bruxelles, across top. *HG 95,* lower right.
Diameter 14.5 (5¾)
Maison à Uckfield / Angleterre, upper left. *HG,* lower right.

Paris, Bibliothèque des Arts Décoratifs, Inv. 7931–32. Gift of Mme. Hector Guimard, 1948.

Executed during Guimard's trips to England in the summer of 1894 and to Belgium and Holland in the summer of 1895 (when he met Victor Horta in Brussels).

Exh: Paris 1896, Salon SNBA; Paris 1971b, no. 112; Münster 1975, No. 6.

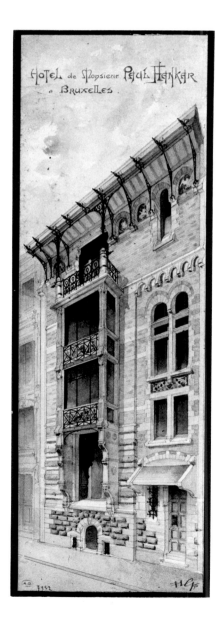

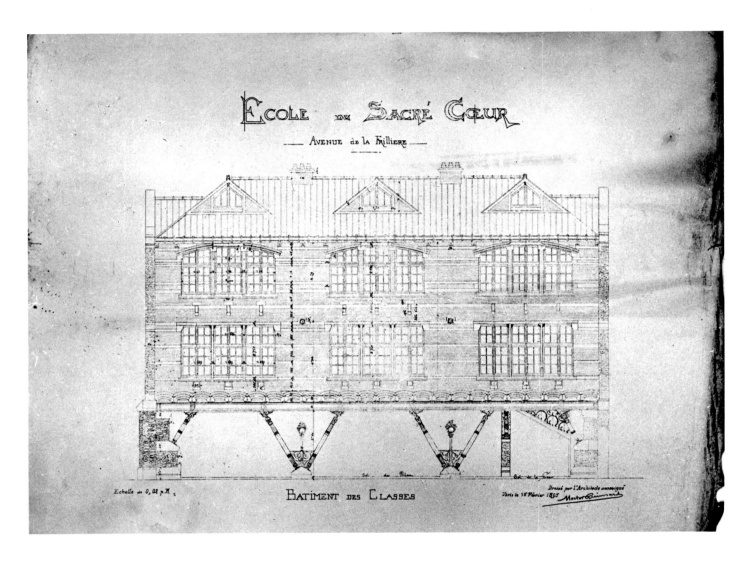

611

Ecole du Sacré-Coeur, 9 avenue de la Frillière, Paris 16. Elevation [photograph exhibited].
Hector Guimard. 1895.
104 x 70 (41 x 27½)
Ecole du Sacré Coeur / Avenue de la Frilliere, at top.
Batiment des Classes, at bottom. *Echelle de 0,02 p.M.,* lower left. *Dressé par l'Architecte soussigné / Paris le 15 Février 1895 / Hector Guimard,* lower right.

Archives de Paris.

Built for the Société d'Immeubles pour l'Education et la Récréation de la Jeunesse in 1895. The cantilevered facade is supported by an exposed metal beam which rests on two V-shaped units, each composed of two cast-iron columns united at their base by a block of stone. Guimard's inspiration for this arrangement is obviously Viollet-le-Duc's

proposed design for a covered market beneath a large meeting hall (illustrated here). There is also a certain proximity with the bridge-construction principle and general silhouette of Jules Saunier's Menier chocolate factory at Noisiel, Seine-et-Marne (1871–72), which Viollet-le-Duc had mentioned approvingly in the text of the *Entretiens*.

Bibl: Brunhammer et al. 1971, p. 142.

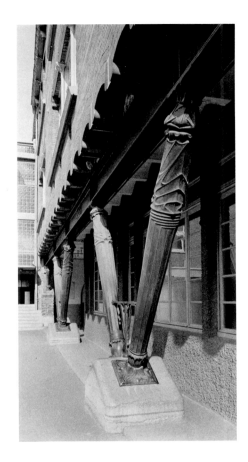

612
Ecole du Sacré-Coeur. Detail of the facade.
Hector Guimard. 1895.

613
Plate 21 of Viollet-le-Duc's *Entretiens sur
l'architecture.*

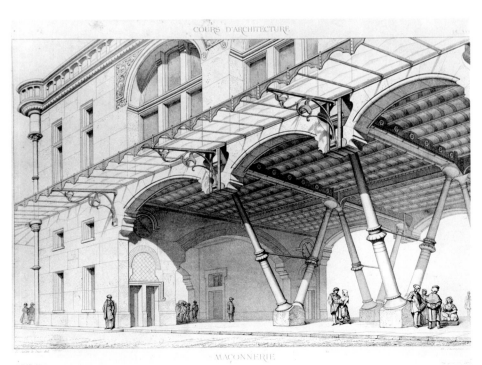

8 mai 96

614
Letter to Victor Horta [photograph exhibited].
Hector Guimard. May 8, 1896.
Brussels, Commune de Saint-Gilles, Musée Horta.

Written after Guimard's revelatory visit to Brussels, where he saw the newly completed Hôtel Tassel by Horta and was inspired to make substantial changes in the design of the Castel Béranger (cat. nos. 586, 587), this letter frankly displays Guimard's admiration for his Belgian colleague.

8 May 96

My dear Sir and esteemed Colleague—
 Your recommendation is very precious to me, and if this is agreeable to you I am entirely disposed to accept your protégé. The training you must have given him will already have prepared him for my work, which fits in well with yours.
 At the salon this year I exhibited the result of my research in other countries, and as I was so happy to tell you, in you I have met the architect truly worthy of the name; and I was determined to present your house [the Hôtel Tassel] in the rue de Turin, the facade and the two interiors seen from the staircase, after the engravings which you sent me.
 Alas, the views give an idea of what the house is like, but no more than that, for, as you know as well as I do, architecture is not drawn, it is built; but your work, placed in the center with others to either side, is the expression of the superiority of your talent over that of the others. All the architects to whom I have been able to show your works (and this gave me the pleasure of telling them that you were the only "ARCHITECT" I knew) render homage to your talent. I present you these compliments not so that you may rejoice in successes already won, but so that at difficult moments you may find encouragement in them and may know that time will do you the justice that I am so pleased to render you right away.
 I wish you some interesting projects and the time to give them the care and study needed to reach and surpass the goal already attained; and it will be a treat for me to see what you produce.
 I had counted on seeing you this winter, but, I beg you, take advantage of the salon to come and see me, and I will be happy to have *from you* the frank, loyal criticism of a colleague for whom I feel warm affection. . . .

Hector Guimard

615
Maison Coilliot, 14 rue du Fleurus, Lille.
Facade.
Hector Guimard. 1898–1900.

The Maison Coilliot, a combined store and
residence, was commissioned in 1897 by Louis
Coilliot, the head of a ceramics firm. Its
entrance hall is decorated with glazed lava
panels surrounded by an iron framework, while
the upper part of the hall is of molded stucco.
Completed in 1900, this is one of the rare
Guimard houses to remain intact.

Bibl: Miotto-Muret and Palluchini-Pelzel
1969, pp. 75–78.

Exh: New York 1970, p. 10; Paris 1971b,
no. 146.

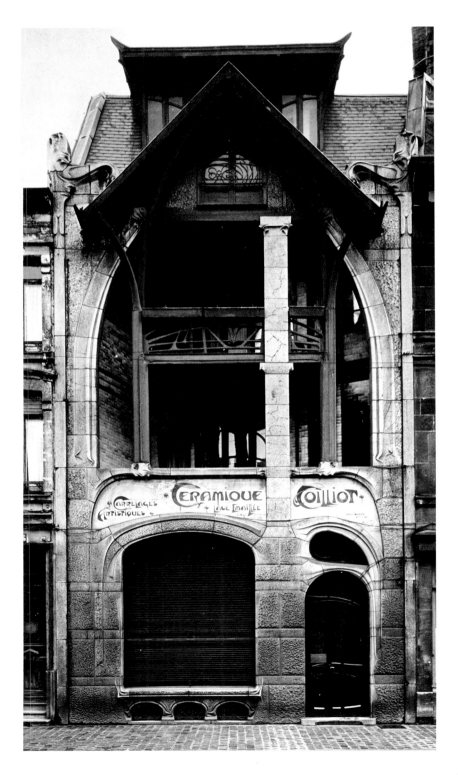

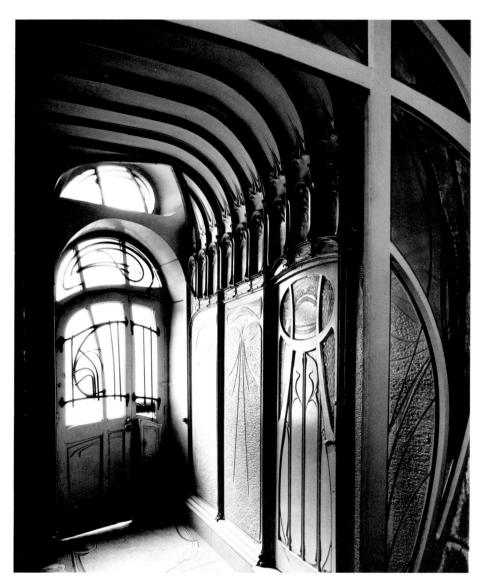

616
Maison Coilliot, Lille. Entrance hall.
Hector Guimard. 1898–1900.

Also illustrated in color.

617
Humbert de Romans Concert Hall, 60 rue
St-Didier, Paris. Longitudinal section.
Hector Guimard. c. 1898–1900.
Sepia print and india ink on paper.
61 x 95 (24 x 37¼)
Salle / Humbert de Romans / Rue St Didier, upper
left. *Coupe Longitudinale,* upper right. *Echelle de
0.02 pm,* lower left. *Paris le 15 Janvier 1900 /
L'Architecte / Hector Guimard,* lower right.
Paris, Musée des Arts Décoratifs.

The building was demolished c. 1905–1908.

Exh: New York 1970, no. 22; Paris 1971b,
no. 167; Münster 1975, no. 50b.

618
Study for a panel for a stone balcony.
Hector Guimard. c. 1898–1900.
Pencil and india ink on paper.
34 x 49.5 (13⅜ x 19½)
Paris, Musée des Arts Décoratifs.

Initially created as a radiator grille for the
Humbert de Romans Concert Hall (cat. no.
617), this design was later executed in cast iron
and included among the *Fontes Artistiques* (cat.
no. 663).

Exh: New York 1970, no. 92; Paris 1971b,
no. 176; Münster 1975, no. 105.

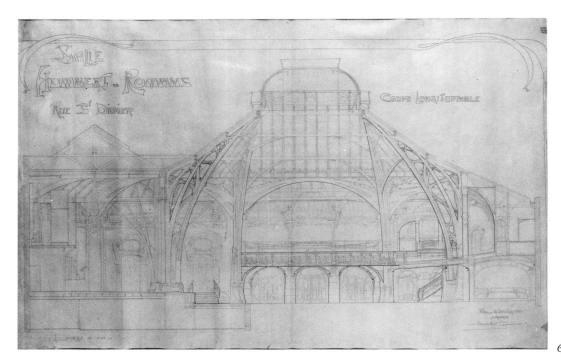

617

618

413

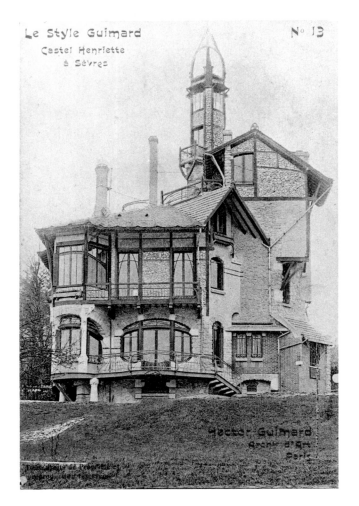

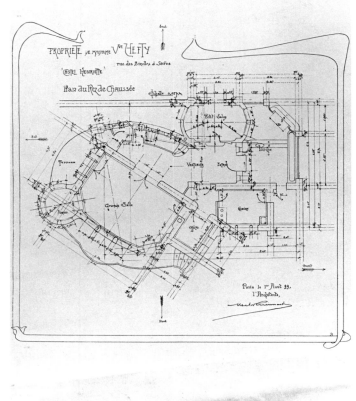

619
Castel Henriette, rue des Binelles, Sèvres.
Period postcard [photograph exhibited].
Hector Guimard. 1899–1900, with
modifications in 1903.
The building was demolished in 1969.

The estate included a garage, a wooden
cottage, and a lava fountain in the garden, all
designed by Guimard. In its original state,
before the destruction of the spire in 1909, the
house demonstrated Guimard's mastery of his
trade—his skill in uniting a condensed plan
and an elevation, or in playing with volumes
and a variety of materials to achieve the
expression he sought on the interior. It is not
without a certain humor that Guimard created
this suburban architecture. Its intentional lack
of coherence, and certain odd elements like the
upper panels of the roof, magnify a popular
stylization which falls between the grace of
Marie-Antoinette's Hameau at Versailles and
the simplicity of the corner towers on medieval
fortifications.

Exh: New York 1970; Paris 1971b, no. 148.

620
Castel Henriette, Sèvres. Proposed plan of the
ground floor [photograph exhibited].
Hector Guimard. 1899.
India ink on paper.
71 x 52 (28 x 20½)
*PROPRIETE de madame Vve HEFTY / rue des
Binelles à Sèvres / "Castel Henriette" / Plan du Rez
de Chaussée / Echelle 0,02 p/m,* upper left. *Paris
le 1er Aout 99, / l'Architecte / Hector Guimard,*
lower right.
Paris, Musée des Arts Décoratifs.

Exh: Paris 1971b, no. 147.

621

Two Métro entrances, Paris. Period
photographs.
Hector Guimard. 1900.

Such covered entrances were designed and
erected in 1900 at all of the major stops along
the Métropolitain's line no. 1 (Porte de
Vincennes—Porte Maillot). Though Guimard
had created two basic models, he designed
special entrances for the Etoile and Bastille
stops; the construction materials common to
all were cast iron, glass, and glazed lava, which
was chosen in preference to stoneware for its
resistance to rapid temperature changes. The
structures prompted a good deal of criticism.
Nevertheless new ones were built until 1904,
when the Métro company refused Guimard's
proposal for an entrance at the Opéra, saying
that that monument's architectural style
should be respected. The action reflected
mounting public sentiment against Art
Nouveau in general. Today the only one of
these entrances to remain intact and in its
original location is that of the Porte Dauphine.

Bibl: Guerrand 1968, pp. 108–109;
Brunhammer 1971, pp. 161–62.

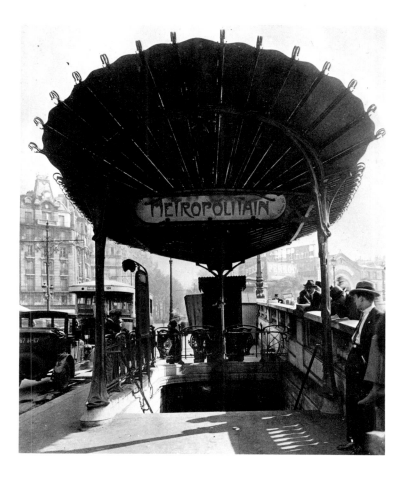

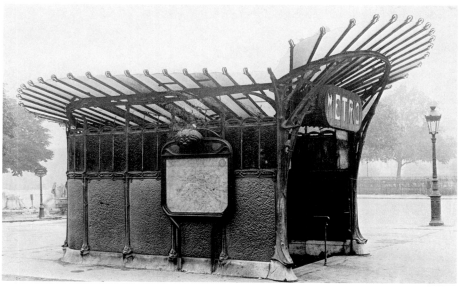

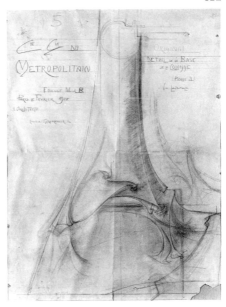

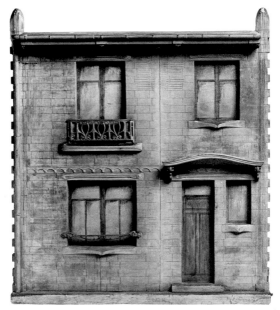

622
Design for the base of a column, Métro
entrance.
Hector Guimard. 1900.
Pencil and charcoal on paper.
98 x 69 (38½ x 27¼)
*Cie. Gle. du / Metropolitain / Edicule Modele B /
Paris le Fevrier 1900 / L'Architecte / Remis a
l'Entrepreneur le,* upper left. *Original / Detail de
la base / de la colonne / Pierre a / Vue laterale,* upper
right.
Paris, Musée des Arts Décoratifs.

Exh: New York 1970, no. 15; Paris 1971b,
no. 158; Münster 1975, no. 68.

623
Study for a balustrade panel of a Métro
entrance.
Hector Guimard. 1900.
Charcoal and chalk on tracing paper.
66.5 x 52 (26¼ x 20½)
Paris, Musée des Arts Décoratifs.

Exh: New York 1970, no. 18; Paris 1971b,
no. 159; Münster 1975, no. 71.

624
Model for a standard house facade.
Hector Guimard. c.1906-10.

624

Carved and painted wood.
75.5 x 64 (29¾ x 25¼)
Hect. Guimard, painted lower right.
Paris, Musée des Arts Décoratifs. Gift of
Mme. Hector Guimard, 1948.

The only extant model by Guimard. The
window railing and balcony panels are among
the *Fontes Artistiques* (cat. nos. 674, 655).

Exh: Münster 1975, no. 108.

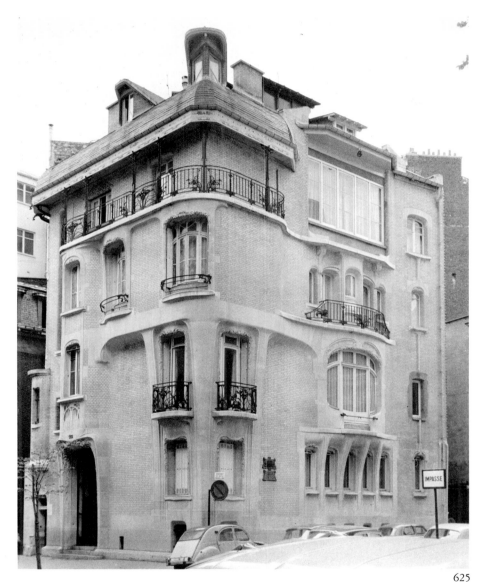

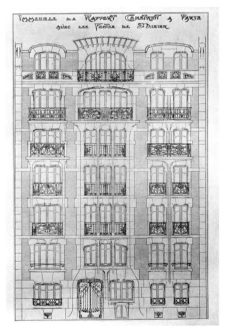

626
Immeuble de Rapport Construit à Paris avec les Fontes de St-Dizier.
Hector Guimard. c. 1910.
Engraving.
53 x 34.2 (20⅞ x 13½)
New York, Cooper-Hewitt Museum of Design, Smithsonian Institution,
Inv. 1950–66–55.

This facade is that of the apartment building at 11 rue François-Millet, Paris 16, which dates from 1910.

625
Residence of the architect, 122 avenue Mozart, Paris 16.
Hector Guimard. 1909–12.

Built by Guimard shortly after his marriage to the American Adeline Oppenheim, this private house contained reception and living quarters, Guimard's office suite (moved from the Castel Béranger) on the ground floor, and a studio for Mme. Guimard, who was a painter. The building was sold in 1947 or 1948, when it became clear that Mme. Guimard's dream of transforming it into a Guimard museum could not be realized. The new owners transformed it into an apartment building, as it remains today. Mme. Guimard donated the furniture to museums in New York, Paris, and Lyons.

Bibl: Brunhammer et al. 1971, pp. 175–76.

GUIMARD'S ORNAMENTAL CAST IRON

627
Fontes Artistiques pour Constructions, Fumisterie, Articles de Jardins, et Sepultures. Style Guimard. Catalogue.
Hector Guimard. Published by the Fonderies de Saint-Dizier (Haut-Marne), 1907.
27.4 x 37.5 (10¾ x 14¾)
Houston, Menil Foundation. Gift of the Galerie du Luxembourg, 1971.
Exh: New York 1970, no. 66; Paris 1971b, no. 127.

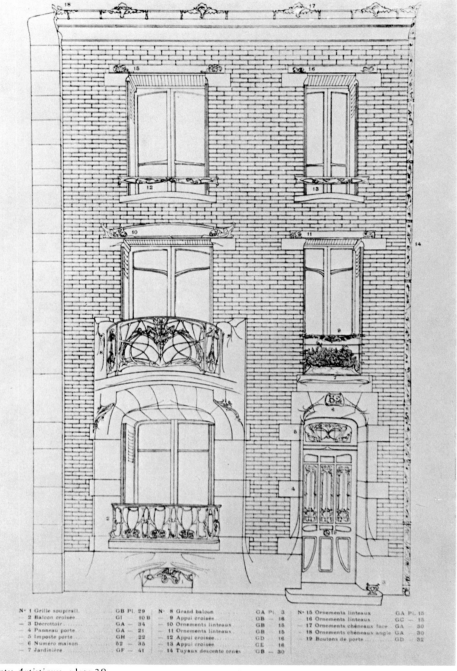

Fontes Artistiques, plate 38.

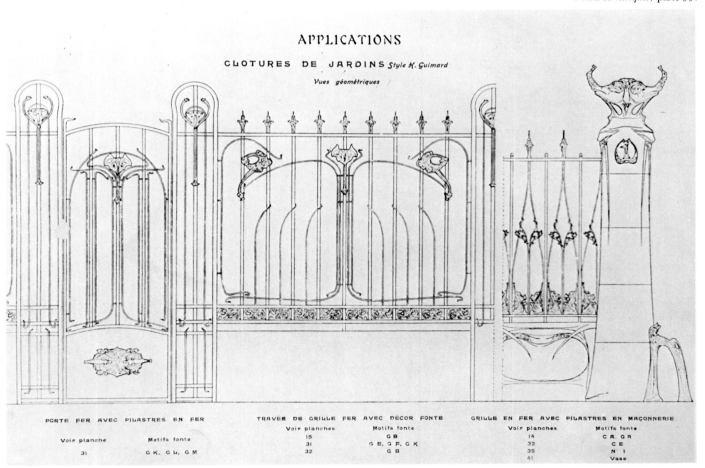

APPLICATIONS

CLOTURES DE JARDINS *Style H. Guimard*

Vues géométriques

PORTE FER AVEC PILASTRES EN FER		TRAVÉE DE GRILLE FER AVEC DÉCOR FONTE		GRILLE EN FER AVEC PILASTRES EN MAÇONNERIE	
Voir planche	Motifs fonte	Voir planches	Motifs fonte	Voir planches	Motifs fonte
31	G K, G U, G M	15	G B	14	C A, G R
		31	G E, G F, G K	32	C E
		32	G B	35	N I
				41	Vase

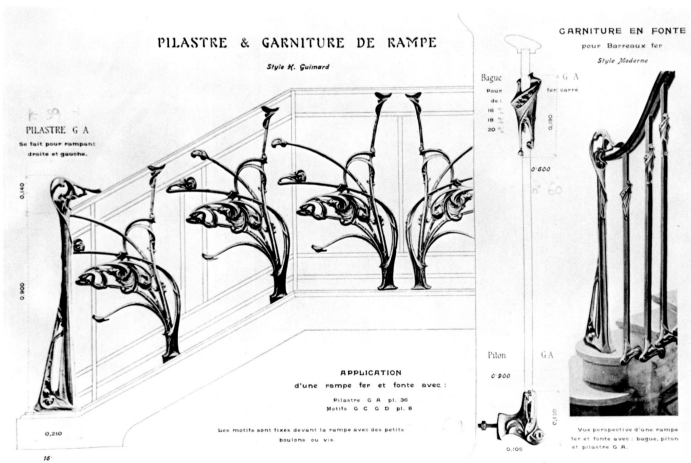

Fontes Artistiques, plate 36.

PILASTRE & GARNITURE DE RAMPE

Style H. Guimard

PILASTRE G A

Se fait pour rampant
droite et gauche.

0,140

0,900

0,210

16°

APPLICATION

d'une rampe fer et fonte avec :

Pilastre G A pl. 36
Motifs G C G D pl. 8

Les motifs sont fixés devant la rampe avec des petits
boulons ou vis.

Bague
Pour
de :
16
18
20

fer carré

0,190

0,600

n° 60

Piton G A

0,900

0,105

0,120

GARNITURE EN FONTE

pour Barreaux fer

Style Moderne

Vue perspective d'une rampe
fer et fonte avec : bague, piton
et pilastre G A.

421

TUYAUX DE DESCENTE ORNÉS

ORNEMENTS DE CHÉNEAUX

Style H. Guimard

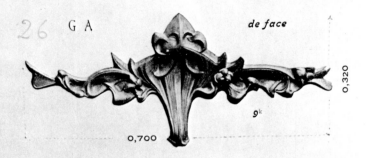

26 G A *de face*

0,320

9^k

0,700

APPLICATION

Vue de Face d'un Chéneau avec Ornement et Tuyau orné

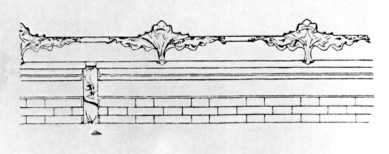

Coupe

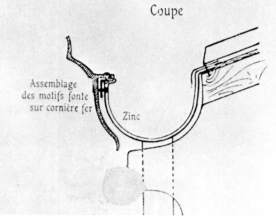

Assemblage
des motifs fonte
sur cornière fer Zinc

Fontes Artistiques, plate 30.

422

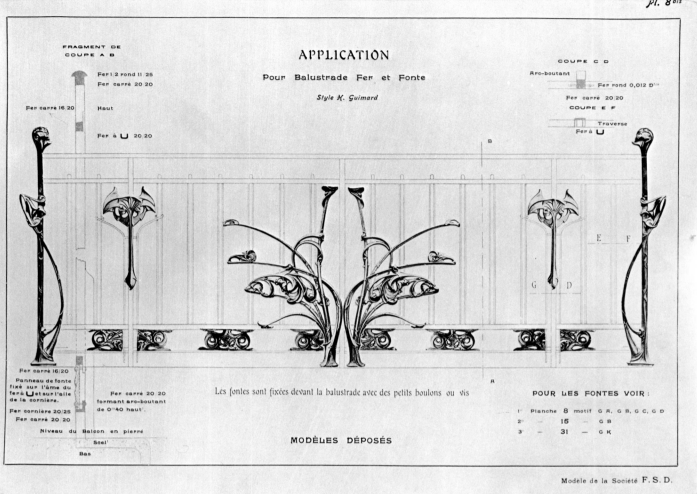

Inside the plate, the following text appears:

Pl. 8 bis

FRAGMENT DE
COUPE A B

Fer 1 2 rond 11 25
Fer carré 20 20

Fer carré 16 20 Haut

Fer à U 20 20

APPLICATION

Pour Balustrade Fer et Fonte

Style H. Guimard

COUPE C D

Arc-boutant

Fer rond 0,012 D^r

Fer carré 20 20

COUPE E F

Traverse

Fer à U

B

E F

G D

Fer carré 16/20
Panneau de fonte
fixé sur l'âme du
fer à U et sur l'aile
de la cornière.
Fer cornière 20/25
Fer carré 20 20

Niveau du Balcon en pierre

Scel^t

Bas

Fer carré 20 20
formant arc-boutant
de 0^m 40 haut.

A

Les fontes sont fixées devant la balustrade avec des petits boulons ou vis

MODÈLES DÉPOSÉS

POUR LES FONTES VOIR :

1^o Planche 8 motif G R, G B, G C, G D

2^o 15 G B

3^o 31 G K

Modèle de la Société F. S. D.

Fontes Artistiques, plate 8 *bis.*

The following pieces are the carefully chased original iron castings from which it is believed that the molds for subsequent castings were made. All are in the Menil Foundation Collection, Houston. In the description of each, the approximate weight is given when available, and the addresses of known buildings (by Guimard unless otherwise noted) where the piece is used.

423

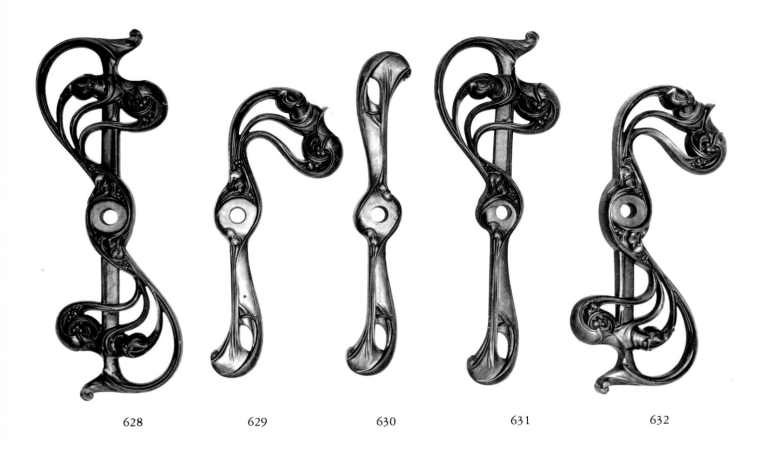

628 629 630 631 632

628
Anchor.
69 x 24 (27⅛ x 9½)
8 kg. (17.6 lbs.)
Bibl: Guimard 1907, pl. 26GA.
Exh: Paris 1971a, no. 1.

629
Anchor.
56 x 21 (22 x 8¼)
5 kg. (11 lbs.)
Bibl: Guimard 1907, pl. 26GB.
Exh: Paris 1971a, no. 2.

630
Anchor.
61 x 9 (24 x 3½)
3.5 kg. (7.7 lbs.)
Bibl: Guimard 1907, pl. 26GC.
Exh: Paris 1971a, no. 3.

631
Anchor.
68 x 23 (26¾ x 9)
5.1 kg. (11.2 lbs.)
Bibl: Guimard 1907, pl. 26GD.
Exh: Paris 1971a, no. 4.

632
Anchor.
59 x 23 (23¼ x 9)
7.3 kg. (16 lbs.)
Bibl: Guimard 1907, pl. 26GE.
Exh: Paris 1971a, no. 5.

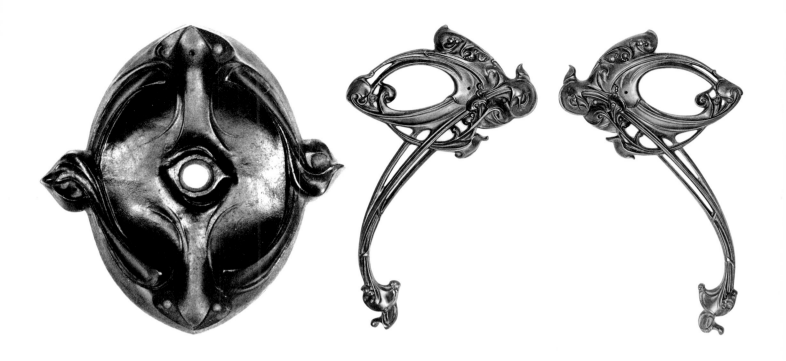

633

634

633
Anchor.
26 x 25 (10¼ x 9⅞)
5 kg. (11 lbs.)
Bibl: Guimard 1907, pl. 26GF.
Exh: Paris 1971a, no. 6.

634
Palmette (left and right motifs).
Height 37 each (14⅝)
1.3 kg. each (2.9 lbs.)
Bibl: Guimard 1907, pls. 31GE (left), 31GF
(right), 33.
Exh: Paris 1971a, nos. 7 and 8.

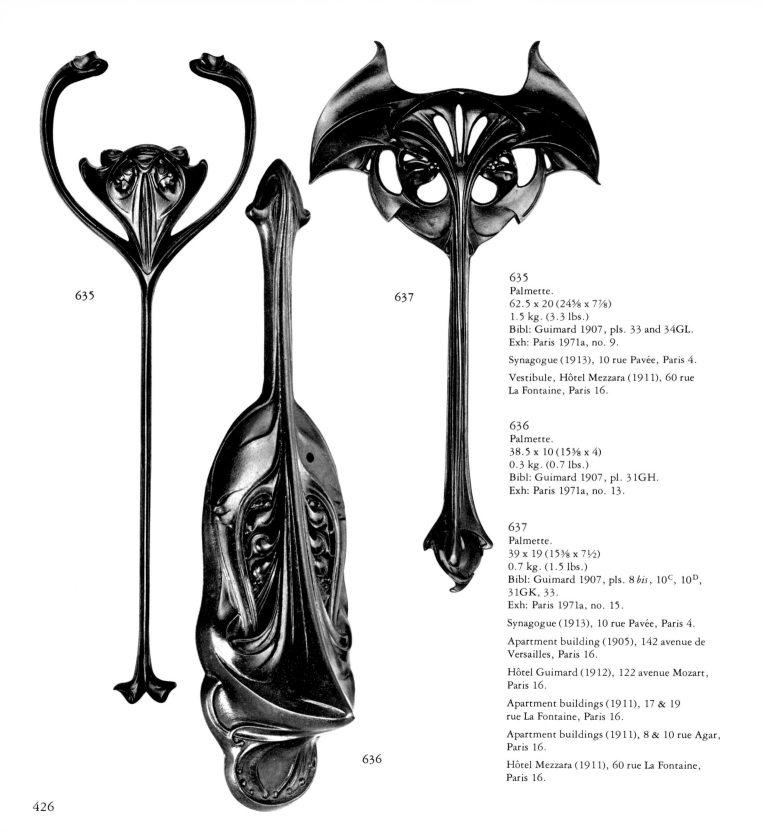

635

637

635
Palmette.
62.5 x 20 (24⅝ x 7⅞)
1.5 kg. (3.3 lbs.)
Bibl: Guimard 1907, pls. 33 and 34GL.
Exh: Paris 1971a, no. 9.

Synagogue (1913), 10 rue Pavée, Paris 4.

Vestibule, Hôtel Mezzara (1911), 60 rue
La Fontaine, Paris 16.

636
Palmette.
38.5 x 10 (15⅜ x 4)
0.3 kg. (0.7 lbs.)
Bibl: Guimard 1907, pl. 31GH.
Exh: Paris 1971a, no. 13.

637
Palmette.
39 x 19 (15⅜ x 7½)
0.7 kg. (1.5 lbs.)
Bibl: Guimard 1907, pls. 8 *bis*, 10C, 10D,
31GK, 33.
Exh: Paris 1971a, no. 15.

Synagogue (1913), 10 rue Pavée, Paris 4.

Apartment building (1905), 142 avenue de
Versailles, Paris 16.

Hôtel Guimard (1912), 122 avenue Mozart,
Paris 16.

Apartment buildings (1911), 17 & 19
rue La Fontaine, Paris 16.

Apartment buildings (1911), 8 & 10 rue Agar,
Paris 16.

Hôtel Mezzara (1911), 60 rue La Fontaine,
Paris 16.

636

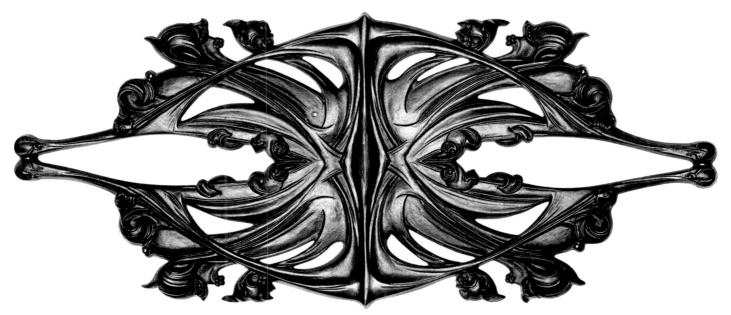

638

638
Palmette.
25 x 56 (9⅞ x 22)
0.56 kg. (1.2 lbs.)
Bibl: Guimard 1907, pls. 31GM and 33.
Exh: Paris 1971a, no. 12.

Apartment building (1928–29), 38 rue
Greuze, Paris 16.

Synagogue (1913), 10 rue Pavée, Paris 4.

639
Palmette (left and right motifs).
Height 37 each (14⅝)
0.45 kg. each (0.99 lbs.)
Bibl: Guimard 1907, pls. 31GI (left) and
31GJ (right).
Exh: Paris 1971a, nos. 10 and 11.

Apartment building (1910), 11 rue
François-Millet, Paris 16.

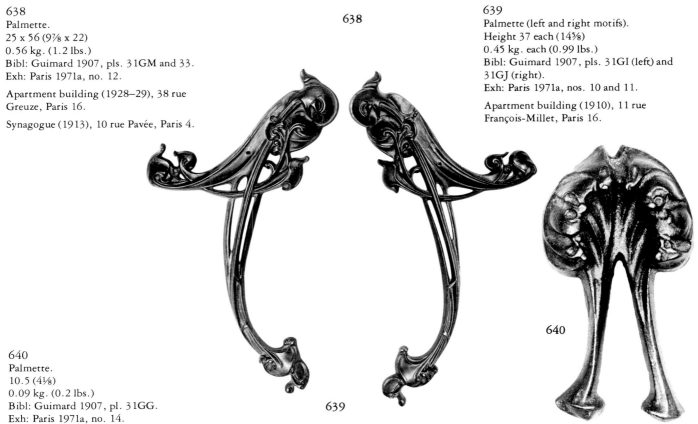

640

640
Palmette.
10.5 (4⅛)
0.09 kg. (0.2 lbs.)
Bibl: Guimard 1907, pl. 31GG.
Exh: Paris 1971a, no. 14.

639

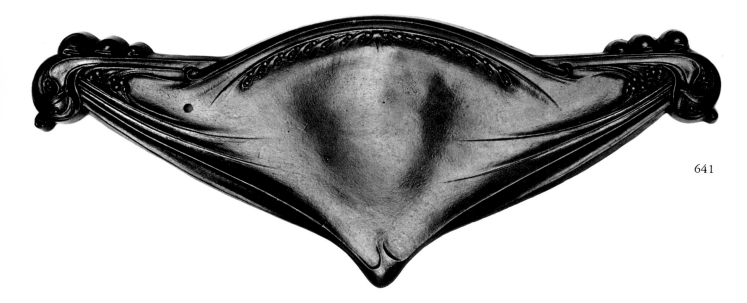

641

641
Palmette.
18 x 43 (7⅛ x 16⅞)
0.43 kg. (0.9 lbs.)
Bibl: Guimard 1907, pl. 31GN.
Exh: Paris 1971a, no. 16.

642
Bracket.
18 x 29 (7⅛ x 11⅜)
0.9 kg. (2 lbs.)
Bibl: Guimard 1907, pl. 32GA (left).
Exh: Paris 1971a, no. 18.

643
Basement window grille.
29 x 57 (11⅜ x 22½)
6.5 kg. (14.3 lbs.)
Bibl: Guimard 1907, pl. 29GC.
Exh: Paris 1971a, no. 19.

Hôtel Guimard (1912), 122 avenue Mozart,
Paris 16.

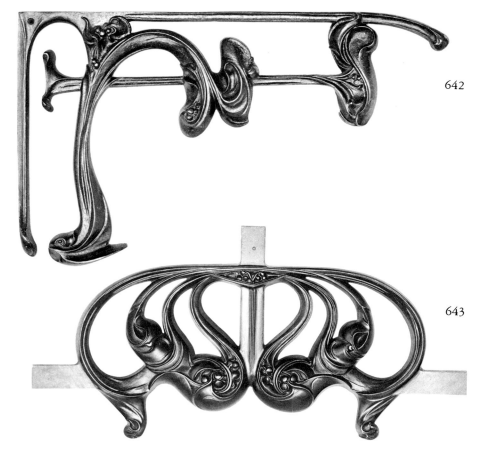

642

643

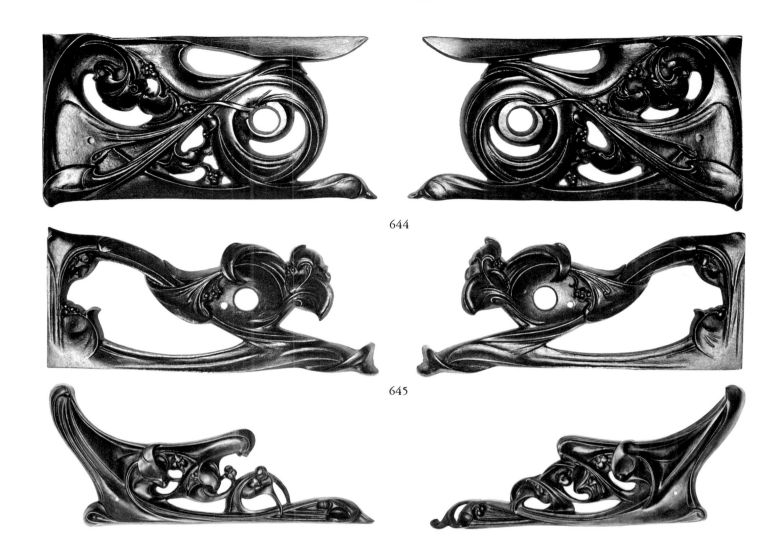

644

645

646

644
Lintel ornament (left and right motifs).
10.5 x 20 each (4⅛ x 7⅞)
1 kg. each (2.2 lbs.)
Bibl: Guimard 1907, pls. 10^C, 10^D, 15GB (left and right), 33.
Exh: Paris 1971a, nos. 20 and 21.

Hôtel Guimard (1912), 122 avenue Mozart, Paris 16.

645
Lintel ornament (left and right motifs).
8.5 x 19.5 each (3⅜ x 7⅝)
0.5 kg. each (1.1 lbs.)
Bibl: Guimard 1907, pl. 15GC (left and right).
Exh: Paris 1971a, nos. 22 and 23.

646
Lintel ornament (left and right motifs).
25 x 59 each (9⅞ x 23¼)
5 kg. each (11 lbs.)
Bibl: Guimard 1907, pl. 15GD (right and left).
Exh: Paris 1971a, nos. 24 and 25.

Apartment building (1905), 142 avenue de Versailles, Paris 16.

Apartment building (1905), 1 rue Lancret, Paris 16.

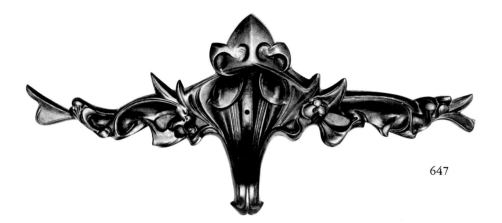

647

647
Eaves gutter ornament.
32 x 70.5 (12⅝ x 27¾)
9 kg. (19.8 lbs.)
Bibl: Guimard 1907, pl. 30GA.
Exh: Paris 1971a, no. 26.

648
Center panel of a balcony railing.
82 x 172 (32¼ x 67¾)
45 kg. (99 lbs.)
Bibl: Guimard 1907, pl. 2GB.
Exh: Paris 1971a, no. 27.

Apartment building (1910), 11 rue
François-Millet, Paris 16.

Hôtel Mezzara (1911), 60 rue La Fontaine,
Paris 16.

Autos-Cycles-Armes store (not by Guimard), 5
place des Halles, Marcigny (Saône-et-Loire).

648

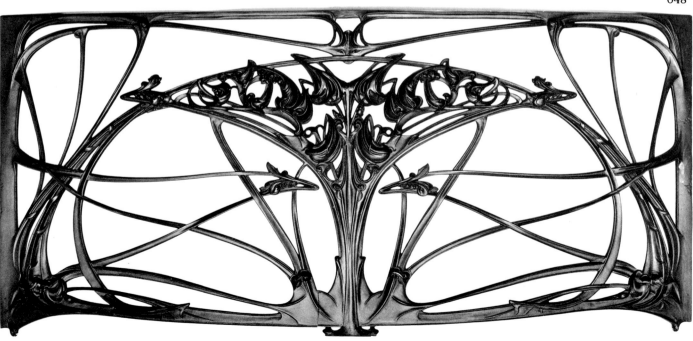

649
Center panel of a balcony railing.
82 x 129 (32¼ x 50¾)
37 kg. (81.4 lbs.)
Bibl: Guimard 1907, pls. 1GA and 3GA.
Exh: Paris 1971a, no. 28.

Hôtel Deron-Levent (1907), 8 Grande Avenue
de la Villa de la Réunion, Paris 16.

Hôtel Guimard (1912), 122 avenue Mozart,
Paris 16.

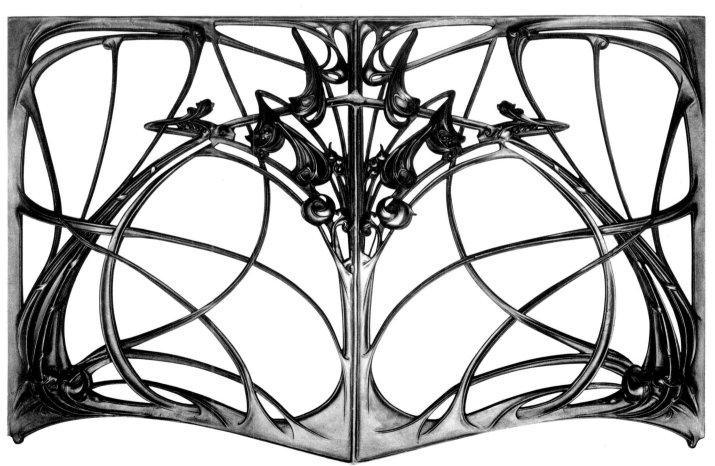

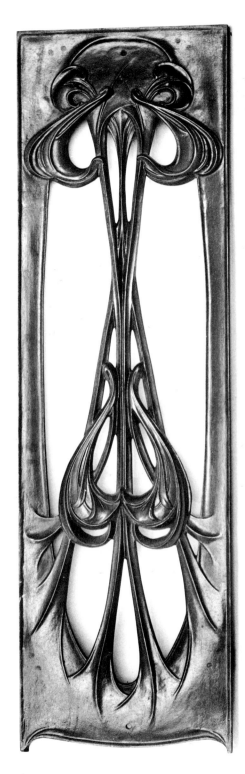

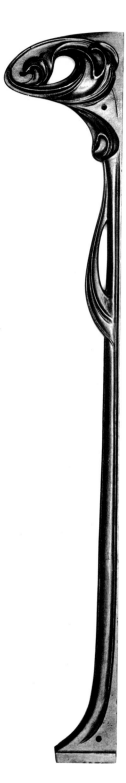

650

651

650
Panel of a balcony railing.
82 x 23 (32¼ x 9)
7.5 kg. (16.7 lbs.)
Bibl: Guimard 1907, pls. 3 and 5-1.
Exh: Paris 1971a, no. 29.

Autos-Cycles-Armes store (not by Guimard), 5 place des Halles, Marcigny (Saône-et-Loire).

651
End-piece of a balcony railing.
Height 88 (34⅝)
3.5 kg. (7.7 lbs.)
Bibl: Guimard 1907, pls. 1 through 4, 5-5.
Exh: Paris 1971a, no. 29 *bis*.

Autos-Cycles-Armes store (not by Guimard), 5 place des Halles, Marcigny (Saône-et-Loire).

652
Balcony railing for a casement window.
55 x 116 (21⅝ x 45¾)
21 kg. (46.2 lbs.)
Bibl: Guimard 1907, pl. 14GA.
Exh: Paris 1971a, no. 31.

653
Center panel of a balcony railing.
82 x 140 (32¼ x 55⅛)
34 kg. (74.8 lbs.)
Bibl: Guimard 1907, pl. 4GC.
Exh: Paris 1971a, no. 30.

Autos-Cycles-Armes store (not by Guimard), 5 place des Halles, Marcigny (Saône-et-Loire).

652

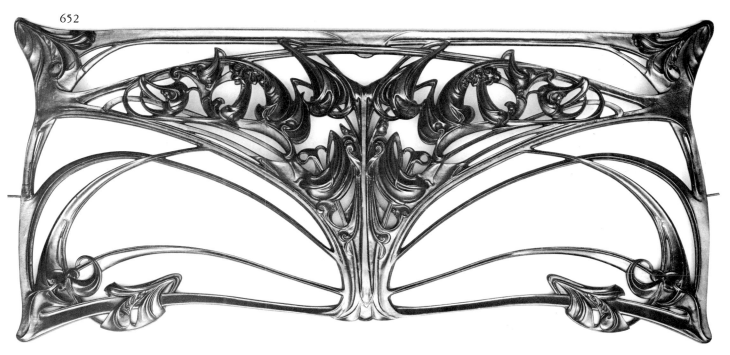

653

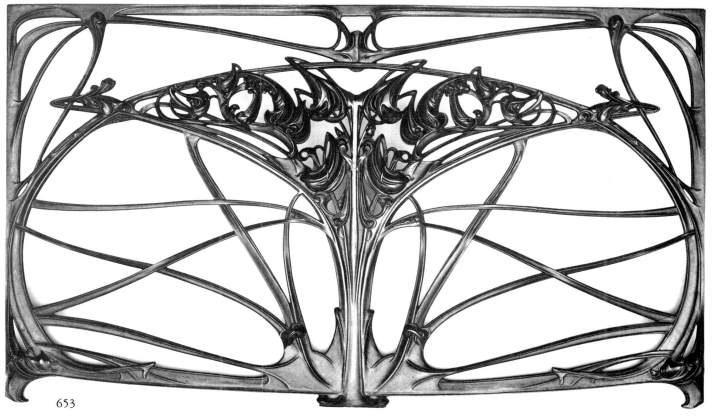

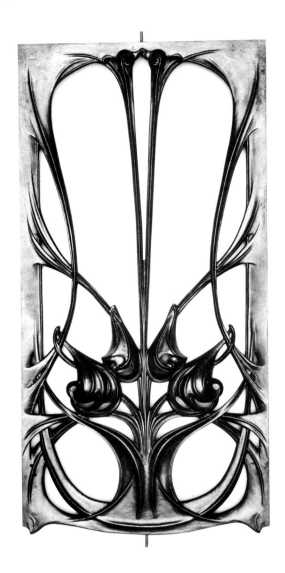

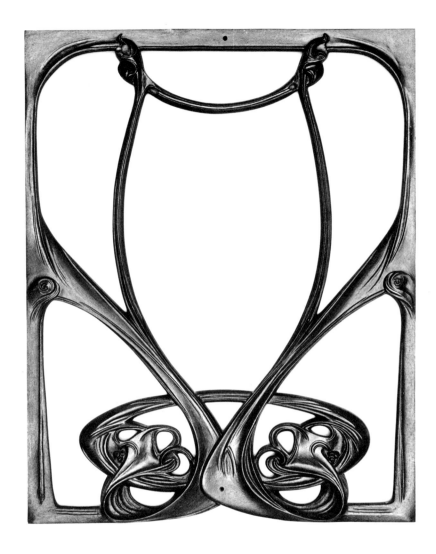

654
Panel of a balcony railing.
82 x 39 (32¼ x 15⅜)
10.5 kg. (23.1 lbs.)
Bibl: Guimard 1907, pl. 5-2.
Exh: Paris 1971a, no. 30 *bis*.

Autos-Cycles-Armes store (not by Guimard), 5 place des Halles, Marcigny (Saône-et-Loire).

655
Panel of a balcony railing for a casement window.
50 x 38 (19¾ x 15)
4.7 kg. (10.3 lbs.)
Bibl: Guimard 1907, pl. 10^BGI-1.
Exh: Paris 1971a, no. 32.

Apartment building (1910), 11 rue François-Millet, Paris 16.

Hôtel Mezzara (1911), 60 rue La Fontaine, Paris 16.

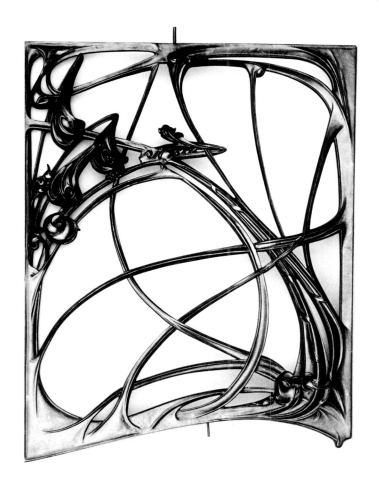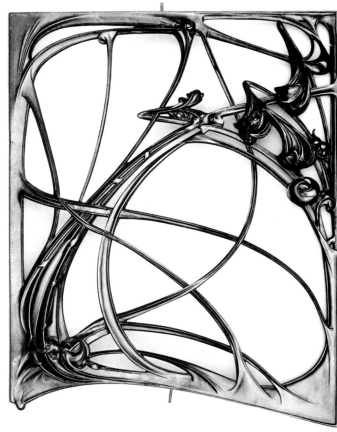

656
Panel of a balcony railing (left and right
motifs).
82 x 64 each (32¼ x 25¼)
19 kg. each (41.8 lbs.)
Bibl: Guimard 1907, pls. 5-3 (left) and 5-4
(right).
Exh: Paris 1971a, nos. 33 and 34.

Autos-Cycles-Armes store (not by Guimard), 5
place des Halles, Marcigny (Saône-et-Loire).

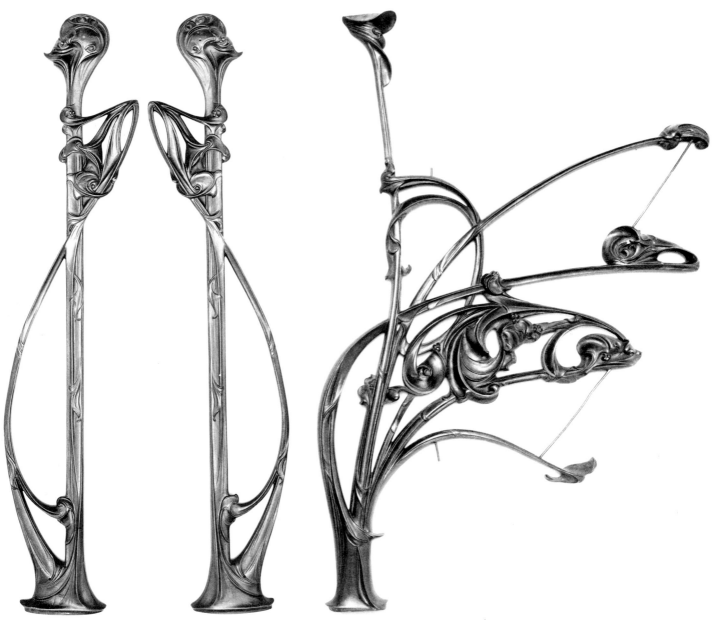

657
End-post of a balcony railing (left and right motifs).
Height 95 each (37⅜)
4.7 kg. each (10.3 lbs.)
Bibl: Guimard 1907, pls. 8GA (left), 8GB (right), 8 *bis*.
Exh: Paris 1971a, nos. 35 and 36.

658
Balustrade ornament (left and right motifs).
Height 85 each (33½)
7.5 kg. each (16.5 lbs.)
Bibl: Guimard 1907, pls. 8GC (left), 8GD (right), 8 *bis*.
Exh: Paris 1971a, nos. 37 and 38, p. 35 illus.

Hôtel Deron-Levent (1907), 8 Grande Avenue de la Villa de la Réunion, Paris 16.

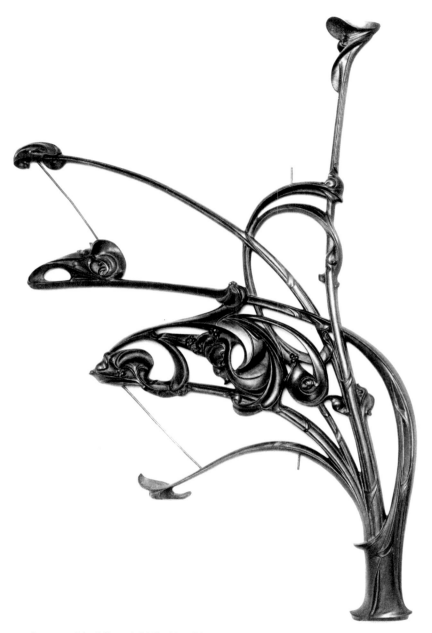

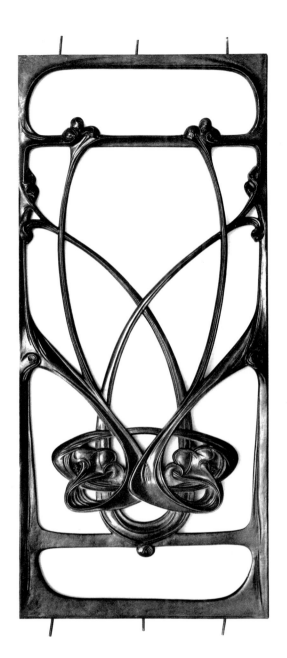

Apartment buildings (1911), 19 & 21 rue
La Fontaine, Paris 16.

Apartment building (1919), 10 rue Bretagne,
Paris 3.

Hôtel Guimard (1912), 122 avenue Mozart,
Paris 16.

Apartment buildings (1911), 8 & 10 rue Agar,
Paris 16.

659
Panel of a balcony railing.
90 x 37.5 (35½ x 14¾)
8 kg. (17.6 lbs.)
Bibl: Guimard 1907, pl. 10AGG-2.
Exh: Paris 1971a, no. 40.

Apartment buildings (1911), 19 & 21 rue
La Fontaine, Paris 16.

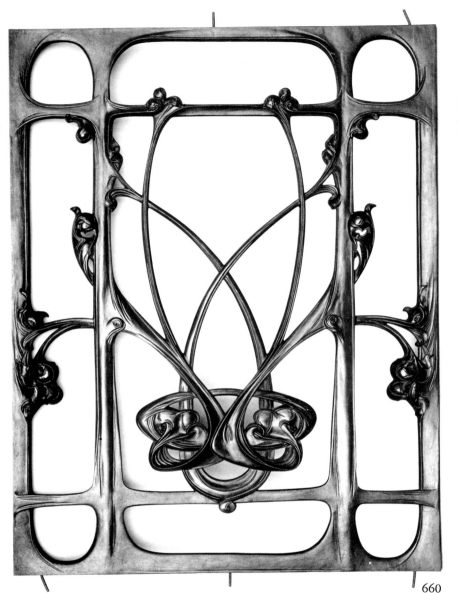

661

661
Anchor screw for a balcony railing.
Length 19 (7½)
0.9 kg. (1.9 lbs.)
Bibl: Guimard 1907, pl. 14GA.
Exh: Paris 1971a, no. 41.

Apartment buildings (1911), 19 & 21 rue
La Fontaine, Paris 16.

662
Center panel for a stone balcony.
39 x 98 (15⅜ x 38⅜)
24 kg. (52.8 lbs.)
Bibl: Guimard 1907, pl. 11GA.
Exh: Paris 1971a, no. 42.

663
Panel for a stone balcony (right motif).
31 x 47 (12¼ x 18½)
11 kg. (24.2 lbs.)
Bibl: Guimard 1907, pl. 11GC.
Exh: Paris 1971a, no. 43, p. 30 illus.

The design of this panel was originally
conceived for a radiator grille for the Humbert
de Romans Concert Hall (1898–1900) in Paris
(see cat. no. 617).

660

660
Panel of a balcony railing.
90 x 67 (35½ x 26⅜)
17 kg. (37.4 lbs.)
Bibl: Guimard 1907, pl. 10^AGG-1.
Exh: Paris 1971a, no. 39.

Apartment building (1928–29), 38 rue
Greuze, Paris 16.

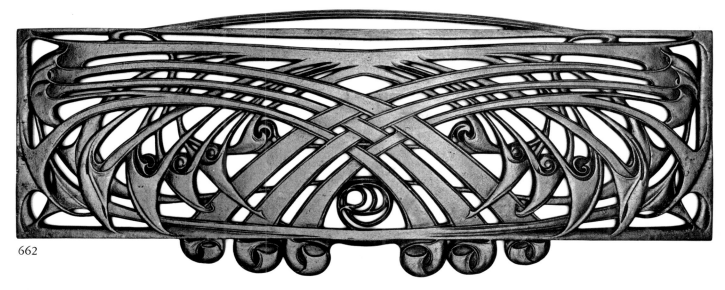

662

663

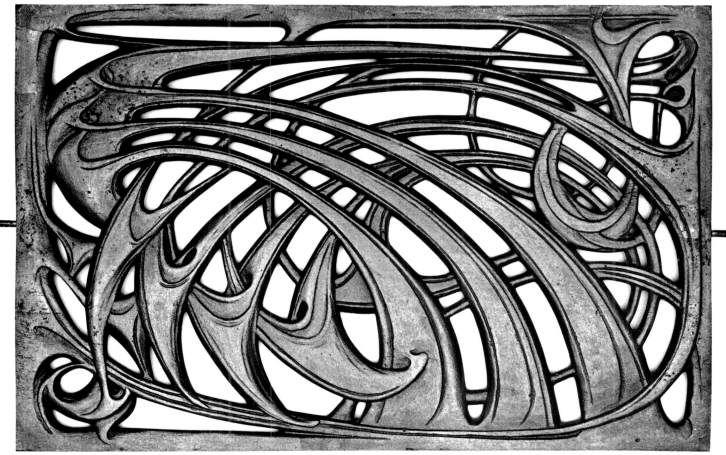

439

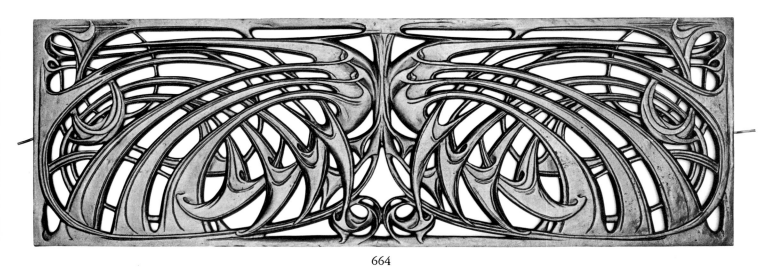

664

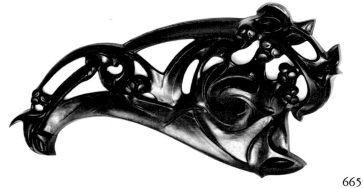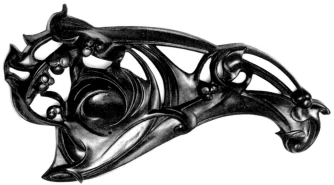

665

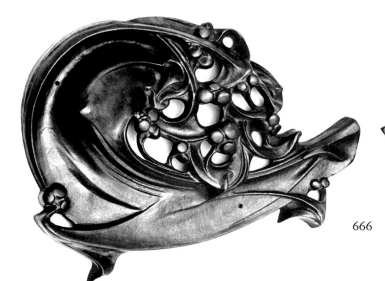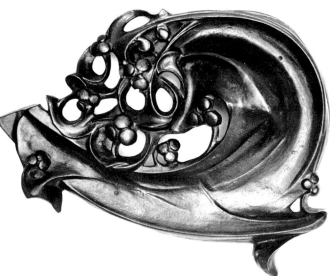

666

440

664
Center panel for a stone balcony.
31 x 90.5 (12¼ x 35⅝)
21 kg. (46.2 lbs.)
Bibl: Guimard 1907, pl. 11GB.
Exh: Paris 1971a, no. 44.

Synagogue (1913), 10 rue Pavée, Paris 4.

665
Balustrade ornament (left and right motifs).
30 x 52 each (11⅞ x 20½)
6 kg. each (13.2 lbs.)
Bibl: Guimard 1907, pl. 12GB (left and right).
Exh: Paris 1971a, nos. 45 and 46, p. 32 illus.

Apartment building (1905), 142 avenue de Versailles, Paris 16.

Apartment building (1905), 1 rue Lancret, Paris 16.

Hôtel Guimard (1912), 122 avenue Mozart, Paris 16.

666
Balustrade ornament (left and right motifs).
42 x 48 each (16½ x 18⅞)
10 kg. each (22 lbs.)
Bibl: Guimard 1907, pl. 12GC (left and right).
Exh: Paris 1971a, nos. 48 and 49, p. 34 illus.

Apartment building (1905), 142 avenue de Versailles, Paris 16.

Apartment building (1905), 1 rue Lancret, Paris 16.

667
Balustrade ornament.
49 x 50 (19¼ x 19¾)

11 kg. (24.2 lbs.)
Bibl: Guimard 1907, pl. 12GA.
Exh: Paris 1971a, no. 47, p. 32 illus.

Apartment building (1905), 142 avenue de Versailles, Paris 16.

Apartment building (1905), 1 rue Lancret, Paris 16.

668
Balustrade ornament (left and right motifs).
23 x 30 each (9 x 11⅞)
3.5 kg. each (7.7 lbs.)
Bibl: Guimard 1907, pl. 12GD (left and right).
Exh: Paris 1971a, nos. 50 and 51.

Apartment buildings (1911), 19 & 21 rue La Fontaine, Paris 16.

Apartment buildings (1911), 8 & 10 rue Agar, Paris 16.

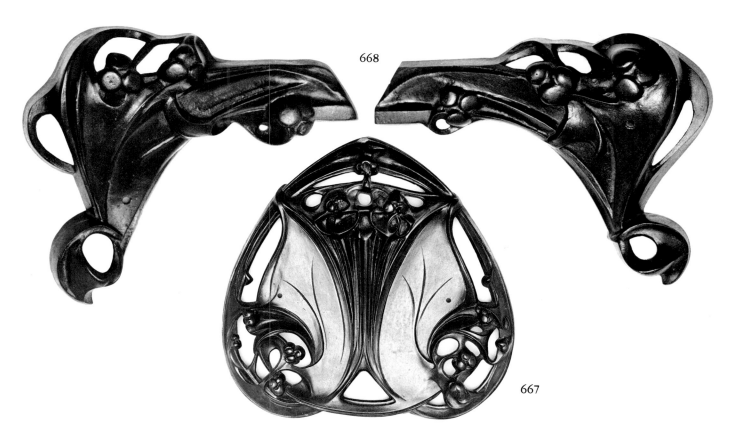

668

667

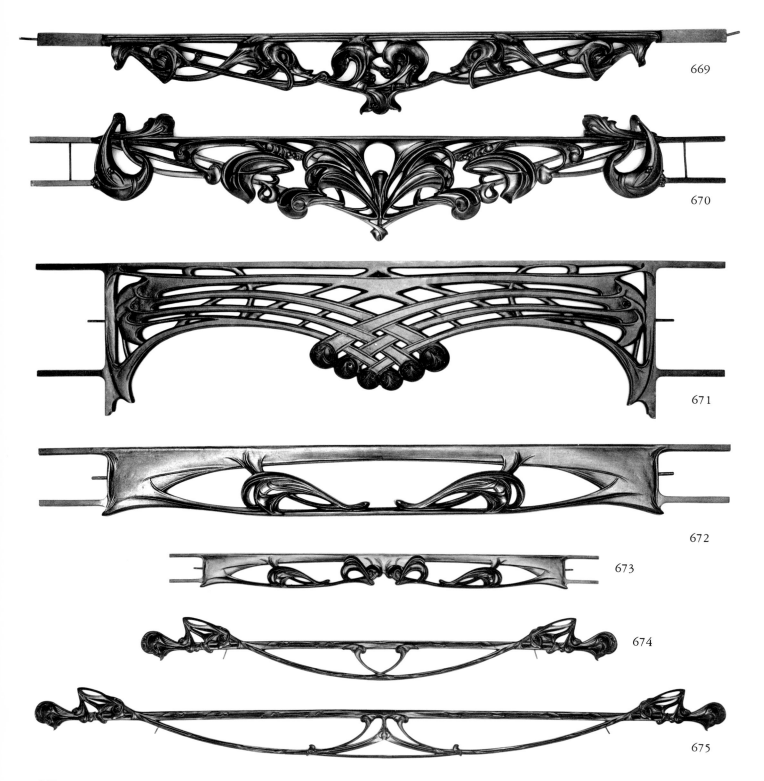

669

670

671

672

673

674

675

442

669
Railing for a casement window.
14 x 90 (5½ x 35½)
5.8 kg. (12.8 lbs.)
Bibl: Guimard 1907, pl. 16GA.
Exh: Paris 1971a, no. 52.

670
Railing for a casement window.
20 x 100 (7⅞ x 39⅜)
8.5 kg. (18.7 lbs.)
Bibl: Guimard 1907, pls. 16GB and 38.
Exh: Paris 1971a, no. 53.

671
Railing for a casement window.
26 x 90 (10¼ x 35½)
11.5 kg. (25.3 lbs.)
Bibl: Guimard 1907, pl. 16GC.
Exh: Paris 1971a, no. 54.

672
Railing for a casement window.
11.4 x 111 (4½ x 43¾)
5 kg. (11 lbs.)
Bibl: Guimard 1907, pls. 16GE and 38.
Exh: Paris 1971a, no. 55.

Apartment building (1910), 11 rue
François-Millet, Paris 16.

673
Railing for a casement window.
11.4 x 141 (4½ x 55½)
6.5 kg. (14.3 lbs.)
Bibl: Guimard 1907, pls. 16GD and 38.
Exh: Paris 1971a, no. 56.

674
Railing for a casement window.
Length 157 (61¾)
9 kg. (19.8 lbs.)
Bibl: Guimard 1907, pl. 17GG.
Exh: Paris 1971a, no. 58.

675
Railing for a casement window.
Length 214.8 (89½)
12 kg. (26.4 lbs.)
Bibl: Guimard 1907, pl. 17GG.
Exh: Paris 1971a, no. 57.

Hôtel Mezzara (1911), 60 rue La Fontaine,
Paris 16.

676
Newel post.
Height 104 (41)
16 kg. (34.3 lbs.)
Bibl: Guimard 1907, pl. 36GA.
Exh: Paris 1971a, no. 59.

Apartment buildings (1911), 8 & 10 rue Agar,
Paris 16.

Apartment building (1910), 11 rue
François-Millet, Paris 16.

677
Ornament for a baluster.
Height 19 (7½)
0.6 kg. (1.3 lbs.)
Bibl: Guimard 1907, pl. 36GA.
Exh: Paris 1971a, no. 60.

Apartment buildings (1911), 17 & 19 rue
La Fontaine, Paris 16.

Apartment buildings (1911), 8 & 10 rue Agar,
Paris 16.

677

676

443

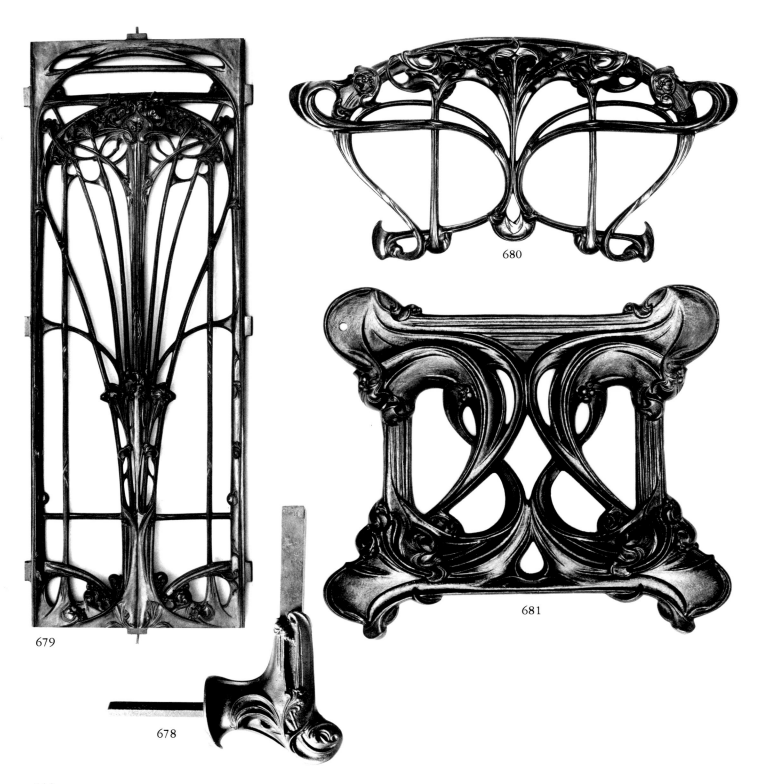

679

680

681

678

444

678
Anchor for a baluster.
12 x 10.5 (4¾ x 4⅛)
0.9 kg. (2 lbs.)
Bibl: Guimard 1907, pl. 36GA.
Exh: Paris 1971a, no. 61.

679
Grille for a door.
97.5 x 34 (38⅜ x 13⅜)
13 kg. (28.6 lbs.)
Bibl: Guimard 1907, pl. 21GD.
Exh: Paris 1971a, no. 62.

680
Fanlight grille.
29 x 56.5 (11⅜ x 22¼)
5 kg. (11 lbs.)
Bibl: Guimard 1907, pls. 22GH and 38.
Exh: Paris 1971a, no. 63.

681
Transom grille.
19.5 x 21.5 (7⅝ x 8½)
1.3 kg. (2.9 lbs.)
Bibl: Guimard 1907, pl. 22GI.
Exh: Paris 1971a, no. 64.

682
Bars for a door or window.
Length 175 (68⅞); 170 (67); 85 (33½)
Bibl: Guimard 1907, pl. 25GA.
Exh: Paris 1971a, nos. 65, 66, 67.

683
Fence spike.
Height 25 (9⅞)
0.6 kg. (1.3 lbs.)
Bibl: Guimard 1907, pl. 32GA.
Exh: Paris 1971a, no. 68, p. 40 illus.

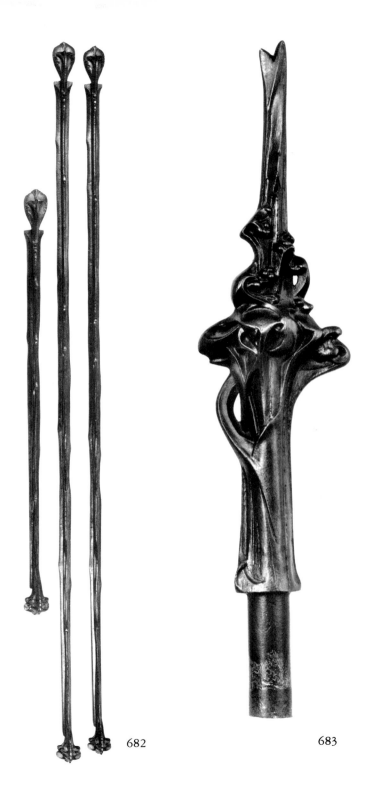

682 683

684
Fence spike.
Height 20 (7⅞)
0.7 kg. (1.5 lbs.)
Bibl: Guimard 1907, pl. 32GB.
Exh: Paris 1971a, no. 69.

Villa (1910), 16 rue Jean-Doyen, Eaubonne.

685
Fence spike.
Height 17 (6¾)
0.6 kg. (1.2 lbs.)
Bibl: Guimard 1907, pl. 32GC.
Exh: Paris 1971a, no. 70.

686
Fence spike.
Height 14 (5½)
0.4 kg. (0.8 lbs.)
Bibl: Guimard 1907, pl. 32GD.
Exh: Paris 1971a, no. 71.

687
Door handle (left and right motifs).
Length 28 each (11)
1 kg. each (2.2 lbs.)
Bibl: Guimard 1907, pls. 32GA (left) and
32GB (right).
Exh: Paris 1971a, nos. 72 and 73.

688
Escutcheon/ lintel ornament.
Diameter 10.5 (4⅛)
0.4 kg. (0.8 lbs.)
Bibl: Guimard 1907, pls. 10D, 15GE, 32GO.
Exh: Paris 1971a, no. 17, p. 41 illus.

689
Doorknob.
Diameter 9 (3½)
Bibl: Guimard 1907, pls. 32GD and 38.
Exh: Paris 1971a, no. 74, p. 41 illus.

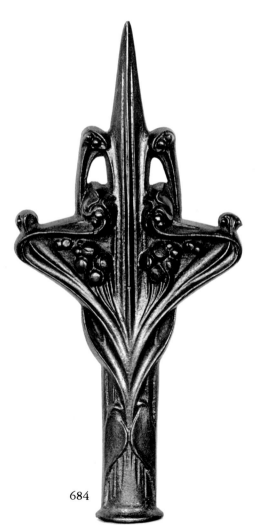

684

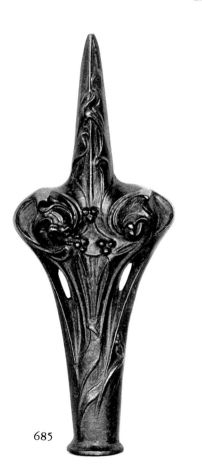

685

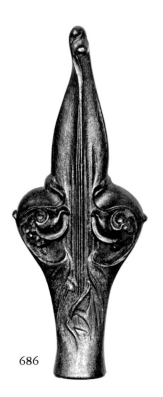

686

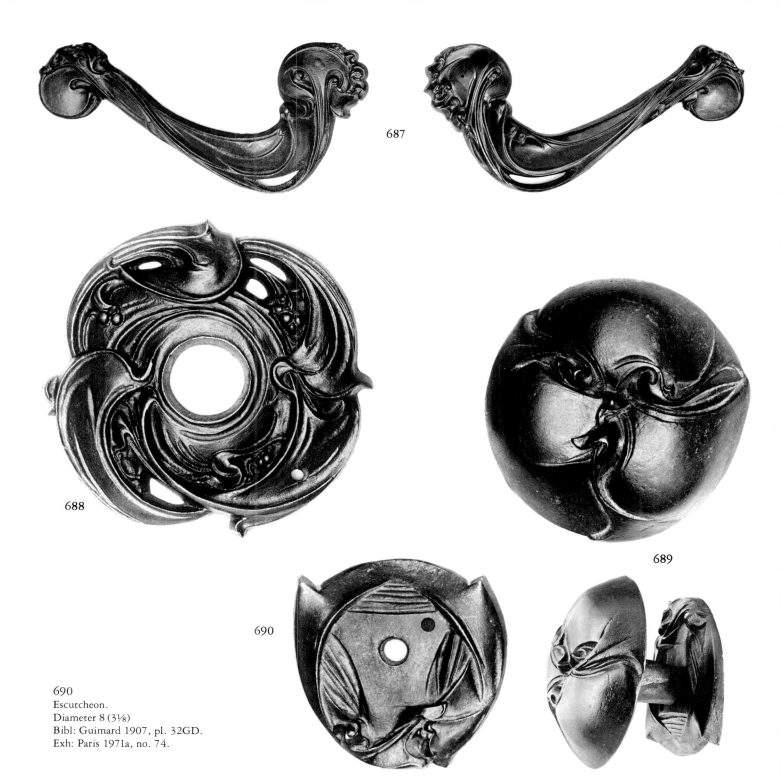

687

688

689

690
Escutcheon.
Diameter 8 (3⅛)
Bibl: Guimard 1907, pl. 32GD.
Exh: Paris 1971a, no. 74.

690

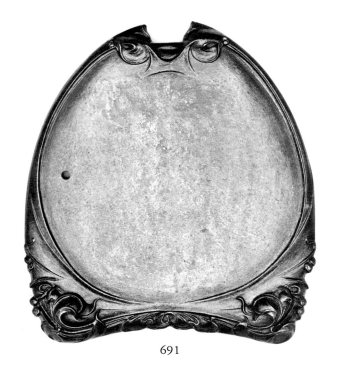

691

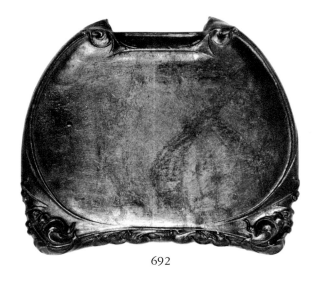

692

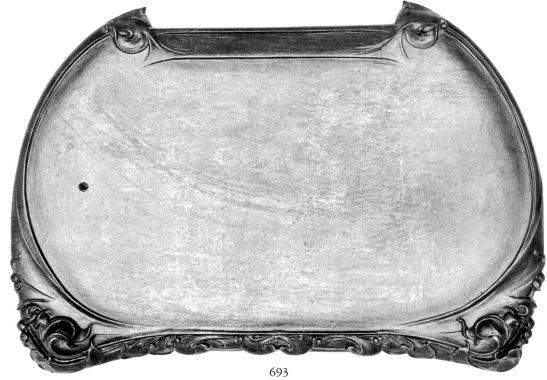

693

448

694

691
Address plate.
22 x 19 (8⅝ x 7½)
2.3 kg. (5 lbs.)
Bibl: Guimard 1907, pls. 33 and 35.
Exh: Paris 1971a, no. 75.

Apartment building (1905), 1 rue Lancret,
Paris 16.

Hôtel Deron-Levent (1907), 8 Grande Avenue
de la Villa de la Réunion, Paris 16.

Apartment building (1911), 8 & 10 rue Agar,
Paris 16.

692
Address plate.
22 x 31 (8⅝ x 12¼)
Bibl: Guimard 1907, pls. 35 and 38.
Exh: Paris 1971a, no. 76, p. 36 illus.

Hôtel Mezzara (1911), 60 rue La Fontaine,
Paris 16.

693
Address plate.
22 x 41 (8⅝ x 16⅛)
Bibl: Guimard 1907, pl. 35.
Exh: Paris 1971a, no. 77.

694
Address numerals.
14 x 10 each (5½ x 4)
Bibl: Guimard 1907, pls. 33, 35, 38.
Exh: Paris 1971a, no. 78, p. 36 illus.

Apartment building (1905), 142 avenue de
Versailles, Paris 16.

Hôtel Guimard (1912), 122 avenue Mozart,
Paris 16.

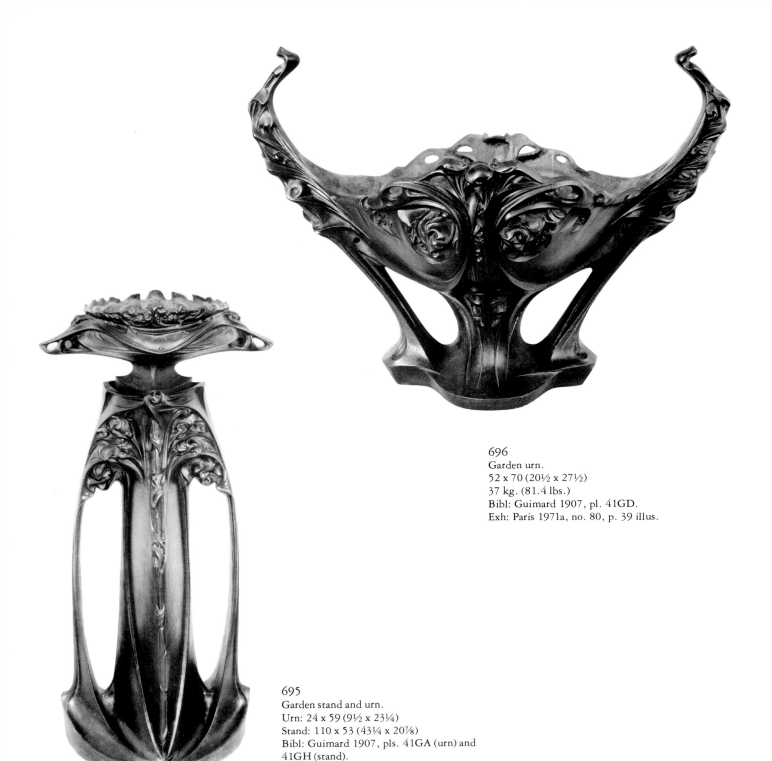

696
Garden urn.
52 x 70 (20½ x 27½)
37 kg. (81.4 lbs.)
Bibl: Guimard 1907, pl. 41GD.
Exh: Paris 1971a, no. 80, p. 39 illus.

695
Garden stand and urn.
Urn: 24 x 59 (9½ x 23¼)
Stand: 110 x 53 (43¼ x 20⅞)
Bibl: Guimard 1907, pls. 41GA (urn) and
41GH (stand).
Exh: Paris 1971a, no. 79, pp. 38 and 39 illus.

697
Garden urn.
33 x 55 (13 x 21⅝)
23 kg. (50.6 lbs.)
Bibl: Guimard 1907, pl. 42GE.
Exh: Paris 1971a, no. 81.

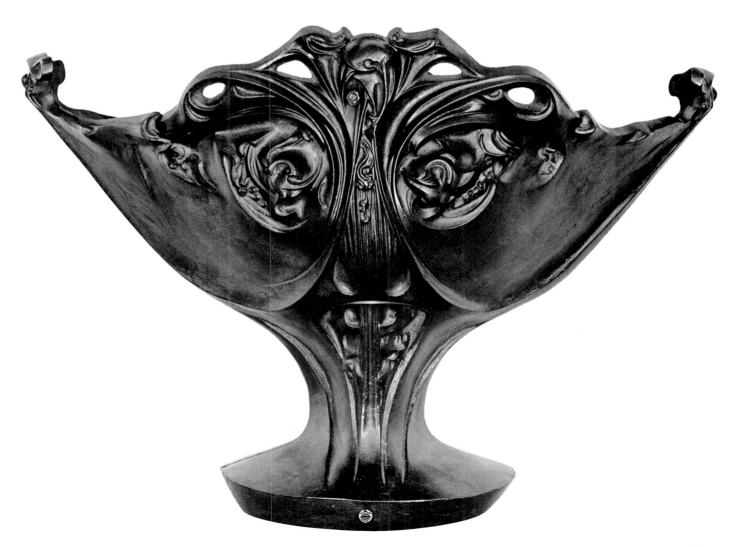

698
Base of a pedestal table.
70 x 31 (27½ x 12⅜)
9 kg. (19.8 lbs.)
Bibl: Guimard 1907, pl. 40GA.
Exh: Paris 1971a, no. 82.

699
Leg of a trestle table.
69 x 50 (27⅛ x 19¾)
7.5 kg. (16.5 lbs.)
Bibl: Guimard 1907, pl. 40GA.
Exh: Paris 1971a, no. 83.

700
Frame of a theater seat.
Height 89 (35)
9.5 kg. (20.9 lbs.)
Bibl: Guimard 1907, pl. 40GA.
Exh: Paris 1971a, no. 84.

Humbert de Romans Concert Hall
(1898–1900; demolished 1905), 60 rue
Saint-Didier, Paris 16.

701
Frieze ornament (left and right motifs).
Length 14 each (5½)
0.18 kg. each (0.4 lbs.)
Bibl: Guimard 1907, pls. 32GP (left) and
32GQ (right).
Exh: Paris 1971a, nos. 85 and 86.

702
Frieze ornament (left and right motifs).
Length 20 each (7⅞)
0.38 kg. each (0.83 lbs.)
Bibl: Guimard 1907, pls. 32GR (left) and
32GS (right).
Exh: Paris 1971a, nos. 87 and 88.

703
Frieze ornament (left and right motifs).
Length 16.3 each (6⅜)
0.3 kg. each (0.66 lbs.)
Bibl: Guimard 1907, pls. 42GT (left) and
42GU (right).
Exh: Paris 1971a, nos. 89 and 90.

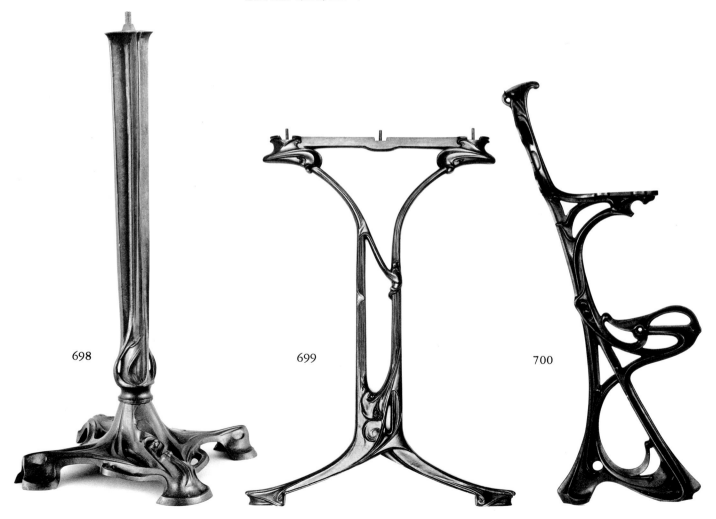

698 699 700

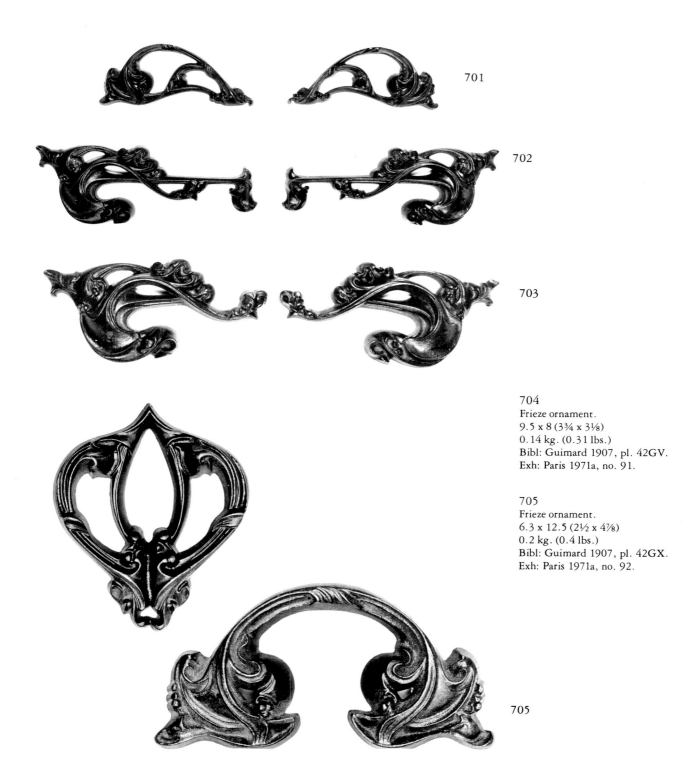

701

702

703

704
Frieze ornament.
9.5 x 8 (3¾ x 3⅛)
0.14 kg. (0.31 lbs.)
Bibl: Guimard 1907, pl. 42GV.
Exh: Paris 1971a, no. 91.

705
Frieze ornament.
6.3 x 12.5 (2½ x 4⅞)
0.2 kg. (0.4 lbs.)
Bibl: Guimard 1907, pl. 42GX.
Exh: Paris 1971a, no. 92.

705

706
Shelf bracket.
13 x 21 (5⅛ x 8¼)
0.6 kg. (1.3 lbs.)
Bibl: Guimard 1907, pl. 40GA.
Exh: Paris 1971a, no. 93.

707
Coat-hook.
Height 19 (7½)
0.8 kg. (1.8 lbs.)
Bibl: Guimard 1907, pl. 40GA.
Exh: Paris 1971a, no. 94.

708
Umbrella and cane stand.
Height 82 (32¼)
14 kg. (30.8 lbs.)
Bibl: Guimard 1907, pl. 40GA.
Exh: Paris 1971a, no. 95.

Another example in the collection of the
Museum of Modern Art, New York (Gift of
Madame Guimard, 1945).

709
Mantelpiece.
93.2 x 101.4 (36¾ x 40)
Bibl: Guimard 1907, pl. 61GB.
Exh: Paris 1971a, no. 96.

Apartment buildings (1911), 8 & 10 rue Agar,
Paris 16.

710
Andiron.
Height 49 (19¼)
6 kg. (13.2 lbs.)
Bibl: Guimard 1907, pl. 60GA.
Exh: Paris 1971a, no. 97.

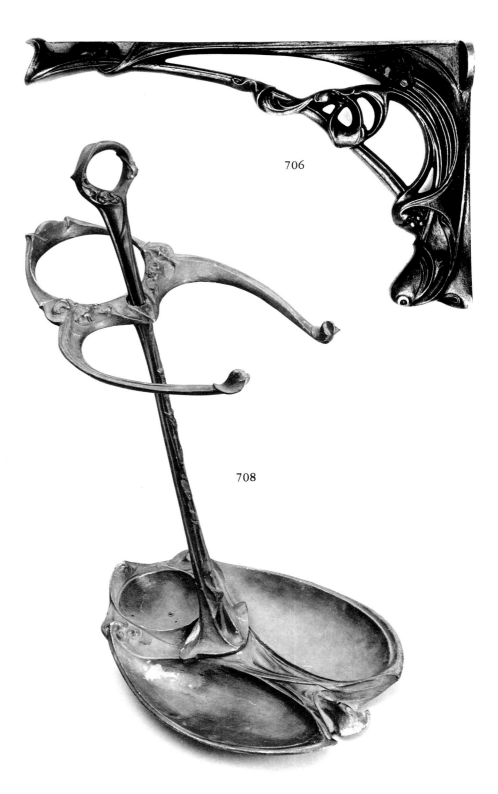

706

708

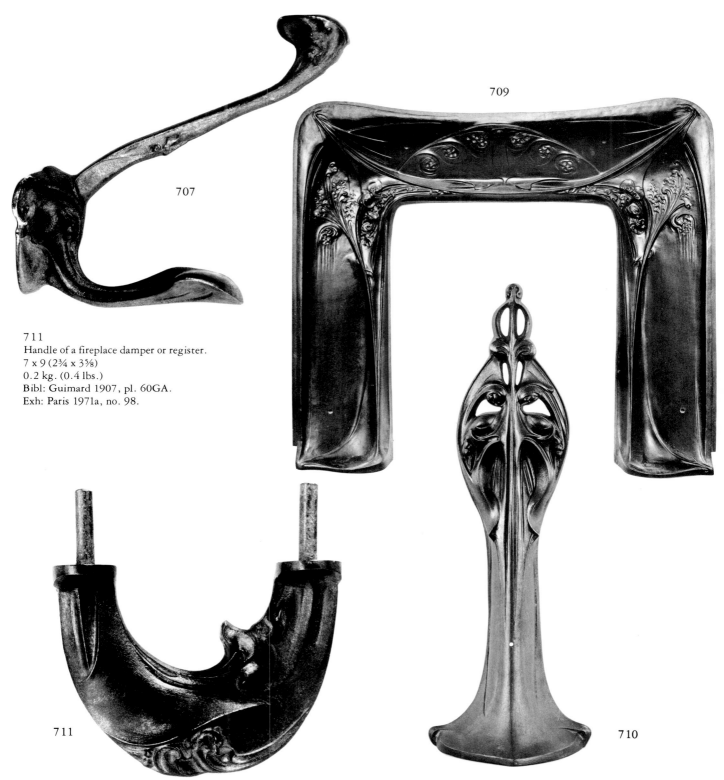

707

709

711
Handle of a fireplace damper or register.
7 x 9 (2¾ x 3⅝)
0.2 kg. (0.4 lbs.)
Bibl: Guimard 1907, pl. 60GA.
Exh: Paris 1971a, no. 98.

710

711

712
Ventilator grille.
6 x 21 (2⅜ x 8¼)
0.33 kg. (0.73 lbs.)
Bibl: Guimard 1907, pl. 60GB.
Exh: Paris 1971a, no. 100.

713
Ventilator grille.
7 x 22.5 (2¾ x 8⅞)
0.7 kg. (1.5 lbs.)
Bibl: Guimard 1907, pl. 60GA.
Exh: Paris 1971a, no. 99.

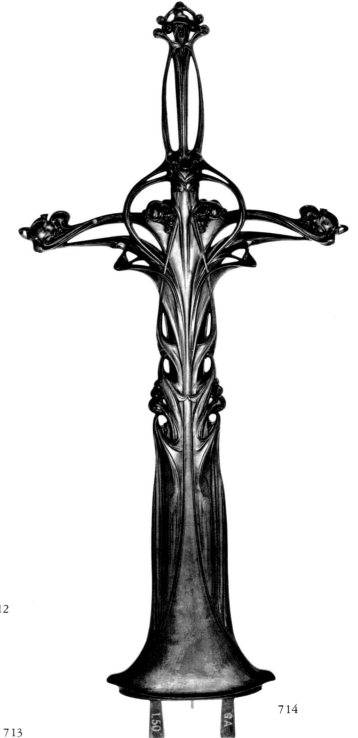

712

713

714

456

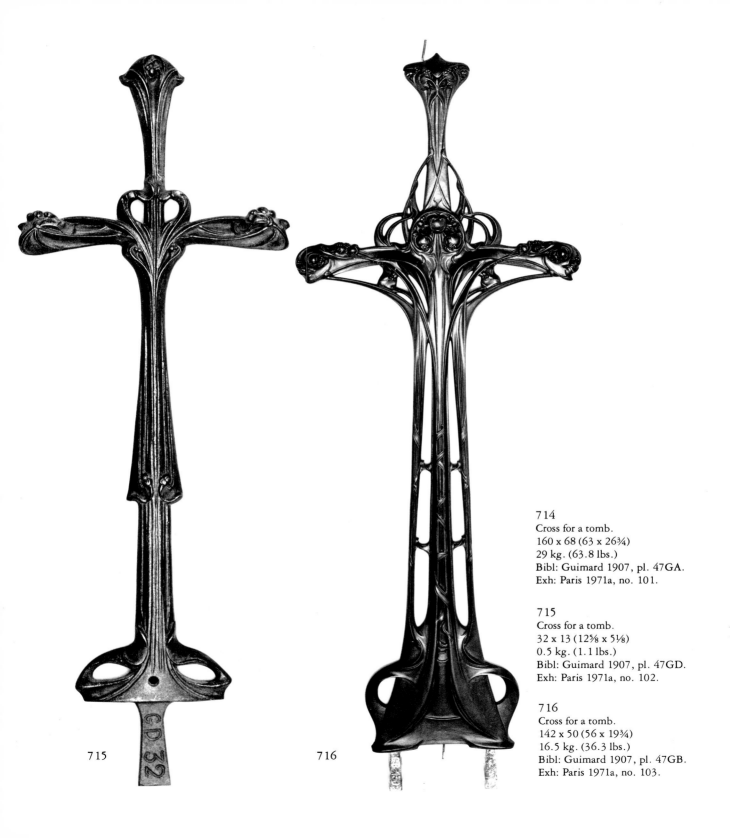

715

716

714
Cross for a tomb.
160 x 68 (63 x 26¾)
29 kg. (63.8 lbs.)
Bibl: Guimard 1907, pl. 47GA.
Exh: Paris 1971a, no. 101.

715
Cross for a tomb.
32 x 13 (12⅝ x 5⅛)
0.5 kg. (1.1 lbs.)
Bibl: Guimard 1907, pl. 47GD.
Exh: Paris 1971a, no. 102.

716
Cross for a tomb.
142 x 50 (56 x 19¾)
16.5 kg. (36.3 lbs.)
Bibl: Guimard 1907, pl. 47GB.
Exh: Paris 1971a, no. 103.

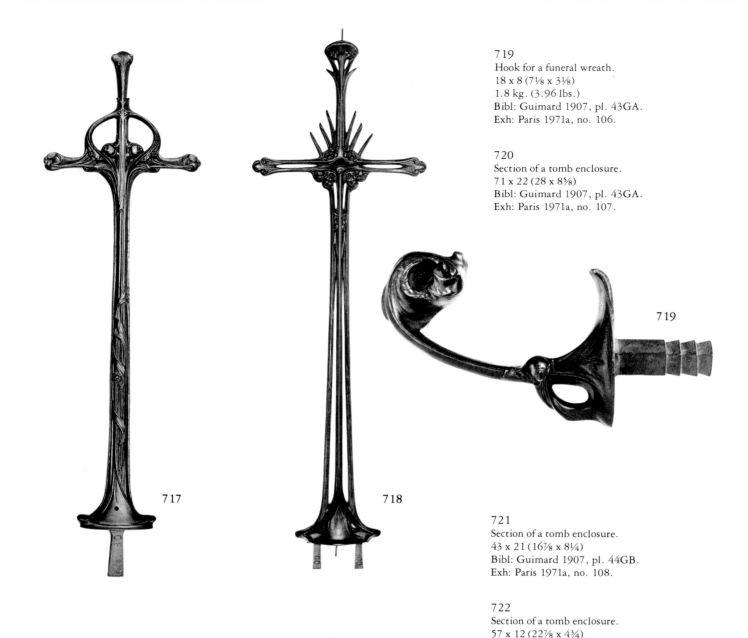

719
Hook for a funeral wreath.
18 x 8 (7⅛ x 3⅛)
1.8 kg. (3.96 lbs.)
Bibl: Guimard 1907, pl. 43GA.
Exh: Paris 1971a, no. 106.

720
Section of a tomb enclosure.
71 x 22 (28 x 8⅝)
Bibl: Guimard 1907, pl. 43GA.
Exh: Paris 1971a, no. 107.

719

721
Section of a tomb enclosure.
43 x 21 (16⅞ x 8¼)
Bibl: Guimard 1907, pl. 44GB.
Exh: Paris 1971a, no. 108.

722
Section of a tomb enclosure.
57 x 12 (22⅞ x 4¾)
Bibl: Guimard 1907, pl. 43.
Exh: Paris 1971a, no. 109.

723
Length of chain for a tomb enclosure.
Double links (5): Length 16 each (6⅜)
Single links (4): Length 9.5 each (3¾)
3.45 kg (7.6 lbs.)
Bibl: Guimard 1907, pl. 44.
Exh: Paris 1971a, nos. 110 and 111.

717
Cross for a tomb.
55 x 18 (21⅝ x 7⅛)
1.5 kg. (3.3 lbs.)
Bibl: Guimard 1907, pl. 47GE.
Exh: Paris 1971a, no. 104.

718
Cross for a tomb.
109 x 34 (43 x 13⅜)
5.5 kg. (12.1 lbs.)
Bibl: Guimard 1907, pl. 47GC.
Exh: Paris 1971a, no. 105.

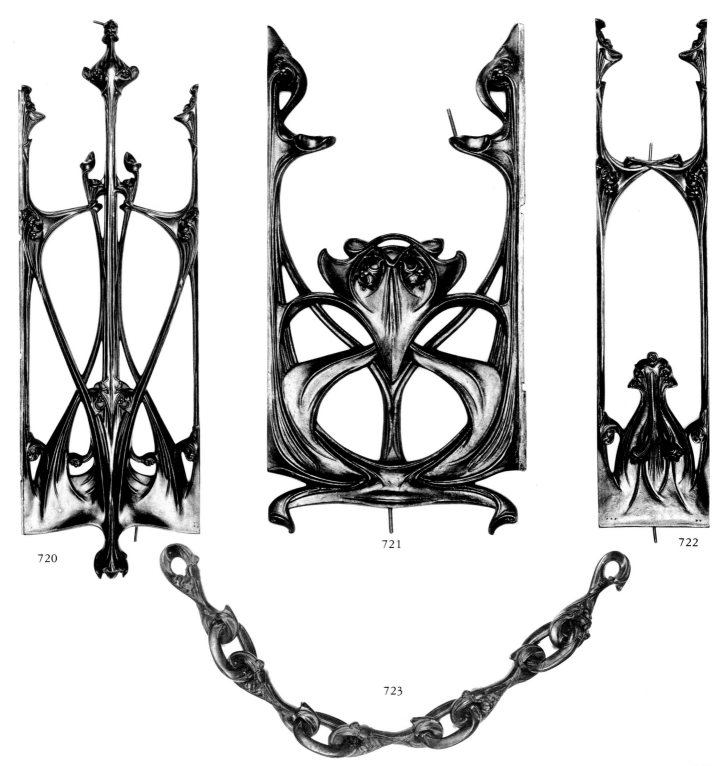

720

721

722

723

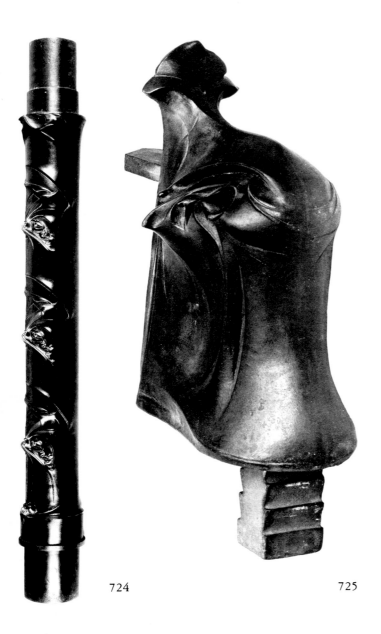

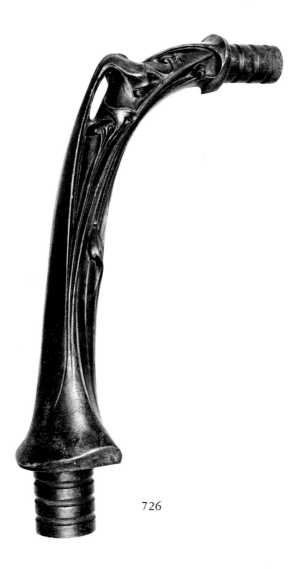

725
Fender.
32 x 21 (12⅝ x 8¼)
29 kg. (63.8 lbs.)
Bibl: Guimard 1907, pl. 34GC.
Exh: Paris 1971a, no. 114.

726
Fender.
Height 53 (20⅞)
17 kg. (37.4 lbs.)
Bibl: Guimard 1907, pl. 34GD.
Exh: Paris 1971a, no. 115.

724

725

724
Downspout.
110 x 11 (39⅜ x 4⅜)
22 kg. (48.4 lbs.)
Bibl: Guimard 1907, pl. 30GB.
Exh: Paris 1971a, no. 112, illustrated on title
page.

Hôtel Guimard (1912), 122 avenue Mozart,
Paris 16.

726

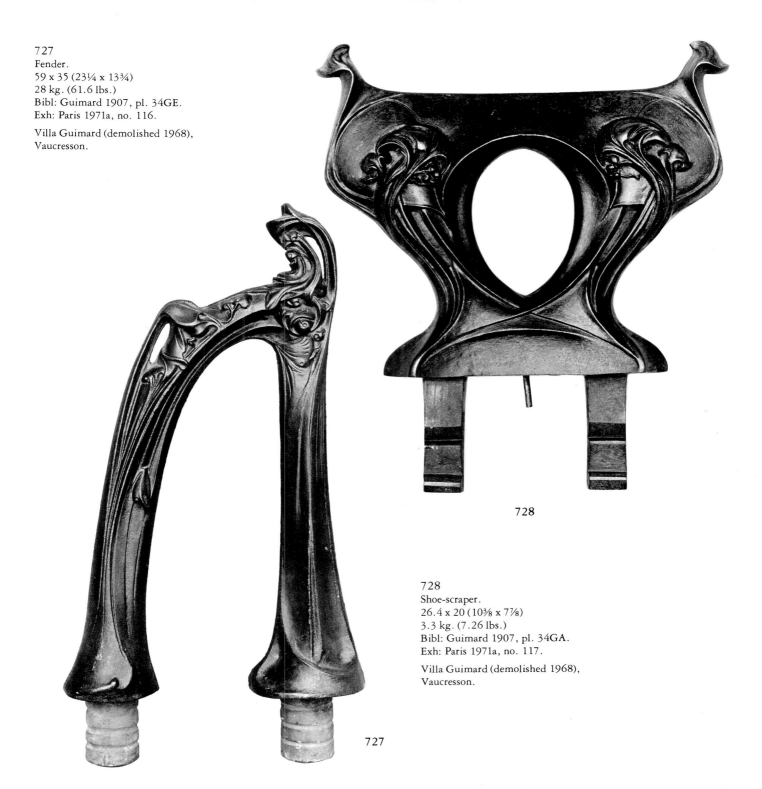

727
Fender.
59 x 35 (23¼ x 13¾)
28 kg. (61.6 lbs.)
Bibl: Guimard 1907, pl. 34GE.
Exh: Paris 1971a, no. 116.

Villa Guimard (demolished 1968),
Vaucresson.

728

728
Shoe-scraper.
26.4 x 20 (10⅜ x 7⅞)
3.3 kg. (7.26 lbs.)
Bibl: Guimard 1907, pl. 34GA.
Exh: Paris 1971a, no. 117.

Villa Guimard (demolished 1968),
Vaucresson.

727

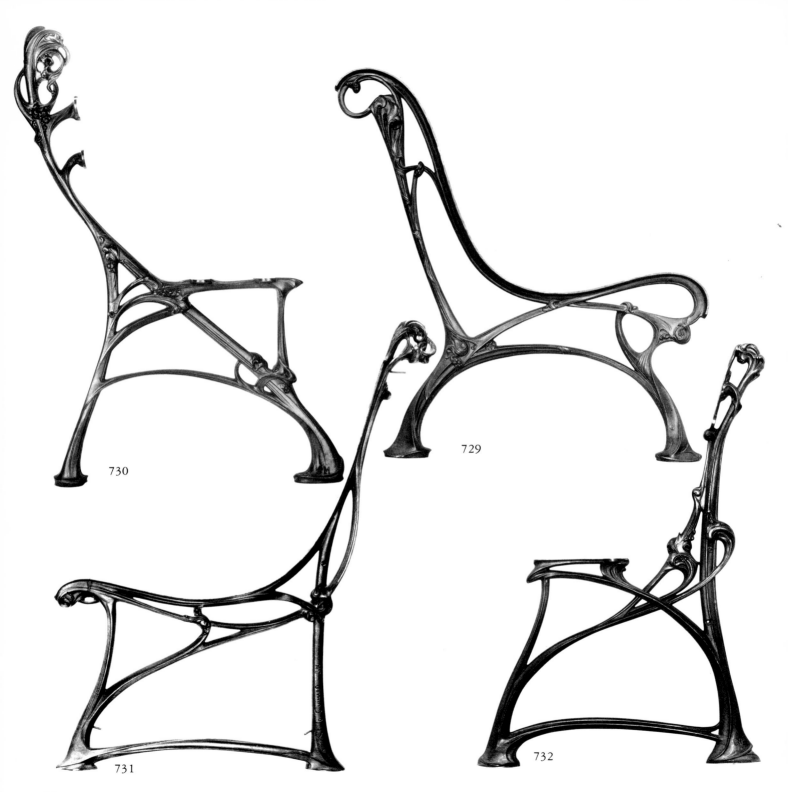

730

729

731

732

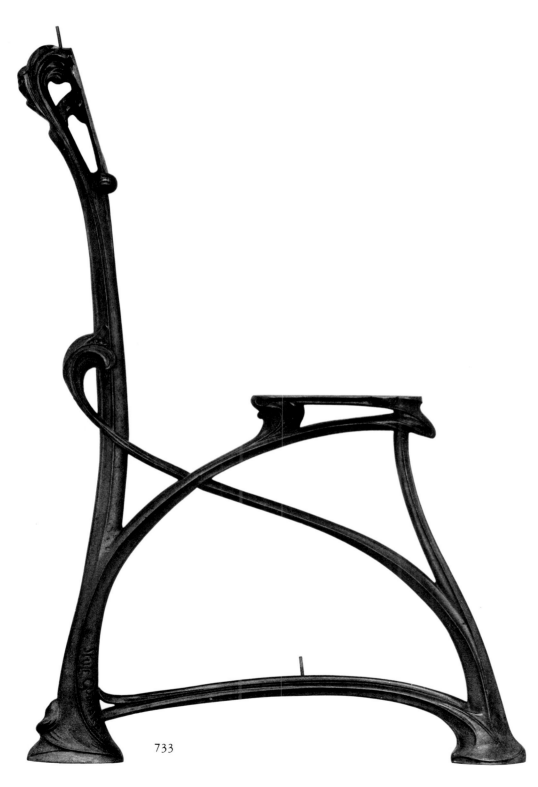

733

729
Frame of a garden bench.
74 x 58 (29⅛ x 22⅞)
11 kg. (24.2 lbs.)
Bibl: Guimard 1907, pl. 41GL.
Exh: Paris 1971a, no. 118.

730
Frame of a garden bench.
90 x 56 (35½ x 22)
12 kg. (26.4 lbs.)
Bibl: Guimard 1907, pl. 41GM.
Exh: Paris 1971a, no. 119.

731
Frame of a garden bench.
92 x 57 (36¼ x 22½)
13.6 kg. (30 lbs.)
Bibl: Guimard 1907, pl. 42GN.
Exh: Paris 1971a, no. 120.

732
Frame of a garden bench.
66 x 56 (26 x 22)
10.5 kg. (23.1 lbs.)
Bibl: Guimard 1907, pl. 42GO.
Exh: Paris 1971a, no. 121.

733
Frame of a garden bench.
85 x 56 (33½ x 22)
Exh: Paris 1971a, no. 122.

Biographies of the Artists

EDMOND FRANCOIS AMAN-JEAN
French, b. Chevry-Cossigny (Seine-et-Marne) 1860, d. Paris 1936.

Aman-Jean received formal training at the Ecole des Beaux-Arts, and with a fellowship made the classic "journey to Rome" in 1886. Puvis de Chavannes, with whom he worked as a student and as an assistant, had a decisive influence on him. His connection with the literary circle of Symbolism and with the Sâr Peladan oriented his taste. Women, both dreamy and subtly sensual, were his favorite subject matter.

EMILE ANDRÉ
French, b. Nancy.

Emile André was a founding member and the foremost architect of the Ecole de Nancy. An advocate of unity of the arts, he designed furniture to coordinate with the houses he built. His entry at the Ecole de Nancy exhibition in Paris, March 1903, included architectural studies and photographs of homes, apartment buildings, and stores he had built; studies from trips to India, Egypt, and Tunisia; and furniture resembling that of Louis Majorelle. His best buildings are the residence at 92 and 92 *bis* Quai Claude-le-Lorrain (1903) and the house at 34 rue du Sergent-Blandan (1903), both in Nancy. His sons Jacques and Michel took over their father's business and collaborated with, among others, Jean Prouvé, the son of Victor Prouvé (*Exposition Ecole de Nancy* 1903, p. 7; Oudin 1970, pp. 21–22).

ATCHÉ
Atché, a poster artist working in Paris, was a friend of Mucha and was greatly influenced by him. Before their meeting Atché had produced a poster for Vincent chocolate comparable to the poorest Chéret, but his poster for Job cigarette papers is one of the most beautiful of the time: the woman, and the smoke from her cigarette playing with the letters, are Art Nouveau to perfection. Atché left his career to become director of the casino at Nice (Mucha 1966, p. 244). A.W.

BAPST ET FALIZE
Paris.

The firm of Bapst et Falize, goldsmiths and jewelers, was founded in 1879 by scions of two famous families of jewelers: Germain Bapst's forebears had been jewelers to the court of France continuously since 1752; Lucien Falize (1839–97) was the son of Alexis (1811–98), a noted jeweler who had established the family firm in the Palais Royale in 1838. Inspired by a collection of Japanese art they saw in London in 1862, and by Christofle's use of enamels, Alexis and Lucien Falize had revived the Japanese technique of cloisonné enameling on jewelry during the late 1860s. Lucien, who collaborated on works with Emile Gallé and Paul Grandhomme, was also a contributor to Bing's *Le Japon Artistique.*

Germain Bapst retired from the firm in 1891. Lucien Falize continued working until his death in 1897, when the enterprise passed into the hands of his sons André (1872–1936), Pierre, and Jean. As Falize Frères, under André's direction, the firm exhibited at the 1900 Exposition Universelle, and many years later received a commission to execute the swords awarded to French generals after World War I (Vever 1908, pp. 498–500; Gere 1975, pp. 149–50, 176–77; Eidelberg 1975, pp. 148, 169, 187).

AUBREY VINCENT BEARDSLEY
English, b. Brighton 1872, d. Mentone (Nice) 1898.

Eminently gifted, Beardsley sold his first drawings when he was eleven; at twenty-two, with the *Salome* illustrations and *The Yellow Book,* he was notorious. His art was shaped by influences as diverse as Blake, Morris' Kelmscott Press, Whistler, Japanese prints, and Greek vases, yet the graphic style that emerged was original and intensely personal, and became a source of inspiration to artists from America to Russia. Beardsley's drawings for *Salome* were exhibited at La Libre Esthétique in 1894, those for the *Morte d'Arthur* in 1895; his works were shown again at the 1900 Exposition Universelle in Paris, two years after tuberculosis had ended his brief career.

EDMOND BECKER
French, b. Paris.

Becker, a woodcarver, studied under Hiolon and Valton. Works he produced in collaboration with the Parisian jewelry firm of Boucheron combined such materials as gold and enamel with ebony and other rare woods. Becker exhibited with the Société des Artistes Français from 1898 on; his entries in the salons around 1901 won him considerable notice in art reviews (Bouyer 1901b; Sylvestre 1901).

EMILE BERCHMANS
Belgian, b. Liège 1867, d. Liège 1947.

A painter, decorator, illustrator, and poster artist, Berchmans received his early training from his father, also an artist, and at the academy in Liège. With Rassenfosse, Donnay, and Maurice Siville he founded the *Caprice Revue;* he exhibited at La Libre Esthétique in 1895, 1896, and 1899 and with L'Art Indépendant (for whom he created a poster in 1897) in Paris. Berchmans was a talented poster artist, his brushstroke firm and assured, his figures strongly outlined in black or white, or often both. He used both allegorical themes (*Légia Art et Charité, Exposition Architecture et Art Décoratif*) and scenes from everyday life (*Savon Sunlight, Lampe et Fourneau Belges);* women often figure in his compositions (Oostens-Wittamer 1975, pp. 13–17). A.W.

HENRI BERGÉ
Henri Bergé, sculptor, painter, and glass designer, worked in Nancy from around 1897 to 1914, where he was the artistic director for the Daum design studios. After 1908 he made models for the *pâte de verre* sculptures Almaric Walter produced in a studio provided by the Daums. Bergé was a member of the Ecole de Nancy; flower motifs and landscape scenes predominate in his paintings (Hilschenz 1973, p. 356).

EMILE BERNARD
French, b. Lille 1868, d. Paris 1941.

At seventeen Bernard entered the studio of Cormon, where he met Toulouse-Lautrec and Anquetin. In the summer of 1888 he was introduced to Gauguin, who was working at Pont-Aven in Brittany. Their encounter was a turning point in the history of art: the change from Impressionist technique and purpose to a more abstract form of art with emphasis on well-

delineated areas of flat colors, as in cloisonné enamel and Japanese prints. Bernard was perhaps the first to have hit upon this "cloissonism" or "synthetism," as it was called before it developed into Symbolism. Yet it has been pointed out that the work Gauguin had done on ceramics with Chaplet, using a "cloisonné" technique, already could have had an influence on Gauguin's style.

Bernard exhibited at the Café Volpini in 1889, with the Nabis at Le Barc de Boutteville's in 1892 and 1893, with Les Indépendants in 1891, 1892, 1893, and 1902, and in the first Salon de la Rose+Croix in 1892. Bernard traveled extensively, spending several years in the Near East. He corresponded with Gauguin, Cézanne, and Van Gogh. An excellent writer, he wrote studies on the latter two painters. S.C.

JOSEPH BERNARD

French, b. Vienne (Isère), d. Paris 1931.
The son of a stonecutter, Joseph Bernard began to do sculpture at an early age. He studied at the Beaux-Arts schools in Lyons and Paris, then worked independently, quickly moving from clay to direct carving and work with dry plaster, which served as a starting point for his bronzes and marbles. His major works date from the 1910s and 1920s. Besides exhibiting regularly at the Salon d'Automne and the Salon des Tuileries he sent a group, *Séparation,* to the Exposition Universelle of 1900; for the 1925 Exposition des Arts Décoratifs in Paris he executed the large *Bas-Relief de la Danse* in the Pavillon Ruhlmann (Riotor 1908). Y.B.

PAUL BERTHON

French, b. c.1848, d. 1909.
A disciple of Grasset, Berthon declared in a famous text: "We want to create an original art, with no model but nature, with no rule but imagination and logic, while using the French flora and fauna for details and closely following the principles that made the arts of the Middle Ages so decorative. I try only to copy nature in its very essence." Berthon's posters feature women of medieval appearance surrounded by flowers: *L'Ermitage* (1896), *Salon des 100* (1895), *Source des Roches, Liane de Pougy* (1895), and *A l'Eglantine.* Besides posters, he did several decorative lithographs—landscapes with a strong Japanese influence, a series of European sovereigns, and numerous women—all with green and yellow as the main colors. A.W.

ARISTIDE BÉZARD

French.

Around 1902 Aristide Bézard made earthenware with barbotine decoration at Marlotte, where in the 1870s a small factory for the production of decorated revetment tiles in earthenware had been located. His associate, Emile Moussaux, created flambé stoneware. Bézard was killed in World War I; Moussaux closed the factory around 1930–32 (Lesur 1957, p. 365). C.C.

LOUIS BIGAUX

French.
Around the turn of the century Louis Bigaux, an architect, began to develop new concepts of form and decoration for the art of interior design. To that end he gathered around him a group of young artists who worked under his direction and who contributed significantly to his projects. Bigaux's studios were organized to answer every problem of decorative art— painting, design, sculpture, carpentry. For the Exposition Universelle of 1900 Bigaux created a luxurious interior realized with the help of manufacturers who had called on him to update their patterns: it included bronzes by Eugène Baguès, wallpaper by Isidore Leroy, ceramics by Alexandre Bigot, furniture and paneling by Le Coeur, and marbles by Poincet (Soulier 1900c). C.C.

ALEXANDRE BIGOT

French, b. Mer (Loire-et-Cher) 1862, d. 1927.
A physics and chemistry professor, Bigot discovered stoneware and porcelain from the Far East at the Exposition Universelle of 1889 and at the same time discovered his vocation as a ceramist. He was especially interested in Chinese porcelain and its decoration: unlike European porcelain the clay was not translucent, while the glazes were colored, sometimes opaque. He decided to work in stoneware (a less expensive medium than porcelain), carrying on his research in his home town, and in 1894 showed his first pieces, simple forms with yellow, green, and brown mat glazes.

At the 1900 Exposition Universelle Bigot received a grand prize. He had executed the animal frieze for the exposition's monumental gateway, now at the Musée des Arts Décoratifs, after the sculptor Paul Jouve's designs. He reproduced a smaller version of it in a studio he opened in Paris at 13 rue des Petites Ecuries, where he specialized in the production of "flambé stoneware: art objects, vases, statues, etc. . . . and designs for architecture such as bricks, tiles, friezes, decorative panels, and special pieces." Following the example of Emile

Müller, Bigot took up the production of architectural ceramics: "I took it as a matter of principle to put my artistic and scientific knowledge at the disposal of architects who wanted to create personal designs in their constructions. . . . Having at hand a beautiful and durable material with varied tones effected by firing, I dedicated all my efforts to the interior and exterior decoration of our dwellings. I tried to produce in an economic way colorful decorations for private residences or apartment houses. The experiment was undertaken and the results were conclusive! It was no more costly to decorate a facade with stoneware than with carved stone" (Bigot 1902, preface). Along with his own models he offered tile friezes designed by Guimard, Van de Velde, Roche, Jouve, Sauvage, Majorelle, de Baudot, Formigé, and Lavirotte; he worked with Bourdelle, Fix-Masseau, and Charpentier, and exhibited with Bing in 1897. Colonna designed mountings in silver and silver-gilt for several of his pieces. Bigot also executed the ceramic interior decoration of Lavirotte's building at 29 avenue Rapp, and the entrance hall of Guimard's Castel Béranger. In addition, his catalogue showed stoneware stoves and bathtubs. Bigot stayed in business until 1914, when for financial reasons his shop was closed (Bigot 1894; Bigot 1902). Y.B.

MARCEL BING

French, b. Paris 1875, d. Paris 1920.
The son of Samuel Bing, Marcel Bing evidently held a managerial position in his father's firm. He was also something of an artist in his own right, for he studied at the Ecole du Louvre and in addition to bronze sculpture designed some jewelry for L'Art Nouveau. However, this sort of activity was relatively restricted; his sole salon entry was a group of jewels submitted in 1901 to the Société Nationale des Beaux-Arts. After his father's death in 1905 Marcel took complete control of the firm, moving the shop to 10 rue St-Georges and dealing in oriental antiques and a few medieval objects. That he reverted to his father's original business was a sign of the times, for the Art Nouveau style was dying in France.

Bing, who served as an interpreter during World War I, made three caravan voyages to the Far East—in 1911, 1914, and after the war. He left again in 1919, but on this last journey was stricken by disease and returned to Paris only to die (Eidelberg, forthcoming, part 3, n. 5). M.E.

WILLIAM BLAKE

English, b. London 1757, d. London 1827.

Blake left off a regular education to enter a drawing school at age ten (he subsequently educated himself), and by twelve was already writing estimable poetry. At fifteen he was apprenticed to a master engraver for seven years, and while he also later painted and exhibited small pictures in tempera, copper engraving was the medium of his most important work, the illuminated books. These he printed and bound in his own publishing establishment (where he also did illustrations for and produced the work of others), hand coloring the prints at the time a copy of a book was ordered. He also went to printing in various colors and then to richly colored monotypes produced by applying opaque pigments thickly to the etched plate.

Blake's illuminated books, little known or sought after in his lifetime (and so he made only a small number of any of them), contain his lifelong development as a marvelously eccentric controversialist in theology, politics, and morals. As a young artist he admired prints after Michelangelo and Raphael, and his art likely also drew some inspiration from Gothic tombs in Westminster Abbey and medieval manuscripts. Apart from his doctrinal intentions, Blake's highly imaginative and romantic pictorial inventions for allegorical purposes—flame arabesques, embodiments of rushing winds, and figures floating in a trance—serve as an important precedent for Art Nouveau, as did his incorporation in the engravings of his own poetical texts as important design elements.

Blake held an exhibition in 1809 which was a failure, and of his culminating work in illuminated books, *Jerusalem,* which he first printed in 1818 after not less than fourteen years' work, he had not sold one copy at his death in 1827. Interest in Blake was renewed in the late 1840s by the Rossettis, and thereafter his reputation grew with poets and artists. Selwyn Image lectured on him, Crane reproduced one of his illustrations in *Ideals in Art,* the Rossettis in 1864 completed the biography begun by Alexander Gilchrist, and Swinburne wrote an important essay on him. Nearly all artists of the time, both British and Continental, found some source of inspiration in Blake's work. S.C.

PIERRE BONNARD

French, b. Fontenaye-aux-Roses 1867, d. Le Cannet 1947.

Bonnard's father, an official in a ministry, insisted that his son study law and later made him take a modest job in a government administration when Bonnard failed his oral examinations. While working, Bonnard attended classes at the Ecole des Beaux-Arts and entered the Académie Julian after he had failed the competition for the Prix de Rome. He encountered there Vuillard, Sérusier, Denis, and Ranson. The young men met after work at a nearby cafe, where endless discussions and growing friendship bound them together. Sérusier named them the Nabis (for *nebiim,* meaning "prophets" in Hebrew). Others joined: Ker-Xavier Roussel, Aristide Maillol, the musician Hermant, the actor Lugné-Poë, the Dutchman Verkade, and the Swiss Vallotton.

In the fall of 1888 Sérusier returned from Brittany fired up by Gauguin. He showed his friends a small abstract painting with juxtaposed pure colors, executed under Gauguin's direct instructions. Sérusier's famous "talisman" was considered to be the first totally Synthetist painting. Bernard and Gauguin in the summer of 1888 had developed this new style of flat colors, outlined by sinuous curves; and Sérusier elaborated a theory about it. Bonnard's early work, with flat silhouettes and arabesques, reveals the influence of Gauguin and of Japanese prints. Among his brother Nabis he was known as the "Nabi japonard."

In 1890, after his military service, Bonnard shared a studio with Vuillard on the rue Pigalle. A meeting place for the Nabis, it was occasionally visited by Gauguin. Bonnard had his first commercial success in 1889 with a poster designed for a champagne firm, *France-Champagne.* Lithography was a medium he used frequently, for theater programs, music sheets, a decorative screen, and book illustrations. He collaborated with *La Revue Blanche* and worked for Ambroise Vollard, producing for him a portfolio of color lithographs (*Quelques aspects de la vie de Paris*). An important graphic artist, Bonnard illustrated many books, including Verlaine's *Parallèlement* and *Daphnis et Chloé* for Vollard, each with over one hundred lithographs.

Bonnard participated in the dealers' group shows—Le Barc de Boutteville's, Durand-Ruel's (where he had his first one-man show in 1896), Ambroise Vollard's, and Bernheim-Jeune's. He was invited several times to exhibit at La Libre Esthétique and was a fairly regular contributor to Les Indépendants and at the Salon d'Automne (Rewald 1948; Humbert 1954).

LUCIEN BONVALLET

French, b. 1861, d. 1919.

As a student at the Ecole Nationale des Arts Décoratifs from 1878 to 1885, artist and decorator Lucien Bonvallet took courses from Lechevallier-Chevignard, the director of the Manufacture de Sèvres. Auguste Delaherche and Lucien Hirtz were among his school friends. Bonvallet designed fabric, lace, and furniture, but from 1885 on he specialized in metal and was to become a master of copper work. He designed a number of mountings, executed by Cardeilhac, for works in ceramic or glass by such masters as Dalpayrat and Gallé; the style of the mountings harmonizes with that of the vases they adorn. In 1902 Bonvallet exhibited vases in repoussé copper and silver which also demonstrate his concern for the unity of form and decoration (Demaison 1902; Belville 1910). C.C.

FRÉDÉRIC BOUCHERON

French, b. 1830, d. 1902.

Boucheron began his jewelry apprenticeship at fifteen under Jules Chaise; in 1858 he founded his own firm, whose success soon warranted a move to the place Vendôme. Using stones from the recently discovered South African diamond mines, Boucheron showed lavish diamond jewelry in innovative styles at the Centennial Exhibition in Philadelphia in 1876 and at the Expositions Universelles in Paris in 1867, 1878, and 1889. The firm's successes continued at the Exposition Universelle of 1900, where the Musée du Luxembourg bought some of its Art Nouveau pieces. The artists in Boucheron's employ included Jules Brateau and Lucien Hirtz. Boucheron died in 1902 and his son Louis succeeded him as director; Louis was followed by his sons Frédéric and Gérard, then Gérard alone. The firm, noted during the Twenties for its Art Deco jewelry, is still in business in the place Vendôme (Vever 1908, pp. 395–442; Verdier 1964).

FIRMIN BOUISSET

French, b. Moissac (Tarnet-Garonne) 1859, d. 1925.

A painter and graphic artist who studied under Cabanel at the Ecole des Beaux-Arts, Paris, Bouisset is essentially known for having created the little girl for Menier chocolate (1892) and the chimney sweep for Job cigarette papers—two of the great poster personalities of the time. Children always figured in his posters, and his style ordinarily had little to do with Art Nouveau, but Bouisset's poster for the Salon des Cent succumbs to the floral style typical of Art Nouveau. A.W.

EUGÈNE BOURGOUIN

French, b. Rheims 1880, d. 1925.
The works of the sculptor Eugène Bourgouin—statues, small busts, and bas-reliefs—included a monument to the dead of World War I. He exhibited at the salon of the Société Nationale des Beaux-Arts and at the Salon d'Automne from 1907 to 1924.

MAURICE BOUVAL

French, b. Toulouse, d. c. 1920.
Bouval, a student of Falguière, made lamps, pin trays, and other small bronze objects, often gilt and usually incorporating the female form. He exhibited with the Société des Artistes Français regularly, first as a sculptor, then in the decorative arts section (Detouche 1900; Thomas 1901).

FÉLIX BRACQUEMOND

French, b. Paris 1833, d. Sèvres? 1914.
Bracquemond, who participated in the Salon des Refusés in 1863 and then in the first exhibition of the Impressionists in 1874, was a principal founder of the Société des Aquafortistes in 1862 and first president of the Société des Peintres-graveurs in 1889. Interested in engraving by Joseph Guichard, he played a significant role in the renaissance of engraving in the second half of the 19th century. In 1856 he discovered a copy of Hokusai's *Manga* and with it the special perspective of Japanese woodcuts —an event which marked the beginning of "Japonisme" in France. He designed a series of woodcuts with birds and flowers, directly inspired by Hokusai, which Eugène Rousseau used in 1866 to decorate a table service known as the "Service Rousseau." Bracquemond's interest in ceramics dated from the early 1860s, when he produced several large earthenware plates for Deck. After a short and disappointing stay at the Manufacture de Sèvres he accepted, in 1872, Charles Haviland's offer to take over the artistic direction of the latter's new studio at 116 rue Michel-Ange in Auteuil.

Finding at Auteuil a situation that enabled him to realize his own aesthetic ideas, Bracquemond remained there until 1881. He surrounded himself with painters and sculptors, among them Albert and Edouard Dammouse, Eugène Delaplanche, Edouard Lindeneher, and Jean-Paul Aubé; in 1875 he invited the ceramist Ernest Chaplet to join the studio. Bracquemond himself created numerous designs there for use as ceramic decorations. After leaving Auteuil he devoted himself to engraving (which he had never given up), to writing art criticism and theoretical texts (*Du Dessin et de la couleur,* 1885), and to organizing exhibitions; he was active as well in various societies, among them the Société Nationale des Beaux-Arts, of which he was a founder. Around the turn of the century he tried his hand at interior design, collaborating with Alexandre Charpentier and Jules Chéret on a billiard room for the Baron Vitta that was shown at the 1902 SNBA salon. He designed objects as well, including enameled jewels executed by Alexandre Riquet, bookbindings by Marius-Michel, and vases executed by Emile Müller (*Félix Bracquemond and the Etching Process,* 1974; d'Albis et al. 1974). Y.B.

JULES-PAUL BRATEAU

French, b. Bourges 1844, d. Paris 1923.
A student of the sculptor Auguste Nadaud at the Ecole des Arts Décoratifs and of the jeweler H.-S. Boudoncle, Brateau after long studies and an apprenticeship became the preferred collaborator of numerous jewelers, among them Boucheron and Bapst et Falize. He also collaborated with the enameler Paul Grandhomme.

Besides being one of the best jewelers of the period, Brateau contributed to the renaissance of the art of pewter in France in the last years of the 19th century, making lovely objects in an inexpensive material available to a large public. He showed both jewelry and pewter at the Exposition Universelle of 1889 and met with great success; in 1900 he showed more pewter objects, as well as several fine pieces of jewelry. In about 1910–12 he produced delicate objects in *pâte de verre* that were inspired by the creations of Dammouse (Falize 1889, pp. 217–20; Molinier 1897; Hilschenz 1973, p. 153; Gere 1975, pp. 65, 155).

PHILIPPE-JOSEPH BROCARD

French, d. 1896.
A collector and restorer of art objects, Brocard studied the craft of glassmaking in order to produce mosque lamps with enameled decoration like those he had seen in the Cluny Museum. He rediscovered the process of using enamels in the Islamic style—a difficult technique to master, demanding precision in baking time and temperature in order to make the enamel adhere to the glass. Brocard hand-painted his designs in gold and enamel on white or lightly tinted glass. At the beginning he simply copied Egyptian and Persian lamps, vases, and bowls, perhaps even the glassware produced in the Islamic factories in Venice. He was also inspired by Gallo-Roman, German, and Italian Renaissance glassware. His pieces were noticed in the Expositions Universelles of 1867 and 1878; he revived enameled glass in France and was the best craftsman in this medium. Didron, reporting on the 1878 exhibition, noted that "the copies of Moorish lamps, and Arab or Persian vases and bowls, show a remarkable understanding of the color and decorative feeling of the Orient." He took note as well of Gallé, who, drawing inspiration from Persian models, "by associating engraving and enamel and in borrowing several laws from Japanese art, seems to be preparing an evolution that might give some excellent results."

If Brocard introduced Gallé to the art of enameled glass, Gallé in return introduced Brocard to naturalism. Around 1880 Brocard began using European forms and decorating them with mistletoe, satinpod, and cornflowers. In 1884 his son Emile joined him; together they produced glass with enameled decoration on gold, silver, platinum, or copper and signed their works *Brocard et Fils* (de Liesville 1879, pp. 430, 432; Didron and Clémendot 1880, p. 14; de Fourcaud 1884, p. 261; Bloch-Dermant 1974, pp. 22–26). Y.B.

CARLO BUGATTI

Italian, b. Turin 1856.
Bugatti, a native of Turin who worked most of his life in Milan, was active in several fields but was best known as an architect and designer of furnishings. The exotic furniture he exhibited in Turin in 1898 received a first prize and won a good deal of notice: not only was it covered with parchment rather than the customary wood veneer, but its form and decoration broke completely with traditional concepts of furniture design. Such radicalism looked forward to Futurist tenets; at the same time, however, an Islamic influence is suggested in Bugatti's style. His furniture again caused a sensation at the Paris Exposition Universelle of 1900, where it was exhibited along with that of Eugenio Quarti, another innovative Italian designer and a member of Bugatti's workshop in Milan. Bugatti's sons were also successful artists, Rembrandt as a sculptor, and Ettore (1881–1947) both as a painter and as an automobile designer (Portoghesi 1972, pp. 287, 289–90).

FRANÇOIS RUPERT CARABIN

French, b. Saverne 1862, d. 1932.
The son of an Alsatian forest ranger, Carabin arrived in Paris with his family in 1872 and lived the meager existence of the refugee in Montmartre. In 1873 he carved cameos for a

living, then learned woodcarving under a sculptor in the Faubourg Saint-Antoine. He exhibited his works at the Salon des Indépendants from its opening in 1884. In the Montmartre bars he frequented—La Nouvelle Athènes and Le Chat Noir, where he met Lautrec, Manet, Monet, and Cézanne—he found the subjects of his small sculptures. The most famous of these are his figurines of Löie Fuller (1896–97) in which he portrayed the dancer realistically, in contrast to the sculptures of Théodore Rivière, Raoul Larche, and Pierre Roche.

In 1889 a commission for a bookcase from the collector Henry Montandon gave Carabin an opportunity to reexamine his conception of furniture, its structure and ornamentation: for Carabin, furniture was not architecture but sculpture, on which the artist could impose his own laws. Hence decoration was both sculpture and symbol. The caryatid, associated with a bestiary of cats, mice, and frogs, was a constant theme in his work; from 1899 on he used the female form, with its symbolic suppleness, in objects like mirrors and pin trays as well. Carabin loved wood—pear, oak, and especially walnut, which he polished with his thumb with linseed oil for hours at a time, for days.

Carabin experimented with a number of other techniques, making jewelry, medals, and ceramics with Carriès from 1890 on. Convinced that art could be expressed as well in objects as in sculpture, he helped open the salons to the applied arts. In 1914 he gave up his work in art, then in 1920 became director of the Ecole des Arts Décoratifs of Strasbourg, where he put in practice teaching methods he had seen in Germany at the turn of the century (Brunhammer et al., 1974, and bibliography). Y.B.

CARDEILHAC

Paris.
Established in 1804, the firm of Cardeilhac specialized for many years in flatware and cutlery; to this successful production the founder's grandson, Ernest Cardeilhac (1851–1904), added gold- and silversmithing. After an apprenticeship under Harleux, he entered works at the 1889 Exposition Universelle and won a silver medal; at the exposition of 1900 Cardeilhac exhibited gold and silver pieces done in collaboration with Lucien Bonvallet as designer. Works by Cardeilhac typically have restrained naturalistic decoration that is sometimes varied with the use of ivory, wood, or different patinas (Bouilhet 1912, pp. 363–67). C.C.

EUGÈNE CARRIÈRE

French, b. Gournay (Seine-et-Marne) 1849, d. Paris 1906.
The youngest of nine children in a very poor family, Carrière left his home in Strasbourg at the age of nineteen to work for a lithographer in Saint-Quentin, where he came in contact with Quentin de La Tour's portraits. After being released as a prisoner of the Franco-Prussian War, he moved to Paris, where he entered Cabanel's studio at the Ecole des Beaux-Arts, working at the same time as a commercial lithographer. In 1872 and 1873 he was in Jules Chéret's atelier; and during a stay in London in the 1870s he was greatly impressed by the work of Turner.

Gauguin, Edmond de Goncourt, Verlaine, and Rodin were among the artist's friends. Together with Rodin and Puvis de Chavannes he founded the Société Nationale des Beaux-Arts in 1890, and from 1898 to 1903 he conducted the Académie Carrière.

Carrière, who in 1892 did decorations for the Sorbonne and the Hôtel de Ville in Paris, was invited to exhibit at the first Salon de la Libre Esthétique in 1894. Two years later he was given an exhibition room there for the first retrospective of his work.

His paintings—mostly portraits and maternities—have a moody quality which links him to some aspects of Symbolism. Though his monochrome palette is far removed from Art Nouveau colors, his brushstrokes have a fluid quality which evokes the rhythm of the 1900 style. S.C.

JEAN CARRIÈS

French, b. Lyons 1855, d. Paris 1894.
Carriès began his career as a sculptor at the age of nineteen, when he arrived in Paris, and created his most important sculpture in the years between c. 1878–80 and 1888. In 1878 he discovered the Japanese section at the Exposition Universelle: with his friend Eugène Grasset, he marveled at the beauty of the stoneware. Ten years later he moved to a small potters' village, Saint-Amand-en-Puisaye (Nièvre), to learn stoneware techniques. His first pottery exhibition, held in his Parisian studio on the boulevard Arago at the beginning of 1889, aroused the interest of the Princess of Scey-Monbéliard, who commissioned him to do a monumental doorway in glazed stoneware. Executed after the plans of Grasset, who designed a decoration of masks and a disturbing bestiary, the sculpted door soon became a disastrous financial burden for the potter.

The presentation of his pottery at the salon of the Société des Artistes Français in 1892 showed to what degree Carriès had mastered the art of stoneware. A wide variety of forms is seen in his works: Chinese or Japanese shapes, rustic pieces, vases inspired by gourds and pumpkins, pinched pots without handles, pear shapes, pieces with regular form with or without necks, large vases, and pieces decorated with sculpture. They are covered with glazes ranging from wood ash to copper base. Carriès also created ceramic sculpture, which typically represented masks, monsters, or babies (Alexandre 1895; Camart et al. 1971, p. 17; Heuser and Heuser 1974, pp. 122–23; Hakenjos 1974). Y.B.

LOUIS CHALON

French, b. Paris 1866.
Chalon, a student of Lefebvre and Boulanger, began his career as a painter and illustrator. Besides illustrating the works of Rabelais, Boccaccio, and Balzac, he contributed to the periodicals *Figaro illustré, L'Illustration,* and *La Vie parisienne.*

Around 1898 Chalon turned to sculpture. Although he worked mainly in bronze, producing small objects like lamps, inkwells, vases, and clocks, he was eclectic in his use of materials and created wood and ivory sculptures as well as furniture. He received honorable mentions at the Expositions Universelles of 1889 and 1900 (Rod 1891; Forthuny 1900; Thomas 1901). C.C.

ERNEST CHAPLET

French, b. Sèvres 1835, d. 1909.
Ernest Chaplet belonged to the generation of French potters who in the second half of the 19th century reinvented the art of ceramics. Until 1870, with few exceptions, ceramic production in France was limited to tableware, either purely functional or conventionally elaborate; but in a few years all would change, mainly because of the impact of Japanese art. The search for new forms and unique decoration caught artists' imaginations, and ceramics took its place among the major arts. Chaplet, who had the good fortune to be always in touch with the avant-garde, thanks to his superb technical skills was able to apply the new ideas he gathered there to a pioneering oeuvre that made him one of the great French ceramists.

Born in Sèvres in 1835, at twelve he went to work at the Manufacture, where he learned design, painting, and the rudiments of techniques that he would later apply to his own creations.

From 1857 to 1874 he worked with Laurin, a manufacturer of everyday pottery at Bourg-la-Reine, first making painted faïence that sold very poorly, then lamp bases that sold very well. He also met the enameler Claudius Popelin and Camille Moreau, who may be considered the earliest theoreticians of the ceramic revival.

Chaplet perfected barbotine on terracotta—a decorative process in which slips mixed with coloring oxides are applied with a brush—at Bourg-la-Reine in 1871, but it was not until he went to work at Haviland's Auteuil studio in 1875 that he was able to exploit the possibilities of the technique fully. Thanks to technical advances there the range of colors was extended and more subtle shadings could be achieved in the backgrounds. At the same time Bracquemond, the artistic director of the studio, called on a team of artists particularly sensitive to the aesthetic ideas of the moment to create Japanese-style, and really Impressionistic, vases. The pieces had no commercial success, so their production was stopped.

The year 1881 marked a turning point for Chaplet. During a stay in Normandy he discovered folk pottery made of brown stoneware; he began to work with this material, perfecting it in a studio on the rue Blomet, Paris, put at his disposition by the Havilands. The studio artists there, particularly Albert and Edouard Dammouse, Hexamer, Albert Kalt, Jean-Paul Aubé, and Ringel d'Illzach, added decorations in colored slips in Japanese or naturalistic motifs—sometimes sculpted in low relief or even painted with coloring oxides and outlined with gold—to the high-fired stoneware forms, whose brown mat surface was left otherwise unglazed; in 1884 the Haviland factory at Limoges did porcelain pieces with high-fired decoration in this style, using molds sent to them from the rue Blomet. Chaplet's brown stoneware showed the influence not only of the Norman pottery but also of Japanese stoneware, which had strongly impressed him at the Expositions Universelles in 1867 and 1878. From then on he concentrated more and more on making ceramics whose form, material, and decoration were intimately bound together.

At the same time Chaplet began his research on the famous *sang-de-boeuf* glaze, a copper-red glaze whose process had long been the secret of the Chinese. Applying it first to stoneware, then to porcelain, he had success with it in January 1885. The rue Blomet studio was concurrently producing stoneware that was partially or entirely glazed, with floral or animal motifs outlined in black or gold. But the Havi-

lands, discouraged by the poor sales of their products, decided to close the studio. At the beginning of 1886 they turned it over to Chaplet, who continued to produce glazed stoneware there and especially to study the copper-red glaze.

In 1886 he and Gauguin began their famous collaboration; in 1887 he settled in his last place of work, a studio at Choisy-le-Roi that would later belong to one of the best ceramists of the Twenties, Emile Lenoble. There Chaplet, having perfected the *sang-de-boeuf* glaze, explored the other possibilities of copper glazes, which with different firing methods could produce colors ranging from deep violet to celadon green to white—a palette Chaplet could manipulate with exceptional virtuosity.

Thus secure in his technical mastery, Chaplet was able to begin concentrating on problems of aesthetics: without apparent effort he adapted sumptuous glazes to forms that became more and more severe, thus creating a ceramic style specifically European, no longer based on oriental models. In this sense he can be considered practically the inventor of modern ceramics.

At the end of his life Chaplet was troubled by advancing blindness, which caused him to abandon his work (d'Albis et al. 1976). Y.B.

ALEXANDRE CHARPENTIER
French, b. Paris 1856, d. 1909.
A sculptor, medalist, and decorator, Charpentier was very active between 1890 and 1902 in both sculpture and decoration. He exhibited at Brussels with Les Vingt in 1895 and at the Salon de la Libre Esthétique in 1899. With Dampt, Aubert, Selmersheim, and Moreau-Nélaton he formed Les Cinq, a group which became Les Six when Plumet joined, then L'Art dans Tout with the addition of still more members.

Charpentier touched on all aspects of decoration: furniture, interior design, designs for metal, ceramic, and leather objects. His feeling for volumes, his baroque taste, and his vivid imagination made him one of the best representatives of the Art Nouveau style in Paris. The numerous interiors he designed included a dining room at Champrosay for Adrien Bénard, president of the Société du Métropolitain—the same Adrien Bénard who commissioned Guimard to design the Métro entrances. He also collaborated with Bracquemond and Jules Chéret on a billiard room for the Baron Vitta (SNBA catalogue 1902).

JOSEPH CHÉRET
French, b. Paris 1838, d. Paris 1894.

The younger brother of Jules Chéret, sculptor and ceramist Joseph Chéret studied under Carrier-Belleuse, whose daughter Marie became his wife. Long associated with the Manufacture de Sèvres, Chéret designed models and decorations for objects to be produced by the porcelain factory, and upon his father-in-law's death in 1887 briefly succeeded him as artistic director. Chéret exhibited at the official salon, where he debuted in 1863, and his ceramic works were awarded prizes at Sèvres during the 1870s and 1880s; in 1891 he entered into the decorative arts section of the Société Nationale des Beaux-Arts salon, becoming a member of that group shortly before his death in 1894. He also worked in pewter, executing a number of centerpieces and plates. During his career he was associated with several firms, including Christofle, Grobé, and Baccarat, while his work for the Maison Fourdinois received a gold medal at the Exposition Universelle of 1889 (Vitry 1900, p. 170).

JULES CHÉRET
French, b. Paris 1836, d. Nice 1932.
For thirty years France's foremost poster artist, and the first to develop a true poster style, Chéret began decorating the streets of Paris with posters in 1866, when a patron set him up in his own print shop. He applied to his art skills acquired during an apprenticeship to a lithographer and went on to develop his own techniques, producing posters whose colors were radiant and light and whose compositions were graceful and light. Chéret was enormously popular: by the time he left lithography in 1900 he had created over twelve hundred posters, and the "Chérette," the laughing girl who so frequently figured in them, had become virtually the symbol of Parisian gaiety.

Later in his career Chéret devoted himself to oil painting and pastel, although he was active in the decorative arts as well. A tapestry designer, he also collaborated with Charpentier and Bracquemond on decorations for the villa of Baron Vitta, a noted collector who owned a number of his works, and painted frescoes for a Parisian restaurant called La Taverne, for the Préfecture in Nice, and for the Hôtel de Ville in Paris (Abdy 1969, pp. 28–36).

CHRISTOFLE
Saint-Denis.
Charles Christofle established his firm under the reign of Charles X and showed himself from the beginning to be a great innovator. He foresaw the importance of the invention of silver-plating

by electrolysis, which was to eventually make his name famous, and to exploit the new technique he called on artists who shared his desire to search out new forms and ideas for metalwork.

At his death in 1863 the firm was taken over by his nephew Henri Bouilhet, a man who understood the importance of Japanese art. Under his leadership and that of Ernest Reiber, his chief designer and one of the foremost early Japonistes, Christofle produced objects of oriental inspiration, particularly pieces with cloisonné enameling, and at the Exposition Universelle of 1878 showed inlaid ironwood and ebony furniture with gilt bronze mounts, and damascened objects, all showing the influence of Japan. In later expositions works designed by notable artists—Roty, Carrier-Belleuse—were part of the firm's display. On the technical level as well Christofle played an important role, using and developing modern techniques like electroplating, mechanical damascening, and electromagnetic engraving. The firm still exists in France today, where the term "christofle" is synonymous with silver-plating (*Christofle orfèvre* 1964; Weisberg et al. 1975, pp. 168–69).

EDWARD COLONNA
b. Germany 1862, d. Nice 1948.
Born near Cologne, Colonna studied architecture in Brussels before moving to the United States in 1882. After a brief stay in New York, where he worked with Associated Artists—a group of decorators directed by Louis C. Tiffany—he left for the Midwest. He settled in Dayton, Ohio, and was employed by the Barney & Smith Manufacturing Company designing railroad cars. It was in Dayton, where he designed some furniture and objets d'art, that he produced his book *Essay on Broom-Corn* (1887). After a brief stay in Canada he went to Paris. There from 1898 to 1903 he worked for S. Bing, designing jewelry, furniture, fabrics, porcelain table services, and vases. With Georges de Feure and Eugène Gaillard he took part in organizing and installing Bing's pavilion at the Exposition Universelle of 1900. When Bing's store closed, Colonna traveled through Europe, then went once again to New York to work as an antique dealer and interior decorator. In 1923 he returned to the French Riviera, where he died in 1948 (Eidelberg 1971). M.E.

GISBERG COMBAZ
Belgian, b. Antwerp 1869, d. Brussels 1941.
Combaz, a man of many talents, was well known as an artist, art teacher, and orientalist; he held professorships at the Académie Royale des Beaux-Arts and the Institut Belge d'Etudes Orientales among others, and wrote several scholarly works on Asian art. From 1897 on, he exhibited regularly at La Libre Esthétique and often designed the poster for the exhibitions. These were all of the same format, the lettering distinctly set apart from the design, while the style of the picture itself varied from year to year. Combaz's compositions—executed in rich colors with the forms vividly outlined in white—show an oriental influence. After 1901, however, his compositions became more classic.

In 1895 he designed the poster *A la Toison d'Or* for the shop which inspired Bing to open L'Art Nouveau in Paris. A.W.

OMER COPPENS
b. Dunkirk 1864, d. Brussels 1926.
Coppens studied painting at the Ghent academy and worked in Belgium. Best known as a painter and engraver, he created several ceramic pieces, some pewter, and bookbindings; he was a founder of the group Pour l'Art, serving as its president in the late 1890s, and a member of L'Essor. He exhibited at the Salon de la Libre Esthétique in 1895 and at the Brussels exposition in 1910. Several of his engravings, highlighted with colors, were sold at the Galerie Dietrich in Brussels. Coppens was a friend of the Nancy artist Emile Gallé, who dedicated one of his vases to him. J.-G.W.

ARTHUR CRACO
Belgian, b. Saint-Josse-ten-Noode 1869.
Arthur Craco, a sculptor, took courses from Constantin Meunier at Louvain and studied at the Brussels academy, then moved to France; he lived in Paris, then in Orchies (Nord), where he first worked with ceramics. With the Antwerp exposition of 1894 Craco, like Philippe Wolfers, began using ivory from the Congo Free State, and at the colonial exhibition in Tervueren in 1897 he exhibited three statues in ivory and bronze. A participant in the salons of La Libre Esthétique in 1894, 1895, and 1897, Craco was one of the founders of L'Art Idéaliste in Brussels in 1896. J.-G.W.

WALTER CRANE
English, b. Liverpool 1845, d. London 1915.
One of the leading exponents of the Art Nouveau style, Crane began his early training at the Royal Academy at seventeen. Actively working to reform concepts of applied and decorative arts, he became a leader in such organi-

zations as the Arts and Crafts Movement and the Art Workers Guild and published numerous essays and books dealing with his theories on the unification of all branches of the arts. He exhibited his work in London, Paris, and Brussels and published illustrations for Morris' Kelmscott Press and Ashbee's Essex House Press, but it was chiefly through his illustrations of children's books that he established his artistic reputation.

Crane drew from such sources as William Morris, Pre-Raphaelite painting, William Blake, Japanese prints, and Greek art, from which he developed an asymmetrical linear style that the *Journal of Decorative Art* (21, p. 237) described as "a swirl and a blob"—a motif which became characteristic of Art Nouveau. While he was one of the greatest influences, both in theory and in practice, of the movement on the Continent, Crane later became highly critical of the development of Art Nouveau as a style. S.C.

ADOLPHE CRESPIN
Belgian, b. Anderlecht 1859, d. Saint-Josse-ten-Noode 1944.
A student in Paris and then in Brussels, Crespin at the age of thirty was made professor of design at the art school opened by the commune of Schaerbeek. There he met Paul Hankar and began a collaboration with the architect; together they were awarded the prize in a facade competition, for a bakery (1896) which Hankar designed and Crespin decorated with sgraffito murals (a technique he also applied to the architect's residence). In 1897 the two designed the interior decoration of the Salle d'Ethnographie in the colonial section of the Exposition Internationale at Tervueren. Crespin, who designed an advertising poster for his colleague Hankar in 1894, had around 1886 been among the first in Belgium to become interested in poster art. Through the 1890s he created a number of significant posters, many done in collaboration with the portraitist Edouard Duyck (1856–97) (Oostens-Wittamer 1975, pp. 35–39). A.W.

VICTOR CRETEN
Belgian, b. Schaerbeek 1878, d. 1966.
Creten, best known as an architect, had an exceptionally prolific and varied career which included teaching drawing and decorative composition. His excursions into poster art were crowned with success when he won competitions in 1905, for a poster marking Belgium's 75th anniversary, and in 1906, for a poster

announcing the 1910 Brussels exposition. In his *Belgische Tentoonstelling* (1907), designed when Art Nouveau strictly speaking was on the decline, one can see the first signs of the Art Deco style (Oostens-Wittamer 1975, pp. 40–41). A.W.

HENRI CROS

French, b. Narbonne dans l'Aude 1840, d. Paris 1907.

Cros, a ceramist, sculptor, and glassworker who studied under Jouffroy, is remembered for having rediscovered the secret of making *pâte de verre,* a technique known to the ancient Egyptians. Seeking a technique for producing colored sculpture, he first had experimented with wax, which produced works that were far too fragile. So he turned to *pâte de verre* and after long research perfected his process: powdered glass, made into a paste with a flux and colored with metallic oxides, was put in a mold and fired at a temperature sufficient to bond the glass but not high enough to cause sections of different colors to run together. Cros sometimes assembled larger pieces from components so produced. His work in *pâte de verre* comprised mainly bas-reliefs and medals, but he also did a few masks, some portraits, and several vases and goblets. His bas-relief *L'Histoire du Feu* won a gold medal at the 1900 Exposition Universelle. Cros' models are now in the collection of the Manufacture de Sèvres, where he had been given a studio to pursue his research (Testoral 1908; Vaillat 1908; Belfort 1967; Duret-Robert 1974). C.C.

PIERRE ADRIEN DALPAYRAT

French, b. Limoges 1844, d. Paris 1910.

A porcelain painter and a potter, Pierre Adrien Dalpayrat lived in Bordeaux (1867), Toulouse, and Monte Carlo (1876–88). After a stay in Limoges he moved in 1889 to Bourg-la-Reine, where he specialized in stoneware and perfected the color "Dalpayrat red," a copper-red glaze that brought him considerable attention at the 1892 salon. He combined this red with yellows, greens, and blues to obtain a marbled effect, applying it to forms inspired by Japanese bottles but usually made in the shape of gourds or fruits, or decorated with figures or animals in high relief or sculpted. Dalpayrat collaborated with Adèle Lesbros and Voisin, who shared his ambition to produce stoneware at a reasonable price. He executed some forms designed by Maurice Dufrêne for La Maison Moderne and others by sculptors like Constantin Meunier. Several of his pieces were mounted in silver by contemporary silversmiths like Cardeilhac (Camart et al. 1971, p. 21; Heuser and Heuser 1974, pp. 150–51; Hakenjos 1974, p. 28). Y.B.

ALBERT-LOUIS DAMMOUSE

French, b. Paris 1848, d. Sèvres 1926.

Son of Pierre-Adolphe Dammouse, a sculptor and decorator of porcelain at the Manufacture de Sèvres, the ceramist Albert-Louis Dammouse took courses at the Ecole des Arts Décoratifs in Paris and then at the Ecole des Beaux-Arts, where he studied under the sculptor François Jouffroy. Intrigued by technical problems, he became first the apprentice and then the collaborator of Marc-Louis Solon, called Milès, who introduced him to the process of underglaze slip decoration (*pâtes d'application*).

Dammouse exhibited for the first time in 1869, then showed works again in 1874 and at the Expositions Universelles of 1878 and 1889. He sent designs to Limoges and entered Charles Haviland's workshop in Auteuil, where he designed the form for the famous "Service aux Oiseaux," decorated with designs after Bracquemond and executed in soft-paste porcelain. In 1882 he helped Chaplet develop his new stoneware; ten years later he opened a studio with his brother Edouard at Sèvres, producing porcelain, earthenware, and stoneware in forms of Japanese and Chinese inspiration. At first limiting the decoration to monochromatic glazes, he later used painted designs of foliage, algae, and flowers.

From 1898 on, however, Dammouse exhibited cups, bowls, and goblets in thin, opaque *pâte de verre,* a material whose delicacy created a sensation at the Exposition Universelle of 1900. He perfected his material by 1904 and went on to develop *pâte d'émail,* a sort of cloisonné *pâte de verre* that was undoubtedly inspired by Thesmar's enameled bowls: the frame was made of *pâte de verre* already baked one time in a mold, and the sections were filled with a paste made of powdered glass that fused at a low temperature. Little is really known about Dammouse's technique, but he probably fired each piece as many times as there were colors (Camart et al. 1971, p. 26; Bloch-Dermant 1974, pp. 178–80). S.J.B./Y.B.

EDOUARD-ALEXANDRE DAMMOUSE

French, b. Paris 1850, d. Sèvres 1903.

Edouard Dammouse studied under Bracquemond as a landscape, portrait, and genre painter. He worked at Laurin's firm with Chaplet, then followed his brother Albert and Chaplet to Haviland's Auteuil workshop to become a member of the group of painters there. He remained at Auteuil until the studio closed in June 1881. In 1882 he moved with Chaplet to the Haviland workshop on the rue Blomet, where he decorated stoneware in both naturalistic and Japanese styles. When the Haviland studio closed in 1886 the Dammouse brothers established a workshop at Sèvres, where they worked with stoneware and later *pâte d'émail.*

Although not as well known as his brother Albert, Edouard nevertheless was a prolific and successful artist. He exhibited at the salons of the Société des Artistes Français from 1878 to 1900 (Heuser and Heuser 1974, p. 162; d'Albis et al. 1974). Y.B.

DAUM

Nancy.

The Daum glassworks started out as a bottle factory in Nancy acquired in 1878 by Jean Daum (1825–85), an Alsatian expatriate. The factory's production gradually became specialized in fine glassware with cut, etched, and gilt decoration in traditional styles. In 1890 the brothers Auguste (1853–1909) and Antonin Daum (1864–1931) began producing colored glass; in 1891 they opened a decoration studio under the direction of Eugène Damman, employing as artists Emile Wirtz, Henri Bergé, and Jacques Gruber. Their efforts in 1891 centered on producing layered glass like Gallé's, cased with first two, then several layers, but the firm gradually perfected a number of original and difficult techniques: decoration using colored glass powder, which was either fired on to the surface or sealed beneath another layer of glass (as in the case of their "jade glass"); wheel-cutting; *martelage* (producing a texture like that of hammered metal); mold-blowing; etching; and the use of applications similar to Gallé's marquetry. The Daum entry in the Exposition Universelle of 1900 bore witness to the firm's expertise in both technique and decoration. Two specialties emerged: *berluzes* (long-necked vases of all sizes) and lamps. The typical decoration was inspired by nature. In 1906, the Daums put a studio at the disposition of Almaric Walter, who worked there with *pâte de verre.*

Closed during World War I and reopened in 1918, the Daum factory began producing works in the new geometric style but continued using the techniques perfected around 1900 (Duret-Robert 1971a; Duret-Robert 1971b; Duret-Robert 1972; Bloch-Dermant 1974, pp. 134–59; personal communication, Michel Daum). Y.B.

ALPHONSE DEBAIN

French.

A metalworker and the son of a goldsmith, Debain while still very young made his debut at the 1889 Exposition Universelle, where he won a gold medal; his entries in the 1900 fair, ranging from historical styles to Art Nouveau, reflected the eclecticism of contemporary tastes in metalwork. For the 1901 salon of the Société des Artistes Français he executed pieces in repoussé silver that were designed by Piquemal and Valery-Bizouard (Vitry 1900; *Revue de la Bijouterie*, no. 16 (1901), pp. 126–30; Bouilhet 1912, pp. 367–68). C.C.

THÉODORE DECK

French, b. Guebwiller (Haut-Rhin) 1823, d. Sèvres 1891.

Deck finished a traditional apprenticeship as a stove-maker by touring Germany before settling in Paris in 1847. Foreman of a ceramic stove factory, he ventured out on his own around 1856 to begin individual work as a ceramist. He was inspired successively by the ceramics of Persia and Asia Minor—especially their floral decoration in cobalt blue and turquoise, with red and green highlights—and finally by those of China, which led to his interest in porcelain. He was the first in France to succeed with red flambé glazes, incised decoration on celadon glazes, imitations of jade, and underglaze enamels. His use of gold underglaze background was inspired by a trip to Venice. He had painters collaborate with him: at his request Ranvier, Glück, Anker, Bracquemond, Harpignies, Raphaël Collin, and Reiber made designs with which he decorated plates shown at the Exposition Universelle of 1878. There he discovered Japanese ceramics, whose influence appeared in his entries to the Union Centrale's exhibition of 1880.

In 1887 Deck became director of the Manufacture de Sèvres, where he perfected soft-paste porcelain and achieved works as large as pieces done in hard paste, with the advantage of having the special soft-paste glazes. He perfected what he called "la grosse porcelaine" and used it for vases, sculptures, and outdoor objects, all covered with durable transparent glazes. The Sèvres entry in the Exposition Universelle of 1889 included several pieces that showed the influence of his research. Deck died in 1891; his work in his own studio on the boulevard St-Jacques in Paris (where Edmond Lachenal worked for ten years) and later at the Manufacture de Sèvres paved the way for Art Nouveau ceramics (Gerspach 1882; Gerspach 1890; Garnier 1891; Girodie 1903; Heuser and Heuser 1974, pp. 68–69, and bibliography). Y.B.

EMILE DECOEUR

French, b. Paris 1876, d. Fontenay-aux-Roses 1953.

Orphaned as a young boy, Emile Decoeur began his apprenticeship at the age of fourteen as a potter under Edmond Lachenal and for ten years studied faïence, glazes, and firing techniques. He became Lachenal's collaborator and added his own monogram to the pieces they produced together, but after a brief period in Rumèbe's studio he was attracted by the beauty of stoneware and gave up faïence. His experiments were numerous: flambé glazes, overflow glazes (around 1905), incised and glazed decoration, and painted decoration (1910–20). In 1907 he established his own studio, at which point he began applying the same techniques to porcelain as well as stoneware. Later in his career Decoeur moved away from Art Nouveau, even going so far as to denounce the style. His attitude hardened over the years: for him decoration lost its intrinsic value, becoming secondary to forms that were purified to the utmost. Around 1927, when he began adding kaolin (porcelain clay) to his stoneware clay, Decoeur realized his purest masterpieces: vases, goblets, and bowls enveloped in sumptuous glazes of yellow, blue, rose, green, and white, which rendered any decoration superfluous (Janneau 1923; Valotaire 1930). Y.B.

FRANÇOIS-EMILE DÉCORCHEMONT

French, b. Conches (Eure) 1880, d. 1971.

The son of a sculptor's assistant in Gérôme's studio, glassworker François Décorchemont was also a painter and remained one all his life. From 1901 to 1903 he produced several stoneware pieces, then from 1903 on, undoubtedly influenced by Dammouse, he created very thin *pâte de verre* pieces that were slightly translucent, with mat surfaces. These were made by mixing together sand, colored oxides, and flux, rather than powdered glass as is usual with *pâte de verre*; this mixture was shaped in a mold, then reworked and reshaped and finally baked without a mold. The resulting small pieces, glasses and vases in pastel colors, were decorated with vegetal and floral designs in low relief. Around 1907 or 1908 Décorchemont began using powdered glass—or rather powdered crystal—that he bought at the Cristalleries de Saint-Denis and much later at Daum. This crushed crystal, colored with oxides, was carefully arranged in the mold so that the desired colors and mixtures would result from the firing. Finally the piece was polished on a cork wheel. This technique permitted him to obtain thick *pâte de verre* that was truly translucent and that sometimes resembled semiprecious stones. Until 1920 Décorchement's forms and decorations were still influenced by Art Nouveau, but at that time he began producing large pieces decorated with flowers, fruits, and animals in the geometric style of the 1920s. He abandoned anecdotal decoration for linear motifs in 1928, then worked in a monumental style before taking up stained glass in 1933. Décorchement created no new designs after 1948 but continued to fire pieces until his death (Décorchemont's notebooks, Association des Amis de François Décorchemont, Musée des Arts Décoratifs, Paris; "François Décorchemont, 1880–1971," *Nouvelles de l'Eure*, no. 42–43 [August 1971]; Duret-Robert 1973). Y.B.

GEORGES DE FEURE

Dutch, b. 1868, d. 1928.

Born in Holland, de Feure was a decorator, painter, lithographer, engraver, and later a professor at the Ecole des Beaux-Arts in Paris. He moved to Paris in 1890 and became Jules Chéret's student. A one-man show at a gallery on the rue de la Paix in 1894 first brought him to the public's notice; that same year he exhibited at the salon of the Société Nationale des Beaux-Arts. He showed works at the 1893 and 1894 salons of the Rose+Croix and at the 1896 Munich Sezession. In 1898 he designed furniture for the Maison Fleury; in 1900 he was one of the artists who designed Bing's pavilion and its furnishings for the Exposition Universelle. At the same time de Feure did illustrations for magazines like *Le Courrier français* and *Le Boulevard,* designed sets for productions at Le Chat Noir, made cartoons for tapestries, and designed stained glass, furniture, and porcelain, often for Bing. His entries for the SNBA salon in 1901 and the Turin exposition in 1902 were particularly well received: porcelain with sea-green and rose-mauve decorations on white backgrounds, executed by Gérard-Dufraisseix-Abbot in Limoges.

De Feure also created many posters. In the better ones, he presented a pale and mysterious woman, the incarnation of the stylish woman who, floating above the crowd, visited exhibitions (*Paris Almanach,* 1893), bought art objects (*Le Journal des Ventes,* 1897), or meditated in front of a flower (*Salon des Cent,* 1893). Everything was in colors of brown, green, and rose. In other posters de Feure shows himself ill at ease:

his palette is garish (yellow, red, and blue) and his compositions are less harmonious (G. Lacambre 1972, p. 49, and bibliography). Y.B./A.W.

AUGUSTE DELAHERCHE

French, b. Beauvais 1857, d. Paris 1940.
Upon leaving the Ecole des Arts Décoratifs, Delaherche helped restore the stained-glass windows of Ecouen with Lechevallier-Chevignard; worked as a designer for Chartier, a religious jeweler on the rue Férou; and directed the electroplating section at Christofle. Meanwhile, between 1883 and 1886, he created his first pots—salt-glazed stoneware inspired by folk pottery—at L'Italienne, a ceramic factory near Goincourt that was directed by Ludovic Pilleux. In 1887 he bought Chaplet's workshop on the rue Blomet and became a full-time ceramist. Chaplet introduced him to all his techniques, with the exception of copper-red glazes; Delaherche went on to develop firing techniques that produced glazes with shaded tones, and succeeded in firing pieces using both oxidation and reduction. After attracting notice at the 1887 exhibition of the Union Centrale des Arts Décoratifs, he won a gold medal at the Exposition Universelle of 1889, where he showed decorated stoneware: gourd vases, pear-shaped cups, and vases with large stemlike handles, with naturalistic relief decoration and blue, yellow, and purplish-blue overflow glazes. During vacations at Héricourt in 1891 and 1892 he fired austere gray and beige stoneware pieces in the kilns of local potters.

In 1894 Delaherche left Paris and moved to Armentières, near Beauvais, naming his house there "Les Sables Rouges" (Red Sands). He gradually abandoned modeled decoration to concentrate completely on overflow glazes that were appropriate to the material and to the unembellished form. He finally ventured into working with porcelain. From 1904 on he threw his own pots and made only unique pieces, often in stoneware with brownish-red, gray, brown, beige, and green glazes, producing at the same time both revetment tiles and delicate porcelain pieces. With Chaplet, Delaherche was the most important ceramist of the turn of the century. Samuel Bing selected his works to exhibit at L'Art Nouveau (Camart et al. 1971, pp. 31–32; Salmon 1973; Heuser and Heuser 1974, pp. 175–92, and bibliography; Hakenjos 1974, p. 55). Y.B.

JEAN DELVILLE

Belgian, b. Louvain 1867, d. Brussels 1953.

After brilliant studies at the Académie Royale in Brussels, Delville participated in starting the Pour l'Art salon in 1892. The same year, in Brussels, he met Joséphin Peladan, whose writings he knew. Captivated by Peladan's ideas Delville soon moved to Paris, where he exhibited in the Salons de la Rose+Croix from 1892 to 1895. Using the Rose+Croix and Pre-Raphaelite movements as models he founded the Salon d'Art Idéaliste in Brussels in 1896. The following year he used the review L'Art Idéaliste as a podium from which to lambast La Libre Esthétique and its exhibitors—notably Seurat, Ensor, Monet, and Gauguin. His zeal and his taste for theoretical questions suited him well in the teaching career he began in 1900 at the Glasgow School of Art.

Delville's theories of mysticism were fundamental to his art. He believed among other things that an astral light exists in every individual to some degree, and in his paintings he consciously sought to create the illusion of that light (Legrand 1972, pp. 80–94, 260). S.J.B.

MAURICE DENIS

French, b. Grandville 1870, d. Paris 1943.
After classical studies at the Lycée Condorcet in Paris, where he met Roussel and Vuillard, Maurice Denis entered the Académie Julian in 1888. With Ibels, Ranson, Bonnard, and Sérusier, and after the historic meeting between Sérusier and Gauguin at Pont-Aven, he founded the Nabi group, whose spokesman and theoretician he became. At the age of twenty, Denis published his first theoretical article in Art et Critique (August 1890): "Définition du Néo-Traditionalisme," which began with the famous sentence: "Remember that a picture, before being a war-horse, a nude woman, or some kind of anecdote, is essentially a plane surface covered with colors assembled in a certain order." His writings were collected in two volumes: Théories (1912) and Nouvelles Théories (1922).

Denis did easel painting, book illustration, and mural decoration. The subjects of his paintings often reflect his ardent Catholicism and devotion to his family. He received important commissions from the Church: decorations for the church at Vésinet in 1899, frescoes and cartoons for stained-glass windows, and mosaics for other churches; in 1919 he and Desvallières founded the Ateliers d'Art Sacré. He painted panels for the bedroom shown at L'Art Nouveau in 1895 and for the Théâtre des Champs-Elysées in Paris (1912).

His decorative work, primarily designs for stained glass and wallpaper, though less known

is still important as an expression of the principles of the Nabis and of contemporary interest in the applied arts. He also created woodcuts and illustrations for numerous books; his lithographs were published in La Revue Blanche and L'Estampe Originale.

Denis' home, the priory of Saint-Germain-en-Laye near Paris, is now the Musée Symbolistes et Nabis (Dayez 1970; G. Lacambre 1972, p. 36). Y.B.

GEORGES DE RIBAUCOURT

French, b. Soisy-sous-Montmorency 1881, d. 1907.
De Ribaucourt, who studied under Hector Lemaire at the Ecole des Arts Décoratifs, began his career as an industrial artist, but in 1902 he entered and won first prize in the annual contest sponsored by the Revue de la Bijouterie, Joaillerie, Orfèvrerie. That same year he exhibited with the Société des Artistes Français at their annual salon. According to the catalogue of that exhibition, his entries included a collection of art objects in various precious materials and "designs for rings." The latter group, a set of drawings, was lent to the salon by Sarah Bernhardt (Revue de la Bijouterie, no. 26 [June 1902], p. 57, no. 27 [July 1902], p. 87). S.J.B.

HÉLÈNE DE RUDDER

Belgian, b. Ypres 1870.
Hélène du Ménil married the sculptor Isidore De Rudder in 1890. In 1895 she exhibited the Paravent des Parques and a decorative panel called Aigle et Cygne, both in embroidery, at the Cercle Artistique et Littéraire in Brussels. At the colonial exhibition held in Tervueren in 1897 she exhibited eight large embroidered panels after designs by her husband: Civilisation and Barbarie, Famille and Polygamie, Religion and Fétichisme, Liberté and Esclavage. J.-G.W.

GEORGES DESPRET

French, b. 1862, d. 1952.
In 1884 Despret became the director of the important Jeumont glassworks, which produced window glass and mirrors in large quantities. Despret, an industrialist as well as an artist, did research in a studio that was located in the factory itself; there, almost simultaneously with Henri Cros, he rediscovered the secret of polychrome pâte de verre.

After entering his works in several salons he enjoyed a huge success at the Exposition Universelle of 1900, where his pâte de verre goblets were particularly well received. Despret borrowed forms and naturalistic themes from the

Japanese but interpreted them freely; he often applied them to cups, vases, and small sculptures, executed in a thick-walled, lumpy, bubbly *pâte de verre,* which he designed for mass production. He was equally interested in using *pâte de verre* to imitate other materials, such as marble, onyx, agate, and even stoneware (Verneuil 1904b; Benedictus 1907). C.C.

CHARLES DESROSIERS
French, b. 1865, d. 1927.
There is very little known about the jeweler Charles Desrosiers, except that he did design jewelry for Fouquet. Some of his original designs are now in the Cabinet de Dessins of the Musée des Arts Décoratifs in Paris.

EMILE DIFFLOTH
French, b. Couleuvre (Allier) 1856.
Ceramist Emile Diffloth studied at the Ecole des Arts Décoratifs in Paris. Around 1899 he was employed at Kéramis, the Belgian pottery of Boch Frères at La Louvière; he left his position as artistic director there around 1910 to join Taxile Doat at University City, Missouri, where he taught ceramic technique. Upon his return to France Diffloth showed works at the Musée Galliera and was a member of the Société des Artistes Français, winning a gold medal in 1929 (*International Studio* 6 [1899], p. 135; Evans 1974, pp. 287–88).

TAXILE DOAT
French, b. Albi 1891, d. 1938.
Taxile Doat took design courses at the Dubouché school while making a living in telegraphy. The technique of *pâtes rapportées,* then being developed, so excited him that he dedicated himself entirely to that process, resigning from his work to enter the sculptor Dumont's studio at the Ecole des Beaux-Arts in Paris. He moved to the Manufacture de Sèvres in 1877. Doat eventually found the division of labor at Sèvres not to his liking; he wanted to follow the fabrication of a piece from its very beginning to its final firing. Around 1892 he installed a kiln at his home on the rue Bagneux and for seven years studied clays and glazes for porcelain. By the time he built a wood kiln at Sèvres in 1898 he was a master of his technique, and his entry in the Exposition Universelle of 1900 gave him a worldwide reputation. He then turned to stoneware and tried to create objects made of both materials, stoneware and porcelain.

The *pâtes rapportées,* which inspired Doat's interest in ceramics, figure frequently in his work: cameos at the center of a plate or on the sides of a vase or a bottle, often accompanied by overflow glazes. He excelled in crystalline and metallic glazes, applying them typically to the gourd vases he produced around 1900. Doat's technical study, *Grand Feu Ceramics,* appeared originally in *Keramic Studio,* then was published as a book in 1905 by the Keramic Studio Publishing Co., Syracuse, New York; a condensed version appeared in *Art et Décoration* in 1906 and 1907. The American Women's League called him to the United States in June 1909 "for a conference with the League's architects in order that the erection of one of the most perfectly designed and equipped art potteries in the world might be immediately begun" (*Women's Magazine,* July 1909, p. 24, quoted in Evans 1974, p. 287). Thus Doat became director of the School of Ceramic Art in University City, Missouri; the first kiln was functioning by April 1910. His influence on the production there was substantial, reflected as much in techniques as in the vocabulary of forms, and University City was for a short time one of the most successful American potteries. The studio closed in 1915, however, and Doat returned to France (Verneuil 1904a; Doat 1906; Evans 1974, pp. 286–91). Y.B.

AUGUSTE DONNAY
Belgian, b. Liège 1862, d. Jette-Saint-Pierre 1921.
Donnay, the son of a sculptor, studied at the academy of Liège while working as a grainer for a house painter. After traveling on a fellowship he returned to Brussels and joined the art group Wallonie in 1887; he exhibited four times with La Libre Esthétique between 1894 and 1904. Donnay's talents ranged from easel painting to decorative frescoes, from poetry illustration to poster design.

Maurice Siville, who had founded *Caprice Revue* with the collaboration of Berchmans, Rassenfosse, and Donnay, commissioned from each of these three artists a poster for the insurance company he directed. Donnay's poster evokes the perils of fire and theft in a violent and powerful manner that neither Berchmans nor Rassenfosse was able to achieve (Oostens-Wittamer 1975, pp. 45–46). A.W.

FERNAND DUBOIS
Belgian, b. Renaix 1861, d. Sosoye 1939.
Fernand Dubois (who signed his works *Fernandubois*) moved to Brussels in 1877, studied the natural sciences at the university in Brussels, and spent his spare time designing. Thanks to his brother, a doctor, he met Constantin

Meunier, whose advice he followed by enrolling at Charles van der Stappen's studio, where he worked for nine years. Specializing in engraving and particularly medal-making, he had his first success with a medal in 1886 and went on to create many others, including one that commemorated the death of Crown Prince Baudouin of Belgium (1902). Dubois exhibited medals, jewelry, chandeliers, candelabra, an inkwell, and ivory figurines set in silver at the Salons de la Libre Esthétique in 1894, 1895, 1897, and 1899. His friend Horta built a house for him at 80 avenue Brugmann, Brussels (1901–1906), and a villa at Sosoye in 1905. The painter Jan Toorop was also a close friend. From 1896 on, Dubois taught metalwork at the Ecole Industrielle in Brussels; he ceased his artistic activities around 1925. J.-G.W.

MAURICE DUFRÊNE
French, b. Paris 1876, d. Nogent-sur-Marne 1955.
While a student at the Ecole des Arts Décoratifs, Dufrêne went to work at Meier-Graefe's La Maison Moderne in 1899. "I had one last chance," he wrote later. "Everything I missed at school was offered to me by this modern workshop. . . . I learned how to conceive things, with the idea of a finished product in mind, for the needs of a client. This serious contact with industry was my real and definitive apprenticeship as a decorator" (Dufrêne 1921, p. 132). Dufrêne touched on all aspects of interior decoration, and his projects were executed in many different kinds of materials: porcelain, earthenware (executed and glazed by Dalpayrat), metal, leather, wood, and textiles. He participated in the founding of the Société des Artistes Décorateurs in 1901; after 1906, like many artists, he reacted against Art Nouveau. Professor at the Ecole Boulle from 1912 to 1923, Dufrêne was a strong advocate of industrial techniques (Dufrêne 1921; Hakenjos 1974, p. 62). Y.B.

JEAN DUNAND
French, b. Lancy, Switzerland, 1877, d. Paris 1942.
After studying at the Ecole des Arts Industriels at Geneva, Dunand went to Paris in 1896 or 1897 (he later became a French citizen) and worked with the sculptor Jean Dampt, an admirer of Ruskin and the Arts and Crafts Movement. From 1896 to 1902 he did sculpture exclusively, but in 1903 he began experimenting with beaten metal and in 1905 showed his first vases, made of hammered copper, steel,

tin, lead, and silver. At first using the vegetal shapes of Art Nouveau, he soon developed his own repertory: bottles with long or short necks, round or octagonal plates, cachepots, and tapered vases. His decoration followed the same evolution as he abandoned relief for patinas and inlay work in soft metals—gold, silver, and nickel. From Art Nouveau flora and fauna he moved, around 1913, to geometric forms. After the war and through the 1920s Dunand successfully exploited the technique of lacquering, using it to decorate both wood and metal (Brunhammer 1973, and bibliography). Y.B.

OTTO ECKMANN

German, b. Hamburg 1865, d. Badenweiler 1902.

Eckmann studied graphics, painting, and the applied arts at the Kunstgewerbeschule of Hamburg and Nuremburg and at the Munich academy. First a painter, he soon switched to the decorative arts. Discovering Japanese art through the collections of the Museum für Kunst und Gewerbe in Hamburg, he studied Japanese printmaking techniques and was greatly influenced by Japanese prints before finding his own personal style. In 1896 and 1897 he contributed ornaments and illustrations to the German reviews *Pan* and *Die Jugend*. From 1897 on, he was a professor at the Kunstgewerbeschule in Berlin, where he devoted himself more and more to the applied arts: he designed textiles, furniture, and rugs, as well as ceramic tiles for Villeroy et Boch, and executed some interiors for, among others, the Grand Duke of Hesse. Eckmann is one of the best representatives of Jugendstil, the Art Nouveau movement in Germany. Y.B.

JAMES ENSOR

Belgian, b. Ostende 1860, d. Ostende 1949.

Except for rare trips to Holland, England, and Brussels and a period of study at the Brussels academy from 1877 to 1880 under Portaels and others, Ensor stayed in Ostende, where his father, an Englishman married to a Belgian, ran a souvenir shop. Besides being a painter whose early works show the influence of Manet, Degas, and the Symbolists, Ensor was a writer, musical composer, draftsman, and engraver.

The name of Bosch has been advanced in connection with Ensor. Yet Ensor's masks and masquerades suggest more bitter comments on society than fantastic art. The skeletons that appear frequently, unlike those in Delvaux's work some sixty years later, do not seem so much to belong to a world of dream as to express despair and social criticism. Ensor was far removed from the optimism of Les Vingt and, although he was a founding member, his *Entry of Christ into Brussels* was refused at the group's exhibition in 1889. Other important salons also banned his work because of its "violence and grotesqueness," and it was not until 1894 that he held his first one-man exhibition in Brussels. He exhibited under the auspices of *La Plume* in Paris in 1898 and in 1910 held a large show in Rotterdam.

Ensor's fame grew, aided by art collector François Franck's interest in him and by the poet Verhaeren's monograph on him in 1908, but it was not until recently that historians have acclaimed him as a precursor of modern Expressionism. S.C.

HENRI EVENEPOEL

Belgian, b. Nice 1872, d. Paris 1899.

Born in France of Belgian parents, Evenepoel was to spend most of his life in France. He did study for a time in Brussels; one of his teachers there was Adolphe Crespin, whose influence is evident in Evenepoel's 1894 poster *Anvers et son Exposition*. Moving to Paris in 1892, he took courses in decorative painting before becoming a student of Gustave Moreau. He mingled with the avant-garde crowd in Paris and did a poster for the Salon des Cent. After making his debut at the 1894 salon of the Société des Artistes Français, he exhibited at the salon of the Société Nationale des Beaux-Arts from 1895 until his death. During 1897 and 1898 he traveled in Algeria, making a number of sketches of Arab life.

A painter in the Impressionist style and an excellent colorist, Evenepoel was scheduled to exhibit at the Salon de la Libre Esthétique in 1900. After his untimely death in 1899 he was praised by Octave Maus, and La Libre Esthétique exhibited a number of his works (Oostens-Wittamer 1975, pp. 50–51). A.W.

JEAN-JACQUES FEUCHÈRE

French, b. Paris 1807, d. Paris 1852.

Sculptor and engraver Jean-Jacques Feuchère, the son of an engraver, made his debut at the salon of 1831 and continued exhibiting there through 1852. Many of his sculptures are in important locations in Paris, including a stone bas-relief on the Arc de Triomphe, three bronze statues decorating a fountain in the place de la Concorde, and a statue of Mary Queen of Scots in the Jardin du Luxembourg; a large fresco in the church of Saint-Paul, Paris, is his work as well.

EUGÈNE FEUILLÂTRE

French, b. Dunkirk 1870, d. Paris 1916.

Feuillâtre was an extremely versatile artist, working as a sculptor, silversmith, and jeweler, but it was in enameling that his remarkable talent was most apparent. He began his career working for René Lalique, and experimented with various methods of enameling on silver and platinum. Leaving Lalique's studio in 1899, he began specializing in plique-à-jour enameling, a technique in which he produced some of the most extraordinary and intricate Art Nouveau metalwork. In 1899 Feuillâtre's work was exhibited at La Libre Esthétique. He also exhibited at the New Gallery, London, at the Exposition Universelle in 1900, and at the Turin exposition two years later. In 1899 he became a member of the Société des Artistes Français, where he exhibited until 1910 (Frantz 1901; Gere 1975).

ALFRED WILLIAM FINCH

b. Brussels 1854, d. Helsinki 1930.

Born of English parents, Willy Finch first took up landscape painting and very soon turned to Impressionism. In 1883 he was a founding member of Les Vingt; in 1886 he traveled to London. There he met Whistler, whom he tried without success (because of Ensor's opposition) to have made a member of Les Vingt. Because of his contacts in England, Finch was familiar with the Arts and Crafts Movement there, and was responsible for spreading knowledge of it to Van de Velde and Les Vingt. In 1888, he discovered Seurat and became interested in Pointillism. At the request of Anna Boch, another member of Les Vingt, in 1890 he entered the Boch factory, Kéramis, at La Louvière, where he remained three years as a ceramic decorator. In 1896 he experimented with glazed pottery in his studio at Forges-Chimay, without however giving up painting. Finch became professor at the decorative arts school in Helsinki, Finland, in 1902 and served as director of the ceramic division at the Iris factory there. J.-G.W.

ARTHUR FOÄCHE

French, b. Janzé (Ille-et-Vilaine).

Landscape painter and poster artist Arthur Foäche worked in Toulouse, a center for lithography and the home of the Cassan printing house, for whom Mucha created a poster. Mucha's influence is clearly visible in Foäche's poster *Garonne;* a more personal style is evident in Foäche's poster for *La Dépêche de Toulouse*—for which Maurice Denis had previously created one. A.W.

PAUL FOLLOT

French, b. Paris 1877, d. Sainte-Maxime 1941.
Sculptor and decorative artist Paul Follot was a student of Eugène Grasset, whom he succeeded as professor of the advanced course in the decorative arts for the city of Paris. He first exhibited at the salon of the Société des Artistes Français in 1901, and made his debut as an independent artist in 1904 after several years spent at Meier-Graefe's La Maison Moderne. At first influenced by Pre-Raphaelitism and the English styles, he soon turned to classic forms ("des architectures calmes") and gave an important place to color, to beautiful materials and techniques (marquetry, lacquers, and bronzes), and to abundant decoration, preferably executed by his collaborator Laurent Malclès. His prolific production comprised furniture, room interiors, rugs, textiles, wallpaper, and table services. Follot, who in 1923 became the director of Pomone, the interior decoration studio of the department store Au Bon Marché, was the defender of an aristocratic tradition of luxury and always remained opposed to mass-produced art. Y.B.

GEORGES FOUQUET

French, b. Paris 1862, d. 1957.
At eighteen Georges Fouquet entered the jewelry firm of his father Alphonse, and took it over in 1895; there he was assisted by designers like Tourette and Desrosiers. Determined to get involved in the modern movement, he distinguished himself at the Exposition Universelle of 1900. Henri Vever wrote: "Georges Fouquet showed a large number of jewels and jewelry with unusual forms . . . that were somewhat eccentric but which were noted nonetheless." He called on Mucha in 1901 for the decoration of his new store on the rue Royale in Paris, and collaborated with Mucha on the famous bracelet-ring for Sarah Bernhardt that was exhibited at the Milan exposition in 1906. Especially interested in settings for jewels, and with a marked preference for the baroque pearl, Fouquet introduced new motifs that were less delicate than those of Lalique: thistles, thorns, insects, and bats (Vever 1908, pp. 623–29). C.B.

PAUL FREY

b. 1855.
The jeweler Paul Frey was associated with the Parisian firm of Antoine Touyon, a company that produced small luxury items like medals, buttons, bracelets, and all sorts of gold jewelry in the then-fashionable English style. Upon as-suming control of the firm in 1890 Frey became the collaborator of some of the principal Parisian jewelers; his innovative ideas won him a silver medal at the 1900 Paris Exposition Universelle. He was assisted by his son André, also a skilled jeweler (Vever 1908, pp. 582–84).

G.D.A. (GÉRARD-DUFRAISSEIX-ABBOT)

Limoges.
G.D.A., which executed ceramics for Samuel Bing's L'Art Nouveau from 1901, was one of the oldest of the Limoges ceramic houses, the successor to a firm founded by François Alluaud in 1797. From 1877 to 1881 it was directed by Charles Field Haviland—the cousin of Charles and Théodore Haviland of Haviland & Co. —who had married into the Alluaud family; in 1882 it was taken over by Messrs. Gérard, Dufraisseix, and Morel. E. Gérard, previously the owner of a decoration studio, acted as manager, with Dufraisseix as a silent partner. Morel withdrew as an associate in 1890, remaining to pursue research on high-fired decoration. The firm did business as Gérard, Dufraisseix & Co. for ten years, becoming known as G.D.A. on December 26, 1900, when an American named Abbot became one of its directors and took charge of its activities in the United States. Bing is known to have placed orders with Gérard, Dufraisseix & Co. before 1901 (personal communication, Jean d'Albis, 1975; Bing to Gérard, Dufraisseix & Co., July 3, 1900, G.D.A. archives, Limoges).

EUGÈNE GAILLARD

French, b. 1862, d. 1933.
With Georges de Feure and Edward Colonna, Gaillard was one of the principal collaborators in S. Bing's shop L'Art Nouveau. The three artists together created Bing's pavilion at the 1900 Exposition Universelle; Gaillard contributed a bedroom and a dining room to this display of six fully decorated rooms. Both are now at the Museum für Kunst und Gewerbe, Hamburg. The furniture he made between 1900 and 1914, simple and refined, achieved the goal he set forth in his A propos du Mobilier, published in 1906: "To put an undeniable artistic character into the most humble object, the ordinary piece of furniture" and "to furnish beautiful prototypes of all kinds for the so-called art industries." In his furniture lines were amplified and refined by the moldings, which "determined the correct proportions for diverse parts"; he felt that the decoration, though inspired by nature, should be "unreal"—"so that it might be completely natural without evoking any precise form from the animal or vegetable kingdoms" (Gaillard 1906; Brunhammer 1964b, p. 106).

LUCIEN GAILLARD

French, b. 1861.
In 1878 Gaillard began his apprenticeship under his father Ernest, a noted jeweler, and in 1892 became director of the family firm. Particularly interested in metalwork, he studied techniques of gilding, alloying, and patinating silver; long research into Japanese techniques led him around 1900 to employ craftsmen from Tokyo in his shop. At the 1889 Exposition Universelle Gaillard's virtuosity won him a gold medal, for heliographically engraved gold and silver. At the 1900 fair his entries were again primarily silver pieces. About this time, however, René Lalique persuaded him to take up jewelry design; moving to a larger studio on the rue de la Boëtie, he began work that suggested Lalique's influence, using not only precious stones but enamels and exotic materials like horn and ivory. He won a first prize at the salon of the Société des Artistes Français in 1904, and thereafter his jewelry, notable for the originality and color of its floral or insectlike settings, met with marked success (Demaison 1902; Karageorgevitch 1903; Oostens-Wittamer 1965, p. 27; Gere 1975, pp. 183–84). Y.B./ C.C.

EMILE GALLÉ

French, b. Nancy 1846, d. Nancy 1904.
Gallé's father Charles was the enterprising proprietor of a store in Nancy where he sold ceramics and glassware, some executed after his own designs, some finished and decorated at a small studio there; around 1850 he acquired an interest in a pottery near Saint-Clément, and employed ceramists and decorators to produce his own line of faïence. It was in the Nancy and Saint-Clément workshops that the young Emile began to learn the skills of the craftsman, painting faïence and helping to cut and enamel the glassware. After studying painting and design under the local artists and botany under Dominique Alexandre Godron, a professor at the university in Nancy, Gallé for the next ten years (1862–72) divided his time between travel, work in his father's studios, and study—a period of intellectual and cultural enrichment. He spent the winter of 1865–66 in Weimar studying philosophy and mineralogy, and it has recently been discovered that he took courses as well at the Atelier für Architektur und Kunstgewerbe, an institute with an excel-

lent collection of historic glassware whose styles would reappear in Gallé's early glass.

From 1866 to 1867 Gallé served a practical apprenticeship in glassmaking at Burgun, Schverer & Co. in Meisenthal. After voluntary service in the Franco-Prussian War he went to London to help E. du Sommerard organize the exhibition "Art de France," taking advantage of his stay there to see the Royal Botanical Gardens at Kew and the collection of the South Kensington Museum. Back in Europe, he spent some time in Paris studying the treasures at the Cluny and at the Louvre, especially the cameos and precious stones in the Galerie d'Apollon—important sources for his own cameo and cut glass.

In 1874 Gallé's father turned over the artistic direction of the family firm to him. It was at the Exposition Universelle of 1878 that his work first attracted public attention—particularly the faïence, which until 1882 was more important in his oeuvre than glass. The glassware he showed was transparent, tinted sometimes to the pale blue *clair de lune* color, painted with enamels, or cut; the decoration was reminiscent for the most part of the Louis XV or XVI styles, although a few examples showed a Japanese influence. Gallé's style in this first period was full-blown historicism.

Gallé made his mark as a true artist in glass at the 1884 Union Centrale des Arts Décoratifs exhibition in Paris, titled "La Pierre, le bois, la terre, et le verre." He showed three hundred pieces there, some in Islamic or medieval style, others cased with up to four layers of glass, with inclusions of air bubbles coloring oxides or enamels, or gold and platinum paillons; for decoration on these latter pieces he used vegetation, flowers, and insects, rarely the human figure. In these compositions was born the "genre Gallé"—the sensitive transposition of organic forms to an inorganic medium, glass, achieved through a complex technology supported by a knowledge of botany as well as an artist's imagination. Floral designs suggested in their delicate tones the mysterious rhythm of nature, and this symbolic message was sometimes accompanied by verses of poetry inscribed on the sides of the vases—Gallé's first "verreries parlantes."

In 1884 Gallé added a cabinetmaking workshop to his studios. The idea of creating furniture came to him, according to his "Notices d'Exposition," during a search for exquisite wood bases for his glassware: fascinated by the grains of exotic woods—"I felt I had discovered India and America!"—he began to dream of making furniture. It seems more likely, if less romantic, that he turned to furniture when the organizers of the 1884 exhibition urged him to begin working with wood, in keeping with the themes of the exhibition.

The first series of Gallé furniture, presented at the Exposition Universelle of 1889, had carving that evoked the Renaissance and marquetry decoration reminiscent of 18th-century cabinetwork. As with his glass, Gallé had two lines of furniture: small pieces like étagères, small tables, nested tables, and pedestals that could be produced inexpensively with the help of machines, and an expensive line, usually commissioned, whose marquetry could involve more than fifty pieces of wood and take years to fabricate. The wood was waxed, never polished or varnished, to achieve a natural effect, and of course the ornamentation was also inspired by nature. But unlike the Guimards, Majorelles, and Vallins, who took an architectural approach to furniture and used curves and angles constructively, Gallé employed ornament merely to hide rather conventional construction: his pieces were only historic styles in disguise.

At the end of 1884 Gallé took advantage of a business trip to Berlin to study the Brandt collection at the Kunstgewerbemuseum. These three hundred pieces of Chinese glass, now destroyed, inspired him to use opaque glass exclusively and confirmed his decision to make cased glassware with nature as a source of ornament. The results of his studies were presented at the Exposition Universelle of 1889 in Paris: he showed no more transparent glass, but cased, colored, and opaque glass with sealed oxides and paillons. The pieces were decorated with polychrome reliefs, carefully wheel-cut, and their success assured Gallé's international fame. From 1891 on he sent individual works to the salons, where, the importance of his work already recognized, they were acquired by museums and collectors.

Gallé's serial production was simpler: the number of layers was reduced to three at the most, acid-etching replaced wheel-cutting and engraving. In his "Notices d'Exposition" of 1889 Gallé had already declared himself a "vulgarizer of art." Besides his splendid unique pieces, he had produced lines of limited editions which he called the "grand genre" and "demi-riche," and now he set about exploiting all three. His industrial glass, what Ada Polak calls "standard Gallé," was produced practically in an assembly line. The use of different colors of glass and the application of a single ornamental design to a variety of forms maintained the myth of individual pieces, as did some of the signatures: *Gallé fecit,* for instance, meant not that Gallé had made the piece by hand, rather that he had designed it and supervised its execution. Other pieces were not even of his design.

After 1884 only the unique pieces for exhibition, the "grand genre," and prototypes for mass production were made in Nancy; the industrial glass was actually fabricated by Burgun, Schverer & Co. in Meisenthal. Only after an expansion in 1894–95 were the facilities at Nancy large enough to house the three hundred workers needed to produce Gallé's industrial glass. It is notable also that Gallé in 1897 received patents for two processes: for marquetry, or inlay, and for *patinage,* or texturing.

Gallé's style in the late 1890s became more and more sculptural, the "verres sculptés" he produced around 1900, with their thick applications, in fact resembling sculpture more than vases. At the Exposition Universelle of 1900, the final triumph of his career, his glass and furniture won him two top prizes and his collaborators were showered with medals.

In 1901 Gallé founded and became the first president of the Ecole de Nancy, with the support of his friend and collaborator Victor Prouvé. This alliance of Lorraine artists exhibited across Europe until 1909 and was a driving, innovative force in French Art Nouveau. Although Gallé participated in the group's triumphant exhibition in the Pavillon de Marsan in 1903, he was unable to witness his friends' hometown success in 1904: a few days before the exhibition was to open in Nancy he died of leukemia, which had afflicted him since 1898.

After his death his wife and daughters continued to supervise the firm's production until 1905, when his son-in-law took over the business. The Gallé glass factory was closed in 1931 (de Liesville 1879; Hannover 1889; Nicolas 1900; de Fourcaud 1903; Henrivaux 1903; Henrivaux 1905; Gallé 1908; Varenne 1910; Marx 1911; Gros 1955; Demoriane 1960; Polak 1963; Charpentier 1965; Dennis 1966; Polak 1966; Bedel 1968; Hakenjos 1969; Hakenjos 1973; Hilschenz 1973). B.H.

Antoni Gaudí

Spanish, b. Reus 1852, d. Barcelona 1926.
An admirer of Viollet-le-Duc's *Entretiens sur l'architecture,* Gaudí like the other Catalan architects of the last quarter of the 19th century benefited from the absence of an architectural tradition in Barcelona (discounting the Catalonian Gothic style). For an uncultured

bourgeoisie, newly enriched by the textile industry, Gaudí was at liberty to apply his own concepts to architecture. These developed from the influences that were apparent in his early works: medieval art in the crypt and transept of the Sagrada Família and the Casa Bellesguard (1900–1902), and Arab art in the Casa Vicens (1878–85) and the Palau Güell (1885–89).

To his architecture Gaudí brought skills as a sculptor, painter, ironsmith, ceramist, mosaicist, and creator of furnishings. His interest in new materials and their unadulterated use ties him with the Art Nouveau movement, as does his conception of the all-encompassing role of the architect. Like Horta at the Hôtel Tassel, Van de Velde at Bloemenwerf, and Guimard at the Castel Béranger, he felt that the architectural interior down to the most minute detail of the furnishings was as important as the construction itself. It was in this spirit that he designed the partitions and furniture for the ground floor of the Casa Calvet (1898–1900), the interior of the first floor of the Casa Battló (c.1907), and the benches in the crypt of the Colonia Güell church at Santa Coloma de Cervelló, near Barcelona (1898–1914). His chairs summarize his art: they are sculptures of organic inspiration in which the functional aspect is not neglected (Tarragó Cid and Brunhammer 1971). Y.B.

PAUL GAUGUIN
French, b. Paris 1848, d. Fatu Hiva 1903.
Gauguin was among the group of painters at the end of the 19th century who took up the decorative arts. Besides carving furniture and other objects, he worked with ceramics during three periods of his career. The first, by far the most prolific, lasted from May-June 1886 to April 1887, when he fired his work in the studio of Ernest Chaplet on the rue Blomet. In some pieces from this period decorative scenes—a Breton woman with geese and sheep or a Breton woman with raised arms—were painted on stoneware forms from Chaplet's repertory, then fired; the marks of Chaplet and Haviland sometimes appear side by side with Gauguin's painted signature on cylindrical vases and cups. Gauguin used his own glazes, which were completely different from Chaplet's. His motifs were *cloisonnés,* that is, separated by a black outline which was sometimes heightened with gold. The technique was standard in Chaplet's studio, done to prevent the glazes from running or mixing. According to Merete Bodelsen (1959) and Jean and Laurens d'Albis (1976), it was this technique rather than the influence of Emile Bernard that gave rise to *cloisonnisme* in Gauguin's paintings. Other pieces were hand modeled, somewhat awkwardly, by the painter himself, with the decoration incised, painted in barbotine, or modeled in relief. Some pieces call to mind 16th-century European folk pottery, while others are reminiscent of the Pre-Columbian pots that Gauguin knew from the years he spent in Peru as a youth. The exact number of objects fired for Gauguin at Chaplet's studio during the winter of 1886–87 is difficult to establish. Gauguin wrote to Bracquemond in January 1887 that he had just taken fifty-five pieces from the kiln; the total number is, according to Christopher Gray, much greater.

Returning from Martinique in 1887, Gauguin began doing ceramics again, this time with Delaherche, who had taken over the studio on the rue Blomet. He spent more time working on technique, the composition of his clays, and the formulas of his glazes. His forms departed farther and farther from those of traditional ceramics; their plastic quality improved; his glazes became more striking. Gauguin found few buyers, however, for his pots; the majority were given to friends or remained with his family in Copenhagen.

From 1889 to 1890 Gauguin was attracted more than before by the symbolic and expressive possibilities of sculptural form. Thereafter, with the exception of pieces of stoneware sculpture done around 1893 and 1895, he abandoned ceramics. Gauguin seemed to be disillusioned by his experience with ceramics; he had not found there the financial benefits he had hoped for, nor had he succeeded in creating "a new direction by the creation of new forms, made by hand" (quoted in Bodelsen 1960, pp. 7, 10) (Bodelsen 1959; Bodelsen 1960; Gray 1963; Camart et al. 1971, p. 35; d'Albis and d'Albis 1976). Y.B./C.C.

LUCIEN GAUTRAIT
Lucien Gautrait, who designed and made jewelry, seems to have worked for Maison Vever in Paris. But he was better known for being the chief engraver at another Parisian jewelry firm, Gariod, for whom he made brooches and pendants (Vever 1908, p. 618; Gere 1975, p. 226).

PAUL GRANDHOMME AND ALFRED GARNIER
French.
Paul Grandhomme, a Parisian jeweler, and Alfred Garnier, a student under Cabanel at the Ecole des Beaux-Arts, each came to enamel painting through reading Claudius Popelin's *Email des Peintres.* The two were introduced in 1877 by a mutual friend, Raphaël Collin, when Garnier sought to learn enamel painting. Grandhomme, who had built a kiln in his home and had actively pursued the technique, taught him all he knew, then sent him to study with more experienced enamelers.

Some ten years later Garnier came into an inheritance, a house with a yard and the means to set up a small studio there. Grandhomme, discouraged and in financial straits from lack of commissions, had just abandoned enameling, sold his tools and kiln, and taken up illustration, when the jeweler Jules Brateau came to him with a commission for an enamel plaque. Grandhomme went to his former student and asked permission to use his studio; from that day on they worked together and signed pieces jointly. Shortly after their collaboration began they entered works in the 1889 Exposition Universelle and had the first of many successes. Their enamel of Gustave Moreau's *Les Voix* was commissioned that year by the Musée des Arts Décoratifs; Moreau was so pleased with their work that he created a watercolor for them whose palette would lend itself particularly to the medium of enamel painting.

Grandhomme and Garnier exhibited together at the salon of the Société Nationale des Beaux-Arts from 1891 until 1898, when they parted company; thenceforth Grandhomme exhibited alone (Falize 1894). S.J.B.

EUGÈNE GRASSET
French, b. Lausanne 1845, d. Sceaux 1917.
Grasset, the son of a cabinetmaker, first studied architecture but left to travel to France and Egypt. When he returned to Switzerland at the end of 1867 he did decorative sculpture. In 1871 he moved to Paris; twenty years later he became a naturalized citizen of France. In studying design he discovered Viollet-le-Duc and the art of the Middle Ages, which would be a lasting source of inspiration in his work. Around 1880–85 Grasset designed a complete interior decor for Louis Gillot's photo studio on the rue Madame, Paris. The oak and walnut furniture there showed the influence of medieval and Renaissance architecture, while the richly carved woodwork wedded curves that proclaimed Art Nouveau to the flora and fauna of the Middle Ages. The original interior of the Gillot studio has remained intact, with the exception of the dining-room furniture, now at the Musée des Arts Décoratifs, for which the museum has designs dated 1880. Grasset also designed mosaic or glazed lava panels, ceramics (some executed

by Emile Müller), and stained-glass windows. These windows, generally of religious subjects, were executed by the glassmaker Félix Gaudin; the Joan of Arc windows for the cathedral of Orléans are the most famous examples. At the 1900 Exposition Universelle Grasset presented a large window entitled *Le Printemps* (now at the Musée des Arts Décoratifs), along with decorative panels on the same subject; his compositions reveal the dual influence of the Quattrocento and Japanese woodcuts. In addition, some of the jewels exhibited by Paul and Henri Vever were of his design.

A well-known illustrator—the *Histoire des Quatre Fils Aymon* (1883) being his first success in this field—Grasset was also a prolific poster designer. Some of his posters reflect his love of stained glass: *Jeanne d'Arc* (1890), *Salon des Cent* (1894). Others show the illustrator's spirit: *Les Fêtes de Paris* (1900) in a medieval style, and *Librairie Romantique* (1890) in a more classical style. His fame brought commissions—for *Harper's* (1892) and the *Century Magazine* (1892)—from the United States; it was Grasset who designed the emblem that for years appeared on the cover of the *Dictionnaire Larousse*. He executed decorative lithographs as well.

Grasset exhibited at the first Salon de la Rose + Croix and several times at the Salon de la Libre Esthétique. As the head of the decorative composition program at the Ecole Normale d'Enseignement du Dessin at Paris, he published for his students (and in part with their help) two volumes—*La Plante et ses applications ornementales* (Paris, 1897) and *La Méthode de composition ornementale* (Paris, 1905)—which exercised a considerable influence on numerous decorator-artists (Alexandre n.d.; Mayor 1918). Y.B./A.W.

HENRI GRAY
French, b. Paris 1858.
Gray, a poster artist whose real name was Boulanger, first worked under the pseudonym Grivois as a caricaturist for Parisian newspapers like *Le Boulevardier*. Later he regularly drew the front page for *Chronique parisienne*, collaborated on the papers *Paris s'amuse*, *Paris illustré*, and *Courrier français*, and did graphic work for the Folies-Bergère.

EMILE GRITTEL
French, b. Strasbourg 1870, d. 1953.
Painter and sculptor Emile Grittel dedicated himself to stoneware under the double influence of Hoentschel and Carriès; at the latter's death in 1894 Grittel produced a portrait of him,

Carriès au chapeau. He divided his time between Saint-Amand-en-Puisaye, where he worked with Eugène Lion, and his own studio in the Parisian suburb of Clichy, where he fired Hoentschel's stoneware. His incised signature is found on pieces of Japanese inspiration—apples and pears with rather dark monochromatic glazes and gold highlights—and on vases with naturalistic reliefs. He was active into the 1920s (Camart et al. 1971, p. 36; Heuser and Heuser 1974, pp. 129–30; Hakenjos 1974, p. 66). Y.B.

JACQUES GRUBER
French, b. Sundhouse (Bas-Rhin) 1870, d. Paris 1936.
Having received a scholarship from the city of Nancy, Jacques Gruber took courses from Gustave Moreau at the Ecole des Beaux-Arts in Paris at the same time as Matisse. Returning to Nancy, he worked for the Daums from 1894 to 1897 and learned the art of engraving, creating decorations that included some inspired by Wagner's operas. In addition he taught decorative arts at the Ecole des Beaux-Arts; the interest of the local industrialists in the modern movement was such that Gruber was able to persuade them to fund his students' projects. Among his students were the painter-designer Jean Lurçat and his brother André, an architect, and the poster artist Paul Colin. All were profoundly influenced by the modernism of Gruber's teaching. At the same time Gruber created furniture designs for Louis Majorelle, ceramic designs for the Mougin brothers, and bookbinding designs for Wiener. In 1900 he went out on his own and for ten years designed and manufactured furniture. Soon afterward he opened a stained-glass studio; the glass for the tearoom and the cupola of the Galeries Lafayette in Paris are his creation, after designs by Cappiello. For a time he pursued both crafts at once, but his interest in furniture gradually diminished. After World War I he moved to a studio in Paris at the Villa d'Alésia, where he produced stained glass for both religious and secular buildings (the choir of the Verdun cathedral, the Nancy steel factory, the French embassies). His son Jean-Jacques worked in collaboration with him, and took over the studio upon his father's death (personal communication, Jean-Jacques Gruber, 1975; Bloch-Dermant 1974, p. 141). Y.B./C.C.

GRUEBY POTTERY
Boston.
William Grueby was born in 1867. After about

ten years' training at the Low Art Tile Works in Chelsea, and a brief partnership, he established the Grueby-Faience Company, acting himself as general manager. Designs for the vases were done by George Prentiss Kendrick, while Grueby was responsible for glazes. Although at first the production was mostly glazed bricks, tiles, and architectural terra-cotta, soon vases were being made, and in 1897 the firm was incorporated and art pottery production expanded. This was also the year of Grueby's exhibition at the Boston Society of Arts and Crafts, the first of a string of successes: the firm took top prizes at the world's fairs of 1900 in Paris and 1904 in St. Louis, while S. Bing in Paris sold its works to such prestigious collections as that of the Musée des Arts Décoratifs.

From 1899 art pottery bore the Grueby Pottery mark, and the Grueby Faience mark thenceforth was usually found only on architectural faience.

All of the art pottery pieces and even some of the tiles were made by hand—hand thrown and decorated. Although the Grueby name became identified with high-quality mat glazes, the contours and the overall integrity of the forms were outstanding as well; both glazes and forms showed the influence of French ceramics, and particularly the work of Delaherche, which Grueby had seen at the 1893 Chicago exposition.

Financial difficulties ensued from 1908, after which few vases were made. Production continued, however, until the pottery burned in 1913 (Eidelberg 1972, p. 136; Evans 1974, pp. 118–23). C.W.C./S.J.B.

MAURICE-GUSTAVE GUERCHET
French.
The son of the jeweler Gustave Guerchet, Maurice Guerchet was a Parisian jeweler noted for creating mountings in silver and vermeil for glass and ceramic pieces, including some vases by Ernest Léveillé (Hilschenz 1973, p. 327).

HECTOR GUIMARD
French, b. Lyons 1867, d. New York 1942.
Guimard was a student at the Ecole des Arts Décoratifs and then at the Ecole des Beaux-Arts in Paris from 1882 to 1885. Before receiving the commission for the Castel Béranger, probably in 1894, he had worked on a restaurant on the Quai d'Auteuil, the Pavillon de l'Electricité at the 1889 Exposition Universelle in Paris, and several houses in Paris and the surrounding areas. With the Hôtel Jassedé in 1893 he had already conceived architectural design in its to-

tality: the building's interior space, decoration, and furnishings all corresponded to its external appearance and structure. But while Guimard's concept was revolutionary, his style was not; he continued to be inspired by the Henri II style, and by the Gothic Revival through the *Entretiens* of Viollet-le-Duc, his theoretical master. The turning point for his style came in 1894 and 1895, when he went to England, there discovering Domestic Revival architecture, and to Belgium, where he visited Horta's recently completed Hôtel Tassel. Thereafter the Style Guimard began to take shape; the Castel Béranger, completed and furnished in 1898, was its first concrete expression. In his buildings Guimard spent as much time and care on the public areas (such as doorways and stairs) as on the private apartments, for which he designed the floor and wall coverings, ceiling ornaments, lighting fixtures, door and window hardware, fireplaces, and complete furnishings. In 1899 the Castel Béranger won a facade competition; the same year Guimard organized an exhibition devoted to his building, illustrating his belief that "the principle of art is logic; its liberty is harmony and sentiment."

The period between 1898 and 1901 was quite fruitful for Guimard: he constructed the Castel Henriette, Sèvres (destroyed in 1969), the Humbert de Romans Concert Hall (demolished c. 1905–1908), and the Maison Coilliot in Lille, designing as well the entrances and railings for the Paris subway system, the Métropolitain. At its peak Guimard's style was elegant but severe, devoid of the mannerism that characterized his later works: the Maison Nozal (1902–1905), the Villa Flore (1910), and the Hôtel Mezzara (1911). Throughout his career, Guimard remained faithful to one fundamental idea: that architecture is an all-encompassing art. He took as many pains in designing the smallest object and the furniture as in creating the plans for the edifice itself.

Guimard continued to build after World War I. His characteristic interest in materials and flair for innovation were reasserted in his country home at Vaucresson, where he used tubular asbestos cement elements designed by the architect Henri Sauvage. But Art Nouveau had long before fallen into disrepute; Guimard's past triumphs were forgotten, his new work ignored. With his wife, Adeline Oppenheim, he left Paris in 1938 and moved to New York, where he died in 1942. Y.B.

HAVILAND
Limoges and Paris.

In 1843 the American David Haviland founded a ceramic decoration studio at Limoges that became, some years later, a famous porcelain firm. His son Charles, born in New York in 1839, became director of Haviland & Co. in 1866 and remained in that position until his death in 1921. In 1873 he opened a research studio at Auteuil, Paris, under the direction of Félix Bracquemond, who introduced him to Philippe Burty. Haviland married Burty's daughter in 1877.

The goal of the Auteuil studio was to design and engrave, on copper or lithographic stone, decorations that would be used on the wares produced at Limoges, where Charles Haviland had opened, next to the porcelain factory, a studio for soft-paste porcelain and *faïence fine*. With the arrival of Ernest Chaplet in 1875, barbotine decorations began to be produced at Auteuil, either by the artists connected with the studio or by free-lance painters and sculptors. The vases produced in this manner did not sell, however, forcing Haviland to leave off their manufacture.

Bracquemond left Auteuil in 1881, followed by Chaplet, who opened a Haviland studio on the rue Blomet, Vaugirard. The studio at Auteuil, however, under the direction of Jochum, continued to create decorations for the porcelain manufactured at Limoges until 1914 (d'Albis et al. 1974). Y.B.

GEORGES HOENTSCHEL
French, b. 1855, d. 1915.
A collector and decorator, Hoentschel joined in his friend Jean Carriès' research on stoneware. He exhibited at the salons of the Société Nationale des Beaux-Arts, and like Carriès underwent a strong Japanese influence, often decorating his vases with gold overflow glazes and metal mountings. After Carriès' death Hoentschel bought the manor house at Montriveau and worked there with Emile Grittel; at the end of his life he left Saint-Amand-en-Puisaye and moved to Paris to work in Grittel's studio. Although the magazines and journals of the time mention him only as a potter, Hoentschel's great creation was the decoration and furnishing of the Salon du Bois for the pavilion of the Union Centrale des Arts Décoratifs at the 1900 Exposition Universelle (Gallé 1900a; Camart et al. 1971, p. 38). Y.B.

JOSEF HOFFMANN
Austrian, b. Pirnitz 1870, d. Vienna 1956.
Josef Hoffmann studied architecture in Vienna under Otto Wagner, whose disciple he became.

He taught at the Kunstgewerbeschule from 1899, then with Koloman Moser in 1903 created the Wiener Werkstätte—the craft studios from which the style of the 1920s emerged. Founder of the Vienna Sezession (1897), he kept in touch with Mackintosh and the Glasgow School and was a self-proclaimed follower of the French and Belgian modern movement. His major works, however—the Purkersdorf sanatorium (1903) and the Palais Stoclet in Brussels (1905–1908), where he carried out a complex design of exterior architecture, interior space, furnishings and decoration to the last detail—differ from the Art Nouveau of Belgium and France. These two works represent a turning point for Hoffmann's art specifically and for European art in general: if their spirit of refined ornamentation is akin to Art Nouveau, the formal repertory is already Art Deco. The 1914 exhibition in Cologne of the Deutscher Werkbund—a movement born in 1907 to develop the quality of industrial art by creating centers for its study—put Hoffmann in contact with the work of Gropius and thus with new forms of contemporary art and architecture (Delevoy 1964b, pp. 154–55, and bibliography). Y.B.

KATSUSHIKA HOKUSAI
Japanese, b. Tokyo 1760, d. 1849.
One of the most important and best-known artists of the Japanese school of color printmakers called *ukiyo-e,* Hokusai, the son of an artisan father, was apprenticed to a wood engraver at fourteen. Ending his apprenticeship in 1779, he became a pupil of the great *ukiyo-e* artist Shunshō; his reputation was so well established by 1794 that he was commissioned to take part in the restoration of the temple of Nikkō. His prestige continued to grow and by 1806 he was considered the most prominent of the *ukiyo-e* artists.

Primarily devoted to book illustration during the years of 1807 to 1819, Hokusai turned to landscape and bird-and-flower prints in 1820. His *Thirty-six Views of Mount Fuji* (1823–29), perhaps the most famous of his works from this period, beautifully exemplifies the monumental yet simplified designs he created from nature.

Hokusai's prints were an essential source of inspiration to French artists of the late 19th century, making him the Japanese artist most acclaimed by European critics by the 1880s. In addition to the appeal of the traditional design devices employed by Japanese printmakers, French artists were drawn to Hokusai's unique gift of observation. It was a volume of his

Manga, a fifteen-volume series of sketches, that Bracquemond discovered in Delâtre's shop in 1856, an event which marked the beginning of the Japonisme movement in France. R.B./S.C.

PAUL JEANNENEY

French, b. Strasbourg 1861, d. Saint-Amand-en-Puisaye 1920.

A collector of Far Eastern ceramics and an admirer of the work of his friend Jean Carriès, Jeanneney learned stoneware techniques after Carriès' death. He moved to Saint-Amand-en-Puisaye in 1902 and worked there until he died in 1920. His art, influenced by Chinese stoneware with flambé glazes and Japanese trompe-l'oeil stoneware, is closely related to that of Carriès. He produced gourd vases, round vases, bottles, bowls inspired by Korean *chawans,* and cups, which he covered with mat glazes ranging from beige to brown. The "champignon" vase, decorated with bracket fungus and topped with a carved wooden lid, was a form he created. His stoneware versions of several of Rodin's sculptures (the head of Balzac and heads of some of the Burghers of Calais) are now in the Musée du Petit Palais, Paris (Camart et al. 1971, p. 39; Heuser and Heuser 1974, pp. 133–37; Hakenjos 1974, p. 67). Y.B.

KÉRAMIS

La Louvière (Saint-Vaast), Belgium.

The Boch ceramic factory at La Louvière, called Kéramis, was created in 1841 by a family of metallurgists from Lorraine who had already founded two ceramic factories, the first in 1767 at Sept-Fontaines in the Grand Duchy of Luxembourg, under the name of Villeroy et Boch, and the second in 1809 in the former abbey of Metlach in the Saar. When Luxembourg was separated from Belgium in 1839 the Belgian branch of the family, especially J. F. Nothomb, insisted that the enterprise be moved to Belgium. The factory produced earthenware and stoneware, and decoration on earthenware was begun in 1847; imitations of Delft china were shown at the 1880 Brussels exposition, imitations of Rouen and Sèvres ware in Paris in 1889. Anna Boch (1848–1936), the daughter of the factory's director, was a painter who became a member of Les Vingt in 1886; she convinced Willy Finch to work at Kéramis, and did some decoration there herself. J.-G.W.

FERNAND KHNOPFF

Belgian, b. Grimbergen 1858, d. Brussels 1921.
Khnopff abandoned the study of law at the university in Brussels to study art at the academy there under Xavier Mellery, who greatly influenced his interest in Symbolism. After going to Paris in 1877 Khnopff visited Lefebvre's studio and while in the city was exposed to and excited by the works of Delacroix and Gustave Moreau, and of Burne-Jones, Rossetti, Watts, and the other Pre-Raphaelites. Khnopff was an anglophile, and spent several years in England. He often gave his works English titles, and he contributed to *The Studio,* a British art periodical, from 1894 until his death. His paintings are often closely associated with the literary Symbolism of Grégoire Le Roy, Verhaeren, who wrote a book on him, and Maeterlinck; the Sâr Peladan asked him to show his work in the first Salon de la Rose+Croix in 1892. Khnopff illustrated books and designed frontispieces for him.

In 1883 Khnopff was a founding member of Les Vingt in Brussels and from 1894 was involved in its successor, La Libre Esthétique. He exhibited in Munich and Vienna with the Sezession groups, in the Paris salon, where he won a medal in 1889, and in several international exhibitions. S.C.

CHARLES KORSCHANN

b. Brno, Moravia, 1872.
A sculptor, decorator, and medalist, Korschann studied in Vienna, Berlin, and Copenhagen before moving to Paris, where he lived from 1894 to 1906. An exhibitor with the Société Nationale des Beaux-Arts (1895, 1898, 1901) and with the Société des Artistes Français (1902, 1903, 1905), he showed portrait busts, medals, and small decorative objects, winning a bronze medal at the 1900 Exposition Universelle. After leaving Paris Korschann worked in Germany and Poland before accepting a professorship at Brno in 1919. Among his many portraits of famous figures is one of Mucha.

EDMOND LACHENAL

French, b. Paris 1855, d. c. 1930.
At the age of fifteen Lachenal entered Théodore Deck's studio and soon became its director. In 1880 he opened his own studio, first at Malakoff near Paris, then at Châtillon-sous-Bagneux. Influenced by Deck, he made pottery in the "Persian style," decorated with stylized figures, landscapes, flowers, and greenery. He exhibited annually from 1884 at the Galerie Georges Petit, on the rue de Sèze. In 1890 he perfected a process of partially dulling a glazed surface with hydrofluoric acid; with Keller and Guérin he did experiments on metallic luster glazes, the results of which he first presented in 1895 at the Galerie Georges Petit along with a group of ceramic sculptures after works by Rodin, Fix-Masseau, Epinay, Madrassi, and even Sarah Bernhardt. About this time an interest in enameled glass led him to work with the Daums at Nancy. Lachenal gradually specialized in the manufacture of ceramic vases whose forms and decoration were directly inspired by the plant motifs then in vogue; they were covered with velvety glazes in colors like "ocean blue," "rock brown," "plum," and "pear." At the same time he produced knickknacks like small figurines and barnyard animals. At the Exposition Universelle of 1900 he presented a suite of stoneware furniture, the culmination of an effort to use stoneware to decorate furniture. Lachenal abandoned ceramics at the beginning of the 20th century and turned over his studio to his wife and his son Raoul (1885–1956) (Esnault 1898; Camart et al. 1971, p. 40; Hakenjos 1974, p. 69; Heuser and Heuser 1974, pp. 92–96, and bibliography). Y.B.

GEORGES LACOMBE

French, b. Versailles 1868, d. Alençon 1916.
Most of Lacombe's artistic production consists of wood objects—furniture and panels—carved in a style related to Gauguin's. But he began by studying painting, first with his mother, then formally with Roll, whose academic training he soon abandoned to enroll at the Académie Julian. He joined the Nabis in 1892 and exhibited his paintings with them in 1893 before taking up wood carving in 1893–94.

Lacombe's mother held the conviction that art was a sacred gift, a ministry, and therefore not to be tainted by commercialization. Probably because of this, Lacombe is said never to have sold a single work during his lifetime—rather he gave them as gifts to his friends and neighbors. Like Ranson, his great friend and fellow Nabi, he had an income from his family which freed him from the need to earn his living (Humbert 1964, pp. 63–84; G. Lacambre 1972, p. 61). S.J.B.

RENÉ JULES LALIQUE

French, b. Ay (Marne) 1860, d. Paris 1945.
From 1876 to 1878 Lalique served an apprenticeship under the goldsmith Louis Aucoc in Paris, and for a brief period he took night courses at the Ecole des Arts Décoratifs. After living in England from 1878 to 1880, he returned to Paris and began creating jewelry designs, which he sold to various jewelers. At the end of 1885 he took over the studio of Jules Destape, then moved to a larger location in

1887; in 1890 he finally settled in a new studio on the rue Thérèse, at the corner of the avenue de l'Opéra, and during his first few years designed and executed jewelry in gold decorated with precious stones, concentrating increasingly on his own designs. Dora Jane Janson writes, "The cost of the larger quarters prodded him to greater production, while at the same time his aroused ambition prompted him to study enameling with an almost ferocious intensity, experimenting with new processes, inventing others, until he had achieved an entirely new palette of colors—the soft colors of Art Nouveau. His interest in glass, of which enamel is only a variant with a low melting point, also took shape in this 1890–92 period" (Janson 1971, p. 10).

Lalique designed stage jewelry for Sarah Bernhardt from 1891 to 1894. He exhibited his jewels for the first time at the 1894 salon of the Société des Artistes Français, where he was a regular exhibitor until 1909. He enjoyed a huge success at the Exposition Universelle of 1900 in Paris, where his display was the outstanding attraction. A number of the remarkable pieces he showed there were purchased by museums, enhancing his reputation as the greatest artistic jeweler.

Lalique turned away from simply mounting stones in precious metals relatively early. Influenced especially by Renaissance and Japanese art, he created a new style for jewelry and elevated his craft to a fine art, thereby exercising an important influence on the jewelers of his time. In 1894 he began creating jewels whose design was almost always figurative—flowers, animals, insects, female figures, even landscapes. He combined gold, silver, and enamel with precious stones and materials like horn, crystal, and ivory; in these pieces—various small objects as well as jewelry—composition and expression are even more important than the materials he used. His interest in glass led him to insert pieces of crystal carved with figurative representations into the jewels he created around 1905; in 1906 the perfumer Coty commissioned him to make bottles in pressed glass. In 1908 Lalique rented a factory at Combs-la-Ville, then after the war had another factory built at Wingen-sur-Moder (Alsace). Following a series of experiments with cast glass using the lost wax process, he abandoned jewelry to concentrated exclusively on pressed glass. S.B.

ABEL LANDRY
French, b. Limoges.
Architect-designer Abel Landry studied at the Ecole des Arts Décoratifs in his hometown of Limoges and later at the Ecole des Beaux-Arts in Paris. At first a landscape painter and architect, he turned to interior design after studying with William Morris in London. Upon his return to Paris, Landry became actively associated with Meier-Graefe's La Maison Moderne, the firm which executed the majority of his designs for interior decorations and household items, generally in porcelain and metal. Like other architects of the period he preferred creating total ensembles down to the last detail, including wallpaper, curtains, carved paneling, even the pictures to be hung on the walls. A member of La Poignée, a group that included Prouvé and Brateau, Landry in 1912 became associated with the Salon des Artistes Décorateurs, among whose members were Follot, Dufrène, Guimard, and Majorelle. In his architectural designs for private homes and villas in Paris, Bordeaux, and Coteaux, and apartment buildings in Lyons and Marseilles, Landry contrasted straight and curved lines, making use of stone and ceramics for exterior ornamentation. Even in his architectural works, Landry's painterly eye for color and design prevailed (Sedeyn 1903, pp. 13–20; *L'Art Décoratif* 6 [1904], pp. 48–56; Leclère 1907, pp. 49–60; *Revue de l'Art Ancien et Moderne* 31 [1912], p. 301). R.B.

FRANÇOIS-RAOUL LARCHE
French, b. Saint-André-de-Cubzac 1860, d. Paris 1912.
The sculptor Raoul Larche began his studies in 1878 under Jouffroy, Falguière, and Delaplanche at the Ecole Nationale des Beaux-Arts in Paris. A regular exhibitor in the official salon from 1884, he was awarded the Second Grand Prix in the 1886 Prix de Rome competition; at the Exposition Universelle of 1900 he received a gold medal. Although Larche created models for small pieces like lamps, goblets, ashtrays, vases, and centerpieces, reproduced in pewter or bronze by Siot-Decauville, he was noted for his monumental sculptures, several of which were purchased by the state and placed in public locations around Paris. Probably his best-known work is the group *La Loire et ses affluents*, commissioned by the state in 1910 for the square du Carrousel. R.B.

LÉON LEDRU
French, b. 1855, d. 1926.
Léon Ledru was an innovative and talented French glassmaker who served as manager of the design section of the Cristalleries du Val-Saint-Lambert in Belgium for thirty-eight years. In this capacity Ledru stimulated an interest in avant-garde design that was first manifested in the pieces Val-Saint-Lambert showed at the 1897 Exposition Internationale in Brussels—surprisingly modern vases whose linear decoration reflected the influence of Van de Velde. Van de Velde's style was again apparent in the vases Ledru exhibited at La Libre Esthétique in 1901, but those he designed for the Paris Exposition Universelle of 1900 had floral decoration in a more naturalistic style, in the manner of Emile Gallé and the Ecole de Nancy. Ledru created traditional pieces as well; he is remembered, however, for his innovations in color, decoration, and technique, successes made possible by a long collaboration with the Val-Saint-Lambert chemist Adolphe Lecrenier (Philippe 1974, pp. 200, 203–205). R.B.

LEGRAS ET CIE.
Saint-Denis.
The French glassmaker Auguste J. F. Legras became director in 1864 of the Verreries et Cristalleries de Saint-Denis et des Quatre-Chemins. Renamed Legras et Cie., the factory under his management became one of the principal French glassworks, and remained so until 1914. In 1897 Legras took over the large Vidié glassworks at Pantin, and by 1908 the enterprise employed fifteen hundred workers; in 1909 Legras' son Charles succeeded him as director. The factory's production, large and varied, was generally of good quality but not exceptional as art, although Legras admired Gallé and attempted to imitate the master. Legras' entries received a gold medal at the 1888 Barcelona exposition and grand prizes at the Paris Expositions Universelles of 1889 and 1900. Closed in World War I, the firm was afterwards reorganized under the name Verreries et Cristalleries de Saint-Denis et de Pantin Réunies (*Exposition Franco-Britannique* 1908, p. 10; Hilschenz 1973, p. 317; Bloch-Dermant 1974, pp. 16–18).

GEORGES LEMMEN
Belgian, b. Schaerbeek 1865, d. Uccle 1916.
Lemmen, a painter who exhibited annually from 1889 in the salons of Les Vingt and later those of La Libre Esthétique, was a pivotal member of the Belgian avant-garde movement and maintained a regular correspondence with the pioneers of Art Nouveau in Belgium, and in France with Toulouse-Lautrec. He was quite active in reviving interest in the decorative arts, designing rugs, tapestries—Lautrec himself purchased a tapestry for which Lemmen had

made the cartoon—ceramics, jewelry (for Philippe Wolfers), and mosaics; book illustration and poster design also claimed his attention, while a collaboration with Van de Velde led him to design the type face for Van de Velde's edition of *Also Sprach Zarathustra,* published in 1908. In his posters, many of which were done for La Libre Esthétique up until World War I, Lemmen moved easily from the linear decorative style of *L. Vandevelde et Cie.* to intimate representations of his own family (Oostens-Wittamer 1975, pp. 60–64). A.W.

MARCEL LENOIR

French, b. Montauban 1872, d. Montricoup 1931.
Marcel Lenoir, the son of a jeweler, was a mystical and religious painter of the generation that evolved from Symbolism and the Rose + Croix to Art Nouveau. He has been credited with the design of *Mérodak,* the poster for the 1897 Salon de la Rose + Croix, where he showed four Symbolist works including a gouache entitled *Le Monstre.* His poster for the print dealer Arnould is remarkable for the richness and harmony of its colors (G. Lacambre 1972, p. 64). A.W.

LUCIEN LÉVY-DHURMER

French, b. Algiers 1865, d. Paris 1953.
Lévy-Dhurmer, trained in painting, lithography, design, and ceramics at the city school of drawing and sculpture on the rue Bréguet, Paris, worked as a ceramist between 1887 and 1895 while serving as artistic director of Clément Massier's factory at Golfe-Juan, in the south of France. At the 1882 salon he exhibited a copy on porcelain of a painting by Cabanel, *La Naissance de Vénus.* A collector of Islamic ceramics, he was perhaps responsible for the rediscovery of the technique of metallic luster glazes used in the Islamic Near East from the 9th century and in 15th-century Hispano-Moresque pottery. This technique consisted in covering a piece, already decorated and fired one time, with a metallic oxide, silver or copper, then firing it again in a reducing atmosphere at a much lower temperature. A red or yellow luster resulted. Unfortunately, the sheen on the pieces Massier and Lévy-Dhurmer produced has not proved lasting.
Lévy-Dhurmer's ceramics were for the most part either light-colored earthenware highlighted with gold, or stoneware with an intentionally somber glaze. He used simple forms, usually in an Islamic style, sometimes elaborated with handles or other relief ornamentation. The decoration, painted or modeled, was often typical of Art Nouveau: botanical motifs, peacock feathers, landscapes, feminine figures, or even Arabic characters. The painted signature *L. Lévy* is found together with that of Clément Massier on certain pieces, perhaps from the last three years of their collaboration.
In 1895 Lévy-Dhurmer made the first of several visits to Italy, a journey which revived his interest in painting. He worked primarily in pastels—a good medium for fine tonal shading and suited to the mysterious, often disturbing sort of supernaturalism found in the majority of his works.
The interest of Belgian Symbolist novelist Georges Rodenbach speeded Lévy-Dhurmer's success and recognition. After 1900 he made several journeys throughout Europe and North Africa, especially the Mediterranean coast, painting landscapes and figure studies. After 1906 he related a series of works to the music of Beethoven, Débussy, and Fauré, and around 1920 he began a literary series based on works like La Fontaine's *Fables.* He painted murals and designed the furniture and paneling for the living room, dining room (now in the Metropolitan Museum of Art), and library of a private home on the Champ de Mars between 1910 and 1914.
Beginning in 1882 Lévy-Dhurmer exhibited at the Salon des Artistes Français, from 1897 he participated in the salon of the Société Nationale des Beaux-Arts, and after 1930 he exhibited at the Salon d'Automne. He was also a member of the Société de Pastellistes Françaises and the Société des Orientalistes (Camart et al. 1971, p. 44; *Autour de Lévy-Dhurmer,* pp. 35–36, and bibliography). Y.B.

PRIVAT LIVEMONT

Belgian, b. Schaerbeek 1861, d. Schaerbeek 1936.
Upon completing his course at the Ecole des Arts Décoratifs at Saint-Josse-ten-Noode, where he would one day be a professor, Livemont won a prize that enabled him to study in Paris. In 1889, after six years of study and work as a decorator, he returned to Belgium. At first employed by several architects, including Paul Saintenoy and Alban Chambon, for the decoration of both public buildings and private homes, he turned to poster design in 1890 with a commission from the Cercle Artistique de Schaerbeek.
The posters in Livemont's mature style always feature a woman with long hair, most often in a floral surrounding with decorative motifs intermingled. His work shows such an affinity with Mucha's that for a long time critics wondered who copied whom: Octave Maus suggested in *Art et Décoration* that Mucha was the imitator, while Henri Guerrand took the opposite viewpoint, but it seems likely that the two artists arrived at their styles simultaneously, uniting the woman drawn from Symbolist iconography with the floral motifs made fashionable by William Morris. In any event, despite the stylistic similarities, Livemont should not be considered a mere imitator like Foäche: his compositions are more delicate than Mucha's, his palette of pale colors far removed from Mucha's golds. The quality of Livemont's work engendered commissions—including *Absinthe Robette* (1896), *Bec Auer* (1896), *Cacao Van Houten* (1897), and *Café Rajah* (1899)—in numbers remarkable for Belgium, where the poster was less widely used than in France (Maus 1900b). A.W.

LUIGI (ALOYS FRANÇOIS-JOSEPH) LOIR

French, b. Goritz, Austria, 1845, d. Paris 1916.
The son of a French couple living in Austria, painter and lithographer Luigi Loir enrolled at the academy of fine arts in Parma at the age of eight. Ten years later he moved to Paris, where he was employed in the studio of a decorative artist; Loir continued to do decorative painting even after his debut at the salon in 1865. He took part in the military campaigns of 1870, then devoted himself almost entirely to painting genre scenes of Paris, for which he became rather famous. Although his style might be considered excessive, he did display a remarkable quality of observation and a talent for rendering details of Parisian life. Also a skilled lithographer, Loir in 1889 received a gold medal at the salon of the Société des Artistes Français, where he was a regular exhibitor. R.B.

CHARLES RENNIE MACKINTOSH

Scottish, b. Glasgow 1868, d. London 1928.
As leader of the Glasgow School, Mackintosh was one of 19th-century Britain's most revolutionary architects, interior designers, and decorators, a pioneer of the modern movement. After being apprenticed to the architect John Hutchinson in 1884 and educated at the Glasgow School of Art in 1889, he joined the firm of Honeyman and Keppie in 1889. Together with a fellow draftsman, J. Herbert MacNair, and two students from the Glasgow School of Art, Margaret and Frances Macdonald (who were later to become Mackintosh's and MacNair's

wives), he formed "The Four" of the Glasgow School. They were influenced by the Arts and Crafts Movement, the Pre-Raphaelites, and the revival of Celtic and Japanese art, yet they developed an extremely personal style that was both austere and elegant.

Among Mackintosh's best-known buildings are the Glasgow School of Art (1897–99), Windyhill, Kilmacolm (1899–1901) and the Scottish pavilion at the Turin exposition of 1902. But probably he is most famous for his interiors, particularly Miss Cranston's tearooms.

Mackintosh had no real following in Great Britain but was heralded in Germany and in Vienna, where he exhibited at Hoffmann's invitation. S.C.

ARTHUR HEYGATE MACKMURDO
English, b. 1851, d. 1942.
Though primarily known as an innovative architect, Mackmurdo was equally talented in the areas of crafts and design. After setting up a private architectural practice in London in 1875, he developed a style, singular in its striking simplicity, which soon brought him fame both in England and on the Continent and eventually influenced such diverse artists as Horta, Serrurier-Bovy, Mackintosh, and Voysey (who later became his friend and pupil). In 1873 Mackmurdo began attending Ruskin's lectures at Oxford, the next year accompanying the master on a trip to Italy. He repeated the journey in 1878 and 1880, making architectural sketches and, surprisingly, becoming even more involved in extensive studies of vegetation, producing notebooks full of nature drawings. It was undoubtedly these studies which inspired the undulating, over-long, spiraling stems and restlessly rhythmic flower forms which became the dominant motifs in his creative designs of the 1880s and 1890s.

When he was twenty-six Mackmurdo met William Morris. Their similar interests in the crafts, design, and architecture formed the basis for an enduring friendship and influenced Mackmurdo's growing interest in the applied arts. Mackmurdo was the founder of the Century Guild, which produced works in all areas of interior design, including wallpaper, furniture, carpets, and metalwork, that met with great success when exhibited in London, Manchester, and Liverpool. In 1884 the Guild began publishing a periodical entitled *The Hobby Horse*, with Mackmurdo as editor of the first issue. Its diversity of contents, stressing the synthesis of all the arts, including music and literature, in addition to its originality of design and typography, made *The Hobby Horse* one of the most important and influential journals of the time. It inspired such later efforts as Ricketts' *The Dial* and was a model for Henry van de Velde and Georges Lemmen in their graphics for *Van Nu en Straks*. R.B.

ARISTIDE MAILLOL
French, b. Banyuls-sur-Mer 1861, d. Perpignan 1944.
While he turned to sculpture and ceramics after 1900, Maillol began as a painter and studied in the ateliers of Cabanel and Gérôme at the Ecole des Beaux-Arts in Paris. As a painter in the 1880s and 1890s he was greatly influenced by Puvis de Chavannes and was indebted also to Gauguin and Monet. Maillol became associated with the Nabis in 1893, and shared with them a commitment to the decorative arts. Putting aside painting, he took up tapestry and became so involved that he even dyed his own wools and established a tapestry studio at Banyuls. S.C.

LOUIS MAJORELLE
French, b. Toul 1859, d. Nancy 1926.
When he was sixteen Louis Majorelle exhibited in the painting section of the salon. He spent two years at the Ecole des Beaux-Arts in Paris, and in 1879 took over the business started by his father, a cabinetmaker and ceramist in Nancy. Soon he left ceramics and dedicated all his time to making furniture. At first he followed directly in his father's footsteps, designing furniture in the Louis XV style, but in 1889 Gallé's successes encouraged him to design in a more personal style. At the Exposition Universelle of 1900 he showed a dining room and a bedroom ensemble (in a style called "Nénuphar" because of their mounts in the form of waterlily pads) which represented the very best of his work. For his furniture he was fond of rounded, ample forms, buttresses, high-relief moldings, and gilt bronze mounts (Cassou et al. 1960–61).

EDGARD MAXENCE
French, b. Nantes 1871, d. La Bernerie-en-Retz 1954.
Maxence, who received his training from Gustave Moreau and from Elie Delaunay, exhibited regularly from 1893 at the salon of the Société des Artistes Français, and at the Salon de la Rose+Croix between 1895 and 1897. A portrait and landscape painter, Maxence is probably better known for his paintings of religious or folkloric subjects (1893 SAF catalogue; *Chronique des Arts* [1904], p. 55).

FRANZ MELCHERS
b. Münster 1868.
After studying painting at the Brussels academy and in Holland under Jan Toorop, whose studio he took over, Melchers specialized in interior genre scenes that were described by Maeterlinck as of "an extremely intimate and taciturn art." He met the poet Thomas Braun in 1896, when Braun was still a student at Louvain; in 1898 Melchers illustrated Braun's poem *L'An* with colored engravings. He exhibited at the salons of La Libre Esthétique in 1896, 1897, and 1900, and resided in Holland at Delft. J.-G.W.

ANDRÉ METHEY
French, b. Laignes 1871, d. Asnières 1921.
Forced to support himself at an early age, Methey attempted apprenticeships in decoration and sculpture before finding a vocation in pottery. From 1901 to 1906 he made flambé stoneware in the Japanese and Korean styles. Discouraged by research that was all too often fruitless, he investigated the French faïence tradition and to that end opened a studio at Asnières. For the decoration of his works he called on a number of painters whom he met through Vollard—Redon, Rouault, Matisse, Bonnard, Vuillard, Valtat, Othon Friesz, Derain, and Vlaminck. The studio produced earthenware pieces whose color range was limited by a high firing temperature. Methey later abandoned faïence for glazed earthenware, returned to stoneware in 1912, and toward the end of his career experimented with *pâte de verre* (Camart et al. 1971, p. 47). Y.B.

HENRI MEUNIER
Belgian, b. Ixelles 1873, d. Brussels 1922.
Henri Meunier—not to be confused with the Frenchman Georges Meunier, Chéret's disciple—was the son of the engraver Jean-Baptiste Meunier and the nephew of the sculptor Constantin Meunier. After studies at the academy of Ixelles he was active as a poster designer, illustrator, bookbinder, and engraver, and exhibited paintings with Le Sillon after 1897. Among the Belgian poster artists Meunier in his work shows the most affinities with modern poster design. His compositions—*Savon Starlight* (1899), *Cartes postales artistiques Dietrich* (1898), and *Rajah* (1897), the poster closest to the Art Nouveau style—seem less dated, and are more difficult to date, than those of his contemporaries, for like Cappiello he used solid backgrounds and clean, well-outlined forms that effectively transmit the advertising message. A.W.

EUGÈNE MICHEL

French, b. Lunéville (Meurthe-et-Moselle), d. c. 1910.

In 1867 Eugène Michel was employed as an engraver and decorator for Eugène Rousseau, and later he worked for Rousseau's successor Léveillé. Around 1900 he established himself as an independent glassmaker in Paris. Like Rousseau, Michel worked primarily with crackled glass, using several different-colored layers, deeply engraved, to create an impressive decorative effect; his work was strongly influenced by Chinese glassware of the 18th and 19th centuries. For a time he collaborated with Eugène Lelièvre, who made metal mountings for Michel's cut and engraved crystal bottles (de Fourcaud 1892, p. 10; Genuys 1904; Hilschenz 1973, p. 329; Bloch-Dermant 1974, p. 44). R.B.

GEORGE MINNE

Belgian, b. Ghent 1866, d. Laethem-Saint-Martin 1941.

Minne studied at the academy in Ghent from 1882 to 1884, then in Brussels from 1895 to 1899. In 1889 he illustrated Maeterlinck's *Les Serres chaudes,* and the encounter with the Symbolist poet proved a determining factor in his career. After a brief influence by Rodin that is evidenced in his early sculptures, Minne gave himself over to the Symbolist movement, stimulated by his rediscovery of the Middle Ages and the Flemish primitives. In 1898 he settled in Laethem, in the midst of a group whose spiritual head he was. Although he is best known for his sculptures of emaciated, mystical adolescents, which he executed with great purity of form, around 1908 he executed several realistic sculptures inspired by Constantin Meunier. From 1912 to 1914 he was a professor at the Ghent academy; during World War I he stayed in England and produced only charcoal drawings. Back in Laethem he returned to Symbolist sculpture expressing meditation and silence. J.-G.W.

GUSTAVE MOREAU

French, b. Paris 1826, d. Paris 1897.

Moreau was the son of an architect. He went to the Ecole des Beaux-Arts at twenty and at twenty-two worked with Chassériau, who had a definite influence on him. His first success at the salon was in 1864, when he presented *Oedipe et le Sphinx.* The mystical atmosphere and erotic overtones of his mythological or biblical compositions led Huysmans to connect him with the decadence of the *fin de siècle* in his book *A rebours* (1884). The younger painters who were breaking away from Impressionism looked on him as a master.

In 1892 Moreau was appointed professor at the Ecole des Beaux-Arts. His reputation as a remarkable teacher, sensitive to the orginality of his students, was established by Matisse, Rouault, and others who worked under him. His pupils were many. Jacques Gruber, Edgard Maxence, Fernand Khnopff, and Henri Evenepoel, who are included in this exhibition, were among them.

Moreau left to the state all his work along with the remarkable studio/home he had built. When his so-called unfinished paintings became known Moreau's art acquired new importance. Done for himself, these small abstract compositions in bright and somber colors are totally unrelated to his time and seem to prefigure Abstract Expressionist painting.

WILLIAM MORRIS

English, b. Walthamstow, Essex, 1834, d. Kelmscott, Oxfordshire, 1896.

Strongly influenced by Ruskin and Pugin, Morris began his training in 1856 in the office of George Street, a Gothic Revival architect. Shortly thereafter he abandoned architecture, but ideas he garnered from the Gothic Revival—cooperation between artist and artisan, inspiration from nature rather than imitation of nature, simplicity, the importance of craftsmanship and the handmade object, the joy of the creative process—were at the origin of the Arts and Crafts Movement. As a painter from 1857 to 1862 Morris was closely associated with the Pre-Raphaelites, and in 1858 he published *The Defence of Guinevere and Other Poems.* In 1861 he founded the firm of Morris, Marshall, Faulkner and Co., Fine Art Workmen in Painting, Carving, Furniture, and the Metals. Ford Madox Brown, Edward Burne-Jones, Dante Gabriel Rossetti, and Philip Webb were also members of the firm, which had its first success at the London exhibition of 1862. Exercising a profound influence on British tastes in furniture and decoration, the firm was reorganized in 1875 under the name of Morris & Co.; its influence was felt well into the 20th century. Morris' Kelmscott Press, established in 1891, took part in the revival of the art of book production. While Morris' work was exhibited in France, Belgium, and Holland, it was through his aesthetic and social ideas, particularly his emphasis on hand craftsmanship, that he most affected the development of Continental Art Nouveau. S.C.

JOSEPH AND PIERRE MOUGIN

French, Joseph b. Nancy 1876, d. Nancy 1961. Pierre b. Nancy 1879, d. Guebwiller 1955.

Joseph Mougin, the son of a master glassmaker, hoped to become a sculptor. He showed promise in his studies at the local academy in Nancy and went to Paris, where he entered the studio of the sculptor Louis-Ernst Barrias at the Ecole des Beaux-Arts. When he was nineteen, however, an exhibition of Jean Carriès' pottery so impressed him that he decided instead to become a ceramist. In short order he built a studio and kiln on the rue Dareau in Montrouge, a sculptor friend named Lemarquier and perhaps his brother Pierre providing help. But the kiln was so inexpertly constructed that it would not fire properly. After two years of discouraging effort Lemarquier abandoned the enterprise, and Mougin went to Sèvres to study his art.

Upon his return to Paris he and Pierre built a new kiln on the rue La Quintinie in Vaugirard. Still plagued by technical difficulties—the firings sometimes took fifty hours—they nevertheless began to produce some excellent and innovative ceramics. In 1900 the young potters were persuaded by an artist from their hometown of Nancy, Victor Prouvé, to exhibit in the various Parisian salons. Their works were well received there, and Mougin ceramics were purchased by museums, collectors, and the state.

After a few years, however, the Mougins decided to return to Nancy, firing a kiln there in 1905. As members of the Ecole de Nancy they collaborated with such artists as Prouvé, Alfred Finot, and Ernest Bussière on works in the Art Nouveau style which they continued to show in Paris and in the Ecole de Nancy exhibitions until World War I. After the war the brothers sought financial security by opening a studio for the production of art pottery in series at the Faïencerie de Lunéville. Joseph, awarded the Grand Prix de la Céramique at the 1925 Exposition des Arts Décoratifs in Paris, left Lunéville in the early 1930s to return to his old studio in Nancy. In June 1936 he fired his kiln; and there, with his daughter Odile and his son François, he continued to create new forms and glazes until he retired in 1960 (Mougin family records; Heuser and Heuser 1974, p. 142; Hakenjos 1974, p. 82).

ALPHONSE MUCHA

Czech, b. Ivancice 1860, d. 1939.

Mucha, whose work is for many people synonymous with Art Nouveau, experienced overnight success with a poster that he created

in 1894 for Sarah Bernhardt in her role as Gismonda. The pleased actress awarded him a six-year contract that produced such posters as *Lorenzaccio* (1896), *La Dame aux Camélias* (1896), *La Samaritaine* (1897), *Médée* (1898), *Hamlet* (1899), and *L'Aiglon* (1900). In France, where the poster played a considerable commercial role, such talent was not likely to escape the notice of publicity-minded industrialists, so Mucha received numerous commercial commissions as well—for posters (*Job, Bières de la Meuse, Cycles Perfecta*), for calendars, for lithographs, for various kinds of advertising material. He did not limit himself to graphic art, however, but also designed jewelry, textiles, bronze work, and furniture, creating an entire decorative scheme for the jeweler Georges Fouquet's shop in Paris in 1901. His versatility as a designer may be seen in *Documents Décoratifs* (1902) and *Figures Décoratives* (1905), publications which provided models for his many followers. A.W.

EMILE MÜLLER
French, d. Paris 1889.
An engineer, Emile Müller in 1854 founded the Grande Tuilerie d'Ivry, a tile factory where he worked at perfecting a high-fired glaze and body, resistant to abrupt temperature changes, that could be made into tiles of large size. His goal was to produce tiles that could be used for monumental decoration, in contrast to the small, regular tiles then available to architects, and to enable architects to have their own designs executed. This new concept triumphed at the Exposition Universelle of 1889. The products from the Müller factory—decorative terra-cotta, glazed bricks and revetment tiles, and stoneware—were so numerous and spectacular that Müller was awarded a grand prize.

Upon Emile Müller's death in November 1889, his son Louis took over the factory, continuing the work of his father under the name Emile Müller et Compagnie. It was undoubtedly Louis who inaugurated the practice of reproducing, in flambé-glazed high-fired stoneware, sculptures by such past masters as Donatello and Verrocchio and such contemporary artists as Antoine Barye, Alexandre Charpentier, Eugène Grasset, and James Vibert. In 1893 Müller produced glazed ceramic panels and roof tiles designed by Hector Guimard for the Hôtel Jassedé, and in 1900 the firm executed Guillot's "Frise du Travail" for the monumental gateway to the Exposition Universelle (de Chennevières 1889; *Exposition d'art décoratif moderne,* pp. 37–38, nos. 528–45). Y.B.

HENRI EUGÈNE NOCQ
French, b. Paris 1868.
Henri Nocq, a sculptor and medalist, did some illustration and graphic design but is best known for his metalwork: lamps, mirrors, small objects, and jewelry. In 1896 and 1897 he exhibited at the Galerie des Artistes Modernes with Les Cinq, along with Dampt, Charpentier, Plumet, and Aubert. A critic and historian, he wrote many articles in the magazines of the period and a major work on silver marks, *L'Orfèvrerie civile française du XVIe au début du XIXe siècle* (Paris: Albert Lévy, n.d.).

MANUEL ORAZI
Orazi, saluted by Maindron as a master lithographer, created several of the most beautiful Art Nouveau posters. The first two, done in collaboration with Gorguet for Sarah Bernhardt's *Théodora* (1884), were treated as Byzantine mosaics; his other posters included one for Peugeot bicycles, one for the opera *Aben Hamet,* and an unusual poster in the form of an old torn manuscript for Massenet's opera *Thaïs.* Orazi's most important creations were the *Loïe Fuller* for the 1900 Exposition Universelle, produced in three color ranges, which beautifully conveyed the movement and spectacle of the dancer's performance; *La Maison Moderne,* which was like an inventory of the Art Nouveau style, showing it in furniture, decorative objects, and even the woman's clothing accessories (later Orazi created several jewelry and table service designs for Meier-Graefe); and finally the poster for the opening of the Hippodrome with the spectacle *Vercingétorix.* A prolific illustrator whose commissions included Jean Lorrain's *Folies Byzantines,* Orazi also did a most unusual calendar in 1895—a masterpiece of design and lithography whose effective use of gold is typical of many of his works. A.W.

CRISTALLERIE DE PANTIN
Pantin, France.
In 1851 E. S. Monot founded the Cristallerie de La Villette, renamed the Cristallerie de Pantin after being moved to the latter town in 1855. Specializing in opalescent and iridescent glass, the firm showed imitations of rock crystal and Venetian glass at the Exposition Universelle of 1878. Upon Monot's retirement, around 1886–88, the enterprise was reorganized as Stumpf, Touvier, Viollet & Cie. and began a varied production, including iridescent, enameled, and frosted glass and imitations of semiprecious stones, under the artistic leadership of Touvier. Stumpf, the director, was suc-

ceeded after 1900 by Camille Tutré de Varreux; during his tenure the firm expanded its repertory to produce cased glass with finely detailed decoration, etched and wheel-cut, and in addition executed table services after designs by the Dutch architect Hendrik Berlage (Hilschenz 1973, p. 353; Bloch-Dermant 1974, pp. 15–16).

ARMAND POINT
French, b. Algiers 1861, d. Paris 1932.
Point was considered by his contemporaries to be at the forefront of the movement to purify modern art by returning to an earlier tradition. Strongly influenced by Ruskin and the Pre-Raphaelites, he endeavored in his works to recreate the atmosphere of 15th- and 16th-century paintings, particularly those of Leonardo and Botticelli. He exhibited with the Salon de la Rose+Croix from its inception in 1892, and in 1895 and 1896 designed its exhibition posters. The 1896 poster, done in collaboration with Léonard Sarluis, showed a Rosicrucian hero holding aloft the severed head of the new Medusa—Emile Zola. In 1896 Point founded Hauteclaire, a community of artists and workers, at Marlotte, and there he supervised the production of a number of bronzes, enamels, ceramics, embroideries, and other decorative pieces (Pincus-Witten 1968; G. Lacambre 1972, pp. 97–99). A.W.

VICTOR PROUVÉ
French, b. Nancy 1858, d. 1943.
Victor Prouvé, a painter, sculptor, and decorator, was one of the most representative artists of the Ecole de Nancy. He designed bindings, made jewelry and decorative bronze objects, and created patterns for embroidery and lace. He worked with Louis Majorelle and was also a close friend of Emile Gallé, for whom he designed glassware, ceramic, and wood marquetry decoration. Y.B.

PAUL-ELIE RANSON
French, b. Limoges 1862, d. Paris 1909.
In 1880 Ranson enrolled at the Académie Julian, where he associated with Denis, Sérusier, Roussel, Vuillard, and Bonnard. They met weekly at the studio of Ranson and formed the Nabi group in 1889. Together with Vuillard, Bonnard, and Sérusier he worked on stage sets for the Théâtre d'Art in 1892, and for Lugné-Poë's new Théâtre de l'Oeuvre in 1893. Ranson also organized a puppet theater for which he wrote skits, and he even staged Maeterlinck's *Les Sept Princesses* and medieval plays, Denis and

Vuillard making the scenery and Lacombe molding the heads of the puppets.

Besides easel painting, Ranson was interested in applied arts. He is mostly remembered for his tapestry cartoons with women and arabesques in Art Nouveau style. About half a dozen were executed by his wife, France, in thick wool and gros point technique. One (Le Tigre) was woven by the Manufacture des Gobelins. One year before Ranson died, he and his wife opened the Académie Ranson. His Nabi friends offered to criticize the work of students. Denis, Maillol, Sérusier, Vallotton, and Bonnard taught there. S.C.

ARMAND RASSENFOSSE

Belgian, b. Liège 1862, d. Liège 1934.
A native of Liège like Berchmans and Donnay, with whom he founded the *Caprice Revue*, Rassenfosse was an engraver, illustrator, and painter who designed his first posters in 1888. He became the close friend of Félicien Rops, working with him on engraving techniques, and exhibited regularly at La Libre Esthétique, the Salon des Cent (for whom he did two posters), and L'Art Indépendant. In 1896 he was commissioned by Maurice Bauwens to do the cover for *Les Affiches étrangères illustrées*. Despite his mastery of lithography Rassenfosse seems less at ease with commercial subjects than with purely artistic ones: thus such posters as those for the Salon des Cent are perhaps more successful than *Huile Russe* (1897) or *The Fine Arts Insurance* (1896). Unfortunately, although his work is often the equal of Rops', Rassenfosse is too often overshadowed by his associate, and his talent as an engraver has been underestimated. A.W.

MAURICE RÉALIER-DUMAS

French, b. Paris 1860, d. Chatou (Seine-et-Oise) 1928.
At one time a student of Gérôme, Réalier-Dumas worked as both a genre painter and a designer of posters. He exhibited with the Salon des Artistes Français, receiving a third place medal in 1896 and winning a bronze medal in the 1900 Exposition Universelle. In his posters, Réalier-Dumas always used a woman in antique costume as his central figure; Maindron (1896) compared the placement of his figures to the decoration on a Greek vase. The colors he used most frequently were delicate tones such as rose, pale blue, and beige. Posters by Réalier-Dumas include *Bec Auer* (1895), *Paris Mode* (1896), *Champagne Mumm* (1895), and *Protector* (1899). A.W.

ODILON REDON

French, b. Bordeaux 1840, d. Paris 1916.
A solitary childhood spent in an old country house, delicate health, and late schooling developed Redon's dreamy disposition. Recollections of the semiabandoned park and the woods surrounding the house were to remain a source of inspiration. Apprenticeship to the engraver Bresdin and visits to the museum in Bordeaux achieved his training without much affecting the style of his art. Redon was self-taught, highly original, and independent of artistic trends. His favorite medium was lithography, and also charcoal, which suited his melancholy nature. It was only when he had reached fifty that he took up pastel and started producing his amazing works in vivid yet subtle colors.

Recognition came late. His first modest exhibitions, in 1881 on the premises of a Paris weekly and the following year at a newspaper office, met only with the indifference of the public and harsh comments from critics — except one, who wrote that Redon "should be considered one of our masters." With the emergence of Symbolism, a climate existed at last in which his work could be understood. He was noticed by Huysmans, who was then writing *A rebours*. Huysmans introduced him to Mallarmé. The poet and the artist discovered their deep kinship and became friends — even brothers.

In 1886 Redon was invited to exhibit with the Belgian group Les Vingt and exhibited there again in 1890, meanwhile showing his work with Les Indépendants. Although he was still ignored by the public, one or two collectors had become enthusiastic about his work, and he had gained the friendship of the young Nabis, especially Bonnard, Vuillard, and Denis. Gauguin on his return from Tahiti wrote an article on Redon to promote the sale of his work, calling him "this extraordinary artist whom people obstinately refuse to understand." Denis summed up the feelings of the Nabis and Symbolists' generation when he wrote, "He [Redon] is at the origin of all aesthetic innovations or renovations, of all the revolutions of taste which we have witnessed" (Rewald 1961).

ALOÏS REINITZER

Czech, b. Prague 1865.
Reinitzer, a sculptor, was the student of Hellmer in Vienna from 1883 to 1885, then worked in Prague from 1885 to 1889. He moved to Paris and worked at the Académie Julian; in 1900 he won a bronze medal at the Exposition Universelle.

CHARLES RICKETTS

English, b. Geneva 1866, d. London 1931.
An Englishman born in Switzerland and raised in France, Ricketts' talents were diverse, but it was primarily his graphic work that was important to the Art Nouveau movement. An artist of the "decadent Nineties," he worked in much the same vein as his contemporary Beardsley. He and his friends, principally Charles Shannon, shared a great admiration for William Morris and Mackmurdo. They based their journal *The Dial* to a large extent upon the Century Guild's magazine *The Hobby Horse*. In addition to being coeditor with Shannon and chief illustrator of *The Dial* from 1889 to 1897, Ricketts also executed woodcut illustrations for several books, including Wilde's *A House of Pomegranates* (1891) and *Daphnis and Chloe* (1893), which led him to found his own Vale Press in 1896. In Ricketts' illustrations for *The Dial* and the Vale Press publications one can see the influence of Morris and the Pre-Raphaelites. Like Beardsley, Ricketts skillfully fused the artist's imagination and the abstract elements of the design space.

A painter and sculptor, Ricketts was also a versatile craftsman who produced small bronzes and jewelry; he worked as well as a reformer of the English theater, in the area of stage and costume design. R.B.

RICHARD RIEMERSCHMID

German, b. Munich 1868, d. 1957.
Like many other artists at the end of the 19th century, Riemerschmid turned from painting to the applied arts, participating in the founding of the Munich Vereinigten Werkstätten in 1897. He designed the interior decoration for the Munich theater (1901), built several artists' studios in Hellereau (1910), and exhibited with the Deutscher Werkbund, becoming known in France when he showed with them at the Salon d'Automne in 1910. Around 1899, Riemerschmid and his brother-in-law Karl Schmidt began to study the possibilities of inexpensive furniture. Their first models, conceived "in the spirit of the machine," were exhibited in 1905 (*Dictionnaire de l'Architecture Moderne*, p. 241; Verneuil 1910).

THÉODORE LOUIS-AUGUSTE RIVIÈRE

French, b. Toulouse 1857, d. Paris 1912.
A student at the Ecole des Beaux-Arts in Paris, Rivière exhibited for the first time at the salon of 1875. His career progressed only slowly — in 1884, for instance, his salon entry was refused on political grounds — and in 1890 he left Paris for Tunisia, where he lived for three years,

teaching drawing at a seminary in Carthage. He came back to France with several small figures inspired by Flaubert's *Salammbô* that restored his reputation and brought him some measure of fame. Rivière became a member of the Société des Artistes Français in 1894; the next year his *Salammbô chez Mathô,* one of the salon's greatest successes, was acquired by the state. The 1900 Exposition Universelle brought him a gold medal.

Rivière did some large-scale sculptures, state commissions, but was best known for his miniature groups and figurines—*Le Voeu, Charles VI et Odette, Phryné,* and *Loïe Fuller*—worked in elegant materials like bronze, onyx, and ivory. R. B.

PIERRE ROCHE
French, b. 1855, d. 1922.
Pierre Roche—born Fernand Massignon—was a sculptor, engraver, and metalworker. After studying medicine he learned design and painting; in 1888 his entry in a sculpture contest attracted the attention of Dalou, whose student Roche became. A charter member of the Société Nationale des Beaux-Arts, Roche also exhibited at the salon of the Société des Artistes Décorateurs and several times at the Musée Galliera. After becoming interested in ceramics and lead casting, he executed several works inspired by Loïe Fuller—a series of painted sketches, some statuettes, and a statue for the facade of Henry Sauvage's Théâtre de la Loïe Fuller at the 1900 Exposition Universelle. He used his technique of gypsography (in which the composition is obtained by engraving on plaster, tinting the excised portions with watercolor, and then pressing on a piece of wet paper to create an impression) to illustrate a book by Roger Marx dedicated to the dancer. Roche also created architectural sculpture, including a St. John for the basilica of Montmartre, Paris, and medallions of Tragedy and Comedy for the theater at Tulle. C.B.

AUGUSTE RODIN
French, b. Paris 1840, d. Meudon 1917.
Rodin was enrolled at the age of fourteen in the "Petite Ecole" (now the Ecole Supérieure des Arts Décoratifs), where he received a thorough and traditional training in drawing and modeling. Having completed his studies there, he tried and failed three times to enter the "Grand Ecole" (the Ecole des Beaux-Arts).

In the ensuing years he took whatever odd jobs he could find, working for a plasterer, a decorator, a jeweler, and part time for the fash-

ionable sculptor Carrier-Belleuse. Meanwhile he worked at night on his own sculpture, producing *The Man with the Broken Nose,* which was rejected by the 1864 salon.

In 1871 he went to Belgium to escape the turmoil following the Franco-Prussian War and entered a partnership to execute sculpture on important buildings. He left Belgium for two months to visit Italy, where he experienced firsthand the works of Donatello and Michelangelo, spending a week studying the Medici Chapel.

In 1877 he settled permanently in Paris, doing architectural decoration for his livelihood. He went back to work for Carrier-Belleuse, now art director of the Sèvres porcelain factory. He worked also on a major enterprise: *The Gates of Hell,* a monumental portal for the projected Musée des Arts Décoratifs.

Recognition came to him in the 1880s. A short visit to England brought him in contact with influential writers. The patronage of a diplomat's wife opened to him the doors of Paris society and secured him commissions for many portrait busts. In 1885 the city of Calais asked him to make a momument to the six famous burghers, and in 1887 he obtained a government commission for *The Kiss.*

In 1890 he was invited by the state to make a monument to Victor Hugo for the Panthéon, and in 1892 by the Société des Gens de Lettres, at the instigation of Zola, to make a monument to Balzac. Both of his models met with strong opposition. In poor health and embittered by the fight over his monuments, particularly by criticisms leveled against his *Balzac,* Rodin retired to Meudon, outside of Paris, in 1894.

At the Exposition Universelle of 1900 in Paris, Rodin himself, at his own expense, presented a retrospective of his work. Yet he had already gained international recognition, and each year increased his fame: visits of royalty; triumphal receptions in Holland, in Prague, in London; innumerable commissions for portrait busts, for bronze casts and marble editions of his work; publications about him and by him. He had greatly augmented the number of his collaborators and founded the Académie Rodin. In 1916 he donated all his work to the state, to be installed in the Hôtel Biron, now the Musée Rodin; he died the following year.

Rodin's genius transcends any aesthetic movement, yet in many respects he belongs to Symbolism and Art Nouveau. To support himself he designed furniture, jewelry, and ceramics and worked as a decorative sculptor. Though the tradition of the artist as a decorator

and craftsman is of long standing, it had become the credo of Art Nouveau.

Rodin's interest in contemporary dancers like Loïe Fuller, whom he befriended, also reveals his closeness to Art Nouveau. Yet it is on a deeper level that a relation is felt. It is revealed by the flowing lines of his wash drawings, and in the very style of *The Gates of Hell.* With their overall decoration of fluid interwoven bodies, they are the glorious epitome of the baroque side of Art Nouveau.

DANTE GABRIEL ROSSETTI
English, b. London 1828, d. Birchington 1882.
The precocious child of an Italian expatriate living in London, Rossetti was reading Dante and writing poetry at sixteen. As a young man he borrowed ten shillings from his brother to purchase Blake's notebook. Through Rossetti's championing, Blake became the ideal for a whole school of poets and artists.

With Hunt and Millais, Rossetti founded the Pre-Raphaelite Brotherhood in 1848. William Morris, G. F. Watts, Burne-Jones, and John Ruskin began supporting the Pre-Raphaelites in 1851 and later became members. Rossetti married Elizabeth Siddal, who together with Jane Morris became the feminine ideal of the movement and the model for Pre-Raphaelite fashion.

Rossetti's attention was drawn to the Orient through his friend Whistler; like Whistler, he began to collect Chinese porcelain and Japanese woodcuts in the 1860s.

After the death of Elizabeth in 1862, Rossetti became more and more eccentric and disturbed until he ceased painting in 1877. His *Poems* were published in 1870, and *Ballads and Sonnets,* his last work, in 1881.

At the urging of Hunt, who believed in the overall responsibility of the painter, Rossetti designed furniture and stained glass, contributing his designs to William Morris' firm, but it was in graphic design that his influence was most felt on the Continent and in America. S.C.

FRANÇOIS-EUGÈNE ROUSSEAU
French, b. Paris 1827, d. 1891.
Rousseau, a ceramist who worked with Louis Solon, was also the owner of a crystal and china shop at 41 rue Coquillère, Paris, and as such had an earthenware table service executed in 1866 after Félix Bracquemond's drawings in Hokusai's style—the famous "Service Rousseau."

A distinctly Japanese influence is evident in Rousseau's own designs, done several years later

when he had turned to glass production. The designs, applied to clear or slightly colored glass, were engraved by such decorators as Eugène Michel and Alphonse-Georges Reyen, then executed in the Appert brothers' glassworks at Clichy. Rousseau was one of the first to regularly produce cased glass, a technique known to the Venetians and to the Chinese of the 18th century. He engraved on an opaque, vibrantly colored outer layer, which made visible in places the translucent inner layer. His innovations—imitations of semi-precious stones which even copied their natural imperfections, cased glass engraved with flowers or landscapes in the Japanese style—aroused considerable interest from the public and the critics at the Exposition Universelle of 1878. The technical research he carried out with the Apperts resulted in an uproar at the Union Centrale exposition in Paris in 1884, where he showed his famous crackled glass (produced by immersing the glass in cold water between two firings—a technique copied from the 16th-century Venetians).

From 1885 on, Rousseau was associated with his friend Ernest Léveillé, producing works that again show Japanese inspiration. By creating new effects with old techniques and interpreting Japanese and Chinese styles, Rousseau had a marked influence on the modern revival of glassmaking (Hilschenz 1973, p. 342, and bibliography; Bloch-Dermant 1974, pp. 33–35). Y.B.

VICTOR ROUSSEAU

Belgian, b. Feluy 1865, d. Forest-Brussels 1954.
The son of a quarry worker, Victor Rousseau learned the profession of stonecutting in the quarries of Feluy and from 1876 to 1883 worked with his father on the sculptures for the Palais de Justice in Brussels. From 1888 to 1890 he was a student of Charles van der Stappen at the Brussels academy; a prize won in 1890 permitted him to travel in England, France, Italy, and Greece. Rousseau, who was the friend of numerous poets, musicians, and artists in Brussels, exhibited in the avant-garde salons—L'Art Idéaliste, Pour l'Art, Les Vingt, and La Libre Esthétique. He seems to have expressed himself best in small formats, in studies or first stages of larger works where the harmony of line, intimacy of facial expressions, and serenity of his figures are apparent. He also did paintings, watercolors, and drawings, and served as professor of sculpture at the Brussels academy from 1890 to 1910. J.-G.W.

LÉONARD SARLUIS

French, b. The Hague 1874, d. 1949.
Sarluis, a Dutchman who came to Paris when he was twenty and later became a naturalized citizen, was greatly admired by Jean Lorrain but saw himself severely described in Bénézit: "An aesthete lost between antiquity's models and the suspect graces of the modern style." Besides the poster for the Salon de la Rose+Croix, done in collaboration with Armand Point, his works include newspaper and book illustrations. A.W.

CRISTALLERIE SCHNEIDER

Epinay-sur-Seine.
By the time Charles Schneider (1881–1952) founded the Cristallerie Schneider with his brother Ernest in 1903, he had solid training behind him. A native of Nancy, he had studied at the Ecole des Beaux-Arts there under Emile Gallé and had worked in Gallé's factory at the same time. He had also designed for Daum Frères for a while before finishing his studies at the Ecole des Beaux-Arts in Paris.

The Cristallerie Schneider was located at Epinay-sur-Seine, about seven miles from Paris. Ernest, the elder of the brothers, was the firm's administrator, while Charles oversaw the production of art glass and served as art director until 1944. Most of those employed to execute Charles' designs had received their training from him as well. The great bulk of the firm's output was art glass until 1925, when demand began to diminish; eventually the production of art glass became unprofitable and was discontinued altogether (Graves 1967). S.J.B.

CARLOS SCHWABE

Swiss, b. Altona 1866, d. Davon (Seine-et-Marne) 1926.
Born in Germany, the painter and engraver Carlos Schwabe was raised in Switzerland and became a naturalized citizen of that country in 1888. After studying with J. Mittey at the Ecole des Arts Industriels in Geneva, he moved to Paris in 1890, where he was to spend most of his time thereafter. Schwabe was first known as a wallpaper designer but almost immediately turned to book illustration, receiving a commission to illustrate Zola's novel Le Rêve in 1891; between then and 1908 he was to illustrate many more books, including Baudelaire's Les Fleurs du Mal and Catulle Mendès' translation of L'Evangile de l'Enfance de Notre Seigneur Jésus-Christ selon Saint-Pierre. Closely tied to the Symbolist movement, Schwabe was commissioned by the Sâr Peladan in 1892 to create a poster for the first Salon de la Rose+Croix, where he exhibited sixteen works as well as his preparatory studies for Le Rêve. The poster, an allegorical treatment of the theme of initiation, displays the painstaking execution and complex personal symbolism that characterize Schwabe's work (G. Lacambre 1972, pp. 140–44). R.B./A.W.

PIERRE SELMERSHEIM

French.
Pierre Selmersheim was a collaborator of the architect Charles Plumet, as was his brother, the architect Tony Selmersheim. At the 1902 salon of the Société Nationale des Beaux-Arts he exhibited an office interior that avoided "superfluous ornamental forms and acrobatic accomplishments"; his concern for utility rather than decorative effect was evident in an apartment he decorated that same year.

GUSTAVE SERRURIER-BOVY

Belgian, b. Liège 1848, d. 1910.
A highly influential designer, Serrurier-Bovy was born into a family of cabinetmakers. While studying architecture at the academy of Liège, around 1874, he became enthusiastic over the theories of Viollet-le-Duc; during a trip to England in 1884 he discovered the work of Ruskin and Morris and studied the accomplishments of the Arts and Crafts Movement. In Liège that same year he opened a furniture shop where he sold products from Japan and from Liberty's of London, and eventually he abandoned his architectural practice to devote all his time to designing and producing furniture. At the first Salon de la Libre Esthétique in 1894 he exhibited a completely furnished study of popular inspiration; his presentation the following year, a room for a worker's house, demonstrated his interest in designing furniture for rich and poor alike. In 1895 he organized L'Oeuvre Artistique at Liège, an international exhibition of decorative arts where he showed his own pieces along with those of numerous other artists. His work was exhibited abroad as well: at the London Arts and Crafts salon in 1896, and at the Salon du Champ de Mars (SNBA) in Paris from 1896 to 1903. He was also charged with organizing and designing the hall that housed the imports section of the Tervueren colonial exhibition, a part of the Brussels Exposition Internationale of 1897.

In 1899 Serrurier-Bovy opened a large furniture factory at Liège, with an outlet in Paris called L'Art dans l'Habitation. He participated in the Paris Exposition Universelle in 1900 with the installation of the Pavillon Bleu, and in the

Louisiana Purchase Exposition in St. Louis in 1904. At the international exposition at Liège in 1905 he exhibited a worker's home whose furnishings were remarkable for their simplicity and ingenious design; he created display stands for the Salons de l'Automobile held in Paris from 1904 to 1906, and shortly before his death installed his own pavilion at the Brussels international exposition of 1910. J.-G.W.

MANUFACTURE DE SÈVRES

At the end of the 19th century, the Manufacture de Sèvres underwent a profound structural change when it was divided into artistic and technical branches. Alexandre Sandier, the director of the art branch, had at his disposal four types of materials: hard-paste porcelain, Sèvres *pâte nouvelle* (which is fired at a lower temperature than hard paste), soft-paste porcelain, and stoneware. He perfected the technique of crystalline glazes on hard-paste porcelain, known before 1900 but never considered more than an unfortunate accident. In 1900 Sèvres exhibited vases with a crystalline glaze and in 1903–1904 the Manufacture commissioned new forms, to be completely covered with crystalline glazes, from Hector Guimard. Sandier also brought unglazed porcelain back into vogue: a series of fifteen dancing figures, inspired by Loïe Fuller and modeled by Agathon Léonard, was one of Sevres' most popular entries in the Exposition Universelle of 1900. In its stoneware Sèvres followed the style of the times, producing vases and small sculptures. The factory also initiated a series of new forms that carried the names of cities and provinces in France and were decorated in Art Nouveau style by the painters at Sèvres (Camart et al. 1971; Fay-Hallé 1975, p. 11).

FERNAND THESMAR

French, b. 1843, d. 1912.

Thesmar, the son of a banker who moved to Mulhouse in 1852, loved chemistry as a young boy but had to interrupt his studies when he was fourteen. In 1860, after serving four years as an apprentice in a textile factory, he went to Paris, where he entered first a workshop for industrial design and then a studio for theater decoration. He was appointed director of the tapestry factory in Aubusson, then worked at the Barbedienne foundry (but did not sign his work there) from 1872 until he obtained his own studio at Neuilly. There he specialized in the study of cloisonné enameling on precious metals. He entered a tray made by this technique at the exhibition of the Union Centrale des Arts Décoratifs in 1874. At the exposition of 1878 Japan bought two of his works, *Le Printemps* and *L'Automne,* for which the artist had reduced the number of sections and shaded his enamels. In 1888 Thesmar showed his first work in translucent plique-à-jour enamel, a technique in which the metal backing is removed after firing, leaving a network of gold thread which holds the enamels suspended in a pattern of almost invisible links. In 1895, after two years in London, the artist exhibited pieces in a new technique: translucent cloisonné enamels on soft-paste porcelain from the Manufacture de Sèvres. C.B.

HENRI THIRIET

History often neglects poster artists. Except for Chéret or Mucha, if they were not known as illustrators or decorators, we find few details about their work. Such is the case with Henri Thiriet, who did several very lovely Art Nouveau posters in the 1890s, beautifully combining the theme of the mysterious woman with the vegetal ornamentation so popular at the time. He created posters for Cycles Omega, Absinthe Berthelot, Cycles Griffith, and Pierrefort (with Sagot and Arnould one of the foremost print dealers). A.W.

THONET

Vienna.

Michael Thonet (1796-1871) was brought to Vienna from his native village on the Rhine by Metternich, the chancellor of Austria, who saw Thonet's furniture on a trip to Germany in 1841. He soon had such success that he became a favorite cabinetmaker of Vienna's imperial court and nobility, but he continued working with a larger clientele in mind, and with mass production as his goal. By 1856 he had designed his first factory—from the buildings to the machines themselves. He built in the Moravian forests, close to the supply of beechwood which would be used to make his bentwood furniture.

Thonet's oeuvre served as an example to later artists, both in the character and quality of his design and in his successful use of modern manufacturing techniques to make fine furniture available inexpensively. S.J.B.

LOUIS COMFORT TIFFANY

American, b. New York City 1848, d. New York City 1933.

Instead of working in his father's Fifth Avenue jewelry firm, Louis C. Tiffany decided to become a painter and in 1866 began studies under George Inness; in 1868 and 1869 he worked in Paris under Léon Bailly, who introduced him to Islamic art and culture, then with a friend, Samuel Colman, he toured North Africa before returning to New York and life as a painter. Although quite successful—his works were shown at the 1876 and 1878 world's fairs in Philadelphia and Paris—Tiffany realized his limitations as a painter and turned more and more to the applied arts. In 1879, with Colman and Candace Wheeler, he founded the decorating firm of Louis C. Tiffany and Associated Artists. The partnership created lavish, exotic interiors whose contents were coordinated into a harmonious whole, setting a new style in interior design; its successes were crowned with a commission to redecorate several rooms of the White House (1882–83).

Tiffany had begun experimenting with glass in the 1870s; he developed opalescent glass, first using it in a window in 1878, and patented a method for producing luster glass in 1881. Although he remained active in the decorating business throughout the 1880s and 1890s, with the dissolution of his decorating firm he was able to concentrate his attention on the new medium and in 1885 founded the Tiffany Glass Company; the stained-glass windows it produced proved enormously popular. On a visit to Paris in 1889 he arranged to produce art windows for display under the auspices of Samuel Bing, who had furnished him with oriental objects as early as the 1870s: the collaboration thus begun between the two men, both committed to the development of the decorative arts, put Tiffany in touch with European artists and encouraged him to greater creativity in his art. Bing, as his exclusive European distributor, commissioned designs from artists including Bonnard, Lautrec, and Vuillard for a series of seventeen stained-glass windows to be executed at Tiffany's studios; it was he, too, who encouraged Tiffany to enter a display at the World's Columbian Exposition at Chicago in 1893.

Encouraged by his reception in Chicago, Tiffany about the same time opened a furnace at Corona, L.I., for the production of blown glass objects, an endeavor inspired by the Gallé glassware he had seen at the Exposition Universelle of 1889. The first major exhibition of "Favrile" glass—the trademark was registered in 1894—was the opening of Bing's L'Art Nouveau in December 1895, when the series of stained-glass windows, exhibited at the Société Nationale des Beaux-Arts earlier that year, was also shown. An immediate artistic and commercial success, Tiffany glassware was acquired by numerous European museums and was widely admired and imitated by other artists.

Although it is for his glassware that he is best known, Tiffany also produced lamps, metal objects, enamels, jewelry, furniture, and textiles, depending on the superlative craftsmen in his studios to execute his designs. His exposure to French Art Nouveau ceramics, especially at the 1900 Paris Exposition Universelle, undoubtedly inspired him to begin producing ceramics, which he introduced after several years' experimentation at the St. Louis world's fair in 1904. On shapes which were most often decorated with natural motifs Tiffany's craftsmen applied glazes whose subtle color effects have been compared to those he achieved in his remarkable glass vases (Bing 1895; Koch 1961; Eidelberg 1972, p. 164; Evans 1974, pp. 282–84). S.C.

GEORGES TONNELLIER
French, b. Paris 1858.
A sculptor and silversmith, Tonnellier studied under Charles Gauthier and A. Millet. He took part in the salons of the Société des Artistes Français from 1887, and at the Exposition Universelle of 1900 was awarded a gold medal. The Musée Galliera possesses a number of his cameos, including *Idylle* and *Tentation de Sainte-Antoine,* while the Louvre holds others —*La Traversée du Styx, Portrait du sculpteur Ch. Gauthier,* and *Enlèvement de Déjanire* (Escard 1914; Oostens-Wittamer 1965, p. 64). J.-G.W.

JAN TOOROP
Dutch, b. Java 1858, d. The Hague 1928.
Toorop spent the first eleven years of his life in Java. He was educated in Amsterdam and then moved to Brussels, where he became a member of Les Vingt after 1887. Drawn to Symbolism by Maeterlinck, in his early manner he reflected Khnopff's and Minne's work. However, England provided Toorop with his closest ties: his mother was English, and his wife, whom he met on his first trip to England with Verhaeren in 1884, was Irish. The Irish Celtic element, Rossetti and the Pre-Raphaelites, William Morris' work in the decorative arts, Ricketts, Beardsley, and Java all influenced the work of Toorop.

He exhibited in the first Salon de la Rose+Croix in 1892 and at the Durand-Ruel gallery the same year. He also exhibited regularly with Les Vingt. S.C.

HENRI DE TOULOUSE-LAUTREC
French, b. Albi 1864, d. Malromé 1901.
In 1891 the director of the Moulin Rouge gave Lautrec the opportunity of doing his first poster, thus introducing the painter to the technique of lithography which would make him famous. By 1900 the artist had created thirty-one posters, including such masterpieces as *Aristide Bruant, Divan Japonais, Jane Avril,* and *May Milton.* His work, like that of Bonnard, shows the influence of the Japanese *ukiyo-e* prints, particularly in the layout, the use of large flat areas of color, the outlining of figures, and the frequent inclusion of blank areas in compositions. Lautrec's economy of line and forceful style were ideally suited to posters.

Lautrec was closely connected to both French and Belgian Art Nouveau. From 1888 on he was invited by Octave Maus to exhibit at the Salon des Vingt; from his journeys to London and Belgium he brought back rugs and pottery to decorate his studio. He was in addition one of the artists from whom Samuel Bing commissioned a stained-glass window; it was executed in Tiffany's studios in New York. The design, entitled *At the Nouveau Cirque: The Dancer and the Five Stiff Shirts,* is now in the Philadelphia Museum of Art. A.W./S.C.

FERNAND TOUSSAINT
Belgian, b. Brussels 1873, d. Brussels 1955.
Toussaint, a student of Portaels at the Brussels academy, was a genre painter whose works show a strong Symbolist influence. Two posters by him are known, *Café Jacqmotte* (1897) and *Le Sillon* (1895). The latter, his first, was described by Roger Marx in *Les Maîtres de l'Affiche:* "Glory, personified as a winged young woman, surrounded by wheat stalks, a sheaf in one hand, a sickle in the other, reaps flowers for the chosen ones." It was done at a time when the artistic movement Le Sillon had not yet taken the realistic stance that would later characterize it. Toussaint exhibited with Le Sillon, as well as with the Société des Artistes Français in 1901 and La Libre Esthétique in 1910. A.W.

ADOLPHE TRUFFIER
French, b. Paris.
Adolphe Truffier was a designer who exhibited at the salon of the Société des Artistes Français in 1897, 1899, 1901, 1903–1904, and 1906.

UNIVERSITY CITY POTTERY
University City, Missouri.
Edward Gardner Lewis founded the American Women's League in 1907, to provide American women with educational opportunities. A program of correspondence courses was offered to League members by the People's University, and by 1910 over 50,000 women had enrolled.

A few of exceptional talent among them were invited to study at University City under the personal supervision of the faculty there.

Because of Lewis' interest in art, the Art Institute was the most developed of the departments at University City, boasting a distinguished faculty and courses in painting, metal and leatherwork, elementary handiwork, and ceramics. Through his own work as an amateur ceramist Lewis knew the great technical book, *Grand Feu Ceramics,* and he invited its author, Taxile Doat, to set aside his work at the Manufacture de Sèvres to become director of the School of Ceramic Art. The League also purchased for its museum Doat's permanent collection of two hundred pieces made at Sèvres.

Doat came to University City in 1909; the first kiln was fired under his supervision there in 1910. The faculty of the Ceramic School also included several distinguished American ceramists: Frederick Rhead, Adelaide Alsop Robineau, Kathryn E. Cherry, Edward Dahlquist, and Frank J. Fuhrmann, as well as Eugène Labarrière and Emile Diffloth, who had been associated with Doat in Europe. In all they taught some thirty students by correspondence and about ten in residence.

Availing themselves of fine native clays, these ceramists developed a number of simple shapes to supplement those brought by Doat from Sèvres, and a range of glazes—mat and gloss, crystalline, oriental crackle, alligator skin, etc. That they won the grand prize at the international exposition in Turin in 1911, competing with the greatest products of Europe, attests to their work's quality. That same year, however, the American Women's League fell apart. Doat remained at University City, but Rhead and the Robineaus left; Lewis and his wife moved in 1912 and founded Atascadero, the California colony of the American Women's Republic. University City Pottery was reorganized in 1912 and production continued until 1915; Doat returned to France that year (Evans 1974, pp. 286–91; Eidelberg 1972, p. 173). C.W.C.

ANNA MARIE VALENTIEN
American, b. Cincinnati 1862, d. c. 1950.
Anna Marie Bookprinter was an artist in the decorating department of Rookwood Pottery. In 1887 she married Albert Valentien, head of the decorating department there. Anna Marie Valentien's study under Rodin in France was reflected in her work, and, although she failed in her attempts to introduce such sculptured forms at Rookwood, she would later pursue

them at the pottery which she and her husband founded. Leaving Rookwood in 1905, the Valentiens stayed in Cincinnati until 1907, when they settled in San Diego; there they established the Valentien Pottery, which is believed to have been in business from about 1911 to 1914. Albert and Anna Valentien were listed in the 1913 *American Art Annual* directory as "painter, potter" and "sculptor, potter" respectively. Anna outlived her husband by a quarter century (Evans 1974, pp. 294–96). C.W.C.

FÉLIX VALLOTTON

French, b. Lausanne 1865, d. Paris 1925.
Arriving in Paris from his native Switzerland at the age of seventeen, Vallotton enrolled at the Académie Julian but soon gave up formal education to study the masters—Holbein, Dürer, Ingres—firsthand at the Louvre. He became a contributor to *La Revue Blanche* and developed a friendship with its founder and director, Thadée Natanson. From 1891 to 1898 he devoted most of his time to woodcuts and exhibited with the Nabis and Les Indépendants. Like the other Nabis he worked for Lugné-Poë and his Théâtre de l'Oeuvre.

Vallotton was influenced by Japanese prints. His woodcuts are strongly outlined with large areas of solid black on white. R.B.

VAL-SAINT-LAMBERT

The Société Anonyme des Verreries et Etablissements du Val-Saint-Lambert was founded in 1826 in a former Cistercian abbey near Liège. The establishment, whose first workers came from the old Vonèche factory, soon took over the glassworks of Mariemont, Herbatte (Namur), and Vaux-sous-Chèvremont. Val-Saint-Lambert crystal was shown in 1835 at the Exposition de l'Industrie in Brussels, and like Baccarat soon became famous the world over. A branch was opened in London in 1861.

Val-Saint-Lambert's greatest and most creative period was between 1880 and 1914, especially in the factory near Jemeppe, founded by the well-known Léon Ledru. Henri and Desiré Muller, students of Gallé in Nancy, worked there in 1906 and 1907, producing pieces with etched decoration. Other artists of note collaborated with Val-Saint-Lambert: Van de Velde; Philippe Wolfers, who made models to be executed at the factory; and Serrurier-Bovy, who created designs for stained glass, lamps, and goblets. J.-G.W.

ARTUS VAN BRIGGLE

American, b. Felicity, Ohio, 1869, d. 1904.

While a painting student in Cincinnati, Artus Van Briggle supported himself painting dolls' heads at the Avon Pottery. A year later, in 1887, he joined Rookwood Pottery, and by 1891 he was a senior decorator there. His talent was such that in 1893 Rookwood sent him to Paris, where he studied for three years; it was there that he met Anne Gregory, whom he later married.

After his return to Rookwood, the object of his personal research was the rediscovery of Chinese mat glazes. Despite his success, however, tuberculosis forced him to seek a more salubrious climate. Thus he founded his own pottery at Colorado Springs, Colorado, in 1899, with financial assistance from Mrs. Storer of Rookwood. The Van Briggle mark is a double A—for Artus and Anne.

In 1904 Van Briggle died; his widow Anne took over the pottery, which still exists today. During the five years Artus personally directed the factory, it won more awards than any other American pottery of that era—at the 1903 salon of the Société des Artistes Français, the St. Louis Louisiana Purchase Exposition of 1904, and the Lewis and Clark Centennial in 1905 (Henzke 1970, pp. 257–64; Eidelberg 1972, p. 158; Evans 1974, pp. 297–302). C.W.C.

CHARLES VAN DER STAPPEN

Belgian, b. Brussels 1843, d. 1910.
Van der Stappen studied sculpture at the Brussels academy and made several extended visits to Italy: to Florence in 1871, Naples in 1873, and Rome from 1876 to 1879. After a brief stay in Paris, he returned to Brussels and around 1875 and 1876 produced several pieces of decorative art. He founded his own studio before becoming professor of sculpture at the Brussels academy. Although he was invited three times to the salon of Les Vingt, his work remained rather classical. In 1891, with his creation of a table centerpiece for the city of Brussels, Art Nouveau tendencies began to emerge; they are especially evident in the smaller pieces he created. His *Sphinx Mystérieux* in silver and ivory was exhibited along with other works in the colonial section in Tervueren of the 1897 Brussels Exposition Internationale. J.-G.W.

THÉO VAN RYSSELBERGHE

Belgian, b. Ghent 1862, d. Saint-Clair (Var) 1926.
A painter and graphic artist, Van Rysselberghe was born to a family of architects in Ghent. He began studies at the academy of Ghent and later moved to Brussels to continue his education

there. After producing several paintings in strictly classical style, he became interested in the work of Seurat and adopted a Neo-Impressionistic style. As a close friend of Octave Maus, and in contact with the great poets, writers, and painters of his time, he became an influential figure in Les Vingt and La Libre Esthétique. He was himself a regular participant in their salons and created several posters for the latter group. Later in his life he lived and worked on the French Riviera.

MAURICE PILLARD VERNEUIL

French, b. Saint-Quentin 1869.
Verneuil wrote on the applied arts for *Art et Décoration,* and was a graphic artist in his own right. He collaborated with Grasset on *La Plante et ses applications ornementales,* and then himself published *L'Animal dans la Décoration.* His posters always show a woman in profile surrounded by vegetal decoration (Wittamer 1961, p. 95). A.W.

PAUL AND HENRI VEVER

French, Paul b. 1851, d. 1915. Henri b. 1854, d. 1942.
Descendants of a family of jewelers who moved from Lorraine to Paris after the Franco-Prussian War, the Vever brothers took part in turn-of-the-century world's fairs both in Paris and abroad. While their entries were well received at the expositions of 1878 and 1889, their renown dates from the Exposition Universelle of 1900, where they and René Lalique showed works that represented the most advanced trends in jewelry. In 1904 the Vever brothers set up shop on the rue de la Paix. Henri Vever created some of their designs himself but also called on such artists as Edward Colonna and especially Eugène Grasset. Henri's *La Bijouterie française au XIXe siècle* (1906–1908), a comprehensive history of 19th-century French jewelry, is an authoritative and sometimes unique source for information about many of his contemporaries (Oostens-Wittamer 1965, p. 69).

JAMES VIBERT

Swiss, b. Geneva 1872, d. 1942.
The brother of the painter and woodcarver Pierre Eugène Vibert, James Vibert began his training as a metalworker and then studied at the Ecoles des Beaux-Arts in Geneva, Lyons, and Paris. In 1891 he worked in Rodin's studio in Paris. He first exhibited at the salon of the Société Nationale des Beaux-Arts in 1893, showing a work entitled *Vita in Morte.* A professor at the Ecole des Beaux-Arts in Geneva from

1903 to 1933, Vibert was awarded a silver medal at the Exposition Universelle of 1900. In his work he collaborated often with Louis Müller, the son of Emile Müller, designing figures which clearly show the influence of Rodin (Woeckel 1968).

CHARLES FRANCIS ANNESLEY VOYSEY

English, b. Hessle, Yorkshire, 1857, d. Winchester 1941.

Voysey trained as an architect at Dulwich College, was apprenticed to J.P. Seddon, and then set up his own practice in 1882; but like the English artists influenced by the Arts and Crafts Movement, he also wrote about his economic theories and designed furniture, wallpaper, textiles, and metalwork. It is in his metal vessels that the most Art Nouveau characteristics are expressed. Voysey's first textiles and wallpapers, designed in 1883, reflected the influence of Mackmurdo, with whom he had worked. He was also strongly influenced by Japanese art.

Among the homes Voysey designed are the Forster house in Bedford Park (1891), the Julian Sturgis house in Surrey (1899), and Broadleys in the Lake District. His architecture, demonstrating the concern for functionalism and reduction of ornamental detail that link him to the modern movement, was represented at the 1894 and 1897 Salons de la Libre Esthétique; he also exhibited along with the Glasgow School at Liège in 1895, and at Turin in 1902. S.C.

VUILLARD, EDOUARD JEAN

French, b. Cuiseaux (Saône-et-Loire) 1868, d. La Baule 1940.

Vuillard's father, a retired colonial official, died in 1883, and his mother supported her three sons by opening a couture atelier in her house.

Vuillard went to the Lycée Condorcet. Among his classmates were Ker-Xavier Roussel, Maurice Denis, and Lugné-Poë, who became close friends. He studied at the Ecole des Beaux-Arts and in 1888 went to the Académie Julian. With Denis, Sérusier, and Ranson he formed a group of avant-garde painters which Sérusier pedantically named the Nabis (from the Hebrew for prophet). The Nabis were strongly influenced by Gauguin's new "synthetist" style, which they were able to study at the Café Volpini exhibition during the 1889 Paris Exposition Universelle.

In 1890 Vuillard shared with Bonnard a small studio—28 rue Pigalle—which was also used frequently by Denis and Lugné-Poë. A year later he exhibited with the other Nabis at Le Barc de Boutteville's and on the premises of *La Revue Blanche*. Articles by critics, particularly an article by Albert Aurier, "Le Symbolisme en Peinture," attracted attention to the Nabis.

When Lugné-Poë opened the Théâtre de l'Oeuvre in 1893 Vuillard along with the other Nabis designed and painted stage sets for his productions, an experience that oriented him toward working in a larger scale. He began doing decorative panels and screens, in 1894 providing Thadée Natanson, editor of *La Revue Blanche*, with nine landscape panels for his home and receiving commissions for decorative plans from his friend Dr. Vasquez in 1896 and from the novelist Claude Anet in 1898. In these large panels, and in his intimate interior scenes, Vuillard reached the summit of his art. Gradually around 1910 his painting became more conventional and lost all traces of Symbolism.

Vuillard was an important graphic artist. In 1899 Vollard commissioned a porfolio of color lithographs, *Paysages et Intérieurs*. He also made lithographs for Meier-Graefe, for *Pan*, for *L'Estampe Originale*, and others. Vuillard, however, attempted only one poster, *Bécane*, an advertisement for an apéritif appealing to bicyclists (*bécane* being the slang word for bicycle) (Ritchie 1954; Russell 1971). R.B.

ALMARIC-V. WALTER

French, b. Sèvres 1859, d. Nancy 1942.

A potter and glassmaker trained at the Ecole Nationale de la Manufacture de Sèvres, Walter began working with *pâte de verre* in 1902. From 1908 to 1914 he was employed by the Daums to make glass sculpture, the firm's artistic director Henri Bergé providing the models. In 1919 he opened his own *pâte de verre* workshop in Nancy and by 1925 employed ten workers. There he produced windows and objects, many copied from earlier models like the Tanagra figurines in the Louvre and 18th-century reliefs (Hilschenz 1973, p. 356).

PHILIPPE WOLFERS

Belgian, b. Brussels 1858, d. 1929.

Born into a family of jewelers, Philippe Wolfers began learning his profession in his father's studio; in 1875, when he was seventeen, he completed his studies at the Brussels academy. Although the jewelry designs he created from 1880 to 1885 were all in the Louis XV style, the influence of Japanese art appeared as early as 1882. Wolfers did his first sculpture in 1890. In 1892 he produced a series of floral designs for jewelry; all of his designs were based on thousands of studies he made of flora, fauna, and the human body throughout his career. For his jewels, Wolfers preferred baroque pearls or stones of an unusual shape and always used opaque or translucent enamels; with these materials he strove to represent an idea or a symbol. From 1894 on he used ivory from the Congo Free State, exhibiting sculpture in Antwerp in 1894 and at the colonial section of the Brussels Exposition Internationale in 1897.

Wolfers' last jewelry dates from 1904; thereafter he dedicated himself to bronze or marble sculptures inlaid with precious materials. His son Marcel was a noted decorative artist of the Twenties. J.-G.W.

Bibliography

ABDY, JANE. 1969. *The French Poster: Chéret to Cappiello.* New York: Clarkson N. Potter.

ADAMS, J. BROOKS. n.d. "Two Chairs by Joseph Hoffmann." Unpublished article for Museum Studies, The Art Institute of Chicago.

ADHÉMAR, JEAN. 1965. *Toulouse-Lautrec: His Comple. Lithographs and Drypoints.* New York: Harry N. Abrams.

AHLERS-HESTERMANN, F. 1914. *Stilwende.* Berlin.

"Alban Chambon." *Journal de la Marbrerie et de l'Art Décoratif* 44 (August 16, 1905).

Albert Moore and His Contemporaries. 1972. Newcastle upon Tyne: Laing Art Gallery.

L'Album d'Art. 1904.

Album d'estampes originales. 1897. Paris: Vollard.

ALEXANDRE, ARSÈNE. n.d. "L'Oeuvre d'Eugène Grasset." In *Catalogue de la Deuxième Exposition du Salon des Cent Réservée à un ensemble d'Oeuvres d'Eugène Grasset.* Paris.

———. 1895. *Jean Carriès.* Paris.

ALISON, FILIPPO. 1974. *Charles Rennie Mackintosh as a Designer of Chairs.* Milan: G. Milani; London: Warehouse Publications.

AMAYA, MARIO. 1966. *Art Nouveau.* London: Studio Vista, Dutton Pictureback.

Annuaire de l'Union Centrale des Arts Décoratifs. 1904.

ANSIEAU, J. 1969. "Georges Lacombe, peintre et sculpteur." Master's thesis, Ecole du Louvre, Paris.

APPERT, LÉON, AND HENRIVAUX, JULES. 1894. *La Verrerie depuis vingt ans.* Paris.

L'Art Décoratif. 1898–1913.

L'Art Décoratif aux Expositions des Beaux-Arts. n.d. Paris: Armand Guérinet.

L'Art Décoratif Moderne. 1896.

L'Art Décoratif pour Tous.

Art et Décoration. 1897–1913.

L'Art et les Artistes. 1905–20.

Art in 1898. Special number of *The Studio,* 1898.

L'Art Moderne. 1881–1914.

Les Arts. 1902–20.

ASHTON, DORE. 1961. "Gustave Moreau." In *Odilon Redon, Gustave Moreau, Rodolphe Bresdin.* New York: The Museum of Modern Art.

ASLIN, ELIZABETH. 1969. *The Aesthetic Movement: Prelude to Art Nouveau.* London: Elek.

Auguste Rodin: An Exhibition of Sculptures/Drawings. 1963. New York: Charles E. Slatkin Galleries.

Autour de Lévy-Dhurmer: Visionnaires et Intimistes en 1900. 1973. Paris: Musées Nationaux.

BARILLI, RENATO. 1966. *Il Liberty.* Milan: Frattelli Fabbri.

———. 1967a. "Aspetti dell'arte europea alla fine del secolo." *L'Arte Moderna* 2, pp. 241–80. Milan: Fratelli Fabbri.

———. 1967b. "Il Gruppo dei Nabis." Ibid., pp. 81–120.

———. 1967c. *Il simbolismo nella pittura francese dell'ottocento.* Milan: Fratelli Fabbri.

BARTEN, SIGRID. 1973. *René Lalique: Schmuck und Objets d'art, 1890–1910.* Ph.D. dissertation. Hamburg.

BARTH, W. 1929. *Gauguin—Das Leben, der Mensch und der Künstler.* Basel.

BATTERSBY, MARTIN. 1969. *Art Nouveau.* Feltham.

BAUWENS, MAURICE, ET AL. 1897. *Les Affiches Etrangères illustrées.* Paris: G. Boudet.

BEAUNIER, ANDRÉ. 1902. "Aman-Jean." *Art et Décoration* 11, pp. 132–42.

BEDEL, JEAN. 1968. "Emile Gallé, cet inconnu." *Guide des Antiquités,* no. 40, pp. 27, 43–45.

BELFORT, ANNE-MARIE. 1967. "Pâtes de verre d'Henry Cros." *Cahiers de la Céramique* 39, pp. 182–85.

BELVILLE, EUGÈNE. 1910. "Lucien Bonvallet décorateur." *L'Art Décoratif* 23, pp. 16–26.

BENEDICTUS, EDOUARD. 1907. "Pâte de verre: G. Despret, F. Décorchemont." *L'Art Décoratif* 17, pp. 211–16.

BÉNÉDITE, LÉONCE. 1898a. "Les Salons de 1898." *Gazette des Beaux-Arts,* June.

———. 1898b. "Les Salons de 1898." *Gazette des Beaux-Arts,* July.

———. 1900a. "La Bijouterie et la Joaillerie à l'Exposition Universelle de 1900: René Lalique." *Revue des Arts Décoratifs* 20, pp. 201–10, 237–44.

———. 1900b. "Le Bijou à l'Exposition universelle." *Art et Décoration* 8, pp. 65–82.

———. 1908. "Madame Marie Gautier." *Art et Décoration* 23, pp. 137–44.

———. 1918. "Auguste Rodin." *Gazette des Beaux-Arts,* January-March, pp. 5–34.

BÉNÉZIT, E. 1948. *Dictionnaire critique et documentaire des Peintres, Sculpteurs, Dessinateurs et Graveurs.* Paris: Librairie Gründ.

BENNETT, IAN. 1975. "Three French Potters." *Crafts,* November–December, pp. 13–17.

BERRYER, ANNE MARIE. 1944. "A propos d'un vase de Chaplet." *Bulletin des Musées Royaux d'Art et d'Histoire,* January–April, pp. 13–27.

BERTRAND, J. -L. 1901. "Les Bijoux aux Salons de 1901." *Revue de la Bijouterie,* no. 14, pp. 41–53.

BEYER, VICTOR. 1952. "Originalité du XIVème siècle." *Revue*

d'Alsace 91, pp. 81–91.

Bibliothèque Raphaël Esmerian. Vol. 5, *Livres Illustrés Modernes (1874–1970).* 1974. Paris.

BIDOU, HENRY. 1910. "Les Salons de 1910." *Gazette des Beaux-Arts,* July, pp. 26–50.

BIGOT, ALEXANDRE. 1894. "Emaux pour Grès." In *Le Moniteur de la Céramique et de la Verrerie.*

———. 1902. *Grès de Bigot.* 2nd ed. Paris.

BING, SAMUEL. 1888. "Programme." *Le Japon Artistique,* May, p.5

———. 1896. *La Culture Artistique en Amérique.* Paris, 22 rue de Provence. English translation by Benita Eisler, *Artistic America, Tiffany Glass, and Art Nouveau,* edited by Robert Koch. Cambridge, Mass.: MIT Press, 1970.

BLOCH-DERMANT, JANINE. 1974. *L'Art du verre en France, 1860–1914.* Paris: Denoël.

BLONDEL, ALAIN, AND PLANTIN, YVES. 1970. "Guimard, architecte de meubles." *L'Estampille* 10, pp. 32–40.

———. 1971. *Hector Guimard, Fontes Artistiques.* Paris: Galerie du Luxembourg.

BLUNT, ANTHONY. 1959. *The Art of William Blake.* New York: Columbia University Press.

BODELSEN, MERETE. 1959. "The Missing Link in Gauguin's Cloisonism." *Gazette des Beaux-Arts,* May–June, pp. 329–44.

———. 1960. *Gauguin's Ceramics in Danish Collections.* Copenhagen: Munksgaard.

BOILEAU, LOUIS-AUGUSTE. 1886. *La Cathédrale Synthétique.*

BOILEAU, LOUIS-CHARLES. 1899. "Causerie: L'Exposition des Oeuvres de M. Guimard dans les Salons du 'Figaro.'" *L'Architecture,* April 15, pp. 126–33.

BONNIER, LOUIS. 1909. *Rapport sur la Révision des ordonnancements de la voie publique.* Paris.

———, AND POËTE, MARCEL. 1916. *Enquêtes sur l'expansion de Paris.* Paris.

BORSI, FRANCO, AND PORTOGHESI, PAOLO. 1969. *Victor Horta.* Rome: Edizioni del Tritone. French translation, Brussels, 1970.

———, AND WEISER, H. 1971. *Bruxelles, Capitale de l'Art Nouveau.* Brussels.

———. 1974. *Bruxelles 1900.* Translated by Jean-Marie Van der Meerschen. Brussels: Marc Vokaer.

BOSQUET, E. 1901. "La Reliure Etrangère à l'Exposition." *Art et Décoration* 9, pp. 99–104.

BOSSAGLIA, ROSSANA. 1972. *Le Mobilier Art Nouveau.* Paris: Grange-Batelière.

BOTT, GERHARD. 1972. *Ullstein Juwelenbuch.* Berlin.

———. 1973. *Kunsthandwerk um 1900: Jugendstil, Art Nouveau, Modern Style, Nieuwe Kunst.* Darmstadt: Hessisches Landesmuseum.

BOUDON, FRANÇOISE. 1973. "Recherche sur la pensée et l'oeuvre d'Anatole de Baudot." *Architecture, mouvement, continuité,* no. 28 (March), special number.

BOUILHET, HENRI. 1912. *L'Orfevrerie française aux XVIIIe et XIXe siècles.* Paris: H. Lauren.

BOUYER, RAYMOND. 1901a. "La Décoration des montres." *Art et Décoration* 11, pp. 37–40.

———. 1901b. "Edmond Becker, Sculpteur." *Art et Décoration* 9, pp. 107–19.

———. 1902. "Quelques nouveaux bijoux." *L'Art Décoratif* 7, pp. 54–55.

BRICON, ETIENNE. 1920. "Les Salons de 1920." *Gazette des Beaux-Arts,* July, pp. 14–28.

British Sources of Art Nouveau. n.d. Manchester: Whitworth Art Gallery.

BRUNHAMMER, YVONNE, AND RICOUR, MONIQUE. 1958. "Le Style 1900." *Jardin des Arts,* August, pp. 653–55.

———. 1964. "1900 un Style." *La Maison française,* November, pp. 162–68.

———. 1966a. *Les Années "25."* Paris: Collections du Musée des Arts Décoratifs.

———. 1966b. *Il Mobile en Europa dal XVI al XIX secolo.* Novara: Instituto Geografico de Agostini.

———; CULOT, MAURICE; AND DELEVOY, ROBERT-L. 1971. *Pionniers du XXe Siècle: Guimard, Horta, Van de Velde.* Paris: Musée des Arts Décoratifs.

———. 1973. Introduction to *Jean Dunand—Jean Goulden.* Paris: Galerie du Luxembourg.

———. 1974. "Un Oublié de l'Art Nouveau." *Plaisir de France,* no. 421, pp. 52–53.

———; MERKLEN, COLETTE; PLANTIN, YVES; AND BLONDEL, ALAIN. 1974. *L'Oeuvre de Rupert Carabin, 1862–1932.* Paris: Galerie du Luxembourg.

———, AND BIZOT, CHANTAL. 1975. *Image des Années Insouciantes, 1900/1925.* Tokyo: Isetan.

———; BUSSMANN, KLAUS; AND KOCK, ROSWITHA. 1975. *Hector Guimard, 1867–1942.* Münster: Landesmuseum.

CAMART, J.-P., ET AL. 1971. *L'Art de la Poterie en France de Rodin à Dufy.* Sèvres: Musée National de Céramique.

CARABIN, RUPERT. 1910. "Le Bois." *Art et Industrie,* March, pp. 1–24.

CASSOU, JEAN, ET AL. 1960–61. *Les Sources du XXe siècle.* Paris: Musée National d'Art Moderne.

———; LANGUI, EMILE; AND PEVSNER, NIKOLAUS. 1962. *The Sources of Modern Art.* London: Thames and Hudson.

Le Castel Béranger: L'Art dans L'Habitation Moderne. 1898. Paris: Librairie Rouam.

Catalogue of A. H. Mackmurdo and the Century Guild Collection. 1967. Walthamstow: William Morris Gallery.

Catalogue Officiel 1893, Exposition Universelle de Chicago, Section Française, Beaux-Arts. Paris: Imprimerie de l'Art.

Catalogue Officiel des Collections du Conservatoire National des Arts et Métiers. Fasc. 4. 1908. Paris.

Catalogue of the Morris Collection. 1969. Walthamstow: William Morris Gallery.

CHAMPIER, VICTOR. 1896a. "Les Expositions de l'Art Nouveau." *Revue des Arts Décoratifs* 16, pp. 1–6.

————. 1896b. "Les Artistes Décorateurs: Fernand Thesmar." *Revue des Arts Décoratifs* 16, pp. 373–81.

————. 1899. "Le Castel Béranger et M. Hector Guimard." *Revue des Arts Décoratifs* 19, pp. 1–10.

————. 1903. *Les Industries d'Art à l'Exposition Universelle de 1889.* Paris: Bureaux de l'Art Décoratif.

CHAMPIGNEULLES, BERNARD. 1972. *L'Art Nouveau.* Paris: A. Somogy.

CHANTELOU. 1974. "Au gré des ventes—L'Hémorragie ou le garrot." *Le Monde* (Paris), April 4, p. 21.

CHARPENTIER, FRANÇOISE-THÉRÈSE. n.d. *Le Musée de l'Ecole de Nancy.* Lyons: Imprimerie Lescuyer.

————. 1964. "L'Ecole de Nancy et le renouveau de l'art décoratif en France." *Médecine de France,* July, pp. 17–32.

————. 1965. "Quelques sources de décor des verriers lorrains entre 1867 et 1900." *International Congress on Glass, Comptes Rendus,* II, no. 210, pp. 1–5.

————. 1972. "A Marriage Chest by Emile Gallé." *Apollo,* August, pp. 128–31.

CHASTEL, ANDRÉ. 1946. *Vuillard.* Paris: Librarie Floury.

CHEVALIER, MICHEL. 1851. "1er Aperçu Philosophique." In *L'Exposition Universelle de Londres considérée sous les rapports Philosophique, Technique, Commercial et Administratif au point de vue français (Ouvrage dédié aux producteurs de la Richesse Universelle).* Fasc. 1. Paris.

CHICAGO, ART INSTITUTE. 1961. *Paintings in The Art Institute of Chicago.*

Christofle orfevre—Cent ans d'orfevrerie d'avant-garde, de Napoléon III à nos jours. 1964. Paris: Musée du Louvre, Musée des Arts Décoratifs.

"Chronique." *La Saison d'Ostende,* July 15, 1902.

CLOUZOT, HENRI. 1921. *Le Travail du Métal.* Paris: F. Reider.

————. 1922. *André Metthey—décorateur et céramiste.* Paris: Librairie des Arts Décoratifs.

Collection Adolphe Neyt. 1920. Sale catalogue. Ghent, Hôtel Digne de Brabant.

CONRARDY, CHARLES, AND THIBAUT, RAYMOND. 1923. *Paul Hankar.* Brussels: Tekhné.

COQUIOT, GUSTAVE. 1900. "Les Beaux-Arts à l'Exposition, III: La Décennale." *La Plume,* June 1.

————. 1907. "Les Figurines de Carabin." *L'Art Décoratif* 9, pp. 25–30.

CORDIER, GILBERT. 1970. "A propos des Expositions Universelles, essai d'intégralisme." *Architecture, mouvement, continuité,* no. 17.

CREMONA, I. 1964. *Il Tempo dell' Art Nouveau.* Florence.

CRESPIN, ADOLPHE. 1901. "La Vie et l'art de Hankar." *La Ligue Artistique* (Brussels), February.

CROQUEZ, ALBERT. 1947. *L'Oeuvre Gravé de James Ensor.* Geneva and Brussels: Pierre Cailler.

CULOT, JEAN-MARIE. 1954. *Bibliographie de Emile Verhaeren.* Brussels.

CULOT, MAURICE, AND TERLINDEN, F. 1969. *Antoine Pompe et l'Effort Moderne en Belgique.* Brussels: Musée d'Ixelles.

————, AND DELEVOY, ROBERT-L. 1973. *Antoine Pompe ou l'Architecture du Sentiment.* Brussels: Musée d'Ixelles.

D'ALBIS, JEAN, ET AL. 1974. *Céramique Impressioniste: L'Atelier Haviland de Paris-Auteuil, 1873–1882.* Paris: Société des Amis de la Bibliothèque Forney.

————; D'ALBIS, LAURENS; AND ROMANET, C. 1976. *Ernest Chaplet, 1835–1909.* Paris: Presses de la Connaissance.

DALLIGNY, A. 1898. "Les Salons de 1898: La Société Nationale des Beaux-Arts." *Journal des Arts,* May 21.

DARZENS, RODOLPHE. 1895. "Notes sur les ouvriers d'art: Rupert Carabin." *L'Art Moderne,* pp. 261–62.

DAUBERVILLE, JEAN, AND DAUBERVILLE, HENRY. 1965. *Bonnard: Catalogue Raisonné de l'Oeuvre Peint, 1888–1905.* Paris: J. et H. Bernheim-Jeune.

DAY, KENNETH, ED. 1965. *Book Typography, 1815–1965, in Europe and the United States of America.* Chicago.

DAYEZ, ANNE. 1970. *Maurice Denis.* Paris: Réunion des Musées Nationaux.

DAYOT, ARMAND. 1902. "Le Salon des Boursiers de Voyage." *Art et Décoration* 11, pp. 113–22.

DE CHENNEVIÈRES, HENRY. 1889. "Exposition Universelle de 1889, la céramique monumentale, M. Emile Müller." *Revue des Arts Décoratifs* 10, pp. 129–36.

La Décoration Ancienne et Moderne 4 (1895).

DE FÉLICE, ROGER. 1906. "La Société des Artistes Décorateurs, Deuxième Exposition." *L'Art Décoratif* 8, pp. 201–12.

DE FOURCAUD, LOUIS. 1884. "Rapport Général." *Revue des Arts Décoratifs* 5, pp. 261–66.

————. 1892. "Les Arts décoratifs au salon de 1892." *Revue des Arts Décoratifs* 13, pp. 1–14.

————. 1903. *Emile Gallé.* Paris.

Dekorative Kunst. 1897–98.

DE LABORDE, LÉON. 1856. *Travaux de la commission française sur l'industrie des nations: Exposition universelle de 1851.* Paris.

DELEVOY, ROBERT-L. n.d. *Victor Horta.* Brussels: Meddens.

————. 1963. *Henry van de Velde, 1863–1957.* Brussels: Palais des Beaux-Arts.

————. 1964a. "Paul Hankar." In *Dictionnaire de l'architecture moderne.* Paris: Fernand Hazan.

————. 1964b. "Joseph Hoffmann." Ibid.

————. 1971. "Victor Horta." In *Pionniers du XXe Siècle: Guimard, Horta, Van de Velde,* by Yvonne Brunhammer et al. Paris: Musée des Arts Décoratifs.

DELHAYE, JEAN. 1968. "Victor Horta et la Maison du Peuple." *Cahiers Henry van de Velde,* no. 9–10.

DE LIESVILLE, A. R. 1879. "La Verrerie au Champ de Mars." In *L'Art Moderne à l'Exposition de 1878,* edited by Louis Gonse. Paris.

DE LOSTALOT, A. 1898. "Le Salon de 1898, Société Nationale des Beaux-Arts." *L'Illustration,* April 30.

DELTEIL, LOYS. 1913. *Le Peintre-Graveur Illustré.* Vol. 8, *Carrière.* Paris.

———. 1920. Ibid. Vols. 10–11, *H. de Toulouse-Lautrec.* Paris.

———. 1925. Ibid. Vol. 19, *Leys, De Brackeleer, Ensor.* Paris.

DE MAEYER, CHARLES. 1963. *Paul Hankar.* Brussels: Monographies de l'Art Belge.

DEMAISON, MAURICE. 1902. "Les Montures de Vases." *Art et Décoration* 12, pp. 201–208.

DE MARCEY, R. 1910. "Le Mont des Arts." *Le Siècle Illustrée* (Paris), June 12.

DEMORIANE, HÉLÈNE. 1960. "Le Cas Etrange de Monsieur Gallé." *Connaissance des Arts,* August, pp. 34–41.

DENIS, MAURICE. 1912. *Théories, 1890–1910: Du Symbolisme et de Gauguin vers un nouvel ordre classique.* Paris: Bibliothèque de l'Occident.

———. 1957. *Journal.* Paris: Editions du Vieux Colombier.

DENNIS, RICHARD. 1966. "The Glass of Emile Gallé." In *Antiques International: Collector's Guide to Current Trends,* edited by Peter Wilson. London.

DE ROTONCHAMO, JEAN. 1925. *Paul Gauguin, 1848–1903.* Paris.

DESTRÉE, JULES, AND VANDERVELDE, EMILE. 1898. *Le Socialisme en Belgique.* Paris: Girard. ·

DESTRÉE, JULES. 1913. *Semailles.* Brussels: Henri Lamertin.

DETOUCHE, HENRY. 1900. "Les Bronzes d'art à l'exposition universelle de 1900." *L'Art Décoratif* 6, pp. 189–97.

Deutsche Goldschmiedezeitung (Leipzig), April 1902.

Deutsche Kunst und Dekoration. 1898–1904.

DEVINOY, PIERRE, AND JARRY, MADELEINE. 1948. *Le Siège en France du Moyen-Age à nos jours.* Paris: P. Hartmann.

DE WOUTERS DE BOUCHOUT. 1903. *L'Art Nouveau et l'Enseignement.* Malines.

The Dial. 1889–97.

Dictionnaire de l'architecture moderne. 1964. Paris: Fernand Hazan.

DIDRON AND CLÉMENDOT. 1880. *Exposition universelle internationale de 1878—Rapport sur les Cristaux, la Verrerie, et les Vitraux.* Paris: Imprimerie Nationale.

DIGAETANO, YOLAND CIFARELLI. 1971. "Art Nouveau." *The Museum* 23 (Newark, N.J.), pp. 1–35.

DOAT, TAXILE. 1906. "Les Céramiques de Grand Feu: La Porcelaine dure et le Grès-Cérame." *Art et Décoration* 20, pp. 87–104, 153–63. Ibid., 21 (1907), pp. 68–80.

DORIVAL, BERNARD. 1954a. *Carnet de Tahiti.* Paris: Quatre Chemins-Editart.

———. 1954b. "Nouvelles Acquisitions au Musée National d'Art Moderne." *Revue des Arts,* September.

DREXLER, ARTHUR, AND DANIEL, GRETA. 1959. *Introduction to Twentieth Century Design from the Collection of The Museum of Modern Art.* New York: The Museum of Modern Art.

DUBOUCHÉ, ADRIEN. 1876. "La Céramique Contemporaine à l'Exposition de l'Union Centrale des Beaux-Arts." *L'Art,* October 15, pp. 52–57.

DUFRÊNE, MAURICE. 1921. "Notre Enquête sur le Mobilier Moderne." *Art et Décoration* 39, pp. 129–43.

DUGDALE, JAMES. 1967. *Edouard Vuillard, 1868–1940.* London: Knowledge.

DURET-ROBERT, FRANÇOIS. 1971a. "Ecole de Nancy III. Verres: Daum." *Encyclopédie Connaissance des Arts,* October.

———. 1971b. "Très diverses sont les techniques utilisées dans les ateliers Daum." Ibid., November.

———. 1972. "Daum de 1914 à nos jours." Ibid.

———. 1973. "François Décorchemont." Ibid., June.

———. 1974. "Verre: Henri Cros." Ibid., December.

———. 1975. "Un Sculpteur de Meubles: Carabin." Ibid., January.

Echo de Paris, December 9, 1893. Supplement.

EIDELBERG, MARTIN P. 1968. "Tiffany Favrile Pottery, a New Study of a Few Known Facts." *Connoisseur,* September, pp. 57–61.

———. 1971. "Edward Colonna's 'Essay on Broom-Corn': A Forgotten Book of Early Art Nouveau." Ibid., February, pp. 123–30.

———. 1972. "Art Pottery." In *The Arts and Crafts Movement in America,* edited by Robert Judson Clark. Princeton, N.J.: Princeton University Press.

———. In press. "The Life and Work of E. Colonna." *Connoisseur.*

ELSEN, ALBERT E. 1960. *Rodin's Gates of Hell.* Minneapolis: University of Minnesota Press.

———. 1963. *Rodin.* New York: The Museum of Modern Art.

EMERY, MARC. 1971. *Un Siècle d'architecture moderne: 1850–1950.* Paris.

Emulation (Brussels), December 1895.

ERNOULD-GANDOUET, MARIELLE. 1970. "La Bague, bijou symbolique et objet d'art." *Jardin des Arts,* no. 182 (January), pp. 41–50.

ERNSTYL, MAUD. 1900. "Les Bijoux d'art à l'Exposition de 1900." *Revue de la Bijouterie,* no. 8, pp. 111–20.

ESCARD, JEAN. 1914. "Les Gemmes gravées." *L'Art Décoratif* 31, pp. 79–88.

ESCHOLIER, RAYMOND. c.1913. *Le Nouveau Paris: La Vie artistique de la Cité moderne.* Paris: Nillson.

ESNAULT, LOUIS. 1898. "L'Exposition Lachenal." *Revue des Arts Décoratifs* 18, pp. 335–38.

EVANS, PAUL. 1974. *Art Pottery of the United States.* New York: Scribner's.

Exposition d'art décoratif moderne. 1894. Paris: Galerie Georges Petit.

Exposition Ecole de Nancy. 1903. Paris: Union Centrale des Arts Décoratifs.

"Exposition Edgard Maxence." *Chronique des arts* (1904), p. 55.

Exposition franco-britannique, catalogue officiel de la section française. 1908. London.

Exposition Internationale des Arts Décoratifs et Industriels Modernes, Paris, 1925: Rapport Général, Section Artistique et Technique.

Exposition Internationale Universelle de Saint-Louis, 1904: Catalogue général officiel de la Section Française. Paris: Vermot.

Exposition Universelle de 1867: Rapports du Jury International, Meubles, Vêtements et Aliments de toute origine distingués par les Qualités Utiles unies au Bon Marché. Paris.

Exposition Universelle Internationale de 1900 à Paris: Actes Organiques. 1896. Paris.

FABRE, ABEL. 1901. "Du Gothique au Moderne." *Le Mois littéraire et pittoresque*, September, pp. 290–302.

FALIZE, LUCIEN. 1889. "Exposition Universelle de 1889. Les Industries d'Art: L'Orfèvrerie." *Gazette des Beaux-Arts*, pt. 2, pp. 197–224.

———. 1894. "Claudius Popelin et la Renaissance des Emaux Peints." Ibid., pt. 1, pp. 130–48.

FAY-HALLÉ, ANTOINETTE. 1975. "Première période, 1800–1847." In *Porcelaines de Sèvres au XIXe siècle.* Paris: Musées Nationaux.

FEARING, KELLY; MARTIN, CLYDE INEZ; AND BEARD, EVELYN. 1969. *The Creative Eye.* Vol. 2. Austin: Benson.

Félix Bracquemond and the Etching Process. 1974. Cleveland: John Carroll University.

FERN, ALAN M. 1959. "Graphic Design." In *Art Nouveau: Art and Design at the Turn of the Century,* edited by Peter Selz and Mildred Constantine. New York: The Museum of Modern Art.

FIÉRENS-GEVAERT, H. 1898. "Fernand Khnopff." *Art et Décoration* 4, pp. 116–24.

FLOUQUET, P.-L. 1950. "Paul Hankar." *La Maison*, June.

FORTHUNY, PASCAL. 1900. "Louis Chalon." *Revue des Arts Décoratifs* 20, pp. 97–112.

———. 1901. "L'Art dans Tout." *Revue des Arts Décoratifs* 21, pp. 97–112.

———. 1919. "L'Art décoratif moderne: une salle à manger du peintre Lévy-Dhurmer." In *La Renaissance de l'art français et des industries de luxe,* edited by Henry Lapauze. Vol. 2, pp. 290–94. Paris.

FOUCART, BRUNO. 1969. "La 'cathédrale synthétique' de Louis-Auguste Boileau." *Revue de l'Art* 3, pp. 49–66.

FOURNIER, G. A. 1903. "The Master Jeweller—René Lalique and His Work." *Magazine of Art*, pp. 25–26.

"François Décorchemont, 1880–1971." *Nouvelles de l'Eure* 42–43, August 1971.

FRANGIAMORE, CATHERINE. 1973. "A Half Century of Decorative Arts." *Smithsonian*, May, pp. 38–41.

FRANTZ, HENRI. 1896. "Industrial Art in the Paris Salons of 1896." *Magazine of Art*, pp. 457–60.

———. 1901. "E. Feuillâtre, Emailleur." *L'Art Décoratif* 3, pp. 164–70.

FREDEMAN, WILLIAM E. 1965. *Pre-Raphaelitism: A Bibliocritical Study.* Cambridge, Mass.: Harvard University Press.

FRYBERGER, BETSY G. 1975. *Morris & Co.* Stanford, Calif.: Department of Art, Stanford University.

GAILLARD, EUGÈNE. 1906. *A propos du Mobilier.* Paris.

GALLÉ, EMILE. 1900a. "Le Pavillon de l'Union Centrale des Arts Décoratifs à l'Exposition Universelle." *Revue des Arts Décoratifs* 20, pp. 217–24.

———. 1900b. "Le Mobilier Contemporain Orné d'après la Nature." *Revue des Arts Décoratifs* 20, pp. 333–41.

———. 1908. *Ecrits pour l'Art.* Paris: Henri Laurens, Librairie Renouard; Nancy: Berger et Levrault.

GARNIER, EDOUARD. 1891. "Biographie: Théodore Deck." *Revue Encyclopédie*, pp. 463–64.

GARVEY, ELEANOR M. 1958. "Art Nouveau and the French Book of the Eighteen-Nineties." *Harvard Library Bulletin* 12, pp. 375–91.

———; SMITH, ANNE BLAKE; AND WICK, PETER A. 1970. *The Turn of a Century, 1885–1910: Art Nouveau—Jugendstil Books.* Cambridge, Mass.: The Houghton Library, Harvard University.

GAUGUIN, PAUL. 1946. *Lettres à sa femme et à ses amis.* Edited by Maurice Malingue. Paris: Bernard Grasset.

———. 1950. *Lettres à Daniel de Monfreid.* Paris.

Gazette des Beaux-Arts. 1889–1908.

GEFFROY, GUSTAVE. 1890. "A propos d'une bibliothèque du sculpteur Carabin." *Revue des Arts Décoratifs* 11, pp. 42–49.

———. 1895. *La Vie artistique.* Vol. 4. Paris: E. Dentu.

———. 1897. Ibid. Vol. 5. Paris: H. Floury.

———. 1901. *Les Industries artistiques françaises et étrangères à l'Exposition universelle de 1900.* Paris: Les Beaux-Arts.

———. 1903. *La Vie Artistique.* Vol. 8. Paris: H. Floury.

———. 1905. "Des Bijoux. A propos de M. René Lalique." *Art et Décoration* 18, pp. 176–88.

GELBERT, A. 1910. "Le Salon des Artistes Décorateurs au Pavillon de Marsan." *La Construction Moderne*, April 9, p. 333.

GENSEL, WALTER. 1901. "Tiffany-Gläser auf der Pariser Welt-Ausstellung." *Deutsche Kunst und Dekoration* 7, pp. 90–96.

GENUYS, CHARLES. 1904. "L'Exposition de la Société des artistes décorateurs." *Art et Décoration* 15, pp. 82–91.

La Gerbe. July 1899.

GERDAIL, O. 1901. "L'Intérieur et le Meuble." *L'Art Décoratif* 3, pp. 158–62.

GERE, CHARLOTTE. 1975. *American & European Jewelry, 1830–1914.* New York: Crown.

GERMAIN, ALPHONSE. 1901. "Les Bijoux de Vever." *L'Art Décoratif* 3, pp. 137–46.

GERSPACH. 1882. "Les Maîtres de l'Industrie Française au XIXe siècle, Théodore Deck." *Revue des Arts Décoratifs* 3, pp. 282–98.

———. 1890. "Théodore Deck et son Influence sur la céramique moderne." Ibid., 11, pp. 353–58.

GIBBS-SMITH, C.H. 1964. *The Great Exhibition of 1851.* London: Victoria & Albert Museum.

GIRODIE, ANDRÉ. 1903. "Biographies Alsaciennes XIII: Théodore Deck." *Revue Alsacienne Illustrée*, pp. 45–60.

GRAHAM, F. LANIER. 1970. *Hector Guimard.* New York: The Museum of Modern Art.

GRAPPE, GEORGES. 1927. *Catalogue du Musée Rodin*. Paris.

GRASSET, EUGÈNE. 1909. "Formes et Décoration des Vases." *Art et Décoration* 25, pp. 131–40.

GRAVES, JOHN W. 1967. "Schneider Art Glass." *Spinning Wheel* 23, pp. 10–11.

GRAY, CHRISTOPHER. 1963. *Sculpture and Ceramics of Paul Gauguin*. Baltimore: Johns Hopkins Press.

GROS, GABRIELLA. 1955. "Poetry in Glass: The Art of Emile Gallé, 1846–1905." *Apollo*, November, pp. 134–36.

Le Groupe des XX et son temps. 1962. Brussels: Musées Royaux des Beaux-Arts; Otterlo: Rijksmuseum Kröller-Müller.

GROVER, RAY, AND GROVER, LEE. 1967. *Art Glass Nouveau*. Rutland, Vt.: Charles E. Tuttle.

———. 1970. *Carved and Decorated European Art Glass*. Rutland, Vt.: Charles E. Tuttle.

GUERRAND, ROGER H. 1965. *Art Nouveau en Europe*. Paris: Plon.

Guide illustré du Musée des Arts Décoratifs. 1923. Paris.

GUILLEMOT, MAURICE. 1910. "La Verrerie au Musée Galliera." *Art et Décoration* 28, pp. 23–24.

GUIMARD, HECTOR. 1907. *Catalogue des Fontes Artistiques, Style Guimard*. Fonderies de St. Dizier.

GYSLING-BILLETER, ERIKA. 1975. *Objekte des Jugendstils*. Bern: Benteli; Zürich: Museum Bellerive.

HAKENJOS, BERND. 1969. "Arbeiten von Emile Gallé im Kunstgewerbemuseum Köln." *Wallraf-Richartz-Jahrbuch* 31, pp. 259–70.

———. 1973. "Emile Gallé: Keramik, Glas, und Möbel des Art Nouveau." Ph.D. dissertation, University of Cologne.

———. 1974. *Europäische Keramik des Jugendstils, Art Nouveau Modern Style*. Düsseldorf: Hetjens-Museum.

———. 1976. *Glas vom Art Nouveau bis zur Gegenwart, Sammlung Gertrud und Dr. Karl Funke-Kaiser*. Cologne, forthcoming.

HAMEL, M. 1898. "Les Salons de 1898." *Le Revue de Paris*, June 15.

HAMMACHER, A. M. 1967. *Le Monde de Henry van de Velde*. Antwerp: Fonds Mercator; Paris: Hachette.

HAMMER, K. 1968. *Hittorf, ein Pariser Baumeister*. Stuttgart.

HANNOVER, EMILE. 1889. "Emile Gallé." *Tidsskrift för Kunstindustri*, pp. 192–97.

HAUSSMANN, GEORGES-EUGÈNE. 1890–93. *Mémoires*. Paris.

HAUTECOEUR, LOUIS. 1957. *Histoire de l'architecture classique en France*. Vol. 7, *La Fin de l'architecture classique, 1848–1900*. Paris: A. Picard.

HAVARD, HENRI. 1894. *La Verrerie*. Paris.

HÉNARD, EUGÈNE. 1903–1909. *Etudes sur les transformations de Paris*. Paris.

———. 1909. *Les Espaces libres de Paris*. Paris.

———. 1910. *Rapport sur l'avenir des grandes villes*. London.

HENDERSON, PHILIP. 1967. *William Morris—His Life, Work, and Friends*. New York: McGraw-Hill.

HENRI, MARCEL, AND MAGNE, LUCIEN. 1922. *Le Décor du métal*. Paris: H. Laurens.

HENRIVAUX, JULES. 1889. "La Verrerie à l'Exposition Universelle de 1889." *Revue des Arts Décoratifs* 10, pp. 169–85.

———. 1897. *Le Verre et le cristal*. 2nd ed. Paris.

———. 1903. *La Verrerie au XXe siècle*. Paris.

———. 1905. "Emile Gallé." *L'Art Décoratif* 7, pp. 124–35.

———. 1911. *La Verrerie au XXe siècle*. 2nd ed. Paris.

HENZKE, LUCILE. 1970. *American Art Pottery*. Camden, N.J.: Thomas Nelson.

HEUSER, MARIA, AND HEUSER, HANS-JÖRGEN. 1974. *Französische Keramik zwischen 1850 und 1910*. Munich: Prestel-Verlag.

HILLIER, J. 1955. *Hokusai: Paintings, Drawings, and Woodcuts*. London: Phaidon.

HILSCHENZ, HELGA. 1973. *Glassammlung Hentrich: Jugendstil und 20er Jahre*. Düsseldorf: Kunstmuseum.

HITCHCOCK, HENRY-RUSSEL. 1958. *Architecture: Nineteenth and Twentieth Centuries*. Baltimore: Penguin.

HOFSTÄTTER, HANS H. 1963. *Geschichte der europäischen Jugendstilmalerei*. Cologne: M. DuMont Schauberg.

———. 1968. *Jugendstil Druckkunst*. Baden-Baden.

HOLMES, C. J. 1936. *Self & Partners (Mostly Self)*. London.

HORTA, VICTOR. Unpublished memoirs. Brussels: Musée Horta.

HOWARTH, THOMAS. 1952. *Charles Rennie Mackintosh and the Modern Movement*. London: Routledge Kegan Paul.

HUGHES, GRAHAM. 1964. *Modern Jewelry*. London: Studio Vista.

HUMBERT, AGNÈS. 1954. *Les Nabis et leur époque, 1888–1900*. Geneva: Pierre Cailler.

HÜTER, K. H. 1967. *Henry van de Velde*. East Berlin: Akademie.

HUYGHE, RENÉ, AND RUDEL, JEAN. 1969. *L'Art et le monde moderne*. Vol. 1, *1880–1920*. Paris: Larousse.

HUYSMANS, JORIS-KARL. 1898. *La Cathédrale*. Paris.

International Studio. 1897–1914.

IVES, COLTA FELLER. 1974. *The Great Wave: The Influence of Japanese Woodcuts on French Prints*. New York: The Metropolitan Museum of Art.

JACQUES, G. M. 1900. "Exposition Universelle, L'Art Nouveau Bing." *L'Art Décoratif* 21, pp. 88–97.

JANNEAU, GUILLAUME. 1923. *Emile Decoeur*. Paris.

JANSON, DORA JANE. 1971. *From Slave to Siren: The Victorian Woman and Her Jewelry, from Neoclassic to Art Nouveau*. Durham, N.C.: The Duke University Museum of Art.

Le Japon Artistique. 1888–91.

JOBARD. 1848. "Une Architecture Nouvelle." *Journal de l'Architecture*, April.

JOURDAIN, FRANTZ. 1899. "En vue de l'Exposition de 1900: Le Deuxième Concours ouvert par l'Union Centrale des Arts Décoratifs." *Revue des Arts Décoratifs* 19, pp. 114–21.

JOUVANCE, L. 1901. "Les Bijoux de l'Art Nouveau Bing." *Revue de la Bijouterie*, no. 11, pp. 211–17.

JULLIAN, PHILIPPE. 1969. *Oscar Wilde*. Translated by Violet Wyndham. London: Constable.

———. 1971a. "Autour de trois peintres symbolistes, d'étranges

beautés." *Plaisir de France,* January.

―――. 1971b. *Dreamers of Decadence: Symbolist Painters of the 1890's.* New York, Washington, and London: Praeger.

―――. 1973. *The Symbolists.* London: Phaidon.

KAHN, GUSTAVE. 1900. "L'Art à l'Exposition. La Décennale." *La Plume,* November 1.

―――. 1902. "Les Objets d'art aux Salons." *Art et Décoration* 12, pp. 24–32.

KARAGEORGEVITCH, B. 1903. "Les objets d'art au Salon des Artistes Français." *L'Art Décoratif* 4, pp. 219–24.

KAUFMANN, EMIL. 1933. *Von Ledoux bis Le Corbusier.* Vienna.

―――. 1955. *The Architecture of the Age of Reason.* Cambridge, Mass.: Harvard.

KEYNES, GEOFFREY. 1964. *William Blake: Poet, Printer, Prophet.* New York: Orion.

KOCH, ROBERT. 1959. "Art Nouveau Bing." *Gazette des Beaux-Arts,* March, pp. 179–90.

―――. 1964. *Louis C. Tiffany, Rebel in Glass.* New York: Crown.

―――. 1970. Introduction to *Artistic America, Tiffany Glass, and Art Nouveau,* by Samuel Bing. Cambridge, Mass.: MIT Press.

―――. 1971. *Louis C. Tiffany's Glass, Bronzes, Lamps: A Complete Collector's Guide.* New York: Crown.

KOHLHAUSSEN, H. 1955. *Geschichte des deutschen Kunsthandwerks.* Munich.

KOVEL, RALPH M., AND KOVEL, TERRY H. 1974. *The Kovels' Collector's Guide to American Art Pottery.* New York: Crown.

LACAMBRE, GENEVIÈVE. 1972. *French Symbolist Painters.* London: Arts Council of Great Britain.

LACAMBRE, JEAN. 1972. "Nouvelles Acquisitions des musées de province: Peintures et dessins du XIXème siècle." *Revue du Louvre* 6, pp. 473–80.

LAHOR, JEAN. c.1902. *L'Art pour le peuple à défaut de l'art par le peuple.* Paris: Larousse.

LAMI, STANISLAS. 1919. *Dictionnaire des sculpteurs de l'école française au 19e siècle.* Paris.

LÁZÁR, BELA. 1907. "Gauguin." *L'Art Moderne,* pp. 385–87.

LECLÈRE, TRISTAN. 1907. "Abel Landry, architecte et décorateur." *L'Art Décoratif* 9, pp. 49–60.

LE CORBUSIER. 1925. *L'Art décoratif d'aujourd'hui.* Paris: Grès.

―――. 1929. Introduction to *Le Corbusier et Pierre Jeanneret, Oeuvre complète, 1910–1929.* Zürich: Girsberger.

LEGRAND, FRANCINE-CLAIRE. 1971. *Le Symbolisme en Belgique.* Brussels: Laconti. English translation by Alistair Kennedy, *Symbolism in Belgium.* Brussels: Laconti, 1972.

―――. 1972. "Avant-dire: La Marée symboliste." In *Peintres de l'imaginaire: Symbolistes et surréalistes belges.* Paris: Galeries Nationales du Grand Palais.

LE GRANDE, LÉON. 1901. "Le Home Hankar." *La Ligue Artistique* (Brussels), October.

LENNING, H.F. 1951. *The Art Nouveau.* The Hague.

LEROY, MAXIME. 1903. "L'Ecole de Nancy au Pavillon de Marsan." *L'Art Décoratif* 5, pp. 176–82.

LESBRUÈRE, M. 1963. "Maisons 1900 de Paris." *Bizarre,* no. 123, special number.

LESUR, ADRIEN. 1957. *Poteries et faïences françaises.* Paris: Editions Tardy.

LA LIBRE ESTHÉTIQUE. Catalogues of the salons, 1894–1914.

LINK, EVA M. 1973. *The Book of Silver.* Translated by Francisca Garvie. New York: Praeger.

LOEBNITZ, M.J. 1891. "Group III, Classe 20, Céramique: Rapport du Jury International." In *Exposition Universelle Internationale de 1889 à Paris: Rapports du Jury International,* edited by Alfred Picard. Paris: Imprimerie Nationale.

LOOS, ADOLF. 1908. *Ornement et crime.*

La Lorraine. 1900.

LOYER, FRANÇOIS. 1971. "L'Espace d'Horta." *L'Oeil,* no. 194 (February), pp. 14–19.

LUCIE-SMITH, EDWARD. 1972. *Symbolist Art.* New York: Praeger.

MACLEOD, ROBERT. 1968. *Charles Rennie Mackintosh.* London.

MADSEN, STEPHAN TSCHUDI. 1956. *Sources of Art Nouveau.* New York: George Wittenborn.

―――. 1967. *L'Art Nouveau.* Paris: Hachette.

Magazine of Art. 1878–1904.

MAINDRON, ERNEST. 1896. *Les Affiches illustrées.* Paris: G. Boudet.

MANNONI, EDITH. 1968. *Meubles et Ensembles Style 1900.* Paris: C. Massin.

MARX, ROGER. 1890. *La Revue Encyclopédique,* September 15.

―――. 1896–1900. *Les Maîtres de l'Affiche.* Paris.

―――. 1899. "René Lalique." *Art et Décoration* 6, pp. 13–22.

―――. 1901. "La Décoration et les Industries d'Art." *Gazette des Beaux-Arts,* pt. 1, pp. 53–83.

―――. 1906. "Auguste Delaherche." *Art et Décoration* 19, pp. 52–63.

―――. 1911. "Emile Gallé." *Art et Décoration* 30, pp. 233–52.

MASON, STUART. 1914. *Bibliography of Oscar Wilde, with a Note by Robert Ross.* London.

MAUS, MADELEINE-OCTAVE. 1926. *Trente années de lutte pour l'art.* Brussels: L'Oiseau Bleu.

MAUS, OCTAVE. 1897. "La Sculpture en Ivoire à l'Exposition de Bruxelles." *Art et Décoration* 2, pp. 129–33.

―――. 1898. "Charles van der Stappen." *Art et Décoration* 4, pp. 51–59.

―――. 1900a. "Le Salon de la Libre Esthétique." *Revue des Arts Décoratifs* 20, pp. 173–76.

―――. 1900b. "Privat Livemont." *Art et Décoration* 7, pp. 55–61.

MAYOR, J. 1918. "Eugène Grasset (1845–1917)." *Gazette des Beaux-Arts,* July-September, pp. 257–72.

MEIER-GRAEFE, JULIUS. 1898. "Henry van de Velde." *L'Art Décoratif* 1, pp. 2–8.

MELLERIO, ANDRÉ. 1968. *Odilon Redon.* 1913. New York: Da Capo Press.

MEURRENS, H. 1972. *Philippe Wolfers (1858–1929), Précurseur de*

l'Art Nouveau statuaire. Brussels: L'Ecuyer.

MEUSNIER, GEORGES. 1901. *La Joaillerie française 1900.* Paris: Henri Laurens.

MICHEL, A. 1929. *Histoire Générale de l'Art.* Paris: Librairie Armand Colin.

MIOTTO-MURET, LUCIANA, AND PALLUCHINI-PELZEL, VITTORIA. 1969. "Une Maison de Guimard." *Revue de l'Art,* March.

MOLINIER, EMILE. 1897. "Notes sur l'étain." *Art et Décoration* 2, pp. 81–88, 97–104.

———. 1901. "Les Objets d'Art aux Salons." *Art et Décoration* 9, pp. 185–92.

MONTAGU, JENNIFER. 1963. *Les Bronzes.* Paris: Hachette.

MOORE, T. STURGE. 1933. Introduction to *Charles Ricketts R.A.: Sixty-five Illustrations.* London.

MOUREY, GABRIEL. 1900. "L'Art Nouveau de M. Bing à l'Exposition Universelle." *Revue des Arts Décoratifs* 20, pp. 257–68.

———. 1907. "Alexandre Charpentier." *L'Art et les Artistes* 6, pp. 336–44.

———, ET AL. 1973. *Art Nouveau Jewelry and Fans.* New York: Dover.

MUCHA, JIRI. 1966. *Alphonse Mucha: His Life and Art.* London: Heinemann.

———; HENDERSON, MARINA; AND SCHARF, AARON. 1971. *Alphonse Mucha: Posters and Photographs.* London: Academy.

———. 1973. *The Graphic Work of Alphonse Mucha.* London: Academy; New York: St. Martin's.

NEVEUX, PAUL. 1900. "René Lalique." *Art et Décoration* 8, pp. 129–36.

NICOLAS, EMILE. 1900. "Emile Gallé à l'Exposition." *La Lorraine,* pp. 98–99, 113–15, 163–69.

NOCQ, HENRY. 1895. "L'Exposition de la 'Libre Esthétique.'" *Revue des Arts Décoratifs* 16, pp. 141–48.

NOVOTNY, FRITZ. 1969. *Toulouse-Lautrec.* Translated by Michael Glenney. New York: Phaidon.

OCULI. 1901. "L'Orfèvrerie Etrangère à l'Exposition de 1900: Belgique." *Revue de la Bijouterie,* no. 10, pp. 195–99.

Oeuvres de Georges de Feure. c.1903. Paris: L'Art Nouveau.

O'GORMAN, JAMES. 1973. *The Architecture of Frank Furness.* Philadelphia: Philadelphia Museum of Art.

OLMER, PIERRE. 1927. *La Renaissance du mobilier français (1890–1910).* Paris and Brussels: Vanoest.

O'NEAL, WILLIAM B. 1960. "Three Art Nouveau Glass Makers." *Journal of Glass Studies* 2, pp. 124–37.

OOSTENS-WITTAMER, YOLANDE. 1965. *Le Bijou 1900.* Brussels: Ministère de l'Education Nationale et de la Culture.

———. 1973. *Art Nouveau: Affiches Belges, Projets et dessins, 1892–1914.* Warsaw: Muzeum Plakatu.

———. 1975. *L'Affiche Belge, 1892–1914.* Brussels: Bibliothèque Royale Albert Ier.

OSBORN, MAX. 1900a. "S. Bing's 'Art Nouveau' auf der Welt-Ausstellung." *Deutsche Kunst und Dekoration* 6, pp. 550–90.

———. 1900b. "Henry van de Velde." *Innen Dekoration* 11.

———. 1901. "La Maison Moderne in Paris." *Deutsche Kunst und Dekoration* 7, pp. 99–103.

OSTHAUS, KARL ERNST. 1920. *Van de Velde: Leben und Schaffen des Künstlers.* Hagen.

OUDIN, BERNARD. 1970. *Dictionnaire des Architectes.* Paris: Seghers.

PALADILHE, JEAN. n.d. *Catalogue des Oeuvres de Gustave Moreau, Musée Gustave Moreau.*

PAZAUREK, GUSTAVE E. [1901]. *Moderne Gläser.* Leipzig: Seemann.

PELADAN, JOSÉPHIN. 1891. *Salon de la Rose+Croix, Règle et Monitoire.* Paris: Dentu.

PENNELL, JOSEPH. 1893. "A New Illustrator: Aubrey Beardsley." *Studio* 1, pp. 14–19.

Le Petit Bleu (Brussels), January 19, 1901.

PEVSNER, NIKOLAUS. 1936. *Pioneers of the Modern Movement from William Morris to Walter Gropius.* London: Faber & Faber.

———. 1950. *Charles Rennie Mackintosh.* Milan.

———. 1960. *Pioneers of Modern Design.* London: Penguin.

———. 1968. *The Sources of Modern Architecture and Design.* London: Thames and Hudson.

———. 1969. *Ruskin and Viollet-le-Duc: Englishness and Frenchness in the Appreciation of Gothic Architecture.* London: Thames and Hudson.

PHILIPPE, JOSEPH. 1974. *Le Val-Saint-Lambert: Ses Cristalleries et l'art du verre en Belgique.* Liège: Librairie Halbart.

PICARD, ALFRED. 1891. *Rapport du Jury International, Exposition Universelle Internationale de 1889: Groupe III, Mobilier et accessoires.* Paris: Imprimerie Nationale.

PIERRON, SANDER. 1900. "Philippe Wolfers." *Revue des Arts Décoratifs* 20, pp. 153–60, 225–32.

PINCUS-WITTEN, ROBERT. 1968. *Les Salons de la Rose+Croix, 1892–1897.* London: Piccadilly Gallery.

POËTE, MARCEL. 1924–31. *Une Vie de cité, Paris de sa naissance à nos jours.* Paris.

———. 1929. *Introduction à l'urbanisme.* Paris.

POLAK, ADA. 1956. *Fire Pionerer I Nyere Fransk Glasskunst.* Arbok: Saertrykk Av. Nordenfjeldske Kunstindustrimuseum.

———. 1962. *Modern Glass.* London: Faber & Faber.

———. 1963. "Gallé Glass: Luxurious, Cheap, and Imitated." *Journal of Glass Studies* 5, pp. 105–15.

———. 1966. "Signatures on Gallé Glass." *Journal of Glass Studies* 8, pp. 120–23.

POPPENBERG, F. 1903. "René Lalique Magien." *Vossische Zeitung,* October 22.

PORTOGHESI, PAOLO. 1972. "Art Nouveau in Italy." In *Italy: The New Domestic Landscape,* edited by Emilio Ambasz. New York: The Museum of Modern Art, in collaboration with Centro Di, Florence.

PUAUX, RENÉ. 1903a. "Georges de Feure." *Deutsche Kunst und Dekoration* 12, pp. 313–48.

———. 1903b. "La Maison moderne in Paris." *Deutsche Kunst und Dekoration* 12, pp. 551–54.

———. 1903c. "L'Art Nouveau Bing." Introduction to *Oeuvres de Georges de Feure.* Paris: L'Art Nouveau.

PUTTEMANS, PIERRE. 1968. "L'Héritage de Victor Horta." *Bulletin de la classe des Beaux-Arts, Académie royale de Belgique,* pp. 271–82.

RABREAU, DANIEL. 1975. "'Ce cher XIXe' ou Palladio et l'éclectisme parisien." *Revue des Monuments Historiques* 2, pp. 56–65.

RANDALL, RICHARD H., JR. 1966. "Walters Art Gallery: Jewellery through the Ages." *Apollo,* December, pp. 495–99.

Rapport sur l'Exposition Universelle de 1867 à Paris. Vol. 2, *Appendice sur l'avenir des Expositions.* 1869. Paris.

READE, BRIAN, AND DICKINSON, FRANK. 1966. *Aubrey Beardsley.* London: Victoria and Albert Museum.

READE, BRIAN. 1967. *Aubrey Beardsley.* New York: Viking.

Revolt of the Pre-Raphaelites. 1972. Miami: University of Miami, Lowe Art Museum.

Revue de la Bijouterie, Joaillerie, Orfèvrerie. 1900–1904.

Revue de l'Art Ancien et Moderne.

Revue des Arts Décoratifs. 1880–1901.

REWALD, JOHN. 1948. *Pierre Bonnard.* New York: The Museum of Modern Art.

———. 1961. "Odilon Redon." In *Odilon Redon, Gustave Moreau, Rodolphe Bresdin.* New York: The Museum of Modern Art.

———. 1962. *Post-Impressionism from Van Gogh to Gauguin.* New York: The Museum of Modern Art.

RHEIMS, MAURICE. 1964. *L'Objet 1900.* Paris: Arts et Métiers Graphiques.

———. 1965. *L'Art 1900 ou le style Jules Verne.* Paris: Arts et Métiers Graphiques.

———. 1966. *The Flowering of Art Nouveau.* New York: Harry N. Abrams.

RICKERT, RAINER. 1960. *Jahrbuch der Hamburger Kunstsammlungen.* Vol. 5.

RICKETTS, CHARLES. 1899. *A Defence of the Revival of Printing.* London.

RIOTOR, LÉON. 1900. "Les Bijoutiers Modernes à l'Exposition: Lalique, Colonna, Marcel Bing." *L'Art Décoratif* 2, pp. 173–79.

———. 1903. "Bijoutiers Modernes." *Les Arts et les Lettres.*

———. 1908. "Un Statuaire, J. Bernard." *L'Art Décoratif* 18, pp. 190–92.

RITCHIE, ANDREW CARNDUFF. 1954. *Edouard Vuillard.* New York: The Museum of Modern Art.

ROBINSON, CERVIN, AND BLETER, ROSEMARIE HAAG. 1975. *Skyscraper Style.* New York: Oxford University Press.

ROD, EDOUARD. 1891. "Les Salons de 1891." *Gazette des Beaux-Arts,* pt. 1, pp. 441–69.

ROOSENBOOM, ALBERT. 1910. "Par Horreur du Modern-Style." *Le Home* 3–4.

ROSENTHAL, LÉON. 1927. *La Verrerie française depuis cinquante ans.* Paris: G. Vanoest.

ROSS, ROBERT. 1909. *Aubrey Beardsley.* London and New York: John Lane.

———. 1912. "A Note on *Salome.*" In *Salome,* by Oscar Wilde. London and New York: John Lane.

RÜCKLIN, RAINER. 1901. *Das Schmuckbuch.* Vol. 2. Leipzig.

RUSSELL, JOHN. 1971. *Vuillard.* Greenwich, Conn.: New York Graphic Society.

RUSSOLI, FRANCO. 1966. *E. Vuillard.* Milan: Fratelli Fabbri.

RUTGERS, THE STATE UNIVERSITY. 1966. *The Fine Arts Collection: A Selection.* New Brunswick, N.J.

The Sacred and Profane in Symbolist Art. 1969. Toronto: Art Gallery of Ontario.

SAINTENOY, PAUL. 1950. *Notice sur Jules Brunfaut.* Brussels.

SALMON, MARIE-JOSÉ. 1973. *Auguste Delaherche.* Beauvais: Musée Départemental de l'Oise.

SANDIER, ALEXANDRE. 1901. "La Céramique à l'Exposition." *Art et Décoration* 9, pp. 53–68.

SAUNIER, CHARLES. 1894. "Les Artistes Décorateurs: Alexandre Charpentier." *Revue des Arts Décoratifs* 15, pp. 549–57.

———. 1900a. "Rupert Carabin." *Revue d'Art,* January 23, pp. 161–68.

———. 1900b. "La Manufacture Nationale de Sèvres à l'Exposition Universelle." *L'Art Décoratif* 3, pp. 8–16.

———. 1901a. "Pierre Roche." *L'Art Décoratif* 31, pp. 1–7.

———. 1901b. "Poteries de la Cie. Grueby (Boston)." *L'Art Décoratif* 35, pp. 205–208.

———. 1902. *Les Industries d'art à l'Exposition universelle de 1900.* Paris: Bureaux de la Revue des Arts Décoratifs.

SCHEFFLER, WOLFGANG. 1966. *Werke um 1900: Kataloge des Kunstgewerbemuseums Berlin.* Vol. 2. Berlin: Kunstgewerbemuseum.

SCHMECK, ADOLF. 1962. *Neue Möbel von Jugendstil bis heute.* Munich: F. Bruckmann.

SCHMUTZLER, ROBERT. 1955. "The English Origins of Art Nouveau." *Architectural Review,* February, pp. 108–17.

———. 1964. *Art Nouveau.* New York: Harry N. Abrams.

SCHURR. 1971. "A la rencontre des petits Maîtres: Les Symbolistes." *L'Estampille,* March.

SCHWEICHER, CURT. 1955. *Edouard Vuillard.* Bern: A. Scherz.

SEDEYN, EMILE. 1901. "Les Nouveaux Bijoux de Georges Fouquet." *L'Art Décoratif* 4, pp. 8–12.

———. 1903. "Intérieurs." *L'Art Décoratif* 5, pp. 13–20.

———. 1921. *Le Mobilier.* Paris: Rieder.

SEGARD, A. 1914. "The Recent Work of Aman-Jean." *Studio,* March.

SELING, HELMUT, ed. 1959. *Jugendstil: Der Weg ins 20 Jahrhundert.* Heidelberg: Keyser.

SELZ, PETER, AND CONSTANTINE, MILDRED, eds. 1959. *Art Nouveau: Art and Design at the Turn of the Century.* New York: The Museum of Modern Art.

SERRURIER-BOVY, GUSTAVE. 1902. "A Darmstadt." *L'Art Moderne* 10, pp. 35–36.

SHARP, DENNIS, AND CULOT, MAURICE. 1974. *Henri van de Velde: Theater Designs, 1904–1914.* London: The Architectural Associ-

ation.

SITTE, CAMILLO. 1889. *Der Stadtbau nach seinen Künstlerischen Grundsätzen*. Vienna. French translation, *L'Art de bâtir les villes*. Paris: H. Laurens, 1918.

SOBY, JAMES THRALL; ELLIOTT, JAMES; AND WHEELER, MONROE. 1964. *Bonnard and His Environment*. New York: The Museum of Modern Art, with the Los Angeles County Museum of Art and The Art Institute of Chicago.

SOCIÉTÉ DES ARTISTES FRANÇAIS. Catalogues of the salons, 1893–1902. Paris.

SOCIÉTÉ NATIONALE DES BEAUX-ARTS. Catalogues of the salons, 1891–1914. Paris: Evreaux.

SOULIER, GUSTAVE. 1897. "L'Art Moderne: Conférence de M. Grasset." *Art et Décoration* 1, pp. 87–92.

———. 1898. "Lévy-Dhurmer." *Art et Décoration* 3, pp. 1–12.

———. 1899. "Carlos Schwabe." *Art et Décoration* 5, pp. 129–46.

———, AND SOULIER, P. N. 1899. *Etudes sur le Castel Béranger, oeuvre de Hector Guimard*. Paris: Rouam.

———. 1900a. "L'Ameublement à l'Exposition." *Art et Décoration* 8, pp. 33–45.

———. 1900b. "La Plante et ses applications ornementales." *Revue des Arts Décoratifs* 20, pp. 93–96.

———. 1900c. "L'Art dans l'habitation." *Art et Décoration* 7, pp. 105–17.

SPENCER, ROBIN. 1972. *The Aesthetic Movement: Theory and Practice*. London: Studio Vista, Dutton Pictureback.

STALEY, ALLEN; REFF, THEODORE; ET AL. 1971. *From Realism to Symbolism: Whistler and His World*. New York: Columbia University, Department of Art History and Archaeology.

STEINGRÄBER, ERICH. 1956. *Alter Schmuck*. Munich: Hermann Rinn.

STERNER, GABRIELE. 1975. *Jugendstil: Kunstformen zwischen Individualismus und Massengesellschaft*. Cologne: M. DuMont Schauberg.

STRAUVEN, FRANCIS. 1973. "La Signification de Victor Horta pour l'Architecture Contemporaine." In *Victor Horta*. Saint-Gilles: Musée Horta.

The Studio. 1893–1913.

SUTTON, DENYS. 1956. "Notes on Paul Gauguin apropos a recent exhibition." *Burlington Magazine*, March, pp. 84–90.

———. 1963. *Nocturne: The Art of James McNeill Whistler*. London: Country Life.

SYLVESTRE. 1901. "Les Bois sculptés de M. Becker." *Revue de la Bijouterie*, no. 11, pp. 228–35.

SYMONS, A. J. A. 1930. "An Unacknowledged Movement in Fine Printing, the Typography of the Eighteen-Nineties." *Fleuron* 7, pp. 83–119.

TAEVERNIER, AUG. 1973. *James Ensor*. Ghent: N. V. Erasmus Ledeberg.

TARRAGO CID, SALVADOR, AND BRUNHAMMER, YVONNE. 1971. *Pionniers du XXe siècle: Gaudí*. Paris: Musée des Arts Décoratifs.

TAYLOR, JOHN RUSSEL. 1967. *The Art Nouveau Book in Britain*. Cambridge, Mass.: MIT Press.

TERRASSE, ANTOINE. n.d. *Denis: Intimités*. Paris: Bibliothèque des Arts.

TESTORAL, MAURICE. 1908. "Henri Cros." *L'Art Décoratif* 18, pp. 149–55.

THIEME, ULRICH, AND BECKER, FELIX. 1907–47. *Allgemeines Lexikon der Bildenden Künstler*. Leipzig: E. A. Seemann.

THOMAS, ALBERT. 1901. "Petits Bronzes d'art." *L'Art Décoratif* 7, pp. 181–89.

TOWNDROW, KENNETH ROMNEY. 1952. "French Painters: Bonnard." *Apollo*, March, pp. 79–83.

UZANNE, OCTAVE. 1894. "Eugène Grasset and Decorative Art in France." *Studio* 4, pp. 37–47.

———. 1898. *L'Art dans la Décoration Extérieure des Livres en France et à l'Etranger*. Paris: Société Française d'Editions d'Art, L. Henry May.

———. 1899. "Couvertures Illustrées de Publications Etrangères." *Art et Décoration* 5, pp. 33–42.

———. 1901. "Georges de Feure." *Art et Décoration* 9, pp. 77–88.

VAILLAT, LÉANDRE. 1908. "La Pâte de verre: Henri Cros." *L'Art et les Artistes* 7, pp. 26–29.

VAIZEY, MARINA. 1971. "The Robert Walker Collection, Part 1." *Connoisseur*, September, pp. 16–26.

VALLOTTON, MAXIME, AND GOERG, CHARLES. 1972. *Félix Vallotton: Catalogue Raisonné of the Printed Graphic Work*. Geneva: Editions de Bonvent.

VALOTAIRE, MARCEL. 1930. *La Céramique Française*. Paris.

VANDERVELDE, EMILE. 1906. *Essais Socialistes*. Paris.

VAN DE VELDE, HENRY. 1916. *Les Formules de la beauté architectonique moderne*. Weimar.

———. 1962. *Geschichte meines Lebens*. Translated and edited by Hans Curjel. Munich: R. Piper.

VAN DOVSKI, LEE. 1950. *Paul Gauguin oder die Flucht von der Zivilisation*. Olten: Delphi.

VARENNE, GASTON. 1910. "La Pensée et l'art d'Emile Gallé." *Mercure de France* 21, pp. 31–44.

VENTURI, ROBERT. 1966. *Complexity and Contradiction in Architecture*. New York: The Museum of Modern Art.

VERDIER, J. P. 1964. *Contribution à l'histoire de la haute joaillerie française au 19 et 20 siècles*. Saint-Germain-en-Laye.

VERDIER, PHILIPPE. 1968. "Les Céramiques de Gauguin." *Cahiers de la Céramique, du Verre, et des Arts du Feu* 41, p. 46.

VERHAEREN, EMILE. 1898. "Charles van der Stappen." *Magazine of Art*, pp. 295–99.

VERNEUIL, M. P. 1900. "Les Etoffes tissées et les Tapis—Séries à l'Exposition." *Art et Décoration* 8, pp. 111–25.

———. 1902. "L'Exposition d'Art décoratif moderne à Turin." *Art et Décoration* 11, pp. 65–112.

———. 1903. "Les Objets d'art à la Société des Artistes Français." *Art et Décoration* 14, pp. 217–36.

———. 1904a. "Taxile Doat, Céramiste." *Art et Décoration* 16,

pp. 77–86.

———. 1904b. "Les Arts appliqués au Salon." *Art et Décoration* 15, pp. 166–96.

———. 1910. "Le Salon d'Automne et l'Exposition des Arts munichois." *Art et Décoration* 28, pp. 129–60.

———. 1913. "Le Salon de la Société des Artistes Décorateurs en 1913." *Art et Décoration* 33, pp. 88–100.

VEVER, HENRI. 1898. "Les Bijoux aux Salons de 1898." *Art et Décoration* 3, pp. 169–78.

———. 1908. *La Bijouterie française au XIXe siècle.* Vol. 3. Paris: H. Floury.

VIAUX, JACQUELINE. 1962. *Le Meuble en France.* Paris: Presses Universitaires de France.

LES VINGT. Catalogues of the salons, 1884–93.

VIOLLET-LE-DUC, EUGÈNE EMMANUEL. 1854–68. *Dictionnaire raisonné de l'architecture française du XIe au XVIe siècle.* Paris.

———. 1863, 1872. *Entretiens sur l'architecture.* 2 vols. Paris: A. Morel.

VITRY, PAUL. 1900. "L'Orfèvrerie à l'Exposition." *Art et Décoration* 8, pp. 161–76.

———. 1904. "Pierre Roche." *Art et Décoration* 15, pp. 117–27.

———. 1905. "Le Nouveau Musée des Arts Décoratifs." *Art et Décoration* 18, pp. 65–104.

VOLLMAR, HELENE. 1903. "René Lalique, Paris." *Deutsche Kunst und Dekoration* 13, pp. 153–73.

VOLLMER, HANS. 1955. *Allgemeines Lexikon der Bildenden Künstler des XX. Jahrhunderts.* Leipzig: E. A. Seemann.

WARE, DORA. 1967. *A Short Dictionary of British Architects.* London: Allen & Unwin.

WEISBERG, GABRIEL P. 1969a. "Samuel Bing: Patron of Art Nouveau. The Appreciation of Japanese Art." *Connoisseur,* October, pp. 119–25.

———. 1969b. "Samuel Bing: Patron of Art Nouveau. Bing's Salons of Art Nouveau." Ibid., December, pp. 294–99.

———. 1970. "Samuel Bing: Patron of Art Nouveau. The House of Art Nouveau Bing." Ibid., January, pp. 61–68.

———. 1971a. "Samuel Bing: International Dealer of Art Nouveau. Contacts with the Musée des Arts Décoratifs, Paris."

Ibid., March, pp. 200–205.

———. 1971b. "Samuel Bing: International Dealer of Art Nouveau. Contacts with the Victoria and Albert Museum." Ibid., April, pp. 275–83.

———. 1971c. "Samuel Bing: International Dealer of Art Nouveau. Contacts with the Kaiser Wilhelm Museum, Krefeld, Germany, and the Finnish Society of Crafts and Design, Helsinki, Finland." Ibid., May, pp. 49–55.

———. 1971d. "Samuel Bing: International Dealer of Art Nouveau. Contacts with the Museum of Decorative Art, Copenhagen." Ibid., July, pp. 211–19.

———. 1971e. "Bing Porcelain in America." Ibid., November, pp. 200–203.

———, ET AL. 1975. *Japonisme: Japanese Influence on French Art, 1854–1910.* Cleveland: The Cleveland Art Museum, The Rutgers University Art Gallery, and The Walters Art Gallery.

Whistler: An Exhibition of Paintings and Other Works. 1960. London: Arts Council of Great Britain.

WHITBY, MRS. J. E. 1901. "The Art Movement. Art in Belgium: The Work of M. Philippe Wolfers." *Magazine of Art,* pp. 322–26.

WICHMANN, SIEGFRIED. 1972. "The Rose-Water Sprinkler—Its Role between East and West around the Year 1900." In *World Cultures and Modern Art,* edited by Siegfried Wichmann. Munich: Bruckmann.

WILDE, OSCAR. 1906. *Decorative Art in America.* New York.

WILDENSTEIN, GEORGES. 1964. *Gauguin.* Paris: Les Beaux-Arts.

WILSON, ARNOLD. 1961. "A. H. Mackmurdo and the Century Guild." *Apollo,* November, pp. 137–40.

WITTAMER, YOLANDE. 1961. *Affiches de la Belle Epoque.* Brussels.

WOECKEL, GERHARD P. 1968. *Jugendstilsammlung.* Kassel: Staatliche Kunstsammlungen.

WOLFERS, MARCEL. 1965. *Philippe Wolfers, Précurseur de l'Art Nouveau.* Brussels: Meddens.

YOUNG, ANDREW MCLAREN. 1968. *Charles Rennie Mackintosh (1868–1928): Architecture, Design, and Painting.* Glasgow: Scottish Arts Council.

YOUNG, J. 1878. *The Ceramic Art.* New York: Harper & Bros.

Exhibitions Cited

AMERSFOORT 1972: Sonnehof. *Sierrad 1900–1972.*

ANTWERP 1894: *Exposition Universelle.*

BEAUVAIS 1973: Musée Départemental de l'Oise. *Auguste Delaherche (1857–1940).*

BERLIN 1965: Staatliche Museen Preussicher Kulturbesitz, Haus am Waldsee. *Der Japonismus in der Malerei und Graphik des 19. Jahrhunderts.*

BOSTON 1975: Museum of Fine Arts. *French Art Glass.*

BREMEN 1971: Kunsthalle. *Maurice Denis—Gemälde Handzeichnungen Druckgraphik.*

BREST 1971: Musée des Beaux-Arts. *Le Temps de Gauguin.*

BRUSSELS 1896: Salon de la Libre Esthétique.

BRUSSELS-TERVUEREN 1897: *Exposition Internationale.*

BRUSSELS 1899: Salon Pour l'Art.

BRUSSELS 1900: Salon de la Libre Esthétique.

BRUSSELS 1962: Musées Royaux des Beaux-Arts. *Le Groupe des XX et son Temps.*

BRUSSELS 1963a: Pro Civitate, Palais des Beaux-Arts. *L'Art et la Cité.*

BRUSSELS 1963b: Palais des Beaux-Arts. *Henry van de Velde 1863-1957.*

BRUSSELS 1965: Hôtel Solvay. *Le Bijou 1900.*

BRUSSELS 1970: Ministère de l'Education Nationale, Galerie L'Ecuyer. *Henry van de Velde 1863-1957.*

BRUSSELS 1972: Galerie L'Ecuyer. *Philippe Wolfers. Précurseur de l'Art Nouveau Statuaire.*

BRUSSELS 1973: Hôtel de Ville de Saint-Gilles and Musée Horta. *Horta.*

BRUSSELS 1974: Musée Horta. *Alphonse Mucha.*

BRUSSELS 1975: Musées Royaux d'Art et d'Histoire. *L'Art français aux Musées Royaux d'Art et d'Histoire.*

CAEN 1963: Maison de la Culture. *Exposition inaugurale.*

CAIRO 1969: *Peinture en France de Signac au Surréalisme.*

CAMBRIDGE 1961: Harvard College Library and Boston Museum of Fine Arts. *The Artist and the Book, 1860-1960, in Western Europe and the United States.*

CAMBRIDGE 1970: Harvard University, The Houghton Library. *The Turn of a Century, 1885-1910.*

CAMBRIDGE 1972: Massachusetts Institute of Technology. *Images of the Feminine in the Belle Epoque.*

CARDIFF 1957: *Vuillard.*

CHICAGO 1893: World's Columbian Exposition.

CHICAGO 1971: University of Chicago, The Joseph Regenstein Library. *Victorian Bookbinding.*

CLEVELAND 1975: The Cleveland Museum of Art, The Rutgers University Art Gallery, and The Walters Art Gallery. *Japonisme: Japanese Influence on French Art, 1854-1910.*

COLOGNE 1974: Kunstgewerbemuseum der Stadt Köln, Overstoltzenhaus. *Französische Keramik zwischen 1850 und 1910: Sammlung Maria und Hans-Jörgen Heuser, Hamburg.*

COPENHAGEN 1893: Gauguin exhibition.

DARMSTADT 1898: *Kunst und Kunstgewerbe—Austellung.*

DRESDEN 1899: *Deutsche Kunstausstellung.*

DRESDEN 1901: *Internationale Kunstausstellung.*

DRESDEN 1906: *Das Deutsche Kunstgewerbe.*

DÜSSELDORF 1963: Kunstmuseum. *Glassammlung Hentrich, Antike-Jugendstil.*

DÜSSELDORF 1967: Galerie Horstmann. *École de Pont Aven.*

DÜSSELDORF 1974: Hetjens-Museum. *Europäische Keramik des Jugendstils: Art Nouveau Modern Style.*

GHENT 1962: Musée des Beaux-Arts. *Théo van Rysselberghe.*

HAGEN 1959: Karl-Ernst Osthaus Museum. *Der junge Van de Velde und sein Kreis.*

HAGEN 1963: Karl-Ernst Osthaus Museum. *Henry van de Velde: Gebrauchsgraphik, Buchgestaltung, Textilentwurf.*

HAGEN 1968: Karl-Ernst Osthaus Museum. *Art Nouveau in England und Schottland.*

HAMBURG 1963: Museum für Kunst und Gewerbe. *Plakat- und Buchkunst um 1900.*

HAMBURG 1974: Museum für Kunst und Gewerbe. *Wir öffen die Schatzkammern-Textilien.*

HANOVER 1969: *Kunst- und Antiquitätenmesse.*

HONFLEUR 1975: Salles d'Exposition du Grenier à Sel. *Exposition Maurice Denis 1870-1943.*

KREFELD 1900: Kaiser-Wilhelm-Museum.

LAFAYETTE 1967: Lafayette Art Center, Indiana. *Auguste Rodin: An Exhibition of Small Sculpture, Drawings, and Prints.*

LAWRENCE 1968: The University of Kansas Museum of Art. *The Golden Age of the Woodcut/The Woodcut Revival.*

LILLE 1967: Palais des Beaux-Arts. *Emile Bernard: Paintings, Drawings, Prints.*

LONDON 1952: Victoria and Albert Museum. *Victorian and Edwardian Decorative Arts.*

LONDON 1957: *Vuillard.*

LONDON 1961: Goldsmith's Hall. *International Exhibition of Modern Jewellery.*

LONDON 1963: Victoria and Albert Museum. *Mucha.*

LONDON 1966a: Royal Academy of Arts. *Pierre Bonnard 1867–1947.*

LONDON 1966b: Tate Gallery. *Gauguin and the Pont Aven School.*

LONDON 1966c: Victoria and Albert Museum. *Aubrey Beardsley.*

LONDON 1968: Scottish Arts Council in association with the

Edinburgh Festival Society, Victoria and Albert Museum. *Charles Rennie Mackintosh (1868–1928): Architecture, Design, and Painting.*

LONDON 1970: Wildenstein Gallery. *Pictures from Southampton.*

LONDON 1972: Arts Council of Great Britain, Hayward Gallery. *French Symbolist Painters: Moreau, Puvis de Chavannes, Redon, and Their Followers.*

LONDON 1974a: Architectural Association. *Antoine Pompe: The Architecture of Sentiment.*

LONDON 1974b: Architectural Association. *Henri van de Velde: Theater Designs, 1904–14.*

MADRID 1972: Museo Español de Arte Contemporáneo. *El simbolismo en la pintura francesca.*

MANNHEIM 1963: Kunsthalle. *Die Nabis und ihre Freunde.*

MILAN 1973: Museo Poldi Pezzoli. *Gioielli di Artisti Belge dal 1900 al 1973.*

MUNICH 1899: Sezession exhibition.

MUNICH 1964: Haus der Kunst. *Sezession: Europäische Kunst um die Jahrhundertwende.*

MUNICH 1966: Galleria del Levante. *Pont-Aven et Nabis.*

MUNICH 1968: Haus der Kunst. *Vuillard.*

MUNICH 1969: Museum Stuck-Villa. *Internationales Jugendstilglas: Vorformen moderner Kunst.*

MUNICH 1972: Haus der Kunst. *Weltkulturen und moderne Kunst.*

MÜNSTER 1975: Landesmuseum. *Hector Guimard, 1867–1942.*

NAMUR 1958: Galerie d'Art de Namur. *Exposition la Collection Vanuytrecht.*

NANCY 1963: Musée des Beaux-Arts. *Hommage à Roger Marx.*

NEW YORK 1956: Wildenstein. *Gauguin.*

NEW YORK 1959: Durand-Ruel. *Bernard.*

NEW YORK 1960: The Museum of Modern Art. *Art Nouveau.*

NEW YORK 1961: The Museum of Modern Art and The Art Institute of Chicago. *Odilon Redon, Gustave Moreau, Rodolphe Bresdin.*

NEW YORK 1967: Grolier Club. *The Art Nouveau Book.*

NEW YORK 1969: Finch College Museum of Art. *Art Nouveau.*

NEW YORK 1970: The Museum of Modern Art. *Hector Guimard.*

NEW YORK 1971: Columbia University, Department of Art History and Archaeology, and Philadelphia Museum of Art. *From Realism to Symbolism: Whistler and His World.*

NEW YORK 1972: The Museum of Modern Art. *Symbolism, Synthetism, and the Fin-de-Siècle.*

NEW YORK 1974a: The Museum of Modern Art. *Felix Vallotton: Woodcuts.*

NEW YORK 1974b: New York Cultural Center. *Painters of the Mind's Eye.*

NEW YORK 1975a: The Metropolitan Museum of Art. *The Great Wave: The Influence of Japanese Woodcuts on French Prints.*

NEW YORK 1975b: The Museum of Modern Art. *Points of View.*

OSLO 1970: *Henry van de Velde.*

OSTENDE 1967: Musée des Beaux-Arts, Kursaal. *Europa 1900.*

PARIS 1876: Union Centrale des Beaux-Arts.

PARIS 1884: Musée des Arts Décoratifs. *La Pierre, le Bois, la Terre, et le Verre.*

PARIS 1889: *Exposition Universelle.*

PARIS 1891–1914, Salon SNBA: Salons of the Société Nationale des Beaux-Arts.

PARIS 1892: Le Barc de Boutteville. Nabi exhibition.

PARIS 1893: Durand-Ruel. *Oeuvres récentes de Gauguin.*

PARIS 1894: Galerie Georges Petit. Dalpayrat-Lesbros exhibition.

PARIS 1897–1910, Salon SAF: Salons of the Société des Artistes Français.

PARIS 1900: *Exposition Universelle.*

PARIS 1902: Salon des Boursiers de Voyage.

PARIS 1903: Musée des Arts Décoratifs. *Exposition Ecole de Nancy.*

PARIS 1906–13, Salon SAD: Salons of the Société des Artistes Décorateurs.

PARIS 1907a: Musée des Arts Décoratifs. *Auguste Delaherche.*

PARIS 1907b: Ecole des Beaux-Arts. *Exposition de l'Oeuvre de Eugène Carrière.*

PARIS 1910: Musée des Arts Décoratifs. *L'Oeuvre céramique du potier Chaplet.*

PARIS 1924a: Rue de la Ville-l'Evêque. First exhibition benefitting the Friends of the Luxembourg.

PARIS 1924b: Galerie Balzac. *Georges Lacombe.*

PARIS 1931: Le Portique. *Gauguin.*

PARIS 1933: Musée des Arts Décoratifs. *Le Décor de la Vie sous la IIIe République de 1870 à 1900.*

PARIS 1934a: Musée des Arts Décoratifs. *Exposition rétrospective E. J. Ruhlmann.*

PARIS 1934b: Musée Galliera. *Rupert Carabin.*

PARIS 1937: Musée des Arts Décoratifs. *Le Décor de la Vie de 1900 à 1925.*

PARIS 1938: Musée des Arts Décoratifs. *Vuillard.*

PARIS 1943: Musée des Arts Décoratifs. *Soieries lyonnaises de 1800 à nos jours.*

PARIS 1951: Musée des Arts Décoratifs. *L'Art du Verre.*

PARIS 1955: Musée National d'Art Moderne. *Bonnard, Vuillard et les Nabis.*

PARIS 1957: Bibliothèque Nationale. *Gustave Geffroy et l'Art moderne.*

PARIS 1960: Musée National d'Art Moderne. *Les sources du XXe siècle: Les Arts en Europe de 1884 à 1914.*

PARIS 1961: Musée du Costume. *Modes de la Belle-Epoque 1890–1910.*

PARIS 1962: Galerie Bellier. *E. Bernard.*

PARIS 1964: Musée des Arts Décoratifs. *Cent ans—Cent Chefs-d'oeuvre.*

PARIS 1966: Bibliothèque Forney. *Un Maître de l'Art Nouveau: Alphonse Mucha.*

PARIS 1967: Musée des Arts Décoratifs. *Trois siècles de papier peint.*

PARIS 1969: Musée des Arts Décoratifs. *César/Daum.*

PARIS 1970a: Musée Galliera. *Esthètes et Magiciens.*

PARIS 1970b: Orangerie des Tuileries. *Maurice Denis.*

PARIS 1970c: Musée des Arts Décoratifs. *Souvenir d'Aman-Jean (1859–1936)*.

PARIS 1970d: Bibliothèque Nationale. *André Gide*.

PARIS 1971a: Galerie du Luxembourg. *Hector Guimard, Fontes Artistiques*.

PARIS 1971b: Musée des Arts Décoratifs. *Pionniers du XXe Siècle: Guimard, Horta, Van de Velde*.

PARIS 1972: Grand Palais. *Peintres de l'imaginaire: Symbolistes et Surréalistes Belges*.

PARIS 1973: Grand Palais. *Autour de Lévy-Dhurmer: Visionnaires et Intimistes en 1900*.

PARIS 1974a: Ancien Hôtel des Archevêques de Sens. *Céramique Impressioniste: L'Atelier Haviland de Paris-Auteuil, 1873–1882*.

PARIS 1974b: Galerie du Luxembourg. *L'Oeuvre de Rupert Carabin, 1862–1932*.

PARIS 1974c: Musée des Arts Décoratifs. *Matière-Technologie-Forme*.

PARIS 1974d: Musée du Louvre. *Renaissance du Musée de Brest*.

PAU 1973: Musée. *L'Autoportrait du XVIIIe siècle et nos jours*.

PHILADELPHIA 1876: *Centennial International Exhibition*.

PONT-AVEN 1960: *Bernard*.

PRINCETON 1972: Princeton University Art Museum. *The Arts and Crafts Movement in America, 1876–1916*.

RICHMOND 1971: Virginia Museum of Fine Arts. *Art Nouveau*.

SAINT-AMAND-EN-PUISAYE 1967: Mairie. *Hommage à Jean Carriès*.

SAINT-DENIS 1961: Musée Municipal. *La Bretagne*.

SAINT-GERMAIN-EN-LAYE 1892: *Exposition des Beaux-Arts*.

SAINT-GILLES 1973: Hôtel Communal de Saint-Gilles. *Victor Horta*.

SAINT LOUIS 1904: *Louisiana Purchase Exposition*.

SANTA CRUZ 1974: University of California at Santa Cruz, Sesnon Gallery. *Fin de Siècle: The Art Nouveau and Symbolist Era*.

SÈVRES 1971a: Musée National de Céramique. *L'Art de la Poterie en France de Rodin à Dufy*.

SÈVRES 1971b: Musée National de Céramique. *Porcelaines de Sèvres au XIXe Siècle*.

STUTTGART 1963: Württembergischer Kunstverein. *Henry van de Velde zum 100 Geburtstag*.

SYRACUSE 1964: Syracuse University, The School of Art. *Art Nouveau*.

TERVUREN 1967: Musée Royal de l'Afrique Centrale. *Terveuren 1897*.

TOKYO 1961: National Museum. *Exposition d'art français contemporain*.

TOKYO 1968a: Seibu de Shibuha. *Art Nouveau*.

TOKYO 1968b: National Museum. *Rapports de l'Art Japonais et de l'Art Occidental*.

TOKYO 1975: Isetan de Shinjuku. *Image des Années Insouciantes 1900/1925*.

TURIN 1902: *Il primo Esposizione Internazionale d'Arte Decorativa Moderna*.

TURIN 1961: *Mode, Style, Costume*.

WARSAW 1973: Muzeum Plakatu. *Art Nouveau: Affiches Belges, Projets et dessins 1892–1914*.

ZÜRICH 1952: Kunstgewerbemuseum. *Um 1900. Art Nouveau und Jugendstil*.

ZÜRICH 1958: Kunstgewerbemuseum. *H. van de Velde 1863–1957, Persönlichkeit und Werk*.

ZÜRICH 1966: Kunsthaus. *Gauguin et le Groupe de Pont Aven*.

ZÜRICH 1975: Museum Bellerive. *Objekte des Jugendstils*.

Index of Names

Page numbers are given throughout; **bold-face** indicates works included in the exhibition.

512